VISUAL VITRIOL

THE WEED
THE NEED
APRIL 2
9pm Rice Coffee House
Rice Campus
Entrance 13
info? 713.348.ktru

VISUAL VITRIOL

THE STREET ART AND SUBCULTURES OF THE PUNK AND HARDCORE GENERATION

David A. Ensminger

FEB 08 2012

University Press of Mississippi / Jackson

www.upress.state.ms.us

The University Press of Mississippi is a member of the
Association of American University Presses.

Portions of this material have been previously featured
in *Artcore*, *Left of the Dial*, the *Journal of Popular Music
Studies*, *Houston Press*, and *Postmodern Culture*.

Page ii: The Need, original mock-up, Rice Campus,
Houston, Texas, by Russell Etchen.

First printing 2011

∞

Library of Congress Cataloging-in-Publication Data

Ensminger, David A.
 Visual vitriol : the street art and subcultures of the
punk and hardcore generation / David A. Ensminger.
 p. cm.
 Includes bibliographical references and index.
 ISBN 978-1-60473-968-8 (cloth : alk. paper) — ISBN
978-1-61703-073-4 (pbk. : alk. paper) — ISBN 978-1-
60473-969-5 (ebook) 1. Street art—Themes, motives.
2. Punk culture and art. I. Title. II. Title: Street art and
subcultures of the punk and hardcore generation.
 ND2590.E57 2011
 751.7'3—dc22 2010049508

British Library Cataloging-in-Publication Data available

In memory of
Todd Moore,
Dixon Coulbourne,
Randy "Biscuit" Turner,
and
Olin Fortney, Deaf Club punk veteran

Dedicated to Julie Ensminger

Contents

VISUAL
VITRIOL

Introduction

The art of the past has

apparently become a free-

for-all for everybody. I like

that word "free-for-all." It

means democratic, also no

values, and everything goes,

and anybody can do it and

everybody's doing it.

—AD REINHARDT, painter, 1958

January 8, 1981. Someone snaps a Kodak picture in my bedroom. My arms are half-raised, crooked. Showing the lens a handheld RCA cassette recorder, I smile and arch back a bit, looking like a TV baby in the womb of consumer capitalism. A Muppets poster dots the wall, a Mickey Mouse quilt keeps me warm during the Midwest nights, blue Star Wars pajamas make me a member of the Lucas craze, and Raggedy Andy sits in the lap of a stuffed rabbit. The room appears frozen in amber: yellow shag carpeting, loose golden curtains, and mustard-colored walls surround me. Nearby is my brother, who is ten years older. We once shared this space before Dad put plywood walls and corkboards down in the basement, providing him a nest. He is scruffy: a peroxide stripe runs down the middle of his black hair. He looks at the floor, shiftless and bored. Years later he wonders if this demeanor was due to the drugs. He has three records with him, by Public Image Limited, Siouxsie and the Banshees, and Cockney Rejects. I can still hear my mom crying next to the washing machine, wondering what the hell is happening to her eldest son. This begins my descent into punk rock.

In the thirty-five years since the now-defanged Sex Pistols spat in the face of pop culture and the Ramones buzzsawed through dinosaur rock, few former punks forget the zero hour in each of their lives—the rupture, the shock wave, the going "against the grain" that defined their relations to institutions and informal networks of subcultures. Punk rock is a landscape of memory, therefore sometimes a minefield of contested truths. For some, punk is nothing more than an ever-mutating genre, for others an attitude or a lifestyle, for still some others a gestalt, a way to organize perceptions. Media theorists like Al Larsen, who studies the logos rampant in punk visual culture, imagines it as "a grassroots 20th century folk culture . . . that developed its own DIY (Do-It-Yourself) media ecology" (2010: 2). As he infers, punk is much more than music percolating in the outer limits of pop fandom.

We recall rites of passage: electrifying records bought and traded; the in-crowds, comrades, and even psycho people who populated shows; cops who grimaced and sometimes launched attacks; dank and shabby roach-ridden clubs; boots that hugged sore slamdance feet; blank-faced or venal parents; the crude art of nihilism on leather jack-

Flyers are one embodiment of the democratization of art that Punk brought about.

—WELLY, editor of Artcore fanzine, 2004

ets, flyers, and bodies. To many, being punk meant not falling prey to bland clichés of the "good life"—home, school, God, and country—that were shattered in the post–Me Generation era. Our own stereotypes of rebellion took hold. Even today our memories ricochet against the lore of others as we roam Facebook and blogs, recounting the dizzying nights of punk pandemonium; often, the lathered-up angst still burns inside us like phosphorous.

This book does not attempt to capture all the fuss and fury and spend its cultural capital on socio-anthropological methodology or literary

theory. The book is a way to trace the social discourse of punk: it examines the ways punks talk about themselves. By way of folklore and media analysis, I attempt to cohere this scattershot community, though I do not touch upon all groups. The mods, skinheads, and ska factions will be chronicled by others. I attempt to create a space mostly for the voices of North American and British punk and hardcore, from 1976 to the present; consequently, sometimes for the first time, different generations cohabit in an uneasy dance within the text.

Please don't expect this book to be an encyclopedia or an armchair compendium for record collectors who relish every last detail. Although I have presented many "factoids" in order to bear the burden of proof, gaps are bound to exist. I also do not wax overly theoretical (I hope), challenging stalwarts like Dick Hebdige and Jon Savage. Think of this book as an entranceway, a self-reflexive ethnography intended to capture an ever-shifting history still unfolding. It caters to a conversation that will always be unstable. The theory is meant to provide context and offer points of departure for readers. If they indeed want more information on carnivalesque, liminal, and hybrid tendencies, they may do so, free of my imprint and assumptions, after they finish reading. I offer them conversation and substance, folk history and ways of reconsidering punk issues.

Ten years ago, I picked up the hardcover edition of *Fucked Up and Photocopied* and realized that I too stashed flyers in bent boxes in my parents' basement—plus I continued to make batches for my own bands, which I tacked on local city walls, poles, and boards. Though the collection in the book mesmerized me, the original format was a coffee-table publication that felt a bit too posh. I decided to bring flyers and some theory directly to communities by using close-to-the-ground strategies that focused on worldwide possibilities. Calling my project Visual Vitriol, I soon amassed 3,000 posters, handbills, and flyers from across the globe by eliciting contributions from Italy, where the Manges, a Ramones-style band, sent me their own collection; Australia, where I swapped flyers with Scotti from Au Go Go Records; Germany, where record collector Joe Becker offered both rare female band flyers and small current handbills; South Korea, where young punk Han Suk Zoo sent me flyers, compilation CDs, and ephemera; Ireland, where editor Ed Hannon from *Ed on 45* fanzine offered a bundle; and Japan, where Yukihiro Yasuda sent me records and unique Tokyo handbills. I built a repository without walls, showing how punk aesthetics crossed borders and created transnational communities.

Only about 30 percent of the overall collection consists of original, authenticated items; the rest are duplications, including large photocopied collections of Randy "Biscuit" Turner of the Big Boys, Welly from *Artcore* and the band Four Letter Word (Wales), Remi of Modern City Records, Bob Weber and U-Ron Bondage (Ronnie Bond) of Really Red, Trish Herrera of the Mydolls, Tony Barber of the Buzzcocks, vocalist Aziz from the band NRA (Netherlands), who received many of his own from Poison Idea, Jeff Nelson from Minor Threat, and Joe of *Coolshit* photozine. That is just a small sampling. To me, this makes perfect sense. Xerox art, especially flyers, is meant for endless copying. Most flyer artists did not toil with messy markers, press-on letters, and small cut-and-paste collages in late-night binges to make scarce, one-off high art statements but to highlight and promote shows for bands. They wanted distribution, for the most part. So, I disseminated them across America, Europe, and Bangkok, where local American Ed Rudy (Hot Box Review Records) debuted a portion at a punk and skateboard rally. In Italy, we displayed them in an old WWII hangar, the basement of a leftist community center, and the yard of an old brick school next to vineyards. In England, we set them up at pubs, concert halls, and skateparks. In Oregon, we posted

them on the walls of libraries, record stores, and coffee shops. In New Mexico and Texas, they were warmly received at gallery spaces. In each location, they became a meeting place, triggering memory and nostalgia, debate and fanfare.

They represent some of the finest urban folk art and vernacular street art of my generation. Even the so-called primitive and "incompetent" ones are armed with desire. The crudeness, to paraphrase Russian poet provocateur Mayakovsky, often signifies a slap in the face of public and aesthetic taste, a way to resist the gentrification of poster craft, often lionized in the age of psychedelia. A punk rock collage from the Roxy club from 1976 made by the black artist Barry Jones beckons Dada back from the dustbins and challenges the safe space of minimalism, which held ludicrous artistic sway in an era of revolution and killing fields, terrorism and unemployment.

As Welly from *Artcore* argues as well, photocopy art is democratic and participatory, a way for everyday youth to become involved. This is practically punk protocol, for Sex Pistols manager Malcolm McLaren wanted to examine how "consumer goods, tourism, and mass media turns people into passive consumers. The Sex Pistols poured scorn on holidays in the sun and fast food products. They also encouraged the young to become producers of culture rather than consumers" (1999). The first waves of such punks were the harbingers of things to come, producing a deluge of fanzines and flyers, which some punks turned into business ventures.

Yet these torn-and-tattered, cut-and-paste leftovers of punk history are becoming relics in this teeming, high-speed Internet access world. Many "designers" no longer feel inclined to shred magazines, phonebooks, and catalogs, or even drag a pen or pencil across paper, let alone indulge in time-consuming press-on letters. The age of Adobe Illustrator has made even the most computer-illiterate feel welcome. The hum and whir of copy machines, along with the secret theft of

paper, toner, and ink from workplaces across the world, is fading away.

Flyers once rushed through late-night copy machine binges now spread virally on MySpace while one washes the dishes. In many places, telephone poles, once littered with layers of discolored flyers, are less and less tagged with flyers touting touring bands with unmentionable names, from the Dicks to Asshole Parade. Instead, corporate online social sites are the virtual street corners teeming with so-called friends, digital flyers, and bands selling themselves to strangers, replacing the rented halls and CBGBs of another era. What was once a brutal and raw flyer style that mirrored the post-industrial age (think of cities like Cleveland and Manchester), forming the visual backdrop of discord, from the Sex Pistols and Crass to Born Against and Assuck, is now associated with an age of slick, professional themes. Silkscreened skull T-shirts found at any Target store mimic legendary flyers. The stark and apocalyptic aesthetics of both Pushead and Profane Existence have become templates for endless middle-class commodity, built on the backs of cheap foreign labor. The occasionally vitriolic DIY art of 1982 is now just a reference point in the branding of watered-down youth culture style. The risk, spasm, and edginess of early punk art have been processed, diluted, and sprung on the streets again.

By examining flyers we can map out the punk landscape. They are not mere advertisements. They are mini-histories compressed onto yellowing, flimsy paper. Sometimes they are the only means by which we can document the existence of short-lived bands or sites. I imagine them as archival mile markers and assertive mementos, a way to witness the social milieu from which they arose. They became a platform for personal correspondence, a practical method to inscribe set lists and guest lists, and an avenue to disseminate the aesthetic template of future fanzines and record art. They also became meaningful gifts, tokens from regional punk scenes separated by pricey

phone calls, miles of boredom, and energy crisis gas station lines.

My punk memories often involve such give-and-take, like Biscuit from the Big Boys handing or mailing me troves of homemade art; John Stabb from Government Issue staying at my house on tour and giving me flyers and stickers; trading my leather shoes to NOFX for their first record after sharing frozen pizza; giving my Big Black LP to Shawn Brown from Swiz; Ray Cappo from Youth of Today giving me a copy of *The Higher Taste*, inaugurating my vegetarianism; giving mixed tapes of roots music to Peter Case, grunge music to Bun E. Carlos of Cheap Trick, and classic punk to Thomas Barnett from Strike Anywhere; Peter Case sending me the first issue of *Slash* and posters of the Nuns and Plimsouls; giving Jon Langford from the Mekons a Burl Ives LP; sharing dinner with members of Trenchmouth, the Circle Jerks, and Mars Volta; sharing my house or apartment with Swiz, Trusty, Moral Crux, and Aminiature; sharing my friends' homes with NOFX, SNFU, and Youth of Today.

This text attempts to refocus the way in which we encounter that personal history and recall the in-between spaces—the voices that often get lost, misunderstood, or forgotten in North American punk. My future work will include a focus on Deaf punks, Muslim punks, Native Americans, and Asian Americans, who have been members of seminal bands like the Subhumans (Canada), Marginal Man, Channel 3, Conflict (San Francisco), SNFU, Red C, Double O, Bitch Magnet, and Aminiature as well. The worldwide punk scene deserves attention, too. For now, we examine the often overlooked presence of African Americans, Hispanics, women, and gays and lesbians who have indelibly impacted the worldviews and music of the punk subculture. This is very personal to me.

My former punk brother (who attended a show during Black Flag's first tour, while I saw the last) is gay; the singer of my band the Texas Biscuit Bombs (featuring the indomitable Randy "Biscuit" Turner of the Big Boys) was gay (see Afterword); my sister offered me endless hours of Iggy Pop, Gun Club, and 999; my first wife was part of the Rockford hardcore and punk community, where we attended the same shows, like Fugazi, while women have joined six bands with me and worked for *Left of the Dial*; and some of the first African Americans I met included members of Swiz, Trenchmouth, and Kingface, while Chuck Ushida of the Defoliants/No Empathy was the first Asian man I spoke to. Granted, I grew up in the last ring of suburbs outside a factory town, but I have always equated punk with such convergence culture. Through punk, I connected with people outside the nearly all-white, ranch home, middle-class community of my life. It was my true schooling.

In the early 2000s, I began my stint as a music journalist, falling under the generous sway of *Houston Press*, *Magyar Taraj* from Hungary, and *Thirsty Ear* magazine, a free roots rock and Americana magazine based out of Santa Fe, where I once lived. In the 1980s, I briefly published two issues of a Xeroxed fanzine, *No Deposit No Return* (the title was lifted from a Henry Rollins spoken-word piece), while the third issue remained designed but untouched for almost fifteen years. After a year of writing reviews and engaging artists like Alejandro Escovedo, Violent Femmes, Merle Haggard, and Peter Case, I collected substantial interviews that were only partially used for print, so I decided, quite off the cuff, to take the leftover material and create my own magazine. With a policy of issuing no reviews, ever, I aimed the content solely at detailed interviews. To launch it, I culled bits from interviews with Gary Floyd (The Dicks, Sister Double Happiness), Ian MacKaye (Minor Threat, Fugazi), and Jello Biafra (Dead Kennedys), not to mention TSOL. The kind workers at *Skyscraper* zine helped guide my diligent designer Russell Etchen (later replaced by Ellen Dukeman) through the process. The resulting

magazine was thick, perfectly bound, and looked the part of something semi-professional, but we never featured a staff and we never made money. In fact, $23,000 later, the books remain collectors' items for the curious and a goldmine of information for this book, which is a natural extension of those interviews. In fact, those texts, along with the original Visual Vitriol catalog essay, which ended up reprinted in both *Artcore* and *Left of the Dial*, became the genesis of this book.

In 2005 my second wife and I headed to Oregon, to be close to the coast where she had spent time as a child. After a few years teaching in a small university town and living next to a dry grass seed farm, I decided to return to school to pursue a second master's degree at the University of Oregon. After researching the tantalizing work of Prof. Daniel Wojcik, a former punk himself (with early 1980s letters from Mike Muir of Suicidal Tendencies as proof) who authored an important book on punk and tribalism, I entered the Folklore Program, a melting pot of interdisciplinary studies. Under his guidance and tutelage, I shaped the original versions of this manuscript. The input of fellow university faculty also helped: Doug Blandy, John Fenn, Lisa Gilman, Sharon Sherman, Gabriela Martinez, and Debra Merskin. I am indebted to them all. The staff at University Press of Mississippi has been equally patient, forthright, and generous as well, especially Craig Gill, who oversaw this project from my first letter onward.

Most of all, I am thankful that my wife, herself an indie rock girl from the 1980s, believes in this project and travels with me as a co-curator over the years. Her diligence, attention to detail, and patience are pronounced and vital. More so, my parents never questioned my record collection habits. My mother spent hours chauffeuring me as I sifted through vinyl stacks before I could even drive, and she encouraged me to write. My father, himself a longtime craftsperson, printed my fanzines after hours at his office at a nearby factory. Such a family made the process of a book like this possible.

As I finished this manuscript, my mother phoned to tell me that Todd Moore, a maverick American poet who helped define "outlaw poetry," had died. As an authentic slice of raw Midwest lyricism, his titanic poem *Dillinger* is as expansive, dense, and fragmented as seminal work by William Carlos Williams, Ezra Pound, and Walt Whitman. My brother discovered his books, each marked with a dot of blood on the inside, while working at the Strand bookstore in New York. He gave them to me in the late 1980s when I visited him on East 7th St., down the street from fanzine shop See/Hear. I soon discovered that Moore lived the next town over from me, where he taught high school English. We struck up a friendship, swapping stories about B-movies, gangster lore, beatniks, and hardboiled novels. He introduced me to *Gun Crazy*, now one of my favorite films, and took my first wife and me to the opening of *Pulp Fiction*. In fact, he was one of the major reasons I moved with her to New Mexico, where he relocated after retirement. He was the first writer I knew, and the first writer to treat me as an equal. I hope that he has met Dillinger on the other side of Lethe. He was the last poet of his kind, a bridge between the quick and the dead. I miss him and Biscuit of the Big Boys deeply. These people should not remain lost in the recesses of history. This book also honors Dixon Coulbourn, who published the small but vital fanzine *Idletime* in Austin during the 1980s. He was a longtime friend of Biscuit: tragically, they died within weeks of each other. As editor of *Left of the Dial*, I published a large portion of his photo archive and his keen interview with Mark E. Smith of the Fall. He embodied a warm and earnest personality, edgy intelligence, and DIY spirit.

—DAVID ENSMINGER, Summer 2010

CHAPTER ONE
The Second Skin of Cities

The posters were a decla-
ration of war against art.
These posters screamed
ugliness all across town—
designs made to address
an army of disaffected
youth. These were the rats'
ears of the city fighting
the consumerist ideology
of the mainstream . . .

—Malcolm McLaren (1998)

The posters . . . reflect
all that vitality, sense
of absurdity, even the
occasional dark optimism
that accompanied the
whole scene.

—Robert Newman (1985)

Snatch greedily the big healthy chunks of young
brutal art that we give to you.

—Vladimir Mayakovsky (Futurists Gazette, 1918)

In almost every large city in the United States, vestiges of flyer art remain on traffic and light poles, kiosks, the sides of buildings, cramped record store spaces—just about anywhere one can use glue, wheat paste, tacks, thumbnails, tape, or staples. These works, whether intact or ripped, shredded, or faded, embody a living, not-so-secret visual history of a generation. They also reflect years of diligent, ongoing work on the part of artists and bands; one can peel back the past like a sequence of skins.

Punk flyers have become both collectible ephemera and the trash of a subculture, serving as instant, temporary, and often insurgent expressions. They chronicle technological and cultural shifts in contemporary history. Products of self-taught, naive, or frequently skilled artists, they often do not mimic previous eras of rock 'n' roll posters. They do not mirror the "boxing style" posters of the 1950s and early 1960s, nor the organic, curvy, bright lines of psychedelic posters. Instead, they unveil a new language of rupture and roughness, though they sometimes reflect minimalism and mere utility, too. Artist Winston Smith summarizes their ethos accordingly: "They are potent examples of how one can use a ball-point pen, a little glue, some typing paper, and a photocopy machine to help change the world" (1993).

As social texts, they pay witnesses to punk's ceaseless and potent tenet—Do It Yourself—a metaphor for punk's challenge to watered-down corporate mentality. Such posters also openly espouse punk's sense of endless struggle, its hope and hopelessness, and its irony and humor, which are often overlooked. As Chris Salewicz attests in the liner notes for *Burning Ambitions*, a punk music compilation: "It was both rebel music and very funny: a broad, baroque vein of humor ran through it whose closest comparison lay in the

There was a feeling that you didn't need any special training to create a project if you had a good idea to express . . .

One of these outlets was for a band member or a friend to create a different poster for each performance. It didn't matter whether a punker had art training or not—DIY, do it yourself, was in the air. . . . Objects d'art were being made by people with very little capital.
—East Bay Ray (Dead Kennedys, 1998)

brief satire movement of the early 1960s" (1982). Mike Palm from Agent Orange shares a similar vein of thought: "People think that punk is just this nasty thing, but really, I think it was an intelligent movement that sort of paraded as idiocy, for the fun of it" (2010). Punk tapped such humor to expose the underlying seriousness of art and politics.

Songs like "Institutionalized" by Suicidal Tendencies (1983) have become classics now played on broadband and satellite FM radio: the vexed young narrator desires to sit in his room, drink a Pepsi, and think "about everything . . . and nothing," but is misunderstood by his family, who want him to undergo psychiatric treatment. He fights their accusations, reminding them, "I went to your schools, your churches, and your institutional learning facilities." Yet, they want "to give me the needed professional help, to protect me from the enemy, myself." The song deftly recounts

and balances a sense of fomented, blistering anger and family meltdown with an edge of humor that was personally experienced in households across America by thousands of youth during the initial waves of punk and hardcore.

Flyers reflect this alienation. They are instant, short-lived, photocopied art forms; as such, they are made with built-in obsolescence. The content often embodies crude aesthetics on paper that is "here today, gone tomorrow." They reveal punk rock as different in the engulfing barrage of pop culture because the genre tends to reveal the bracing, even vociferous postures of a counter-culture clamoring towards anti-authoritarianism. Likewise, punk is in part a history lesson, of being bilious and vile, of people smart and unruly, pragmatic and idealistic; it evokes a republic of Xerox, forged by principled provocateurs trumpeting politics brimming with indignation. Punk embodied a restless culture of politics rooted in music that "is always the gristle. That doesn't break down in the crucible of pop culture ... [since] ... everyone in [first generation] punk was descended, within one–two generations, from some social injustice somewhere" (Nylons 2006: 136). On some level, this genre testified while the rest of pop music entertained.

The Dissemination of Discord

The migration and dissemination of punk art, especially flyers, can be understood as revealing the essence of DIY culture, long before one could purchase the *Design It Yourself Deck* and *Guerrilla Art Kit* at huge retail bookstores. Throughout the last thirty years, punk flyers often have been posted illegally. Most communities treat flyer art as a nuisance, vandalism, and even a form of graffiti. Hence, the spread of these flyers can be understood as events, often done late at night, by street teams or artists who wish to

spread information about shows but also to infiltrate mainstream culture by producing instant art with political or social content that combines a sense of agitprop and aesthetic agitation. Note the case of bands like Black Flag, who routinely co-opted or kidnapped the designs of Raymond Pettibon and made thousands of copies. The flyering process was furtive, marked both by purpose (to promote) and "kicks" (to have fun), resulting in hordes of Xeroxed or offset press flyers stuck to city walls, train bridges, and utility poles, some weathered but still visible for years.

As bass player Chuck Dukowski admits on the liner notes to their double album *Everything Went Black*, "We . . . plastered the city with our posters . . . with a literal vengeance" (1982). Four of these Raymond Pettibon posters frame the back sleeve of the record, revealing police, priests, horned men, and the invitation to "Creepy Crawl" at the Whisky A Go Go, a well-known Los Angeles venue that witnessed the early hardcore dance. The migrated phrase could even be heard invoked by the band Cause for Alarm during their Rock Against Reagan set in 1982 at CBGB ("Creepy Crawl NYC style y'all!"). Variations abounded within Black Flag lore, such as "Creepy Crawl the Starwood. The Starwood must be creepy crawled" and "Creepy Crawl a Slumber Party" with a picture of a teenage girl carving a cross into another's girl's forehead. When asked by Al Flipside in 1980 about the meaning of the phrase, singer Dez Cadena summarized it as "an exercise in fear, give someone the shakes," referencing Manson Family "crawls" in middle-class homes during the night, when they would rearrange furniture (#22).

While Black Flag was pursuing hit-and-run postering in the bowels of L.A., in Canada Joey Shithead, then with the Skulls (later the singer behind punk band DOA, which still records and tours) practiced the same guerilla media.[1]

According to Shithead in his autobiography *I, Shithead*:

I would jam my backpack full of posters, squeezing in a bag of flour and staple gun, and take along my trusted bucket. Then I would hop on a bus and go to it. When there was nowhere to use the staple gun, I would stop at a gas station for some water and mix up a thick, gooey mixture of water and flour. I'd spread the goo on some metal light standards with my hands, and stick up the poster. (Some of those posters stayed up for years, which is saying something considering the long periods of rain we endure on the West Coast). After a short while my jeans and leather jacket were so covered with the shit that I looked like a drywaller. (2004: 36)

One of the posters he hung, advertising a show featuring the Skulls and the Lewd, had a huge image of the word PUNKS lettered in graffiti style across the top half, replete with mock drippage, amplifying the links between both forms of insurgent street art.

During the same time frame, the *Final Solution* zine staff based themselves in New Orleans. They reported that the lead singer of the Hates, a band from Houston, Texas, was chased down by locals for flyering in Houston, while a member of the Re*Cords (Reversible Cords) was supposedly sought by the FBI in Austin for printing flyers on the back of IRS forms in 1979. By early 1983, Dave Dictor, singer for Millions of Dead Cops informed *Suburban Voice* that the band Crucifucks made a poster filled with images of dead cops promoting a concert with the two bands in Lansing, Michigan; in response, police shut down local punk shows and attempted to squelch the community.

Even the Clash, the most successful punk band prior to Green Day and Nirvana, feature their own flyer lore. Broke after a night of flyering London with gig handbills glued to surfaces with a mixture of flour and water, they ate from the same bucket to quell their hunger. As described in the book *Babylon Burning*, guitarist Mick Jones was no art amateur, for he "had already worked for fashion designer Zandra Rhodes, [and] hit upon an original flyer design that used the technology of colour Xeroxing and juxtaposing discordant images to catch the eye even when no larger than A4. It defined a handbill style that would endure through all the hardcore years" (Heylin 2007: 194). Thus, if a unifying lore exists for punk flyer dissemination and style, it might reside within such episodes.

Flyers were also used as mailers, letter stock, or easily reproduced and packaged promotional tools. For instance, Mike Muir from Suicidal Tendencies used flyers as letterhead to fans, and the label BYO would include a handful of flyers when shipping items to buyers across the world, with a handwritten thank you note, often from Becca Porter, a worker at the small office. SST, the label behind Black Flag, Hüsker Dü, and the Minutemen, would also regularly provide free posters, stickers, flyers, and tour dates, as would Alternative Tentacles, who produced the Dead Kennedys, Dicks, Butthole Surfers, and many more. By the mid-1980s, Dirk Dirksen, infamous show promoter for clubs like Mabuhay Gardens in San Francisco, who also managed the Dead Kennedys, established a flyer art mail-order service that featured both original copies and reprints on heavy stock paper. Magazines like *Maximumrocknroll* and *Flipside* regularly featured flyer art in the design layout for articles, as would some record labels when designing LP materials. For instance, the *Can You Hear Me? Music from the Deaf Club* LP features flyer designs in the liner notes, which is one of the only means of documenting the unique club's short-lived existence. Lastly, in the age of the Internet, digital flyers, which may only exist as virtual designs and sometimes never printed, often reach fans via email sites or social networking sites such as MySpace and Facebook. However, poster street teams still operate in most large urban cities, such as Portland, where one poster

distributor in 2006 earned five cents for every poster he was able to affix to wooden and metal utility poles or windows in local businesses.

Yet the business of promotion may actually be secondary to the conversation that these posters enable. "While flyers do not work as successful advertisements for specific shows," Barry Shank suggests, "they do not draw people into the clubs to see bands they have never seen before— they do work as another way to display aspects of a band's image to those willing to pay attention. . . . Some bands use their flyers to carry on public conversations with critics, with booking agents, and with other bands" (1994: 4). Thus, the medium represents not just a temporary slice of DIY art that slides innocuously into a sticker- and paper-besieged city. The medium is actually endowed with back-and-forth interrogations of youth issues.

I believe that the wellspring from which punk poster art has emerged is deep and wide, not simply a byproduct of late capitalism's rampant youth cultures. It is much older, perhaps reflecting the robustly executed nineteenth-century advertising posters that "decorated the once gray streets of Paris. Long before the age of mass media, the posters were the principal means of advertising products, stores, theaters, ballets and local performers" (Lyons 2001).[2]

Shortly after their inauguration in the city of light, collecting the posters became a quick and easy way to "bring the 'museum of the streets,' into homes. It was a modern, inexpensive way to decorate. The posters could easily be ripped off outdoor walls and kiosks. Serious collectors hoarded the advertising posters with a vengeance, amassing an average of 500 to 600 posters each" (Lyons 2001). Punk posters, long before the Internet became accessible, also seized the public's imagination, not for their charm and splendor but for their brute style. Like an earlier era, fans of either the bands or the art were also driven to collect the "instant art" to preserve them or to decorate their own dwellings.

At least in their early rugged forms, flyers serve as an update of this advertising trend, nearly one hundred years later. Instead of responding to the gray city pall with rich tapestries of willowy, naturalistic pen lines and soft colors, punk art actually mirrored the rust-tinged, scarred industrial landscapes and attempted to penetrate deep into the recesses of the modern "hive"—the city. Just as the Ramones' first record was a "bold swipe at the status quo" (Sculatti 1976), punk posters were a bold swipe at the workaday routines and habits of life in the bustling but conformist grid of cities, testing the boundaries that constitute "space as territory . . . imposed on an often-recalcitrant topography" (Shields 2006). When business and civic groups, neighborhood watch groups, or concerned neighbors join with police to monitor street art—graffiti or postering—what they really monitor are the borders and the recalcitrant artists who utilize the topography to their own ends, including even simple acts of graffiti-as-commemoration. These might be spiked with social commentary, such as in Salt Lake city during the late 1980s, where "along the side of the viaduct ramp, you'd see graffiti reading, 'This ain't the summer of love, this is the summer Jim died,' with a stick figure dinosaur painted beside it" (Anderson 2006).

In addition, punk and new wave ("new music") posters have roots in other various periods and genres: the harsh political machinations unearthed by painters like Goya, Munch, and Grosz; the solidarity-inspired, bold geometry, and intense color of Russian constructivist designs from the 1920s; the stylistically varied and vibrant WPA posters of the 1930s, the style and mass commercialism of movie handbills and advertisements, most notably including the work depicting horror movies; the naïve and art brut philosophy and tactics of Dubuffet; the collage and cut-ups of Dada and Surrealism; and the sordid and widely loved comic transgressions such as *Tales from the Crypt, Zap Comix*, and *MAD*.

Barry Jones reinforces the link between comics and Xerox flyers: "The cut-up . . . doing

collages was great. I was really into (teen) comics at the time . . . and I'd just discovered colour Xerox. I'd just discovered how it changed the textures of the colors—how it gave it this look—so I started just pasting things up" (Heylin 2007: 374). Others in New York were creating fanzines with a similar technique, including the founders of *PUNK*. Using their "collective media-drenched consciousness . . ." inundated with a diet of "comic books, *MAD* magazine, science fiction novels . . . grade B movies . . . and Saturday morning cartoon shows," such early participants "dissected and rearranged" them until they were "regurgitated into new forms" (Hager 1986: 1, 5). John Holstrom, one of the founders of *PUNK*, explained to an interviewer for *Kicking and Screaming*, "We thought we were going to be the new *Banana*'s magazine or the new *MAD* magazine. Like a *MAD* magazine for rock 'n' roll" (#12, 2005). On both sides of the Atlantic, denizens of punk—actively converging such styles and eras—fast became the eyewitnesses, chroniclers, promoters, and visual art mavericks of the so-called punk first wave.

Still, a poster is not a sum of references to other eras and trends, an amalgam of clip art. This would reduce flyer making to mere assemblage, like a puzzle, with little distinct style or felicity. Punk poster art did not dwell in this ghetto. Chon Noriega, in a survey of Chicano street posters, notes: "The medium is the message. But if the medium is poster art . . . the message is the community. The poster exists somewhere between the unique art object and the mass media. It blends the formalities of both in order to reach an audience neither cares about: urban exiles in search of a community" (1977: 23).

Definitions, Aesthetics, and History

Whereas Dada had been essentially anti-art, punk was supposedly anti-design (Hollis 1994: 188).

Early English punk flyers were ragtag, hasty, bare-bones affairs. Essentially both a threat to everyday order and cleanliness and a mirror of punk's disaffection, they disavowed the popular culture (welfare state culture) of the day and promoted a maximum tour de force of mostly young outsider art. The Sex Pistols used a series of one-sided collages with crude, hand-painted logos laid over pictures of the group. Soon such style was replaced by a sequence of logos forged with "ransom-note" lettering—with each letter cut out of existing periodicals and papers, then tossed together. This approach, former band manager Malcolm McLaren attests, can be traced to a female acquaintance, Helen, who would sit on the floor of their Bell Street flat and slice up the *Evening Standard*, letting the Sex Pistols hand-bills speak in codes to punks and artists even as they demonstrated a strong wish to involve mass media (Savage 1991: 201).

They were a single facet of an ongoing punk cultural trend, partly epitomized by Malcolm McLaren's and Vivien Westwood's shop Sex. During this "ground zero" punk era, French Internationalist–style placards and axioms were swiped and revitalized for a new generation of Londoners who did not experience the Paris revolts of 1968 but who were inundated by the growing disenfranchisement and go-nowhere stigmas of housing projects and unemployment lines that doubled from 1974 to 1978.[3]

Stewart Home, author of *Cranked Up Really High*, now published for free online, offers an alternative overview.[4] He posits that punk had no concrete links to Situationalism or the events in Paris student revolt of 1968, which has often been a staple comparison by rock writers trying to connect the dots between Jamie Reid's early graffiti and training, Malcolm McLaren's philosophies and work methods, and punk rock art, or anti-art, that the two engineered for the Sex Pistols. For instance, art historian John Walker concludes that McLaren employed at least five Situationist methods: the construction of situations, an attempt to

overcome consumer-based passivity; detournement, the re-using and recycling of material in order to invert or alter its original meaning; a call for the demolition of the work ethic; a critique of the society of spectacle, in which the calling card of punk—Do-It-Yourself—encourages young punks to produce their own culture rather than be mere consumers; and the avid use of shock tactics to disrupt norms and official culture. All these provided an acrid critique of bourgeois attitudes and values (1987: 120–21).

Additionally, writing for *Maximumrocknroll*, Bill Brown declared that the Sex Pistols understood the societal weaknesses that were exposed in the post–May 1968 era. In doing so, "like the Situationists before them . . . the Sex Pistols only organized the detonation . . . the connection between the Pistols and the SI is literal" (#19, 1984). As proof, Brown taps the Sex Pistols' song catalog. "God Save the Queen" exemplifies how "the sacred has been overtaken by ideology"; "Pretty Vacant" refutes the "cult of the image"; "Holidays in the Sun" demands the "right to make history." As such, the Pistols "accomplished several things at once," including making revolutionary ideas central to their stance. More so, "by asserting that dissatisfaction with society is either profound or it is nothing, it revealed the desperation behind society's official proclamation that it was in a state of crisis." Brown seems to insist the Sex Pistols were instigators furthering the ripples of May 1968 in a cogent and unified way.

Yet, in the chapter titled "Journalism Jive" from *Cranked Up*, Stewart Home argues that Neil Nehring, author of *Flowers in the Dustbin: Culture, Anarchy, and Postwar England* (usually a well-received book), misconstrues the May Revolution in 1968, which was characterized by graffiti slogans such as "Imagination is Power." Home argues that this was the work of the March 22nd Movement, who were subsequently criticized by the Situationalist Internationale in an uncredited article called "The Beginning of an Era." Hence, he

savages the "hacks [who] have fallaciously claimed that the Situationalists were a major influence on the events of '68, and the Punk Rock phenomenon" (1997). He explores this further in an interview with the zine *Fear and Loathing*, positing that "a lot of what happened was far more spontaneous, it certainly wasn't the Situationists that caused it . . . and the whole idea that punk was a Situationist movement, that's complete crap" (1994). Even though some people can link Malcolm McLaren to King Mob, he insists, that same group had no formal membership structure, and it was expelled from Situationist International because of their connections to the New York–based Motherfuckers, whose modus operandi and philosophy was closer to the approaches of Dadaists and anarchists (1994).[5] Again, this draws links between Dada and punk's first art mavericks.

Despite Home's argument, the spirit of 1968 was in the air: a hectic Clash traveled to Paris for a last-minute gig (which the Clash had previously cancelled for a spell and were previously replaced by Subway Sect, also managed by Bernie Rhodes) "celebrating the tenth anniversary of the French uprising in May 1968. Organised by the largest French Trotskyist organisation, the Ligue Communiste Révolutionnaire, it was held in the Hippodrome which is normally used as a circus" (Silverton 1978). The gig was so frenzied and unstable, one breakaway French political faction wore crash helmets and supposedly released ammonia before being outnumbered by the other gig goers, who chased them out the door. According to the writer present from *Sounds*, who traveled with the Clash, ". . . the rest of the crowd broke into a couple of verses of the Internationale to clear the air and psyche themselves up for a touch of le vrai punk politique" (Silverton 1978).

In the mid- to late 1970s, some of the vitriolic items that might appear to be Situationalist inspired included fanzines like *Sniffin' Glue, London's Burning, Situation 3, Vomit, Skum, New Rose, Jolt, Zip Vynil, Trash '77, Chainsaw,*

and *Ripped and Torn*; slogan-heavy stickers like "Save Petrol Burn Cars," "Keep Warm This Winter Make Trouble," and "This Week Only This Store Welcomes Shoplifters"; and T-shirts with silk-screened images of death row inmate Gary Gilmore, gay cowboys, or the image of a safety pin through the cheek of the Queen of England. It was as if, "after the explosion of all radical causes, a gray empty land was being coated by a drizzle of old phrases and names that had no meaning. This fallout, this radioactive ash of failed avant-garde dreams, offered none of the old optimism. Yet, perversely, even this ultimate alienation gave punk real force and power, and thus its own kind of hope" (Aronson 1998). This feverish zero-hour mentality, a narcotic-like nihilism, reverberated through punk culture.[6]

Generally speaking, the punk belief system consistently constructed a potent, generative, fiercely democratic point of view laced with poetic license. A clean slate emerged in the middle of boredom. Fueled by the twin desires of possibility and purpose, anyone could become a creative force or construct an identity off the cuff. As Peter Shelley, singer of the Buzzcocks (an original 1976 punk band) noted to me in 2004, a person could follow a band into a bathroom, do an impromptu interview, and print a fanzine the next day, like *Sniffin' Glue*. According to Shelley, this invited people to stir up culture from below, to become agents of culture and change: "Most of the things written in *Sniffin' Glue* were written straight down, no looking at it later, which is why you get all the crossing out," argues editor Perry. "People never believed me at the time, but I didn't really care about the magazine. It was the ideas that were important . . ." (qtd. in Savage 1991: 202). This echoes McLaren's perspective. One minute there was "No Future," the next minute pop culture had been infiltrated, if only fleetingly, by a teenager with a head full of ideas and enough money to print a few Xerox pages that inadvertently became the backbone of the punk print

revolution. One minute a punk was nobody, the next minute Johnny Rotten told the world that the Queen of England makes people a moron, a potential H-bomb. The world listened, even in the heart of Texas, one of the few tour stops during the Sex Pistols' beleaguered 1978 stateside tour.

In New York (where some argue that punk ripened first), under the helm of early fanzines like *PUNK*, even in its initial stages punk poster art had more of a two-tract framework. One was a cartoonish, Robert Crumb–leaning, midnight B-movie monster feel, like Cramps and Misfits posters; the other, epitomized by Patti Smith, Television, and others, reflected a more straightforward aesthetic directly embodying a 1950's rock 'n' roll visual formalism. One must remember that rock 'n' roll was rebel music in its heyday—white kids appropriating "race music" and resisting Tin Pan Alley's rather innocuous "ear candy." The flyers looked like components of a future punk A&R kit, including well-shot "arty" photos and slightly offbeat lettering, producing a rather tame effect, in which the bands are punk but the design rather conventional.

Obvious exceptions existed, especially the hand-drawn splatter expressionism of Suicide flyers. Though Television and Richard Hell added verses by Verlaine to their flyers, they did not re-imagine typography or the space itself. Ironically, when these posters were brought back to England, they signaled a new aesthetic era, as Clash biographer Marcus Gray insinuates: "Malcolm McLaren brought a Xeroxed flyer for Television back from New York and put it on the wall in Sex. It featured a photograph of the band in action, along with selected titles from their repertoire, and it gave London punk the ripped T-shirt, the spiketop hairdo, some lyrical pointers (the title 'Blank Generation' being enough to inspire the Sex Pistols' 'Pretty Vacant') . . . and, of course, the Xeroxed flyer" (2007). Although the flyer style itself was not duplicated per se (the crude cut and paste and collage methods of London became

more significant markers in public and pop history memory than the rather demure Television flyer itself), the photograph of "raw" New York–style punk clothes and attitude did spur repeat offenders in London 1976.[7]

In California, the far edge of America, the punk visual boom also made a broad and layered impact on graphic artists and bands. Fanzines like *Search and Destroy, Damage, We Got Power*, and *Slash* documented the upsurge of the vitriolic underground punk scene. New bands were rampant. Crime posed themselves in police uniforms and chose heavy metal–inspired lettering to announce their shows; the Screamers sometimes adopted stark, black and white, flat, iconic, one-perspective, mutated, wood-cut looking flyers; the Dils blended agitprop and minimalism; X produced punk folk art heavily influenced by Latin culture, while later bands like 45 Grave absorbed and promoted a morbid, fantasy-inspired death culture.

The distinctive allure of flyers often relates to the impromptu methods developed by artists struggling with both time and resources. "Computers were out of reach," Jello Biafra reminds us, "rub-on letters were a luxury, so we improvised. Aping Jamie Reid's (Sex Pistols) cut-out art was step one." Furthermore, they understood that a sometimes heavy-handed, even cynical style—"dark retakes on the plastic Amerika that spawned us"—could reveal their intense reaction to both pop culture and politics. "Without knowing it, we learned that putting any picture or collage on a punk flyer could make that image more ridiculous—or sinister—than ever" (Turcotte and Miller 1999). That alone did not assure a vivid aesthetic value. As artist Winston Smith, recognizes: "Most [flyers] were lame—either intentionally vapid from an artistic point of view or just sheer inept design" (Turcotte and Miller: 1999). Known for his work with the Dead Kennedys and Green Day, he even stresses, "I don't think I'm Van Gogh or anything or I'm not Rembrandt, but some of these pieces I thought I could

do better than that if I had one arm tied behind my back" (Chick 1996).

Time was also often a catalyst. Hit-and-run art attempting to get raw information across to passers-by begat hasty and sometimes one-dimensional graphics. "Shows were organized, promoted and presented in a matter of days, last minute fund-raisers staged in response to various emergencies (trouble with the law, medical costs, stolen instruments), birthday bashes, record-release parties," Kristen McKenna observes. "All were conceived and brought to fruition quickly and on minimal funds. Available cash was usually spent on beer, and people weren't thinking about posterity when they set out to advertise whatever it was they were up to" (1999: 30–31). Therefore, under such circumstances, not every flyer can be expected to convey a sense of handmade felicity and adept artfulness.

The Norm Is Flux

Certain norms have been established simply due to a sense of utility: flyers are an extension of the process of promotion and dissemination, which shape the expressive range of the art. A flyer is a microcosm of information too, both apparent and latent. For instance, most list dates, venues, bands, and sometimes address and phone numbers. Also, information about a venue, or directions to the show, may be included. Some may include the signature of the artists, especially if the art is a handmade illustration. Flyers can feature auxiliary text that relate to the art, to the bands, or to the time and sense of culture from which the flyer appears. For instance, on a TSOL flyer from Phoenix, the artist incorporates text lifted from a Dead Kennedys flier, "Welcome to 1984," that originally appeared in a poster by Winston Smith. Below this appropriated text is the following suggestion: "Investment Problems? Start a War!" Such sentiments can be considered part of

punk flyer art normal form, revealing the political and economic anxiety of the Reagan era from the point of view of punk culture. Also, similar uses of pastiche highlight punk's sharp sense of irony, parody, and protest. In the eyes of Dick Hebdige and other cultural studies critics, punks have been described as actively practicing such bricolage to reveal the flux, tension, and irony of modern life.

A living example might include Johnny Rotten going to a pub to try out for the Sex Pistols. At that time, a moment when pub rock was peaking and glam rock was fading from media attention, he donned disparate, even absurd attire. First, he had a jagged green hair cut, when many Brits wore longer hair. Secondly, he wore "safety-pinned baggy trousers, and open-toed plastic sandals [holdover from hippie culture]. . . . Lydon seemed like a street urchin, right out of Dickensian London. Not quite the sex symbol McLaren was looking for" (Burchill and Parsons 1978: 18). He was wearing a Pink Floyd T-shirt, a "dinosaur" rock band of the psych era, but he had scrawled the words "I Hate" right above the official band logo. Thus, he had de-centered the meaning of the items he was wearing, exposing the underbelly of punk rock as oppositional, acerbic, ironic, and unstable.

Punk writer Kathy Acker was a similar avatar of bricolage who used "poaching" or cut-up techniques (borrowed from William Burroughs, among many) to appropriate texts from Charles Dickens and others, weaving them into her own brand of feminist fiction. Likewise, Darby Crash's lyrical style is "indebted to and sometimes plagiarizes Nietzsche, detective novels, and Scientology" (Newlin 2009: 2). Another example might include the song "Group Sex" by the Circle Jerks. The lyrics seem no more than a series of swinger classified ads poached from sex trade magazines and casually read to hyper-fast hardcore music. Another is when John Dewey from the Weirdos "had the wit to cut-up hi-fi magazines to make a montage for a flyer, describing the Weirdos early sound euphemistically as 'superior music . . .

incredible range . . . flawless attack and sustain . . . a hint of harmonic distortion. The cardioid pickup pattern feedback with rich sustaining sound power together in lightning fast runs'" (Heylin 2007: 374). Such cut-up, poetic style became one of the dominant templates of early era punk and hardcore.

Much punk rock music seems to be intertextual, too. Guitarist Sylvain Sylvain of the New York Dolls imagines their music as ". . . a skyscraper soup, a big mélange of everything that we saw from the '60s, the '50s, the blues era, from the jazz era, from the cabaret era, from the war-in-Vietnam era" (2006). One may imagine the punk rock on the Ramones' first several records as an assemblage/pastiche and conversation between eras, styles, and symbols. Their songs may have sonic references to 1960s bubblegum pop (they even cover such songs as "Let's Dance" and "Needles and Pins"); when they sing "Second verse, same as the first" on "Judy Is a Punk," they mimic the Herman's Hermits hit "Henry the Eighth, I Am," which some writers suggest is a proto-punk song. Early Ramones songs also mention pinheads (with nonsense choruses like "gabba-gabba hey!"), Nazi references (blitzkriegs), and sniffing glue, which combine a history of war, juvenile youth culture (comic books, carnal drugs), and carnival freaks. Even furtive, illicit sex is revealed in their lyrics. In the song "53rd and 3rd," bass player Dee Dee recounts his days as a street hustler. Thus, a single Ramones song (let alone an album) can exemplify an unstable patchwork of pop culture in the 1970s.

As Everett True notes in his biography of the Ramones, such pastiches do not mean that the Ramones "were patronizing their dysfunctional subjects and cretin dancers" (2002: 95). In fact, the Ramones were presenting a sincere, witty, and wily evocation of everyday elements readily drawn from their lives that transcended gender lines as well. As Tobi Vail, from Bikini Kill, wrote in her elegy for Joey Ramone: "I was a Ramones fan! A Cretin! Because Joey said 'Gabba Gabba We

Accept You We Accept You ONE OF US!' I was 'one of us'—accepted for who I was: A weirdo in a group of other weirdos. That's all I've ever wanted, really. If Sheena was a punk rocker and Judy was a punk, I knew I was really one too, even if no one else knew it" (2001: 79). Tens of thousands of men and women across America became part of the makeshift, oddball, tattered jeans, heart-on-the-sleeve Ramones family.

With similar effortlessness, but with considerably more irony, late 1990s "post-hardcore" bands like Nation of Ulysses adopted similar songwriting techniques, though their debt to the Ramones might be entirely latent or subconscious. In lines like "I'm not talking about a Beatles song / written one hundred years before I was born," the song "N-Sub Ulysses" appears to allude to the Clash's "1977" ("No Beatles, Elvis, or Rolling Stones . . . in 1977!"). Additionally, the line "they're talking about the round and round" might signify the Animals, or any group that covered the hit Chuck Berry song "Around and Around," while the line "100 flowers bloom, 100 schools of thought contend" also appears to drop a direct reference to Chairman Mao (The One Hundred Flowers Campaign from 1956–57) by supplying a slight variation on the actual slogan of the campaign. Though this may not echo their same hamburger-and-pizza domain, it does reveal how the Ramones' intertextual style was canonized, becoming an unofficial template of punk rock—a perfect fit for the age of total irony.

Punk Art School and Clothing as Raw Power

In places throughout the United States during the final years of the 1970s, punk took hold, usually drawing from the art, rock 'n' roll, and gay communities, obviously appealing to those, as Hart Crane succinctly wrote a hundred years earlier, who were searching for "new anatomies, new thresholds." Youth were seeking kicks that could somehow defend them against the deluge of Linda Ronstadt and Leif Garrett copycats. Punk (new wave, no-wave, hardcore, or whatever its permutations) was a bulwark, a way of resistance meant to offend, repel, and call to arms. In Chicago, Athens, and Austin, like in San Francisco, universities and art schools supplied a steady supply of cadres. This was especially true overseas.

The ties between new music and art were vividly expressed in 1976 when Genesis P-Orridge, a college drop out from Hull University who formed the quintessential art punk band Throbbing Gristle, staged the exhibition "Prostitution" at the Institute for Contemporary Art. Alongside his partner Cosey Fanny Tutti, he displayed used tampons and street level porn that were instantly decried by Prime Minister Nicholas Fairbairn, whose comments were featured in the *Daily Mail* next to a picture of the lead singer of Siouxsie and the Banshees with the caption, "What today's connoisseur is wearing."

Two years later, Herman Nitsch, a German artist with a proclivity for splotch and spectacle dubbed Aesthetic Terrorism, was invited to Southern California by the production company Some Serious Business, and, together with local artists Susan Martin, Elizabeth Freeman, and Nancy Drew, put together a night of dead animals, buckets of blood, and nude young men with blindfolds. In 1978, the Bags played a convulsive set at The Los Angeles Institute of Contemporary Exhibitions (LACE) for the opening of the Dreva/Gronk art exhibition. Perhaps not surprising for the time, overcrowded patrons and police soon fissured into a small riot that ruined some of the art.

In most places galleries were elitist and off limits, but punk signifiers were avidly worn on the body as mobile physical codes in the form of reimagined thrift store clothes and buttons. Such tendencies ran the gamut from classic 1976-era punk bands to early NYC hardcore teenage thrashers like The Young and the Useless

(featuring future Beastie Boys), who purposely wore old men clothes scoured from Salvation Army. Member Adam Yauch made homemade buttons as well. Meanwhile, second wave British political punks Crass, according to member Penny Rimbaud, "bunged all the stuff we bought into the washing machine and dyed it black . . . You saw punk clothing turning up in all the local clothes stores, a pale reflection at too big a cost. For us it was an attempt to say, 'Fuck That!'" (Robb 2007). For punks across the States as well, making one's own clothes or transforming and remaking clothes already owned was a (sometimes secretive) habit, often driven by lack of money but also signifying how they used vernacular expressions to reclaim the commoditized space of clothes. As Denver punk Bob Medina explains, "I would usually shove my punker pants (bleached and torn jeans attacked by a sharpie of every punk band I knew scrawled on them) and homemade band shirts into my book bag between my Trapper Keeper, and science book. Total DYI fashion since I lacked funds to buy proper band shirts from Wax Trax" (2008).

Punks and non-punks alike maintain an image of safety pins and torn garments in their imagination of 1976. In the essay "Rip It Up Cut It Off Render It Asunder," the author suggests that such clothing serves as metonymy for the body: "Punk might be read as a sacrificial tearing-up of the body. . . . Cutting up and pulling together garments by using safety pins made the materiality of the fabric irrelevant, or reduced it to visuality. The moment you incise the fabric with zips or orifices of tears, you draw attention to the materiality. You render a different meaning to it. . . . Something familiar . . . becomes estranged" (Brooks 2007). This poetic notion suggests that, as people become estranged, their clothing signifies their subcultural status, which echoes the premise of Hebdige's *Subculture: The Meaning of Style*. Gary Valentine, former founding member of Blondie, makes a more succinct point: "It was charity shop chic . . . stuff you'd get out of rubbage bins or thrift stores" (True 2002: 49).

In the late 1970s, Billy Childish joined a band called the Pop Rivets, who released a DIY album in a small pressing of 500 on blank sleeves. This approach was not simply relegated to the band's recording output: "We always made our own clothes—painted them up—and had our own look, and never became fashion-punks wearing leather. Consequently, we were never considered a punk-rock group" (Vale 2001). Yet, as Captain Sensible of the Damned has insisted, the reigning punk style was not leather but democratic-imbued thrift duds: "I loved the fact that if anyone wanted to be at the 'height of fashion' [during the Roxy punk era] they had to dress in ripped charity shop togs—it was a great leveler—posh kids were not able to flaunt their wealth via their fancy clothes anymore" (qtd. in Marko 2007: 114). In the twenty-first century, although a resurgence in DIY clothing is apparent, so is the overarching presence of independent secondhand stores, which often send buyers to huge Goodwill bulk "bins" where they can buy clothes by the pound. Hot Topic, a chain store found in malls, offers readymade punk and goth accessories for the current Generation Y. This store might be understood as an enterprise built on reconstructing punk clothing for profit in the same vein of first-wave punk profit seekers who tacked slogans like "Punk Rock" on cheap fabric riddled with bubblegum letters in 1979.

Humor, Angst, Protest, and Survival

Many have argued that, as punk took hold throughout suburbia, the music began to narrow, becoming less and less about ideas and more about rigid, humorless conventions and codes. John Doe of X reminisced in the alternative country zine *No Depression*: "I always thought the point of punk was coping with bullshit. Humor

is an important part of it—the insanity, the goofy clothes, the song titles like, 'Our Love Passed Out on the Couch.' That's why I changed my name to John Doe—not to be a rock star or taken seriously, but because I thought it was funny that Declan McManus changed his name to Elvis Costello. Unfortunately, after the hardcore bands took over punk, the humor got lost" (2000: 83). "I wish hardcore had more sense of humor—more like Bugs Bunny," Dee Dee Ramone admitted to *Hard Rock Video* magazine, reminding the writer, "Hardcore is a little narrowminded" (Farber 1986: 17). Such alter-ego aliases like Ramone and Doe, symbolizing a ritual of renaming oneself for the sake of punk, allow for both a sense of sovereignty and a sense of humor. Inventive and ironic, they subvert the "everyman" concept. In Doe's case, the image of an anonymous body bag victim is triggered, while Dee Dee Ramone sounds like teenage lingo torn from the pages of *Archie* comics.

Likewise, the names Johnny Rotten and Sid Vicious heighten a sense of teenage terror and destruction, signifying the threat implicit in punk. Each name carries some kind of commentary that stirs people within the cultural void. As Jon Savage outlines in *England's Dreaming*, at his initial tryout for the Sex Pistols, John Lydon marked his passage into punk—his Rotten persona—by launching "into a sequence of hunchback poses—screaming, mewling, and puking . . ." (1991: 121). This evoked the carnivalesque as well, though safely ensconced within a pub on King's Road.[8] Other stand-out name mutations from the punk and hardcore era include Johnny Thunders, Steve Ignorant, Lora Logic, Will Shatter, U-Ron Bondage, Lucy Toothpaste, Raidy Killowatt, Bruce Barf, Sue Tissue, Penny Rimbaud, Rat Scabies, Stiv Bators, Arcane Vendetta, Glen Danzig, Darby Crash, Il Duce, Axxel G. Reese, Victor Venom, Hellin Killer, John Stabb, Cheetah Chrome, Cinder Block, Kid Congo Powers, Tomata Du Plenty, Mish Bondage, Frank Discussion, Pushead, Kevin Seconds, and many more.

As stated, humor was intrinsic to punk ethos,[9] not just part of the modus operandi of bands like the Meatmen, Descendents, Angry Samoans, Dead Kennedys, the Queers, The Freeze, Adrenalin OD, Murphy's Law, the Toy Dolls, and the Big Boys (whose EP *Fun Fun Fun* is an unofficial manifesto of sorts). But if one band was able to merge the forceful blitz and buzzing thrust of hardcore, not to mention suburban teenage angst and pop culture wit, with nimble musicality, Adrenalin OD is a prime example. Drummer Dave Scott recently explained their jest:

> We were raised on *The Uncle Floyd Show*, Creature Feature horror Sundays, the "acidelic" world of Sid and Marty Krofft, and *Abbott and Costello Meet Frankenstein*. We were much more about the B-movies than the blockbusters . . . There were so many serious bands back then that people forgot how tongue and cheek the original punk movement was. How many times could you say "Fuck Reagan"? We actually started off with political songs until we realized that the best stories are from experience. The band got its voice I think when Paul wrote the song "Suburbia" from the *Let's Barbeque* EP. It really put to music how we felt growing up. Most people from New Jersey have a wise-ass sense of humor. It's in our DNA. We were always funny people influenced by funny things, and it made the band unique for its time. We amused ourselves in pushing the boundaries of what people thought was punk. At our show at Danceteria in NYC, we came out in nun costumes. Halfway through the set, I did a drum solo while the band changed into prom dresses. It's pretty amusing to see people moshing to a bunch of ugly dudes in prom dresses. I remember after the show walking past the singer and guitarist for Iron Maiden, and they gave me a look of disgust, like I walked into church with my dick out. That alone was priceless. (2010)

Adrenalin OD aimed their humor not only at the teenage and adult world—corporate fast

food America, idols like the Pope and Elvis, and matinee monsters like Godzilla—but at the insular scenes of punk and even metal audiences. As Scott confirms: "Punk wasn't about playing by rules, and yet there were so many out there: how to dress, how to act. We would raid the Salvation Army drop boxes before our CBGB's matinees and wear the most ridiculous thing we could find just to take the piss and vinegar out of the crowd and remind them it's about having fun" (2010). Bands like this were a kind of leverage, a way of balancing the bile of politics with the spit and vinegar of humor.

In light of punk subgenres like queercore and homocore, some punks like Pansy Division, Black Fag, and Youth of Togay act as raconteurs of the "fun" form, poaching old hardcore standards from the likes of Youth of Today and Black Flag. Black Fag replaces the black stripes (an anarchy flag) associated with the original band with rainbow colors. When they adapted the *Everything Went Black* LP cover, they replaced the word Black with Pink and the menacing open bladed garden shears with an eyelash curler. Jack Grisham, singer for TSOL, sported a Black Fag T-shirt when interviewed for the comedian Tom Green's web site. This humor seems truly consistent with both the struggle for gay empowerment and punk rock. If punk in general can be linked to Dada, perhaps humor is the looking glass.

Jeff Nelson, the drummer for hardcore pioneers Minor Threat (whose members briefly played with the Meatmen) and part owner of Dischord Records informed me that Positive Force, a D.C.-based community organization, "along with Fugazi, represented . . . the overpoliticization of music and of 'the scene,' that ruined large aspects of it by being overly serious and taking all the fun out of it" (Ensminger and Welly 2008). This did not dissuade Nelson, a poster artist himself and designer for the label, from creating posters such as "Meese is a Pig," which sardonically attacked the Reagan-appointed attorney general who tried to remove *Penthouse* and *Playboy* from store shelves, subjected federal judges to conservative litmus tests, and imbedded himself in the Iran-Contra affair, among other notorious acts. This form of visual iconoclasm is similar to Winston Smith, whose work for the Dead Kennedys included Christ on a crucifix fixed to a backdrop that is a magnified image of paper money. This served as the album art for *In God We Trust, Inc.* Smith describes his work as "graphic wisecracks . . ." (Hooten 2001). He admits, though, that such collages had a "vandal appeal. You were destroying something that someone else had made, then you were substituting your own slant on it" (Blush 2001).

For many observers and participants, punk created a performative space that actively, though perhaps through spectacle alone, created a liminal space of inversion, parody, and metamorphosis. Such methods ranged from the Dada tactics of early punk bands like the Screamers and the Bags, to the cult of teenage angst, violence, and blurred sexual identity of the Germs, to the Sex Pistols' overall assault on good taste, in concert and on TV shows such as Bill Grundy's U.K. talk show in December 1976, in which the young rockers unleashed a whole series of profanity-laced invectives during a primetime segment. Another critic suggests that songs like "God Save the Queen," taken as political statements, are "little more than Oedipal kitsch. For violence, shock, assassination, and rage are not negative or radical in themselves" (qtd. in Nyong 2008: 109). Likely, the Pistols would agree. Listening to the Pistols did not bring down Parliament, nor did it free political prisoners. But it could free a listener from "mind-forged manacles"—the mental chains that bind our thoughts and hopes—described by Blake in his poem "London."

Deeds become paramount in punk when examining political action versus mere performance, rhetoric, and spectacle during uncertain times. The National Front newspaper *Bulldog*

proclaimed Johnny Rotten "no better than a nigger" and "Rotten showed his feelings towards the loathsome thugs when he enrolled in the newly-formed Anti-Nazi League" (Burchill and Parsons 1978: 31). Rotten made his attitude clear by telling one interviewer that he despised the National Front. He implored: "No one should have the right to tell anyone they can't live here because of the colour of their skin or their religion. . .. How could anyone vote for something so ridiculously inhumane?" (qtd. in Manzoor 2008). Bands like Sham 69 continuously dealt with large, often right-wing, untameable skinhead contingents, much to the dismay of singer Jimmy Pursey. Touring U.S. bands in later years were not immune to the tactics of these coteries as well. DRI, the seminal hardcore band from Texas, played an anxious set in Canberra, Australia, in 1988. Ten to fifteen skinheads nearly took over the show. Their leader confronted bass player Josh Pappe with taunts of "we're going to crush and kill you Jews" and jumped on stage, only to be met with DRI and the crowd forging a defensive bond. People used cymbal stands, guitar racks, and other stage items to chase them off while chanting "Skins out" and "Nazis suck" until the police hauled them away (Bibs 1988). Skinheads also reportedly confronted Dave Dictor, singer of MDC, outside of CBGB, but were held off by two members of the Cro-Mags, John John and Haley Flanagan, who claimed the territory as their own. In Portland, MDC was met with skinhead threats, but a posse of activist punks convened and scattered the skins. These do not represent clashing abstract symbol systems but genuine street-savvy, close-to-the-ground political fissure and friction.

Politics radiates from punk culture in varied forms. The Sex Pistols played a benefit for striking firemen in Huddersfield, England, in 1977, while the Clash, Gang of Four, Stiff Little Fingers, the Ruts, Slits, the Jam, Generation X, and X-Ray Spex played major Rock Against Racism gigs. These gigs were not without controversy.

Neither were they considered just a response to the growing influence of the National Front, since many considered the concerts as platforms for Trotskyite-modeled leftism. The Dicks, DRI, and MDC forged the Rock Against Reagan tour in the United States. Gerry Useless of Canadian punk band DOA, known as part of the Vancouver Five/Squamish Five, was imprisoned for supporting Direct Action, a group protesting nuclear and cruise missile facilities through propaganda and self-styled "urban guerrilla" actions. Dennis Jagard of Scared Straight was arrested for participating at a sit-in at U.C. Berkeley against campus recruiters for McDonnell Douglas, who were selling helicopters to the government of El Salvador armed with miniguns used to "depopulate" the border with Honduras of rebels (Morf 1990). These incidents, representing just a tiny fraction of punk history, reveal a kind of sacrifice—choices not easily undertaken—that reveal the nature of punk as vital, critically aware, and empowering. This is rarely recognized in punk revisionist writing.

In October 1996 *Rolling Stone* reported that Fugazi played a benefit at Fort Reno Park for the Northwest Youth Alliance, a non-profit group that worked with underprivileged teens, a description that once fit a teenage Ian MacKaye, singer of the band, according to president Paul Strauss. In one concert alone on March 8th at the Citadel Sound Stage in 1990, the bands Geek, Fugazi, and Sonic Youth played a Positive Force benefit that raised almost $4,000 for three Washington, D.C.–based groups, including Washington Inner City Self Help (anti-gentrification), Roots Activity Learning Center (an alternative school), and Sasha Bruce Youthwork (who worked with at-risk kids). In July 1991 No Means No, the Ex, and Fugazi played a Positive Force benefit for the D.C. Free Clinic, drawing 1,200 people to the St. Augustine gym and generating $1,800 for a clinic that provided medical services to homeless people in need, according to a *Maximumrocknroll* D.C. Scene Report (*Option*

magazine reported in their November/December 1991 issue that the contribution amounted to nearly $5,000). One can compare that to the earnings of the political-minded, and soon to be major label, band Bad Religion.

According to Lawrence Livermore (of Lookout Records) in 1990, Bad Religion were paid $4,500 for a Los Angeles show with MDC and Neurosis. During this same time frame, Social Distortion, who were already signed to Epic, were making guarantees that hovered around $1,250 a show. These details suggest that money mattered, both in the hands of bands aspiring to escape the punk ghetto and those using these same opportunities to funnel funds toward social causes that could help local communities. As Fugazi lead singer Ian MacKaye framed it, "we literally play dozens and dozens of benefits. That way I know the money is going to the front lines like for soup kitchens to buy food, for AIDS hospices, for AIDS education . . . and I think if we weren't in the music I'm sure a few of us would definitely be working in those groups as well" (qtd. in Ciaffardini 1990: 36).

1980s punk bands like Verbal Assault played a show to benefit a "right to shelter" ballot in the D.C. area and actively campaigned for Amnesty International, as have others, including street punk icons the Business (in relation to incidents at Belmarsh Prison), while contemporary punkers Anti-Flag have pressured lawmakers to create military-free zones in high schools and released an EP to raise funds for victims of violence. Others have played countless benefits for anti-racist organizations, miner's groups, women's rights and animal rights organizations, WTO/globalization protests, anti-war efforts, Food Not Bombs, prisoner rights leagues, and myriad other causes. Punks have supported boycotts, such as against Arizona Tea and Crazy Horse malt liquor products for incorporating Native American symbols on product artwork. In the late 1990s, Dexter Holland of the Offspring and Jello Biafra of the Dead Kennedys briefly formed FSU, which stood

for both "Fuck Shit Up," according to Biafra (half-jokingly), and "Freedom Starts Underground" according to Holland. With a series of shows including the likes of the Offspring, Mad Caddies, Joykiller (former TSOL members), and the Dwarves, the proceeds were directed to AIDS Project L.A., Poor People's United Fund, Trees Foundation, and Amnesty International.

By 2004, Fat Mike of NOFX launched Rock Against Bush, a two-volume CD/DVD and tour package that concentrated on swing states during the Bush/Kerry election. Also, the success of neo-punk label Sub City (Weakerthans, Thrice, Fifteen) at raising money for pre-designated charities is impressive: in fall 2007 they reached the $1,000,000 mark. This slim overview does not intend to offer an incomplete or one-dimensional valorization of punk as a bona fide humanitarian culture but as a way to prove that bands did/do actively critique and shape culture beyond being mere loudmouthed performers. They network, support, and challenge communities by exploring the notion that punk is "more than music," as Verbal Assault sang. In addition, such tendencies mirror the belief that, as Hannah Arendt says, the heroism associated with politics is not the mythical machismo of ancient Greece but something more like the existential leap into action and public exposure (qtd. in Pitkin 1998: 175–76).

The Contradictions of Caring: The Clash

The Clash are a prime example of the link between early rap, reggae, and punk, between the wheat paste handbills of 1977 and the phat lines of graffiteros. They were a deeply conflicted band that reflected a typical punk paradox. In songs like "London's Burning" and "Career Opportunities," they struck symbolic blows against the disquieting flops of 1970s British society and a class system that seemingly devoured youth,

simultaneously turning themselves into beloved rock 'n' roll stars. Their politics did strike many listeners as suspicious, then and now. Some Marxists theorists have placed it within a vague "site of unconscious class struggle, displaced from its 'true' arena (work, politics) into leisure, where victory can only be achieved in a temporary symbolic or 'magical' manner'" (Laing 1978: 128). Glen Matlock, bass player for the Sex Pistols, has noted that the Clash material was a bit like schoolboy politics, torn from the pages of magazines, like the back of *Time Out* (Heylin 2007: 179). Signing to CBS Records did not help shore up their political credibility either, as Captain Sensible from the Damned infers about those first wavers who signed corporate contracts:

> . . . this punk thing . . . said we ain't gonna become a part of this stinking industry, we're going to turn it all upside down, all the horrible rock n roll lifestyle, all the cocaine, the groupies, and the big fat record company cigar bastards. We're going to tell all those people to fuck off. Then, of course, when the Damned signed to a small label, Stiff Records, believing in what we were saying, what were the others doing? Singing to the biggest fucking fat cat labels they could possibly get their hands on. So, that was another bit of hypocrisy. I thought bloody hell. (2003)

Musically, the Clash explored a panoply of styles—dub reggae, ska, disco-funk-punk, rockabilly—but by the time the fourth album *Sandinista!* arrived in record bins, many believed they were unable to juggle or shape these syncretic influences effectively. Despite these tendencies, the band remained potent to fans like the author Jonathan Lethem, who believes the band did mark a line in the sand of pop consciousness:

> The Clash promised to heal every breach with their proletarian rage, to recuperate the nihilism of the Sex Pistols, to drag punk through politics and then

squarely into the history of rock and roll. They promised not only never to betray their fans, they promised to remain fans themselves. They meant to change the world, and they might have been the last good band to try . . . we certainly felt the vibrancy of their collision. *London Calling* was our *Blonde on Blonde*, our *Exile on Main Street*, but where those double-LPs brilliantly charted their makers' final disenchantment with utopian possibilities, the Clash's claimed that on the ashes of rock dreams past a new castle might be built, one with its doors open to the audience, and to history. (2000)

In contrast, Crass powerfully reminds us (in the liner notes to the record *Best Before '84*) that such figurative language and youthful adoration should be pushed aside, for the Clash were actually quite problematic beneath their own banners: "The Clash and all the other muso-puppets weren't doing it [D.I.Y.] at all. They may like to think they ripped off the majors, but it was Joe Public who'd been ripped. They helped no one but themselves, started another facile fashion, brought a new lease of life to London's trendy Kings Road and claimed they started a revolution." Such a fiery reaction to the Clash might have been foreshadowed in larger terms by theorists as early as 1978, when Dave Laing wrote, "The introduction of politics into the heart of the leisure-apparatus by the Clash Is one sign that the demise of punk may mark the beginning rather than the end of a fruitful phase of ideological struggle within popular music" (128).

As punk's first wave became markedly more mainstream, "second wave" punk and hardcore became more highly charged and iconoclastic. To many of them, the Clash's quasi-revolutionary style inaugurated punk as commodity industry—sloganeering designed to entrench buying habits, even when those buying habits, such as purchasing their single "The Call-Up" (1980), did expose fans to slogans such as No Draft (next to the single's

official CBS label imprint) and provided addresses for organizations like Campaign for Nuclear Disarmament and Immobilise Against the Draft. While offering such seemingly co-opted guerrilla aesthetics, in which pro-peace messages are juxtaposed next to corporate insignia, the Clash appeared to have a tense relationship with their one and only label. In the late 1970s Joe Strummer complained to *Record Mirror*:

> . . . all companies are the same. They're as bad as
> each other. We've never been with another com-
> pany, so I haven't got anything to compare it to.
> It's just, like they released rubbish. They picked
> the worst track off the album to release as a single.
> With us, they don't know who we are, or what we're
> about or how to deal with us, they still don't know.
> All companies are as bad—they're all after money.
> If you move records they're prepared to smile at
> you. (Clash 1978)

Yet, the band endured, and some might suggest they thrived: even their compilation record *Black Market Clash*, a selection of old singles and new mixes released in 1979, went on to sell three million copies.

Hardcore Hooligans?
The Rise of Suburbia

As punk morphed into hardcore in the early 1980s, the style associated with "punk" was deemed too soft, arty, insipid, anachronistic, or indulgent, and the leaner, more choleric, and marshaled maelstrom of speed and fury known as hardcore (typically epitomized by songs that are short bursts—frenzied, no-frills, and aggressive) became the bearer of an emerging teenage subculture. Punk militarized itself, developed divisions and classifications, and infrequently transgressed those same borders. One flyer from the mid-1980s personifies this clique syndrome.

One side shows a peace punk modeled on the Crucifix variety, with anarchy signs and spiked hair as the chosen regalia; the other depicts an Agnostic Front skinhead replete with tight rolled-up jeans, crisp T-shirt, and tattoos—two worlds, often hostile to one another, that converged in the hardcore punk sphere.

This splintering subgenre was often more crude and coarse than its forebears. Such caustic outpouring sometimes became a musical ghetto that combined steadfast musical assaults and shock troop psychology that attempted to vex and bewilder shopping mall–prone, plastic- and fiberglass-shielded, man-on-the-moon nostalgic American suburbs. Hardcore youth enduring the last embers of the 1970s showed no willingness to harbor bloated illusions left over from the Me Generation. Their attitude and gestalt threatened to level and pillage everybody's "duplex of pretend." Gene October echoed such metaphors when speaking to Chris Salewicz, explaining: "what they've got on their plates now is the real tough stuff. I'm talking about people like the Exploited. Who are really radical. I don't think most people could stand the gigs. They're guttersnipe kids. Mohicans. Real heavies. It is real glue music—nothing more to think about at all. They're just there to shatter your brain" (1982).

Little did October, with his references to the Clash ("guttersnipes" suggesting lyrics from the song "Garageland") and the Ramones ("glue" suggesting "Carbona Not Glue" and "Now I Wanna Sniff Some Glue"), know that such a genre would dominate punk for the next thirty years, becoming the de facto trademark sound of punk in America, where blitzkrieg speed, defoliating directness, and aggressive animalism stole the punk mantle. Early 1970s self-styled subcultural "outsiders" like Lester Bangs, declared:

> . . . at its real core this music [hardcore] is as
> comforting and predictable, safe and conservative
> (even reactionary) as the heavy metal whence it

sprang. . . . hardcore's three chords provide its fans with walls that shut them in and any other world out—even when they're slamming in the pit. Hardcore is the womb. . . . Dead Kennedys lyrics . . . veer towards antisocial juvenile delinquent antics like stealing people's mail, with a marked tendency to mutate, perhaps through methamphetamine logic [*cf.*: "Drug Me"], into hateful but impotent fantasies like "Let's Lynch the Landlord" and "I Kill Children" (closest thing to a funny line: "Offer them a helping hand/Of open telephone wires"). (2003)

To Bangs, hardcore's "symbolic challenge" to hippie, classic, soft rock and mainstream American sensibilities was not really new at all, since he had seen it five years before in England, and even ten years earlier with Iggy Pop.

Long-lasting punk bands like the Fastbacks also voiced their concern that hardcore lacked some essential punk elements: heart, soul, and other emotional qualities. "I thought hardcore was really bogus. I guess there were good songs, but to me it lacked urgency," bassist and vocalist Kim Warnick noted to *Ruckus* zine (Fastbacks 1993). First-wave 1970s West Coast punkers sometimes considered the new breed, like the bands affiliated with SST Records, as "machine bands." Chip Kinman from the Dils pointed out: "Punk rock was transmuting into hardcore—there were a lot of code and restrictions going down. When you turn quantity, like speed or amount of notes, into a quality, like 'speed is good,' 'slow is bad'—that to me is the death of creativity" (qtd. in Flipside and Hessing 1988). By the mid-1980s, even hardcore pioneer Jello Biafra of the Dead Kennedys considered "90% of what is labeled as punk and hardcore today [is] a new form of conservatism and cliché," especially "the crossover garbage that substitutes ever racist, sexist, and macho lyrical cliché for what could have been an avenue to reach people" (qtd. in Yohannen 1986). Perhaps musical formula should actually be a secondary concern, while ethos considered the pivotal marker of the

subculture. Joe Strummer remarked to *Creem* that "Hardcore has forgotten that it ain't the studs, it's the thoughts" (qtd. in Holdship 1984: 38).

Yet hardcore *was* awash in ideas and philosophy. MDC espoused deep political concerns, as did many bands of the era. The music did not just evoke simple, truculent manifestoes serving as musical wallpaper to punks donning motorcycle boots tied with bandanas. For one, John Stabb, in the liner notes to a concert DVD by Government Issue, recalls the 1982 hardcore era as a time of "innocence and joy" that has not been recaptured by later hardcore music (2008). Further, even if the songs seemed to lack urgency, Kent McClard suggests that attitude and DIY underpinnings matter more. As he wrote for *Give Me Back* zine: "The point of hardcore for me has always been to say what we do matters. Our lives and our actions are anything but meaningless. Do it yourself is about our power. It is about our participation. It is about realizing our self-worth and the communities we build . . . our lives matter" (2007).

These sentiments were long echoed in the hardcore community, from the zine and music compilation titled *We Got Power* to the refrains of Verbal Assault, whose singer Christopher told me "Looking back and getting older, I think that punk/hc—like a lot of other underground cultural movements—makes itself felt in subtle, long-term ways: it influences kids (like myself) who then bring that influence to bear on the way they go about living in this world, et cetera. I suppose this is a bit ironic, since its stance is so immediate and militant, but there you go: life and history have a way of doing that" (2008). Hardcore and punk shape the contours of one's life, long after the music dims. As for the politics embedded in hardcore, bands like False Prophets declared: "A lot of hardcore politics is complete bullshit. If you're going to be political, worry about serious things, like stopping capitalist imperialism or getting kids out of hellholes like the Martinique Hotel, instead of picayune Stalinist crap like 'It's

politically incorrect to like Madonna' or 'It's a moral imperative to play thrash.' . . . the best role for music to play is to be something that makes people feel, that's neither fluff nor propaganda" (qtd. in Yohannen 1986). In such reflections, the ideas, ethos, and content of hardcore punk matter to some participants far more than the rigidity of the music brought to bear by purists.

In Redondo Beach, California, during the early 1980s, punk gave birth to a suburban trend called beachcore that filled venues like the Fleetwood, where the Kill-Hate-Destroy/wrecking crew slam-dance pit mentality held powerful sway and the knifing of long-hairs was both troublesome and routine. Critiques have been rather severe: Mike Patton of Middle Class argues, "The Huntington Beach scene killed off the original open interpretation of punk rock"; Exene Cervenka, singer for X, decried it was "all dumbing down into this mob mentality where we couldn't even play a show because the audience hated us so much"; and Keith Morris of the Circle Jerks admitted "when the hardcore thing took off, it became more of a macho testosterone over-drive thing" (qtd. in Mullen and Spitz 2001: 223–25).

As producer/engineer Spot noted in the liner notes to *Everything Went Black*, "The Huntington Beachers were all leather jackets, chains, macho, bloodlust, and bravado, and exhibited blatantly stupid military behavior" (1982). He describes a gig at Baces Hall in East Hollywood in which dozens of cops showed up to shut down the gig, causing people to throw beer and spit in riotous "pandemonium" as a helicopter circled above. In *Waiting for the Sun: The Story of the L.A. Music Scene*, Greg Shaw and Pleasant Gehman outlined the differences between this second wave and Los Angeles's original sect:

> Punk was urban, hardcore was suburban. Punk had been arty and conceptual, but then came the kids from the beach, boneheads who'd heard that punk was violence but didn't realize it was metaphorical

violence. Punk was doing things and making things and starting bands and magazines. We thought hardcore people were sorta like dumb kids—some bands were great, but it was hell trying to see them because there'd be a bunch of football jocks and mohicans there. (Hoskyns 1999: 303)

"I'll second it, 'cause none of those guys were going to use real violence. With a lot of the early arty bands, they were arty guys," Jack Grisham of TSOL concurred during a late winter 2001 tour stopover in Houston. "We loved them, but those weren't the kind of guys who were going to get in a Sunday football game with their friends. When it trickled out to the beach stuff, that's what it was. A bunch of athletes. A lot of the surfers were punk kids. They were guys in shape. If you look at the early surf history of the '50s and '60s, they were punks before there was punk, driving around with swastikas on their woodies, being fucked, you know" (2001). This suggests punk changed from within, but a question still lurks: Were punks more prone to violence because the form migrated from Hollywood to the suburbs and beach communities, or because the press, from local papers to *Penthouse*, continuously propagated a sense of violence due to misunderstanding the psyche and physicality of punk, including dances such as the worm, slamming, moshing, creepy crawl, and the Huntington Beach stomp? Lisa Fancher from Frontier Records stresses:

> You have to separate the actual fighting, which oftentimes was considerable, from the slam pit. To the outsider, that might *seem* like violence but it was a completely visceral reaction to the music coming from the stage. A few bruises here and there, no problem (fighting was not prevalent in the X/Weirdos/Screamers era). The beach punk hardcore scene was young and a high testos-terone scene and alas there were kids that were morons and came to shows with the goal of land-ing punches. A lot of this centered about the

Huntington Beach crowd, but I also witnessed gnarly fights in Long Beach, San Pedro, Hollywood, and the SF valley. The most common was a pack of punk rockers chasing after a long-hair but they certainly liked to fight with each other too, make no mistake! These morons were also responsible for shutting down the Whisky (throwing bottles at the police) and causing many other venues to ban punk rock or specific bands like Black Flag. (2005)

Negative, exploitative media coverage might have inadvertently exacerbated the situation, drawing people with violent inclination to shows. As Steve Soto from the Adolescents noted to me:

The Fullerton punks were never a tough bunch, and we steered clear of the whole violent end of the scene. It was no myth. There was definitely a "thug" element that reared its head sometime during 1980. The Fleetwood in Redondo was a rough place. I can see where that bummed out some of the older bands. It bummed us out too. Tony used to stop songs if it got too out of hand. It was weird. It used to flare up here and there and then the media picked up on it and there was an article by Pat Goldstein of the *L.A. Times* and then that seemed to open the floodgates to a ton of jock assholes who came to kick ass and could give a fuck about the music. (2006)

Mike Palm from Agent Orange additionally stresses the pernicious role of media in the history of punk:

. . . there was a *L.A. Times* article where they coined the term "slamdance" and in the same article they said we're a band banned forever, along with other bands as well. The article said all these bands had been blacklisted from all the clubs. I don't think a blacklist really existed until they printed that article. . . . advertise it as [violent], who's going to show up with a flowerpot on their head? They are going to show up with a leather jacket and a switchblade. That's what everybody thought it was. If you didn't know, you certainly weren't going to come unprepared. This whole false picture that the press painted, a lot of kids followed it. You still see it in out-of-the-way places. (2010)

This was the "end time" or closing years for many first-generation punks, who saw the original burst of savvy and weird, loony creativity give way to martial, uniform, blitzcore beats and heavy, machismo stances. These trends—the migration of punk into suburban regions and a resulting escalation of violence—were not restricted to the United States. Across the Atlantic the issues, as retold by Cherry Vanilla keyboardist Zecca Esquibel to *Punk77*, were the same: "There was alcohol fueled violence but mostly it was not from the original punks. It was mostly from the suburban kids who came later and wanted to be punker than what we were. The ones that didn't fake sticking safety pinks through their cheek but actually did because they hadn't quite figured out how you could do that. Those suburban hooligans who came later were . . . aggressive." (2006)

Every region, from Minneapolis (Replacements, Hüsker Dü) to Phoenix (JFA, Meat Puppets), had a seemingly different trademark musical style that by the mid- to late 1980s was seemingly homogenized by commercial forces, just as the Cro-Mags, Bad Brains, D.R.I. and Gang Green tasted the brink of success with audiences outside the punk ghetto. One has to remember the stranglehold that TV had on this same generation, a consumer magic wand that, according to Barbara Kruger, makes "difference the enemy. [It] focuses on the moment and not the process, the individual not the scene, the figure and not the body. Current events, national struggles, and sexualities are created, renewed, or cancelled like sitcoms" (1989: 10). The greatest TV network of all was MTV, branded by Greil Marcus as "the stupor

of reification. So ugly, so directly productive of esthetic and moral shame, as to be fundamentally obscene" (1987: 12). If hardcore was sometimes reactionary, inflexible, overwrought, and its own worst enemy, it was partly due to a gripping siege mentality. As Pushead told *Heart Attack* zine, "even in the early 1980s conservatism about punk and hardcore had already set in—clear definitions of what was 'punk' or 'hardcore' in terms of style, content, dress, etc. . . . Rules . . . for something that was actually defining itself at the time and relatively new" (#53: 2002).

Yet, as Vic Bondi hints in his liner notes included with *Core*, the Articles of Faith reissue album from Germany's Bitzcore Records, hardcore was about a kind of honor code that overlapped into community building. The strategy insisted that people, especially teenagers, could not be bought and sold, and that consumer society could not easily absorb youth rebellion, especially one that was, at least on the surface, so consistently pitted against the powers that threatened to squander it. Hardcore was a truculent answer to "a recklessly dishonest time," Bondi insists, in which "Nothing is more unwanted than an unwanted truth" (2002).

This sentiment appears wholeheartedly reinforced by the Riot Grrrl movement's self-determined and vigorous grassroots feminism of the mid-1990s, which centered on bands like Bratmobile, Heavens to Betsy, Bikini Kill, and others. In her article "Riot Grrrl: Revolutions from Within" from *Signs: A Journal of Women in Culture and Society*, author Jessica Rosenberg quotes two scenesters—Madhu, who implores: "Through Riot Grrrl, we can get with people with similar problems and interests, and constructively try to change our world. It's a community, a family"; and Emily, who called the movement "an underground with no Mecca, built of paper, which later evolved to the Internet" (1998: 811). For a generation of young punk women in the 1990s, Riot Grrrl punk was both a tinderbox of spirit and

ideas and a counterattack against all the inherited, short-sighted male chauvinism of the scene.

According to writers like Gina Arnold, punk persevered until the mid-1990s because it preserved an "honest voice, a musical lack of pretense, and a sound that cried havoc. Punks play with ideas of outlawry and rebellion. It pretends it is not sincere but, at bottom, it is as committed to its cause as anything that came before it, positing an ideology as devoted to freedom and kindness as any world religion. Punk must feel righteous, not popular; alone, not nurtured, it has to be embattled to exist at all" (xii: 1997). Sometimes the battle was with itself. Exemplified in part by Eric Weisbard's adroit phrase, "Punk remains a baptism in heresy. So long as we can disagree about its essence, punk will never die" from his May 2001 *Spin* piece that sketches a hip, concise portrait of punk's not-so-sinister (as Mom and Dad once thought) twenty-fifth anniversary. Still, many were wary of punk's slide toward cliché. For instance, by the mid-1980s, John Lydon (formerly Johnny Rotten) outlined the hardcore scene in London to *BAM* magazine in demeaning terms— "Punks, the Mohicans, they're tourist attractions. On King's Road, coachloads of tourists get off and take pictures . . . You're a joke. They've become circus figures. A freak show" (Darling 1984: 30). Many worry that punks have carried this shameless style-mongering, not the core ideas of punk, into the new millennium.

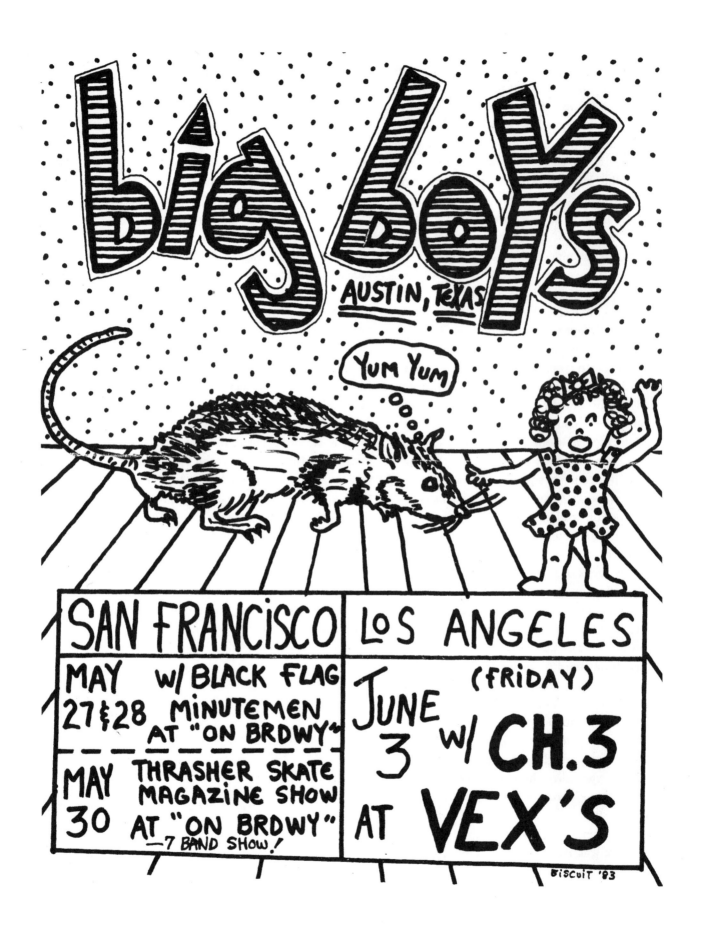

Big Boys' California tour flyer, including the Vex, by Randy "Biscuit" Turner, 1983.

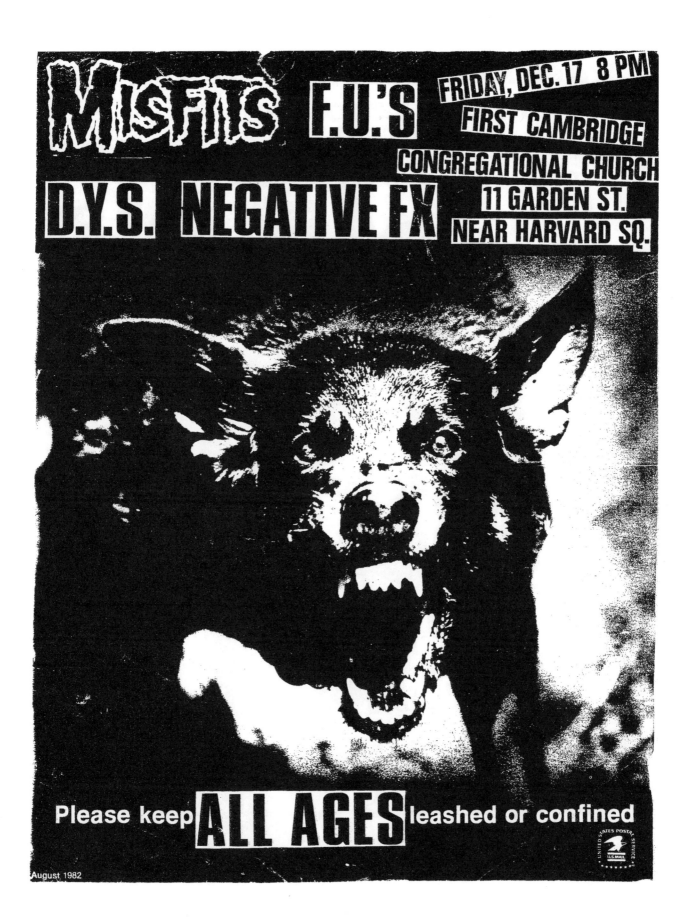

Misfists, DIY, FU's, and others, 1980s, First Cambridge Congregational Church, Cambridge, Massachusetts.

Neon Christ and Corrosion of Conformity, 1980s, Durham, North Carolina.

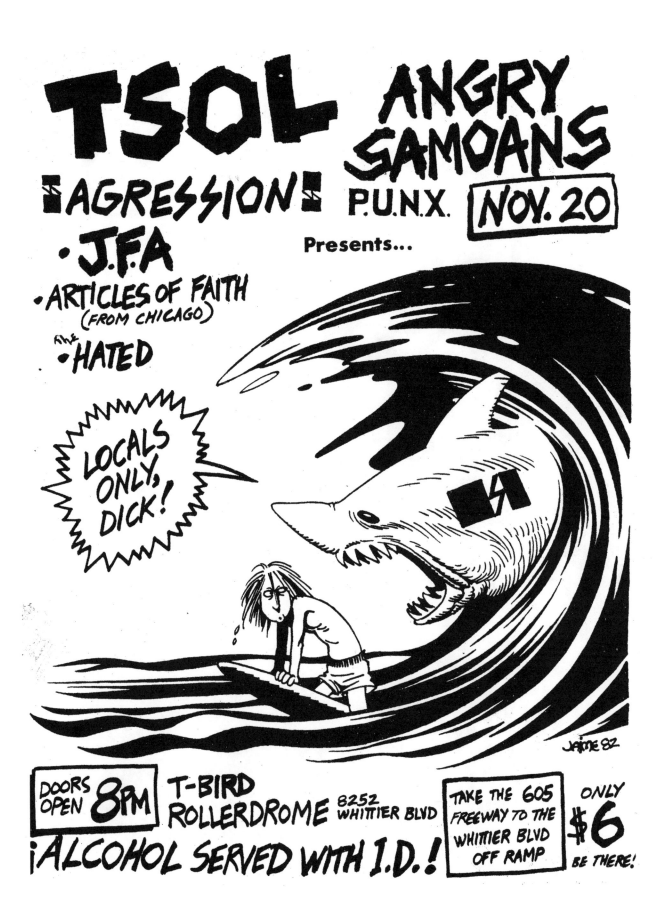

TSOL, JFA, Aggression, and others, 1982, T-Bird Rollerdome, Pico River, California, by Jaime Hernandez.

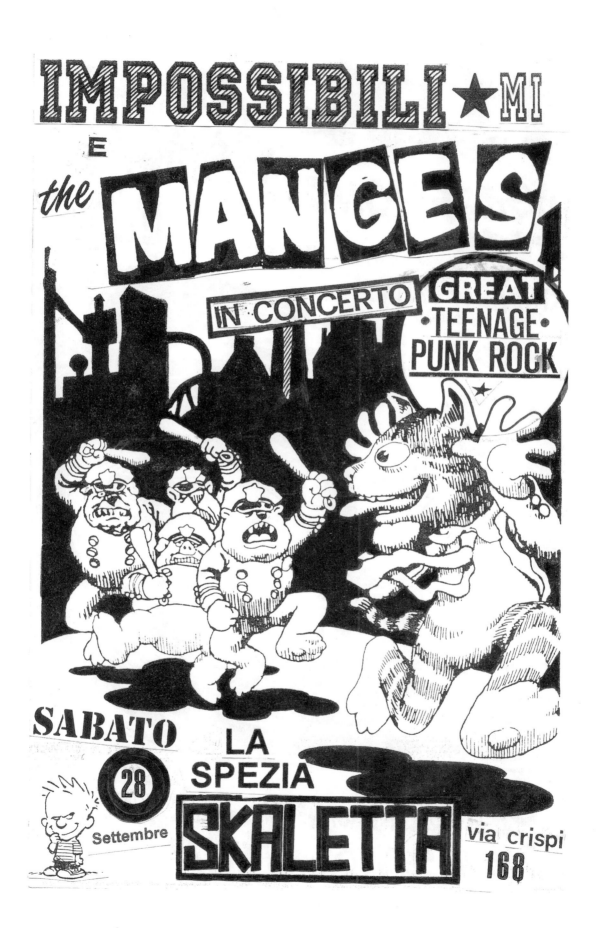

Original mock-up, featuring appropriated Fritz the Cat image, for The Manges at
Skaletta in La Spezia, Italy, 1990s, provided by Andres Manges.

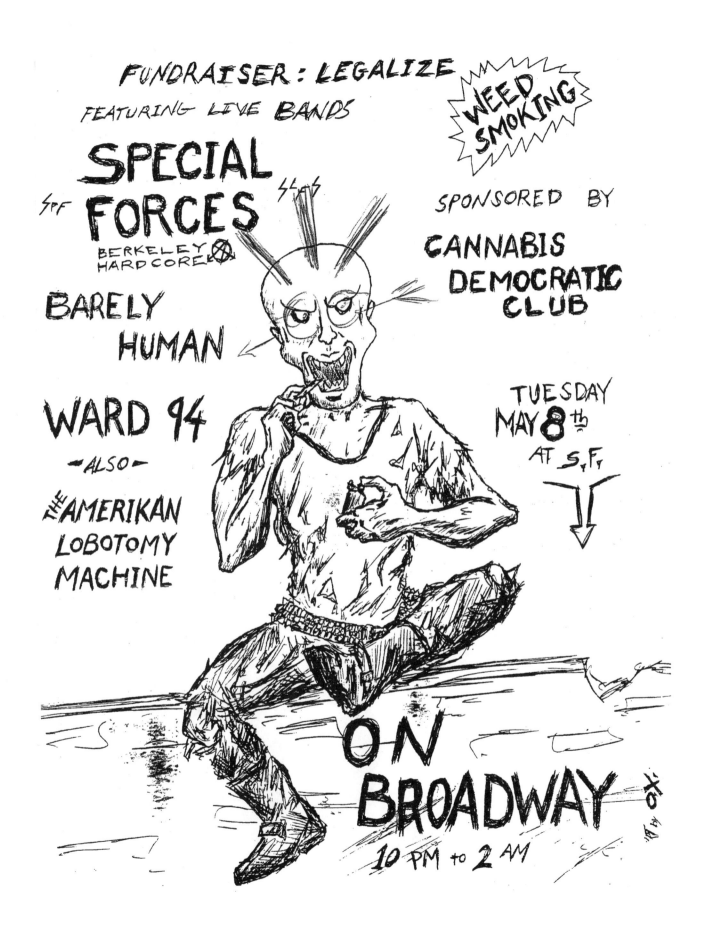

Fundraiser: Legalize Weed Smoking, by Orlando X, 1980s, On Broadway, San Francisco.

Jello Biafra for Mayor Campaign Fundraiser, late
1970s, Mabuhay, San Francisco.

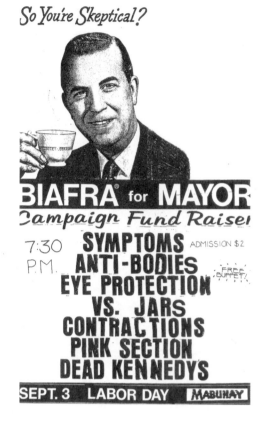

So You're Skeptical?

BIAFRA® for MAYOR
Campaign Fund Raiser

7:30 P.M. **SYMPTOMS** ADMISSION $2.
ANTI-BODIES
EYE PROTECTION FREE BUFFET!
VS. JARS
CONTRACTIONS
PINK SECTION
DEAD KENNEDYS

SEPT. 3 LABOR DAY MABUHAY

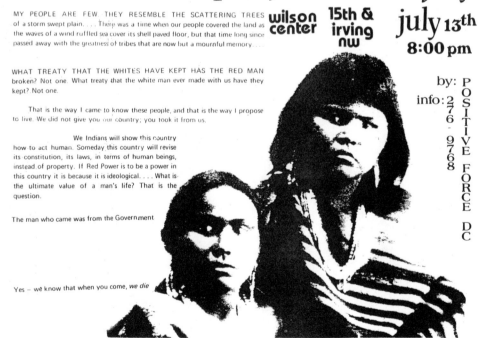

verbal assault fire party all white jury

MY PEOPLE ARE FEW. THEY RESEMBLE THE SCATTERING TREES
of a storm swept plain. . . . There was a time when our people covered the land as
the waves of a wind ruffled sea cover its shell paved floor, but that time long since
passed away with the greatness of tribes that are now but a mournful memory. . . .

WHAT TREATY THAT THE WHITES HAVE KEPT HAS THE RED MAN
broken? Not one. What treaty that the white man ever made with us have they
kept? Not one.

That is the way I came to know these people, and that is the way I propose
to live. We did not give you our country; you took it from us.

We Indians will show this country
how to act human. Someday this country will revise
its constitution, its laws, in terms of human beings,
instead of property. If Red Power is to be a power in
this country it is because it is ideological. . . . What is
the ultimate value of a man's life? That is the
question.

The man who came was from the Government

Yes — we know that when you come, *we die*

wilson center 15th & irving nw july 13th 8:00 pm

by: POSITIVE FORCE DC
info: 276-9768

BENEFIT FOR BIG MOUNTAIN LEGAL DEFENSE FUND

Benefit for Big Mountain Legal Defense Fund,
1980s, Wilson Center, Washington, D.C.

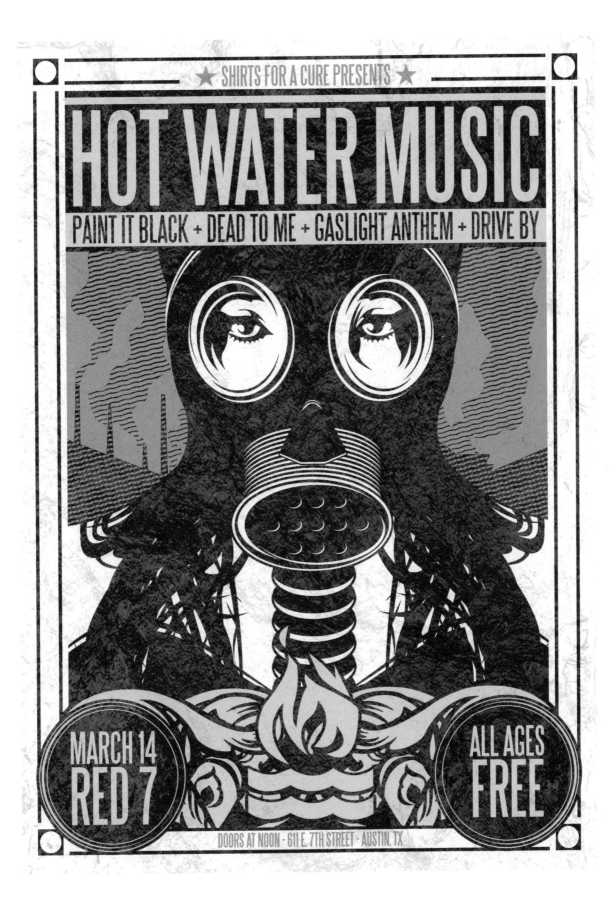

Shirts for the Cure, Red 7, Austin, Texas, 2008, by Zak Kaplan.

BENEFIT FOR THE **FREE CLINIC**

SACRED HEART CHURCH (16TH & PARK RD. NW)

FUGAZI*THE EX*NO MEANS NO

A quick picture of the American way—

A THOUSAND POINTS OF BLIGHT

Graphic courtesy of Lane/TIME'S UP #2
1101 W. Broadway, Columbia MO 65203

info. 703-276-9768

Recycled Paper

8PM MONDAY, JUNE 17 $5

Benefit for the Free Clinic, graphics courtesy of Lane/Time's Up #2, Sacred Heart
Church, Washington, D.C.

BENEFIT FOR HOPI INDIANS

PLH
TRIAL
TREASON
TEENAGE WARNING
CRUCIFIX
A) STATE OF MIND

OUR GOVERNMENT IS ALWAYS STEPPING ON
SOMEONE FOR WHAT THEY CALL THE GREATER
GOOD OF OUR COUNTRY. SOONER OR LATER
WE ALL GET STEPPED ON.

WEDNESDAY 17 AUGUST
ON BROADWAY

435 BROADWAY SF

EVERYONE IS WELCOME

Peace
Through
Anarchy

THIS FLYER BY OHT PRODUCTIONS 1983

Benefit for Hopi Indians, On Broadway, San Francisco, 1983.

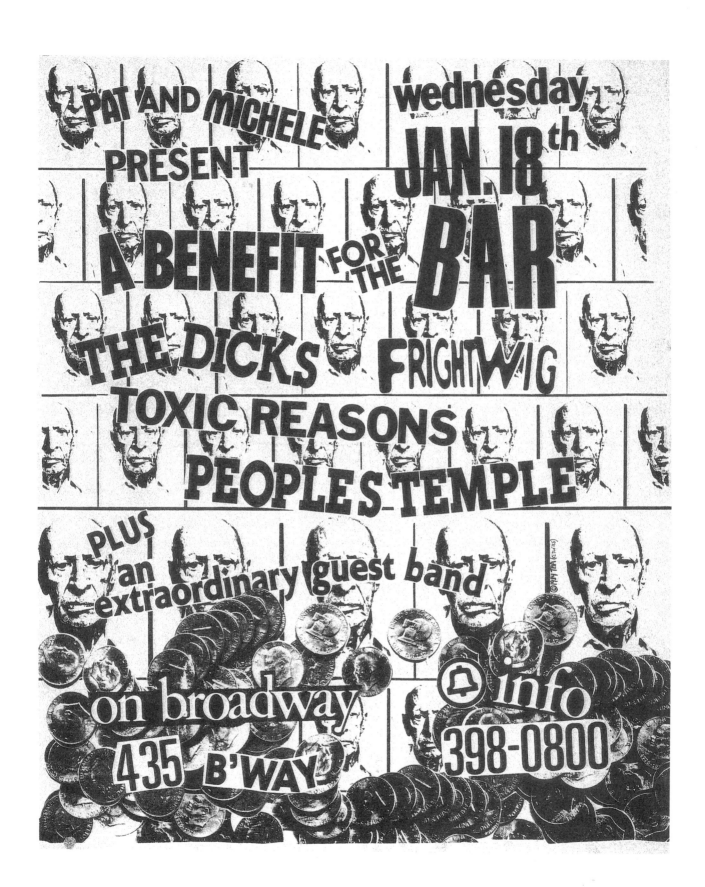

A Benefit for the Bar, 1984, by TBA, On Broadway, San Francisco.

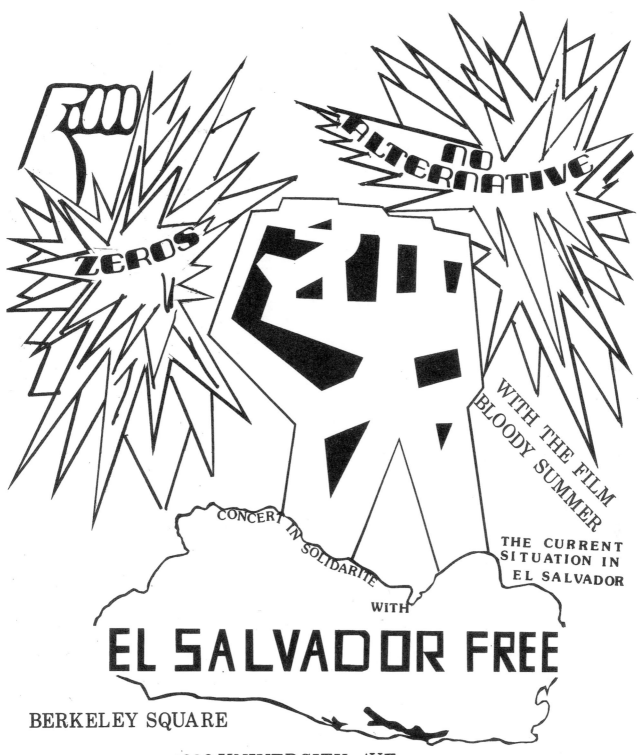

ZEROS

no ALTERNATIVE

WITH THE FILM
BLOODY SUMMER

THE CURRENT
SITUATION IN
EL SALVADOR

CONCERT IN SOLIDARITE

WITH

EL SALVADOR FREE

BERKELEY SQUARE

1333 UNIVERCITY AVE. BERKELEY
TUESDAY DECEMBER 2-80
9:30 P.M.

Concert in Solidarite with El Salvador Free, Berkeley Square, 1980, Berkeley, California.

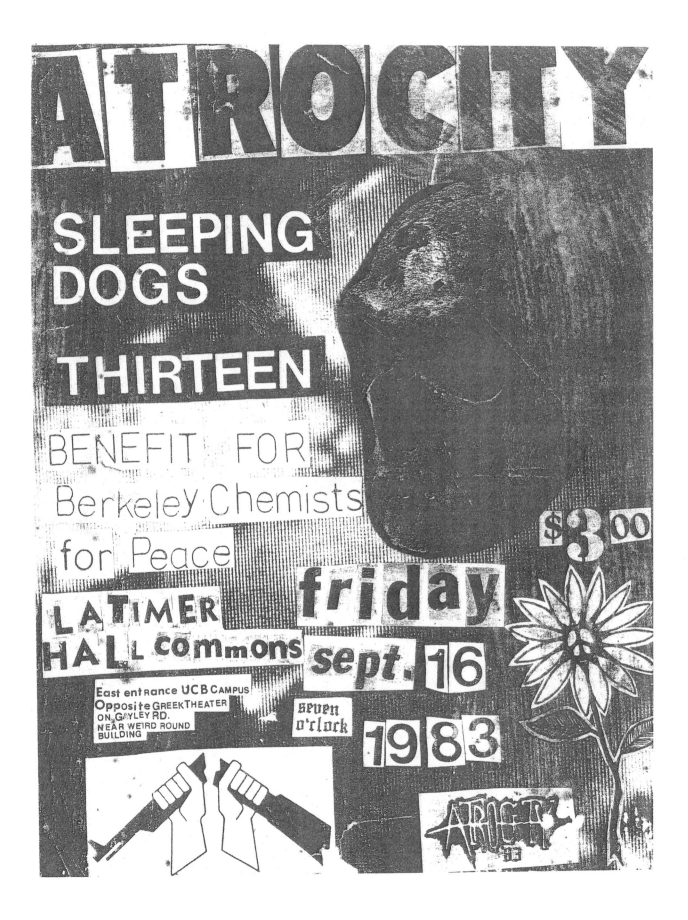

Benefit for Berkeley Chemists for Peace, 1983, University of California, Berkeley.

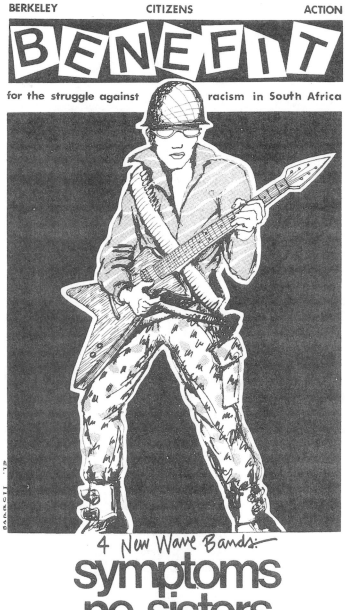

BERKELEY CITIZENS ACTION

BENEFIT

for the struggle against racism in South Africa

4 New Wave Bands:

symptoms
no sisters
pink section
the urge

fri march 30

Barrington Hall · 2315 Dwight Way
· 8:30 · beer & wine · $2.50 ·

Benefit for the Struggle Against Racism in South Africa, by Barrett, 1979,
University of California, Berkeley.

CHAPTER TWO

INCITE AND INCORPORATE

Punk Art
Exploring the
Usable Past

Piercing Our Plastic Lives: From Pop to Op

Some punk art summons and mirrors the trends of its older cousin Pop Art, for "it could invest meaning and beauty in things intended to be fugitive, summoning a relevance where none was needed" (Brauer 2001). Pop Art style is directly referenced, even mimicked, in the cover art for singles like "At the Edge" by Stiff Little Fingers, "Teenarama" by The Records, "Strobe Light" by the B-52s, and flyers for the Plimsouls and others. Granted, these bands might be considered closer to New Wave than punk, but even the Rezillos' "Cold War" and "Top of the Pops" singles, both from 1978, feature prominent Pop Art stylization and aesthetics. This does not make it easy to understand whether or not the purpose was to be ironic, reflexive, or simply a gesture of nostalgia—homages to pre-punk gestalts in a punk-stricken era of strife, envisioned as a time of corroded social and economic values, an era in which British youth were enduring race tension, high unemployment, even a relentless garbage strike. In this light, bands and artists might be considered in tandem, fleshing out the not-so-subtle possibilities of punk.

Roy Lichtenstein's paintings were actually faulted by commercial comic artists for being too "flat and static for the spatially oriented choreographic plausibility of modern comics," meaning they were somewhat fossilized, torn from context, stiff, and lacking in fluid contextual relationships (Alloway 1983: 23–24). In an earlier era, Alloway attests, such commercial art was imagined as signposts of an entire world outside of fine art. Lichtenstein attempted to collapse these high and low art distinctions and fault lines. Blending genres and modes, he incorporated them as both lingual and visual terrain: he readily adapted such spaces by changing text style, choice of words, opacity and density, even the momentum and narrative of a cell, to fit his own agenda (1983: 31).

To some degree, Lichtenstein was a precursor to punk art that also appropriated pop images, though perhaps he offered more subtlety and a different set of overall painterly values. Alloway further notes he was not engaged in mutual collaboration but in acts of annexation: "In the 1950s and 60s, popular culture was regarded widely as a system of common property to be claimed by all. Lichtenstein made a point of avoiding famous comic artists like Chester Gould or Al Capp. His iconography was based on style and genre, not on authorship"; he viewed "comics as a continuum of sharable images" (1983: 32). Still, this treats comics as low, "authorless," generic forms of expendable art, when in fact they are not. When Pop artists like Lichtenstein chose, in a conscious and deliberate act, to freeze and colonize such images rather than liberate them, he actually may have been trying to negate the vestiges of power in the comics. If so, this suggests that Pop Art may actually have been quite reactionary, if such artists consciously chose to dismantle and neuter the powerful, latent, and potential ideas previously imbedded in them.

Scott McCloud cautions that, instead, "Cartooning isn't just a way of drawing, it's a way of seeing. . . . by stripping down an image to its essential meaning, an artist can amplify that meaning in a way that realistic art can't. . . . I believe this is the primary cause of our childhood fascination with cartoons, though other factors such as universal identification, simplicity, and childlike features . . . also play a part" (1994: 36). Viewed from this context, comics are already rather mature forms, not mere pop fodder. McCloud further argues that comics are a "dance of the visible and invisible

creating something out of nothing . . . because embedded in all pictures of the visible world are the seeds of the invisible—the seeds of expressionism and synesthetics" (1994: 204).

Part of that inherent, built-in cell-by-cell expressionism is not simply a matter of aesthetics but also the result of the convenient philosophical platform of comic books, which remain an accessible format in which major social, technological, and economic ideas can be explored in concert with fine (or low) design elements. This blurs the line between the two while stirring debate that percolates throughout the cultural conversations of modern times: "I liked reading about heroic behavior, and the constant ethical dilemmas of Marvel characters spoke to me directly," announced writer and pioneering 1990s digital artist Jeremy Blake, who worked with Nation of Ulysses (note the spoken-word intro to their first record, *13-Point Program to Destroy America*) and was a close friend to members of Fugazi. He told an interviewer, "They were a precursor to the punk records I have still not outgrown" (qtd. in Sales 2007).

The concept of using shared and appropriated images may also reference Dada and Surrealist tendencies, which served as precursors to the technique of punk writers like Kathy Acker, mentioned previously, who actively reworked, transmuted, or lifted directly from texts such as *Don Quixote*, *Great Expectations*, and *Treasure Island*, as well as from the writings of Proust and Marquis De Sade. This is not unlike the current trend known as fan fiction: "Undaunted by traditional conceptions of literary and intellectual property, fans raid mass culture, claiming its materials for their own use, reworking them as the basis for their own cultural creations and social interactions" (Jenkins 1992).

After reading Acker's book *Kathy Goes to Haiti*, fan Kathleen Hannah wrote a term paper in fanzine form about, "Why I couldn't write an essay, all the reasons why, and I used weird pieces of fiction in it. I didn't show up for the final but went to Seattle for an Acker workshop. She told me, 'Nobody goes to spoken-word events . . . Why don't you join a band?'" (Vincentelli 1999). Hannah soon became one of the progenitors behind Riot Grrrl, singing with the band Bikini Kill for seven years. She was an empowered fan, driven to see potential and possibility in forms unlocked by the style of Acker.

Some pop art tendencies also lead to the comic/illustration style of prominent flyer artists such as Shawn Kerri, Jaime Hernandez, Raymond Pettibon (problematic, which will be noted), and Victor Gastelum, each of whom worked within the possibilities of supposedly lowbrow art/comics styles. Gastelum informed me:

Comic books affected me like everybody else in that they taught us all how to draw. I was not big on comics except for *MAD* magazine. *MAD* had a big impact on me not only in the drawings but because it was subversive and cynical. *MAD* kind of primed me for punk. *MAD* was like the big brother helping us get hip on consumerism, politics, sex, absurdity in society, celebrity culture, and not taking things too seriously. *MAD* magazine was one of first places I ever heard about punk rock. It was really subversive because your parents would buy it for you and they had no idea what it was. It just seemed like some stupid kid thing because it was illustrated. I wasn't for the most part purposely slipping in some heavy social comment into my art. I think because of being influenced by stuff like *MAD*, when I saw other people do that, it seemed kind of naive. It was a gig flyer, I wasn't trying to get people to think like me or overthrow the government. I was just trying to do something original. . . . I was just looking around my backyard and trying to see what I could use. I was showing you what I knew about, what I have seen. (2008)

Throughout punk history and art, *MAD* is a constantly recurring, iconic reference point and

aesthetic prototype. The Cramps describe their own audience to *Damage* zine as looking "like a picture of a crowd in *MAD* magazine" (quoted in McLinden 1980: 16). The Ramones worked briefly with Paul Kirchner, an assistant to Wally Wood from *MAD* and creator of Dope Rider, for the album art destined for *Road to Ruin* but ended up rejecting thirty of his sketches. During the last stretch of the album art design cycle they gave John Holstrom, illustrator for *PUNK* fanzine and the cover of their previous album *Rocket to Russia* (whose own style strongly resembled the work of *MAD* magazine creator Harvey Kurtzman) $1,000 for the front cover (True 2002: 93).

Similar *MAD*-born styles and reference points can be found throughout Xerox punk gig flyers from the late 1970s through the 1990s, including Shawn Kerri, a flyer illustrator for the Germs and Circle Jerks. She designed album covers for DOA while penning panels for *CARtoons*, *Cracked*, and skin trade magazines like *Chic*, *Velvet*, and *Hustler*. As she acknowledged, "Some of my all-time favourites I was impressed with as a kid were Jack Davis and Bill Elder, who worked for *MAD* in the 1950s" (qtd. in Welly 2002). Her most recognized work was the "skanker," evolved from doodles, that soon graced many Circle Jerks products—an everyman hardcore teen skanking, but caught frozen mid-movement in the shape of a loose swastika. She attests, "He was supposed to be all of them lumped into one. He was every one of those beach brats. I was terrified of them, but they were a lot of fun to watch" (qtd. in Welly 2002). Hence, like Alfred E. Newman, he was a composite: everyone and no one, a vessel embodying long-lasting, fill-in-the-blank hardcore iconography. In fact, on several punk flyers he has been re-imagined by different generations of amateur punk DIY artists, including another woman, Loren, who inscribed a version of him on a Circle Jerks and Toxic Reasons show flyer at the Anthrax in Connecticut in the mid-1980s.

In the poster anthology book *Electric Frankenstein: High-Energy Punk Rock and Roll Poster Art*, Jim Gibson notes that this graphics style approach, which included Frank Kozik's reference point to "the lamest TV cartoons, the most obscure British war books, Ed Roth–style hot rod caricatures, '40s girlie mags and tabloids snatched from washroom floors," points to a convergence between lowbrow culture and the world of punk graphics, which has far less subtle ironic conceits than pop art influences, often retaining a sense of the primordial and atavistic (Canzonieri 2004: 6). In terms of origin, Gibson posits that this style most likely

> started with comic books that parents used to buy for their kids to encourage them to read. It was a great way to stimulate the young, curious mind. The stories and the graphics spoke to the kids in a language they could understand. . . . Also, they were practically wetting their pants laughing while reading Don Martin and the rest of the crew [Wallace Wood, Jack Davis, Harvey Kurtzman, and Basil Wolverton] behind *MAD* magazine. These comics are true Art and are just starting to get their own due, not only because of the craftsmanship that went into them, but because of how they affected their audience. (2004: 5)

The dynamic at work pertains to the relationship that viewers have to the work; that is, the posters speak to culture-specific audiences that can "read" not just the pertinent show information provided by the posters but also the symbolic transgressions latent in the work, even if those transgressions refer less to state-sponsored violence and control and more to a time period of enveloping political correctness and punk's migration towards "emo" forms. Such posters may latently interrogate an era when straight-edge kids with wooden bead necklaces and crisp white T-shirts were plentiful, while "horror punkers" or "hair punks" had receded to the margins.

The Revolt of Rock 'n' Roll within Punk

The hand-printed, screened posters of 1950s and 1960s rock 'n' roll bands mostly relied on photographed images of the artists and solid, flat and clean block printed lettering providing pure unadulterated information. In the 1960s artists began molding the space around the information, filling it with "intense optical color vibration associated with the Op Art movement and swirling forms and lettering bent to the edge of illegibility," including graphics that visually reworked the meaning inherent in the words (Meggs 1998: 403). As Jim Heimann wrote in "Rethinking Illustration" in *Single Image*: "Pop art, super graphics, and bold slashes of color were joined by stylistic revivals. Unfashionable art deco and art nouveau style were suddenly in vogue again. The psychedelic style of San Francisco poster artists, such as Rick Griffin, Stanley Mouse, and Wes Wilson, appropriated a century's worth of imagery and blended it with mind-expanding colors, patterns, and types incorporated into mainstream ads for products like 7UP" (2000).

Increasingly, the style of the work mattered more than the information it conveyed. For instance, on Velvet Underground and MC5 (both seminal, proto-punk bands) posters, the artists sometimes eschewed the image of the band altogether, and the names of the bands and venues were submerged into a web, or better yet, a miasma of psychedelic lettering that re-imagine the curvy natural lines of early Art Deco posters. The artists constructed a strangely harmonious, fluid world, an off-kilter Eden, and a bewildering eye socket that rejected gloomy perspectives in the midst of an era battered by the Vietnam War and race riots. To people outside the youth culture the art might have seemed an insignificant gesture: "According to newspaper reports, respectable and intelligent businessmen were unable to comprehend the lettering on these posters, yet they communicated

well enough to fill auditoriums with a younger generation who deciphered, rather than read, the message" (Meggs 1998: 404). Ironically, the artists needed the collision and intervention of "others," say mothers, schoolteachers, and "squares," to make poster art a place where communal, imaginative gestures could provide a kind of liberation from the strictures of a "normal," middle-class, Protestant upbringing. Without ample friction and context, psych and punk flyers are mute.

Although first shunned by the punk movement, psychedelia would eventually find a home in punk posters, typically in the mid- to late 1980s, when post-punk bands like Helios Creed, featuring a member of former San Francisco punk outfit Chrome, and garage rock bands like the Cynics, utilized posters that echoed psychedelic tendencies, serving as precursors to the work of Frank Kozik, Jason Austin, and others. Kozik, in fact, identifies himself with an earlier generation of poster makers, attesting: "I was the first person in fucking America—since the 60s—to consistently do large-scale, color posters for underground music that got out" (qtd. in Jones 1993: 40). This "high-energy" poster trend that eschewed the style of minimal, crude, black and white, simple cut-and-paste techniques was visible in the 1990s work of Jim Evans and the TAZ collective, Jermaine, and in the 1980s by Art Chantry as well. Writer Sal Canzonieri illuminates the mondo stylistic approach:

> By the early 1990s, a show's poster was often as important as the show itself. . . . Like the music of the bands of the early 1990s, newer poster artists combined elements of the "Psychedelic Era" with that of the "Punk/Hardcore" era, juxtaposing imagery from the whole history of rock 'n' roll with that of popular culture. Bright colors, sardonic humor, and large-sized posters shockingly displayed on telephone poles and record store windows were used to advertise shows. "Do it Yourself" ethic was the major impetus for all we did. . . . It quickly

became obvious that the better the poster or flyer, the more people came to the shows. Seeing people standing around a wall discussing the artwork in a poster or flyer made you realize that this medium was the best way to quickly and effectively get the attention of a lot of people for your band. The artwork—its design, composition, illustration, and typography—excited people enough and connected them emotionally. (2004: 8)

A new epoch of punk emerged, still ignited and framed by DIY, which fluidly linked eras. The new psych punk, or rock 'n' roll punk, or hammy hotrod retro punk, catalyzed a poster style that looked like a pastiche between the era of Blue Cheer and Amphetamine Reptile Records. To some critics, the style resulted in a commoditized, gentrified, and co-opted poster form in which the original concept of punk is altered by a post-hardcore generation that consciously created fine art–leaning posters that were highly collectible, crafted with "engineered scarcity" in mind (limited editions), and usually beyond the graphic means of a typical self-taught teenager creating gig fliers in basements.

"New school" artist Frank Kozik, who now designs Japanese toys, offers this simple maxim: "What is punk rock but free enterprise? It's the purest concept of capitalist democracy: create your own system" (qtd. in Sinker 2001). What remains to question is how such sentiments segue with the concept of being a DIY amateur. In term of the flyers themselves, Robert Newman argues, "they reflected a do-it-yourself attitude . . . any style or skill level was acceptable, and . . . the artform itself was as significant as the music it advertised" (Chantry 1985: 5). However, in at least one case, band members were divided over acceptable DIY flyer style. Springa, singer for the Boston hardcore band SSD, attested to *Suburban Voice* that one reason the band broke up involved key aesthetic differences in regards to a flyer's DIY qualities: "You see, [guitarist] Al's always professional, the

block lettering and stuff. I violated that by making a goofy kindergarten flyer. I guess Al said it looked like it was made with crayons. (in an exaggerated voice) 'It looks like a second grader made it.' . . . And I was like, at least my flyers are out there . . .'" (qtd. in Quint 1993).

Billy Childish of the Milkshakes and Thee Headcoats places a kind of primacy on such techniques, arguing that such an amateur is actually "in the best position to do anything, since you're doing it because of love rather than your mortgage! Amateurism is so under-rated in this society. When you are working at an amateur level all of the time, you've got this massive advantage over everybody else, because you enjoy a certain level of freedom—whereas the professional has all these constraints: 'It's my job. I have to do it like that'" (qtd. in Vale 2001). Yet artists themselves may be torn between the idea of restless innovation versus eventual stasis; a desire for professionalism; and an aesthetic and financial movement toward commodification. Culture critic Tavia Nyong'o outlines the obvious contradiction of prolonged amateurism: "If punk rock dissented in part by rejecting musical virtuosity for pure attitude and ecstatic amateurism, how precisely could it sustain that stance? The more committed to punk one was, the quicker one acquired precisely the expressive fluency the genre ostensibly disdains" (2008: 110).

"I'm a big fan of amateurism, and I think amateurism is where all new ideas come from, the do-it-yourself syndrome, but at the same time, every time there's an introduction of new technology," Art Chantry offered this warning right at the turn of the millennium, " . . . there's an enormous drop in quality while the system and the culture assimilates it. The result is, the design is getting really shitty" (Sheehan 1998). Such debates about amateurism may reflect privileged arguments of people living in Western abundance, for sociologist Susan Willis asserts that such "Subcultures can[not] come into being in societies of scarcity,

not because there wouldn't be enough commodities to make style distinctions, but because participants in subcultures have to be fed, clothed, and to some extent, housed; . . . they do not and cannot make a career out of their practices" (1993: 370). Cast in this context, the fetish for the "cult of the amateur" is played out by the technological haves, while meaningless to the have-nots.

The boundaries between Do-It-Yourself and professionalism increasingly became blurry. Kozik worked for both Nike and Power Computing ("The Mac is Multimedia") during this time, ran his own label Man's Ruin, which produced 200 records/CDs and set him back $800,000 dollars, and directed a video for Soundgarden, all while continuing to make some posters, which he has called pop detritus at best (Davis 2004). In contrast, Art Chantry considers his own poster work to be cultural artifacts. Either way, some argue these posters seem to represent the carnal, craven, indulgent, spoofed, sex-laden "classic sleazeball American trash culture" echoing some of the style of *Zap Comix* contributors R. Crumb, S. Clay Wilson, Rick Griffin, and Robert Williams along with Russ Meyer's appetite for voluptuous bodies (Drate 2003).

Don't Call Me Pop: Pettibon's Painterly Method

Rather than treat his viewers as passive and neutral, Raymond Pettibon's flyers resemble dark, ambient, postmodern Sunday morning comics that capture "real life suffering but only as filtered through films, detective novels, science, the Bible, and People magazine" (Weissman 1990: 197). The drawings interrogate our space, render the familiar unfamiliar. To art critic Weissman, they offer up "The momentary glare of revelation that almost everything is ugly—recycled stray snatches of TV-speak, one-liners, political satire,

streaks of mysticism . . . some kind of uncrackable code" (1990: 197).

Pettibon, whose father taught English and wrote espionage novels, foregrounds language in his art, which likely reflects his own range of literary influences, from Henry James to William Blake. Telling novelist Dennis Cooper in 2001 that literature "was originally and probably still is just as important to me as art," Pettibon discounts his connection to pop art, dismissing the irony of using images like Vavoom (a Pettibon alter ego inspired by Felix the Cat), surfers, Officer Friendly types, square businessmen, Angel Dusted hippies, and Elvis crucified like Jesus (on the cross alongside the text "You didn't love him enough" instead of "God, why have you forsaken me?"). He argues that Joan Crawford, Vavoom, and Gumby are not campy pop culture figures in his art but a way to explore the roots of language, expression, and communication (Turner 1999). Additionally, he stresses: "On the surface, the look of my work has something to do with comics or cartoons or illustrations, fine. But my work has nothing to do with comics and if it were part of that 'High/Low' show it definitely shouldn't be included in the low part alongside Robert Crumb. My art refers to a lot of things, but it's as far away from cartoons and comics as anything. . . . No one in comics would ever think of my works as comics" (McGonigal 1991: 83).

Still, Pettibon was featured in a group show of "Pathetic Art" (titled *Just Pathetic*). The show essay describes the artists making "no bones about their sympathy for the trashy end of the cultural spectrum" (1992). In Pettibon's work that "trash" is mediated, not just splashed on a high-energy rock 'n' roll poster. It does not act as a homage or a quick nod to the power of nostalgia. Instead, the icons are caught within the feedback loop of a very enclosed, claustrophobic space—the page itself. Ominous figures blend with utterances, thoughts, or narratives that may or may not flow

seamlessly with our impression of what should be offered, told, or reinforced about the inky image. As Pettibon describes his use of Vavoom: "When I'm doing drawings of Vavoom I create a situation of putting him in this epic, sublime, romantic landscape and he is this little guy with a booming voice. It's a perspective that has this panoramic scope to it" (*Art 21*). One narrative may seem in taut, nervy tandem with the often seedy, marginal characters, but another narrative establishes a mysterious tension, one that opens up into poetic conceits poached from historical sources with the instinct of T. S. Eliot.

Thomas Mie-gang posits that Pettibon works within a "referential framework of a universal distrust towards the dollar's sway over the aristocracy of the galleries and museums; a revolt of the street urchins against those cultural institutions" (2007). Seen from this perspective, Pettibon is akin to a reporter. His antennae send signals from gangland and the counterculture, becoming a "critic of the American way of life and its rebellious counter-universes" (2007). As such, his punk art, whether a flyer furtively tacked on a wooden telephone pole or expertly arranged on the wall of a gallery, is a critique of culture, not unlike historic painters like Goya or others, that reminds viewers of rifts and fissures in culture. In casting an astute eye toward J. Edgar Hoover, Ronald Reagan, and the seemingly "burlesque" tribulations of Patty Hearst and the SLA, Pettibon marks a spot in culture where humor, anger, and political discourse fuse. He traces such tendencies back to the Three Stooges, Molière, and the Greek tradition of satire and rancor, aimed at the "pretentious, the powerful, the decadent and the corrupt" (*Art 21*).

Linking Pettibon to punk politics is difficult, however, because he maintains that punk was essentially "an excess of hormones" in which politics manifested as "bruised tattoos" (Turner 1999). Pettibon's work, endowed with features that resonate well beyond record store bins, did find a second life in gig flyers, becoming definitive visual hallmarks in punk history. As Jay Babcock has written in a mini-history of Black Flag, "the fliers' content—and their ubiquity on telephone poles and street walls—contributed to the band's already edgy, menacing mystique" (2008). This, however, does not equate his work with advertising. Pettibon insists:

> My work was displaced historically. . . . The flyers weren't done as commercial art or advertising. You could have stuck anything on a photocopy machine and put the band name and made an advertising flyer, but these weren't done like that. . . . I would give them original art and it would come back to me scrawled upon and taped over or whited out, and I'd always ask, nicely, "Could you please make me a copy of this first and then do that?" Their master tapes were deemed sacrosanct, while my work was considered as completely disposable. (qtd. in Mullen and Spitz 2001: 198–99)

Though Pettibon once was infamous to both Los Angeles youth and police for the unique visual imprint of Black Flag flyers, he has since become a kind of blue-chip artist who straddles both the rarefied fine art (gallery and museum shows, coffee books) and commercial art worlds (Sonic Youth and Foo Fighters album art). His early art works, now coveted punk memorabilia, still speak for and chronicle the dizzying rise of suburban hardcore punk.

Xerox Nation

Though ideology-driven bands like Crass railed against monolithic, multinational corporations in absolute terms, photocopy companies like Xerox were evoked, at times in romantic irony, in songs such as "Xerox" by Adam Ant even as companies like IBM were depicted as logos on skull tanks

(military tanks made from huge human skulls) produced on artwork for bands like MDC. Punks were steadfastly aware that the "Age of Xerox had begun: endless contorted images spread from the photocopy machines as bands and writers everywhere rejoiced in the democratization of the publicity process" (Buchloh 1998). The idea of "rejoiced" may smack of hyperbole, but the fact is that Xerox and others produced machines that freed punk graphic artists from the demands of money, time, and energy by handing them a machine that could act as a Trojan horse. As Winston Smith attests: "At least we can utilize these machines made by giant corporations against the establishment that spawned them!" (1993). Inside these photocopy units manufactured by Canon, Olivetti, Mita, and Xerox, tens of thousands of punk flyers from around the world would be produced. Like Blake, Goya, Grosz, and Daumier before them, punk poster artists, spurred by their early recognition of the impact and options offered by the new technologies of mass production and mass-cultural distribution, could now utilize a medium that ensured easy reproducibility.

More important, punk may have a sympathetic and symbolic relationship to the founder of modern xerography, Chester Carlson, the creator of the process, who grew up in dire poverty with an invalid father and a mother who died when he was a teenager. Carlson's story was examined in the article "Making Copies" published in *Smithsonian* magazine. He was raised in itinerant conditions, at times almost fist-to-mouth: California sand dunes, worthless Mexican acreage; a single room in Los Angeles; a shed in the snowbound mountains; and even a converted chicken-coop. Despite this lack of luxury, Carlson became an industrious student with a keen intuition for technology. After community college and a stint at Cal Tech, he joined Bell Labs in New York City and began his work on a number of different patents, including 400 outlined in the 1930s. By 1938 he had moved his own workshop to Queens, hired a short-term assistant, and created the first Xerox

image—the words "10-22-38 Astoria"—by using a glass microscope, a handkerchief, and sulfur-coated plate. In the 1940s he began to work with the Haloid Company (later the Xerox Corporation), forging what we now know as the office copier, which reached production in 1960 and quickly became one of the nation's most utilized inventions.

Yet, according to Owen, Carlson never bought a car, attempted to travel third-class in Europe, and gave much of his wealth away, including providing money to Cal Tech for a chemistry building in honor of his own mentor, offering large sums to international groups for world peace and national civil rights organizations. He also purchased buildings in New York City and Washington and integrated them, provided money to the United Negro College Fund and black colleges, and even provided the bulk of funding for the Center for the Study of Democratic Institutions, which invited speakers like Aldous Huxley, Cesar Chavez, and Upton Sinclair, among other notables. He also heavily supported schools, relief agencies, and pacifist organizations.

The democratic potential of the Xerox machine, or xerography itself, can thus be seen as an extension of the creator's desire to see a more diverse, integrated, and participatory American culture. One can only imagine what Carlson would have thought of a punk network that U-Ron, from Texas-based punk band Really Red, describes as fostering a culture in which "fanzines exploded and every little town had a rag with interesting scene reports and reviews. Dozens upon dozens of little Xeroxed zines full of rants and reviews" (2004). He also might have recognized the intriguing nature of punk in the early years, when "right from the start everything was DIY. . . . Sometimes when people knew about a show in advance, a bunch of people would all make posters—you might have four different posters made by people who just wanted to be involved. That's a whole different spirit; it's against mere consumerism" (Vale 2006). This

is the sentiment of Crime poster artist James Stark, who suggests that such approaches created a bond of social unity sadly absent today, since culture has become inherently linked to a consume-or-die mentality. In contrast, artists represent one of the few ways to resist the "consuming machine" (Vale 2006).

The very existence of these flyers and zines promoted individual agency, free expression, and a culture of participation, a notion of stirring up culture from below, all while depending on the very technology that Carlson invented. One English art student in the late 1970s, entrepreneur Nigel Wingrove, now known as a "mogul of sleaze-purveying, neo-exploitation Salvation Films," contacted Rank Xerox and rented a Xerox machine that he hid behind the couch in his mother's living room. At one point, the industrious Wingrove churned out twenty-four local zines, between 20 and 100 copies each, until he received a bill for thousands of pounds. His mother was able to plead to the company that a poor art student could not be expected to pay such debts, and they held the salesperson responsible (Colegrave and Sullivan 2001: 155). The incident underscores surreptitious Do-It-Yourself as a cornerstone of production, for xerographic capabilities allowed suburban teenagers, from the very beginning of punk, to become cultural insurgents by agitating culture or expressing "dissatisfaction with humdrum conventional life, with capitalism creating our desires and then selling those back to us as needs" (Warr 2007). In 1967, Guy Debord described similar conditions as the "degradation of being into having."

Current commercial advertising often looks remarkably punk in terms of its editing and content—as if punk worked less as a firestorm, and more like a permanent, slowly modulating, ongoing revolution that eventually partially dictated the aesthetic terms of a new generation that was raised on "Xerox music," a term for punk coined by the band Desperate Bicycles (Laing 1985: 17). "Punk rock had devastated the graphic world," Ian MacKaye of Fugazi and Minor Threat explains, "[along with] the musical world of world and fashion" (Hensley 1996: 122).

In Paul Hodkinson's work on goth culture during late 1990s Britain, he opines that flyers and fanzines represent "a small-scale specialist micro media" that "are deemed to have been significant in distributing practical information about music and events" while "construct[ing] and facilitat[ing] . . . a subculture" that reveals "overall levels of distinctiveness, shared identity, and commitment" (2002: 753). This distinctiveness has been partially co-opted over the last two decades by companies large and small that seek, in the words of the band Jawbreaker, to sell "kids to others kids." This may reveal that the "great white hope" of punk has become just another trend marker in the commoditization nation, in the teenage desire to be different and unique, which is often pursued through purchase power alone. Thus, as if a joke, all the misfits and weirdos look like clones of the Misfits and Weirdos.

Like other subculture theorists, Hodkinson ignores flyers as text. Flyers are not just a means to an end, not solely a way of getting information to audiences through graphic means or through niche or micro channels. The format of the work—the choice of media, the use of language as primary visual element, the unusual setting in which the flyers are placed—echoes the style of pithy 1980s artists like the Guerrilla Girls and Barbara Kruger. Flyers are a way of re-seeing band, venue, and cultural information as a total aesthetic miniature—the page as totality—in which the styles, theories, and practices of a culture, even in a hodgepodge or piecemeal manner, undergo a mirror effect and a surge in expression; thus they represent both revitalization and resurrection (Schor 1990). This is further supported by the claim of Mark P, editor of England's *Sniffin' Glue*, who argued: "It was the ideas that were important. The point was access" (qtd. in Savage 1991: 202), while Malcolm McLaren insisted: "If punk was just about music this thing would have died years ago" (qtd. in McDermott 1987: 57).

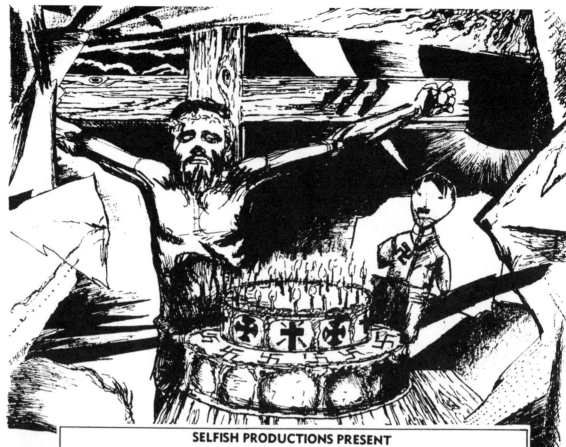

Circle Jerks and Social Distortion at the Stardust Ballroom, 1984, by J. Messer.

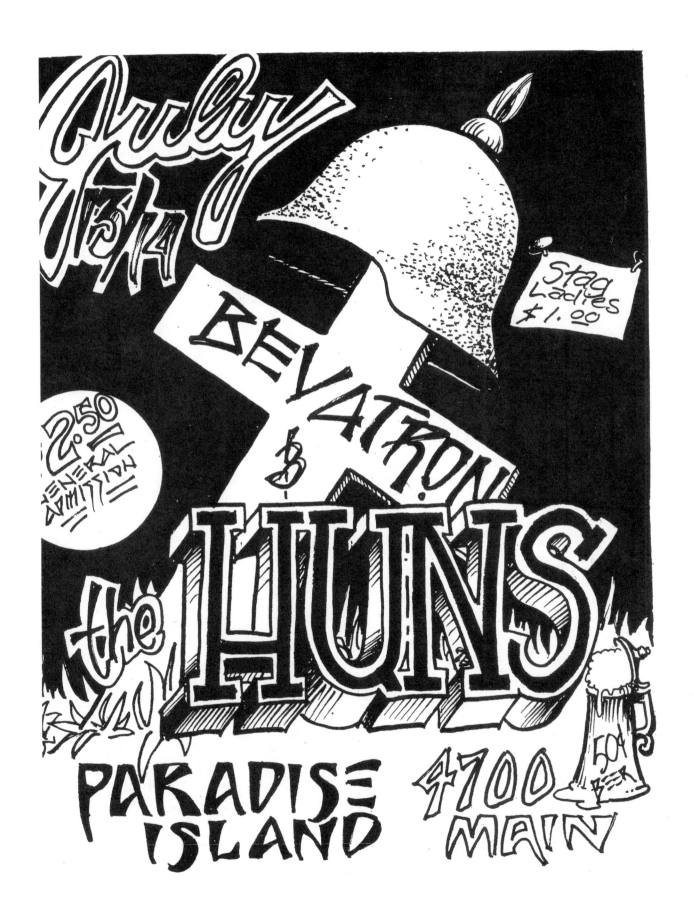

Bevatron and the Huns at Paradise Island, 1970s, Houston.

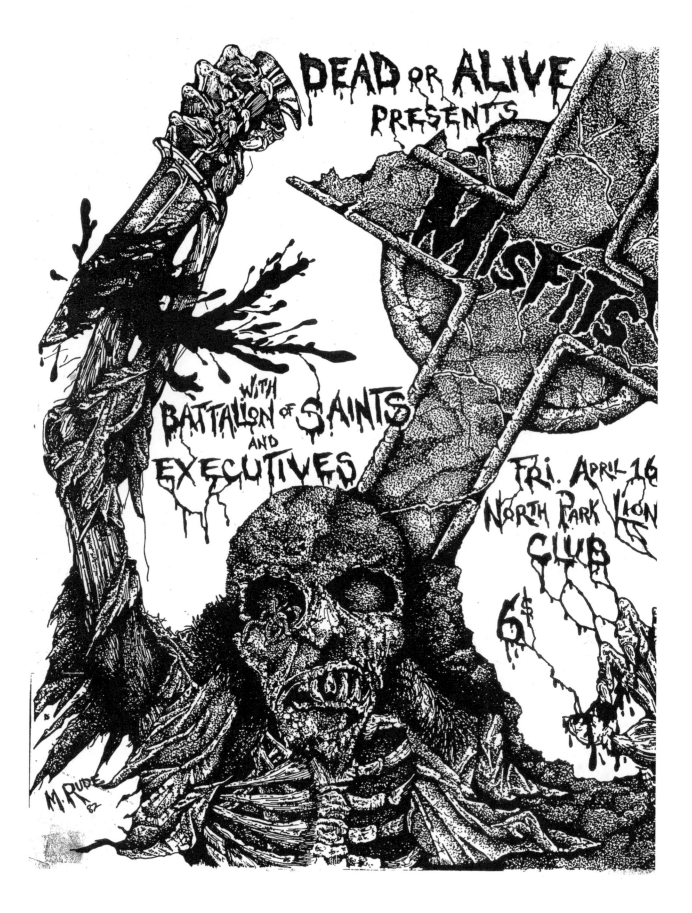

The Misfits and Battalion of Saints at North Park Lion's Club, San Diego, by Mad Marc Rude, 1982.

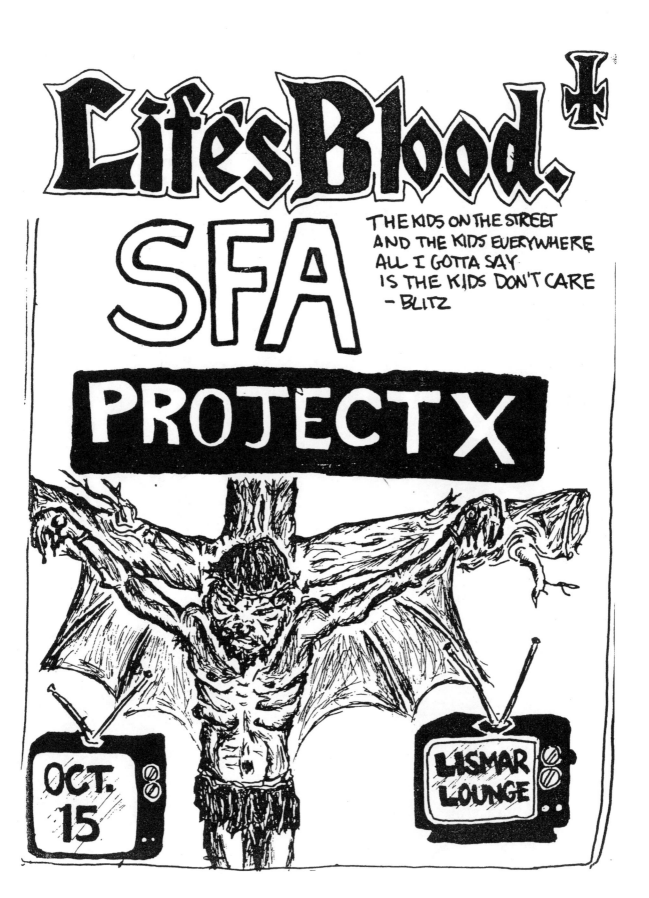

Life's Blood and SFA at Lismar Lounge.

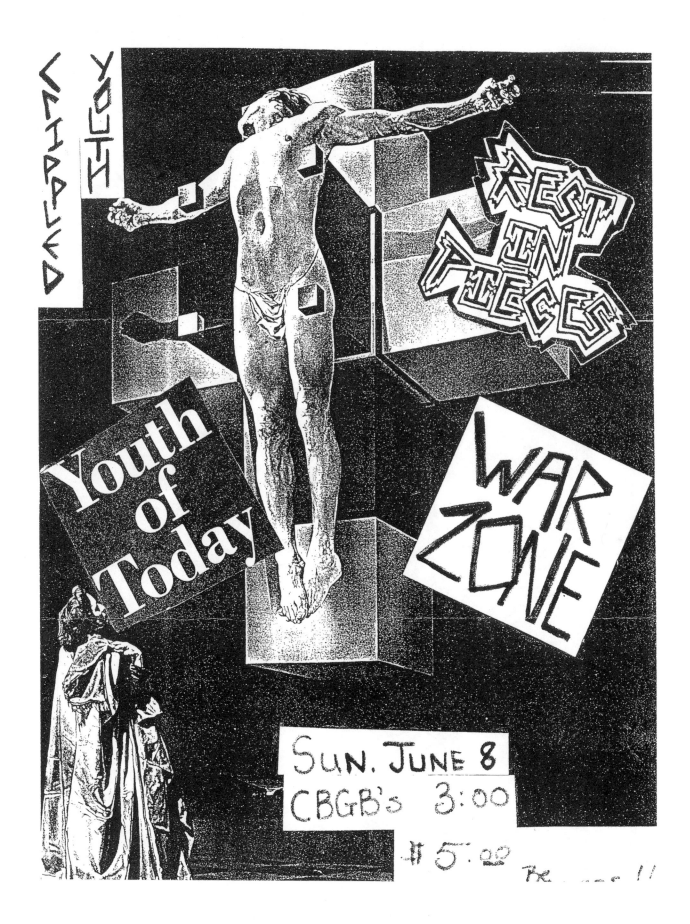

Rest in Pieces, War Zone, and Youth of Today at CBGB, New York City, 1980s.

Good Clean Fun at Urban Underground in Houston, by Russell Etchen.

The Makers, Guitar Wolf, and Nervous Breakdown at Marcus in Japan by Kacky, 1999.

Hand-drawn flyer by author, Pong and Texas Biscuit Bombs at Rudyards in Houston, 2004.

First flyer made by author, Adolescents and SAT at Rotation Station, photo by Bruce Rhodes, mid-1980s, Rockford, Illinois.

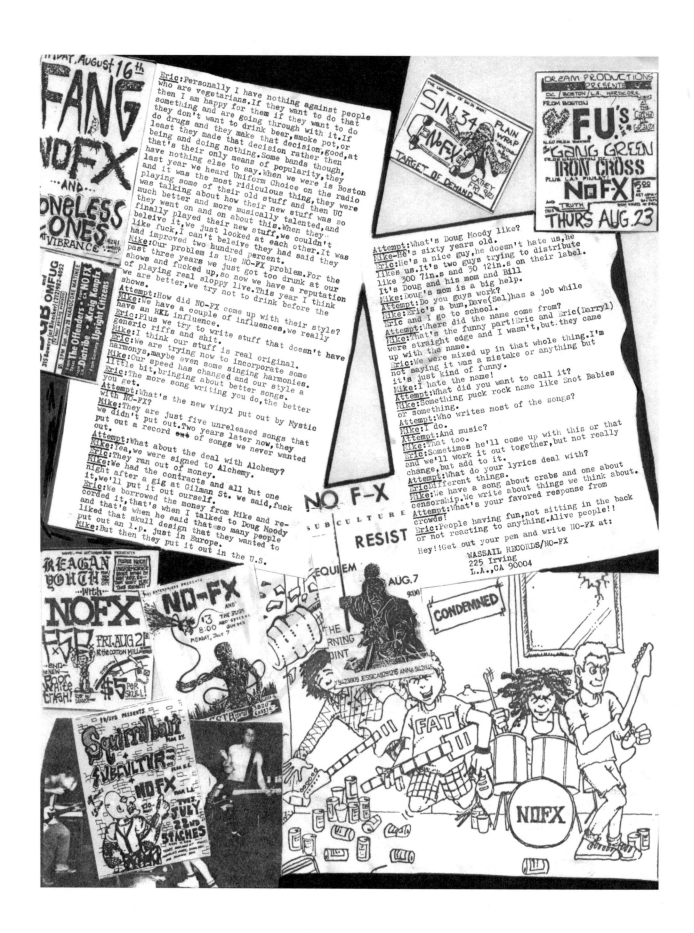

Flyers incorporated into the zine *Attempt,* produced by author, mid-1980s.

Elvis Hitler and Loco Gringos at the Axiom, Houston, 1980s.

Sleaze Party USA featuring Dead City Psychos and others, Ulana's Nightclub, Philadelphia, by Mato, 1999.

Swine King and Pork at Emo's, Austin, Texas, by Randy "Biscuit" Turner, 1993.

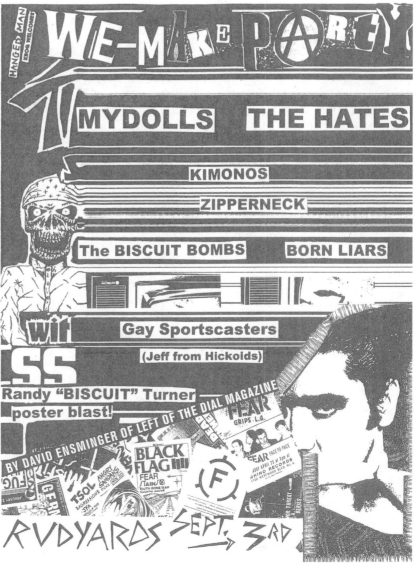

Mydolls, the Hates, Zipperneck, the Biscuit Bombs, and others at Rudyards in Houston, Texas, by David Ensminger, September 2010.

CHAPTER THREE

WAILING ON THE WALLS OF SIN CITIES
Graffiti and Punk Syncretism

The young and poor were being warehoused, not helped.

What could come after squatting, welfare, and graffiti?

Only homelessness, despair, and punk.

—MARK ARONSON, *Art Attack: A Short Cultural History of the Avant-Garde*

Norman Mailer once called graffiti "their text on our text," meaning that by the 1970s and 1980s young urban Americans had forced people to realize that the eyes and hands of the subproletariat, so-called wild kids and banditos, were right around dark corners with spray cans, illuminating America's underbelly. The authorities, and even neighborhood residents, often abhorred graffiti as the reckless and ferocious habits of the "natives," casting them into the roles of outlaws and saboteurs. However, historian Joe Austin has placed such identification within a wider context, suggesting that these insurgent art actions elicit meaning well beyond being mere marginalized activity. Such actions are shaped by the specific ways youth have been left "without legitimate spaces in which to live out their autonomy outside of adult surveillance. Young people are pushed to either 'Take Place' by appropriating nomadic, temporary, abandoned, illegal, or otherwise unwatched spaces with the landscape, or to 'hide in the light'" (1998: 14). To emphasize the notion of "take," one can reflect on this phrase by art theorist Ellen Handler Spitz: "Graffiti turns art into a verb" (qtd. in Phillips 1999: 32).

Austin further argues that New York City "wild style" was a keenly felt response to compounded alienation: the aftermath of the Cross Bronx Expressway construction, which dislocated entire communities; white flight from the boroughs to the suburbs; landlords burning buildings for insurance money; a changing and even hostile economic landscape (such as graffiti artist Futura learning printing press skills right as the industry became automated); urban renewal that tended to further ghettoize people; a 1977 power outage that inspired looting; and crass Hollywood portrayals that normalized the Bronx as "Fort Apache" while silencing local voices. Graffiti was a way for

This is what a lot of us had hoped would happen in the digital age: the technology would put low-cost, easy-to-use tools for creative expression into the hands of average people. Lower the barriers of participation, provide new channels for publicity and distribution, and people would create remarkable things. Think of these subcultures as aesthetic Petri dishes. Seed them and see what grows.

—HENRY JENKINS, "Taking Media in Our Own Hands"

youth to make a neighborhood's feelings visible. Street art allowed young taggers and artists a way to seek fame in their own "alternative economy of recognition and prestige" by painting surfaces that were hard to reach (1998: 242). Sometimes the surfaces moved beyond the city, like in the case of subway cars and commuter trains. In short,

graffiti allowed young people to feel independent, empowered, creative, and heard.

Graffiti plays with words and surfaces, visually reshaping the sides of dumpsters, the walls of buildings, sides of trucks, bridge support beams, street signs, and innumerable types of spaces. This fulfills a desire for people to insert these surfaces back into the public eye. Spraycan art revels in being two-sided: it is often hasty yet also mapped and planned. It is messy and refined, unseen and an eyesore, primal and modern. It is art that can further trap, alienate, blight, and tarnish a neighborhood. Yet, it also sometimes reflects a color-drenched, vibrant edginess, marking the "hip" section of city. It can be a sophisticated symbol, rippling the Botoxed surfaces of a city, revealing that no system, architecture, or project can silence the voices of people who lack traditional power. Indeed, graffiti projects the power of vandalism—vicious in the eyes of mainstream society but vitalizing if imagined as a canvas in the living museum of the street. It is a code for the quick—an aerosol demonstration of skill and desire that "burns time": rejuvenating drab architecture while exposing it as well; rupturing links between generations; and inserting new meanings that evoke absence and presence of an artist, like a teasing drama of street life (Spitz 1993: 39).

American city authorities often utilize people doing community service or jail time to eliminate graffiti, painting over or blasting tainted/blighted areas with high-power water hoses. Such repainting has even been codified as *The Subconscious Art of Graffiti Removal*, the title of a 2002 film from Portland, Oregon. The filmmakers adopt the discourse of documentaries to interrogate one central, yet complex notion—what exactly is art?—while suggesting that the paint-overs, or buffs, are essentially fascinating, public financed modern art projects, since the cover-ups look quite similar to the prior modernist style of both Constructivism (like Alexander Malevich) and Abstract Expressionism (like Mark Rothko).

Municipalities sometimes work with local artists in a creative effort to curtail the habit, replacing graffiti-prone spaces with murals. In the late 1980s Peter Quezada taught himself how to "draw and paint" so he could create vibrant public neighborhood art in Los Angeles with messages and images that would deter "vandalism," such as "Drinking and Drugs Aren't Magic; Don't Do 'Em," "Pray to End Gang Violence," and "Have the Courage to Say No to Gangs," among others. Other phrases included odes to the sense of place, such as "Take Area Pride" and " . . . A Little Bit of Graffiti Hurts a Lot of Bodies." He told folklorist Sojin Kim that he didn't want his neighborhood to look like a "dump"; hence, this was a proactive, pro-neighborhood attempt to close the gap between the social dimension of public art and the very real need to reclaim territory from people deemed destructive (Jones 1995: 263). Quezada's murals were sometimes not sanctioned, and to some his approach was not dissimilar to the graffiti he was supposedly challenging.

In the eyes of many artists and critics, graffiti reveals the distress that coheres at the margins of power, and is a functioning code and custom that runs counter to the direction of conquest. Graffiti may actually reveal "places marked by history and time, sites that no one is using for anything else. . . . Abandoned houses are used as artistic media, giving new value and utility to their textures . . . walls, signs, benches, and streetlamps . . . once dead, gain new meaning" (Bou 2005). Unlike art traditionally placed in galleries, graffiti is sometimes open source, ready to be reworked by the actions of other artists, or affected by sun and weather that transform it. The deterioration becomes part of the new texture, perhaps even revealing latent ties to the "informalism of American abstract expressionism" (Bou 2005).

Graffiti is by no means localized; the "artists share a worldwide network. . . . Messages, meanings, and symbols born in New York surge across state lines and national borders," especially since

modes of dissemination have included close-to-the-ground train cars, which moved wild style beyond local turf while pop culture magazine layouts featuring graffiti have shaped cultural discourse since the mid-1970s (Chalfont and Prigoff 1987). Today, graffiti has proven that national borders are permeable membranes, for graffiti has auto-migrated on a global scale, resurfacing trains in Europe and marking punk bars in Thailand. One can easily browse books on graffiti in London, Berlin, Brazil, and Japan at any large bookstore; this suggests that the form has been lionized and neutralized at the same time, to some degree.

In punk rock terms, graffiti might be considered a way of defending a vulnerable sense of oneself from the mummifying trends of consumer society. To adopt and adapt Daniel Wojcik's notion of graffiti as "unauthorized, masterful . . . contemporary folk art," I suggest that such street "logos" (graffiti) mirror punk art, such as flyers, stencils, and stickering, for it embodies a "grassroots form of aesthetic behavior, largely the creation of ordinary people who do not necessarily think of themselves as 'artists'" (Wojcik 1995: 12). The squiggles and looping lettering of what is known as wild style—immediate, crowded, intensely colored, strident, even sensual—form a new urban babelogue that few can forestall, eliminate, or crush. Taggers crop up everywhere and refuse subjugation.

In the 1980s, blue-chip art was reborn when Jean-Michel Basquiat and Keith Haring married graffiti to the inevitable capitalistic ends of their work. Such gray areas have been described as the result of collectors who are "fascinated by these voices from the ghetto; they want pieces that capture the combustion in the subways. They want tame tigers. Lame tigers. The paintings are mind-blowing, but nothing compares to a train hit. Nothing" (Sacha Jenkins 1999: 39). This irony did not dissuade South Bronx space Fashion Moda, whose exterior was spray-painted by Crash, to promote graffiti art's acceptance by the art world

by working with figures such as John Fekner, Basquiat, Jenny Holzer, and Haring. As described in a Sally Webster essay, "Fashion Moda: A Bronx Experience," Crash, then a nineteen-year-old graffiti artist, curated the space's first graffiti show and invited eleven of his mostly male black and Puerto Rican compadres like Mitch 77, Kel 139, Disco 107, with lone female Lady Pink (who actively collaborated a few years later with Jenny Holzer). The works, either sprayed directly on the walls or on canvas, ranged from blown-up tags to full narratives and included works by Futura 2000, who soon worked with the Clash.

In the mid-1970s two books highlighted L.A. graffiti: *Los Angeles Barrio Calligraphy* (1976) by Jerry Romotsky and *Street Writers* (1975) by Gusmano Cesaretti. Meanwhile, the commodification of graffiti happened as early as 1973 (the same year a whole subway car, windows and all, was painted 3-D style by Flint 707) with a gallery exhibit of twenty acclaimed giant canvases. This same year saw Richard Goldstein, in an article in *New York* magazine, argue that graffiti was "the first genuine teenage street culture since the fifties" (qtd. in Chang and Herc 122). However, backlash was inevitable. Also in 1973, New York mayor John Lindsay established the graffiti task force. Yet, by 1974, the Razor Gallery show in SoHo offered $1,000–$3,000 pieces from the likes of Phase 2 and Bama. Graffiti represented both maelstrom and money, or as Ellen Handler Spitz summarizes, "from subversive to constructive finish, from becoming to being, from maker to market or museum" (1993: 37).

Still, during this period graffiti continued to be seen as the poetry of predominately working-class, electric boogie kids scrawled on the brick and steel papyrus of cities for a generation raised on parachute pants, microwave milkshakes, and Oliver North (Thompson 1990: 136, McEvilley 1992: 93). The legacy of the 1970s generation seems to symbolize graffiteros "armed with Krylon, Rust-Oleum, Red Devil spray paint, Flo[-]master

Ink—and a relatively new bit of technology, the felt-tipped pen. Students . . . used the tools of the painter, art student, and teacher, not to defile but to create guerrilla art" (George 1998). Even today, the Harlem-based Graffiti Hall of Fame on 106th Street enshrines examples of current work in a sunken concrete playground as a homage to that generation.

Whether on the side of a subway car or garbage dumpsters, on bridges, or on the nice walls of a renovated condo, graffiti is a blunt reminder that two worlds exist simultaneously, and not very independent of one another. The dichotomies are visible. Cities are the topography of privilege, of locked gates that speak of maid service and architecture that freezes time and space in the form of credit cards and stocks. Graffiti is less a comment on social struggles for power and more a form of resilient, outsider assertiveness—a kinetic language unwrapped on top of the other (Thompson 1990, McEvilley 1992). It creates wailing walls that announce gangs, crews, rappers, taggers, breakers, graffiteros, and the names of the dead. It suggests that modern consumerism has certain edges, or tensions, that false trickle-down economics cannot gloss over.

Spray Cans Spouting Analog Anarchy

Xerography was a low-cost, easy-to-use tool providing new channels of distribution and fomenting a Petri dish of vernacular expression that helped fuel punk's long-lasting sense of community. Within this subculture, Xerox flyers, sometimes illegally posted and short-lived—a kind of instant art meant to biodegrade (or to poach a phrase from Henry Jenkins: "edge towards extinction," a planned obsolescence) in the long autoclave heat of summer or be torn down by an angry passerby or the rare rabid collector—are akin to graffiti, which I briefly surveyed in the previous chapter.

If any doubts persist, one should notice how the city of Plymouth, England, lumps the renegade/outlaw media together on its official web page, which advertises anti–street art services, including: "Removal of illegal graffiti and flyposting. 1 x operative (variable number of hours per day) additional staff used if required due to heavy attack of graffiti or flyposting." The war metaphor denotes the sanctioned, defensive, and hostile hegemonic reaction to the subversive creation and dissemination of both forms. Taking a macro view of punk within the digital age, Kevin C. Dunn writes: "For the past thirty years, punk rock has simultaneously worked within and against the hegemony of capitalistic telecommunication networks, navigating an increasingly interconnected and mediated world; the medium itself becomes a subversive message in its own right, offering both agency and empowerment" (2008: 194).

From the early years of 1975 (almost synchronous with early rap), punk took an outward-looking stance against the Teflon-coated autonomy of government and corporate enterprise, and catalyzed social, political, and aesthetic concerns in Britain and the United States. As a loose-knit community, punk responded by grafting its own succinct styling on top of the architecture it disdained, thus evoking the relationship between modes of power and the vulnerability of individuals in a rapidly accelerating society. In the book *Instant Litter*, a work that featured punk posters from the 1978–83 Seattle scene, poster maker Art Chantry muses:

> Artists preferred to post in very specific neighborhoods where the images scared off the common folk and caught the attention of those who understood. The result was more of a community primal scream than advertising. . . . The street poster was the medium of communication, a punk community billboard back in the days when even college radio wouldn't play the music. . . . They were urban folk art, a sort of printed graffiti with a dark and sinister

edge . . . any style of skill level was acceptable, and . . . the art form itself was significant as the music it advertised. (1985: 3)

Punk still actively promotes do-it-yourself ethics, action-oriented political theory, and a bristling underdog psychology, though some critics underscore that these political "actions" are most often realized only in a form of street theater and spectacle, not in concrete terms. Sometimes this spectacle involves rampant stage diving and moshing, which, according to Tomas of Beefeater after one mid-1980s tour, "wasn't a sincere release of energy, a sincere form of bodily expression. It was just a . . . social ritual. . . . In a way they [punks] are society now too and that's a shame. They still buy 7-11 food, they have no impact on the government, or the economy. They still entertain themselves the same way, they have the same values and futures as everybody else . . . so there's no anarchy, rebellion there at all" (Beefeater 1986). Furthering this notion a bit, Bob Mould of Hüsker Dü told *Interview* magazine: "People want to think they are outside the norm, but in reality everyone is inside this pink bubble. Clusters of radicals are still part of society. All you do is influence the trends of the norms. You can just change where the balloon stands, you can't change what's in it" (Rabid 1986: 128). In this light, punk rebel yells might be considered no more than hollow exercises linked to feverish alienation.

Yet even the Buzzcocks, usually noted for their jagged romantic pop songs, wrote little political diatribes like "Autonomy." Guitarist Pete Diggle told me that this was Joe Strummer's (the Clash singer and most political member) favorite Buzzcocks song. Diggle added: "I was always conscious of writing stuff that is universal and slightly philosophical and is about the human condition and the nature of people, but also the plights of people" (2004). Although it was not as pointed or detailed as many Clash songs, it did serve to establish that the band was not just concerned about

rampant sexual proclivities ("Orgasm Addict"), musical maelstroms ("Noise Annoys"), and heart-break ("Promises"). They were concerned with personal sovereignty and individual agency in a time of an ongoing political crisis during the low points of Labor rule in late-1970s Britain, with its high unemployment rates, police actions, right-wing National Front growth, and garbage collector strikes. In the liner notes for *Burning Ambitions*, a punk compilation, Chris Salewicz described this time: "Mid-1970s Great Britain had been a dull, grey, disgusting place, in which rising unemployment and inflation stymied the country, especially its youth" (1982). Punk responded by producing a cultural revolution. Pete Shelley, singer of the Buzzcocks offered to Salewicz: "It changed a lot of people's lives. It made virtually everybody self-employed, and doing things they wanted to do. It gave the people the necessary impetus" (1982). "We were as political as the Sex Pistols and the Clash," attests Diggle in the documentary *Punk's Not Dead*: "in an existentialist way . . . we realized life was full of complexities" (Dynner 2007). Examining Buzzcocks song texts for their political undercurrent, and the relationship of a band's message to the status quo or to the culture at large during such a time period, enlarges one's notion of politics within punk.

If television, newspapers, and radio represent the old, unidirectional, "push" media of communication, the "pull" medium of the Internet, in which people become nomadic and participatory, taking what they want, may be a useful metaphor to explore the dynamism of the first punk era. Yielding a nuanced and often fissured alliance between unlikely partners, as Henry Jenkins has noted in his introduction to *Democracy and New Media* (2003), the politics of the Internet remain unstable. Leftists imagine the World Wide Web as a public commons that fosters a new tribe of mind. With bravura they announce that the vested interests, perhaps the manacles, of corporations and national governments lack sovereignty over

them. Libertarians imagine the same space as an electronic frontier, akin to the American West in the minds of settlers, a place of endless individual agency and free, unfettered expression, which should remain as-is. Others see it as a federal project not unlike an information superhighway, a term coined by former Vice President Al Gore, who recognized the possibility of regulation and monitoring. Still, Jenkins has continued to question whether this space, like underground punk culture, actually nourishes personal empowerment and citizenship or simply displaces actions into a subcultural lifestyle that is rife with a form of politics that feels as broken as democracy. It may simply be a dystopia.

The Internet, like underground punk, may foster counterculture materialism and consumption that become the virtual equivalent of a shopping mall, in which consumers are simply pitched products while their actions, to borrow from Jenkins again, are "displaced from real-world involvement into a narrow, vulgar, trivial, aggressive, and isolating," similar to the identity politics cemented under the concept of punk (2003). Fanzines and punk culture, in some ways, may manufacture consent of their own. As Matt Wobensmith, the editor of *Outpunk* fanzine posits: "[punk culture] is just like a monoculture; just like society at large. They want to cut you off. They want to take away your roots. They want to give you a false identity and a false reality" (qtd. in Schalit 1997: 320). Still, some portions of punk culture remain potent: the vernacular expression of flyers and graffiti.

Flyers, the scattered folkways of the international punk culture made visible, belong to no one and everyone. They are unstable entities edging toward extinction or disappearance in cities marked by flux. In communities that have laws on the books that try and curb the spread of flyer art on and around public spaces, the art is often the hallmark of anonymous artists creating instant media while working in the subterfuge of night. Therefore, the act is tinged with the furtive and

sometimes vapid romance of breaking rules, both legal and aesthetic: "Black Flag went deep into the culture, bringing out LA in a rash of minor vandalism. . . . [They] took it further than anybody, perfecting a hit and run technique that double-dared authorities. Graffiti of Ray Pettibon's bars were all over, and flyers, slapped up with wheat paste and white paint and sun-dried onto every lamppost or boarded store-front for a ten block stretch, [were] almost impossible to remove" (Parker 1998). In an interview with David Grad in *Punk Planet* in 1997, Black Flag guitarist and founder Gregg Ginn noted that, "We weren't doing anything illegal, except for graffiti—they never got us for that! There was so much of it, we were probably known to the general public from that—we were merciless. We felt that it was our only outlet. If the media was controlled, what other way was there to get information out there? It had a big impact on the visibility of the band, since we did it on real high-profile freeways!" (1997). One Pettibon flyer for a Black Flag concert at the Mabuhay, perhaps from 1981, features a staring doberman dog, a smiling police officer with a woman hanging on his shoulder, and a child tagging a building with a spray-painted flowery form—the symbol of the Symbionese Liberation Army—likely remembered in public memory from a photo featuring a gun-toting Patty Hearst in front of a dark orange banner with the image. By the mid-1980s, punk bands such as Crimpshrine in the Berkeley area, who became part of Lookout Records' roster, was also notorious due to their graffiti. Note this exchange in *Maximumrocknroll*, linking underage youth carving out DIY messages in contested spaces, harnessing angst latent in teenage boredom, and undergoing media hype and scrutiny:

MRR: The impression that I got was that you already had a plan of what you wanted to do with the band before it even started. Mostly what I'm referring to is the "media" hype, the name everywhere, the graffiti.

JEFF: Most of that stuff wasn't planned, it was like when some woman from the (*Oakland) Tribune* came to Berkeley High looking for high school bands to write about, and said, "Do you want to be in the newspaper?", and we'd be like, "Yeah, sure". In terms of all the television and newspaper stuff, none of that was like we went out and tried to do it, and in terms of graffiti, we were just basically bored. (Crimpshrine 1988)

The emphasis on using the public space as an alternative to mass media represents street art as a mode of vernacular expression and instant media that compensates for a lack of access in the decades prior to "become the media" campaigns, guerrilla video networks, YouTube, and blogs. As Jenkins now notes, such media is everywhere and converging.

Punk folkways, including the creation and posting of flyers and the spraying of graffiti, represent the tense and fractured transition to this era. Joey Shithead of DOA testifies: "It was the only thing I could do to drum up some publicity for the band. I would spraypaint the band's name and various slogans outside clubs, on churches, on walls, anywhere" (2004: 36). Spraying did not represent just a point of access; it could also reveal a point of pride, as noted by Henry Rollins when he told an interviewer, "Black Flag is the hardest playing band in the world, you can spray paint on any wall and sign my name to it," thus marking the wall as a site of ratification and endorsement, too (Harlan 1983). One could also challenge such a band logo as well. Prior Black Flag singer Keith Morris, who joined the Circle Jerks, was accused of spraypainting over the Black Flag graffiti with the Circle Jerks logo, though Morris claims the culprit was probably Jerks "nonstop knucklehead" bass player Roger Rogerson (Babcock 2001). So, fault lines among band members, and former band members, were made visible in the street art of the city.

Fellow SST Records label mate and bass player Mike Watt has admitted that Martin, the singer for his pre-Minutemen band the Reactionaries, tagged a Hollywood wall with the band name before or after an early area gig with the Alley Cats and Plugz, inciting the whole town to want to kill them. In response, they quickly changed their name to the Minutemen (Mullen and Spitz 2001: 194–195). Negative Approach members actively stenciled "NA" around the industrial innards of Detroit and beyond. In a mid-1980s Canadian episode, a letter to the editor in the fanzine *Maximumrocknroll* described another Michigan band, Boom and the Legion of Doom, as "spraypainting Satanic garbage all over" Guelph, Ontario (Baird 1986). And Neil Stewart, in an article titled "Hardcore Is Alive and Well in Montreal," eyed local punk graffiti (the band name "Genetic Control" in red spray paint, underneath which the seemingly smug phrase "Idiot Control" was also tagged), near the Place d'Armes Metro Station, and decided such interrogations were "an appropriate comment on Hardcore" (N.A.).

Granted, this graffiti likely did not mimic the flair and funk of hip hop styling, but as Jenkins notes in "Taking Media in Our Own Hands," any such work should be understood within its own context: "Amateur creativity should be valued on its own terms, judged by the criteria of the subcultures within which these works get produced and circulated. . . . When we are talking about traditional arts, we value amateur expression as much for the process as for the product" (2004). Punk graffiti may be crude and sparse, like punk flyer art, but within the community, this style has iconic merit, not the simple sneer of vandalism. This does not mean that punk bands did not use graffiti to threaten or vandalize.

A 1986 *Maximumrocknroll* scene report from Houston describes how the band Afterbirth, who played a show with Life Sentence and Vicious Circle at the club Cabaret Voltaire, felt they did not receive adequate pay for their performance. Even after the booking person explained the expenses, the band returned on the following Sunday night

and "spray painted all sorts of hate and Nazi slogans. A swastika on the door with 'fag bar' written on top. Stars of David with 'fag' written in the middle. 'Gates is a Jew.' 'Ronnie's Rip-Off Bar.' 'Make Money off Punks.' Their intention was to have us closed down as well as intimidate me with the landlord and the neighboring landlords" (Gaitz). This may be linked to earlier Cabaret Voltaire street art discussed in an article in the zine *United Underground* that also deplored the situation: "Somebody decided to graffiti all the neighborhood buildings. How rad. Too bad it invoked the wrath of the neighbors across the street. The next night (for Articles of Faith) the police camped out there refusing to let anyone even walk over there. Ronnie Gates has asked people repeatedly not to graffiti the neighborhood so as to avoid the harassment or possible shutting down of the club" (A.C. 1985).

Though these episodes might be rare, punks sometimes used street art to target and punish their own community for imagined trespasses, using a venal discourse that mimicked mainstream bigotry or targeting neighbors deemed unworthy of respect.

Although Black Flag did create radio spots, as evidenced on their *Everything Went Black* double LP (which contains a whole album's side of such recordings), street art such as graffiti and fliers were not just acts of vandalism but a means of infiltrating public consciousness, establishing a temporary free zone, decolonizing or reclaiming public space, and creating an avenue for expression when major media was off-limits. That public space could even be the compound walls of a police station, as Chuck Dukowski reminds us in a mini-overview of the band, "For one of those early shows, we put fliers somewhere, and Greg had to go to court for it. And they fined him or something. Our response to that was to go right from the courthouse to the Redondo Beach police station and graffiti the station wall in broad daylight" (Babcock 2008).

Still, that freedom was short-lived, and creating that space came with consequences, such as early Black Flag singer Keith Morris, later of the Circle Jerks, getting charged or arrested with littering due to the flyers that had been placed throughout the city for an early daytime show at Polliwog Park (Steve S. 1998). Morris described the tumultuous event to me: "It was an early afternoon Sunday. A picnic in the park with the pond and the ducks. About six dozen picnicking families, and 300 hundred punk rockers. And the whole place just exploded. There was food flying from all directions" (2002). In an earlier interview he notes: "The newspapers thought we were anarchists and terrorists who came to town to ruin things. From that point on we came under police scrutiny" (qtd. in Mullen and Spitz 2001: 218). Punk remade the public park, just as families were attempting to enjoy a supposedly safe public space in the middle of the afternoon. Revealing the melee, Morris recalls "20 dozen picnicking families there—all these pastel colors, an Easter basket spread out across the park, and all of a sudden there's this line of leather-clad, torn Levis, black t-shirts, spiky dyed hair guys coming in: surf rats, skaters, skiers, a sprinkling of druggie friends.... Then we launched into our set, and for ten minutes it rained orange peels, cantaloupes, half-eaten Kentucky Fried Chicken drumsticks" (Babcock 2001).

In an even darker episode relating to punk graffiti and police, Dave Dictor, singer for the band MDC (once featured in an Italian *TVOR* fanzine layout alongside the graffiti "End State Oppression") was arrested on Memorial Day 1983, in New York City for spray painting the band's logo on a subway wall. He attested to me:

It took me three days to go from different precincts to different precincts, and eventually I ended up in a place called the Tombs, where basically you start out chained together with all the other prisoners and you work your way up and you finally get out

to court. There I was literally on the group bench with all these momma rapers and sister rapers, these people with blood all over them, pretty harsh people, and there I was for graffiti. In fact, while I was in jail, all those guys there were like, "Graffiti? I want your bologna sandwich." So, I'd just give them my bologna sandwich. (2008)

An undercurrent of vandalism, disruptive and marring messages, even an eyesore energy, was often expressed in the act of flyer construction and dissemination, just as it was imbedded in graffiti tagging. For instance, in Austin, Fred Shultz, drummer for the Big Boys, intentionally mixed egg white with flyer paste in order to make the posters nearly impossible to remove after being under the Texas sun for days. In Washington, a former girlfriend of singer John Stabb from the band Government Issue graffitied "Boycott Stabb" in the area, but the band immortalized the scrawls by naming their first full-length album *Boycott Stabb* (1983) and even used an image of the graffiti for the album art.

Another important D.C. musician and artist, Jeff Nelson, drummer from Minor Threat and Dischord designer, acknowledged to me:

> I have always hated graffiti, and believe it harkens and hastens the decay of cities. . . . In general, I think most of my peers in "the scene" were above the crude nature of graffiti. I know that Brendan Canty from Fugazi/Rites of Spring, etc., had a bedroom covered with graffiti when he was in the band Deadline and lived in his parents' house in DC. I would guess it was something done sporadically by some, and outgrown. . . . When wheat-pasting posters, I always made a point of NOT putting them on nice buildings, and tried to put them only where others had put up posters, such as on signal control boxes or plywood walls surrounding construction sites. The act of putting up a poster with wheat paste was far more brazen than stapling up flyers, and it felt increasingly risky to do so. I

always envied Europe their large poster kiosks, specifically meant for the posting of bills. (Ensminger and Welly 2008)

Still, Nelson recognized that the bands' flyers likely were perceived as a form of graffiti: "I am sure many felt that our flyers and posters were no better" (2008). More importantly, he draws attention to the lack of city funding for truly public social and physical space, which leads youth to create their own form of DIY media by "any means possible."

Similarly, if Black Flag was the most notorious band in the greater Los Angeles area, actively "spraying their name and logo on virtually every highway overpass and abandoned building," their ability to mobilize people to distribute what some have suggested were thousands of flyers was a way of cementing their subcultural presence at a time when SST ads read "Unite Against Society" (Blush 2001). This, however, did not make them loners in the field. As Mark Vallen notes on his web site *Art for Change*, "LA's punk rock underground was promoting itself with the only means available to it . . . the hand made Xeroxed flyer. The established corporate media barely acknowledged punk (except to belittle it), and so it was necessary for punk to create its own media" (2007). With roots as far back as 1977, such flyers were so rampant "that one couldn't see a bare lamppost anywhere in Hollywood, and those sometimes crude flyers helped build a tiny scene into a mass movement" (2007). This suggests that Black Flag flyer crews were merely applying the lessons of punk's first wave but seeking greater results.

Victor Gastelum, who later worked for several years for Gregg Ginn at his label SST, offered another insight to me during an email exchange, positing that the purpose of graffiti and flyers remain different at their core:

> I see it as a low-end form of advertisement art. By the time I was doing flyers (1985), people did not

post them because you would definitely get busted. They still get posted in parts of L.A. like Silverlake and Hollywood. In the big city, the movie studios have always been going off and must have some shady agreement with the cops because I'm sure it's just as illegal for them to do it. Posting doesn't happen in the suburbs much though. I don't see it as part of the graffiti scene because flyers were serving a commercial purpose, and even though you had a lot of freedom, it was not for the purpose of total self-expression. It was a place to develop an illustrator style. Experiment with graphics, typography, and a way to participate in punk besides being an audience member. I see it more in following the tradition of the rock posters and poster bills of the 1950s and 60s. (2007)

Gastelum suggests that punk art and the tradition of graffiti were mostly separate and distinct, though he does underscore that they might converge when vying for public space alongside quasi-sanctioned commercial posters in urban environments. Rat Skates, drummer for thrash metal band Overkill, suggests similar street art in his overview ("Born in the Basement") of the band's early incarnation, which would play clubs in NYC in 1979 and see punk graffiti, such as the logo for the band the Misfits, scrawled on sidewalks and buildings in or near the East Village (2007). In D.C walls were sprayed with the phrase "Straight-edge," while Los Angeles was marked by the gang-signifying graffiti phrase "Suicidal Boyz," signaling the early Hispanic and African American based fan culture of the Suicidal Tendencies.

This contested sense of space, the wrangling over private and public, used and unused, colonized and liberated spaces, resembles the public commons concept of the Internet, including the tensions between subcultures, with their participatory ethos, and the ever-increasing sense of branding and pitches for product—the concentrated power of the market economy nimbly at work. If this space, the Internet, provides room

for renegades such as hackers, culture jammers, and open source advocates of grassroots communities, the pre-digital days of punk flyers and graffiti were a bellwether, urgently anticipating the age of New Media, whose mantras, according to Jenkins, are access, participation, reciprocity, one-to-one viral marketing, decentralization, dispersal, and contradiction.

Some of these sentiments are underscored in article that Lance Hahn, iconic punk legend from the bands Cringer and J-Church, wrote for *AOK* zine, titled "Save Your Local Graffiti Writers": "Our society is uptight. Graffiti is the voice of the unheard. . . . graffiti has been around for centuries. . . . there will always be those out there who have something to say and will say it however they please. Even if the meaning is personal and no one can relate" (1985). He notes that local authorities adopted "sneaky work"—surveillance—in order to "exterminate" the street art ("heathen scum graffiti") in Hawaii, where his band was based. The contradiction between personal and public (graffiti script that lives in public spaces with private meanings), and the tensions between "boring and ugly" blank walls of the city versus "wildfire" new graffiti styles is well-noted, signaling that Hahn is more interested in a city (and island) government that grants access and participation, not "goon squads" that enforce law and order and attempt to control the vivid aerosol expressions of youth—the instant DIY media of kids speaking out. Even fanzine writers, like the *Flipside* crew, joined the efforts too. "Graffiti? Us? On a Sunset Strip billboard and overlooking the 101 Freeway. Cheap guerrilla publicity," admitted Pat DiPuccio (Pooch), one of the founding staff members (1996).

One might consider graffiti artists culture jammers, a term coined by the band Negativland that generally refers to appropriating and adapting mass media to produce critiques, protest, or insight into that media. Granted, aerosol art may lack subtle interplay with the already existing

messages, but it does try to redefine the essence or visual culture of a city by working with and against the visual fabric. Imagine the topography of the city as a series of skins that are being contested, but people must live within these skins. On one hand, as well-regarded graffiti artist Banksy notes in the book *Wall and Piece*, such a skin, like a wall, "Has always been the best place to publish your work . . . the people who run our cities don't understand graffiti because they think nothing has the right to exist unless it makes a profit, which makes their opinion worthless" (2006). The skin is no more than commercialized property, to be controlled by the status quo. He insists that insurgent street art is dangerous to only three people: the politician, the advertising executive, and the graffiti writer. He stresses that street artists do not pose the greater threat by defacing neighborhoods but that "companies that scrawl giant slogans across buildings and buses trying to make us feel inadequate unless we buy their stuff" do threaten people (2006). Street artists give a community back, to some degree, a sense of urgency, agency, and freedom.

Punk graffiti, like gig flyers, reveals an international underground culture taunting powers-that-be and passers-by in the inner sanctum of cities towering with rigid glass and steel. It also offers a sense of history, identity, and gossip to disheveled punks in dank and roaring clubs and bars. Such rebel graffiti forms, often short-lived and unstable, edge toward their own deterioration or disappearance—here today, gone tomorrow. But they can be long-lasting and mythic, too, like CBGB, preserved punk in a cocoon. In communities that have laws on the books that try to curb the spread of street art and control public spaces, the art can be understood as instant insurgent media, an outlet carved in nighttime prowls or daylight boldness. Therefore, the act is tinged with the furtive and deep impressions of breaking rules, both legal and aesthetic, as people visibly challenge authorities.

Then They Shouted, Crass!

In England, the band Crass took street art to a whole new level of confrontation, which they outlined in the liner notes to their album *Best Before 1984*: "Since the graffiti days of '77 we had been involved in various forms of action, from spraying to wire cutting, sabotage to subterfuge . . . throughout Central London. . . . Our stenciled messages, anything from 'Fight War, Not Wars' to 'Stuff Your Sexist Shit' were the first of their kind to appear in the UK and inspired a whole movement that sadly, has now been eclipsed by hip-hop artists who have done little but confirm the insidious nature of American culture." According to Tony D, who was interviewed by John Robb of the Membranes for the book *Punk Rock: An Oral History*, bands like Crass also heavily appealed to squatter communities: "Squatting was becoming a big thing for all these people. Our squat applied to the European Union to become a free state! . . . People from all over Europe were coming, people hitchhiking in from France with a pound! People now started writing on their clothing at every gig. The graffiti on the wall would be Crass and the Ants [Adam and the Ants]" (2006: 429–30).

Paul Weller, the singer of the Jam, noted to *Uncut* magazine that in the mid- to late 1970s he visited Joe Strummer, singer of the Clash, who lived in a squat near Regent's Park—a "horrible place but it had this big fish thing spray-painted on the wall"—which underscores the long relationship and history between squats, punks, and graffiti (1993: 50). As columnist Sheri Gumption stressed in *Maximumrocknroll*, "Squatting and graffiti" can represent a punk mode of activism, for they "are good examples of creative approaches to resisting the takeover [of gentrification]" (1998). Such varied wall markings signify a temporary flux zone, a subculture/opposition culture microcosm, an in-between place (unused/remade), a place of inversion, despair, hope, and promise.

This might include sites like the Black Hole, the nickname given to Unit 2 of a nondescript apartment complex next to a school in relatively sleepy Fullerton, California, where a group of firebrand punk kids lived in 1979–80, forming the nucleus of the impending Orange County punk rock legacy, including bands Social Distortion and the Adolescents, whose song "Kids of the Black Hole" cemented the site in punk history. The apartment has since been envisioned as a hive—"a punk refuge" and a "parent's horror"—torn apart when the young punks "wrecked the single bedroom apartment in a vandalistic frenzy in which cabinets were torn from hinges, sinks were ripped from their moorings, and walls were kicked in and spray-painted with graffiti" (Boehm 1989: 49-B). Though perhaps mindless and stigmatizing, one may also begin to imagine such violence as physical signifiers—the upheaval of a battered generation who simply would not enter into the night quietly, but instead (à la Dylan Thomas) burned and raged at the end of the day.[1]

On the website for Southern Records, the current distributor of the Crass catalog, a mini-history of the band's art actions is provided, including prominent images of their handbill art handed out at gigs, which included pithy statements such as "These Agents of the Law, and the Wealthy Elite, which they serve, are in reality the agents of death. . . . we may be a nuisance, but they are deadly." In the same panel as the text, a little girl (resembling Little Bo Peep) holds a jumping rope. She is juxtaposed next to a denuded landscape and a cloaked skull figure, with an iron cross on his trench coat. As the web site further notes, "During the lifespan of the band, Crass blitzed [the metaphor for street war] London with stencil graffiti containing messages . . . sprayed directly onto ads that were degrading to women. The graffiti was motivated in an attempt to counteract the mental rape inflicted by the advertisers. Stencils were made to fit inside paper carry bags, which had the bottoms cut out. This way, when a target advertisement was located, the stencil could be sprayed with less risk for being caught."

One must be careful not to assume that such sloganeering stencils were rampant, though, or even more visible than the band's trademark logo itself, as Paul Cooper, who grew up near the Crass commune, attests:

As for graffiti, you would see band names scrawled on walls, bus shelters etc. with marker pens, but again it was not overly original. Living only 15 miles from Dial House where Crass lived and worked meant that the Crass symbol and the logo with the broken rifle above the Crass name in a circle would often be sprayed around Romford where I lived using stencils. Due to the fact the graffiti was really only punks writing either band names or their own pseudonyms in marker pen it would have been considered petty vandalism I suppose. Crass were very well respected with my punk friends. Crass and Conflict were a big influence on me and my friends as they got us into animal rights. I still don't eat meat today, which is a direct result of listening to Crass/Conflict and reading their record sleeves. I don't remember seeing any of the Crass slogan stencils; their sleeves/ posters stimulated enough conversation themselves. (2008)

Crass was not alone in their efforts either. Guitarist Kevin Hunter recalls the Epileptics (who later would become Flux of Pink Indians and join ranks with the Crass circle) announcing their presence in 1978 "in their home town of Bishop's Stortford, Hertfordshire that summer with spray-painted graffiti. Together with their name, they had a logo and a slogan—'Smash Guitar Solos.'" The bands' messages seeped through both subculture and mainstream culture, colliding and converging with regular media. Arguably, Crass' reach was more expansive—via music, stencils, graffiti, and record sleeves that could be folded out into posters the size of a dinner table. They had a sometimes indelible, lifelong impact, cementing

an alternative lifestyle for portions of an entire generation.

The editors of *World War III Illustrated*, which was readily available during the 1980s on shelves alongside other illustrated comic/zine hybrids such as the oversized *RAW* and plentiful punk zines, recognize the connection between punk and street art when discussing how magazine art could be stored in file cabinets or have a second life on the street, driven by the ingenuity and work ethic of readers: "One of the things that I always liked about the punk scene is that art itself is part of a total way of life" explains Seth Tobocman, who chooses not to separate the feelings, aesthetics, or artistic aspects of people from their lives (qtd. in Sprouse 1991). During the same conversation in *Maximumrocknroll*, Peter Kuper outlines how such an egalitarian philosophy affects street culture by disseminating ideas beyond the printed page: "A lot of our graphics from the magazine get out of it and are nearly public domain. The work just goes out and the magazine doesn't stop at the border of the page. We all love the idea of our work being something you can see on a telephone pole or being made into a stencil," that people would wheat paste all over the skin of a city. "The whole idea was to get the art to as many people as possible" (qtd. in Sprouse 1991). For instance, beginning in 1981 Alphabet City, the term for the area of New York's East Village with Avenues A, B, C, and D, witnessed a profusion of stenciled "signature skeletons scaling buildings and flying angel cats" by Michael Roman, whose winged cat faces and beehives of human faces later lined the walls of the gay and punk hotbed Pyramid Club. In 1984, he was featured in a Stencil and Sprayshow at the Chelsea-based gallery Proposition and later worked on album art for the Doughboys (Canada) and Die Toten Hosen (Germany) and stadium rockers like Madonna and the Rolling Stones (Hammond 2005). Whether or not he subverted such stadium rock is unclear.

The origins of stenciling might be traced back to Europe during the forties and fifties, when communist and fascist parties adopted such methods to disseminate their issues and propaganda.[2] Even critiques from within the Eastern Bloc were aided by stencils, such as one Marxists-Leninist cell in East Germany that claimed "3,000 copies of the 'GDR edition' of the Roter Morgen, several inner-party materials, a homemade printing apparatus for printing up to 50 stencils, a homemade [Rollapparat], a typewriter, one 35 mm camera as well as printer's ink and ink pads were smuggled in with the aid of a handful of couriers until 1979," all intended to change "bureaucratic state capitalism" from within (Polifka 1997). It is no odd paring— the sheer utility or readymade prepared messages with the quickness, efficiency, and effectiveness of transmission. In a recent study of stencil art, Josh MacPhee posits that the "political street stencil is a direct extension of industrial usage. . . . It is harder to remove than posters and flyers, and it creates a uniform clean image that can be repeated over and over, saturating an area. . . . In a world run by the capitalist need for everything to have a fixed meaning . . . the open sign of the stencil can be disorienting, confusing, and even liberating" (2004). This makes stenciling an extremely relevant model for Crass, a means by which the band could foster a sense of urgency, encode their messages with a street level legitimacy, and offer easily discernible visual dialect—agitated people versus the impervious state, or emboldened women versus bankrupt, repressive gender codes.[3]

The Southern Records web site provides examples of Crass street stencils, as if to reinforce the concept of a street art user's manual. Images such as "In All Our Decadence People Die, Who Do They Think They're Fooling: You? Wealth is a Ghetto," is tagged with the following note:

THIS IS A SAMPLE OF SOME OF THE SPRAYS THAT WE USE FOR VARIOUS GRAFFITI PROJECTS. IF YOU CUT THESE STENCILS OUT,

PERHAPS IT WOULD BE BETTER TO COPY THEM ONTO THIN CARD FIRST . . . YOU CAN BUY ALPHABET STENCIL KITS IN MOST SHOPS THAT SELL ART MATERIAL. YOU CAN ALSO BUY CRAFT KNIVES WHICH ARE THE BEST TYPE FOR CUTTING STENCILS. SOME OF THESE STENCILS ARE THE ONES WE USE ON POSTERS (ETC.) TO LET PEOPLE KNOW WE WON'T PUT UP WITH THE SHIT THEY'RE PROMOTING. IT'S A COOD [sic] WAY OF SPENDING AN EVENING, GRAFFITI IS A REALLY EFFECTIVE WAY OF LETTING YOUR OPINIONS BE SEEN, BUT DON'T GET CAUGHT . . .

Despite Crass stencils being considered agitprop anarchistic rantings from marginalized communities, such material eventually ended up in trendy boutiques: "the [Crass] logo made its way onto fashion-punk shirts, like . . . one worn by old-school hip hop artist, Junior," as seen in a photo from *Melody Maker* on June 23, 1983, page 33. Later, bands from the Crass circle, including New Model Army, signed to major labels like EMI and were attacked by the anarcho band Conflict, who penned one album title as *Only Stupid Bastards Sign to EMI*, a direct reference to a T-shirt worn by the singer of New Model Army on *Tops of the Pops* that stated "Only Stupid Bastards Do Heroin." The band proves that language itself can be seen as a kind of contested space, in which a phrase or logo can be appropriated, co-opted, and fissured.

Street Art as Punk Trope

When the section of an art show called De-signs was put together for the exhibit titled *The Downtown Show: New York Art Scene, 1974–1984*, the section covered graffiti and punk rock posters from acts such as Talking Heads, Television, Richard Hell, and the Ramones (Spears 2006). When critics

and performers look back at the volatile late seventies and early eighties, they see converging street art cultures. The artist Lydia Lunch (New York post-punk No Wave singer for Teenage Jesus and the Jerks, anti-star of transgressive Richard Kern films, and spoken-word performance poet) likened her work to the visible "outsider" urban folk art: "I had only been scribbling in notebooks, like all the other delinquents if they hadn't been writing on bathroom walls or subway trains. The stage at CBGBs, that's where I took my atrocities" (Beatty 1989). Young entrepreneur artist Fred Baithwaite, better known to the world as Fab Five Freddy, started organizing graffiti artists and promoting them on the downtown art scene then blossoming in tandem with the punk rock club scene. He believed that living, aggressive street art was a perfect fit with the same antiestablishment attitudes that ruled at punk landmarks like CBGB.

If punk was rebel music, this was truly rebel art. Samo, a thin Brooklyn renegade, became the art world's primitive savant under his real name Jean-Michel Basquiat, who would later perform at the Mudd Club, another NYC punk haunt (George 1998). The Samo tags were mostly confined to SoHo, as if Basquiat was directly confronting art "authorities," or conversely, seeking their blessings.

Fab Five Freddy has also noted that Basquiat's work reminded him of the painter Cy Twombly, even though it conveyed a sense of "dilapidated graffiti-slashed slum buildings," which Basquiat loved to hear (qtd. in Vassel 2007). Diego Cortez, a highly influential member of the scene who helped foster the connections between street art and new wave trend makers, insists that Basquiat "really was a punk—that was really his identity, which is kind of outside of black and white issues . . . a whole side of punk is very aggressively anti-intellectual. It is a ploy, the punk ploy" (qtd. in Vassel 2007). The ploy part is essential, for it suggests that the anti-intellectual stance is a mask, a performance, which helps legitimate the art and

music as bona fide forms of resistance in the eyes of the community.

Although 1977 photos of the dressing room of the Marquee in London reveal a scattered cornucopia of layered graffiti that forms a visual counterpoint to the sweat-slickened, half-naked appearance of bands like Generation X, CBGB became a temple of punk graffiti, bar none. In his essay "CBGB as Physical Space," Richard Hell provided this overview right before the site closed:

> The graffiti has gotten thicker, but that happened quickly too. It took only three–four years for the place to acquire the garish veneer that's become its distinguishing mark—Hillary's stunning, and stunningly effective inertia . . . his lack of interest in removing any defacement. . . . All those spectra of marker scrawls, blurred spraypaint swaths, and day-glo stickers comprising the interior planes of a shimmering temple of impulse-to-assert, can't truly be seen as "self-assertion." It's more like mob behavior, like what goes on in a mosh pit, or like blank genetic reflexes, than anything to do with anyone's self. It provokes [kids'] absence, their faceless selves buried under the next pretty layer of pointless assertion. The walls are an onslaught of death and futility as much as they are of life and utility . . . It's about being young and hungry, about energy, anger, sex; pure formless assertion. Or not; it's about boredom and frustration. (Salyers 2006)

In addition to CBGB, graffiti was an intrinsic and steady staple of the visual aesthetic of clubs and spaces ranging from Al's Bar, Godzillas, and the Vex in L.A., to Huntington Beach, where Jim Kaa, guitarist from the Crowd, explains: "Our story is the local Snack Bar at Brookhurst Street Beach. It would get graffitied one week and painted over the next week" (2008); to the dingy bar O'Banions in Chicago, which hosted punk shows. In the mid-1980s Dallas punks spray-painted the Twilite Room with band names such as "Ramones!"

"Dicks!" and "Dogslaughter!" while the *Houston Post* ran an article describing the local club, Paradise Island, as a bastion of graffiti: "Highway 59 snakes overhead while kids with spray cans of paint christen its concrete supports. They scrawl strange words for daytime people to ponder as they sit at stop lights. 'Anarchy in the UK' says a cryptic message. Sloppy letters spell out 'Legionnaire's Disease,' 'Dog's Breakfast,' 'The Damned,' and 'Kill the Hippies'" (McIntosh 1980: B1).

In addition, Frank Schumann penned a fanzine review of an Introverts show in Houston in the early 1980s that featured "an urban animal" (in-line skater) that whipped "out a can of spraypaint and wrote (cryptically) on the wall, 'Them That Can't Fuck With Them That Do'" after the singer had been attacked by two women from the crowd who sprayed shaving cream on him (date unknown). The Connecticut-based all ages club Anthrax featured an array of graffiti as well. Jeff R., writing about the space for *Maximumrocknroll*, emphasized, "Vandalism is virtually nonexistent, other than the graffiti on the walls, which is openly encouraged" (1984).

The Whiskey a Go Go was layered with tags such as "Give Me a Break," "This is the World Famous Whiskey a Go Go?" "Gonna Kill Ya Someday," and "Eat Shit and Die." Graffiti also adorned the walls of the club Godzillas in L.A. (booked by the Stern brothers from Youth Brigade), which can be seen in a photo of No Crisis from *Flipside #31*. In fact, the *Los Angeles Times* reported: "Punks of all persuasions, from skinhead beach kids to style-mongers with hair waxed into outlandish shapes, circulated easily through the spacious rooms, adding graffiti to the walls, sprawling in dark corners, even indulging in a bit of free-for-all handball against one of the high walls" (6 January 1982). Such description teems with subtext suggesting the site is underground, unconventional, and full of otherness.

Even in the deep South, writer Barry Shank describes the original Raul's in Austin as a place

where "walls were caked with graffiti and sweat so that when you leaned up against them . . . splinters didn't pierce your skin but instead band names—like the Offenders, and the Huns, and Re*Cords—would be imprinted backwards on your shirt," like a tattoo or remnant of the club itself (1994: 2). The brick exterior walls were also covered with bands names scrawled from top to bottom, including the Dicks, Offenders, Huns, and F-System. Another club in Austin, Duke's Royal Coach Inn, was also marked with rampant graffiti, like "No Frats," "Brad First Your Last," and bands names like the Inserts, Delinquents, S.T.B. (Sharon Tate's Baby), and the Recipients. A famous photo of the Big Boys, seen squatting in front of the club's logo, features a graffiti backdrop of the band's name and the phrases "No Frats" and "No KKK No War," the latter likely spray-painted by the local band the Stains (later known as MDC), since it was a refrain from their song "Born to Die."

The Ritz on 6th Street used white-sheet backdrops lined with graffiti, which can be seen in live shots from a Circle Jerks/Big Boys show. Also, a Skunks (early Austin punk band) photo taken at Crazy Bob's in 1979 features an array of graffiti, including the band's logo, in the backstage room. Such graffiti not only marked the site of punk and the carnivalesque, it also was utilized by punks to deface the sites of others, as Biscuit breathlessly wrote in *Left of the Dial*: "Midnight runnin' on a bicycle with a spay can lookin' for trouble! If the fraternity/sorority BMW has a frat sign on the window, it gets red spray painted noodles down the side. I spray painted DEAD FRAT on a thirty square block area on all four street corners" (2004). In the mid-1980s, Biscuit was featured in an ad for $6.95 "Thrashirts" in the infamous skate zine *Thrasher*, posed in a skinny Thrasher shirt and a can of spray paint, his finger affixed to the nozzle, with scrawled tags and a large flag reading "fun" (referencing their record *Fun Fun Fun*) behind him. This outsider punk artist, known for his ample and keen flyering, wonky album

art, and day-glo assemblages, was now known to the public as a street artist as well, blurring the boundaries between forms.

In D.C., on a wooden sign posted outside Madame's Organ, a venue that once hosted the Bad Brains and Teen Idles, graffiti ("Punk Rock Killed Me," plus other scrawls) is documented on a photo used as the flyer for a May 1980 film called *Wet Streets At Night*. The Masque in L.A., despite being home to queer-centered bands like the Screamers, was marked by graffiti blaring "Fags is not Cool" and "Kill All Hippies." At the end of the 1979 film *Rock 'n' Roll High School*—a punk exploitation B-movie featuring the Ramones—the band members join the closing melee, in which the high school is graffitied and trashed as teenagers run amok. Much later, another kind of visual vehemence took place when reactionary graffiti was used to mar or disrupt punk sites, such as KRS Records' office in Olympia, Washington, which was reportedly spray-painted, along with the apartment of its owner, Slim Moon, in the 1990s.

In terms of album art and promotional campaigns, punk attitude and graffiti commingled together to form the signifying style of punk, as evidenced in scholarly work beginning with Dick Hebdige, who wrote in 1979: "the graphics . . . used on record covers and fanzines were homologous with punk's subterranean and anarchic style. . . . [One typographic style] was graffiti which was translated into a flowing 'spray can' script" (112).

Notable manifestations of graffiti at the time of the first and second waves of British and American punk include the logos or lettering, with graffiti motifs sometimes implied instead of overt, include (singles except as noted) the Jam's *In the City* (1977) album, plus several singles, including "Down In the Tube Station at Midnight," "Modern World," and "News of the World"; the Undertones' "Teenage Kicks" ("The Undertones Are Shit"); the Avengers' "We Are the One"; the Dead Boys' "Sonic Reducer"; Wayne County and

the Electric Chairs' *Blatantly Offensive* EP (in the form of latrinalia); the Ramones' "Sheena Is a Punk Rocker"; the Saints' *I'm Stranded* album; the U.K. Subs' "CID"; Subway Sect's "Nobody's Scared"; the Radiators' "Lets Talk About the Weather"; Patrick Fitzgerald's "Safety Pink Stuck in My Heart"; the print ad for the Vibrators' album *V2* (German graffiti along a wall protecting a missile, on location in Germany), and the logos of bands like the Banned and Suburban Studs; Killing Joke's first self-titled LP; the Exploited's *Punks Not Dead* album; the Ejected's album *A Touch of Glass*, in which the band is shown against a graffiti-covered wall opposite of three female punks in miniskirts; GBH's album *City Babies Attacked by Rats*; and press photos for the bands Action Pact and Anti-Pasti.

Two key videos from the 1976 first wave of punk feature graffiti, including the promo clip for the Damned's "New Rose," especially the walls behind drummer Rat Scabies, which seem to have DEATH written in red, and the opening shot of the Sex Pistol's "God Save the Queen," which has the band's logo spray-painted on one of the amplifiers. During the same period, Ray Stevenson's photographs of the Bromley Contingent featured them in Linda Ashby's graffitied apartment in the Saint James Hotel ("Anarchy in the UK means free from the police state . . ." and "Banshee Legend they don't want anarchy," among other phrases) while several photographs from the Derek Jarman film *Jubilee* contain graffiti, most notably the black and white shots of Gene October from Chelsea lying down and pointing at the camera. Even the 1978 German documentary *Punk in London* by filmmaker Wolfgang Buld begins with the film title and credits spray-painted on a wall.

Punk lore tells that graffiti at the infamous apartment complex Canterbury featured the phrase "Piranhas eat lesbian shit" in an elevator where someone routinely urinated, while other graffiti, like swastikas painted in the lobby, were attributed to "a bunch of junkies calling

themselves the Youth Party." Later those were offset by "a series of Star of David emblems sprayed adjacent to them" (qtd. in Mullen and Spitz 2001: 170–71). Black's Flag's four black bar logos, which depict an impression of an undulating flag, originally conceived by Greg Ginn's brother Raymond Pettibon, were supposedly the result of making the flag easy to quickly graffiti. As imagined by one punk art writer, "What it means is not as important as it is does: acts as a brand identity. Neither Nabisco, Chrysler, nor Sony could claim the true test of customer support that loyal Black Flag followers sport—the tattoo" (English 1995). Moreover, representative graffiti examples abound from the first and second wave of North American punk.[4]

When two staff members of *Final Solution* zine ventured to Britain during 1980, they offered this firsthand perspective of the period:

> London graffiti is created with your giant Pentel felt tip pen that is carried at all times to write on train walls, tube station walls, or any wall that looks like it needs to be written on. There is some great graffiti on the side streets of Carnaby St. and slogans read from anything like "Kill the Mods" or "Elthan Mods" or "Bromley Skins" or "Punx Rule" or whatever. People's names, band's names, your area with your category is the one most seen and general garbage can be found anywhere. (#8, October 1980)

Mark Brennan of the mid-1980s Oi band Business, in the liner notes to his band's *Smash the Discos* re-release, describes this time period: "You'd have one punk gig where there's a bit of graffiti or whatever, and in comes the heavy mob to shut it down" (1997). Graffiti invited trouble from authorities. Even though such street art had become a recurring motif used by recognized, major design firms and installed in galleries, it still signified a real cultural threat, not just a commoditized, aesthetic street style.

In Colorado, the young hardcore band Bum Kon offered the song "Is This Art?" in which the refrain was the pugnacious and pithy testament: "blood on the street / graffiti on the wall, this is art!" In 1980, Sham 69 released the song "Spray it on the Wall" on the album *The Game*, in which Jimmy Pursey frames street art both in terms of creating vital, galvanizing self-made media ("spray it on the wall in capitol letters / tell your friends not in whispers but in shouts") but also in terms of providing agency and autonomy for youth. In the discourse of the Sham 69 song, such art creates spaces for youth to experience a worthy sense of freedom, despite how transient it may be: "Big brother is watching you / . . . you're just another face in the crowd / so come on son shout it out." In 1979 the obscure English power pop/punk band Airship released the single "Gimme a Can of Spraypaint" on Decca Records. In addition, Black Flag sang a thirty-second tirade called "Spaypaint" on their *Damaged* LP, and the Circle Jerks blurt, "You run around and paint graffiti / on everybody's walls" on the song "Up Against the Wall," then remind the characters in the song that such actions "ain't nothing at all" (from *Group Sex*). In the film *The Decline of Western Civilization*, Keith Morris yelps the lines while pointing back at a spray-painted logo of the band (black paint on white surface) that serves as a backdrop to the stage. (The crude backdrop later was replaced by a logo from their first album, juxtaposed next to female illustrator Shawn Kerri's icon: the Circle Jerks skanker, found on the band's early albums and flyers too.)

When the Texas band Legionnaire's Disease headed to California and spray-painted the World Trade Center in San Francisco, they were banned from the city. When Black Flag was cutting the track "No Values" at 4:00 a.m., guitarist Gregg Ginn placed his amp in the hallway and played the savage riffs while nearby kitchen windows were wide open. The police arrived, or committed "breaking and entering," according to the band.

On the way out, they asked what band was playing. When they heard "Black Flag" as the answer, they connected the band to local graffiti. Such a reputation was bound to signal future tension and rancor between the two camps.

Most prominent in the sense of graffiti and punk legends, as noted by Jon Savage in 1991, might be the Clash's white logo near the Westway in London, England:

> When I think of the punk years, particularly 1977, I always think of one particular spot, just at the point where the elevated Westway diverges from Harrow Road and pursues the line of the Hammersmith and City tube tracks. . . . From the end of 1976, one of the stanchions holding up the Westway was emblazoned with large graffiti which said simply, "The Clash." When first sprayed the graffiti laid a psychic boundary marker for the group. (*Evening Standard* 1991)

This is the same Westway featured on the back cover of the Clash' first LP (*The Clash*), which depicts the 1976 riot scene at Notting Hill. This same LP art, "with splurges of red and pink aerosol paint" according to Clash biographer Marcus Gray, also suggests "the neon and graffiti of the urban environment, and evokes the fire and blood of riot" (1995: 229). The tense, alienated urban terrain of the Clash was now central to their lore, which was even further cemented when Strummer supposedly spray-painted "White Riot" on the office of Capitol Records. Later, the Clash would work extensively with graffiti artist Futura X, who appeared on their *Combat Rock* (he designed the cover and sang on the record) and painted their banner for their multiple Bonds Casino shows (and sprayed graffiti live on stage during those performances). His work, including a large Clash banner, appears in their video "This is Radio Clash."

By the mid- to late 1980s graffiti had become part of the aesthetic of New York hardcore band

visual aesthetics. Graffiti style influences can be found in the logos of Pagan Babies, Token Entry, the Crumbsuckers, Vision, Outburst, Comin' Correct, Falling Sickness, 25 Ta Life, and others. Ari Katz, singer for the band Lifetime, described this era as ripe with "young bands . . . starting up, and they were all baseball bats and graffiti" (Edge 2006: 27). The lettering on such band logos is often blocky but frenetic, a hint of wild style submerged as a New York hardcore punk script. The early 1980s afterhours bar A7 (a former Polish social club) in the East Village, where members of Kraut, Warzone, and Murphy's Law worked, featured the territorial slogan, "Out of town bands, remember where you are," spray- painted on the left-hand side door (Rettman 2008). "We started using the term 'hardcore' because we wanted to separate ourselves from the druggy or artsy punk scene that was happening in New York at the time, Roger Miret from the Agnostic Front insists. "That was old Andy Warhol stuff. Just artsy. We were rougher kids living in the streets. It had a rougher edge" (Buhrmester 2009). Though the club also featured jazz and reggae, the hardcore edge was delineated in aerosol warnings.

This occurred prior to the city declaring a war on flyer and concert bill posting during 1988 and 1989, much like its war on graffiti on trains, in the name of "quality of life" issues, when promoters and activists like Bob Zark were systematically fined fifty to one hundred dollars for each handbill he affixed to lampposts, which eventually led him to form the group Stop-Gro (Stop Persecuting Grassroots Organizations). Zark, who provided scene reports to *Maximumrocknroll*, reported in December 1988 that the city had fined him $3,000. With the help of Jello Biafra and poet Allen Ginsberg, he sought out the American Civil Liberties Union, working with the lawyer Ed Baker, who brought a lawsuit against the city.[5] These historic consequences draw links between the subversive style and tactics of people "speaking back" in urban environments, using either graffiti or flyers,

to decolonize spaces and negotiate their messages in a bureaucratic society while literally becoming the media, long before the guerrilla video slogans of the 1990s.

Such actions also relate to skate culture, in that "Youth used graffiti to 'colonize pools,' in which skaters "frequently sprayed the terrain surface not only to mark it for themselves, celebrating its transfer to the domain of skateboarding, but also against others, marking off the terrain" (Borden 2002: 51). Hence, the meaning of such actions can be understood to signify how punks and skaters worked in tandem to inhabit and reimagine spaces often overlooked, neglected, or off-limits.

While graffiti may seem bright, garish, and at times soft as 1960s psychedelia, punk was much more about tatters, appendages, splotches, and cut-ups. It is a visual counterpoint to the flawless mechanism of modern consumerism, where all roughness is glossed over in favor of spry, advertisement-friendly, near-lampoons of American life (prime time TV, boxed dinners, *the National Enquirer*). However hackneyed and trite it sounds, punk intuitively yearns to elicit and touch the bristling, uncosmetic side of (un)popular culture. Like fin-de-siecle bohemians of the late 1800s, punks represented and celebrated a romantic and willful sense of decay that manifested itself from the post-Vietnam, post-Watergate late 1970s through post–September 11. Punk was the insolent leer destabilizing Jimmy Carter's smile and Reagan's Hollywood jaw, and it is the same leer that decimated George Bush's attempted folkisms.

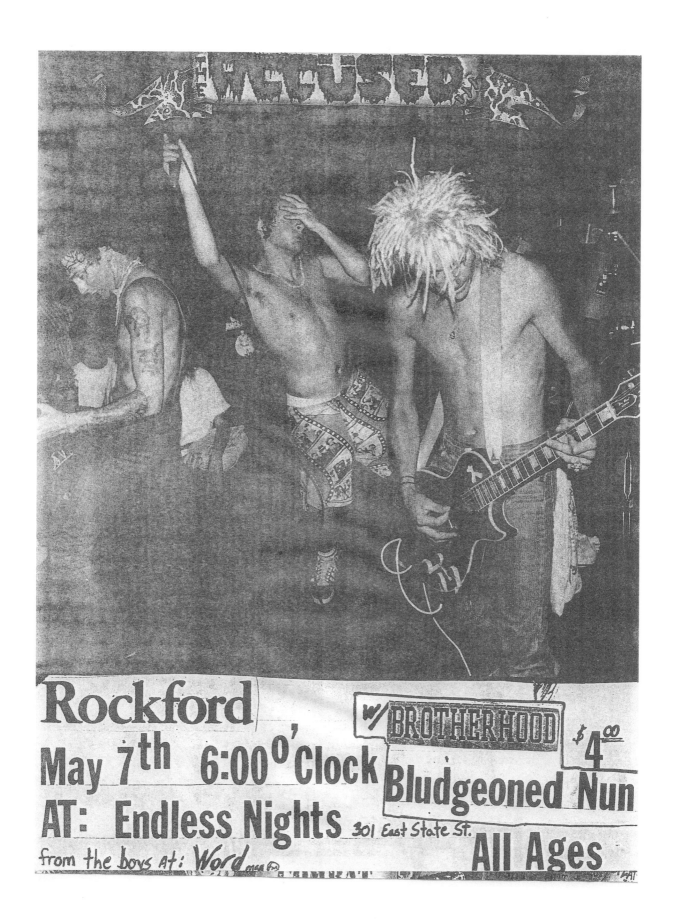

Accused at Endless Nights, Rockford, Illinois, 1980s, by the "Boys at Word mag."

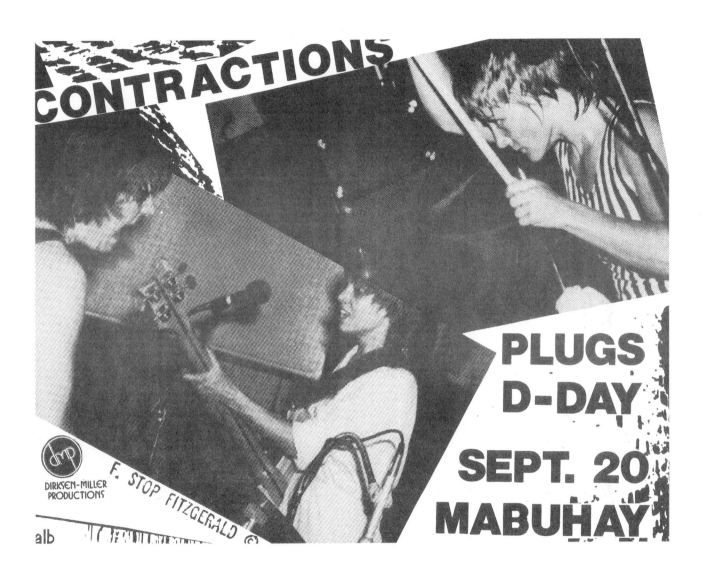

The Contractions at Mabuhay Gardens, San Francisco, 1970s, by Dirksen-Miller Productions, photo by F. Stop Fitzgerald.

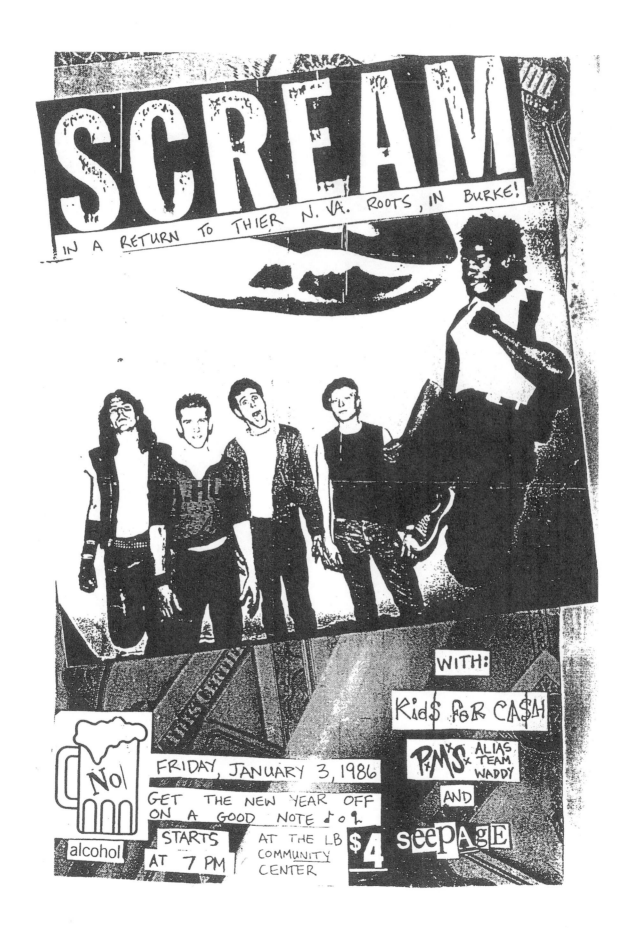

Scream at LB Community Center, Burke, West Virginia, 1986.

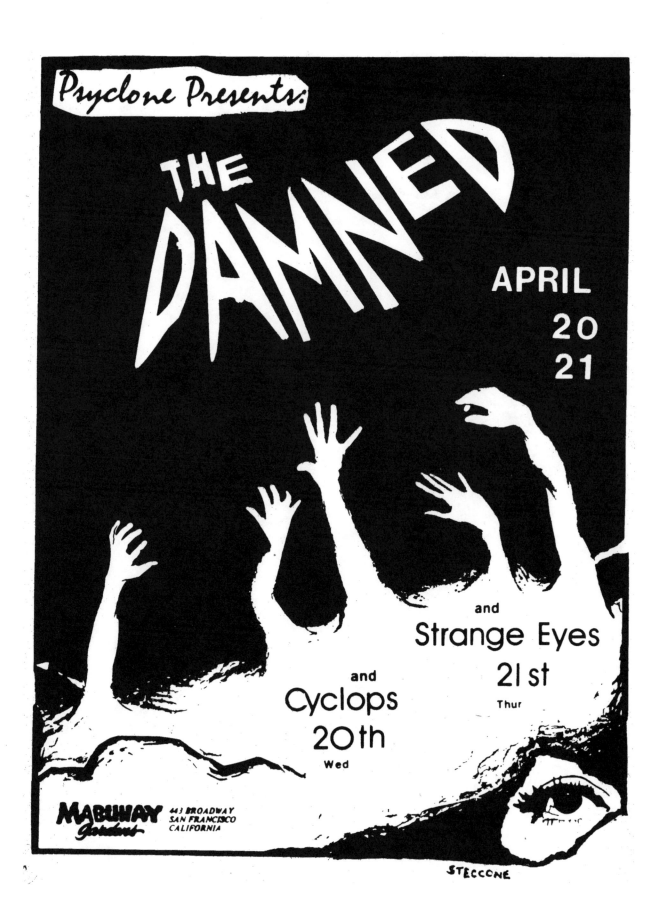

The Damned, Cyclops, and Strange Eyes at Mabuhay Gardens by Judy Steccone, 1977. Purchased by author from Dirk Dirksen "Raw Edged Collectors Items" mail-order during late 1980s.

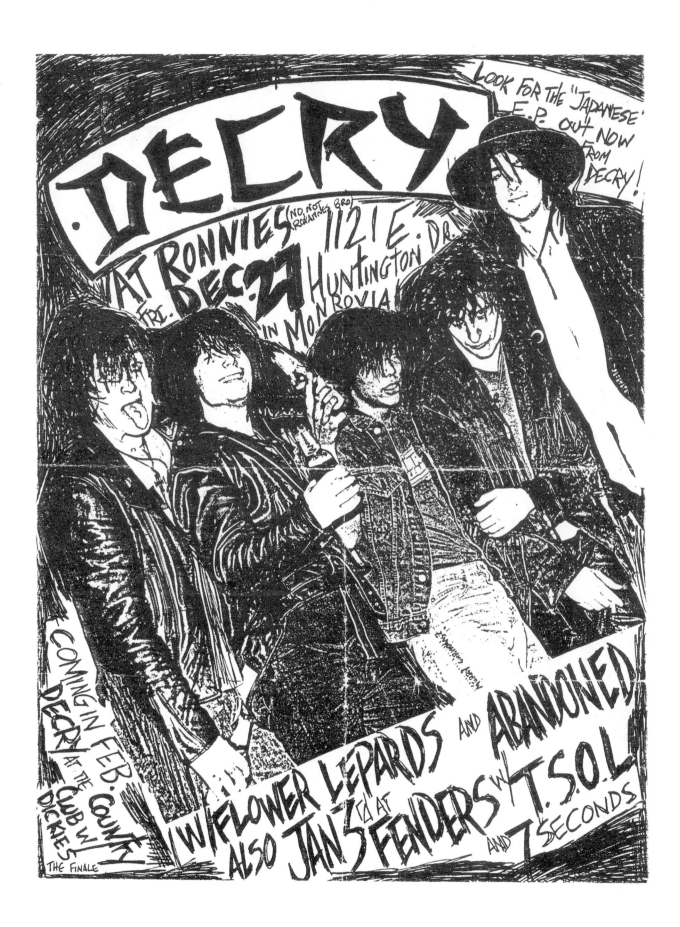

Decry at Ronnie's, Monrovia, California, 1980s.

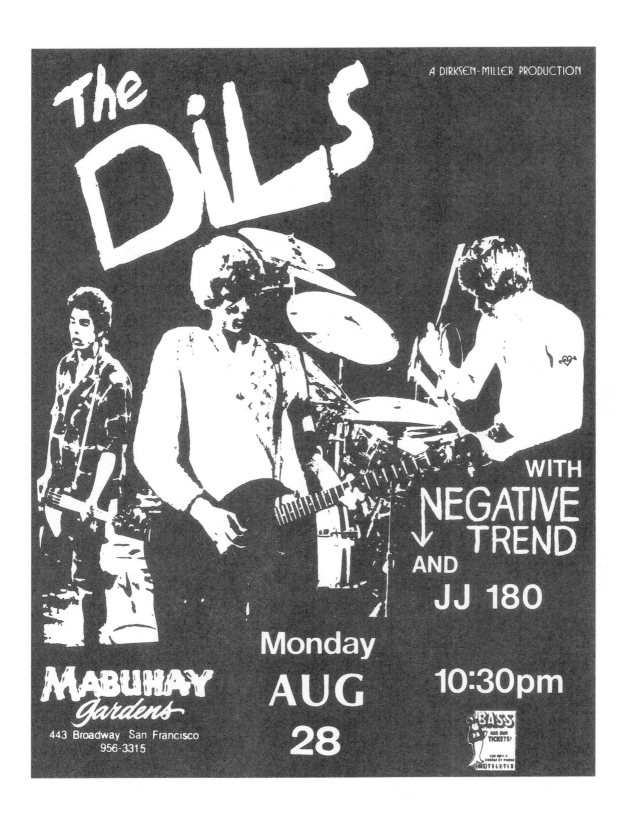

The Dils at Mabuhay Gardens, San Francisco, 1970s, by Dirksen-Miller Productions.

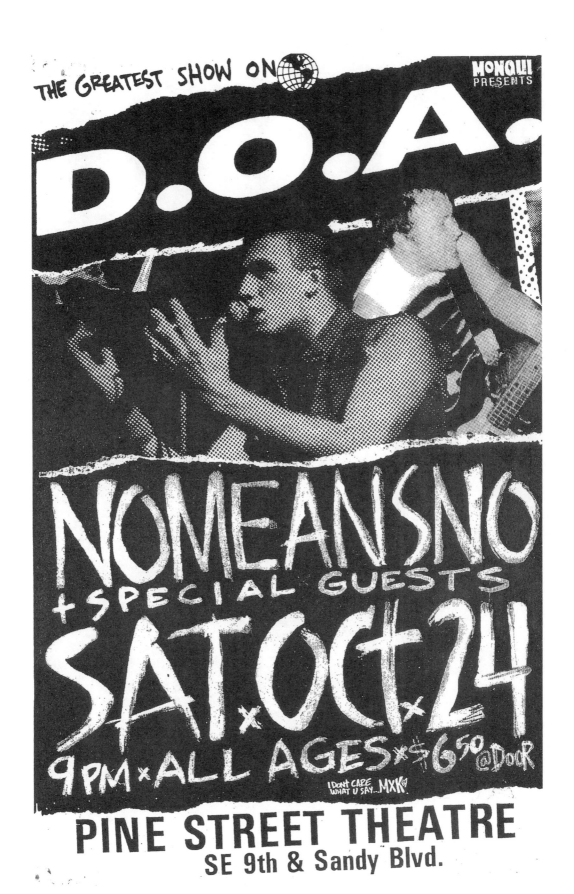

DOA at Pine Street Theater, Portland, Oregon, by MXK.

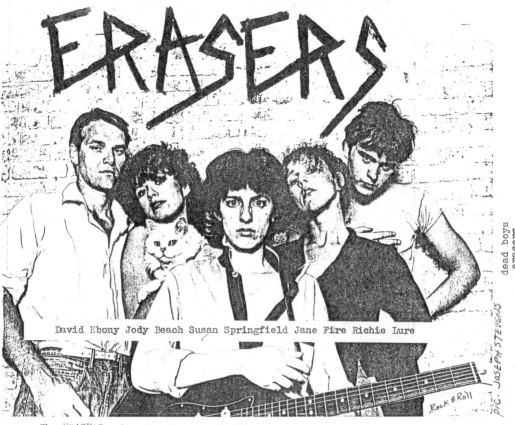

David Ebony Jody Beach Susan Springfield Jane Fire Richie Lure

PIC. JOSEPH STEVENS

Rock & Roll

The ERASERS, who recently recorded two songs— IT WAS SO FUNNY
THAT SONG THAT THEY HEAR and I WON'T GIVE UP— for Ork UK
Records, will be playing at Max's Kansas City on:

Sat. Sept. 16, 1978 with the HEARTBREAKERS
and Sun. Sept. 17, 1978 with the NECESSARIES.

Erasers at Max's Kansas City, New York City, 1978, photo by Joseph Stevens.

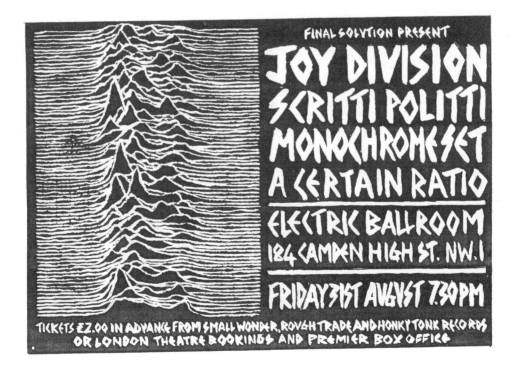

FINAL SOLUTION PRESENT

JOY DIVISION
SCRITTI POLITTI
MONOCHROME SET
A CERTAIN RATIO

ELECTRIC BALLROOM
184 CAMDEN HIGH ST. NW.1

FRIDAY 31ST AUGUST 7.30PM

TICKETS £2.00 IN ADVANCE FROM SMALL WONDER, ROUGH TRADE AND HONKY TONK RECORDS
OR LONDON THEATRE BOOKINGS AND PREMIER BOX OFFICE

Joy Division, Scritti Politti, and others at Electric Ballroom, London, 1970s,
provided by Tony Barber.

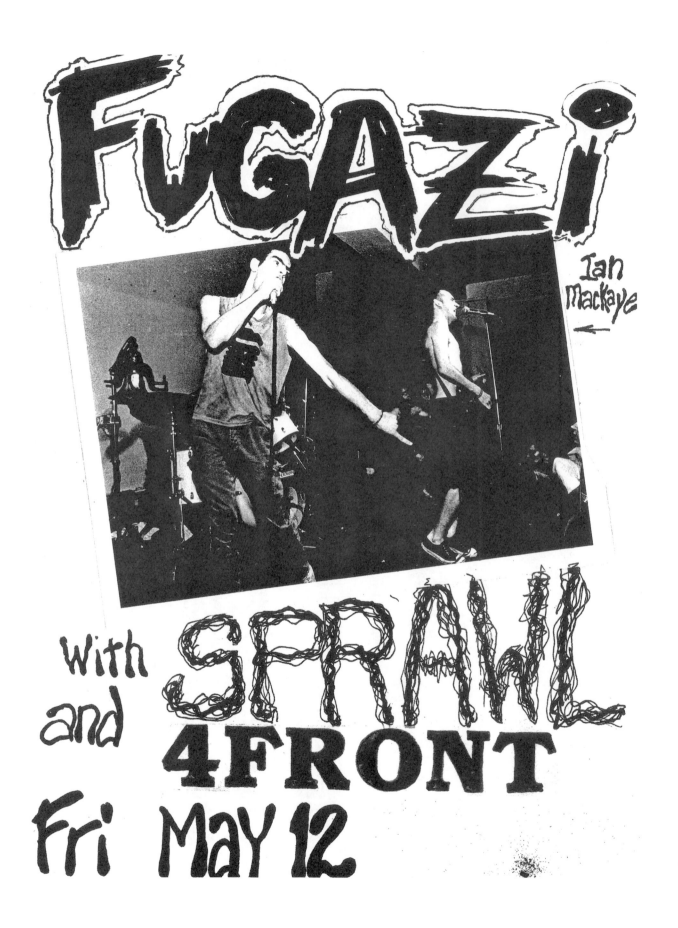

FUGAZI

Ian Mackaye ←

with and SPRAWL 4FRONT

Fri MAY 12

Fugazi at unknown venue.

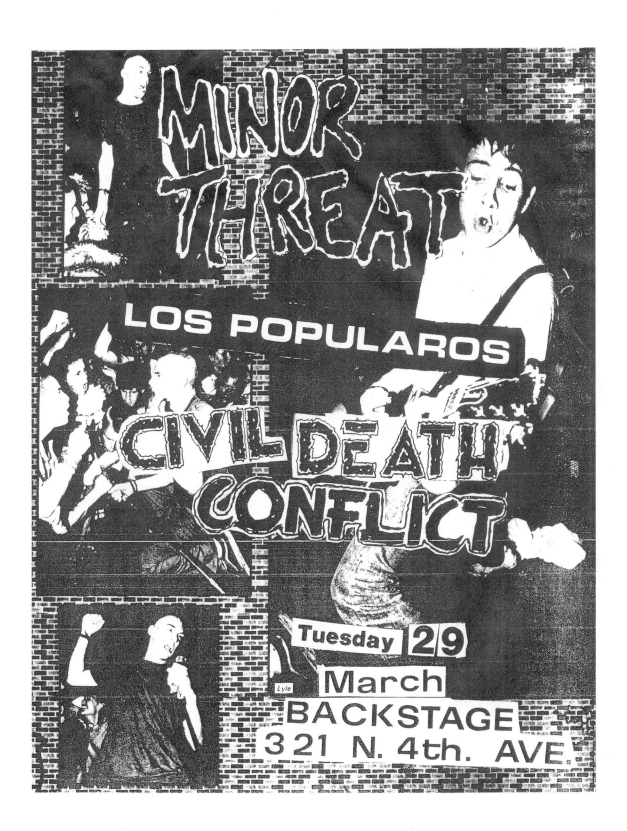

Minor Threat at Backstage, Phoenix, Arizona, 1983, provided by Jeff Nelson.

RAMONES

Doors open at 7 pm. Adv. tickets at Rainbow Ticket Master and
The Fast and Cool Club box office. 6135 Kirby Drive. 526 3456.

The Fast and Cool Club

SUNDAY MARCH 22

Ramones at the Fast and Cool Club, Houston, 1986 or 1987.

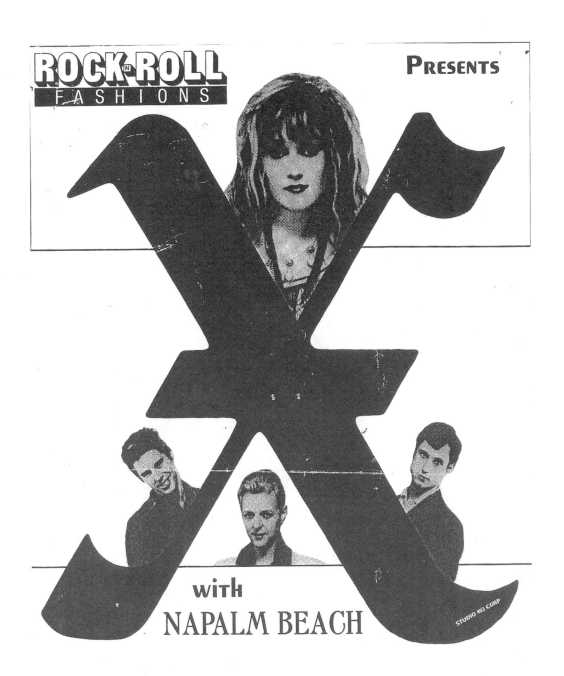

ROCK 'N' ROLL FASHIONS PRESENTS

with
NAPALM BEACH

OCTOBER 24, 1982
EUPHORIA — 8 PM
TICKETS $7⁵⁰

 Tickets available at:
Everybody's Records, Music Millenium, G.I. Joes, Meier & Frank and Euphoria

X at Euphoria, Portland, Oregon, 1982, by Studio 403 Corp.

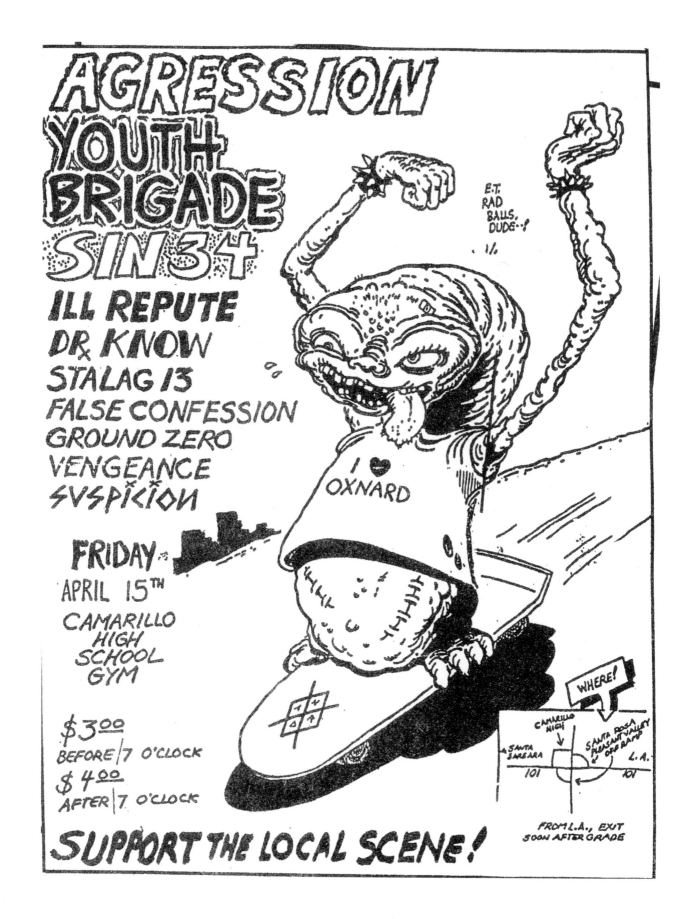

Aggression, Youth Brigade, and others at Camarillo High School Gym, Camarillo, California, 1980s.

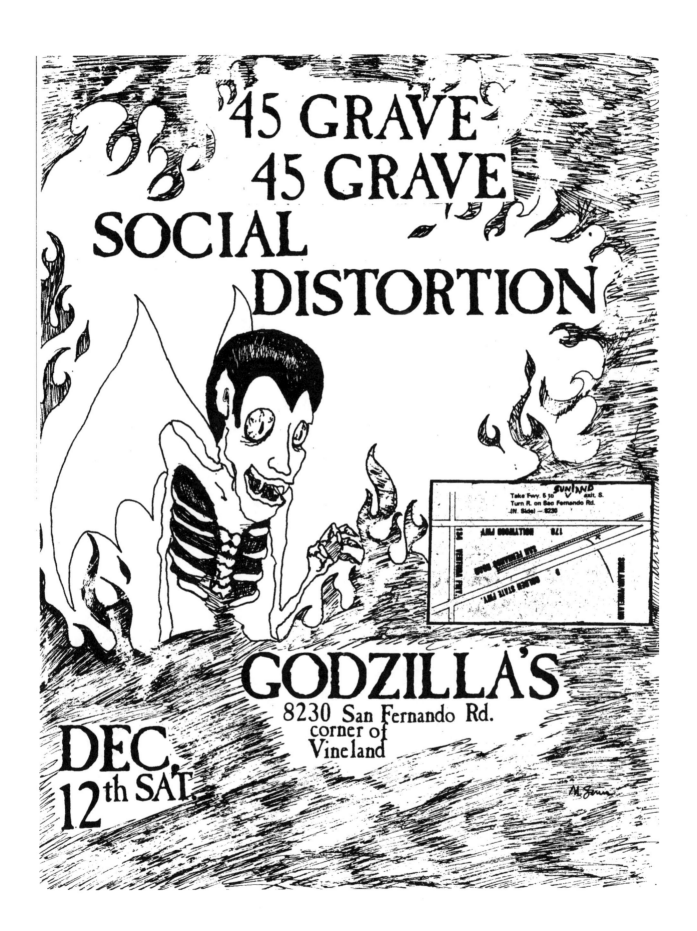

45 Grave and Social Distortion at Godzillas, Sun Valley, California, 1980s.
Provided by Lisa Fancher.

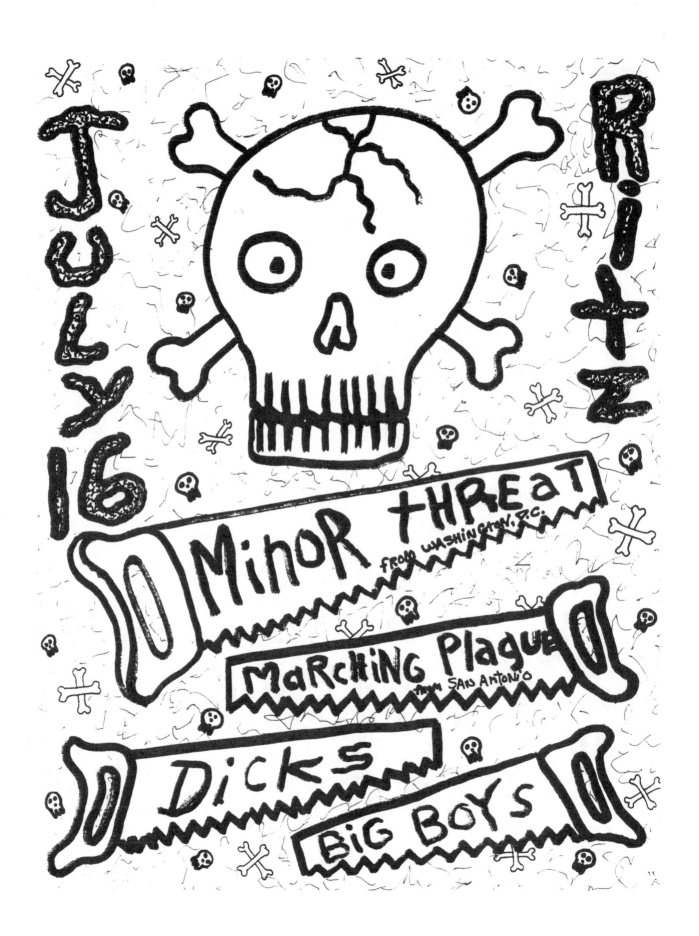

Minor Threat, Big Boys, and others at the Ritz, Austin, Texas, by Randy "Biscuit" Turner, 1982.

Vanilla Chainsaws and others at Evening Star, Sydney, Australia, 1987, by Ashleys Art.

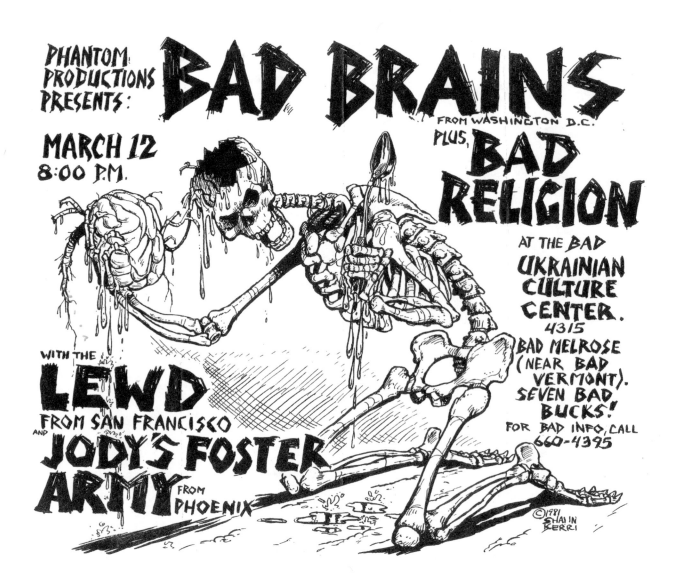

Bad Brains, Lewd, and others at Ukrainian Cultural Center, Los Angeles, 1981, by
Shawn Kerri.

Big Boys, Dicks, and others at Nightlife, Austin, Texas, 1983, by Nobody.

Corrosion of Conformity and others at Turner St., Raleigh, North Carolina, 1980s, provided by Brian Walsby.

Magnetic Four at Mary Janes, Houston, by Charlie Esparza, 2000.

CHAPTER FOUR

RE-IMAGINING THE GEOGRAPHY OF THE WASTELAND

The Convergence of Punk and Skateboarding

Skateboarding is a crucial link between the era of the 1960s post–Beat Generation and the Punks. Driven by a sense of adventure and "surfing" sloped streets, the sport connects the dots between a Beat sense of spontaneous possibility, where coffee shops and jazz can create a cultural renaissance spiked by caffeine and other drugs, to the frenzy and Do-It-Yourself attitude/ethos of punk, in which rented VFW halls, Xeroxed gig fliers, and cheap tape decks could create a whole underground musical community. "Like punk," journalist John Leland writes in regard to Kerouac's *On the Road*, "the characters emerged from dying cities and scarred neighborhoods, flaunting their pariah status and taste for speed—chemical, musical, and vehicular." Both seemed drenched with similar tropes, underlying tensions, fragmented outlooks (2007: 45).

Although a rather mainstream sport in the 1960s, by the 1970s skateboarders fragmented into their own anti-authority subcultures. The mid-1970s Zephyr skate team, noted in documentaries like *Dogtown and Z-Boys* (2001), consisted of teenagers intent on breaking rules, whether the traditional form of the sport itself or taking over empty pools and dirty streets to transform them into usable spaces to vent their restlessness in a creative whir of pavement and urethane wheels. The quote that begins the documentary attests: "two hundred years of American technology has unwittingly created a massive cement playground of unlimited potential, but it was the minds of eleven-year-olds that could see that potential." Many of those kids were already punks. "We were punks, we were tough kids," skater Bob Biniak notes in the film, employing *punk* as both noun and verb, explaining how the Zephyr kids were punkified due to their circumstances of growing up in intense, culturally diverse places like

Dogtown—an amalgam of Ocean Park, Venice, and south Santa Monica.

On an amateur level, skateboarding still appeals to those seeking an alternative to mainstream sports structures. The sport thus mirrors punk's amateur underbelly, for within

this flexible and informal structure, the skateboarders control the physical activity, and are the experts. This popular practice had no rules, no coaches, and no referees. The participants create

... skating is, in part, about the redefinition of life. When you're on a skateboard and everyone else sees sidewalks, I see runways.
—IAN MACKAYE, *Thirsty Ear*, 2001

their own tricks and games and they determine which tricks they practiced and how long. In the process of controlling their own physical activity, the participants also control their own bodies. Such values and behaviors oppose those associated with corporate bureaucratic relations . . . and . . . resistance is evident in the creation of participant-controlled activity that de-emphasizes competition. (Beal 2001: 51)

Beal further notes how the nature of this approach to skateboarding is in direct tension with the massively

commoditized, bureaucratized, X-sports–generated concept of the game, much in the same way that Green Day is a corporate punk model, although traces of rebellion remain latent in each. This aspect has become part of the lore of skateboarding as it actively borrows from street art culture and punk, with their emphasis on reclaiming public space, freedom and open expression, individualism and rebellion. As such a subculture, punk antecedents also encompass surf culture as well, as Mike Palm from Agent Orange intones: "Original surf culture—those guys were all about forging their own paths. They were kind of outcasts. People thought they were degenerate. In reality, they were some of the first people to embrace fitness and clean living and actually living the life they way they wanted to, which is beneficial to your health in the long run. Here I am talking about health and you're trying to link this with punk rock. The point is that mainstream society thought they were freaks. It's the same thing with punks too" (2010).

The work of Iain Borden illustrates how skateboarding says almost "nothing as codified statements, yet presents an extraordinary range of implicit enunciations and meaning"; thus "skateboarding is a production of space, time, and social being" (2001: 1). I will attempt to show that such enunciations often overlap the punk community's production of meanings as well, fostering a social being equally part punk and skater. Or, as one *Texas Monthly* reporter framed the relationship after "visiting Studio D, a punk hangout in Dallas' dingy warehouse district that looks the way Berlin might have if a bunch of skateboarders with Mohawks had won the war ... There's an important metaphysical link between punk and skateboarding that's a little too obtuse for me" (Applebome 1982: 139). Another Texan, guitarist Tim Kerr of the funk-punk band Big Boys, known for the phrase "Skate Tough or Die" and the variation "Skate Tough or Go Home" (partly attributed to Dallas skate shop owner Joe Newton), summed up the link between skating and

punk rock in an exchange with zine editor Al Quint: "Skating's really edge-type stuff. When you go into a pool . . . it's just happening like that and the same thing happens when everybody's dancing . . . and start[s] slamming . . . you've got to face it. The music's the same way" (#7, 1983).

Bands like Free Beer, Code of Honor, Los Olvidados, Big Boys, Drunk Injuns, Gang Green, JFA, and Aggression are known as essential skate punk bands, along with Boneless Ones, Minus 1, The Skoundrelz, Beyond Possession, Fratricide, SNFU, Agent Orange, Stalag 13, Ill Repute, DRI, McRad, and regional/local powerhouses Barkhard (whose motto was "Skate tough, bark hard!"), Skaters Always Rule, Negative Gain, Welfare Skate, Crash Course, Disdain, and contemporary bands such as Millencolin, Bones Brigade, Fields of Fire, and Face the Rail. In fact, 1970s first-wave punk rocker Terry Nails from Killerwatt skated for the Stroker Company while the same era's pro skater Duane Peters continues to sing for punk bands, including the U.S. Bombs, Die Hunns, and The Duane Peters Gunfight. Chuck Treece, who skated for Madrid, Santa Cruz, and Powell-Peralta, played in McRad, Underdog, Bad Brains, and sessions for the likes of Billy Joe and others, while pro Steve Cabellero is well-known as the guitarist for 1980s skate punk band The Faction and later, Mistaken Identity. Other skaters who played in bands include Steve Alba for 10,000 Heartaches/Flamethrowers, Tracy Robar for West End, Steve Olson for the Joneses, and Mario Rubalcaba ("Ruby Mars") for many 1990s bands, including Rocket from the Crypt and Hot Snakes.

Another notable punker/skater is Ron Emery of TSOL, who told me, "I wasn't really into music, ever. I was into surfing and skating, that's it. Then in 1978 the Dickies and Weirdos played a couple blocks from my house. There were Elvis Costello and Joe Jackson. . . . There were all these bands, and I kept going to shows. . . . And standing there watching these guys, I thought, I could do that. . . . I bought my first guitar and tried to do what they did. And I

was really involved in the skate scene back then, so Skip Olson and I started our first band and toured skate parks and played with Jack and Todd's first band" (2001). Even bands like SWA, Die Kreuzen, and Mighty Sphincter played skate rock shows with JFA and the Faction.

Austin-based punk-funk band the Big Boys were the first punk band with their own skateboard, produced by Zorlac, from Dallas, in 1983. Biscuit provided a mini-history of the era for my zine *Left of the Dial #7*:

> We were just a bunch of skateboard "grommets" and "dwids" when we met at the local ditches in 1978. Groups of friends gathered to skate small pockets of local hill areas, embankments, and ditches. The Central Austin, University of Texas area of Austin, was the most whacky, and that's where the Big Boys lived. There were several Gulf Coast surf style boys who influenced us with their "flow and carve," who went to U.T. We have the hills here, so high-speed suburban road runs were customary! There was the Pflugerville Ditch, the 15th St. railroad banks, the abandoned swimming pools at the Monkey Research Labs in Bastrop, plus many downtown parking garages helped spread the fun! Team Gerbil (we would shred) from San Marcos or the Kerrville Ramp Boys would stay overnight and we would roll all night after some sick punk rock shows . . . Tony Alva rode from Los Angeles to San Francisco with us for some shows, and we must have stopped at twenty different ditches.(2004)

Midwest and East Coast skaters are often overlooked, though skaters from such scenes shaped the punk community in ways just as profound as their West Coast counterparts. John Brannon stressed their presence to me in *Left of the Dial #2* (2001):

> It was so dull in Detroit. There was nothing that was kicking your ass anymore. The big things was

like the Romantics, and the real pop retro shit, and all of a sudden, there was all these kids showing up to these shows. It was like a phenomenon in Detroit. Skater kids . . . It seemed at that point that all the kids hanging out were forming bands. The Necros were putting out records and going on tour. It was a kid phenomenon at that point, and was just exciting. Instead of trying to sneak in a bar to see some fucked up old new wave band . . . Well, we were kids back then, playing music for ourselves, which had nothing to do with the jaded fucking Detroit scene. These fifteen year old kids wanted a place to hang out, so we did hall gigs, and the Freezer Theatre was all ages, so we just bypassed the whole bar thing and said fuck it. It was exciting. There were people putting out records, there was Touch and Go magazine, a lot of fanzines out. Kids putting out records. (2002)

Hence the dynamism and collusion between youth, punk and hardcore, and skateboarding may be seen as genuinely empowering: the kids were not bound by generic community attitudes and consumer trends but became producers themselves. They transformed the sense of local landscape and their relationship to commodities, media, sports, and entertainment by forming a micro-economy, even micro-society, of their own—all while remaining committed to a fuzzy set of core values marked by a perceived sense of difference and otherness.

In Madison, Wisconsin, known as the liberal hotbed and "red diaper" campus town for the University of Wisconsin due to old guard leftists sending their children to school next to the lake, young skaters formed Bone Air (see above), with the help of skating members of Mecht Mensch, Tar Babies, and other local bands. They actively organized gigs at the Wil-Mar center, including Die Kreuzen MDC, Minor Threat, and Hüsker Dü, and released records by local acts. In Milwaukee skaters whose scene centered around the shop Beer City Skateboards, which began in 1993,

have continued to preserve and foster the collusion and crossover between skate and punk/hardcore culture by releasing records by DRI, MDC, Verbal Abuse, the Faction, and Toxic Reasons.

On the East Coast, Rat Skates, drummer for early thrash metal pioneers Overkill, was a semi-pro skater, and the singer of Cause for Alarm, Keith Burkhardt, was an active skater. In addition, Ian MacKaye (Minor Threat, Fugazi) and Henry Rollins (Black Flag) were both well-noted skateboarders, and second-generation post-hardcore D.C. band members of Swiz, and brothers Mark Sullivan (Kingface) and Bobby Sullivan (Soulside) were skaters too. *Flipside* #38 features a one-page spread of Jeff Nelson, drummer for Minor Threat, and co-owner of Dischord, demonstrating a "Full Nelson flip-spin 360" in a six-part photo layout.

One short news item from Lawrence Livermore's photocopied zine *Lookout* highlights the contentious connections between bands and communities: the *San Francisco Chronicle* published an article describing how loose skateboards had marred the cars of wealthy patrons in Mendocino Village. The feature also revealed photos of "one youthful delinquent performing stunts. . . . The pictures were particularly disturbing in that the camera revealed on the underside of the young man's skateboard a decal reading JFA," which stood for the band Jodie Foster's Army. Livermore quipped, in a joking manner, that the band had attracted "a nationwide cult of disaffected youth who idolize . . . would-be assassin John Hinckley, and plan to emulate him by attacking public officials with their skateboards" (1986). Mendocino officials later prohibited skateboarding during business hours, but the article's jest and irony was clear cut: whole communities were dealing with the "nuisance" and "delinquents" of skateboarding by regulating public space in favor of business, and bands like JFA were the soundtrack of the "hooligans" attempting to reclaim or re-occupy that same space.

Another connection between punk and skating is the essence that pushes young people, in a spurt of agency and urgency, to fill spaces that might be forgotten or ignored. To a skater, such space signifies potential. Just as there was a literal and metaphoric hole in youth music subcultures that feverish punk rock filled, there was a hole in youth sports culture as well. As Don Redondo from JFA told *Guillotine* fanzine, "When we first started we played for our friends and they were basically skaters. It's like there was a void, just like when you skate around on a ramp or a big pipe. . . . Well, that's what we tried to do, play to fill in the void" (#8, 1984). So, this void was a catalyst for bands like JFA to start bands, stir momentum, and create long-lasting skater communities.

Skate parks, skate bands, and skate communities quickly become a backbone of punk culture all over the country, not just in Texas, where the Big Boys held gigs on half pipes or crisscrossed parking structures in the dry desert heat, or seemingly everywhere in California, the nexus of the industry, but also in Portland, where the loose confederation of skaters known as Rebel Skates held competitions and concerts by groups like 7 Seconds; Salt Lake City, where the record shop Raunch Records became an epicenter for punk and skate culture, including well-recognized Pushead, a preeminent skate punk artist and singer for Septic Death, who made store ads for national magazines like *Maximumrocknroll*; even Rockford, Illinois, home of Cheap Trick, where the family-owned Rotation Station featured dozens of DIY concerts over ten years, hosting bands like Flag of Democracy, Psycho, Verbal Assault, and Youth of Today. Shows like these were held across the skate nation, including Berea Roll 'n' Bowl in Cleveland. This sampling is just a small testament to the skate community's enduring ingenuity and presence within the formative years of American hardcore and DIY culture, perhaps epitomized by Steve Alba's miniature overview: "If you couldn't find punk rock clothes, make them. If you needed

a punk T-shirt, you got some stencils, a can of spray and after a couple of beers you had a killer new look. A new kind of kick. You need some stickers. Take a printing class and viola . . . punk stickers. The whole outlook was punk rock and skateboarding. Nothing more, nothing less."

This early link between punk and skateboarding was also witnessed by Mike Conley from MIA, who told Al Flipside: "I've been skating since the beginning days. All the punk rock scene in Vegas evolved from the skaters" (#40). In Camarillo, California, bands like Ill Repute and Aggression would rent a generator and play a skater-thronged drainage ditch under the freeway. As skaters ventured to hardcore punk shows in increasing numbers, they also transformed "play" (the dynamism of aggressive fun) and fan behavior at gigs and venues. These daring, adrenalin-stoked youth helped transform and reimagine stage dives into acrobatic feats. As Craig Ramsey recalled in the *Maximumrocknroll* "Skate Issue" from 1983: "When you're out on stage setting up for some kind of stage dive loop, it's almost the same as catching a backside air in skating. Now you see a lot of punks doing flips, but the skaters started it. They were the very first to stage dive cause they had already been ten feet in the air and flown all over the place" (#8). For notable skaters and designers like Pushead, the tendency to push boundaries might originate in the fact that skaters are by definition not "normal," as he attests in the same article, because they jump down into ten-foot pools whereas everyday people would not. Hence, they conquer a sense of fear, and this sensibility migrates with them to other areas and lifestyles, acting as precursors to the age of "edge culture" that has surged over the last twenty years.

Part II: Skate Theory

Within the nature and approach of skateboarding, seemingly fixed aspects of a space as mundane as a ditch, curb, set of stairs, or rail become trapdoors of multiple meanings, probable spaces that can be adopted and reclaimed from mere utility, openly rendered with new meaning, and transformed and freshly inhabited. Such spaces become interfaces between people, architecture, and skateboard, thus translating a physical terrain beyond its usual frozen sense of space and time, disconnecting the space from its previous codes, boundaries, and worth. A curious terrain-hungry skater uses a panoptic eye (everything visible at once) to instantly explode the myth of unused space, to revel in the geometric and geographical possibilities of space, providing a human face to the humdrum, forgotten, faceless voids of concrete, metal, and stone. Furthermore, Greg Shewchuk considers skateboarding "an ongoing dance with gravity and acceleration," as a mind-body activity similar to Yoga and Taiji, for a "good skateboarder must be a master of balance, focus, perseverance, creative ingenuity, and fear management. It takes heart and vision . . . not muscle" (2008: 16).

To paraphrase Zephyr skate shop co-owner Skip Engblom, the skater and punk kids took the ruins of the twentieth century and made art from them. Craig Stecyk comments on kids skating the tar playgrounds of California elementary schools: "They took those environments and reworked them, and made them into something different that was more human . . . than what the architects had originally planned" (Peralta 2005). Such spaces become humanized, unbound, suddenly maximized and transitional, transposed as limitless and metaphoric, since skaters "surf" the asphalt, breaking down imagined barriers between natural and manmade landscapes. Such space becomes an extension of being. It now truly exists. To revisit Borden: "The tactics of appropriation, colonization, and identity formation helped skaters to redefine the city and themselves. By making a different edit of the urban realm from alternative locations and times, skateboarders transformed the sedately

suburban character of Los Angeles into dramatic concrete constructions, exploited under an air of espionage" (2002: 53).

Images of skulls and skeletons are omnipresent in punk flyers, which might reveal the influence of skate-core bands like Suicidal Tendencies and their zealous homemade fans who made countless skull shirts (even worn by the lead character in the 1984 film *Repo Man*), who have even been described as a gang and were documented on the back cover of their self-titled first record (Frontier 1983), but also the art of Mad Marc Rude (Misfits, Battalion of Saints, Christ on Parade), Pushead (Septic Death, Corrosion of Conformity), or Shawn Kerri (Germs). Most likely, the roots relate to the 1978 skull-and-dagger graphic designed for the (Powell-Peralta) Ray "Bones" Rodriguez deck by V. Courtland Johnson. Similar skull designs were omnipresent on Powell-Peralta boards throughout the mid-1980s (team decks, plus Kevin Harris, Tony Hawk, Mike McGill, Rodney Mullen, Per Welinder, and others).

The aesthetics of Dogtown/Zephyr likely were influenced by local L.A. Hispanic street culture, which might have been conveyed to Zephyr via murals with skulls, such as the one by La Regeneracion in 1972 at Eastern Avenue and Conley Drive, and the 1974 skull figure stirring a black cauldron by Los Toltecas en Aztlán, a Chicano Arts Collective, that was painted in Balboa Park on a converted water tank. The use of skulls may also allude to Mexican folk art (Posada's Day of the Dead skeletons, etc.), voodoo art, lowrider culture, skull motifs used by Stanley Mouse in early 1970s Grateful Dead art, and outlaw biker counterculture graphics in general. Indeed, the first Powell board graphic to define the company was a skeleton holding a sword, made for the Ray "Bones" Rodriguez line (Hawk 2001: 48). Soon thereafter, skull imagery became normalized and omnipresent within skate culture.

The use of skulls is a visual analogue to the "gnarly" slogan "Skate to Hell," also a song title by

Gang Green (the song title "Skateboards to Hell" by the Weirdos fits here as well). Both hint at the emboldened, free-roaming, atavistic skater lifestyle and rowdiness epitomized by such raucous punk bands. In social spaces marked by rigid and limiting laws, the skeletal figures also convey metaphors of skating as a kind of pestilence: undead figures embody both the unwelcome disease, morbidity, and horror of the contemporary urban wasteland but offer a resilient athleticism and fluidity as well. Tony Hawk once recalled, "I looked like a B-movie mummy with scabies," which shows his allegiance to a sport that by the mid-1970s had become a "dead fad" to other peers at his middle school (2001: 42–43). The skeletal figure is truly unstable: the skeleton skater is dead and undead, alive in death, more than human and subhuman, neither of this world nor bound to the depths of subterranean hell, both margin walker and defiant seeker. The simmering, electric, macabre skeleton reveals a post-death kineticism in which the very nature of the über-punk lifestyle is tattooed into the bone marrow.

The skeleton—wily, gleeful destruction-monger in the wasteland—also links to songs by Tales of Terror (featured on skate videos and one volume of *Thrasher*, "Skate Rock 2," and the name of a 1962 Roger Corman–directed film based on Edgar Allan Poe stories); the Faction's (featuring skater Steve Cabellero) song "Skate and Destroy" (with its anti-BMX, anti-cop, anti-authority renegade exhortation to "be a hood / don't be good"); the name of one of Alaska's first hardcore bands, Skate Death; Blast's song "Surf and Destroy"; plus the Bones Brigade's "Skate or Die," with its insurgent indictment of parent culture and corporate life. Unexpectedly, the lines that begin the song, "parents and teachers could never understand," also parallels the opening lines of Kathy Acker's poem at the end of *Blood and Guts in High School*: "Parents teachers boyfriends / All have got to go."

Perhaps the greatest visual trope of skate and destroy is Suicidal Tendencies' 1986 video for

"Possessed to Skate," featuring countercultural icon Timothy Leary as a clueless, vacationing parent who leaves his young frustrated son to dream and lay waste to the house with a handful of "intruders"—shredders, vatos, and swimsuit-clad women—who proceed to break tables, overturn couches, spray-paint walls, and drain the pool for skating in a mayhem-tinged sequence in synch with the lyrics: "Used to be just like you and me / Now he's an outcast of society / Beware he's possessed to skate!" This notion of outcast youth combining their forces across the racial divide, at the same time period in which Bones Brigade videos by Powell-Perralta and Flipside skate and punk video compilations sold well, seized the imaginations of media-oriented youth. The sheer nature of the sport—the tenacity, speed, and spirit—together with the possibilities of ruining, remaking, and subverting spaces of everyday suburban existence, became legendary archetypes within pop culture.

Black punk rockers such as Mad Dog from the Controllers and Michael Cornelius, bass player for the skate band JFA, symbolize the trans-racial (and gender-crossing) appeal of skateboarding, too. Cornelius even offers a way to interpret the meaning of skate slogans. Rather than assuming that oft-repeated skater slang incorporates nihilism alone, he focuses on the slang's sense of portraying intense energy: "'Skate and Destroy' and 'Skate and Die' have been maligned. People think it means skate and break everything. But it's not that.... It's sort of an energy outlet. To dance with the street, and when you're done you look back and think of all the stuff you did with one little stretch of street, you think to yourself, 'I destroyed that!'" This speaks to the fluid, procreative, and limber aspects of a sport reclaiming the streets rather than reifying the folklore of alienation and angst. Also, as a verb, it metaphorically captures breaking down limits, as Tony Hawk marveled at the "two wunderkinder who *destroyed* anything skateable, Steve Caballero [later of the Faction]

and Mike McGill" (2001: 48). Just as punks sought out gig spaces to forge an independent hive of action and rebellion, skaters could create such spaces on the fly, making the streets temporary free zones.

American punk history is, in large part, the history of skate punk, argues Brendan Mullen, club owner of the Masque, author of the biography of Darby Crash, and co-author of *We Got the Neutron Bomb*, an oral history of L.A punk. Some of his favorite bands were "cheerleaders of pioneering SoCal skatecore" that contrasted "sped-up post Sham 69 Oi! soccer chant-type punk bands" (Ruland 2002). This skatecore defined American punk and, to a large extent, around the world, signing and sealing the message that the two cultures were firmly embedded within each other.

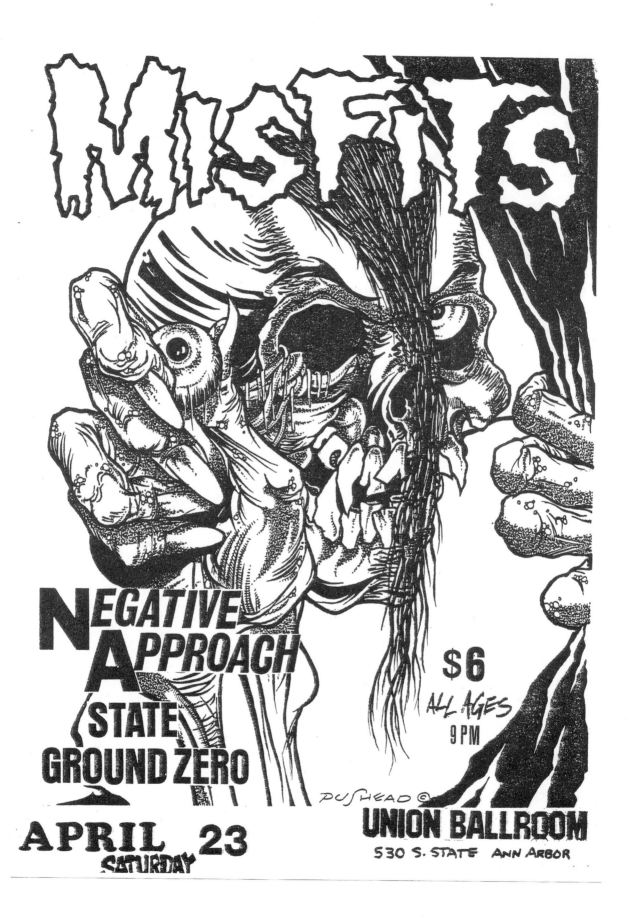

Misfits and Negative Approach at the Union Ballroom, Ann Arbor, Michigan, 1980s, by Pushead.

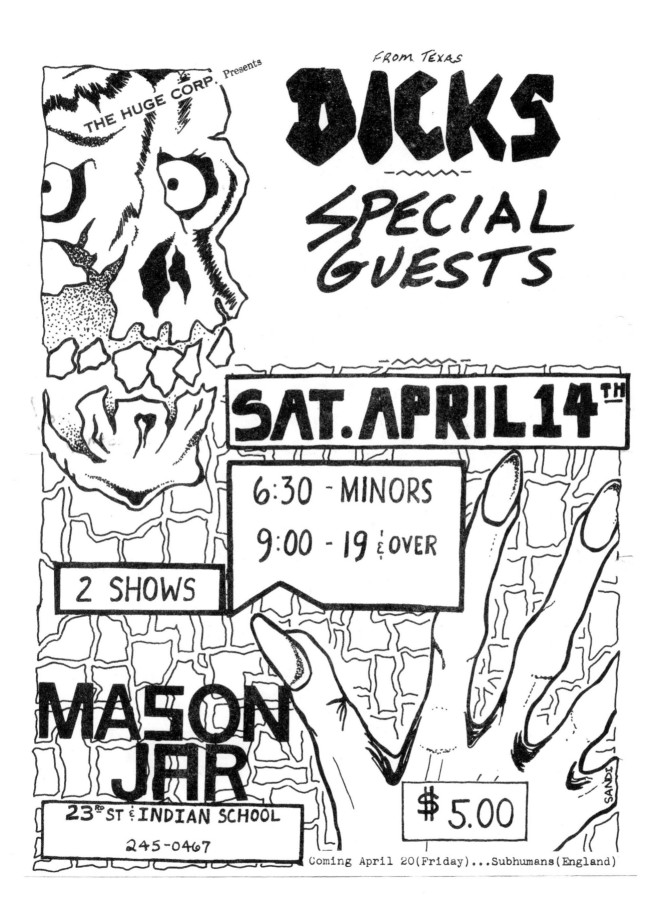

The Dicks at Mason Jar, Phoenix, Arizona, 1980s, by Sandi.

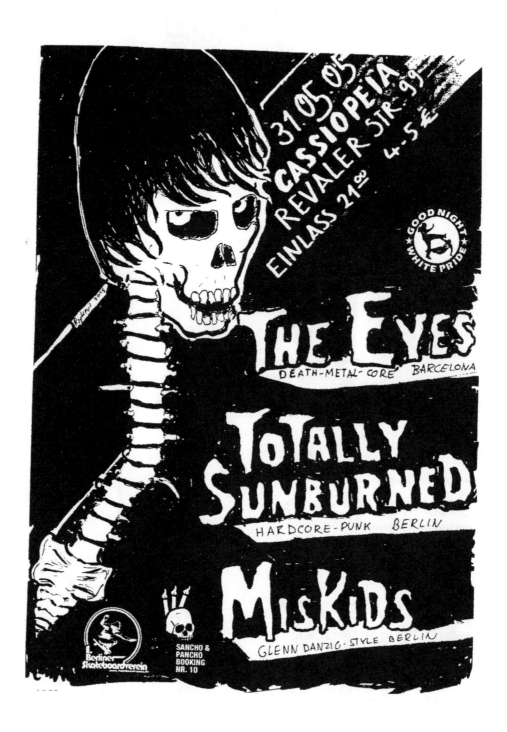

The Eyes, Miskids, and others at Cassiopeia, Berlin, Germany, 2005.

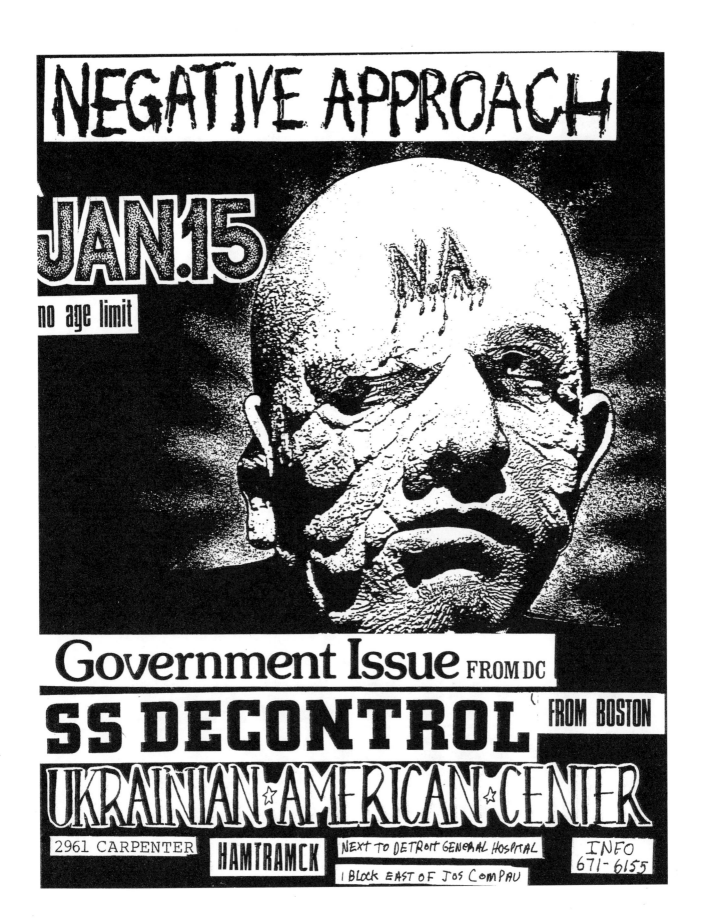

Negative Approach, Government Issue, and SS Decontrol at the Ukrainian American Center, Detroit, 1980s.

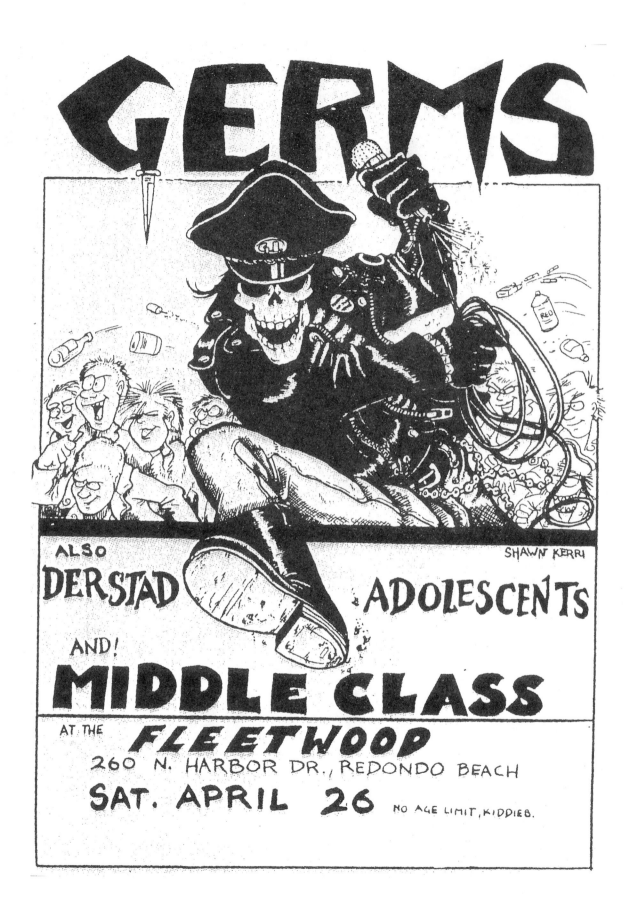

The Germs at the Fleetwood, Redondo Beach, California, by Shawn Kerri, 1980.

GERMS
RETURN!
DECEMBER 3. STARWOOD
(GI)

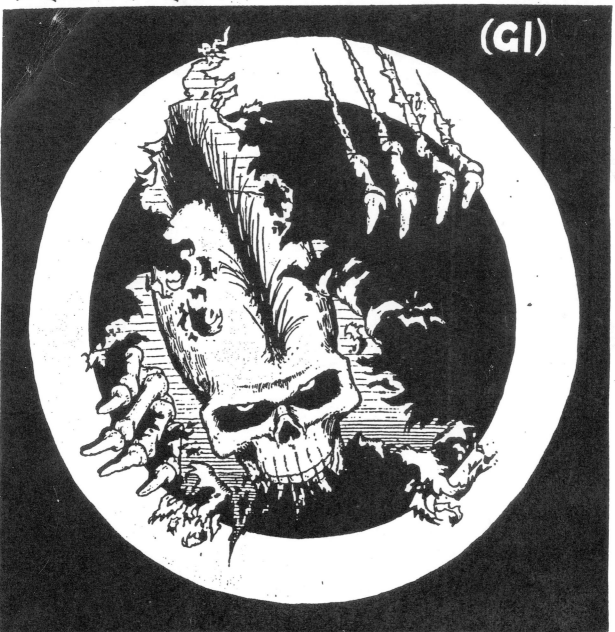

© 1980 SHAWN K.

The Germs at the Starwood, Los Angeles, by Shawn Kerri, 1980.

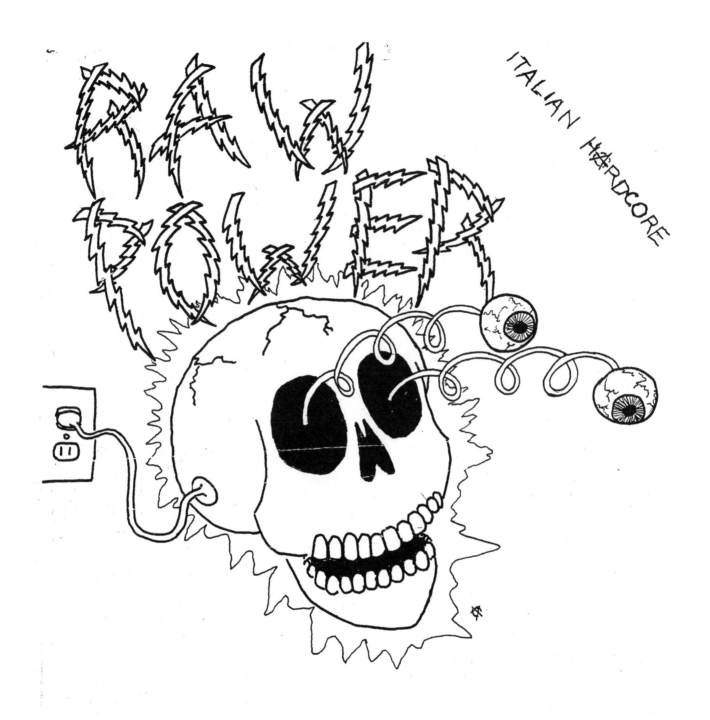

RAW POWER

ITALIAN HARDCORE

FRIDAY MAY 24
CABARET VOLTAIRE II
22 N CHENEVERT

Raw Power at Cabaret Voltaire, Houston, 1980s.

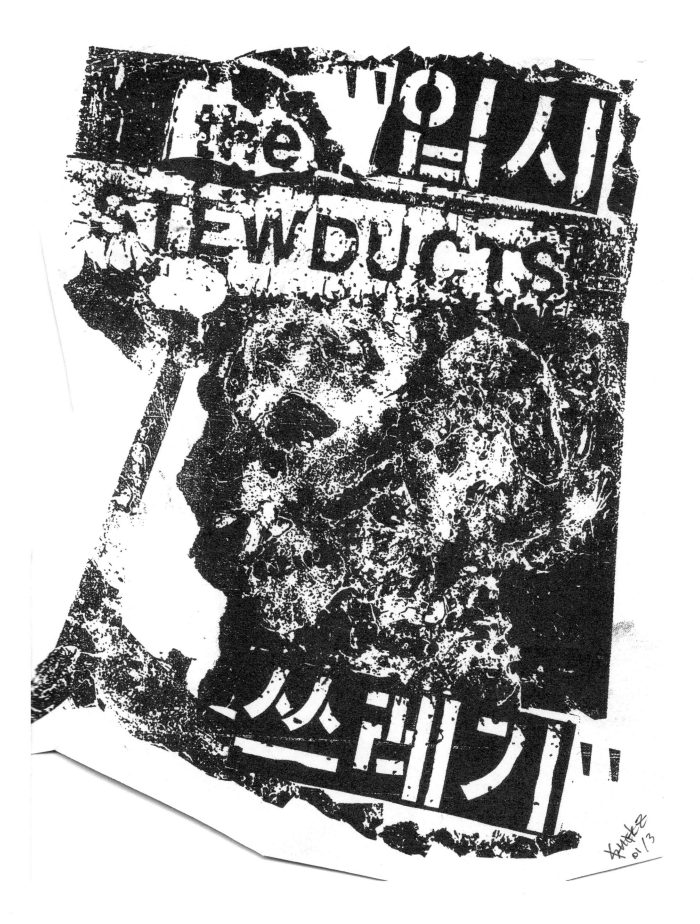

The Stewducts promo flyer, South Korea, by Han Suck Zoo, 2003.

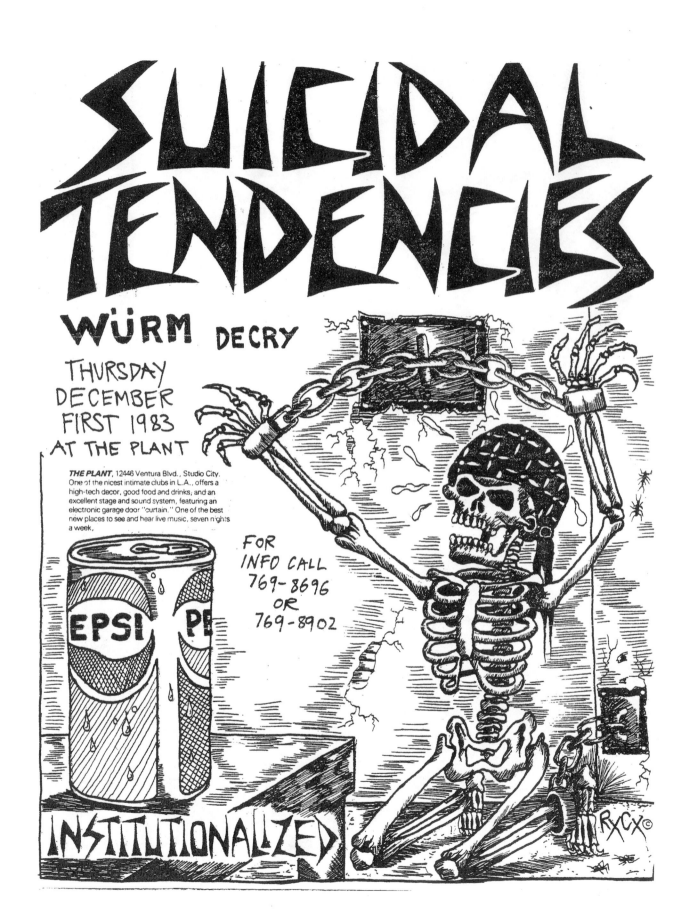

Suicidal Tendencies, Decry, and Wurm at the Plant, Studio City, California,
by RXCX, 1980s.

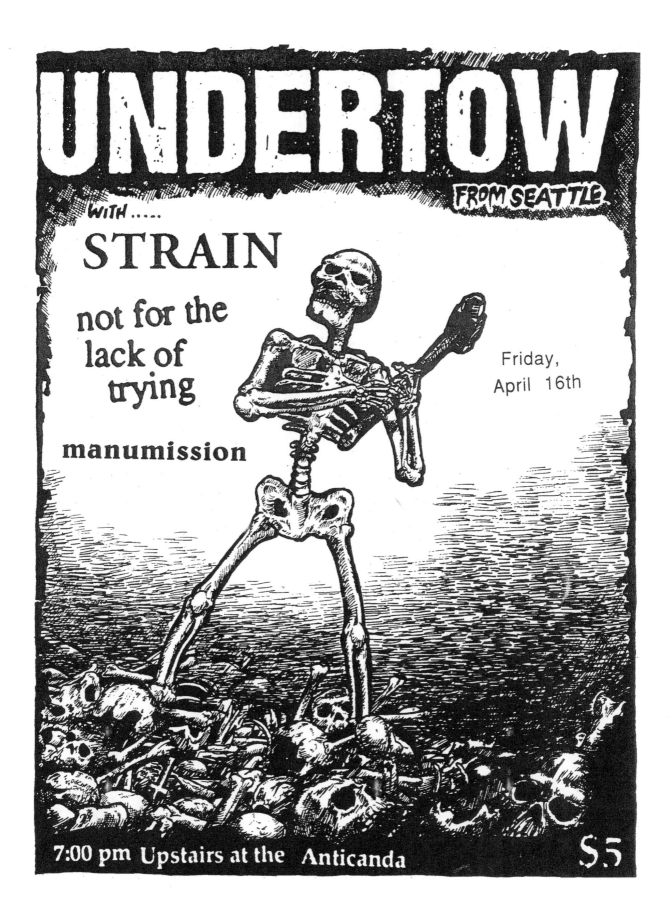

Undertow, Strain, and others at the Anticanda, 1990s, artwork appropriates
1985 Broken Bones flyer.

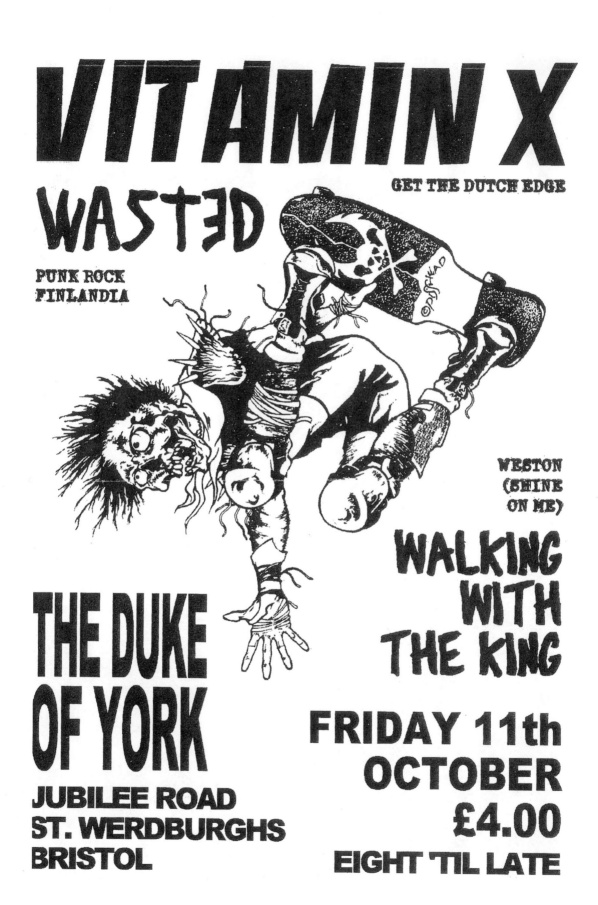

VITAMIN X

GET THE DUTCH EDGE

WASTED

PUNK ROCK
FINLANDIA

WESTON
(SHINE
ON ME)

WALKING
WITH
THE KING

THE DUKE
OF YORK

JUBILEE ROAD
ST. WERDBURGHS
BRISTOL

FRIDAY 11th
OCTOBER
£4.00

EIGHT 'TIL LATE

Vitamin X and others at the Duke of York, Bristol, England, artwork appropriates
Pushead.

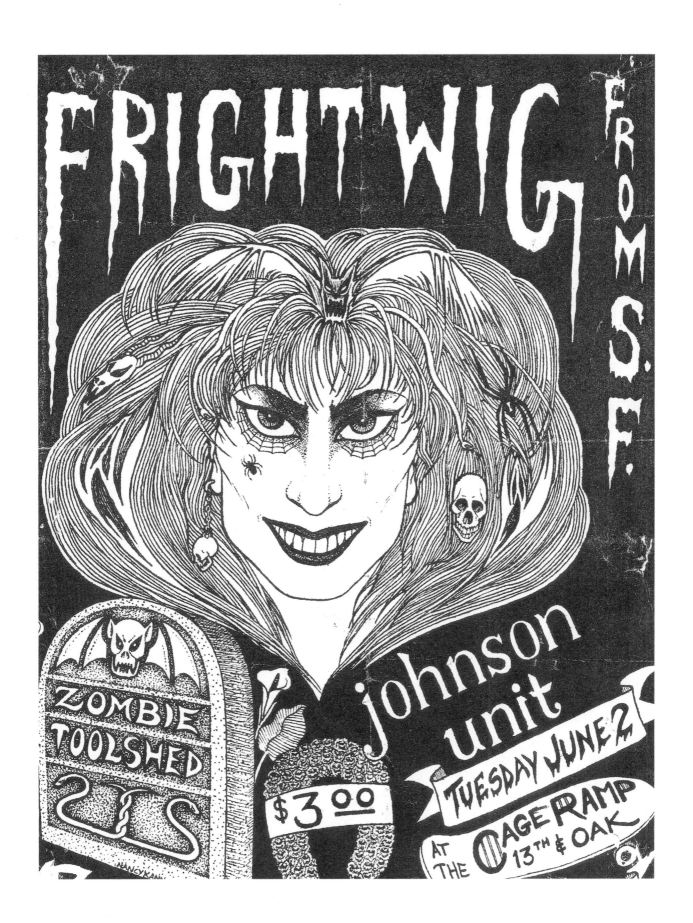

Frightwig, by Nancy K., 1980s.

CHAPTER FIVE

IMAGES FROM THE CRYPT

Undead, Ghoulish, and Monstrous Bodies

Artists have continuously used monstrous depictions to pay witness to the vulnerable lives of people beset by times of virulent politics and war, science that errs, chemical and industrial pollutants, and environments that produce sporadic cataclysmic forces, such as natural disaster, pestilence, and disease. Such art actively interrogates Westernized notions of bodies as discreet and harmonious units—static, whole, and natural—thus delves deep into metaphors of unease. In recent years, concerns about bodies have been mediated by an anxiety and ambivalence linked to "unbound" technology, both in terms of the way technology directly affects bodies (laser-guided bombs from drones or, as filmmaker David Cronenberg and folklorist Daniel Wojcik often highlight, invasive medical technology and genetic mutations) and how technology like YouTube can immediately convey and disseminate the knowledge of these effects. The painter Leon Golub strongly suggested that such a bombarding flux of information does not desensitize but instead heightens the terror:

> It has been said . . . that the images of Vietnam that appeared on American TV, were devalued by advertisements, situation comedies, etc. I think the opposite. The very fact that the ads and the nightly news and all those things were on together bombarding people in their homes made it all the more horrific. All these atomized chaos, all the controlled and uncontrolled verbal and imagistic garbage jitters in the skulls of the onlookers even as it jitters in the skulls of the media manipulators. (qtd. in Gumpert and Rifkin 1985: 75)

One can include the bodies in paintings by Golub, Breughel, and Goya, or photographs of bodies riddled with WWI injuries or suffering

Representations of death pervaded early punk culture The image of a skull with spiked hair or a mohawk, grinning or dancing, became a punk icon Punks not only adorned themselves with such images, but their personas and behaviors often embodied the idea of death.

—DANIEL WOJCIK, 1995

from injuries sustained in the invasion of Iraq. These types of bodies, punctured and mutilated, are mimicked in the inky macabre of flyers strewn on telephone poles and other contested spaces, providing space for narratives that newspapers and news programs often do not address. Such carnage of war is often muted, repressed, and censured. Yet, when subsumed into provocative and suggestive art, it may embody a negative energy that critic Peter Schjeldahl suggests is the "quintessence of politics in art" (2008: 43). A great deal of such art, from Goya's brutal depictions to images of Kent State, "employs images of the dead. . . . Corpses halt thought. Propagandists hope that viewers, while transfixed, will be receptive to the opinions that the dead, now martyrs, are safely presumed to endorse" (2008: 43).[1]

I suggest that punk art may reveal similar underlying tensions: images of death are embedded to speak against the grain of shopping-mall aesthetics, of the so-called objectivity of newspaper-speak, of the commercial veneer of the hyperkinetic modern world. The negative energy is meant to halt us, even if only for a moment, to look into the face of, say, Pol Pot's victims, to understand where punk culture transgresses from a discourse of three chords and jagged T-shirts to a discourse about otherness and abjection, which Julie Kristeva suggests "perturbs an identity, a system, an order" (1982: 127). This victimization haunts and contaminates our social spheres: punks bear witness to an often grim reality that most choose to ignore, representing the disorder that "hovers at the edges or borders of our existence," to poach another phrase from Elizabeth Grosz (1987: 108).

The use of skulls is by no means limited to punk art, as Mexican Day of the Dead celebrations and trinkets and Haitian voodoo Gede/Ghede imagery attest (the Cramps were loosely identified with the occult and voodoo, especially early guitarist Brian Gregory). Skulls were adopted in "teddy boy" culture, a kind of British outlaw dandy aesthetic popular in the pre-punk era of the early 1970s, in which members might wear a "gambler's bootstring . . . held together with a medallion: death's heads, cross-bones skulls" (Steele-Perkins and Smith 1979: 3). Skulls are also prominent in biker culture. In fact, the tattoos of outlaw bikers, including the phrases "Born to Lose," "13" (which punk songwriter Danzig penned a song about, later covered by Johnny Cash) and "1%" are often accompanied by "skulls and death imagery" that developed as bikers and marginalized individuals began "to assert, and challenge, their subordinate position in society" (DeMello 2000: 139). Such an inscribed body (or gear) becomes a vehicle for resistance—oppositional discourse made flesh—especially in the days before 40 percent of young Americans sought out tattoo parlors. DeMello,

however, notes that pre-1950 tattoo culture, such as WWII soldiers, did not see their tattoos as personal forms of expression, backdropped by all-important stories that framed their meaning. Thus, the work might not represent a sense of opposition or rebellion but simply mark a rite of passage or memory.

Punk rock music and fanzine discourse abounds with zombie and undead tropes, like the tunes "Be a Zombie" from the Tulsa, Oklahoma, band Los Reactors and "Astro Zombies" by the iconic Misfits. Meanwhile, the first issue of *Slash*, printed in 1977 in Los Angeles during the genesis of punk's first wave, features such tropes in several places: one anonymous critic describes the sound of Iggy Pop's *The Idiot* as "the sound of someone who has come back from the dead, or is it the sound of someone going there and is trying to take a few traveling companions along?"; editor Claude Bessy describes Dave Vanian, singer of the Damned, as "the creature, the monster, the living dead" whose band helps inaugurate "Hell on Earth!"; while Kickboy Face (Claude Bessy) describes FM rock as "dead meat, zombie food for idiots in nowhere-land," which is leveled by the "all-out front noise" and "aesthetic aggression" of the Sex Pistols' anthemic single "Anarchy in the U.K." (with the titanic snarl, "I want to destroy!"). On one hand, the trope of the zombie serves to stylize punks as campy creatures, unbound by everyday rules, like monsters roaming a dystopia, while writers also imagine zombies as "everyday people"—defiled in Kickboy Face's review as rednecks boogeying in each other's vomit while listening to "good time music."

In punk flyer art, the so-called normal world, subordinate to law and order, is mobbed by ugly and ripped bodies, detested bodies, pathetic and lifeless, like the life of a teenager who cares little for organized sports, religion, or studies. Such "dead" bodies are reanimated in these drawings and illustrations, cocooned in their own sense of power, revealing an instant visual

vocabulary spelling out an anti-authority (God, parent culture, civil society) presence. Feared and loathed, unable to be disciplined or acculturated, such bodies are nimble, fierce, and unbound. They resemble the fragments of our dead past, remaking cities as their own. Carnivorous and devouring, they challenge the righteous inhabitants—the leaders of science and rationality. Incubated in pain, misery, and abjection, these morbid figures redefine reality. Like the Jewish legend of the Golem, who was made from clay and ran rampant in the ghetto, these atavistic, primordial figures transplant the ooze of our most primal selves into the body politic and social discourse. Parents, teachers, scientists, and police try to constrain youth, but imagined as such avatars—the electrified dead body of the miscreant and maladroit—they are indeed uncontrollable.

Jello Biafra, singer for the Dead Kennedys, emphasizes their brand of punk "was an attempt to take Alice Cooper's knack for really graphic, ugly horror, and Iggy Pop's making it personal, in other words not illustrating the horror so much as becoming it, making the horror too close to home" (Sukenick 1987: 268). Hardcore punk band MDC managed to balance their lyrics and visual aesthetics between humor and horror as well, as singer Dave Dictor outlined to me in this exchange:

DICTOR: There was always sarcasm going on in MDC, even when we sang "No War No KKK, No fascist USA." It was heartfelt, and it was serious. We felt the need to turn it around and take the piss out of it, a little. So it didn't come across like we were the angry commies. That's just who we were. There was a silly misfitsness to us. A silly "we don't fit in" thing . . . and we gotta make jokes about it . . .

ENSMINGER: But that seems to be lost on things like the band flyers with a skull tank. Why don't we see flyers for MDC with some humor on them?

DICTOR: Even the skull tank, in its own perverse way, has got its own humor. It's like American power, a tank, that's really a skull that is killing people. And even though that's not funny if you're a Guatemalan farmer getting killed by a right-wing death squad, the visualization of that is going for a sick, ironic, and cynical sense of humor. (2008)

In the landscapes drawn on flyers, punk avatars roam a vast, haunted ground: industrial landscapes of William Blake–like proportions, like London (perhaps reimagined as Babylon) with its "manacles of fear"; Los Angeles' heat-clogged, graffiti-smattered byways and empty lots; the smeared, polluted, blackened hulls of Manchester; Manhattan's concrete jungle with intertwining noir streets; the Red Empire's last gasping concrete Stalin structures; the Middle East's prolonged blast furnace dust and poverty; and various guerrilla war killing fields (El Salvador, Lebanon, Colombia, Rwanda, Chechnya, and East Timor). Sometimes the landscape may be the crooked river in the Industrial Flats of Cleveland, where bands like Pere Ubu, the Pagans, and the Dead Boys were birthed in the stink of sulfur, shadows of iron ore cargo ships, and the sound of tugboats. This was the place, as singer Mike Hudson of the Pagans declared, where "we lived like we were already dead, rushing toward death" in the "beautiful hell" of the Rust Belt (2008: 61, 67).

Yet, even when former Cleveland residents migrated to larger cities, the same tropes stayed with them. Explaining the origins of the Cramps song "Human Fly" to one music writer, singer (and onetime Ohio resident) Lux Interior recalled that a local New York City newspaper had used the term to describe a tightrope walker sneaking across the World Trade Center on the same day that Ivy was "walking along the street at about 6 a.m. in the morning. It felt like *Night of the Living Dead* the way all of the people were wandering around"; furthermore, bassist Poison Ivy described being nearly assaulted by gig goers at

one maelstrom-prone Washington gig as "something straight out of *Night of the Living Dead*." In 1977, while recording the rockabilly song "Red Headed Woman" by Sonny Burgess at Sam Phillips Studio in Memphis with Jimmy Dickinson on vocals and piano, the band underwent a "real voodoo experience" because the place felt haunted by "ghosts of people living or dead" (Johnston 1990: 28, 36, 37). Wherever the Cramps ventured, ghosts and living dead seemed to follow.

Zephyr skate shop cofounder Skip Engblom described Venice Beach, the psycho-geographical site of Dogtown rebel skaters and punks, as a "dead wonderland" in the documentary *Dogtown and Z-Boys*. Another informant calls the site "a carcass of all these rides that are rusted and falling apart, and you can hear the ghosts of the people who were having so much fun." This draws attention to the notion of such punks and skaters being outcast, marginalized citizens of a neglected world they recolonized and made their own by any means necessary, even if it meant surfing amid the detritus of a pier in shambles, surrounded by junkies, gang bangers, and pyromaniacs, the brink of death just one bad move away. Sometimes this meant punks being almost dead themselves, as Hudson testifies; emulating classic B-movie undead tropes, like the Cramps; or tempting death, like the surfers.

This approach to life is similar to the way one informant described the punk era to Daniel Wojcik in his book *Punk and Neo-Tribal Body Art*. His own impression of punk was imbedded in the idea that punks were "kinda mealy looking . . . kinda dead, like after World War III—the walking dead" (1995: 14). A similar description of the drummer of the New York Dolls and the Heartbreakers, Jerry Nolan, first arriving in England by Lee Childers, attests he "was a vampire . . . [who] came into my room with all these tabloid newspapers . . . and every headline said . . . 'The Horror and the Scandal of the Sex Pistols'" (McNeil and McCain 2006: 321). It is no

coincidence that a punk crew forms the main cast of the film *Return of the Night of the Living Dead*, with a soundtrack furnished by "death punks" TSOL and the Cramps, for Wojcik suggests that punk fashion embodies a sense of "pallor and lifelessness. Pale and emaciated, resembling zombies or corpses, punk faces and physiques were often transformed into symbols of death or physical ailment, portraits of a diseased society" (1995: 14).

Punk bands such as the Exploited, Suicidal Tendencies, Social Distortion, TSOL, Misfits, and the Undead all used skulls on album covers, flyer art, T-shirts, or other paraphernalia, explicitly linking punk to the gory and taboo, transgressive and macabre. Punks were the dark side of Carter's maladroit liberalism *and* trickle-down Reagonomics, the black hole in the middle of California's sun. This is perhaps the sentiments of Bad Religion, who titled their debut album *How Could Hell Be Even Worse?* which aptly describes their version of the modern world—a leftover hippie wasteland. In the era of people and limbs replaced by robots and machines, in an era of the impersonal masked as personal mediated by an Internet network loaded with "viruses," in the ultimate consumption era of faulty products and flu contagions, the ghouls remind us how vulnerable we really are. These anxieties become concretized in the very names bands choose, revealing suffering skin and defoliated landscapes, subterranean worlds and anti-worlds. Such sentiments are also signified in the names of genres (grindcore, noisecore, thrash, crust punk, and power violence).

One of the most prominent signifiers is the term Hell, which appears variously as an album title, *Hell Comes to Your House* (a punk compilation); a song title, like "Green Hell" by the Misfits; the first line of the Chelsea song "Urban Kids" ("you try to escape from your urban hell"); the name of a psychobilly punk production company like Mental Hell (Germany); the name of a record label like Hellfire (Germany); or the various ubiquitous permutations found within band names.[2]

Other band names evoke and subvert the figure of Beelzebub,[3] or embody the putrid and grotesque.[4] Some approach band names with an almost Edgar Allen Poe–meets–*Tales from the Crypt* sense of the generic macabre mixed with comic book finesse.[5] One iconic hardcore band—MDC—opted to recycle their own acronym to draw attention to the plight of humanity under brutal or technocratic regimes: Millions of Dead Cops, Millions of Damn Christians, Missile Destroyed Civilization, Multi Death Corporation, Metal Devil Cokes, and Millions of Dead Columnists. Other names disrupt the decorum of dealing with the dead.[6] Sometimes, rather than disturb the dead, the names reveal the death urge, or death culture, or the tropes of being gray, isolated, barren, or alone in punk.[7] Names can depict the onslaught awaiting us in terms of pathological, petrochemical, biological, and extraterrestrial agents that resemble film titles culled from zines like *Psychotronic*.[8] Some band names evoke hordes of the undead.[9] And some signify the dark side of medicine.[10]

Punk artists may employ the zombie archetype to figuratively show how punks represent the abject, unwanted, and marginalized in society; inversely, they may also represent a way for punks to project their own fantasies of "getting rid" of people in their own lives. As Kriscinda Meadows noted in the abstract for her essay "Zombie Culture: The Audience and the Undead," such distressing creatures "represent a kind of 'blank slate' upon which the viewer may impose any sort of image—a boss, a husband or wife, a certain type of person (race, ethnicity, sex, etc.)—so that he or she may dispose of that person/characteristic both guilt- and punishment-free" (2006). Hence, these archetypes of the grotesque undead may represent or evoke both self and object, even simultaneously.

In the essay "Anarchy in the UK: British 1970's Punk as Bakhtinian Carnival," Peter Jones suggests that the punk movement was defined by an egalitarian impulse of sorts, rife with "hedonistic pleasure" and a sense of communal gestures, in which people immerse themselves in dances, such as in the pogo, later the mosh pit, or in jeering. In the early years fans also spit upon bands, a collective jouissance in which borders blurred amongst the frenzy and disorder (Jones neglects to mention band names that also mimic this, such as Disorder and Flux of Pink Indians). Philip Hoare has examined this in comparison with medieval mystery plays, or chivalric tournaments, although punk gigs featured raucous music and gobs of bodily discharge, too. Such bodily contact and immersion in the collective are also prime carnivalesque features. Many punk events, or the music associated with them, were often censored and repressed (such as stores not stocking copies, or bands being banned from radio). Such repression may compare to the state trying to censure carnival and preventing free denizens from exercising "abnormal behavior." Hence, punk is carnival, in which the gyrating pogo-ers embody "the earthly and unruly social-body of the people; an avatar of the grotesque body" (Jones 2002).

Gig goers wore dog collars, wild hair, make-up of all sorts and patterns, and clothes that were mismatched, subverted, or served up as mixed-up arrangements (bondage pants and porkpie hats, etc). Thus, they may represent a hands-on oppositional body, replete with chains, safety pins, and torn-up style that revels in a sense of "filth, unrestrained pleasure, and ugliness," which separates them from classic notions of the discreet, well-mannered, and harmonious body (Jones 2002). Instead, the body, or the image of the body, is distressed. Fans appeared inverted or "inside out": they wore bras on the outside of clothes, or exposed scars and mutilations. All this seemed to reject the typical body of a consumer, one tightly secured by authority and control. The masks of the carnival also symbolize "change and reincarnation" to Bakhtin, for they reveal an otherness or "alterity" that punk mimics with heavy stylized

makeup. Punks renegotiated standards of beauty, flirted with androgyny, and recoded the body as a site of resistance, according to Jones. An eyewitness at the time, Mary Hannon, described the "crazy teenage thing" in London: "there were hundreds of little kids, like nightmares, you know, like little ghouls. . . . It was nightmarish. I was scared" (McNeil and McCain 2006: 303, 306).

All of these tendencies may mimic carnivals, but carnivals also offered, as Jones notes, reaffirmation and renewal, since they were celebratory. Thus, it partners uneasily with punk's "Destroy" mentality, its angst and ennui, cynicism and despair. Yet, Jones fails to note that such images of punk were normalized within the traditions of mainstream media, or even by the fanzine media. For instance, fanzine writers desired to authenticate themselves, so their texts negotiated their status. They project a sense of being bilious and bile but might actually live according to a different set of values. Peace punk bands and skinhead bands (who still claimed a sense of being punk) rarely mimicked traditional punk style or trends. The sense of tattered bricolage is absent in skinhead gear, and Crass peace punks were known to wear all black thrift store clothes with little bright adornment. Each subculture re-arranged the style of punk.

Some people identify first-generation punk with Day-Glo, for such hyper-color "holds nothing back for later—like punk, its mode is the mode of anti-interiority, denial of romantic self, a cheap trick, a cheap trip without innerness, an upfront, slap in the face of public taste. . . . Day-Glo can take us back into the first moments of Punk's immediacy, its shock and exhilaration— the heretical idea of living historically instead of at the behest of the needs of capital accumulation. No past, no future, no capital, no mortgage payments" (Leslie and Watson). Although early American punk bands did not readily use Day-Glo in their aesthetics, Arturo Vega, the visual artist for the Ramones, owned a loft that he filled with Day-Glo swastika paintings in the mid-1970s

while Johnny Blitz, drummer for the Dead Boys, wore a Conan shirt in "big orange Day-Glow colors" (McNeil and McCain 2006: 393).

As Daniel Wojcik explored, punk art often embodies images of the transgressive, taboo, and grisly; hence, flyers often poach and appropriate midnight, horror, schlock, and B-movies—the flickering black and white celluloid terrain of pop culture. The classic monsters of the 1930s—Frankenstein, Wolfman, and Dracula— appealed to bands like the Cramps (whose song titles included "Zombie Dance," "Human Fly," and "I Was a Teenage Werewolf"), the Misfits, Mummies, and countless garage rockers, while sexploitation shock cinema and low budget drive-in slasher flicks shaped the visuals of SCUM rock, from Richard Kern's transgressive punk cinema to the raunch of Pussy Galore, White Zombie, and others. In the 1980s, bands like MAD (Mutually Assured Destruction, soon to be the band Blast) and MDC held forth, and Sane/Freeze was a major focus of activists. Punks worried about the end of the world, in part because students still practiced bombs drills in elementary school. Punks-to-be hunched down in hallways, next to brick halls, hugging their knees on cold linoleum, whereas in 2000 young punks worried about the end of the millennium, a technological meltdown that never materialized as prophesized. Regardless, a steady diet of monsters has been at the core of punk flyers, represented by illustrations that recall *Tales From the Crypt*, Rat Fink, and homegrown terror doodles from anonymous teenagers working in damp basements. Golub has asserted the primacy of monsters in his own work, including mercenaries and torturers: "I am simply a reporter. I report on these monsters because these monsters actually exist. This is not make-believe; this is not fantasy; this is not symbolism. It is but it isn't. These situations which call these forces into existence actually exist. . . . My job is to be this machine that turns out these monsters at this particular point and make them as tangible as possible" (qtd. in Gumpert and Rifkin 1984: 73).

I suggest that the monsters, whether metaphorical, or "real" in the case of Golub and the Cambodians killed by Pol Pot found in Dead Kennedys posters, reveal the stresses and anxieties of a world rife with ongoing calamity. The art is a microscope and a mirror, both a way to reveal pain and suffering and a medium to examine, explore, and enlarge it. Whether such art is inherently political is debatable; for instance, Golub asserts: "Disaffection explodes as a caricature, ugliness or insult and defamation. . . . Such anger today can only be made up of pieces of such art, guises of art, gestures using art, habits, caricature, calumny, etc. This is not political art but rather a popular expression of popular revulsion" (qtd. in Gumpert and Rifkin 1984: 71). Hence, viewers of the art of bands like Crass, Crucifix, and Discharge, with all their brooding, severe, arresting images of constant carnage, may feel repulsed. The bands' political ideologies may not quite be discernable, but one thing is likely certain: power is deadly, especially in the hands of the industrial-military complex, as Golub infers as well.[11]

Hence, punk flyers can act like a newspaper by another means—aggressive one-sheets—and as I have stated earlier, they become a strident media outlet. The images, often stark and striking, retain a sense of page as totality—a means of encapsulating an event. In horror flyers, especially with regard to flyers dealing with actual events playing out in the battered world, the page might be construed as a re-enactment of the events. They unfold on the everyday telephone pole, bus stop window, or record store board. Both confrontational and chaotic, these images remind people that they live in a world that births monsters.

Such flyer art captures blood-gurgling roars, or penetrated, invaded bodies oozing putrid puss—the taxonomy of death and disease in an era of perpetual civil war, global conflict, and AIDS. In these flyers, teenagers grope with realities of "Dead Cities" (the title of an Exploited song). Mike Hudson of the Pagans, the band that penned songs like "Street Where Nobody Lived" and "What's This Shit Called Love," wrote in his biography *Diary of a Punk*, "we lived like we were already dead, rushing toward death, and the odds are you won't see tomorrow" (2008: 67). The undead skateboarders that roam punk posters revel in rock 'n' roll and slam dancing. The abominations and mutations are a call-to-arms, an invitation to retake the landscape of consumer malls and mini-marts.

These depictions signify the margins of our imagination, a lore and trope of bodies driven to a ghastly, in extremis state of being. The plasticity of such dead/undead bodies melts the barriers between genders and species, the possible and impossible, the speakable and unspeakable. They have risen from mold-encrusted, shabby graveyards or the killing fields of napalm, riddled with nail-bombs and landmines, eaten alive by swarms and disease, born misshapen and contorted, driven to die by scientists, F-16s, and shotgun posses. These creatures are the damned, the expelled, the mothballed and moth-eaten, the strange, the evil, and the aberrant.

As such, they disrupt our notions of being colonized infants in the womb of capitalism, passive and helpless, for they show us how to be aggressive and possessive, to carve out a specter of territory and freedom in the back of our minds even when we feel dead and void. The underworld and subterranean depths become ground zero for revolt and cantankerous action; they exist as mirror-worlds for our dark fantasies of how to survive even as our bodies decay and shed their unneeded skin. They are victims and protectors, or simply zombies and gore hounds, cretins and rat boys—a gory intrusion into the world of milquetoast pop music of the 1970s and 1980s. The creatures are travesties, reviled and repugnant, repulsive and rank, aborted and vulgar, a disfigured look at being a punk misfit, an outsider, a heretic, and an iconoclast. They show how pop culture, or parent culture, or hegemonic culture, has attempted to break, disfigure, and mutilate the passions of the people of the punk community.

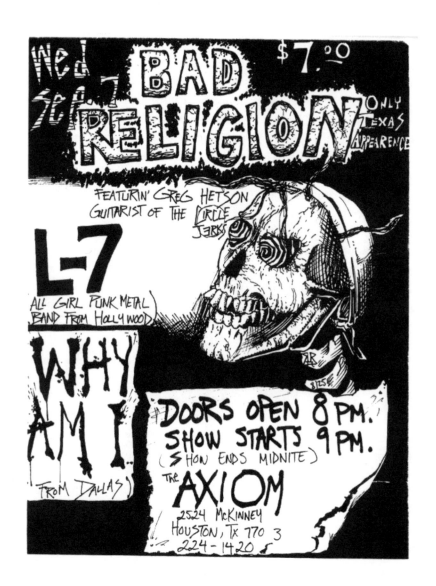

L-7, Bad Religion, and others at the Axiom, Houston, 1990s.

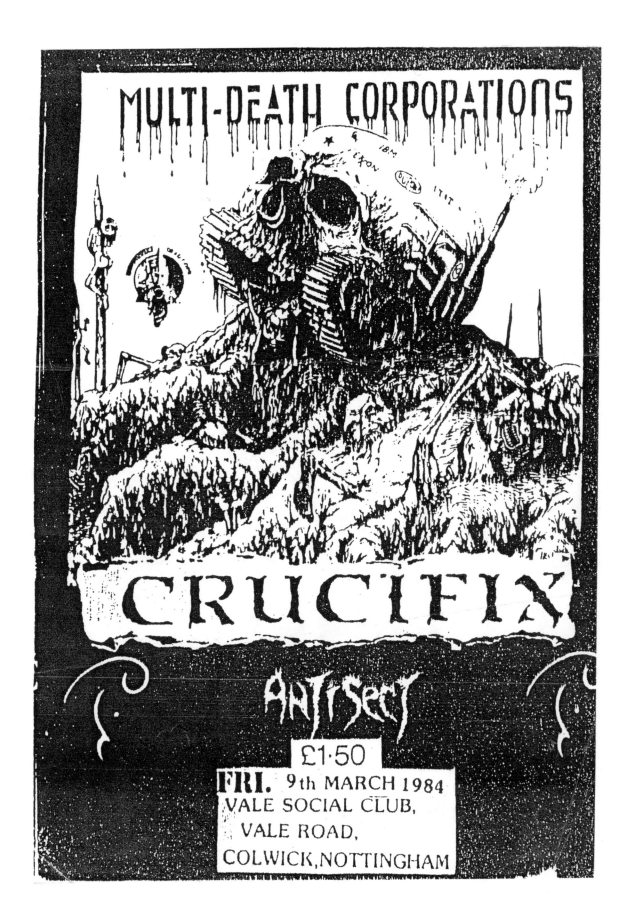

MDC and Crucifix at Vale Social Club in Nottingham, England, 1984. Classic skull tank motif.

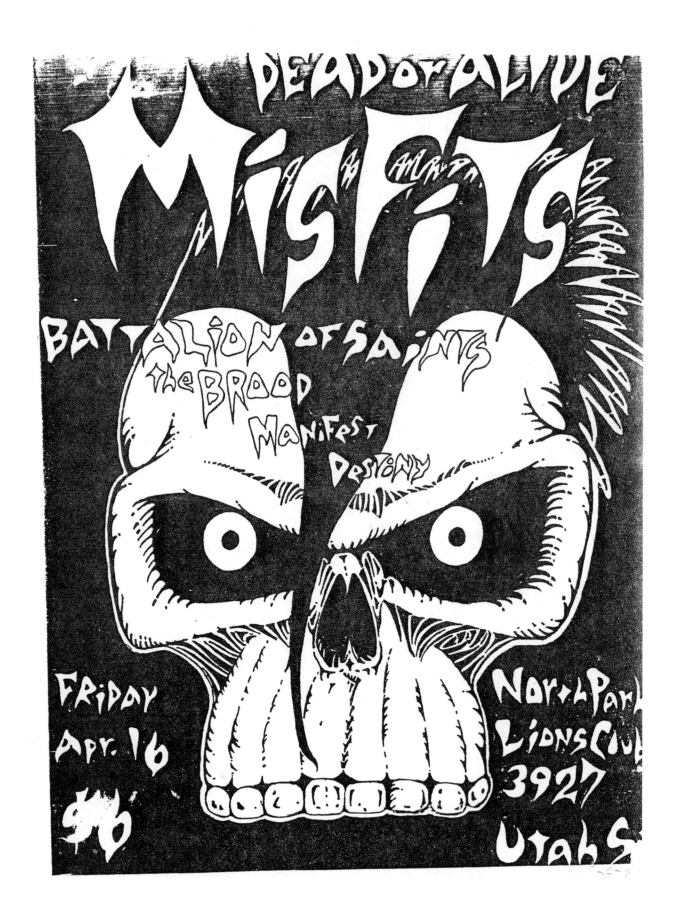

Misfits and others at North Park Lions Club, San Diego, 1982.

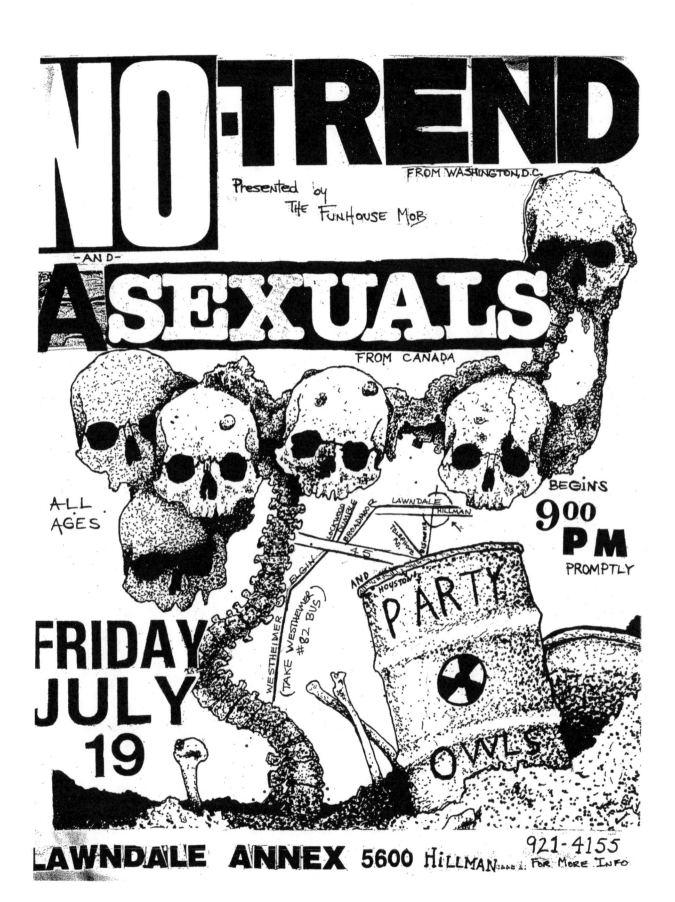

No Trend and Asexuals at Lawndale Annex, Houston, 1980s.

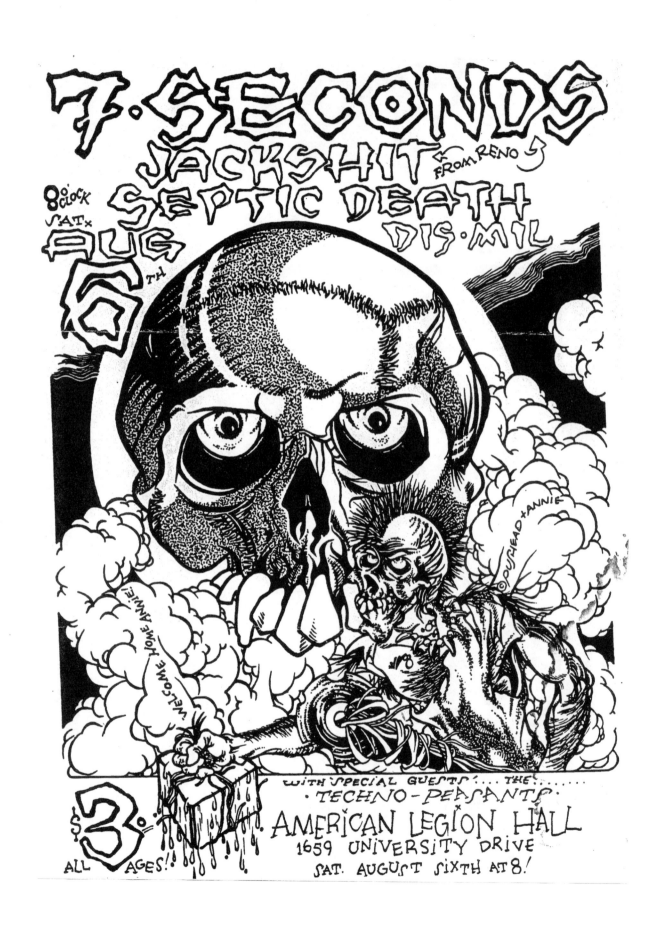

7 Seconds, Septic Death, and more at American Legion Hall, Boise, Idaho, by
Pushead and Annie, 1980s.

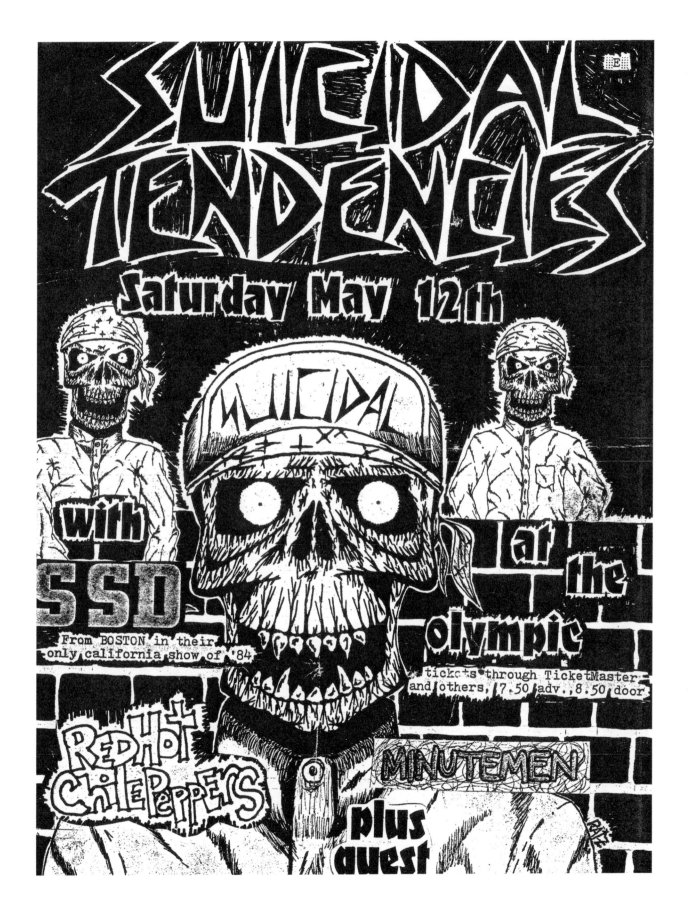

Suicidal Tendencies, Minutemen, and SSD at the Olympic Auditorium, Los
Angeles, 1984, by Ratz.

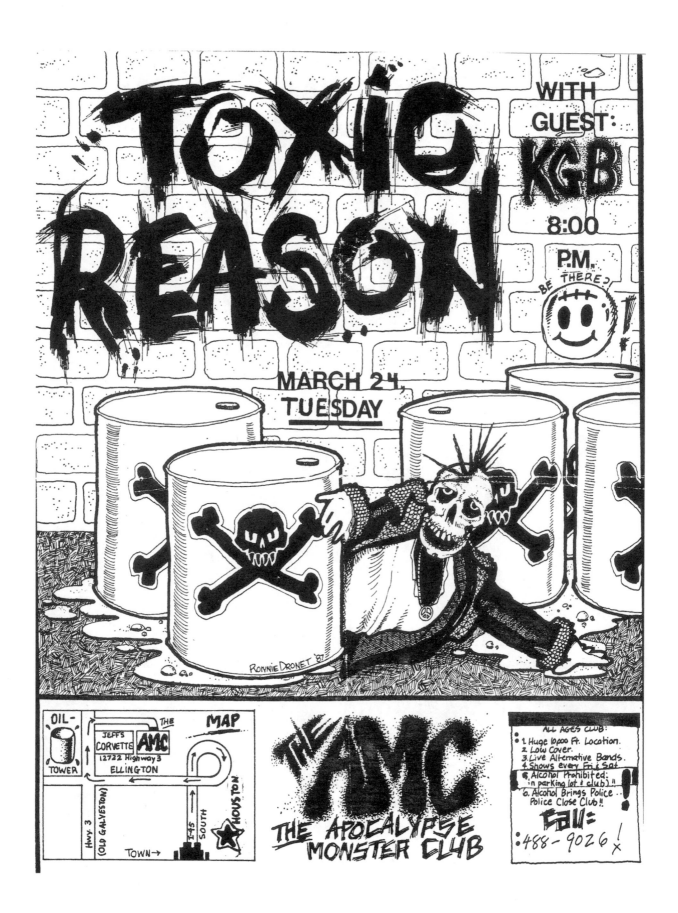

Toxic Reasons and KGB at the Apocalypse Monster Club, Houston, 1987, by Ronnie Dronet.

JUNE UK SUBS

BROKEN BONES · DRESDEN

the **AXIOM** forty · five

224·1420

2425 McKinney

HOGIE

UK Subs and Dresden 45 at the Axiom, Houston, 1980s, by Hogie.

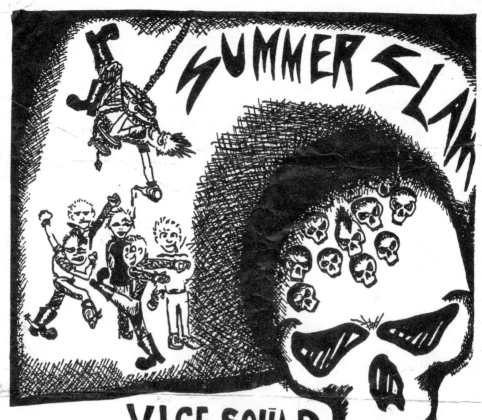

SUMMER SLAM

SUN
AUG 15th

5 PM

INFO
749-5171

9 $

VICE SQUAD
CHRON GEN
WASTED YOUTH
BATALLION OF SAINTS
CH3
CIRCLE-ONE
SHATTERED FAITH
AGRESSION
LOST CAUSE

1801 SO. GRAND, L.A
OLYMPIC AUDTIORIUM

Summer Slam at the Olympic Auditorium, Los Angeles, 1982.

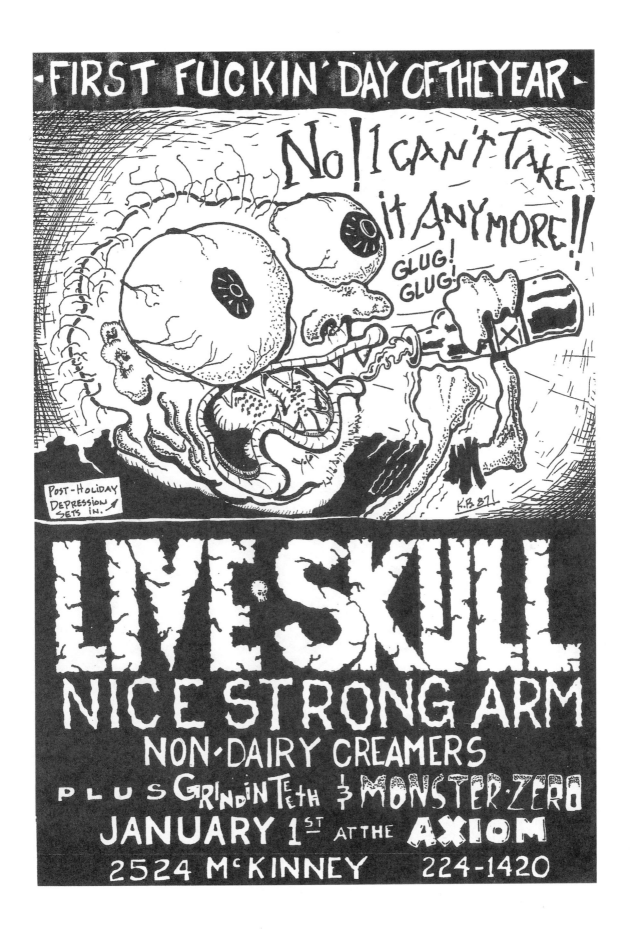

Live Skull, Nice Strong Arm, and others at the Axiom, Houston, Texas,
by Kevin Bakos, 1987.

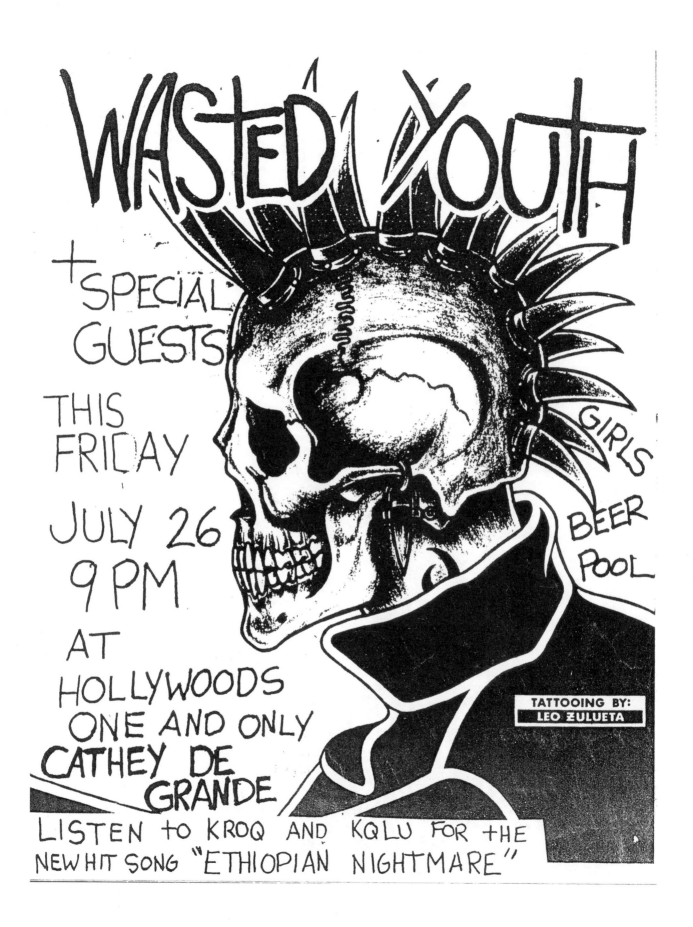

WASTED YOUTH

+ SPECIÄL GUESTS

THIS FRIDAY

JULY 26 9 PM

AT HOLLYWOODS ONE AND ONLY CATHEY DE GRANDE

GIRLS

BEER POOL

TATTOOING BY: LEO ZULUETA

LISTEN to KROQ AND KQLU FOR the NEW HIT SONG "ETHIOPIAN NIGHTMARE"

Wasted Youth and more at Cathay De Grande, Hollywood, California, 1980s.

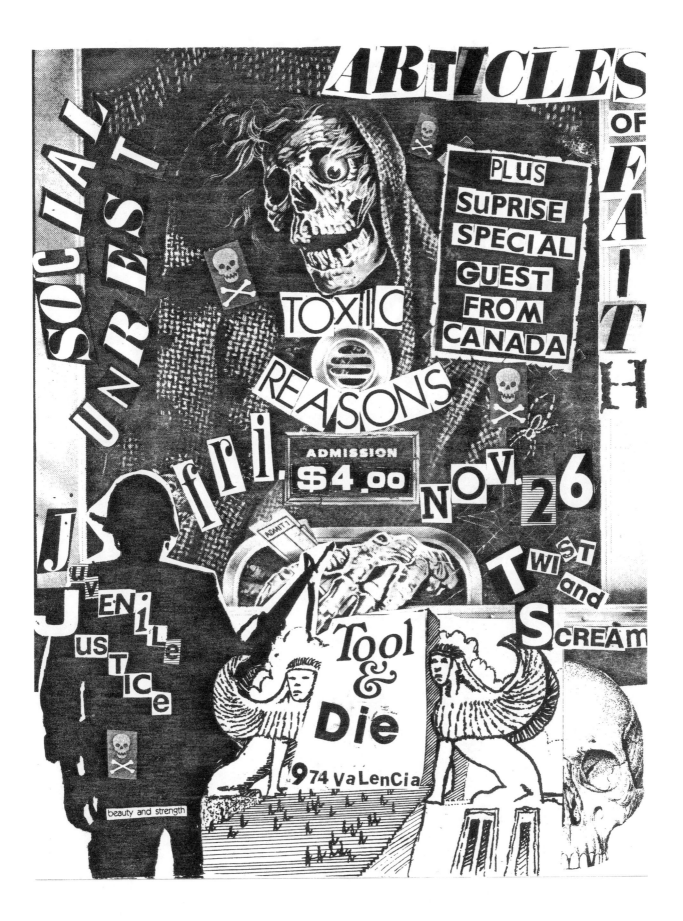

Articles of Faith, Toxic Reasons, and more at Tool and Die, San Francisco, 1980s.

CHAPTER SIX

REDEFINING THE BODY ELECTRIC
Queer Punk and Hardcore

As long as hardcore remains homogenous and dominated by straight, white boys, everyone involved is missing out to some degree.

—MIKE MCKEE, *Heart Attack #31*

There was never any anti-gay feeling to me.

—JIM KAA, guitarist, the Crowd

At first there was a lot of gay people, who . . . were frustrated like a lot of other people.

—DANNY FURIOUS,
the Avengers, *Maximumrocknroll*, Oct. 1991

Queer punks supplied the genre with much of its fierceness and wit, raunch and tenacity, candidness and camp, personality and experimentation. Many would argue that gay participants like Gary Floyd, Bob Mould, Wayne/Jayne County, the Screamers, and Biscuit of the Big Boys readily shaped these sensibilities. Yet, this did not blossom without trials and tribulations, mostly stirred from within the culture itself, which led to outgrowths such as homocore.[1] This chapter will outline a history of gay and punk convergence and tensions, reveal hardcore punk gay allies who contest homophobia, and explore how contemporary gay men "queer" hardcore music by poaching the style and content of the genre, even the gig spaces.

Kira from Black Flag once pointed out to me, "I don't think anyone gave a shit about anyone's gayness. And it was no more shaped by that [punk rock] than by many other things" (2005). This may be true among the Black Flag circle. Brian Grillo, eventual singer for the homocore band Extra Fancy (and a local from Hermosa, too), once was homeless and moved in with fifteen to twenty kids, some gay, at the Church, the infamous Black Flag space. "They didn't care that I was gay," he remembers, describing moments when bands like Redd Kross and the Disposals stopped by (qtd. in Ciminelli and Knox 2005: 22). Later, he briefly dated Tomata Du Plenty from punk pioneers the Screamers, signaling a cross-generational affair across the queer punk spectrum.

British proto-punk Tom Robinson became an active gay ally, while Dead Fingers Talk were openly gay, releasing the tune "Nobody Loves You When You're Old And Gay" in 1978. Transsexual Wayne County (later know as Jayne County), whose band Wayne County and the Electric Chairs started in clubs like New York City's CBGB and Max's

> ... I'll assume that's why most of us came to punk rock—to have that space where we can be comfortable being queer, freakish—to support others who feel alienated from the "mainstream."
>
> —INSIDE FRONT #13

Kansas City, found a large audience in Britain too, with a cameo appearance in queer director Derek Jarman's seminal punk film *Jubilee*, which featured sexually ambiguous Adam Ant in a lead role. A small role featured Gene October from the early punk band Chelsea, who was rumored to have been an actor in gay underground sex films. As early as 1978, writers characterized October as "former full frontal flesh fodder for homosexual skin rags and . . . gay bar habitué" (Burchill and Parsons 34). According to Andy Czezowski, an accountant for proto-punk clothing store Acme Attractions and manager for Chelsea, Generation X, and the Damned:

> Gene was a rent boy and knew this club on Neal Street which was known as Shageramas then, but

became the Roxy soon after. It was owned by two queens, it being an early gay club, one of these was a barrister type just trying to make a quick buck. When he was in Chelsea, Gene had booked them to play at Shageramas and had mentioned this to me. The owners at the time were skint and the club was on its last legs so anything that could possibly bring in money was of interest to them. (qtd. in Stevens 2003)

For one hundred nights, the rechristened club quickly came to be booked by Czezowski and evolved into ground zero for London punk, featuring the Buzzcocks, the Jam, the Clash, the Heartbreakers, Wayne County, Cherry Vanilla, Crass, and endless others. Punk's "salad days" are indebted to a gay rocker and former gay club.

Gays shaped both the looks typifying punk and the history of punk music. As Marcus Gray reminds us, the Ramones, managed by openly gay Danny Fields, likely adopted the rent boy style "Dee Dee saw up on 53rd and 3rd, with the holes in the knees a code signalling how much time the lads in question were willing to spend down on 'em earning their pay" (2007). Meanwhile, the Radiators from Space (from Ireland), the Screamers, Nervous Gender, Noh Mercy, the Nuns, and the Offs, just to name a few, had gay members. As Crime singer Frankie Fix once recalled in *Maximumrocknroll*, the band's first show in 1976 was at the Waldorf during a Halloween-style drag show, and their first manager was a gay nail salon owner who booked their second show at the gay bar Stud. They were quickly banned, though, when the Jewish owner took offense at the band's posters gig featuring Adolf Hitler (LaVella 1989). Additionally, Greg Langston of No Alternative drummed for the Maggot Men—the musicians backing the performance art/drag queen/punk band the Wasp Women, featured in the movie *Whatever Happened to Susan Jane?* Meanwhile in Canada, Club Davids, a "back-alley-gay-bar" hosted the debut show by the B Girls.

Andy Czekowski, mentioned earlier, has insisted that in the "early days of punk there was this very liberal attitude to everything . . . a crossover between the gays . . . who'd come down when the Roxy was Chagarama . . . [also spelled as Chaguaramas]" (Heylin 2002). Such memories suggest that early punk venues were liminal—a place where normalized tendencies (segregation, suppression, and so on) might have disappeared, or been shunned, in favor of libertine impulses. This sense of a negotiated, temporary, unbound cultural space was recently reaffirmed to me by Tony Barber, the bassist for the Buzzcocks since the early 1990s and former guitarist for the post-punk band Lack of Knowledge:

> Somewhere someone is probably already writing a article denouncing punk as being a kind of sicko white working class movement. . . . That's the complete opposite of the reality, because what is now considered to be punk—someone in their leather jacket with studs all over their back—isn't what punk rock was when I was going to gigs in 1977. Just look at the back of the *Live at the Roxy* album: there's three Rastafarians, two working behind the bar, one DJing, and there's black people in the audience. The girls probably outnumber the blokes, and the men are wearing make-up and half of them are gay. This idea that it was some white working class moron movement is absolutely fucking codswallop . . . It's got nothing to do with punk being a white working class thing, which people felt excluded from. . . . I am saying that punk rock in England was probably in a gay club with middle class people. (2008)

A black drag queen in a gold lamé dress graces one of the photographs from the *Live at the Roxy* LP. Meanwhile, black punk and Roxy co-partner Barry Jones made most of the Roxy's colorful collage flyers for acts like Wayne County, Siouxsie and the Banshees, and Cherry Vanilla while hosting gigs by preeminent American punks (with

an R&B edge) the Heartbreakers, whom Jones would later join in the 1980s. On the *Punk77* website, Zecca Esquibel, gay keyboardist for Cherry Vanilla, also echoes Barber's depiction: ". . . at the Roxy I encountered the most fraternal cooperative, friendly, interacting between gays and straights that I have ever seen before or since. There were so many gay people at the Roxy who were just as openly gay as straight people are openly straight and nobody gave a damn. The whole point was to be who you are, what you are and nobody gave a damn" (2006). All these testimonies indicate that the zero hour of punk, especially witnessed through the looking glass of spaces like the Roxy, was a fertile and crosscultural epoch.

During the same time period, Seditionary clothes sold at Malcolm McLaren (manager for the Sex Pistols) and Vivienne Smith's shop Sex had a label attached that said, "for soldiers, criminals, . . . and dykes," while the Sex Pistols and Billy Idol used to hang out at Louise's, a lesbian bar, where the DJ would play "God Save the Queen" as the androgynous women, "fag hags," and gays would supposedly camp it up, mock working-class style, with beer all over the floor. Johnny Rotten, singer for the Sex Pistols, has even posited that early British punks ". . . gravitated toward the gay discos because they were much more tolerant of young people like us being different; they left us alone. Everything sprang from that gay scene" (Lydon and Zimmerman 1994: 173). In the introduction to the biography *Berlin Bromley*, written by a Louise patron (and member of the Bromley Contingent) Bertie Marshall, Boy George summarized the venue as a "seedy after-hours nightclub that attracted many of London's premier" freaks, punks, stars, and Bowie freaks that saw "the movie *Cabaret* with its blatant, and yet matter-of-fact, bisexuality" and wondered what life was like in prewar Germany (2006: 9). Like the Roxy, the bar offered a space where the constraints of mainstream or bourgeois culture were temporarily suspended.

During this fecund era of convergence between punk and queer cultures, photographer Peter Christopherson, a member of the abrasive, experimental noise band Throbbing Gristle snapped promo shots of the Sex Pistols resembling gay hustlers in a YMCA toilet, shocking even Malcolm McLaren. The Rock Against Racism Carnival ("Carnival Against the Nazis!!") in April 1978 featuring the Clash and Tom Robinson illustrates how marginalized punk and queer subcultures functioned as allies:

> After gathering in Trafalgar Square, the RAR carnival wound its way through the streets of London towards the East End. With 100,000 participants, it was the biggest anti-fascist rally in Britain since the 1930s. Labor-union activists, anti-racist stilt-walkers, aging stalwarts of the Campaign for Nuclear Disarmament, dreadlocked rastas, young punks in pink boiler suits, feminists, *militant queers*, and every other possible permutation of Britain's Left united in a celebration of solidarity that decisively rejected the dour thuggery of the NF's bully boys. (Dawson 2005)

One can chart a historic framework by analyzing the symbolic phrases found on the event's flyer, which exhort: "We want rebel music, street music. Music that breaks down people's fear of one another. Crisis music. Now music. Music that knows who the real enemy is." In this case, the real common enemy is hatred, racism, bigotry, homophobia, and narrow-mindedness.

Jon Savage, who penned the much-lauded *England's Dreaming*, a history of the punk era, asserted that the 1970s "were not a great time to be gay" (qtd. in Nyong'o 107–8). Yet this is the precise time period that Tom Robinson sang "Glad to Be Gay" and was even supposedly quietly applauded in person for these efforts by Johnny Rotten. John Robb, who played with the Members in the 1980s and Goldblade during the last two decades (and has written for magazines

since the 1980s), recently compiled *Punk Rock: An Oral History*. He suggested to me that punk did not necessarily absorb or even openly tolerate gay culture, since audiences were often teenagers, sexually awkward, and negotiating values inherited from their parents. But punk did provide a cultural space and opportunity for them to probe and even fissure their link to parent culture by fostering a candid discourse among youth:

> Yes, there were a lot of kids who were uncomfortable about people being gay, but this was the 1970s, and people were every young. I'm not making excuses here, but you have got to realize just how young and dumb a lot of people were at the time, and I think that all youth culture at the time would not have been that hip to homosexuality. At the same time, punk was one of the first youth cultures that raised the debate about homosexuality. I remember fanzines and friends debating the issue, which for the age of everybody was quite remarkable, and nearly everyone I knew was not racist or moaning on about ideology. There were an isolated few who had dodgy views, but punk was remarkably liberal considering how chaotic everything was at the time. (2007)

However, that liberalism did not necessarily hide or mask punk ambivalence toward queer culture.

Mother's, a gay bar on 23rd Street in NYC, hosted concerts by the Heartbreakers and Blondie. *Final Solution* fanzine #8 reported that the nascent punk scene in early 1980s Houston was relegated to places like the Parade, a gay disco, but "such is the order of a day when the only live punk shows take place on Monday night," moaned one fanzine writer. Crime were called a "bad-ass neo-Nazi killer punk band . . . posing as fag punk rockers," by writers in a 1977 issue of *Punk*. Writer Jim T. from *Jersey Beat* once stated, in a review of the book *Punk '77*, that "In New York, it seemed like everybody who liked punk in 1977 was either Jewish or Gay." This seems to echo the sentiments

of Fear, who belt out the line "New York's OK if you're a homosexual" in their song "New York's Alright If You Like Saxophones" and contrast author Brendan Mullen's statement that early New York punk "was basically all about derelict heterosexuals who shoot up heroin and fall about the set" (qtd. in Ruland 2002).

In the film *Decline of Western Civilization*, opera-trained singer and actor Lee Ving and other band members taunt the bristled, raucous audience with oral sex jokes ("Don't bite so hard when I come," "You only spit as good as you suck") and hostile questions ("How many queers are here tonight, how many homosexuals?"). "I can see there's a bunch of fags out there . . . ," he utters to the gig goers on the verge of a melee, forever entrenching and normalizing this kind of discourse in the mythos of punk. Years later, Ving's discourse essentially remained the same, though the target is not beach kids plastering Fear with phlegm but new wave bands from the punk era. Ving refers to them as "lots of art fags" in the zine *Rebel Sound* (Fear 1993). During the same year, he told an interviewer for *Raygun* magazine that, "I still get a kick out of picking on gays verbally. . . . I'm not at all homophobic, but they've got no sense of humor, and that eggs me on. If they weren't so uptight, I'd stop" (Angel 1993). Ving suggests that gays invite such invective; meanwhile, his rationalization seems to mimic hegemonic culture's own bias against homosexuals. Furthermore, some culture critics might argue that offended crowd members were exposing their own "conservative nerves" as well.

Even when bands had good intentions, such as Operation Ivy playing an AIDS benefit in Berkeley, they slipped into banter deemed hostile to gays. As bass player Mike tells it, "Jesse [singer] never uses microphone stands. So he grabbed the stand and said, 'I don't use microphone stands, microphone stands are for fags.'" Somewhat like Ving, Jesse argued to *Flipside* that the bottom line was a misunderstanding about the role of humor: "I guess

to a lot of homosexuals, using the word 'faggot' humorously is like using the word 'nigger' humorously" (qtd. in Joy 1988). Members of the audience did not share the humor or see past the slur.

Creem magazine reported Sid Vicious, bass player for the Sex Pistols, ridiculing the Dead Boys during the Pistols' incendiary tour stop in Tulsa, where he foamed, "They're fucking poseurs. . . . Fucking wanking faggots is what they are, just cheap imitators living off our reputation" (qtd. in Goldskin 1978). When the Sex Pistols hit the stage in San Antonio on the birthday of Elvis Presley in 1978, Johnny Rotten was equally venomous. He taunted the crowd, as patron Bill Bentley recalls, with "All you cowboys are faggots" (Moser 2003: 49). The irony, of course, is that the show did occur at Randy's Rodeo, but the audience, according to writer Margaret Moser, a local writer also in attendance, was "mostly longhaired San Antonio heavy metal fans, and Latinos" (49). Bentley stresses, "If Rotten would have said, 'All you Mexicans are faggots,' I have no doubt he would have been killed" (49). In this light, Rotten's remarks, which can be heard echoed by other members of the band as well on the bootleg of the Dallas show known as *Welcome to the Rodeo*, might have been a script devised for their Texas jaunt, some argue. The vitriol is in tandem with historical punk attitudes, at least in terms of performance rituals, but also might reveal deeper ambivalences as well.

Johnny Thunders, guitarist for the gender-blurring punk icons the New York Dolls, exhibited a "phobia against homosexuals," according to guitarist Sylvain Sylvain (Goddard 78). Handsome Dick Manitoba, of the Dictators, one of the first punk bands (along with the Ramones) in New York to release a record, was rumored to have a "nasty, gay-bashing mentality," according to Blondie member Gary Valentine (Nobakht 2005: 129). Manitoba did suffer an injury when clashing with Wayne County. She hit him with a mic stand one night after Manitoba's heckling infuriated County, whose songs included "Fucked by the Devil," "Rock 'n' Roll Enema," and "If You Don't Want to Fuck Me, Fuck Off." One tense undercurrent to that period for County included her band being basically "stereotyped as nothing but a drag act. Plus I was tired of doing it. It just got to the point where I'd come to the show and say, 'Oh god, there's a wig, I gotta put that thing on here. . . . I had to keep my legs shaved all the time and all this shit ALL THE TIME. 3–4 hours in the dressing room. . . . For awhile it was making me a nervous wreck" (Drayton 1977). That pressure may not have directly led to the confrontation between the two punk icons, but it does serve to remind readers how queer punk performance was not inherently spontaneous and off-the-cuff; instead, it was fraught with preparation rituals, reluctance at times, and varying levels of anxiety.

Even as late as the 1990s, when Motorhead scribed the song "R.A.M.O.N.E.S.," Lemmy felt compelled to note that drummer Marky "takes it up the ass," and the end of Government Issue's early 1980s song "Lie, Cheat, and Steal" ends with the shout, "Buttfucked." An issue of *Modern World*, a fanzine from 1980, featured a review of Cheap Trick by the gay writer Gary Indiana (a longtime contributor to *Flipside*, the *Village Voice*, and other alternative periodicals) while also featuring a review of the Ramones live show that exclaimed that Dee Dee and Johnny were "singing in faggy falsetto" while sticking one finger in their ear and waving the other one at the audience. In an interview with Agnostic Front in *Guillotine* #8 from 1984, singer Roger sums up part of his core philosophy as, " Chaotic anarchy is what punk is all about, not about being a fairy and joining the yippies, telling you what you can't eat" (Wendy and Golf). Even later non-queer bands poached gay slurs to use as names, such as the Queers, the Fags, Faggz, Homo Picnic, Homos With Attitude, Teenage Queers, Homostupids, Billy Bob Faggots, Queenie and the Gaylords, Bobby Sox and the Teenage Queers, Dad-fag, and the Epitaphed Queers.

151

Yet, for each of these tendencies there is a punk counterbalance, in the forms of letters to zines like *Maximumrocknroll*, or in the editorials of smaller DIY zines like *AOK*, based in Hawaii, that offered up reflections like "Life Through Lime Colored Glasses." Inspired by the mainstream discourse of media like *60 Minutes* while also reacting to the anxiety, fear, and loathing fostered in the era of AIDS, the editors point out that the disease crosses sexual identities, infecting straights and gays; meanwhile, people unfairly alienate homosexuals, men react violently to so-called "feminine" gays due to insecurity, and people must "stop building barriers" and exhibit respect (1985: 5–6). In contrast, the zine *Damp* ran an interview with the editor of *Forced Exposure*, in which the interviewer suggests that *Maximumrocknroll* is partly a bastion of queerness: "One of my housemates calls the emotional boy-girl parts you see in films 'queer pain.' I always get large doses of queer pain whenever I read *Maximumrocknroll*" (Bag 1987).

In terms of queers and queer culture, the discourse of punks is anything but stable or fossilized. For instance, a July 1991 issue of *Maximumrocknroll* features columnist Ben Weasel (of the band Screeching Weasel) decrying left-wing political correctness, which he partly imagines as a controlled world where "white students at colleges will be asked to study gay and lesbian culture and become friends with at least two queers," which is immediately followed by Bullshit Mike's (of the band the Go!) column, which conveys a forceful, impassioned argument for gay marriage, concluding with "I'm fighting for the dreams this society has denied me." A series of tense negotiations and contestations regularly took place in the broad spectrum of punk print and music, reflecting the subculture's flexible, open-ended, and self-critical mores.

On the West Coast, the Masque, one of Los Angeles's most prominent punk venues, featured anti-gay graffiti such as "Fags is Not Cool."

In addition, the Angry Samoans released tracks like "Homo-sexual" and "Get off the Air," which tags L.A.'s infamous radio personality Rodney Bingenheimer as a "pathetic male queer." Even more graphic is the Pushead-rendered ad for the Meatmen's "Blood Sausage" EP on Touch and Go that features a cartoon figure with an anti-TSOL (the band True Sounds of Liberty) shirt shouting "Fucking Queer" as he slices up through the genitals and anus of a naked man in an outstretched pose similar to Christ on the cross.

Perhaps not so ironically, Meatmen singer Tesco Vee declared infamous gay director John Waters, a transgressive midnight/underground film provocateur in the 1970s and 1980s, as (without a doubt), "The most righteously cool homosexual in the world" (1987). Perhaps that reflects a sense of gay exceptionalism or an honest homage from one enfant terrible to another. In darker shades, Iron Cross released the track "Psycho Skin," about a skinhead killing a homosexual and serving prison time. D.I. penned the "lighthearted" song, "Richard Simmons is a Faggot"; additionally, singer Casey Royer once informed *Flipside* that, "I work at the Laguna Nursery and we have a new gang together, we're called the L.B.F.B., the Laguna Beach Fag Bashers. And we like beat fags up, like it's cool" (*Flipside* #47, 1985). One flyer for an Adolescents show at the Jackie Robinson YMCA in 1988 declares, "Be there and nobody will think of you as a dick sucking fag!" The Descendents sang, "You arrogant asshole / you fucking homo" on their tune "I'm Not a Loser." After singer Ron Reyes left Black Flag, the band changed his name to Chavo Pederast on subsequent records, inferring he molested boys, which led him to violently confront the band. Meanwhile, for the first punk gig at Fullerton's Galaxy Roller Rink, "the venue was renamed 'Mr. Buffo's'; 'buffo' being a marine corp [sic] slang term for sodomy" (Mitchell 2003), while the gay club Bonham Exchange, which regularly hosted punk shows in San Antonio in the early 1980s, was rechristened Bonham Sexchange

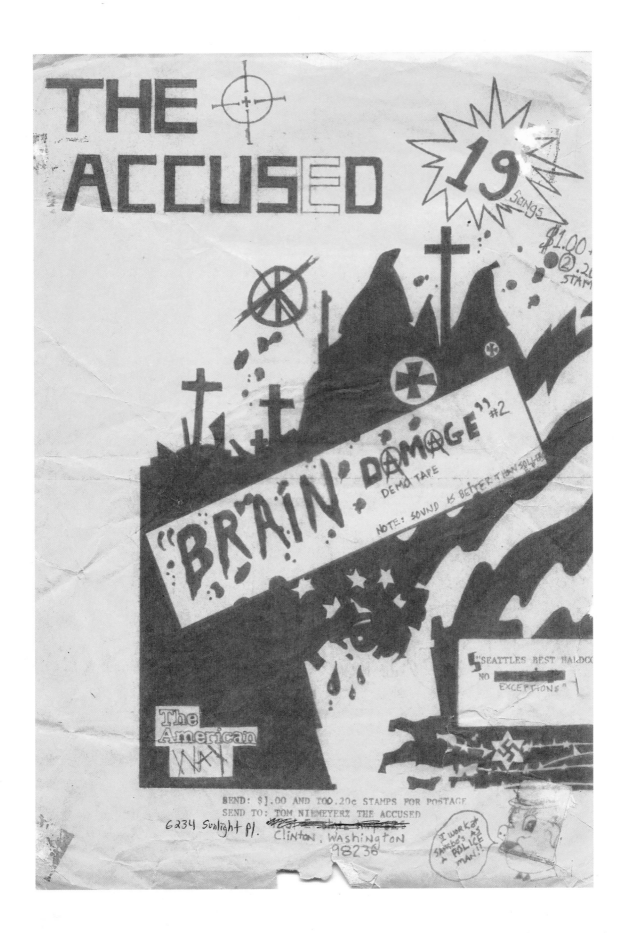

The Accused mail-order flyer for demo tape, early 1980s.

Left of the Dial original issue #7, front cover collage by Randy "Biscuit" Turner, 2004.

Left of the Dial original image #4, front cover collage by Randy "Biscuit" Turner, 2002.

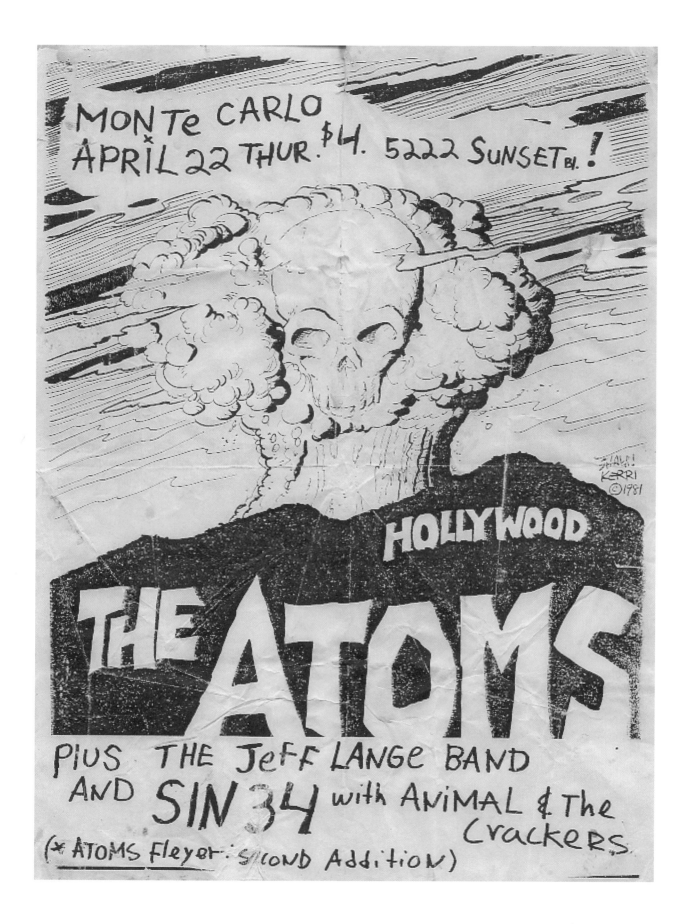

The Atoms, Sin 34, and others at Monte Carlo in Los Angeles, California, by Second Addition, illustration by Shawn Kerri, 1981.

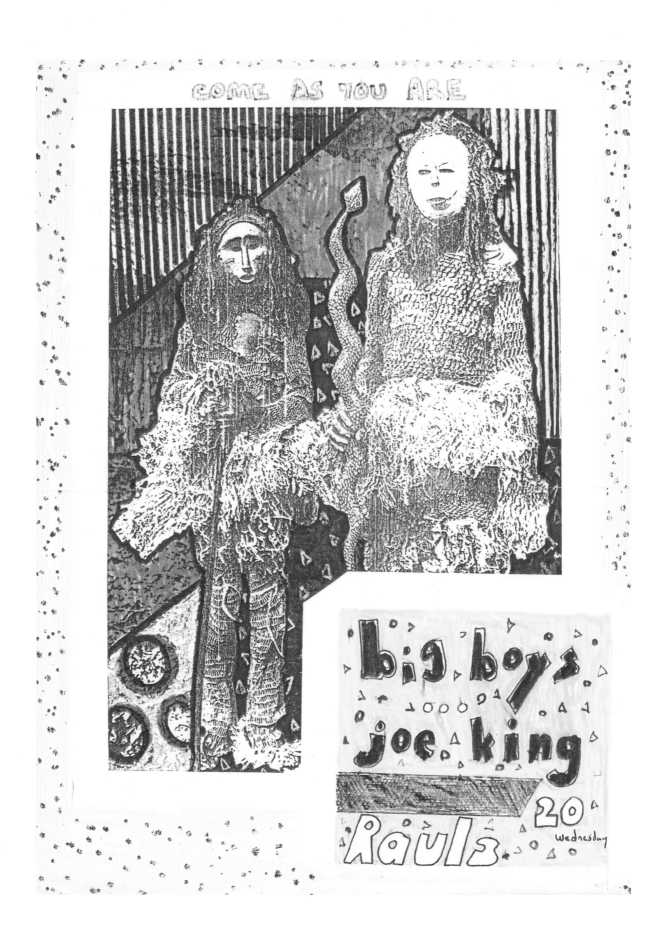

Early color Xerox of Big Boys and Joe King at Raul's in Austin, Texas, by Tim Kerr, late 1970s–80s.

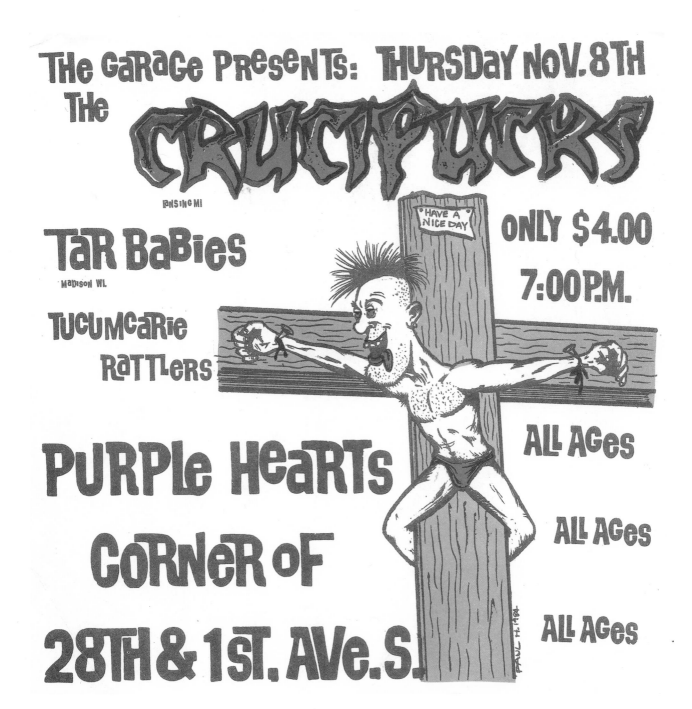

The Garage Presents: Thursday Nov. 8th
The CRUCIFUCKS
Lansing MI

TAR BABIES
Madison WI.

TUCUMCARIE RATTLERS

HAVE A NICE DAY

ONLY $4.00
7:00 P.M.

ALL AGES

ALL AGES

PURPLE HEARTS

CORNER OF

28TH & 1ST. AVE. S.

ALL AGES

PAUL H. 1984

Offset press flyer for Crucifucks show, by Paul H., 1984, Detroit

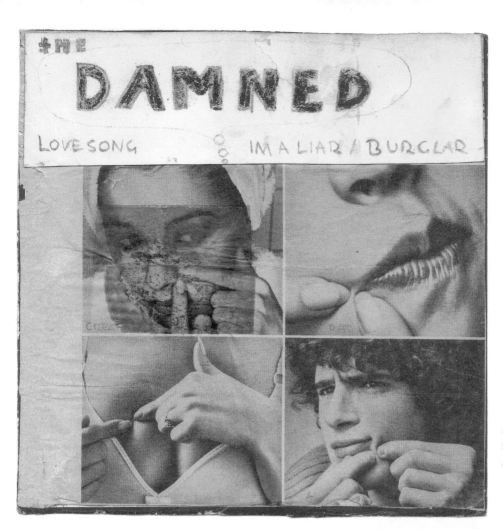

Damned 1. Original mockup for front of the Damned's "Love Song" 7" single, sleeve designed and provided by Captain Sensible. Late 1970s.

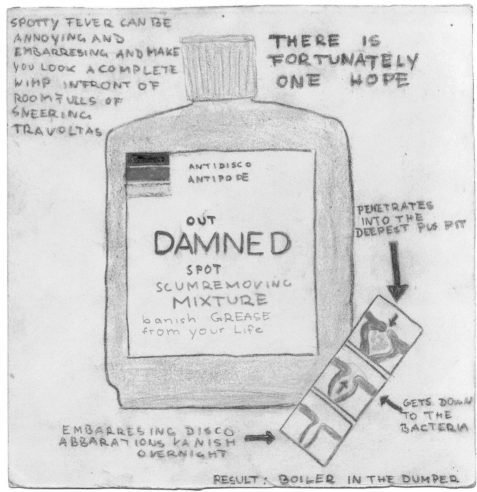

Damned 2. Mockup for back of the Damned's "Love Song" 7" single.

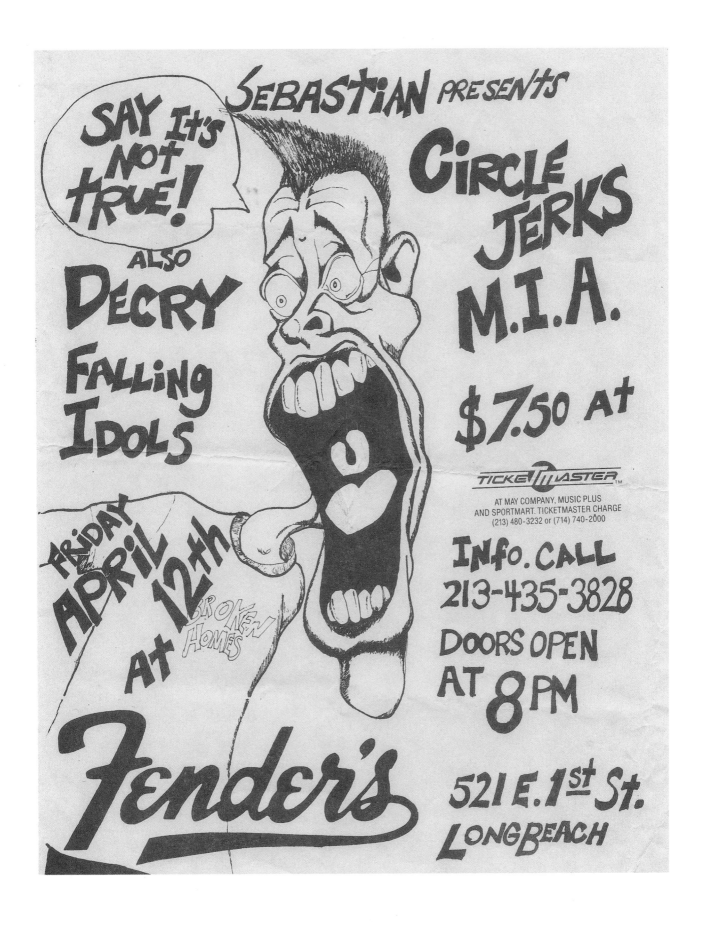

Flyer for Circle Jerks and MIA show at Fender's, Long Beach, California, 1980s.

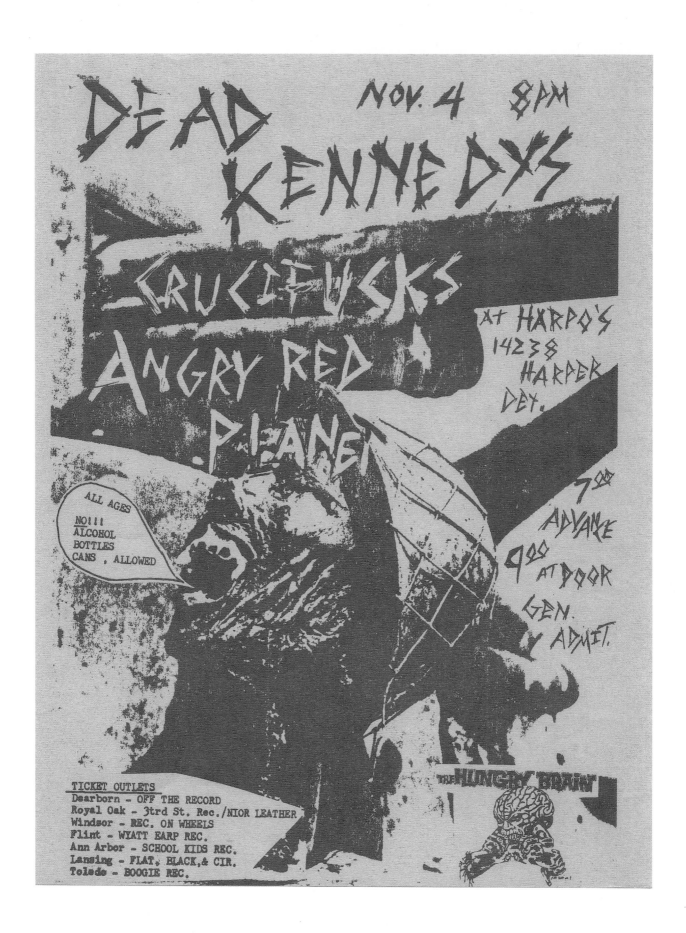

Flyer for Dead Kennedys and Crucifucks show at Harpo's, Detroit, 1980s.

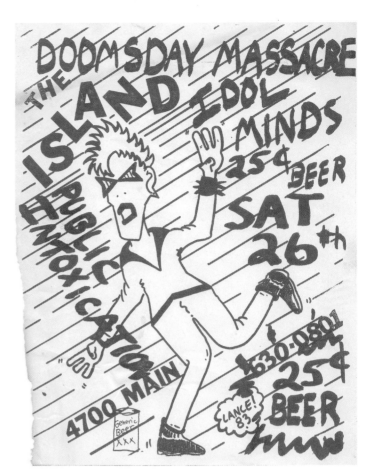

Flyer for Doomsday Massacre and Idol Minds at the Island, Houston, by Lance, 1983.

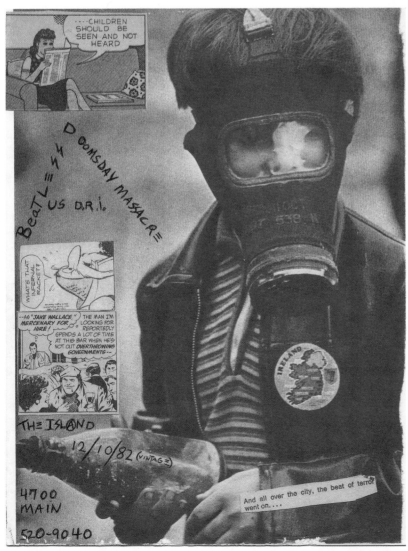

Original flyer mockup for DRI, Beatless, and Doomsday Massacre show at the Island, Houston, 1982, by Torry Mercer.

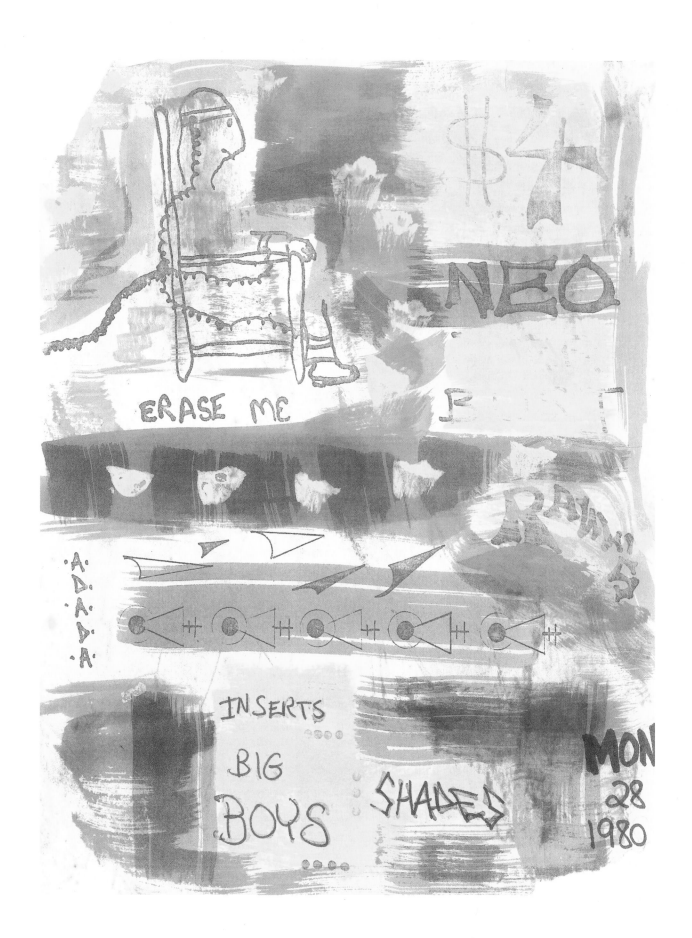

Color Xerox show flyer for Inserts and Big Boys at Raul's, Austin, Texas, 1980, provided by Biscuit of the Big Boys.

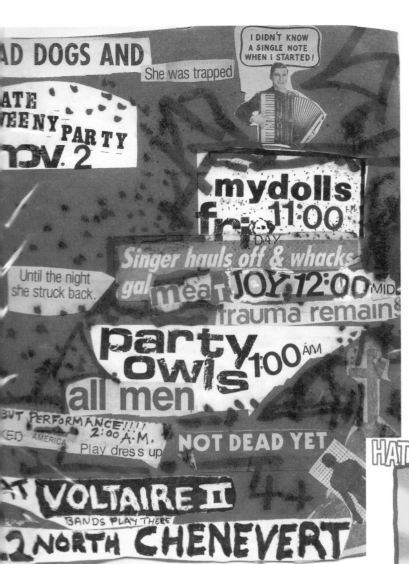

Original flyer mockup for the Mydolls and Party Owls at Cabaret Voltaire, 1980s, Houston, by Trish Herrera.

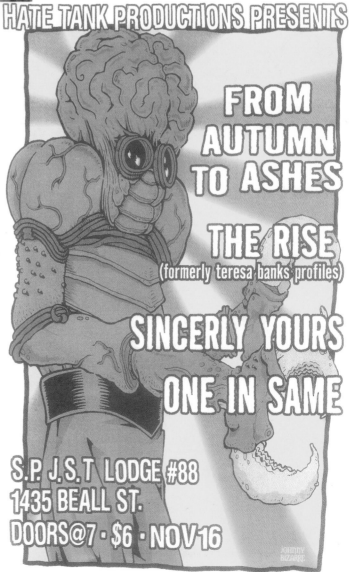

HATE TANK PRODUCTIONS PRESENTS

FROM AUTUMN TO ASHES

THE RISE
(formerly teresa banks profiles)

SINCERLY YOURS

ONE IN SAME

S.P.J.S.T LODGE #88
1435 BEALL ST.
DOORS@7 · $6 · NOV16

Flyer for From Autumn to Ashes and the Rise show at SPJST Lodge #88, Houston mid-2000s, by Johnny Bizarre.

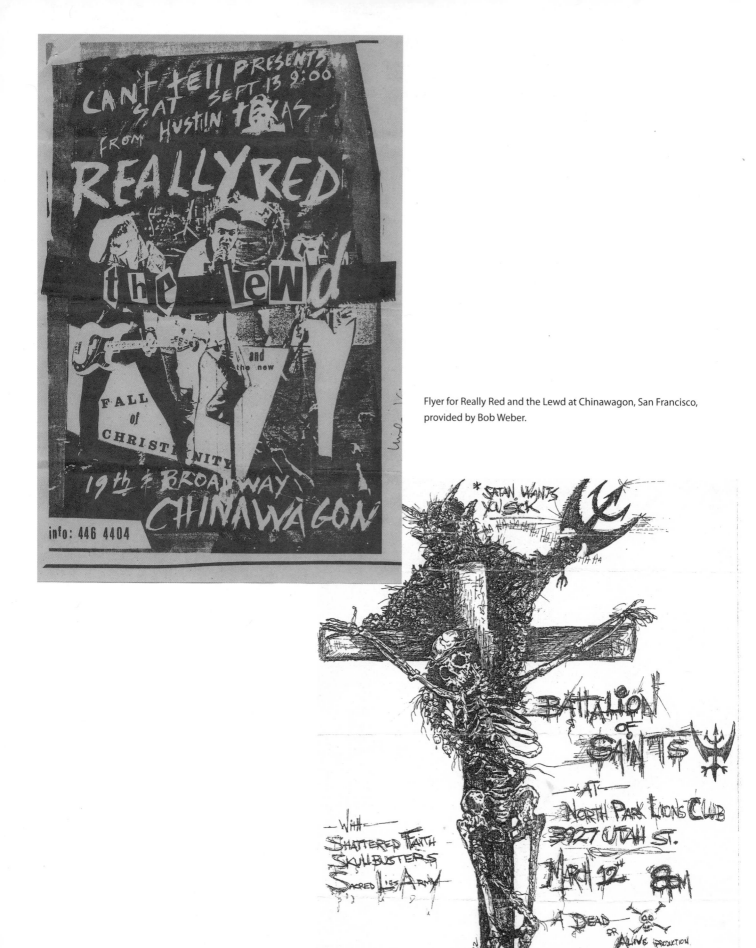

Flyer for Really Red and the Lewd at Chinawagon, San Francisco, provided by Bob Weber.

Rare Mad Marc Rude flyer for Shattered Faith and Battalion of Saints show at North Park Lion's Club, 1980s, San Diego, purchased through Stephen Z.

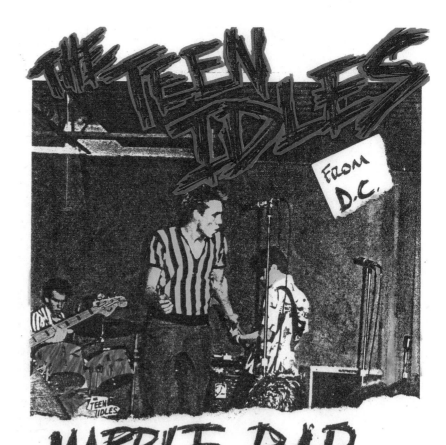

MARBLE BAR
JULY 2ND
w/ JUDIES FIXATION

UNDER
CONGRESS HOTEL
306 WEST FRANKLIN
BALTIMORE

Color Xerox flyer of Teen Idles show at Marble Bar,
Baltimore, early 1980s, provided by Jeff Turner.

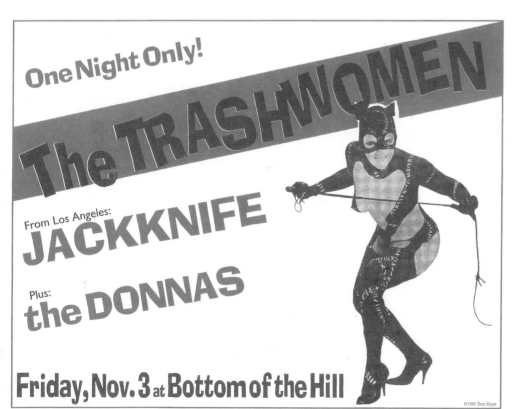

Offset press flyer for Trashwomen and
the Donnas show at Bottom of the Hill,
San Francisco, 1995, by Teen Hype.

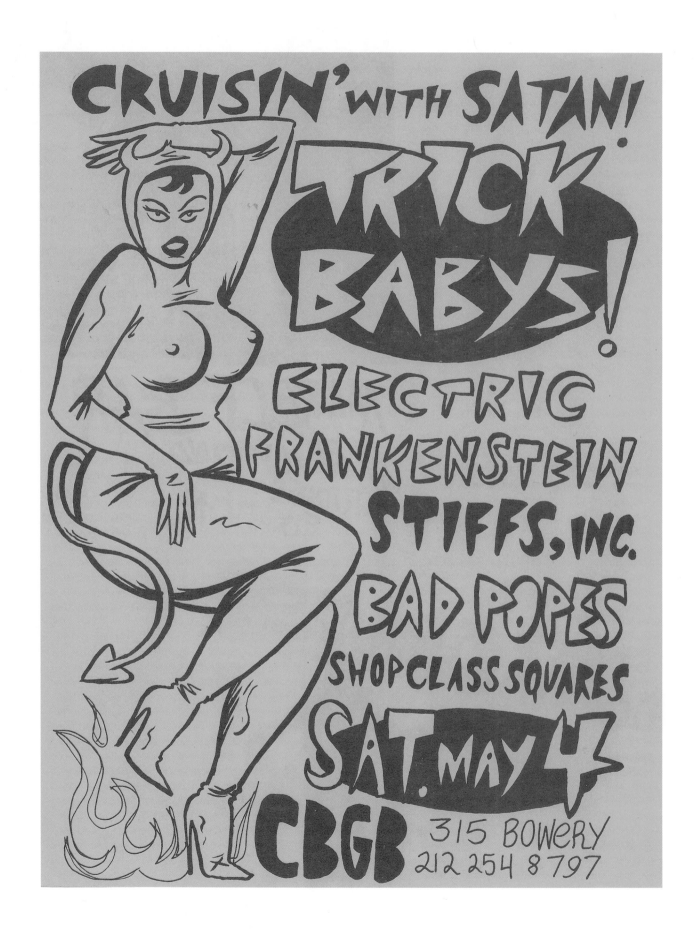

Flyer for Trick Babys and Bad Popes at CBGB, 1997, New York City. Author played this show.

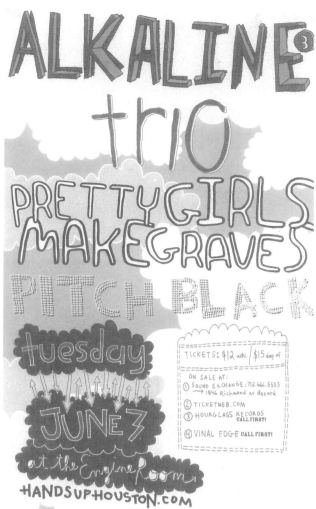

Alkaline Trio, Pretty Girls Make Graves, Pitch Black at the Engine Room, Houston, Texas, by Russell Etchen, early 2000s. Hybrid of hand-drawn typeface and Illustrator program design.

Do-It-Yourself mixed punk cassette cover, front, Michael Ensminger, mid-1980s.

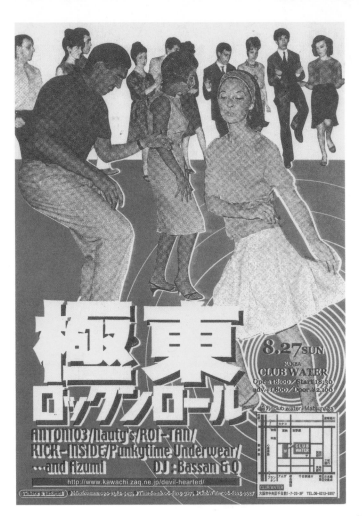

Antonio Three, Nauty's, and others at Club Water in Osaka, Japan, provided by Yukihiro Yasuda, late 1990s.

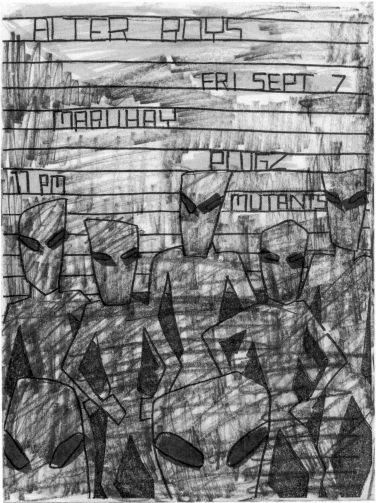

Mutants, Plugz, and Alter Boys at Mabuhay Gardens, San Francisco. Hand-colored.

on a 1982 flyer for a show featuring the Hates and Mannequin Show.

In D.C., rather than punning and offering wordplay, teenagers associated with the punk squad Rat Patrol, including D.C. skins and members of Iron Cross, were "driven by an intense distaste for homosexuality learned initially from the mainstream world" and began harassing gays who "frequented nearby DuPont Circle" and a forested park used for gay trysts (Anderson and Jenkins 2001: 128). What portion of these actions were supposedly "learned" from the mainstream world, and what portion were shaped by the hardcore and punk community's own ambivalence toward homosexuality, is still unknown. Musician Howard Wuelfing, whose early D.C. punk roots predate these teenagers, contextualizes it this way:

I do remember hearing stories of punk kids going gay bashing. D.C had a very visible gay scene with big clubs in central neighborhoods, various cruising zones (I think Rock Creek Park near "M" Street was a big one). But I don't remember that anyone that was an important scene member was involved or condoned that sort of shit. Certainly no one in any notable bands participated, to the best of my knowledge. I don't recall there being a lot of openly gay men and women involved with the scene but then again there was a genial asexuality that pervaded the culture. I think for all of us the focus was MUSIC and most people were not concerned about who was Gay or straight, single or attached. If you were at the shows or in the stores you were a music lover, period and were accepted as such. As per homophobia . . . —this stuff occurs in any population, especially when you're talking about adolescents. The process of transforming your consciousness from that of being a family member to that of being an individual is scary and confusing, especially when your parents are split up, or workaholics or both. There's a lot of new strange stuff to encounter and think about and typically we fear the unknown and often hate most what we fear

most. Add to that the fact that most people make the transition from family member to individual by joining a "tribe" in between—you rebel against your parents' standard by adopting the attributes of some recognizable peer group—punks, goths, nerds, etc. Put these tendencies together and you have a tribe fulla scared kids adopting hatred of some outside group as a standard. And a year or two later they grow out of it. (2008)

The leading punk writer for the *L.A. Times*, and guitarist for both the Bags and Catholic Discipline, was Craig Lee, the queer writer who co-authored the seminal 1980s book on the youth punk subculture explosion, *Hardcore California: A History of Punk and New Wave*. He did face repercussions for his sexuality, as noted in his obituary in the Oct. 18, 1991, *LA Weekly*. In that piece, authors Geza X, Brendan Mullen, and Stuart Timmons attest that Lee was troubled by moments when he was "called a fag on stage and in print." These insults happened even when 35 percent of the overall scene consisted of gays, as Mullen once estimated (Newlin 2010: 2). Jim Van Tyne was a gay DJ who booked "Theoretical" parties with Craig Lee at the Anti-Club during the early 1980s, where punk bands like Redd Kross held sway. In addition, L.A.'s *New Wave Theater*, broadcast locally on UHF but eventually migrating to the cable network USA, was hosted by gay Harvard-educated host Peter Ivers. Though his career in the record business began in 1969, Ivers did not voice his feelings about the gay community until 1977, when he spoke with an *Advocate* writer. His top-drawer show featured no less than a who's who of early punk bands, including the Dead Kennedys, Circle Jerks, 45 Grave, Angry Samoans, and the Plugz. Unfortunately, he was killed at his apartment in 1983.

In the United States, Texas punks like Gary Floyd of the Dicks and Randy "Biscuit" Turner of the Big Boys, mentioned earlier, were open and "out-of-the-closet," which may partly be due to

Raul's (an early Austin punk club) unique band and social scene. Gary Floyd noted that "almost all the really good bands in Austin were fronted by or had gay people in the band. People were pretty open about it then. It wasn't like they were trying to hide and the other thing abut it was that people weren't making a big deal about it. They weren't getting up and giving speeches for gay rights, but they were being themselves and was really wonderful" (Quint 1998). The Dicks' drinking, harangues, and unapologetic lifestyle were infamous. Songs like "Saturday at the Bookstore," with exhortations of "glory-holes" and "sucking dick," boldly expose the irony of anonymous suburban men receiving oral sex and shunning the same boys afterwards: "Seeing me standing there / But you don't even speak to me / You don't wanna know me, do you? / Cause I done sucked your fucking cock through the gloryhole" (1983). The angst, disgust, and snarl that bursts from Floyd challenges any notion that gays are effeminate and cowardly, just as gay skins were adamantly not "poofs." The "deranged" and stubborn slow motion frenzy of " . . . Bookstore" and "Shit on Me" make the anthemic gay rock of Tom Robinson seem like a small rubbery flame of protest and make typical Homocore such as Pansy Division fare feel stilted by pop conventions.

Jello Biafra, singer for the Dead Kennedys, summarizes, in an almost haiku-compressed roll of words, his initial shock and pleasure of seeing Floyd lead this band: "My God, a 300-pound communist drag queen who can sing like Janis Joplin" (Hernandez 2000). Floyd grow up in Palestine, Texas, just a few hours from Janis Joplin's working-class, Gulf Coast home Port Arthur. Just as Joplin became one of the leading voices of the 1960s counterculture who relished roots music, Floyd too sings the blues and was a communist, though not of the Yippie/New Left variety that most people assume, for he saw politics as essentially individualistic. Plus, he added elements that seemed more like brash performance art than electrified soapboxes for Maoist

political diatribes. Regardless, Floyd's incessant interrogation of mainstream ("Rich Daddy") or "subcultural" norms was barbed with humor and intensity:

There was this big picture of me on the cover of *Maximumrocknroll* with a mohawk, and these weird glasses and a big muu-muu on, and it said something like "Commie Fag Band From Texas," and we went out on the road, and there were a lot of people out there who'd seen that magazine who were NOT thrilled to death to see me coming to town. This is 1984 and people who would come to shows, like skinheads, would say "I saw you on the cover of *Maximumrocknroll* magazine. Are you really a fag and a communist?" And I'd say, "Why, no . . . you big fucking hot son of a bitch!" I'd throw shit at people, and rubbers filled with cum. Of course it wasn't real . . . (Kelly 1995)

Floyd told *Suburban Voice* in 1998: "I never joined anything. I was never part of any group. I always thought they were like the religions I hated most. From organized religions to eight people sitting in a room plotting to march down some street and overthrow the government." He also described first arriving in Austin, where he "found a bunch of political gay people and met a lover—he and I and a couple of other guys started The Gay Communist League. We never did anything, but I loved the name" (qtd. in Hurchalla 2006: 135). Though it existed as a communist league in name alone, it does seem to predict Lloyd's later approaches, such as creating gig flyers for the fictitious first version of the Dicks, with addresses that did not exist announcing gigs they had no intention of playing.

Similarly, Winston Smith, the widely celebrated artist responsible for much of the Alternative Tentacles label aesthetic, the Dicks' record label, recalls "not knowing too many bands at the time [1977]. . . . I would compose flyers for bands that didn't even exist that were to perform at clubs

that were equally non-existent" (2003). This was not limited to the Dicks or the Austin and San Francisco scenes, for Poison Ivy from the Cramps revealed to *SuicideGirls.com* that, "When we first started out in 1976 before we even had gigs we had posters for fake gigs we hoped to have which had psychobilly and rockabilly [written] on them" (Epstein 2003). Similarly, Pat Smear, guitarist for the Germs, has recalled, "We'd make posters and put them around town, not for gigs, just to advertise the band" (qtd. in Mullens and Spitz 2001). Winston Smith also made fraudulent gig posters: "Since I didn't know anybody in the scene [in the late 1970s], I made up the bands and I made up some locales that they could play at. Some of the names later on got used for real bands" (Chick 1996). These cases highlight the punk concept of stirring up ideas from the ground up, shaping the style and aesthetics of punk culture, through posters that amounted to "art for art's sake" or through catchphrases engraved on flyers that popularized and legitimized terms like "psychobilly" in the punk rock community.

Sometimes the "queering" of punk rock might be centered on the performative ritual of cross-dressing, the masking of hetero-normative rock 'n' roll posturing. Throughout the 1980s, members of bands like MDC, Beefeater, Big Boys, and Adrenalin OD pushed these boundaries in front of tough audiences. The reasons may be more personal than political or cultural, especially in terms of Jack Grisham, singer of TSOL. One informant in the documentary *American Hardcore* suggests Grisham was the Iggy Pop (late 1960s, early 1970s proto-punker) of the American hardcore identity. Grisham, who regularly wore whiteface goth punk makeup and donned dresses (though likely not in homage to Wayne County and the transgressions of the post-glam era but as an outlet for the well-built surfer to rebel against his family), says: "There's a videotape of me beating up these two cowboy guys, and I was wearing a dress at the time. I was trying to [tick] my dad off for a while,

and [wearing a dress] was working good" (qtd. in Boehm 1998).

Later, when he was interviewed as lead singer for the band Tender Fury, Grisham told *Pussyfoot*: "I acted like a homosexual. I went to bed with so many girls (2–3 a night) I couldn't handle it anymore" (James, Kuban, and Compe). Bandmate Dan notes that Grisham brought style to Orange County punk rock because he was unafraid of being "a faggot who wore make up and nice clothes." Grisham, in turn, points out that he was afraid of the misunderstood effects of herpes, like going blind and having brain damage, so he "pulled the total fag routine and I'd always make sure I had 14 year old guys with me all the time, but they were just friendsI didn't deny it 'cause I'd rather be called fag." He would use the farce to tell girls he didn't want to go to bed with them, and they "would think it was my fault and not theirs" (James, Kuban, and Compe). The ploy was both advantageous and slightly anarchistic, a way to negotiate sexual relationships with women, probe and bend punk gender norms, and actively interrogate so-called family values and definitions of masculinity.

Other contrasting insights might prevail. Mark Philips, Grisham's former bandmate in Joykiller, proposes that "Jack's cross dressing had nothing to do with sexuality. There are a few components to it from what I saw. 1) There's kind of this inside joke aspect to it; 2) The irony of it helped kind of build his legend (which is a core motivation of his in everything he does from what I saw); and 3) On a darwinian level, it helped him (literally) draw in opponents and then destroy them" (2009). Still, Grisham told *Loud Fast Rules*, "I thought Punk was always about experimenting, trying new things. If you want to judge people and do all kinds of shit, that's great, man. But don't complain about other people doing the same shit. Don't complain about the fuckin' government hating you and not appreciating your freedom, when you can't let a gay guy walk down the street without giving him shit. It

155

was really fucking ridiculous" (qtd. in Alexander 2006: 156). If Grisham's words are to be taken at face value, punk should not lose a sense of its historical mindset—to extend freedom. Whether his cross-dressing demonstrated sexual fluidity or blatant attempts to corral and crush opponents remains debatable, though a core truth remains. Grisham's gender bending did *provoke*: "The very first time I saw TSOL (at Devonshire Downs in Northridge), the crowd literally pulled Jack in the audience and beat the shit out of him. Mike Roche brained someone with his bass to get him to let go of Jack! Maybe it was the clown make-up and dress Jack was wearing? Anyhow, no one was immune to the violence, not even those who were on stage" (Fancher 2005).

Other punks performed in drag as well, such as freewheeling guitarist Bob Stinson from the Replacements, but Randy "Biscuit" Turner's (Big Boys) approach to punk-meets-drag performance seemed determined to test's the punk community's own value systems. When a somewhat befuddled *Flipside* reporter began an interview by questioning his pink tights and skirt, "Biscuit" rebounds by stating, "I don't care what you think I am. I'm gonna be an entirely different person next time you meet me, so don't classify me as a drag queen. . . . I could get up there with a T-shirt that says something cool on the front. . . . I choose something different because it's in my heart that I feel a little art needs to happen. . . . I'm 100 different people." Not only does this echo gay poet Walt Whitman's adage, "I contain multitudes," it also suggests that punk identities, as envisioned by Biscuit, are rife with performances unveiling something creative and unstable, morphing and unbound, free-spirited and autonomous.

Other punks evoking drag routines remain under the radar of punk historians, Mike Palm insists:

> One of the great Orange County bands that most people don't know about is the Naughty Women.

They were legendary characters in the scene. Each and every one of them till this day are well known and part of the community. Bill, the guitar player, owns a shop in downtown Fullertown that's the coolest record shop in Orange County, if not all Southern California. These guys were there from the beginning and very different and unique. The Naughty Women, of course, dressed in drag, and they would be standing out in front of the club in their dresses and go, "You know that biker bar around the corner, I'm going to go over there right now and kick over all the bikes, and go, 'You guys are a bunch of pussies.'" They were so funny. Everybody knew it was the Naughty Women, so it would be like, "Awesome, nice dress Beatrice" (laughs). No one took anything too seriously. (2010)

Lux Interior, singer for the Cramps, also blurred the gender lines on stage by wearing stiletto heels and skintight vinyl and leather pants. Greg Kot, writing for the *Chicago Tribune* reveals: "This yin-yang relationship [of the Cramps] . . . [is] far from a traditional one: with the male as sex object and the female as lead guitarist, it subverts decades of rock stereotyping" (qtd. in Brennan 2008). For a fan perspective, a 1979 issue of the zine *Final Solution* offers this observation, written by Hilladdin, which suggested that Lux "was out of hand, or at least more than usual, which included almost an expected display of exhibitionism during 'Human Fly,' perhaps for the benefit of the hippie faggot boys, as they did look a bit startled when this incident occurred." Earlier in the piece, the author notes that such a "display" was actually the result of Lux getting "a little tired of being called hippie faggots whenever there was a break in the set" (16). The writers seem to have reclaimed the term long enough to use them against the same annoying fans who initially flung the slurs.

Lux's gender bending is not the only interesting dynamic here. A not-so-subtle undercurrent of verbal fag bashing, attention to the shifting power of language, and equating "long hairs" to

feminine, faggy typecasting is also evident. Such dynamics are also found in the *Road to Courage* cartoon from 1982, in which the cartoonist Lee (who also published in *Flipside* magazine) equates a music fan with long hair and Van Halen T-shirt as a "butt cherry" and "faggot" who deserves to get stomped by punks and skins until he crumples "on the ground, where [he] belongs, hippie." This violence illustrates the ferocity of the turf war between metal heads, hippies, and punks. The last frame of the comic features one punk noting to the "leader" (with heavy irony) that, "Last week we were all hippies." The leader retorts with a menacing grin, "Yeah, but now we're hardcore." They have become a goon squad of sorts, marking the periphery of the contested physical spaces and the borders of their self-claimed identities with adamant, merciless severity (source unknown, a Xeroxed one-sheet).

Steers, Beers, Punks, and Queers

Stalwarts like Gary Floyd of the Dicks, Randy "Biscuit" of the Big Boys, Dianna of the Mydolls, and members of the Butthole Surfers proved that queer punks in Texas were not a mere novelty. However, as J.D., guitarist for current Houston firebrands Zipperneck tells it, "I used to skate with a lot of those guys around Austin, and I had no idea that Biscuit was gay. I thought he was just weird, like the rest of us" (Ensminger 2009).

This doesn't mean that all of punk fandom—so-called rebel masses at the fringes of rock 'n' roll—eagerly welcomed such gay rockers. Why? Floyd recalls:

Because rock 'n' roll is not free, it's extremely homophobic. It's not free at all. So many people, believe it or not, don't know I'm gay, and if it happens to come out, they act all weird.

They don't want to feel emotional about music that a queer is singing because being queer has

such a weird connotation in this society. My thing is that I'm not a real advocate of going out and screaming in my songs about, "I love him." I keep my work gender neutral, because I want everybody to be able to relate to my music. And I get a lot of shit from queers about that. I don't give a shit. I do what I want to, and I am pretty open about being gay. I always have been, in a kinda redneck way. (2001)

Though the rock 'n' roll scene is still predominately saturated with straight white males, Floyd does not want to play the blame game. "I don't like to criticize the gay community for their lack of support of rock 'n' roll music. A few work really hard to make rock 'n' roll to be part of an accepted thing." Still, as he acknowledges, the stigma attached to rock 'n' roll is partly stirred by the gay community's own attitudes. "The oppressed minority kind of shit will come up, like people are telling people to listen to this type of music, and they do it. But you always have a few rebels, a few rock 'n' roll queers. The smartest people in rock 'n' roll are queer. I always remember that" (2001).

"I really grew up in the punk culture, not really very much in the gay culture," explains Dianna Ray, bass player for the Mydolls, the female post-punk band whose first show was opening for the Hates at a gay club. "I was more likely to go to a gay men's bar, like a disco, to go dancing, then to a woman's bar, because the music really sucked. So many of them were country and western. We didn't dress like them. We didn't act like them" (2009). This was true across the country, as Laura Kennedy's (Bush Tetras) own testimonies concur: "We got kicked out of women's bars . . . there didn't seem to be any room for weirdos, which we were. The punk world was my world, the gay world was definitely not" (qtd. in McDonnell 2000: 87).

For Ray, sexuality was not central and all-consuming. "It's either you were, or you weren't. In the context of being in bands, people just didn't talk about it. It seems clear watching a Big Boys

show, or knowing Biscuit, that he was gay. But no one ever talked about it" (2009).

"Biscuit was an anomaly, abnormal, but in a very good sense of the word," drummer Bob Weber from Really Red remembers. "As the front man he was animated, quick-witted, and a whole lot of fun to be around. He didn't adorn himself in being gay or expose himself, figuratively. Either there was nothing to discuss, or else we'd all been through Bowie's glam years and were blind to it" (Ensminger 2009).

Sexuality seemed subsumed by something greater. "My sexuality was secondary, not really part of the music," Ray attests. Yet, when gay culture had to deal with President Reagan's lack of response to AIDS, sexual identity and punk politics seemed to merge much more openly. "I think a lot of us, myself included, are liberal and vocal about the way we feel about social justice issues, whether they are gay rights or issues with illegal immigration and other sorts of discrimination issues," suggests Ray. "That's why we were driven to punk to begin with. A lot of us, even if they were white males, felt disenfranchised, not part of the common culture" (2009).

She eagerly adds, "I think the politics of the music drew us to it. It was a platform for change, and against Reagan." Ray even supports my own notion that punk shaped the methods of Queer Nation, Act Up, and the Women's Action Coalition. "There were a lot of gay people in punk rock, whether we were very vocal about it or not, so we started having this terrible loss, of people dying" (2009). Punk music formed an outlet in such moments, providing a sharp sense of agitprop brimming with hope and tenacity.

J. R. Delgado, bass player for the Derailers, clearly recalls the early era's gay and punk convergence. "Montrose was booming with rock clubs and gays bars. Every counterculture was out and about, especially gays and transvestites. By the time punk/new wave clubs opened in the late 70s, we were used to seeing gays as part of the

counterculture, as much as Blacks and Hispanics." Jerry Duncan, singer for Legionnaire's Disease, stresses this too: "We always got on good with gays. We were allies" (Ensminger 2009).

The Derailers first gigged at a gay disco called the Parade that featured "New Wave Night" every Wednesday. "There were about 10 folks around. After about fifteen minutes into our set we were abruptly stopped, handed our guarantee, and were asked not to play anymore," Delgado reminisces. "I was devastated. We were bad, but not that bad . . . hey, it was a statement! . . . art in its rawest form!" (Ensminger 2009).

Old school punks Bevatron catalyzed a much different reaction when playing iconic Houston gay bar Mary's. "We were 17 or 18 years old. Our guitarist hadn't been exposed to that scene before. We're on stage, and right in front, one guy drops his shorts and some other guy blows him," singer Allison Fisher recalls. "The guitarist nearly fell over. It didn't faze me in the least. In retrospect, that's very telling" (Ensminger 2009).

Rumors about the sexual preferences of Dave Dictor, longtime singer for the pithy political hardcore band MDC, have persisted for over twenty-five years. They stem from a single set of lyrics, "What makes America so straight and me so bent / they call me a queen / just another human being!" found on their tune "Dead Cops/ America's So Bent" from the band's debut 1982 album. In addition, a photograph of Dictor in drag did appear in the June 1988 *Maximumrocknroll* as well. The truth, Dictor revealed to me, is that he did experiment briefly with his sexuality as a young man, but he is straight, and the song uses a persona—a guise to explore marginalized queer culture and ask intense questions about America's cultural bigotry. He also admits that hardcore was intolerant due to generational differences.

"MDC were very connected to the 1970s punk rock scene, which was more like a freak revolution than say, what started happening in the early 1980s. Like Minor Threat and SSDecontrol and

7 Seconds, more like young guys in the crew" that lacked links to the Dead Boys or New York Dolls. "That was one of the first big divisions that we began to notice—people had different backgrounds. The original pioneers, Ian MacKaye and Kevin Seconds, were not homophobic because they were kind of like leaders in this musical movement. . . . But as it got bigger and bigger, it involved more random, lost, and less focused young people—shows at the Olympic Auditorium stuffed with thousands of people" (2008). This marked the end of one era, shaped by urban queer culture, and the beginning of the next—the rise of the suburbs.

"A lot of those people didn't have the spirit of '81. . . . They didn't have the empathy or connection to the stuff that was pre-1980, which was definitely a lot more open-minded about sexuality than what came out of '82–'84. The hardcore scene *was* rather homophobic. Let's get that out in the air. There were very few out singers that were gay. The ones that were, like Gary Floyd, got a lot of shit. Though they were popular, they'd go and perform at places, people were rough and crazy. More and more L.A. gangs got involved. It just became less comfortable and less fun" (2008).

Yet, gay hardcore punks did exist, such as Aaron Effort, guitarist of Go! Being openly gay in punk rock made him a "stronger person because in regular life you're not forced to stand up for any morals. You're not forced to think ideologically or to use your mind" (Evac at al. 1990). These traits let him carve out a unique perspective, making him realize what he wanted to defend, like the right to proper preventive AIDS information in an era when Section 28 in England expressly banned "the promotion of homosexuality." Mitch Fury, singer and guitarist for the homocore band Skinjobs, gravitated toward the music of Corrosion of Conformity, DRI, and the Accused because they were "real heavy" and offered up "intelligent lyrics": "It appealed to the intellectual political side of me that needed to be nurtured. And through punk rock I developed a certain level of self-confidence so by the time I came out of the closet I was pretty adamant that no one's going to be homophobic to me, because I have been into punk rock since I was 14" (qtd. in Ciminelli and Knox 2005: 89). Despite prevalent homophobia in hardcore, the genre and community inspired kids to navigate beyond guitar lessons and sweaty gigs; in some cases, life-altering choices—such as being openly gay in a homophobic world—were possible due to a bolstered and emboldened sense of self. This appears to be the message of the queer punk compilation *Stand Up and Fucking Fight For It* (2002), in which the Skinjobs were joined by bands like Ninja Death Squad, Best Revenge, Fagatron, Lipkandy, and Fakefight.

In Detroit during the 1990s, the band Demolition Doll Rods employed a similar strategy to make (if I may poach Stuart Hall) stereotypes of rock 'n' roll uninhabitable. One of the gig posters featured the singer and guitarist Margaret with a strap-on dildo, ready to penetrate guitarist/singer Danny, long before such acts became standard fare for pornographic DVD markets. Hence, due to the nature of the depiction—the sheer crudeness or/and assault on gender roles—the posters were rarely displayed. Their albums became another way to also interrogate the hetero-norms of rock 'n' roll, as evidenced by Ben Blackwell, drummer of the local Detroit band the Dirtbombs:

As a teenager I'd thought that *Tasty* was a loose concept album about drag racing as no less than three songs deal with the subject. With perspective, it's clear that while drag racing is rote lyrical fodder for garage rock, its meaning takes a subversive bent with the Demolition Doll Rods. With the confrontational cross-dressing outfits worn by Danny Dollrod (including, but not limited to, pasties, g-strings, wigs, makeup) the duality of the word drag and its conflicting definitions in terms of racing and dressing becomes the perfect summation of the Demolition Doll Rods and *Tasty* itself. . . .

The lyrics to "If You Can't Hang" capture it brilliantly. Dan sings "If you want you can call me a fag" as if without a care in the world. In that one line, where he succinctly pays no mind to one of the harsher put-downs one could level to an American male, he stakes a claim against all the misogynistic, empty and tired mid-nineties garage rock cliches (think naked devil girls, flame decals, songs about beer) and renders them impotent. To not only attack but destroy the basis of an entire genre under the guise of that which they hold sacred . . . drag racing, is unheard of. It's akin to waltzing into enemy territory in broad daylight with your colors flying high and taking the motherfuckers out with their own weaponry.

Blackwell emphasizes Danny actively destabilizing the norms by using the language and reference points of the culture itself to create a new space, one that he can inhabit, in which gender is no longer fixed or fossilized. Yet, Danny likely might argue that rock 'n' roll had already established this, and he was following a certain cue. In regards to such antecedents, he told me:

> At the time (early '90s) it (garage) just seemed ripe for skewering. The whole thing with the hotrods, monsters, bikini/devil/pin-up girls, b-movie imagery, ad nauseam had become such a lazy cliche (and still is). Having been through all that shit with The Gories (we rejected a Coop cover that he did for our Estrus 45 because it was too cliche, shrunken heads and bamboo). Plus, there was the trucker cap wearing, wallet chain havin', tattooed hordes! The close-minded, totally "authentic" rockabilly and garage squares! By the time Margaret asked me to be a "girl" in her band, I was more than ready to turn the whole thing around and shove it in their faces! I thought, ok I like wearing women's clothes and I like (and own, and work on) old cars I like drag racing and demolition derbys, lets explore that double meaning of "drag". I had found some drag magazines

from the early 70's (really more akin to homemade fanzines) and in the crude drawings, layout, and imagery I saw a relation to that and my favorite rock fanzines.

> I expected that some guys who felt threatened by my appearance, or freaked out when they realized that skinny ugly girl they were sort of ogling turned out to be a guy, might want to beat me up, but it never happened. I sure did like seeing the looks on people's faces when they just couldn't believe what they were seeing. That's my idea of fun. It seemed some folks enjoyed having their heads messed with, and I was more than happy to do it. We were never really accepted by the cool garage people, which was fine with me.

> I was more drawn to the '60s stuff at that time like, The Animals, The Who, The Yardbirds, Them, Velvet Underground, etc. This stuff was really blues based music (unlike hardcore punk) and within rock 'n roll/blues (Little Richard who got his start as a female impersonator alongside blues acts in a medicine show) and the blues rock of the long haired British groups there was already a tradition of androgyny. Then with the glam rock which grew out of that (Bowie and Bolan who started out as hardcore mods) it just is not that far of a stretch to Jayne County, The New York Dolls and subsequently The Cramps. (2003)

The New York Dolls punk antecedent is crucial, for as Dictor suggested as well, it reveals Danny's links to the enduring, rambunctious personality of David Johansen, who told *Uncut* magazine that the band "wasn't really considered drag. . . . We took male and female and made this kind of third choice. . . . We were trying to mix and match. . . . It was, 'Look at me, I'm masculine, and I'm feminine'" (qtd. in Goddard 2004: 74). In light of such border blurring, exploring the alternative choices that exist outside binary codes restraining sexual identity, the Demolition Doll Rods were essentially very retro—tradition bearers in debt to pre-punk legacies.

Such so-called unassigned gender, Third Sex "inversions," or carnivalesque tendencies are common throughout the world, like in Indian and Brazilian societies, for instance. Although those forms differ from campy rock 'n' roll in the post-sexual revolution of the 1970s (almost in tandem with Glam Rock penetrating popular culture, producing future stadium rock, like Gary Glitter jock-rock soundtracks), some queer theory may be brought to bear on groups like the Dolls. If we divorce the band from the members' actual sexual practices, they resemble travesties, who Don Kulick has described as "grafting female attributes onto a male physiognomy" (1998: 9). Still, even this is a stretch, for even though such travesties do not identify as women, or transsexuals, they often identify themselves as gay men, which the Dolls did not. Also, several questions remain unanswered: did the gender "shock" and street-tough playfulness of the Dolls, to paraphrase Judith Shapiro, actively destabilize, or even question and probe what creates and maintains gender differences in the social lives of Americans? Were the Dolls, like travesties, envisioned as threatening, portrayed as "dangerous marginals"? Did they, in the end, crystallize—reinforce and underscore—what Americans wanted men and women to be like in the 1970s? (Kulick 1998: 9–11). A whole book is waiting to be written exploring questions like these.

Many punks chose not to reveal their sexual identities until recently, like Bob Mould of Hüsker Dü, even though there has always been references to queer culture in punk, starting as early as 1977 with Wire's record *Pink Flag*. No doubt hardcore's relationship with queer culture has been problematic, controversial, and contradictory; yet at times, it has provided space for gay allies to speak out, including Good Clean Fun, whose song "My Best Friend" addresses how people create special cases for queers: "I Love Ani [DiFranco] and Amy and Emily [Indigo Girls] . . . / but when it comes to special rights like family, / I think marriage

goes a bit too far." According to vocalist Issa, the lyrics are "kind of making fun of people who are all for lesbians or gay people being entertainers and famous and actors and hairdressers and stuff, but don't want them to have actual real rights like normal people" (Quint 2000). In the case of Darby Crash, lead singer for the Germs, a pivotal band that crossed the boundaries between punk and hardcore, his own homosexual leanings were not fully explored until Brendan Mullen's biography *Lexicon Devil: The Fast Times and Short Life of Darby Crash and The Germs*. This exchange between Mullen and *3 A.M.* web zine explores the issue:

A question about Darby's sexuality: did it influence the band's aesthetic? Did it play an important part in Darby's confusion and chaotic lifestyle?

BM: Of course it did. It obviously totally affected his personal lifestyle, but I don't think it was a part of the musical aesthetic of the band at all, although perhaps there was the odd hint in a line or two of his lyrics if you look close enough, like perhaps "Sex Boy" or "The Other Newest One" are examples of ambiguous meanings. As for lifestyle, how many people can live a double life without confusion and chaos, especially if they're out of their tree on drugs and alcohol the whole time? . . . sadly there was a definite correlation between the rise of suburban hardcore at the very beginning and open hostility to the gay lifestyle. What can I say? The origins of hardcore aren't as PC as some people would like to believe. (qtd. in Ruland 2002)

Later in the interview, Mullen recounts Crash saying mean, spiteful things about gays, which suggests Crash had a distressing time coping with his own ambiguous sexuality. Trudie Arguelles recalls, "Darby never said, 'I'm gay.' We kind of figured it out later, but he was very closeted"; furthermore, fellow musician and friend Rik L Rick remembered Darby speaking at length about gay

and bisexual poets Rimbaud and Verlaine, Greeks as the apex of civility and culture, and how the great men who shaped history were homosexual (qtd. in Mullen and Spitz 2001: 164–65). Darby did confide in scene elders, like John Doe of X, who were supportive and tolerant of his sexuality, especially as, according to Judith Bell in *Lexicon Devil*, Darby feared being "outed" amid the growing beach punk contingents. "I suppose that may be true. It never occurred to me," Mike Palm attests, further explaining: "He always seemed so confident to me. It wasn't something I ever considered to be some sort of issue whatsoever. That's one of the things early in the scene, there was a certain alliance, you know, with . . . well, I can't even explain it, to tell you the truth. But guys like [Darby] got it, they got it. Much of it was based on pre-punk stuff. For me, it was like Ultravox, Roxy Music, and Brian Eno" (2010).

Darby tremendously shaped things to come by helping provide the nascent blueprints for a frenzied hardcore sound and "theatre of cruelty" style of performance—a la Iggy Pop many would argue—which quickly rooted itself in international hardcore music. Darby's ambivalence toward his own sexual identity also needs to be contextualized: he died in an era when "homophobia was rampant in the L.A. punk scene," as Tomata Du Plenty asserts, with some regret: "I blame older queers like myself for our silence" (qtd. in Mullen, Bolles, and Parfrey 2002: 248, 260). Vagina Davis, a black rock 'n' roll drag queen with roots in Hollywood's earliest punk era as well, reminds us that "the original punk scene in Hollywood was made up of queers. The queens' queens . . . Those days were fun until the suburban humpy punk poseurs got into the scene and it all went downhill fast, but those beach boys did have the bodies, but were they ever homophobic" (qtd. in Maw 1991).

Some bands have chosen to confront homophobia, unwilling to accept prejudice within a subculture that is supposed to rebel against injustice. In the early 1980s, Really Red examined police brutality and gay bashing in their song "Teaching You the Fear," exclaiming "Try to love another man / get yourself shot dead." Later in the decade Scottish band Oi Polloi offered "When Two Men Kiss." The lyrics examine the senseless mayhem of fag bashing and subsequent fear as well: "When two men kiss . . . The fear of what / You don't understand / Explodes into violence." By the 1990s, Detestation produced "Not Fucking Kidding," which took aim at gay jokes while pressing listeners that "Homophobia is ignorance / no tolerance for it." In 7 Seconds' "Regress No Way," the Reno-based based "positive" hardcore band pursue a related theme: "Why should it bother you? You call me queer/ Wake up . . . the human rights have seen the truth."

Such songs challenge the assumptions of some punks too, such as HR from the Bad Brains, who told Dictor, "I don't want to unite with the faggots" in a heated conversation summarized in the book *Dance of Days* (qtd. in Anderson and Jenkins 2001: 107). For the likes of punk elders like Jello Biafra, whose comments were included in the same book, such homophobia became the source of "heartbreak," which likely grew more intense when HR vented to *Forced Exposure* about Coca-Cola, false gods (Saint Mary, Saint Christopher), and the supposed rampant homosexuality evident in West Coast punk. He described the 1982 hardcore scene as a time when the "'in-thing' was being gay . . . all the hardcore bands were gay" (Bad Brains 1982). For HR the sexuality issue was rather simple: youth should live according to the creeds and commands of the Bible, like an army of the righteous, and renounce such sins: "We already got our government. Our government is the Bible. We already got our political system. Our political system is God. He already gave us laws, statutes, doctrines. . . . There's gonna be a new breed of youths, a revelation that belongs only to God" (Bad Brains 1982).

For Biafra, Dictor, and an untold number of other punks, like Shawn Stern of Youth Brigade, one can assume that they considered such rigid ideology repressive, wrongheaded, and misguided. As Stern informed me in a *Left of the Dial* interview: "There are bands that send us [BYO Records] tapes that call themselves Christian punk rock. That's an oxymoron. There's no such thing. It's ridiculous. How can you believe in Jesus Christ or God or whatever, which is all about faith and following, and say you are into punk rock? Punk rock, for me, is thinking for yourself. That's completely the antithesis of religion" (2005). Hence religion, which actively and often forcefully shapes views on sexuality, fomented a major dividing line in the punk and hardcore community. By the late 1980s, bands like 411, featuring singer Dan Mahoney, former singer for No For An Answer, raised similar issues of stubborn and "stupid masculine pride," hate that expresses fear, and the fact that "love is love" on songs like "Those Homophobic," which was later covered by 1990s hardcore act Indecision.

The link between slamdancing and mostly male sexual energy was vividly explored in a *Penthouse* article; the slam pit at the Starwood is described as "a cross between a cockfight and the Roller Derby . . . the energy in this pit of flesh and sweat is brutally sexual, though few of them will admit it" (Keating 1982: 78). Henry Rollins half-jokingly noted on the documentary *Punk: Attitude* (Letts 2005) that NYC-style hardcore, replete with teenage matinee masses furiously throwing their sweat-swimming bodies into pounding pig piles and mosh pits, was akin to adrenaline-fueled homoeroticism. Yet he readily admitted to the web site *Queerpunks.com* that although he is a gay ally, "I don't know if I would have even made it through a week of Black Flag shows if the audience thought I was gay. That crowd could be extremely intolerant. I think in general, being gay would have marginalized me

to a very visible extent" (Rollins 2007). One *Flipside* review of a Circle Jerks show from 1982 even berated a slam dancer that looked like "Henry from Black Faggot" while the review page also ran a piece describing Danzig, singer for the Misfits, complaining, "Bunch of fuckin homos, can't even move" when enthusiastic fans pressed around him on stage in San Francisco (#31). Skeeter, bass player for Scream, even upset *Maximumrocknroll* editor Tim Yohannen by deeming slam dancing as a kind of "Smear the Queer" kids' game (*Touch and Go* #21).

TSOL singer Grisham reminded the readers of *Pussyfoot* fanzine that Rollins, while in his first hardcore band SOA, would say things like "kill those fucking fags, they have long hair" when TSOL played Washington, D.C., only to grow out his own hair by mid-period Black Flag (James). Rollins has changed, but his sentiments and perspective on the attitude of punk buyers and audiences may well still hold true. When *Left of the Dial* asked Chris Hannah of Propagandhi, a contemporary progressive hardcore band, did the "Gay positive" note *on Less Talk, More Rock* really hurt your record sales? He replied: "Fat Mike [owner of their record label] suggested it had been the reason why it didn't do as well as the first one. But there can be other reasons. It sounds different than what Fat Wreck bands sounded at the time. But if you are 15 and you go into a record store, there's no way I would buy a record that says 'gay positive' on the sleeve, and take it home and have my mum see it" (2004).

So, though hardcore seemed to signify queer in some implicit or unconscious aspects, hardcore shows were not queer-friendly venues, nor are hardcore music buyers and audiences queer-friendly in many cases. Queer punks like Gary Floyd, Randy Biscuit Turner, and even Bob Mould may have simply been rendered exceptional by the hardcore community, mirroring the tendency of heterosexual-dominant liberal capitalism to bend "the rule a bit, tolerating some homosexual activity

under some circumstances for some people. The idea is containment and regulation" (Bronski 1984: 197). Punk rock, the forebear to hardcore, did not escape these similar tensions between not just sexual identities, but race identity as well, as noted by filmmaker Isaac Julien, whose film *Young Soul Rebel* examines the co-emerging British soul and punk communities in the historic framework of the empire's Jubilee celebrations:

> In 1977, young men black men did play with . . . representations, if you think about the whole construction of the young black soul boy, the young black boy who was interested in style and dressing in particular ways which was then considered to be effeminate—wearing buttoned Levi jeans or tight trousers—and which might cost him violence. At this same moment we had punk rock starting to be a strong white youth movement. It was the moment when these different sorts of representations were put up on offer, and this is what I found exciting, that it offered up a different, softer image of black masculinity. (Julien and MacCabe 1991: 135)

In contrast, post-punk, often held in disdain by some members of the hardcore punk community, might have been a space in which sexual identities, music subcultures, and everyday politics might have leaned in favor of collusion.

Post-punk also exhibited strong currents of gay culture, which writer Simon Reynolds revealed to me:

> It's true that there was a strong gay influence in the more arty and theatrical end of postpunk and New Pop—from the gay radical theater input in San Francisco with groups like Tuxedomoon, to the disco-worship and hysteria of the Associates, to Soft Cell's love of the torch song, Northern Soul, and sleaze. Club 57 and B-52s obviously owed a huge amount to gay sensibility, that John Waters–type kitschadelic thing. DAF's homo-eroticism, Japan's neo-glam exquisiteness. . . . Different facets

of gay sexuality, and also a more diffuse androgyny/pansexuality, crop up all over the place. But there was also a lot of stern "heterosexual modernism" about too. . . . The gay element, the glam rock element, it has to be noted, was also there in a big way during punk—Jon Savage has written about how the early punk scene in London resembled the Factory. (2006)

While these developments, including the pioneering gay-identity politics of Bronski Beat and Frankie Goes to Hollywood, do not fall within the parameters of this book, they are worth mentioning because they were inspired and shaped by the gay and punk discourse of the 1970s and early 1980s.

Some queer punks might argue that dark, power-shifting, Swiftian humor might be one way to counter hardcore's ambivalence to gay culture, exemplified by columnist Ted Rall's (Raw Deal) parody on gay bashing, outlined in one of his 1990s *Maximumrocknroll* columns, which addresses space, persecution, laws, biology, and language:

> Straight-bashing: Gays and lesbians should start feeling free to pick on straight people, simply because they are straight. Teenagers who display early signs of heterosexuality should be hounded by parents and shrinks, and the government should develop special strains of bacteria that kill breeders with exquisitely slow pain. Roving gangs of homosexual men should cruise the streets of our cities, looking for guys who look straight to pound and occasionally murder. Suggested appellations: Chick pirate, stick slut, mix-and-matchers, constipoids, poke hounds.

Such diatribes coexisted with the burgeoning *Homocore* scene. Some punk participants viewed the appearance of queercore as a means by which punk rock unnecessarily splintered into subgenres that explored the roles of identity politics almost exclusively.

Some *Outpunk* and *Homocore* writers might counter that they took a "personal is political" approach, using columns and editorials to interrogate a punk rock media that too often ignored queer sexuality in the post-Reagan era, which was suffering the aftermath of the mismanaged AIDS crisis. Even straight fanzine editors like Al Quint of *Suburban Voice* actively interrogated and shunned homophobia. For instance, he used his editorial column, "Random Thoughts," in issue #33–34 to savage slogans like "Burn Fags Not Flags," take skinhead bigots to task, voice his support for an end to the ban of gays in the military (though he questions why they would want to join), support gay participation in St. Patrick Day's parades, criticize a local paper that pulled a comic with an "out" character, condemn attacks on gay parenting, and illuminate wedge issues used by the Traditional Values Coalition to divide black and gay communities (1993).

Outpunk zine founder Matt Wobensmith told *Punk Planet* that he "simply hijacked the DIY thing to disseminate ideas and information," criminally under-priced his products, and was interested in "maximizing the radically democratic inclusive promise that punk once held," not in theory, issues, or facts that could not pay his rent or provide groceries. Wobensmith felt queercore and Riot Grrrl "redirected punk to recognize the human element," in which politics was not theoretical but a real matter of consequence, of action versus inaction (Schalit 2005: 318). He felt that punk had become a monoculture that cut people off from roots, encapsulated them in an identity culture, including products and lifestyles pitched by fanzine makers and record labels, reflecting a world of middle-class, liberal fantasies in which people *think* they know how the world runs. One Wobensmith phrase remains key to these propositions: "Punk is in denial of how the world is" (371). He has also noted that punk and queer culture have ongoing tensions, for "Gay people often sacrifice the cultures they come from just to

belong to something. . . . This sacrifice of a radical culture, whether as an artist, punk or anarchist, is what the queercore movement has always battled against" (Spencer 2005: 279). Consequently, #104 *Homocore* advised queer punks to avoid "repeating the mistakes of the gay movement: ghettoization, liberal reform, class capitulation" (qtd. in O'Hara 1999: 117).

Flamboyant homocore band Pansy Division supported "corporate punk" Green Day on tour in stadiums across America. This level of notoriety, Pansy Division has recounted, resulted from an interview in *Maximumrocknroll* that generated label interest in the band, which finally signed to Lookout Records. The band's wholesale poaching of pop culture for song titles has become one of its most defining features, as exhibited in tracks like "Nine Inch Males," "James Bondage," "Rachbottomoff," "Bill and Ted's Homosexual Adventure" and more. On the surface, the ruffling of cultural norms and recombinatory finesse seemed courageous at first, but critics have questioned the value over time:

> Queercore bands like Pansy Division and Tribe 8 co-opted the in-your-face, live-fast-die-young aesthetic of punk, inviting listeners to throw off the shackles of heterosexual society's expectations and, in the words of Pansy Division, "join the cock-suckers club" . . . Prada and Beyoncé have replaced vintage clothing and queercore as coins of the young gay realm, and the psychological and social effects of the current lust for consumerism and mainstream pop culture on queers today will be for future theorists to puzzle out. (Hargraves 2007)

By the end of the 1990s and early 2000s, the pop punk homocore scene had faded, *Outpunk* was no longer in print, and new queer punk bands were reclaiming hardcore, injecting a sense of gay outsiderness, fetishism, and outlaw sexuality to the "macho" genre, which interrogated the notion of a hardcore punk liberalism that was likely only

surface/skin deep. This caused a tension between communities, especially when the Irish band Knifed, formed by newly "out and proud" singer Mero, toured and directly confronted some more traditionally masculine and hetero-normative elements within a given gig. As Mero, singer from Knifed, explained to Irish fanzine editor Ed Hannon on the *Left of the Dial* website:

> [While] touring England [there] was a town that had a whole load of "bloke punks" that were into football and punk, and we played there twice and there was always shit, not much, but shit going on and I thought I don't fuckin need this I'll never play there again. It was just that they were doing the gay jokes, but they meant it a bit more than being "PC", and they were a little rougher in their moshing and stuff. So, it was just a funny song about, "I'm Gay so I should get all the gay jokes," cause with straight punks they'd say kinda gay stuff, and then if I started dropping in the real filthy jokes, people were like oh hold on I don't wanna hear that. So, it's that whole thing, I'm not allowed to do the filthy gay jokes, but they are allowed to say the little gay jokes. So, basically "Get Off My Bandwagon" is me saying, "I'm really gay, I want to do all the gay jokes not you, you stick to your fuckin straight jokes!" It's the whole thing about the George across the road (infamous Dublin gay pub) when you had bingo. They called it gay mass every Sunday, lots of straight people would go and ogle gay people kissing. It's a bit like, get your own fucking pub, we've only got two fucking pubs in the whole of Dublin, you've thousands, so fuck off. You squashed us down into such a small corner we have to organise our own shit just to get through our lives. (Hannon 2008)

To understand the context, one needs to look at the historical trajectory of "queering" specifically in hardcore and the emergent subgenre of queer-edge, not just homocore/queercore. In the late 1980s, as straight-edge and Krishna Consciousness

took hold within the hardcore punk community as members of bands like Cro-Mags, 108, and Prema adopted Hare Krishna religious practices under the influence of A.C. Bhaktivedanta Swami and others, the philosophy's tendency to shun the gay lifestyle took hold as well. One view of the movement might be centered in the outlook of Ray Cappo, former singer of Youth of Today, Shelter, and others, who at least during the mid-1990s, when he became a brahmana (priest), supported "a conservative social agenda, and like most of his brethren is opposed to homosexuality and abortion" (Davis 2005). Krishna Consciousness does not single out and reject queer culture but instead critiques overall sexual mores within American culture, such as unbound sexual appetites, which many people overly identify with gay male culture.

This uneasy meeting ground between queer and Krishna punk culture was outlined to me by Ben, singer for the band Youth of Togay, which actively poaches, interrupts, and re-imagines the songs of Youth of Today:

> When I first moved to L.A., I answered a Craigslist ad about joining a hardcore band and when I met the guy, he was a Krishna. I am probably one of the most open and accepting people I know. But I started talking to this kid, and of course it got around to sex. He was telling me that in Krishna it is unhealthy to indulge in your own sexual desires. That means: No jerking off, No homosexuality, and No thinking/watching or exploring sexual acts. Wow . . . that's fucked up. God gave us a penis for a reason . . . it doesn't get hard just for kicks. But the real shocker was that this young guy had actually considered castration, just so he wouldn't have to think about sex anymore. Because, of course, this poor 20-something kid couldn't wack it, or fuck. (2008)

When asked about the convergence of straight-edge, parody, and queer culture, Ben Togay confided:

I don't think that we consciously chose straight-edge as a focus point. I think it culminated from our own lives and where we grew up, which then influenced our choices. More than just straight-edge, our focus was really the new generation of hardcore that is even further polarized towards violence and masochistic behavior. Standing on the outside and appreciating the music, yet somehow feeling distant and left out. Like being in a room of 300–400 people and still feeling alone. Feeling like we needed to call people "faggots" just so other people wouldn't think to question our own sexuality. These were the experiences that really pushed me personally to form this band. And the way we chose to express those feelings, were to write and parody songs that would bring them closer to us and make them our own. (2008)

Such lashing irony has been pursued by Black Fag, as noted earlier, while community-based action networks have also blossomed, including the collective Limp Fist—an anarchist, anti-racist, anti-capitalism "cumming together of queers" in Toronto, Canada, whose slogan is "Be Queer Everywhere." Queer punk posters in support of bands like Limp Wrist, whose graphic artist fans sometimes adopt and adapt the infamous images of Tom of Finland, an iconic gay "rough trade" illustrator, defamiliarizing the material just as Sex Pistols T-shirts did. Whereas those were "anti-fashion fashion" clothing for an elite upscale punk crowd, Limp Wrist flyers were cheaply produced and hung in multiple locations. Thus, the once hidden, taboo, and fetish-based images morphed into openly displayed adverts that perhaps shock but also shift the underground gay universe formerly hidden behind pedestrian, nondescript storefronts and adult book stores into the open—public, contested spaces and market places—where they aggrandize the tensions between straight and queer worlds. Bands like Black Fag see value in confronting boundaries—straight and queer, "normal" and "abnormal"—especially when manifested within punk. As Liberace from Black Fag informed me:

Our band is mostly about humor, but there are serious elements to the project. One part of our message is exposing the homophobia that still runs rampant in the hardcore scene. When we play, we're baiting homophobic members of the audience to come out of the woodwork and taunt us in hopes that people will see their true nature, and, on a larger scale, recognize that homophobia is still a problem to be dealt with in the punk scene and in the world at large. I don't think that the continued existence of homophobia represents a failure on the part of the homocore movement any more than the continued existence of racism represents a failure on the part of the civil rights movement. The big problems in our society require a constant fight. (2008)

Queer hardcore and queer edge culture is not satisfied with simply recognizing and exploiting the implicit irony of male-thronged all ages shows, youthcrew fashion semiotics, and the "disruption" of norms within the culture, but also seeks the reclaiming of a space they envision as latently queer.

This is not the same as the gender parody and spectacle of cross-dressing performers like Wayne County, Vox Pop, Toilet Boys lead singer Miss Guy, Six Inch Killaz, Trash Vegas, Pocket Fishrmen, Vaginal Davis, Demolition Doll Rods, plus Hedwig the Angry Inch (John Cameron Mitchell), whose personas reveal the discontinuity of the male/female anatomy (I am a man with lipstick, hear me roar) and highlight the flux and fluidity of gender, considered a fiction (since it is constructed: a "doing" not a "being") that can be recontextualized and interrogated. Due to the lack of a fixed inner core, the punk rocker–cum–drag queen fails to acquiesce to heterosexual codes, thus becomes marginalized, unnatural, and freakish (Ernesto 2005). This may also reflect the

approaches of the ambiguously gendered band Turbonegro, whose prodigious makeup and ribald lyrical exhortations of "denim demons," "saints for semen," "rendezvous with anus," and "sperminator of the asshole," seem to reinvent the genres of hard rock/heavy metal and 1970s glam rock, albeit offering a more pornographic, seedy, and queered version. They are like Kiss, Alice Cooper, and Gary Glitter with Euro trash punk underpinnings. Such parody may "destabilize hierarchal, binary forms . . . such as high/popular culture, straight/gay, and masculine/feminine" by using "the traditionally ambivalent position of the male rock star as both an indentificatory and erotic object to engage in particularly powerful forms of genderfuck" (Dawson 1999: 126–27).

The output of contemporary hardcore bands like Limp Wrist and Youth of Togay does not mimic that world of inversion and purposeful ambiguity; instead, they have invented a sub-genre loosely referred to as queer-edge. Consequently, they re-codify a music scene often derided as a hotbed of macho, lean, and spurious music led at times by a self-righteous, plebian, clean-cut, neo-religious philosophy. Ironically, the scene was/is seemingly saturated with seemingly homoerotic rituals, such as attending concerts that are mostly young and male, advertised through the use of flyers and posters laden with images of muscular, buzz-cut, and agile men who, in turn, mimic and embody the actual concertgoers, who mosh and pig pile, often with their shirts off, and sing along like adamant followers in "erotic contests" that asserts their privilege and status within the group (Ernesto 2005). As Jeff Smith from the Hickoids tells it, "Hardcore at that time was a male oriented phenomena, and I think much of that had to do with the need of young males to engage in pack-like or gang behavior and sexually express themselves, however awkwardly, by touching each other" (2006).

Limp Wrist exploits this ambiguity and insinuates that the whole nature of the event is, implicitly,

a queer staging ground. Their lyrics to the song "Cruisin' at the Show" (2001) reflect this point of view: "You look good with your youth crew wear / Shaved head tough face and your Revelation gear . . . / Your eyes locked into mine and we nodded / Cuz we both wanted it." In an interview with *Suburban Voice*, Sorrenguy explains that some concertgoers will stand aloof and disapproving at the back of their gigs while others join the melee in front of stage, perhaps entirely unaware of their own symbolic behavior. Sorrenguy, who has been known to sing in makeup donning a black punk girl wig while wearing short dresses dotted with buttons, notes: "We enjoyed . . . how these boys were tackling each other, rolling on each other. I mean, that was like dry-humping porn for us (laughter). It really was. I mean we were watching boys, we were teaming up boys that kept going after the same guy, constantly and, it was like, should we give them the van keys and let them use it for awhile? We laughed at it" (qtd. in Quint 2003). The aggression and homophobia become temporarily suspended in such a free-for-all reclaimed space. This notion mirrors the band's ethos as well: "who the fuck is going to tell us we're not legit? For me, it's like reclamation. It's like we're taking things back. We're saying this is us" (qtd. in Quint 2003). Sorrenguy's affirmed straight-edge lifestyle, which predates his involvement with punk rock, makes such "reclamation" even more layered and nuanced.

An overview of straight-edge, hardcore, and youth crew lyrics from the late 1980s reveals genre-defining dictums and slogans that appear to bridge the gaps between hardcore and queer communities in the era of Act Up and Queer Nation. Such slogans could easily fit in both communities: "(Get Up and Fight Back) Take a Stand" (by War Zone); "Growing Stronger" and "Stand Tall" (by Upfront); and "Take a Stand," "Break Down the Walls," and "Shout It!" (by Youth of Today). Even the slogan of the zine *Smorgasbord* avails upon readers to "Stand Hard and Always Speak Out,"

which strikes a chord of righteousness, discontent, and a willingness to stake an issue firmly. This is not to suggest that queer issues are implicit within the hardcore punk genre. That scene is likely more defined by an intense, prolonged sense of adolescence that is heterosexual-dominant and simultaneously homosocial, in which young men bond by forming family-like relationships. Yet, straight-edge and hardcore's concerns and ongoing refrains about pride, self-empowerment, and self-determination, which likely link back to the Bad Brains Positive Mental Outlook concept and the well-honed positive-tinged hardcore of 7 Seconds ("We're Gonna Fight"), Minor Threat ("Stand Up and Be Counted"), Unity ("Breaking Through"), and Uniform Choice ("Screaming for Change"), also resemble the conscious language of gay liberation.

Act Up (AIDS Coalition to Unleash Power) taught civil disobedience training, fostered the catchall gay liberation phrase "Silence = Death," and promised never to be silenced, while the second-generation breakaway, more radicalized Queer Nation avowed in banners that "Dykes and Fags Bash Back." Additionally, some Act Up posters in the early 1990s were created by Jim Evans and the TAZ collective, who also produced posters for bands such as Fugazi, L7, Agnostic Front, Ignite, Agent Orange, Bouncing Souls, NOFX, and Jawbreaker, among many others. Thus, the connection between gay-positive, politically trenchant messages and underground-community means of production also had direct punk links.

Punks had defended themselves for years against punk bashers who often tried to demean, belittle, and terrify them with anti-gay taunts and tirades. Johnny from the Denver-based band Bom Kon told *Maximumrocknroll* that, "It was definitely a big deal to shave your head, you know? It wasn't just self-expression. You thought, 'Now I'm a faggot.' That's what you were in Colorado in 1980, '81. They didn't think of you as new wave or a punk, they would think, 'There's a homosexual,'

and you would hear the brakes of the pick-up truck squeak, and you'd run. Grown men would fuck with you" (qtd. in Hubbard 2008). Another such incident was recalled by the lead singer of the Freeze, who is not gay, in the liner notes to their compilation *Token Bones*: "Six redneck guys got out of their truck and surrounded my car. They punched at my window so I rolled it down. I had the CS [tear gas] in my hand, ready. One guy reached through my window and slapped me in the face, called me a 'punk faggot.' I told him to try it again. Before he could, I pulled out the CS gas and blasted him in the face for a good ten seconds. He fell to the ground, gurgling, gagging." In the band's song "Broken Bones," he recounts a similar incident that took place at a party: thugs threatened the persona of the song with equal vehemence: "All you punks are fucked up fags / those beady little eyes of yours will make great punching bags" (1981).

Likewise, both Tony Cadena of the Adolescents, and Mike Ness from Social Distortion (with red choppy hair and leather jacket), were routinely berated on the streets as "faggots" by construction workers and other bigots (Mullen and Spitz 2001: 261). Lastly, Tony Montana, singer for the Adolescents, once told the *Los Angeles Times* that he was a scrawny, awkward kid in high school that had to endure a Marine-like swim team member who would harass him, first with abusive phrases like "Punk, fag, what's your problem?" that eventually led to even more extreme episodes: "I mouthed off at him. He followed me and smashed my head into a pole, knocked me out cold." In essence, Montana seems to speak for many other punks of the era: "School was a place I could go for a good assault and battery" (qtd. in Boehm 1989: 49-C). Across the country, punks were equated with the outsider status of queers and routinely belittled, demeaned, and violated.

Gary Floyd, offering memories of the Texas punk scene in Austin, especially at Raul's, recalled, "Queers were really obvious . . . if anybody didn't

like it, we'd tell them we'd beat the shit out of them. Get a bunch of queers to beat your fucking ass. It usually never came to that. There was always a lot of mutual respect" (Quint 1998). Such fights and sense of mutual respect can be translated into political action, even if one is simply a supporter of rights, and not necessarily queer, such as Chris from the Portland-based punks Defiance. He told *Suburban Voice* he voted in 1992 due to Initiative Nine [Ballot Measure Nine—all governments in Oregon may not use their monies or properties to promote, encourage or facilitate homosexuality, pedophilia, sadism, or masochism]—an obvious anti-gay measure. Though he recognized that "voting doesn't do much," he felt compelled to make sure "nine could not pass" (Quint 1998).

Other hardcore participants, like Duncan Barlow of By the Grace of God and Endpoint, were allies of queers in punk. Floorpunch's notion that, "If you're straight-edge and don't wear an X on your hand you're one step away from taking a big dick in the ass," was posted online, and on stage they mouthed jibes like "Faggots and pussies get out of the pit." When Barlow tried to discuss the matter with the singer, he was punched in the face, resulting in hospital care. It can be assumed that such altercations were not limited to Barlow's incident. For instance, linkages between the homophobic discourse of Floorpunch and other hardcore bands can be found in an interview with Leeway, whose singer Eddie told *Constructive Rebellion* zine that "All these fuckin' prancing homos and shit (at the Palladium), nothing I hate more than a flesh eating homo. It's like they touch you, you just say, 'Yo man I'll fucking hose you.' You look at them cold and stare them down, they get the idea." Yet, later in the interview, he does acknowledge, "It's OK if they want to come to shows" (date unknown).

The philosophy of Rastafarianism espoused by the hardcore Bad Brains was no more welcoming of a gay lifestyle than Krishna consciousness. After one Bad Brains gig in San Francisco, singer HR

once commented, after seeing men in the Castro district kissing, that the city "has too many gays" (Worth 2007). Perhaps a more accurate account comes from *Flipside #31*, which reports HR announcing that the city had "too many faggots" (1982). Either way, the band did not want to stay in such liberal enclaves, even though they had, by then, settled in New York. According to the book *Dance of Days*, "HR and Earl Hudson would make remarks like 'fire and brimstone, Babylon' when encountering gays on the street in Greenwich Village" (Anderson and Jenkins 2001: 105). To be fair, white punks also denigrated San Francisco too, long after hardcore's heyday. In 1993, Lee Ving of Fear said, "I wouldn't live in that homo city!" (Angel). Perhaps that longstanding political incorrectness is why the band, along with Mentors, are "sometimes pejoratively referred to as 'proto-metal' rather than hardcore or punk rock in chronicles of the era" (Newlin 2010: 10).

Ironically, the Bad Brains initiated themselves to the D.C. scene in 1979 when they handed out flyers to the crowd gathered at a demonstration for radio station WGTB that welcomed both gay and punk subcultures. This seeming respect for tolerance was soon muddled after the Bad Brains gigged in Austin with the Big Boys and stayed at guitarist Tim Kerr's home. Although details are somewhat sketchy, the next morning, after a marijuana sale was brokered the prior evening, the Big Boys were handed an envelope with ashes that read "Burn in hell bloodclot faggot," aimed at Biscuit, the openly gay singer of the Big Boys. At the Bad Brains gig at Esther's Pool with the Big Boys, HR refused to use the same microphone as Biscuit as well.

The incident spurred much negative publicity in the punk and hardcore circuits. In New York, members of the Beastie Boys and Reagan Youth formed the one-off Lucifer's Imperial Heretical Knights of Schism, in which they improvised music and read from a pamphlet titled "What is Rastafari?" which ended with an open call for

questions and members of a "Bad Brains contingent" pelting "them with eggs" (Anderson and Jenkins 135). This set was followed by the mock-band Blood Clot, which included the Bad Brains' own former soundman. MDC wrote *Maximumrocknroll* describing the Texas incident, and later made a flyer, "Boycott Bad Brains," which decries the band's sexism and homophobia. It also criticizes the Bad Brains' condemnation of women who wore short hair and make-up, drink beer, and practice birth control, and gays, whom they considered "bloodclot faggots."

Over the years, the band has tired to explain their sentiments in a variety of ways. Dr. No told one Internet writer, Kthejoker, that, "We wrote that song as kind of an angry warning to homosexuals. We didn't really mean to insult them, but a lot of people we knew seemed to be living with their eyes closed." To which the Kthejoker quipped in his article, "I found his answer at least somewhat compelling in the heyday of late-80s gay politics, or the lack thereof" (2004). Apparently, he was not aware of Act Up or Queer Nation, who combined queer and punk ideology into direct action. More recently, bass player Darryl Jennifer has insisted that the run-ins and intolerance were the result of being young and juggling ideas that were buried within a religious framework that provided the band guidance and a sense of community:

> Going from a young man to an old man, there are different trials, and that one trial was not cool, because people started to call us homophobes. All of our PMA work started to turn into, like, we were misogynistic, we were known for all this homophobic stuff, and it's not true. We are loving dudes. It's just that in our growth in Rasta we may have hit some bumps in some roads, like any young man or any young woman trying to get into anything. One thing in the Christian belief and strongly in the Caribbean and Rastafarian belief, was the disagreement with homosexuality. When you're a young

Rasta, a homosexual is something you're supposed to view with pestilence. So there was a time when we were, god bless us not to be fully into this belief, but there was pressure on us because we wanted to believe in our culture as Rastas and to also understand that this is pestilence. But I wish that as young men we could have been exposed to the blessings that God loves all people, he loves all of God's children, everybody. How you roll out here with your sexuality is your business and your life and what a human being chooses in those respects should have nothing to do with being accepted as Jah children. This is something you have to grow to learn. (Worth 2007)

Though this reasoning seems to express a "learning curve" and movement toward self-recognition of misplaced bigotry, it may not alter the sense that the band made a grave error right during the peak of their influence in the hardcore community. They may have recovered, but their ambivalent attitudes toward queer culture were cemented into punk lore; subsequently, both the Bad Brains and the Big Boys coped with conversations about the subject ("Why did it happen?") and fan repercussions, even after Biscuit's death. For instance, almost two decades later, the editor for *Rumpshaker* zine asked his readers: "could it be that we as individuals in a predominantly white music culture that nonetheless prides itself on its diversity . . . are afraid of being labeled racist by our own peers should we criticize the Bad Brains? . . . If the Bad Brains were Caucasian would their intolerant views about homosexuality have been more widely condemned?" (Weiss 2000).

The Bad Brains were certainly not the only New York City–based band that projected such sympathies. A 1984 hardcore punk piece in the *East Village Eye* depicts skinheads like Harley from the Cro-Mags. As the article tells, he joins others to fight gay men near the St. Marks Baths and the Boy Bar. Another skinhead bemoans the fact that gay men had copped their style—rolled

up pants and shaved heads—making him resent the "West Side assholes." Harley, in turn, attempts to divide up gays between "art fags" who drive up the rent in places like Avenue C, creating tension with Puerto Ricans too, and "homosexuals" for whom he has no love either (Rumsey and Gottesfield 1984: 5).

Despite setbacks, gay and lesbian participation in punk rock is historical and ongoing. Being outsiders, due to a subjugated sexuality, provides them a critical distance to deconstruct punk rock and "allow[s] them the possibility of creating a culture . . . outside the mainstream, which [is] innovative, yet critical of existing social and cultural standards" (Bronski 1984). As such, punk rock and queer culture have recently melded into tenuous and unstable queer-edge and queercore genres. These both continue to inhabit similar roles—resisting hetero-dominant traditions of both mainstream and punk culture through analysis, subversion, and reclamation.

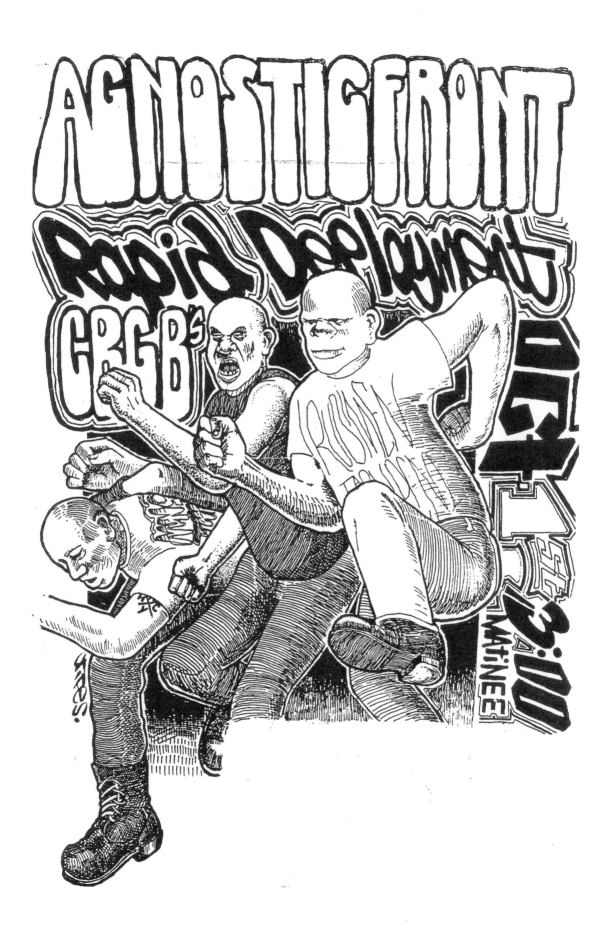

Agnostic Front and Rapid Deployment at CBGB, New York City, 1980s

Sunday June 13, 1999

xLIMP WRISTx
(x-Los Crudos)

Queer Straight Edge Punk – first show!

HAIL MARY

kill the man who questions

At Stalag 13 West Philly 7pm
More Info/Directions 215-474-4532 Andrew.

Limp Wrist's debut show, at Stalag 13, West Philadelphia, 1999, artwork
appropriates Tom of Finland image.

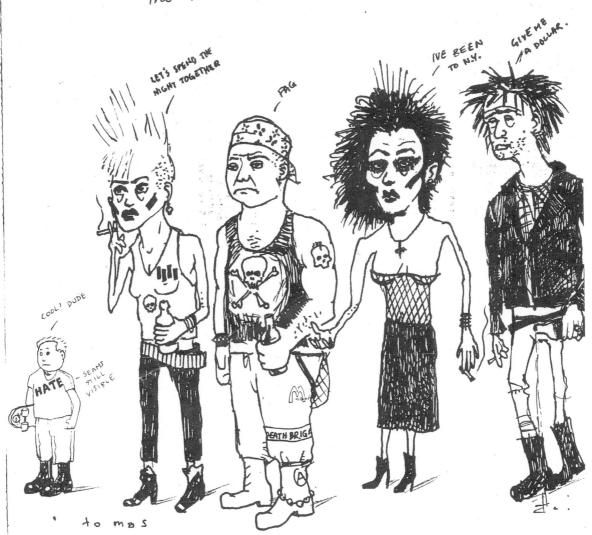

Beefeater at King Kongs, by Tomas, 1984.

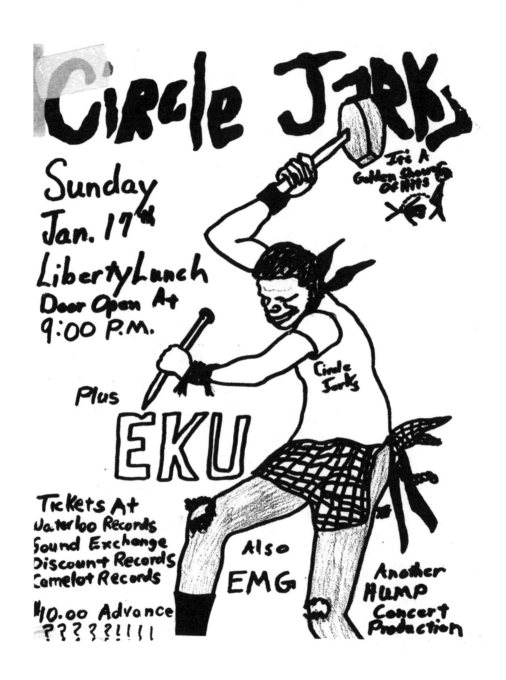

Circle Jerks at Liberty Lunch, Austin, Texas, 1980s.

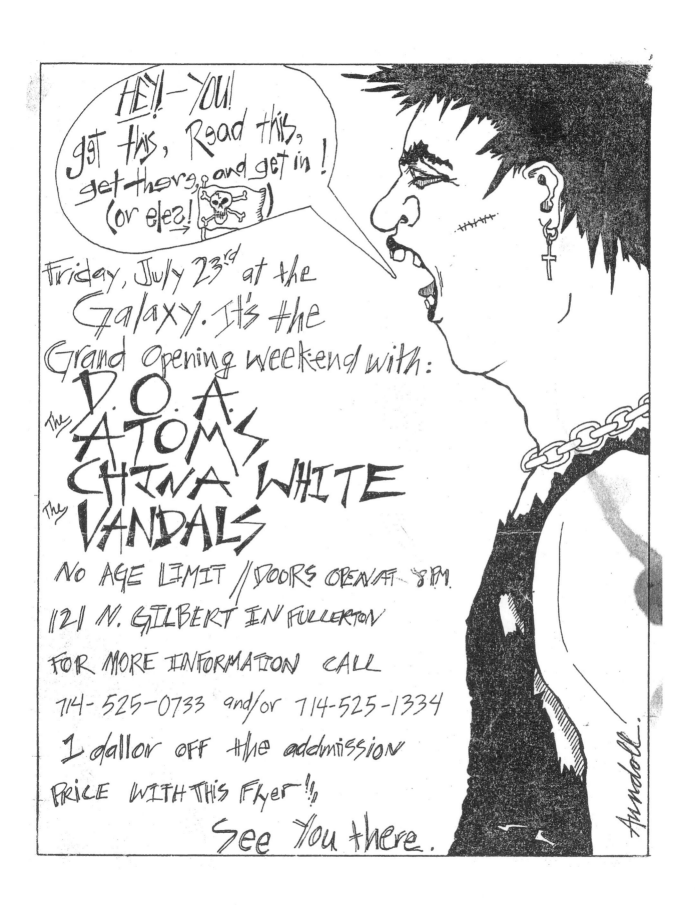

DOA, Atoms, Vandals, and others at the Galaxy Roller Rink, Fullerton, California, by Aundoll, 1980s.

doggy style
FROM CA

damage

di

sfa
NY STYLEE

CBGBS
DEC 6
3:00
5 BUCKS

SFA, DI, Doggy Style, and others at CBGB, New York City, 1980s.

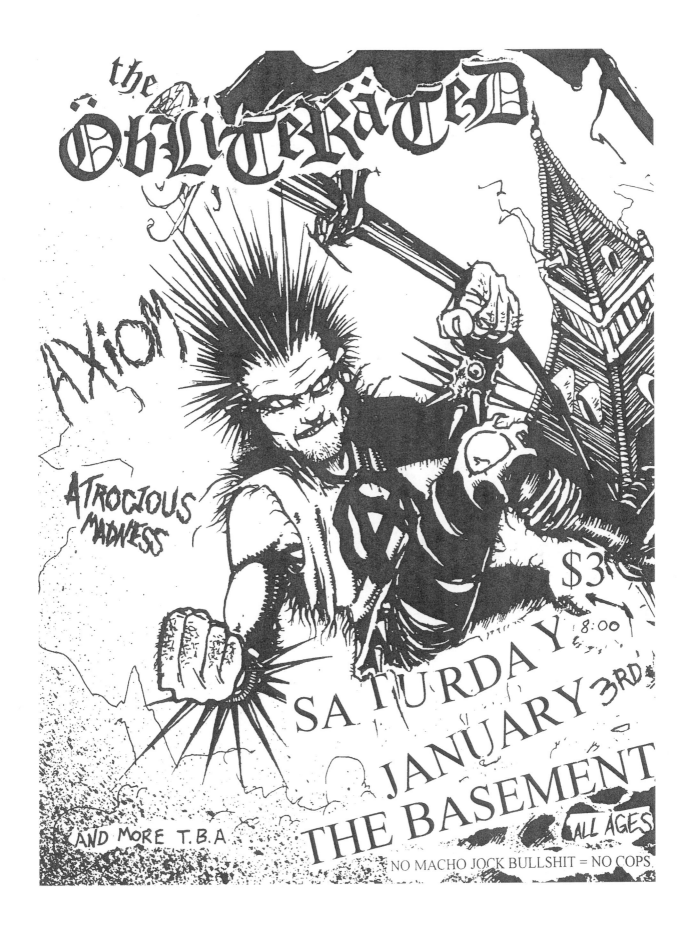

The Obliterated and Axiom at the Basement, Portland, Oregon.

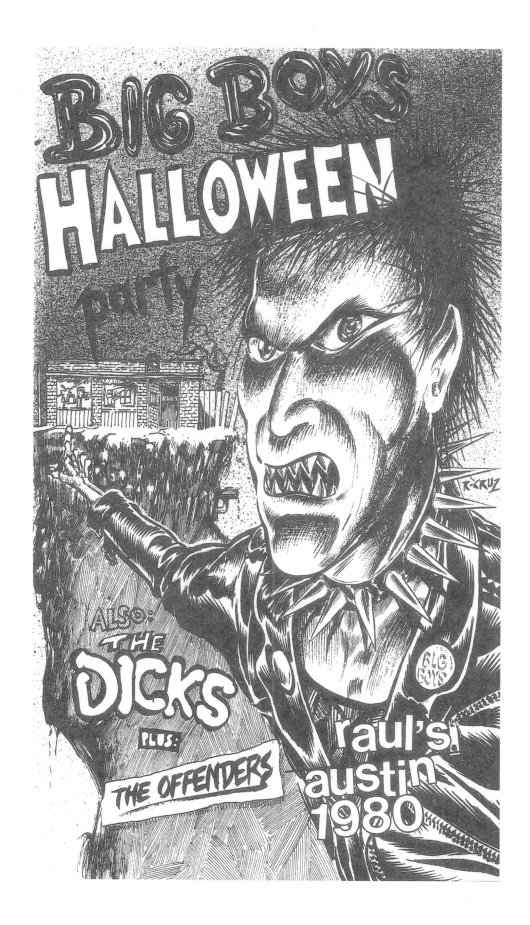

Big Boys, the Dicks, and Offenders at Raul's, Austin, Texas, by Ric Cruz, 1980.

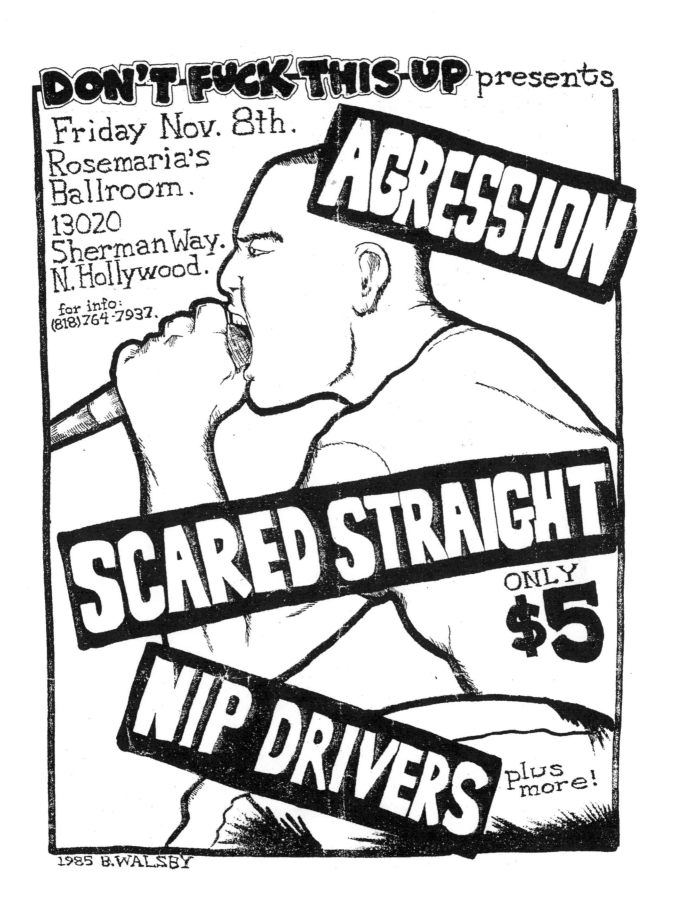

Aggression and Scared Straight at Rosemaria's Ballroom, N. Hollywood, California, 1985, Brian Walsby.

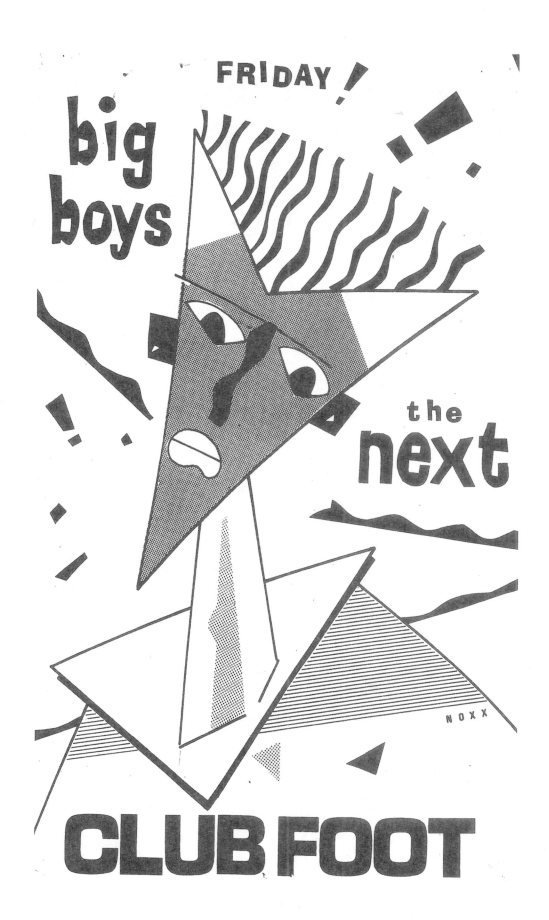

Big Boys and the Next at Club Foot, by NOXX (Michael Nott), 1980s.

BLACK ▌▐▐▌
FLAG

FRIDAY

This show is a legal
benefit for Black Flag/SST
vs. Unikorn Records

W/ FLESHEATERS

THE DICKS
(NEW ALBUM OUT NOW
ON ▬▬▬)

**SACCHARINE
TRUST**

SATURDAY

W/ REDD KROSS

THE DICKS

NIP DRIVERS

FRI & SAT
JULY
22 & 23
VEX
2580 N. SOTO

PH. 222 5600

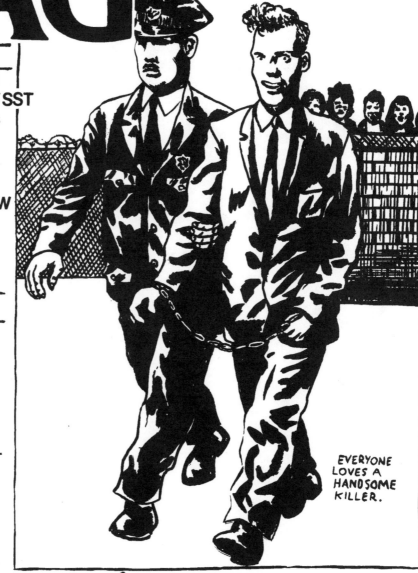

EVERYONE
LOVES A
HANDSOME
KILLER.

ART: Raymond Pettibon

▬▬▬ GIG INFO:
372-1848

Black Flag and the Dicks at the Vex, East Los Angeles, 1980s, by Raymond Pettibon.

CHAPTER SEVEN

CALL ME JEZEBEL

The Electrified, Unholy, and Wicked Women of Punk

. . . they were parading me around the jailhouse like I was the Devil incarnate, like they were exorcising the evil from society by beating the shit out of me.

—WENDY O. WILLIAMS, singer of the Plasmatics, on Milwaukee police (*Genesis,* 1986)

One major difference between punk bands and 1960s rock bands is that many young women abound in punk.

—RICHARD ROBERTSON, "Success Seen in Commercial Field for Punk," *San Antonio Press,* 23 January 1978

Images of women depicted on punk posters are often dominated by fantasy (often not designed by women at all) that reveal them as unstable and voracious creatures, detestable in some cases, purring sex kittens in others, or demure geek chicks in still others. They are hellions, sirens, vixens, and Medusas. They are Betty Page pin-ups, *Playboy* girls gone bad, and *Cometbus* emo queens. They are tattooed temptresses with perfectly manicured hair, or Mohican dominatrices, sultry and fierce. Often, they are buxom bomb-shells and voluptuous victims, or graven and sinister. In all, the array forms clustered libidinal fantasies played out by the fine-fingered, tight coil of boy hands projecting bodies of women seemingly born from the cinders of new and nostalgic girlie mags, all ages punk clubs, and ragtag fanzine piles.

Punk art may reflect or embody some historical themes described by Barbara Creed, a theorist who addresses depictions of the female form in general: "The female body is frequently depicted within patriarchal discourses as fluid, unstable, chameleon-like . . . insofar as woman's body signifies the human potential to return to a more primitive state of being, her image is accordingly manipulated, shaped, altered, stereotyped to point to the dangers that threaten civilizations from all sides" (1995: 87). Many writers imagine the punkified female body as uncontrollable, thus provoking male fear and desire. One might picture the "flagrant fashion" of the early 1976 era, when the workers at Sex would "use sex not to entice but to horrify," including infamous Jordan Hook (a prominent actress in the Derek Jarman punk apocalypse film *Jubilee*) who "wore cut-away-buttock plastic leotards with [a] black suspender belt and thigh high boots" while striving to make her "face and body as puke-promoting

repulsive as possible" (Burchill and Parsons 1978: 30). This was the body that antagonized notions of plasticized sex appeal.

The question remains: if some of these images are envisioned, produced, or authored by the hands of women, or approved by girl bands, can one argue that they employ a unique anti-patri-archal strategy? Such recalcitrant bodies do not acquiesce or comply with the norms engendered by the "system," even one devised by the punk subculture; thus, they might remain explosive

Beware the tagalong woman and her many diseases! Warts. Yeast. Aids.

—Text on a flyer for a L7 and Bad Religion concert, depicting a crucified woman in bikini encircled by snake, date unknown

critiques of gender roles. One should not simply view such flyers as mere male libidinal projections but also as potential sites of feminist discourse, too—cultural codes dismantled and re-imagined. Though male figures may be absent in a picture, their invisible presence on the page sits astride strutting Oi girls, virulent vixens, gutter punkettes, guerrilla Grrrls, scrawny fashionistas, bikini-clad hot rod bimbos, or mod primadonnas. The girls may be clad in white belts, spiked dog collars, and tight T-shirts, or gear that mimics Siouxsie Sioux,

Joan Jett, *and* Sleater-Kinney. Together the male and female presences, both visible and invisible, text and subtext, engage history, aesthetics, and subcultural mores and worldviews—the gestalt rendered by the punk eye.

Such images do have critics, such as Gabriela Halas, who wrote a furious letter to the fanzine *Heart Attack*, condemning an ad for a CD called *America's Hardcore* featuring an image "selling American patriotism and girls with big tits and shapely asses. This is the type of shit I thought I would leave behind when I became attracted to punk . . . this label is selling WOMEN to . . . sell their music, . . . they think it is OK to view our bodies as agents of the marketplace, to be manipulated and put on display" (#35). The editor responded: "it wasn't worth the time or energy" to remove the ad since it was "really lightweight . . . stupid and innocuous." What neither viewer addressed was the style of the art, which mirrored the iconic images of pin-up girls found on the wheel flaps of semi-trucks, which might have been ironically interrogated by the art, or unabashedly celebrated.

Tim Yohannen, the editor of *Maximumrocknroll*, faced a similar protest when reader Rikki Sender, in the letters to the editor section, argued, "I find it difficult to understand how MRR, which aspires to a certain scrupulousness in the type of ads it will and will not run," ends up running ads with "photographs which exploit the image of women as victims and posit them as objects of physical abuse" (1986). Yohannen did reject a Bang Gang advert for their "She Ran Fast . . . But We Ran Faster" EP, telling the band in a letter, "I'm sorry to disappoint you, but after discussing the matter of your possible ad with the staff of the paper, the consensus was that we shouldn't run the ad—due to the sexist nature of the song and the cover art" (1983). However, he did play the band's song "Stupid People" on his radio program and told the band to write back if they felt the fanzine misinterpreted the art.

In these cases, such images were not floating free of discourse in the punk community without resistance or critique. Even as late as 2002, *Maximumrocknroll* was criticized by Adam Wroblewski in a letter to the editors for running 124 interviews with all-male punk bands over a period of 14 straight issues compared to only one all-girl band interview. Likewise, Gigi Fauquet once wrote a letter to *MRR* brimming with indignation: "I still leaf through *MRR* hoping for an enlightening letter or article. But, as my feminist awareness increases, so does my disgust for *MRR*. It's not so much the fanzine itself, but the bands pictured, interviewed and discussed. The hardcore scene is so disgustingly male-centered." She also ventures beyond a mere critique, choosing to end her letter by quoting a portion of Susi Kaplan's *Radical Feminism* and advising women to both "get rid of non-feminist men" as friends and lovers. These remarks follow up, and contextualize, her earlier exhortation to young women: "take up thy guitars and pick!" (1987). These illustrations suggest that readers actively monitored each magazine, attempting to draw attention to the divide between punk's questionable feminist ideals and its everyday products—the very visual and written discourse printed in fanzines that normalize notions of punk to thousands of people every month.

Not all women in punk saw these images as vexing. To suggest so would be to treat women in a totalizing manner, seemingly recolonizing them by putting borders around their perspectives. Indeed, academics have often done that in the wake of the Riot Grrrl punk subgenre, for the critiques stemming from that single faction of punk rock have often homogenized punk discussions, undermining the sense of vibrant difference and polyglossia in punk rock. This left pioneers like the Fastbacks outside the critics' radar. Singer/bassist Kim Warnick proclaimed to *Ruckus* zine, "I'm just a person in a band. I don't have a huge political agenda. I have my own opinions, sure,

both at the site of performance and through everyday interaction by dismantling stereotypes both within the punk subculture and the mainstream, each with a different set of consequences, on and off stage. Such tendencies might culminate in what Karina Eileraas has described in her article "Witches Bitches and Fluids: Girl Bands Performing Ugliness as Resistance" as "an intentional deviation from 'nice, gentle, pretty' ways of looking, talking, behaving, and visualizing," conveying "a resistant practice that challenges cultural representations of 'pretty' femininity" (1997: 122).

For instance, Tina Weymouth explained, "I didn't want to get caught up in that sex symbol thing like poor Debbie Harry. . . . I wanted to downplay that aspect. I asked David [Byrne] to cut my hair short. . . . And I wore plain clothes—kind of a girl in boy drag" (Zeff 1981: 8). In doing so, punk women link to "ugly, unruly and persecuted female identities throughout history," in which they create their own set of images, or remold old sets, that explore "the violence to and alienation from the body that obedient performances of "pretty" femininity entail (Eileraas 1997: 123–24). Additionally, women can redefine "pretty" through their own gender-bending song discourse too, as highlighted by this lyric sung by Diane Chai, bass player and singer of the Alley Cats: "when she smiles she looks so sweet / always wanted to be one of the boys / make all that rock 'n' roll noise" (1982).

The male attitudes encountered by females in the punk club circuit were often a combination of outright, unambiguous, and intentional misogyny offset on other occasions by slightly more innocuous sexist slights. A conversation with Trish Herrera, longtime guitarist, singer, and keyboard player (not to mention flyer artist) for the Mydolls, in which three out of four members were women, contextualizes the efforts of punk women during the early 1980s. A few national recognized male figures helped nurture the band: Ronnie Bond, singer of Really Red, issued their records on his imprint CIA Records, which he began with his wife, Linda, who sang and played guitar for the Mydolls; Calvin Johnson—a Sub Pop fanzine contributor, cassette compilation enthusiast, and later Beat Happening singer—wrote an enthusiastic fan letter asking to include the Mydolls on a cassette-based magazine; producer Spot (Black Flag, the Big Boys) wrote a glowing review in *Flipside* during a Texas trip; German director Wim Wenders befriended the band while visiting Houston and used their song "A World of Her Own" on the soundtrack to his film *Paris, Texas*, and featured members of the band in bit parts; and DJs like Jim M. from KUSF, the radio station associated with University of San Francisco, admired their work while bemoaning the "lost egalitarian 'new wave' viewpoint" that had been supplanted by an attitude "as macho as big time cock-rock" (1981). They might have been unabashed, fervent supporters, but many others fell short. As Trish tells it:

When we played with the Big Boys, Biscuit [the singer] said, "You girls are good but shouldn't you be home cooking eggs?" I love that he was joking, of course, but still . . . Most of the managers/owners of the clubs wouldn't deal with us directly. They wanted to deal with George or Ralph when it came to paying the bands after the shows. Philadelphia had the worst sexists ever. The men there felt really harsh, and I felt like they looked down on us. Maybe I am imagining it. But we had a guitar stolen there too. It felt like punishment to me. It was Linda's guitar. Really felt like a rape.

Phil Hicks, the manager of The Island, a club in our hometown, gave us muffin parties when we played and the boy bands got hot dog parties. So what about that sexism? When we met a band that had a woman in it, we were glued to them. Get Smart and Ragged Rags were great bands with women in them.

We got a little pushed around in the slam dancing piles, but occasionally we would get in the piles with

the guys if we knew them. I never dived off the stage. I was scared because people would back away and let the diver fall on the floor . . . Once in an interview a guy called us Three dykes and their Father, while in Columbus some guy tried to come onto Linda and then wrote an article all about her and how sexy she was, or something to that effect. (2009)

One should recall that such incidents occurred during an era in which fanzine contributors, including a writer for the *Free Beer Press* out of Michigan, prefaced reviews of the Mydolls live shows by stating, "I'm not a chauvinist but I am horney. And women with instruments just make me hornier," followed by "the Mydolls came up next, 3 chicks and what looked like their father on drums. Pigboy says they looked like dykes" ("T-Snakes"). The Mydolls, in turn, did not let this slip beneath their radar. Instead, they sent a letter on CIA (their record label) stationery declaring:

> Got the impression you spend a lot of time wanking off and apparently you're better at masturbation than journalism. . . . Why not reveal your names? . . . You boys play it safe. . . . Your review aimed at "tits and ass" shunned those over 30 and humiliated those overweight. . . . Your comments . . . suggest a pimpled, frustrated, unexposed, blindly middle-class product desperately hoping to shock mom and dad by punking-out and saying dirty words. . . . We call primitive mentality such as yours "RED NECK". (1983)

Punk might have allowed retrograde sexism an opportunity to flourish—via cheap fanzine soapboxes—but it also allowed for feedback, a built-in circuitry of sorts, in which bands featuring women could contest such attitudes and respond, fiercely and intelligently, thereby testing basic punk principles. For the Mydolls, punk defined itself as a vanguard pop culture movement aimed at "dissolving barriers," real entertainment for the "post–Me Generation, male-endowed glitz and glam rock era," not a place for "worthless trash with a pitiful excuse for a prick" to boldly proffer a sexist version of punk values and lore without consequence. Such exchanges were volatile and vitriolic signs of the times.

Describing the band's musical sensibility in the midst of such casual ambivalence, Herrera once told journalist Diana Rubino that the Mydolls' songwriting style was neither coarse nor innocent; instead, it was "ignorant, since we've never really played before." They embodied a truly DIY effort. Following up, she stressed: "I want our band to be intelligent. I don't want to be real cutesy pie or insulting or abrasive. Sometimes I have to be abrasive to make people listen" (date unknown).

"A lot of women get a tough attitude, not aggression but forthrightness, a real strong feeling of who they are," argues Ruth Schwartz, a founding co-editor of *Maximumrocknroll* and entrepreneur behind the independent distributor Mordam Records since 1983. "They're capable of going places where most women would be scared to go, and they take on a group of guys that are assholes and put them in their place" (qtd. in Goldthorpe 1984: 19). Hence, she suggests females in punk exerted a distinct know-how, confidence, and forcefulness that might be mistaken as abrasive by men.

Abrasive also does not have to mean hardcore, either. In an article that deconstructs the performances of Joan Jett, Kathleen Kennedy asserts a third way of constructing identity that is neither masculine nor feminine but an interrogation of both that leads to a distinct, "unruly" Jett style. For instance, she analyzes Jett's "Do You Wanna Touch Me" video, a hallmark early 1980s favorite, and describes how Jett, once described by Raymond Pettibon as having "a bigger dick than Hulk Hogan" (qtd. in Penalty 2010), destabilizes or reverses the "normal" routines propagated during this era:

The video mocks both the traditionally female and traditionally female subject positions in those videos—that of inviting a male to touch her—and the traditionally masculine position of those videos—overpowering women with physical prowess. The body Joan Jett reveals is a mixture of contradictory masculine and feminine signs. It is a position in between the conventionally gendered body. Rather than mimic male masculinity Jett's performance of masculinity interrupted the clear binaries within middle-class society that linked biological sex with appropriate gender and sexual identities (Kennedy 2002: 99).

Such a performance likely attracted a wide audience (the video has logged over 170,000 views on www.youtube.com), including both typical male rock 'n' roll fans but also teenage girls and gays and lesbians. Though Kennedy focuses on Jett's rather ambiguous gendered body—a slim athletic body in a small swimsuit—she chooses to ignore Jett boxing with a well-oiled black man.

They pose together as the scene cuts and back and forth to a huge arena crowd clapping hands in tight, rhythmic unison. Later shots include Jett boxing at the camera (the subject position becoming the viewer) and having lighthearted moments in the beach sand, like Jett smashing a bass drum and an old man scanning the foreground with a metal detector. Is Joan seeking to find gold by smashing stereotypes and aligning herself with the much-maligned black body? That symbol system remains unexplored, but his chest and bicep muscles flex, juxtaposed with full shots of Jett's scantily clad body, backed by this soundtrack: deep growls of "yeah, yeah, yeah." Despite the possibilities, such arena rock, even when shaped by Jett's punk pedigree, likely did not hold too much legitimacy within the hardcore community of the era, even if the performance, to borrow from Ryan Moore, undermined the dominant meaning supplied by the status quo social order and parodied the power behind it, which is what punk ideally tried to accomplish (2001: 311). Also, if this is true, and the performance does not dismantle cliches, has it then, as Hebdige might argue, recuperated rock 'n' roll and reasserted the old "repaired" social order?

These performances existed in an era when punk bands readily offered a steady diet of sexism, like GBH's "Big Women (Dedicated To All You Feminists)"[4] and "Slut," the Queers' "I Want Cunt," the Meatmen's "I'm Glad I'm Not a Girl" and "Lesbian Death Dirge," the Angry Samoans' "You Stupid Asshole," DOA's "Tits on the Beach," the Dwarves' "Skin Poppin' Slut," and the Mentors' "Four F Club" ("Find Her, Feel Her, Fuck Her, Forget Her"). Bill Stevenson from the Descendents, the band who penned both widely loved romantic punk pop songs ("In Love This Way") and raw, juvenile, sexist tirades like "NO FB" ("No Fat Beaver"—with the lines "I don't wanna smell your stinky beave . . . I'd rather be shot") explained to me in 2003:

> We tried to emulate the things we were hearing in the songs and also this kind of prevailing browbeating of girls and women, which you know, that's done by male ignorance because you don't know any better and you're insecure and afraid of women as a young man. . . . I was kind of a dumb kid, I was raised very white bread sheltered. . . . I was raised by a conservative man from the Midwest. My father worked two jobs and didn't have a lot of time to teach me things, and even if he did try to teach me he would teach me to be a racist or something, so I had to learn to be a good human in my 20s and 30s. I am still learning.

As letters to zines like *Flipside* attest, women were regularly harassed by club employees. In 1989, Jacqueline Fauteux described the clubs 1970s, Helter Skelter, and the Stardust Ballroom, where security guards felt "it is their right to touch,

kiss, caress, and maul the female club goers" (#63). Such incidents likely were not rare. By and large, one might argue, the punk scene often mimicked the very culture it supposedly loathed, acting out sexist stereotyping and intolerance; hence, the notion that punk offered different gender roles often is more like a trope or convenient fiction than a reality. That may be just one reason that letters to editors and columns in a wide array of zines constantly illustrated the debate, such as Gabriel Kristal penning one entitled "Why Ending Sexism in the Hardcore Scene Is Men's Responsibility." She suggests men must constantly attempt to recognize the inherent sexism of not encouraging female performers; their own roles in the shaping and fostering of sexist environments through language and pornography; and their failure to address the physical needs of women in punk spaces, such as not providing childcare (2000). Yet, in a *Maximumrocknroll* issue over a decade earlier, V. Verdi, a punk woman writing a letter to the editor, argues that "X-rated movies and *Hustler* exist because of [a] mental difference between men and women," including the fact that their sex drives are often different. Hence, what high-minded moralists call "smut" actually serve a useful purpose. Women should feel thankful" (1986).

In this discourse, Kristal might be targeted as a "moralist." To further complicate matters, *Maximumrocknroll* had previously run an article covering the pornography debate, "Ed Meese and the Question of Pornography" (1988), which was highly critical of the Meese report. Longtime female flyer and album artist Shawn Kerri (Germs, Circle Jerks, DOA) published lewd cartoons. By the 2000s, alt-porn and punk porn became market forces in the era of FrictionUSA, Supercult, Razor Girls, Suicide Girls (including a burlesque show, clothing line, and web site), PunkGrl.com, Heartcore Pictures, Crazybabe.com, Belladonna, Reel Queer Productions, and Joanna Angel (Burning Angel). At least part of the philosophy and overall drive is to reclaim porn from a "fake and

bake" aesthetic, coupled with "punk rock rhetoric and DIY packaging" (Koht 2005). Hence, punk provides no fixed meaning or way to cope with gender issues. Women and men in the scene have to continuously navigate and negotiate these cultural swells.

Early on, a few prominent women writers identified with the shock therapy of bands like the Sex Pistols. Writers like Ellen Willis preferred them to the "women's genre," for they offered "the music that boldly and aggressively laid out what the singer wanted, loved, hated—as good rock 'n' roll did—challenged me to do the same, and so, even when the content was antiwoman, antisexual, in a sense antihuman, the form encouraged my struggle for liberation. Similarly, timid music made me feel timid, whatever its ostensible politics" (qtd. in Stein 2006: 61). In contrast, Karina Eileraas surmises that "the punk aesthetic embodied by the Sex Pistols, consisted of self-defilement, or 'uglification' . . . reductively speaking, punk enlisted cursing, safety-pin fashion, and the animal-like snarl. . . . Punk imagined the body as a quasi-Hobbesian state, rule by uncontrollable urges for sex and violence" (1997: 123) She seems to unconsciously graft two punk song title together here—Devo's "Uncontrollable Urge" and "Sex and Violence" by the Exploited—while countering Willis's premise that punk was anti-sex.

Willis's depiction also suggests that the brash, aggressive, "primitive" modus operandi of the Sex Pistols seemingly trumped the introspective, earnest, and careful approach of the women's genre, which might have merely masked tendencies toward submission, or at least lacked the physical indiscreetness, or raw physicality, of punk.

Still, Camille Paglia argued that women essentially lacked the testosterone and basic hormones of punk. In 1991 she declared that there had not been a great female guitarist in the last twenty years, although Simon Reynolds has suggested that greatness is a kind of broad loose term that should be met with suspicion, since women's

approaches may differ; for instance, he cites the cooperative, mutual guitar interplay of Throwing Muses. Writer Luce Irigaray's work on the nature of female subjectivity may lend credence to the fact that one man's solo may be a woman's gap, breakage, and fragment. Also, the suggestion that girls lack a rock 'n' roll physicality is seemingly interrogated by the following lines, offered as exhortations of the female body: "our living, pariah skin: the memory of our skin; the unforgettable landscape of our skin; the molecular, danceable, corruptible, sickening journey of our skin . . . our fluid, mad, exiled, mutated, villainous, impossible, uncontainable" lives (Golding 1995: 173). These depictions paint a woman's body as being as transgressive and rock 'n' roll as any man's.

Mood Music for Degenerate Girls: The 'Terrible Beauty' of Women in Punk

The arguments of Paglia tend to ignore, even erase, the trailblazing, self-aggrandizing, meaty guitar work of the Runaways, L7, 7 Year Bitch, Lunachicks, and others, whose combined work deflates the notion of rock 'n' roll crunch and swagger as being phallocentric. The blurred gender of rock 'n' roll is a byproduct of a total physical metamorphosis of the body into a metaphoric unit of noise production. In rock 'n' roll, the genderless body segues into technology, fusing industrial-grade parts with organic host sensibilities, becoming an ambiguous body writhing with electrodes. As Larissa, guitarist for the much overlooked Laughing Hyenas, describes it:

> I love music so much. It's so physical for me. People think that dance is the only physical art form, but I don't think it's physical; I think it's visual. It's about how graceful and beautiful the body can be. Music is the only physical art form available, and for me the feeling is irreplaceable. For me, I feel electrified

when I play. It's as if someone shot a lightning bolt through my body and into my guitar, and I just want to explode into feedback. (1989)

This was nothing new. Michelle Hennings explains that, "turn of the [twentieth] century images of electricity and electrification depicted women emanating electricity from the fingers, holding together the wires of the newly electrified city" (1998: 34). Such ambiguous electric or electrochemical processes emanating from women—referenced in archetypes ranging from images of Medusa, to poems by Rimbaud ("Les Chercheuses de Poux"), to an electrified vamp in the film *Metropolis*—typically trigger twin engines of fear and enticement in men who encounter women with such transmogrified bodies. Lisa from Mudwimmin attested to *Puncture* magazine: "Our inspirations are the goddesses of amperage, wattage, and voltage. You're in a room playing electric, and people are listening, and the people are made up of water mostly, and water is major conductor of electricity" (qtd. in Hanrahan 1990: 61). Lisa appears to both describe a kind of religious or out-of-body experience fostered by the unique potential of rock 'n' roll to produce an intense, shimmering electric field.

Rock 'n' roll also offers the possibility for women rockers, and listeners, to experience an all-encompassing, primal, voltage-infused atavism as the body becomes a porous conduit. Thus, the space and time engendered by such music is liminal, popularly imagined as a between and betwixt state, like a "time out of time" experience offering a brief suspension of conventions and norms. Perhaps such space may even be considered a third sex, neither male nor female. As Mish from Sado-Nation explained to me: "I would push it so far sometimes. I would have a sort of out of body experience, and I would get totally lost in the music and the energy. I couldn't always tell you play by play what happened in the show, since I was long gone in a place deep inside me, and

195

what was released was pure primal animal energy. It was no longer me. It was very exhausting and exhilarating at the same time" (2005). "Punk brought me out of my head and into my body," Greta Fine (Mandy White) from Bang Bang!, one of Chicago's premier neo-punk bands, tells. "Nothing was emotional anymore: it was physical. The music was rough and immediate. It was raw and ugly." Punk seemed to be a trapdoor, allowing women to slip away from their habits and roles down into their own physicality.

Though rock critic Joe Carducci infers that girls feminize music, lack the hormonal set-up to feel it in the gut, or are alienated from their own physicality, the descriptions of both Larissa and Mish appear to reveal the self-limiting, inherent sexism of his claims. Electricity recognizes no sex, and it may transform personas, identities, perhaps even bodies. SST's Summer 1984 newsletter hints at this, though jokingly, as well, for Davo announces that Kira "attends UCLA where she holds a PhD in low end and experiments with gene mutation through volume." Unlike Carducci's assumption, women's bodies can be circuits just as well as men's bodies. Rock 'n' roll evokes a genderless body. Yet, an electric female body may be tainted, some argue, due to the "recalcitrant physicality, which breaks out, out of place, as dirt, as disease." This unbound female body threatens the social order of punk (Pacteau 1999: 92). Carducci's claims act as merely part of on ongoing trope, not a truth. He imagines the space of rock 'n' roll as phallocentric.

Even in 2010, *Maximumrocknroll* columnist George Tabb sardonically insists that, "Women do not belong in rock . . . chicks in bands belong in rock 'n' roll about as much as salt belongs on an open wound." He blames genetics for making males more "wild and savage," a foundation for rock 'n' roll behavior, masturbation for men's ability to learn guitar easily, and women's small hands and inability to "wank" and "blow a load" as the common causes of their incompetent guitar

abilities. Girl drummers also have "too many brain cells" to be moron drummers, a necessary precondition of rock 'n' roll percussion. However, lesbians and "loose girls" offer rare exceptions to the rules. Granted, the whole diatribe is meant to be tongue-in-cheek, but it still evokes and mirrors clichés disseminated and naturalized throughout punk discourse.

Whereas art movements such as futurism may have deplored women's bodies, or femininity, as conservative and retrograde (Herring 1998: 32), I suggest that punk electrified the female body, collapsed gender roles, and even perhaps momentarily de-phallicized the rock aesthetic. As Larissa from Laughing Hyenas, whose tastes spanned the art of De Kooning and Rauschenberg to the novels of De Sade and Dostoevsky, told *Maximumrocknroll*: "People ask me about being in a band with three guys, the only difference is that I piss sitting down. I eat, breathe, and feel the music as much as they do" (Walter 1991). The bandmates of Mish Bondage of Sado-Nation similarly noted that she bridged "the gap between male and female, all of a sudden it is non-sex" and described her as being like "any male musician" (*Flipside* #40, 1983). Such "fluidity, ambiguity, and hybridity are 'threatening,'" Karina Eileraas asserts, "because they represent the possibility of an in-between, of contamination" that trace back through a feminist strategy to "generate subversive, feminist reconceptions of sex and identity . . . as artists claim their bodies as their own battlegrounds, waging war on oppressive limits," which relates to queer theory's desire to dismantle them as well (1997: 137).

One can also argue that such women did not and do not necessarily exploit their own tomboy, gender-blurring tactics and presence per se, nor did they feminize the form, nor do they queer it. Instead, they negotiate outside suspicions about social behavior from fans and lovers, navigate the pitfalls of having their aptitude, skills, and abilities deconstructed in terms of gender, and keep keenly aware of the dynamics of off-stage spaces,

such as vans and motel rooms, or the discursive spaces of rock 'n' roll magazines. As Mish Bondage reveals:

It's complicated . . . the whole issue on how women were treated, and what women did or felt they had to do to "get ahead" . . . I have mixed feelings about it. I feel sometimes like I'm under the microscope. If I dare have sex at all I'm a predator with her boytoys. . . . I'm the bitch with the bad reputation who you should know better than to go out with, stay the hell away from the she-devil . . . this mostly from people who don't know me very well personally. I am a threat. Why? Because I dare to follow my own heart and be independent and rely on myself? Bands with harder core women like me many times get ignored by the press cause we aren't a pretty magazine cover. Or the armchair critics who like the male vocals on Sado, but dislike the female ones. Why? Cause girls don't do hardcore? Cause you subscribe to the Tom Lykas bible? Cause women suck in general? Cause women who aren't cute and in their place are fucked? (2008)

Similarly, Kira from Black Flag and Dos also noted to me:

Girls grow up as tomboys all the time and always have, that they would naturally always participate in music and sports in garages and playgrounds. Mo Tucker is a good example and there are many we haven't heard from. There is no obstacles in the playing, in the interest, the capacity, the role, sex symbol or otherwise. The difficulties (from my perspective) come with some personality stuff between men and women, the physical challenges of some instruments, and of touring in general. Guys probably didn't want a girl with them on the road in the van, whether they were dating a member of the band or playing. Any signs of physical weakness or lack of technical prowess (not understanding signal flow) would be accepted between

guys but not by a guy for a girl. And there is this underlying assumption that sex is somehow always at play. If I am in the van talking to someone for a while alone, sex must have occurred. Girlfriends of band members also don't appreciate the girl player who goes on the road with their sweetie while they stay home. (2005)

This is the workaday world of a female band musician, not exactly the intriguing conceptual space coveted by punk theorists. As Greta Fine confers:

As a woman in rock . . . hmm . . . I get a lot of dudes assuming I can't play my instrument until after our shows when they then come up to me saying things like "You play your bass HARD like a guy!" NO dumbass, I play my bass hard because that's how I play! Another fun thing I had someone say was when I was at Guitar Center before our last tour when I asked for my strings and the salesman pointed to the strings I was asking for and said, "These? These are bass strings, ma'am." No shit? Is that the instrument I play? It's not hard being a girl in a band but you do have a lot of colorful assumptions made about you, but I get to set them straight. (2008)

Punk becomes a primary mode for some women to interrogate long-held assumptions about gender and musicianship while also infiltrating and destabilizing typically male spaces, such as musical gear shops (with their pretensions and jargon), and gig spaces like all ages venues. All these were sites of contestation between genders.

Robin Barbier, a punk fan since the mid-1980s from the Midwest and Southwest, drew me a conversational picture of a gig space that offered a sense of community and bonding not overshadowed by boys, who are absent from her depiction. This highlights a sense of women forming their own bonds and associations, molding modes of resistance and learning, and enjoying a tight-knit

scene often overlooked in male-authored histories of hardcore:

> The "hole in the wall" offered us a place to release our anger and pent up frustration. The music was often politically charged and not only did we come out feeling like we could deal with another week we often ended up learning a thing or two. It was an awesome scene; at least from where I was standing. We thrashed hard and I often came home tattered and bruised, but not as a result of fights just from pure unadulterated moshing. If someone fell in the pit numerous hands were on you to pull you out before you got trampled. Being there gave me a feeling of community. One of the chicks from our group used to say something to the effect that we were individualists looking for someplace to belong. Now that might not seem very punk to some out there but it really is more fun to belong to a group of freaks than to be the only one. Being a girl in the scene was a pretty great place to be during the whole high school thing. We didn't care about clothes, being popular, or our hair being perfect which seemed to be a pastime of other girls in the 1980s. That left a lot more time to expand our minds. (2008)

These are not the traditional images of women found in punk posters. Perhaps little more could be expected from the visual culture of men whose behavior is typified, as sociologist Lauraine Leblanc's study shows, by four categories that her women subjects describe, including men "as standoffish, sexist, or abusive, men as protective, chivalrous, or gentlemanly, males as respectful and egalitarian, and men as flirtatious or sexual" (1999: 118). This seems little more than a reflection of men throughout the world at large, which is explained by writer Jen Angel in a 1997 *Maximumrocknroll*:

> though punks leave mainstream society (hopefully) and give up mainstream social practices and expectations, all we do is recreate these expectations on a smaller level in our own society. That sucks. We reject the uniforms and the conformity of society but we not only create but tolerate the same in our own scene. This could mean that our socialization by the dominant culture is so pervasive that we cannot get away from it, or it could make a comment about our basic needs as social creatures (to fit, to conform, to have a peer group).

L7, from Los Angeles, was known to confront males in audiences who harmed girl concertgoers, even hit them with mic stands. Wendy O. Williams, singer for the Plasmatics, was sentenced by an Illinois judge to supervision for one year and fined $35 for supposedly battering a freelance photographer who tried to snap her picture as she jogged along the lakefront circling Chicago. In 1981, *Creem* reported that Wisconsin police had assaulted Williams as well. As she tells it: "In Milwaukee, the cops asked me to step outside. One of them grabbed my tits. Another grabbed my rear end. So I smacked them. Then they threw me down and handcuffed me hostilely in the snow while one of them beat me up. I'd have gone along peacefully, but I was outraged intellectually" (qtd. in Matheu 1981). Years later she described the event slightly differently to *Genesis*: "I was nearly killed by the police . . . they beat the shit out of me. The cops made a circle so nobody could see what was going on . . . it was a disgusting thing" (qtd. in Lovece 1986: 42).

Williams often appeared on stage in a nurse's uniform, electrical tape or shaving cream barely eclipsing her nipples, and attacked guitars with chainsaws, unleashed shotgun bursts at amplifiers, and pounded television sets with sledgehammers—even on live TV such as *Tomorrow with Tom Snyder* (Strauss 1998). Performances by the Clash, Ramones, and others seem mild by comparison. The ribald, uncontrollable, frenzied image of Williams that was broadcast to millions, underscored by her sandpaper-blasted voice and

lean, mean presence, stood in stark contrast to her supposedly reserved vegetarian lifestyle outside the media circus. She single-handedly reversed the notion of what Simon Reynolds and Joy Press have deemed the problem of rebel imaginations of the female, which pictures women as "everything the rebel is not (passivity, inhibition) and everything that threatens to shackle him (domesticity, social norms)" (1995: 3).

She resisted the patriarchal notion that females should embody passivity, restraint, and quietude. A former sex act star from Times Square (Captain Kink's Theatre), who performed non-sex roles in two porn movies (*Candy Goes to Hollywood*, in which she shoots ping-pong balls from her vagina, and *800 Fantasy Lane*), Williams eventually worked with the likes of Gene Simmons from Kiss. Her unabashed approach suggests that sexist, retrograde notions of women were entirely bankrupt by 1980, incinerated in the smoke and ash of Williams's performance. Similar sexist notions of female passivity were also dismantled by the more cerebral, but no less hostile, critiques by Crass on the album *Penis Envy*.

Even Cherry Vanilla, who is often ignored by punk histories, challenged gender norms within the punk cliques. "We were all very sexual animals and the aggressive sexual image had a significant amount to do with our bad press," argues keyboardist Zecca Esquibel to *Punk77*. "I would find it very very difficult to name a single punk band that was sexual. Nobody had the hormonal level we had on stage. We carried ourselves down the street as sexual animals which was very unpunk" (2006). These variations offer a deep critique: punks who abide by a rigid, sexist ideology, which bolsters the underlying social control of women, are no longer really agents of resistance—not punk at all. Punks should break boundaries, not shelter and nurture them.

Karen Neal, the singer of Inside Out, reflecting on the mid-1980s Detroit hardcore era, recalled the band getting into bar fights, including her pulling a knife on a skinhead (Smith et Al. 2005). This was not a college text–driven, hypothetical, feminist disruption of paternal patriarchal symbol systems; this was a turf war in a grimy club. The Lunachicks experienced tame and polite crowds when playing with the Go-Gos, No Doubt, and gender-bending Marilyn Manson, but were met with open hostility when opening for the Offspring. Nearly one entire St. Paul, Minnesota, crowd yelled "Show us your tits," the band asserts. Fans of Guttermouth threw bottles at them in Soma, California, while the Rancid crowd in Washington threw objects until the bass player from Rancid stage-dived during the Lunachicks set, signaling to the crowd that perhaps it was not uncool to like this band. The band describes these males as feeling threatened by these "crazy, larger-than-life, freaked out looking, really strong, tough chicks" (qtd in Drunk Ted 1998). The Lunachicks' disruption was real, and so was the price they paid.

Equally important, women, even those in the era of Riot Grrrl gender politics, did not always pose an alternative, as Brody Armstrong of the Distillers realized: "As far as women and unity within the scene at shows, I felt there was this hypocrisy, because my last band played with some of the 'feminist bands' and for all the shit that they spoke, they didn't live up to any of their ideals in front of me. It was so Nazi to me" (Fleming). Thus, like other punk females, Brody was aware that the "norms of femininity can be changed through practice, and the rules change as we play them out differently" (Leblanc 1999: 139).

Other women also pointed out some shortcomings in the genre/movement. Carrie Crawford, writing in *Heart Attack*, specifies that Riot Grrrl's "version of self-determination . . . just didn't go far enough for me. I didn't want to reclaim girlhood. I needed to situate the notion of women's empowerment in larger context of revolutionary change . . . It wasn't enough to deconstruct the paradigm of power in punk. . . . There was more

than a material battle being waged." Despite such critiques, women in the hardcore punk scene during the midst of Riot Grrrl seem to convey similar sentiments toward its historic significance, perhaps described most succinctly by Rachel Holborow, bass player for the British post-hardcore band Red Monkey: "Riot Grrrl created a crack in punk rock/independent circles where women were only answerable to themselves" (qtd. in Choi 1999).

Unfortunately, critical understanding of women in hardcore history still comes slowly. In the late 1990s singer, label owner, and fanzine columnist Felix Havoc lamented the fact that "After hardcore took over we see fewer women involved. And seriously in the straight-edge scene there were almost no women, as fans," suggesting from personal experience that as hardcore took root in boys' imaginations during the 1980s, Goth took root in the female imagination (*Heart Attack* #18). He uses this summary to explore the issue of labeling any bands as "girl bands" because it seems to frame and even market them as sex objects. He also explores and discusses female participation over the years. First, he recognizes they have held pivotal positions in the music business, but he offers no illustrations, even though Ebullition (Sonia Skindrud), Revelation, Lookout Records (Molly Neuman), Equal Vision, and Frontier Records (Lisa Fancher), who released recordings by the Circle Jerks and Suicidal Tendencies, were partly (or in the case of Frontier Records, solely) operated by women. Next he explores at length a wide range of punk and hardcore bands, including the overlooked Sin 34, Fatal Microbes/Honey Bane (England), GASH (from Australia), and Distjej, Livin' Sacrifice, and Diskonto (the last three being from Sweden).

This at least fills in the gaps that even many women writers have left, such as Maria Raha in *Cinderella's Big Score*. Although the book itself is a noteworthy overview of women's contributions to indie and punk music, author Maria Raha can muster up the name of only one female hardcore

band, the obscure Chalk Circle, thus perpetuating the myth of women being absent from hardcore. This, in effect, unintentionally bolsters the idea, echoed by the controversial straight-edge band One Life Crew, that women were no more than "coat racks" at shows. To be fair, Raha notes that punk scenesters testified to this. Jena Caldwell, the girlfriend of Germs' guitarist Pat Smear, points out that girls were lapdogs waiting around to drive or buy beer for the band. Raha balances this notion with a counter-perspective from Penelope Houston, lead singer of the Avengers: "I felt that things were pretty egalitarian, and I felt like the scene was so small that just being a punk was enough to join you in with a bunch of people, and you were accepted" (2004: 12). Yet Raha's dismissal of hardcore as a male-centered enterprise, devoid of women musicians, has been proven unfounded. This approach effectively dismisses, ghettoizes, and even deletes women from such narratives (supposedly reflecting honest witnessing and truth), which are then legitimized by a female author's voice.

A whole other "real" history exists. Howard Wuelfing recalled D.C. punk for me:

At hardcore shows at the 9:30 Club I'd usually stand in the center of a big old bunch of young women; I recall Lyle Presslar's [Minor Threat] little sister yanking me out of the way as someone stage-dived in my direction! There was always a large female contingent at hardcore shows I attended. The main difference from earlier times is that they seemed to come in large groups whereas it used to be that women attended shows in pairs or with boyfriends or on their own . . . Also right after the first batch of hardcore bands broke up and realigned (this transition saw Teen Idles morph into Minor Threat etc.) that there were suddenly MANY MORE women joining or forming bands. I think that seeing their guy friends actually go thru the process impressed them with how do-able this actually was. (2008)

Women obviously did go to shows, even straight-edge ones, evidenced by Chrissy Piper's published photos of Chain of Strength. What is noticeably absent from most male band straight-edge posters, however, is the presence of women, which would not surprise Ross Haenfler, a straight-edge sociologist who penned a book on the subject; he told the *Chronicle of Higher Education* that straight-edge is "rarely a welcoming space for women" because it is "exclusive and male-dominated," in which women feel "invisible," as if they don't "count" (2007: A18).

Although this may be true for the scenes he witnessed, several glaring exceptions exist. *Heart Attack* zine, originally affiliated to some degree with the straight-edge genre, was co-edited by a woman. XSISTERHOODX, which also presents a radio show, and XGIRLS GOT EDGEX, are/were web sites dedicated to straight-edge women. Other hardcore punk zines and web pages like Clitocore document the voices of women in hardcore. XSISTERHOODX is not a recent development: the page's history section outlines how the blogger/editor came across a website in 1995, essentially "a page about a discussion list called xsisterhoodx. I joined and within a day I was connected to three hundred girls and women of the straight-edge persuasion. Daily I would read their stories filled with fear, empowerment, frustration, and strength" (2007). Later she took on the duties of maintaining the site, providing a transition to a new era of straight-edge hardcore for which the call to power is "Know your role" and "Empower yourself."

Recent seminal posicore band Good Clean Fun's changing lineup has included two women, while newer bands like Gather, Adrienne, Rencilla, and Deathwish feature women as well. When Canadian magazine *Macleans* published an article on straight-edge in 1999, the writer discovered a host of girls who provided candid insight: Bif overcame issues with alcohol and heroin, while straight-edge cleared her perceptions and provided the fuel for self-help; Keeley understood the growing importance of the movement; Shannon critiqued the overly aggressive players and explained how straight-edge means "exploring options and more meaning in life"; and Lauren spoke about overcoming sexual assault through "maintaining good grades, starting a fanzine called *Regulate*, and seeking political power in the future unclouded by drugs and alcohol" (McClelland 1999). Hence, to some degree, Haefler actually creates the perception that women are bystanders, minor players, and boy toys instead of exploring their actual contributions and how they act as the pivotal consciousness of the movement, making sure that boys understand that the straight-edge revolution must be sincere and sexist-free, not just another reflection of mainstream values cloaked in militant clean living and easily digestible philosophical platitudes.

This held true even at the beginning of hardcore in the early 1980s, in places like Texas; Dina T, girlfriend of Big Boys drummer Fred Schulz, told me:

> Basically circa early 1980s I came on "the scene" and I must say it felt like one big family. As a girl, I felt totally part of it. There were some rough characters at times, but I always had guys that looked after me. Once this drunk guy was bothering me and the Big Boys stopped playing. Fred and Chris came off the stage, turned the guy upside down and bodily threw him out of the club! I was on stage with them at Club Foot singing background vocals for the "Superfreak" cover. I also was in a band for awhile with Fred (post Big Boys) and we played a few places too. (2008)

Again, this reinforces the notion that participatory culture remains a hallmark of punk culture, inviting fan kinship, participation, and finally, a model for fans' own ventures. The Big Boys motto: "Go start your own band," was not an empty phrase, but a real, living call to action that transcended gender roles.

The depiction of these women, and women throughout punk, will remain problematic, disconcerting, yet also potentially liberating. To end, I would like to provide this exchange between Jarboe, singer from the Swans, and me, from 2004, which I believe may encapsulate the dilemma:

Ensminger: You've said, "Don't take what men who criticize you say too seriously." Do you feel that men are still unwilling to accept the power, knowledge, and intuition of women who have already repeatedly proven themselves?

Jarboe: Some men, yes. This has been my experience, yes. The Controlling. The Power Play . . . yes, yes, yes. The Alpha Dog Syndrome. The Competition.

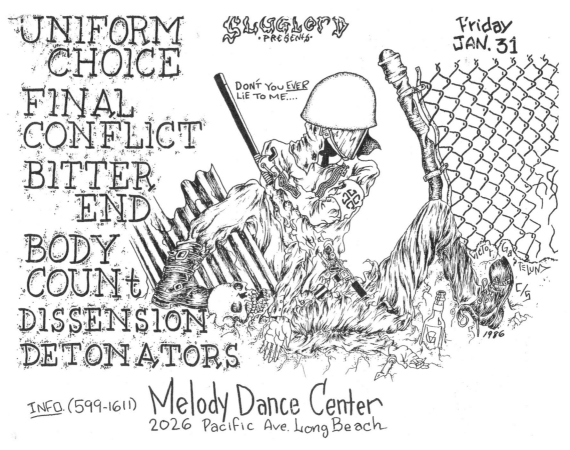

Uniform Choice, Final Conflict, and others at Melody Dance Center, Long Beach, California, 1986, by Victor Gastelum.

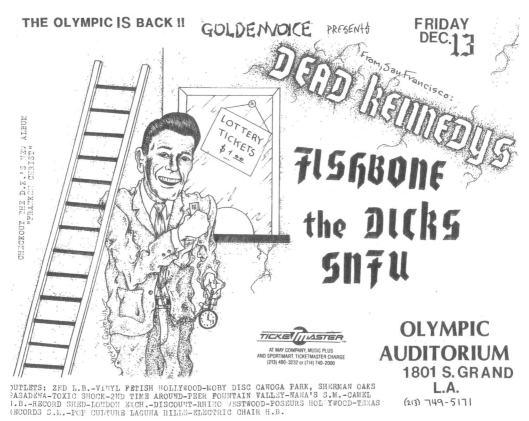

Fishbone, Dead Kennedys, Dicks, and others at the Olympic Auditorium, Los Angeles, 1980s, by Victor Gastelum.

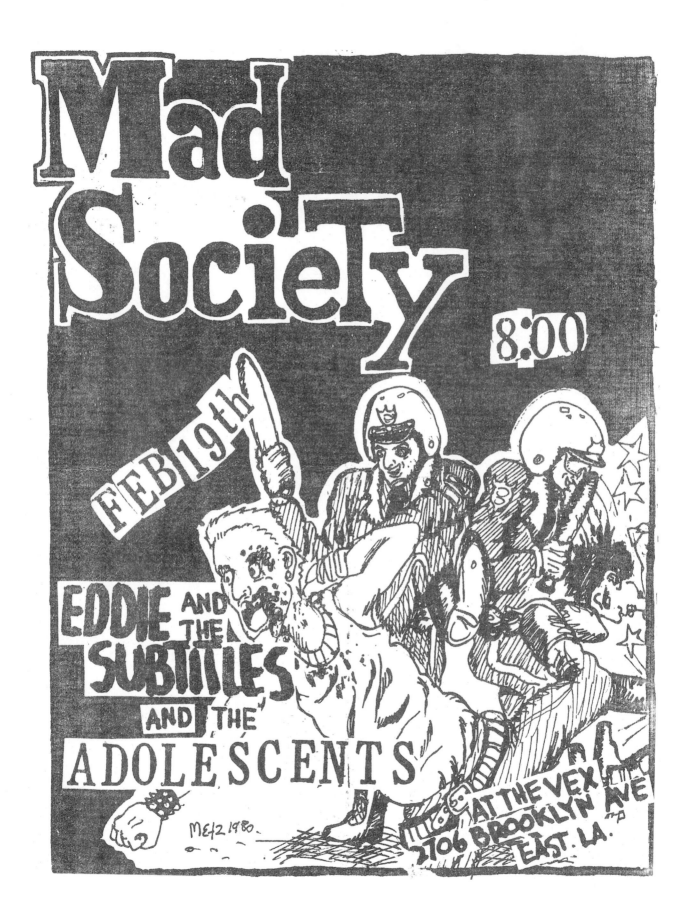

Mad Society and the Adolescents at Vex, East Los Angeles, by Metz, 1980.

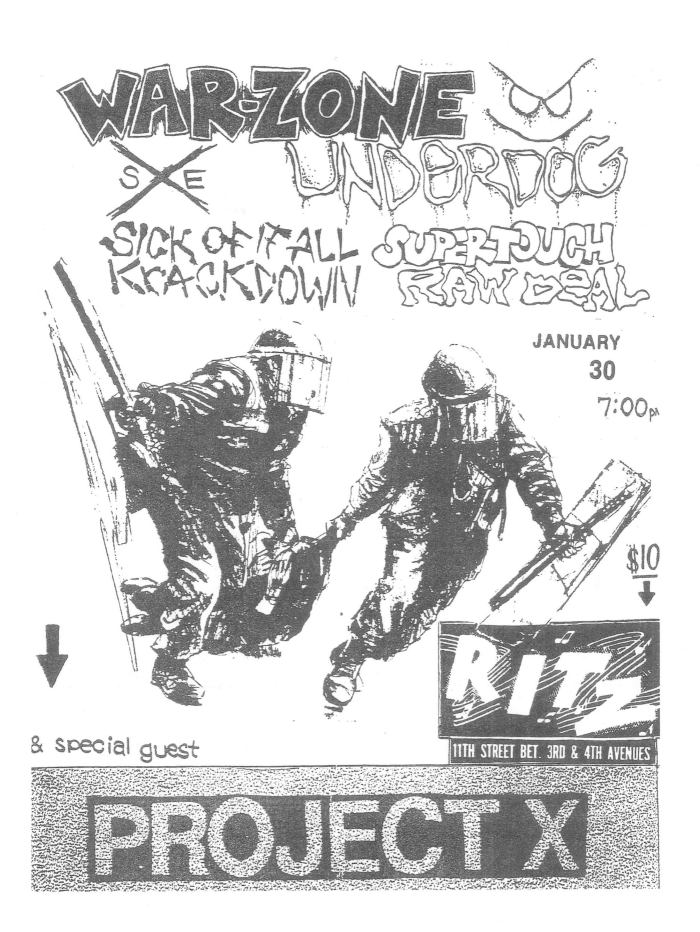

WAR-ZONE
SxE UNDERDOG
SICK OF IT ALL SUPERTOUCH
KRACKDOWN RAW DEAL

JANUARY
30
7:00ᴘᴍ

$10

RITZ
11TH STREET BET. 3RD & 4TH AVENUES

& special guest

PROJECT X

Warzone, Underdog and others at the Ritz, New York City, 1980s.

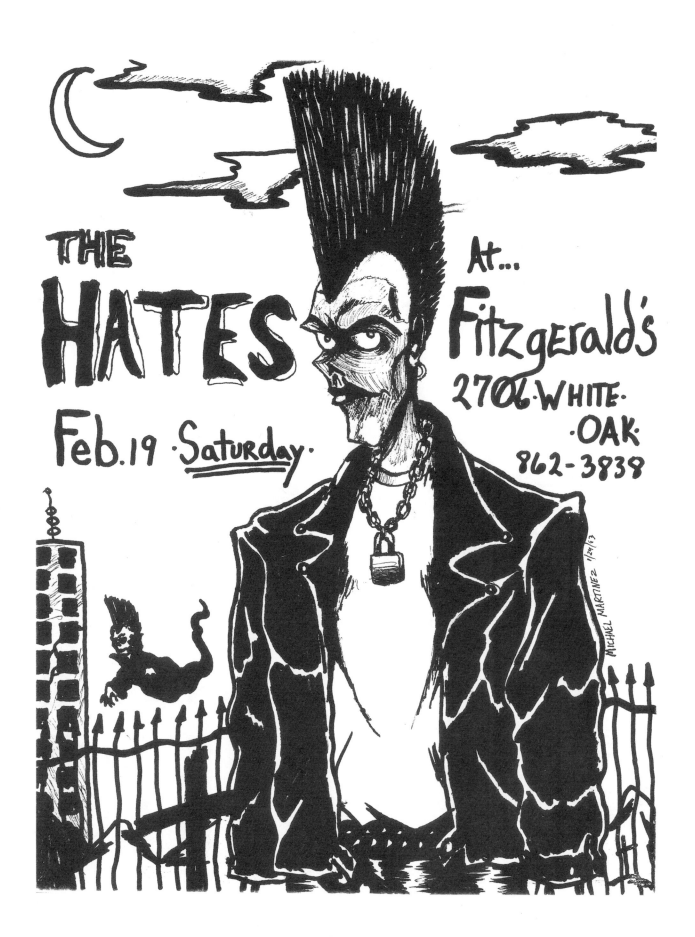

The Hates at Fitzgerald's, Houston, Texas, by Michael Martinez, made
January 24, 1993.

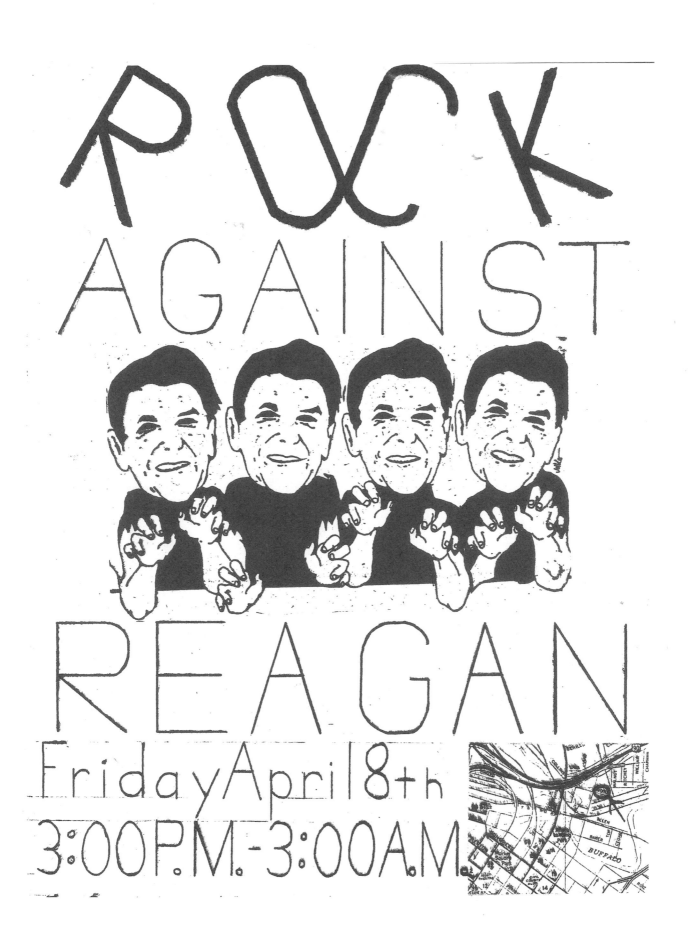

Rock Against Reagan, Houston, 1980s.

Strike Anywhere and Good Riddance at Fitzgeralds, Houston, 2000s.

Coffin Break, Social Joke, Phile 13, and others at the Grange in Fort Collins, Colorado, by Chris Shary.

THE ABUSED WITH T.S.O.L. AND THE Mob

RONNY ROTTEN.

K. CROWLEY ('83) FLYER #12

sun. march 20TH AT Great Gildersleves

TSOL, the Mob, and TSOL at Gildersleeves, New York City, 1980s, by K. Crowley.

PLVGZ
UXA
VKTMS
26TH FRIDAY

MIDDLE CLASS
BAGS
Little Cripples
27TH SATURDAY

BEST FROM L.A.

the DEAF CLUB
Under International License
530 VALENCIA

MINORS O.K.
MINORS O.K.
9 P.M.

Plugz, Bags, and Middle Class at the Deaf Club, San Francisco, 1970s.

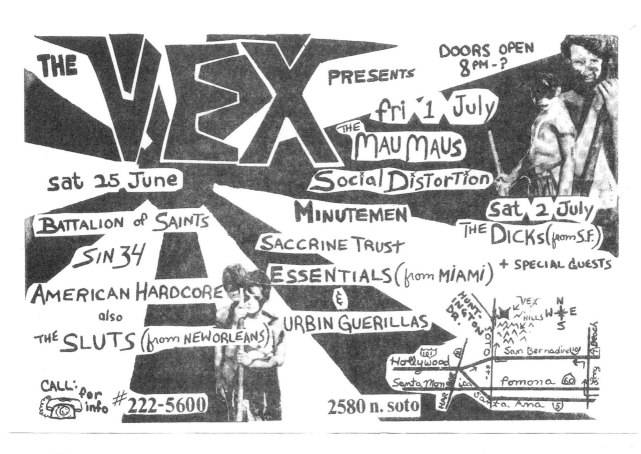

THE VEX PRESENTS

DOORS OPEN 8 PM-?

fri 1 July

THE MAU MAUS
Social Distortion

sat 25 June

Minutemen

sat 2 July
THE DICKS (from S.F.)
+ SPECIAL GUESTS

BATTALION of SAINTS
SIN 34
AMERICAN HARDCORE
also
THE SLUTS (from NEW ORLEANS)

SACCRINE TRUST
ESSENTIALS (from MIAMI)
&
URBIN GUERILLAS

CALL: for info # 222-5600

2580 n. soto

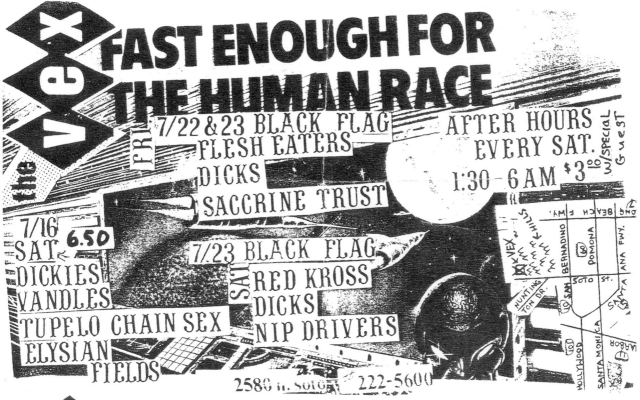

the vex FAST ENOUGH FOR THE HUMAN RACE

FRI 7/22 & 23 BLACK FLAG
FLESH EATERS
DICKS
SACCRINE TRUST

AFTER HOURS
EVERY SAT.
1:30 - 6 AM $3.00
w/SPECIAL GUEST

7/16 6.50
SAT
DICKIES
VANDLES
TUPELO CHAIN SEX
ELYSIAN FIELDS

SAT 7/23 BLACK FLAG
RED KROSS
DICKS
NIP DRIVERS

2580 n. soto 222-5600

Two calendars for the Vex, East Los Angeles, 1980s.

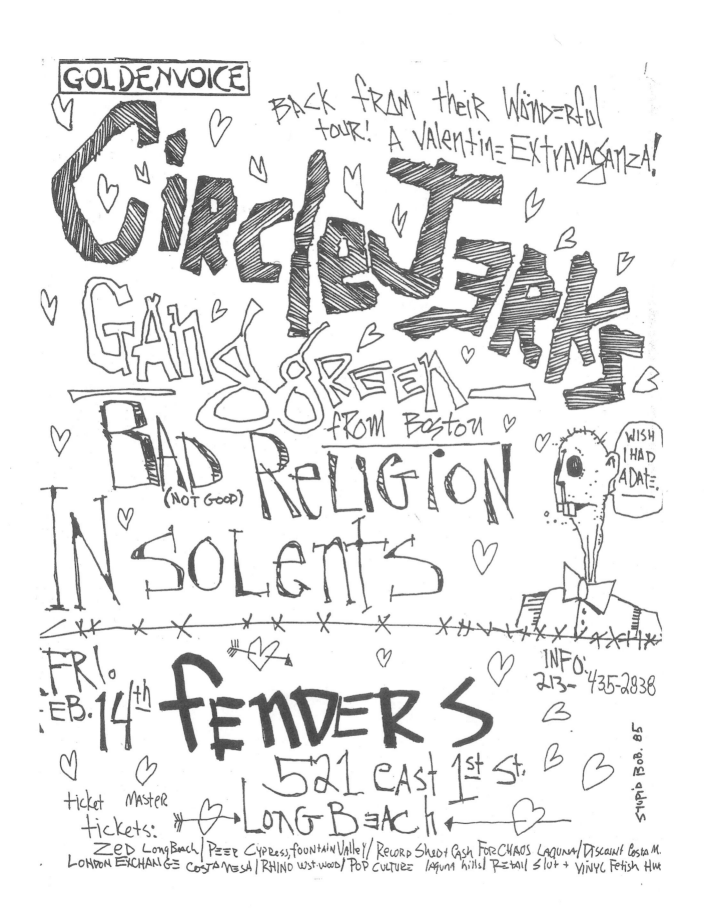

Circle Jerks, Gang Green, and others at Fenders, Long Beach, California, 1985, by
Stupid Bob.

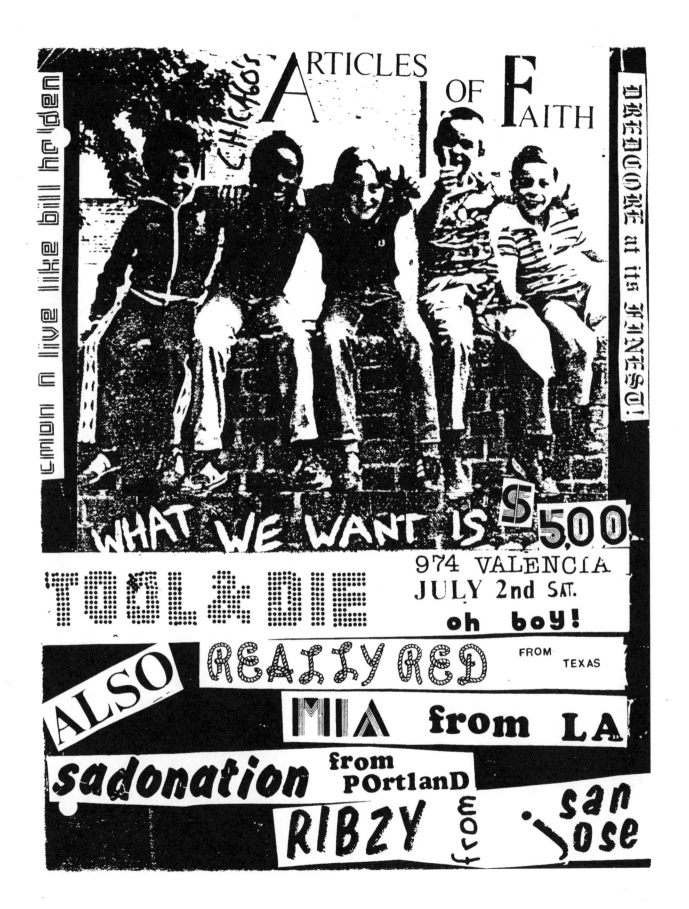

Articles of Faith, Really Red, and others at Tool and Die, San Francisco, 1980s.

CHAPTER EIGHT

WHEN LA RAZA AND PUNK ROCK COLLUDE AND COLLIDE

Hispanics in Punk and Hardcore

In the essay "Soy Punkera, Y Que?" by Michelle Habell-Pallán, found in her book *Loca Motion: The Travels of Chicana and Latina Popular Culture*, she traces the lineage of punk rock, linking its genesis to Hispanics via the 1960s Michigan band ? and the Mysterians, the first band called punk rock by the writer Dave Marsh of *Creem*. Greg Shaw, of Bomp Records and fanzine fame, also named the same band as part of the original punk/garage rock cluster including the Seeds, Count Five, and the Troggs. However, many would also argue that punk's origins are much more diffuse, including Herman's Hermits ("I'm Henry the VIII, I Am"), glam and pub rock, the Detroit bombast of the MC5 and Stooges, the post-Beatles pop of Big Star and Flamin' Groovies, the minimal art rock of Jonathan Richman and the Modern Lovers, even the heavy psych rock of the 13th Floor Elevators, Love, and Moving Sidewalks.

According to Habell-Pallán, other vestiges of punk's ongoing links to Hispanic culture, largely unnoticed in Anglo communities, are:

> First, the DIY (Do-It-Yourself) sensibility at the core of punk musical subcultures found resonance with the practice of rasquache, a Chicana/o cultural practice of "making do" with limited resources; in fact, Chicana/o youth had historically been at the forefront of formulating stylized statements via the fashion and youth subculture.
> . . . Second, punk's critique of the status quo, of poverty, of sexuality, of class inequality, of war, spoke directly to working-class East Los Angeles youth. (2005: 150)

Habell-Pallán also depicts a world of culturally hybrid punks in East Los Angeles, like Alice Bag (Alice Armandariz). As a feminist punk singer for The Bags who chose "shock-level" approaches that mixed art, music, and identity politics, she had one foot in punk sensibilities and one foot in Chicana culture. Her intense, vitriolic performances shattered gender assumptions about women during the halcyon era of soft adult pop music offered by the likes of Karen Carpenter and Carly Simon. Habell-Pallán contextualizes Bag's performances and attitude within a period in which Chicana identities, roles, and politics were being questioned in American culture. Punk also seemed to stimulate discussions often associated with femi-

Without names—language is essentially a system of naming— we cannot truly claim to be.
—N. SCOTT MOMADAY

nism of the day, regarding prejudice encountered at the hands of whites, family violence that took a deep toll on people, and female passivity and victimization (2005: 158).

Although often imagined as an Anglo cultural production (James 1988), the American punk and hardcore genres embody a convergence culture with a tremendous Hispanic presence, which includes the contributions, at the very least, of members from many bands, most notably the New York Dolls (first lineup), the Zeros, the Brat (known as the "Brown Blondie"), the Bags, Saccharine Trust, Los Illegals, the Plugz, the Go-Go's (original lineup), Los Lobos, the Gears, the Plimsouls, Screws, Black Randy and the Metro Squad,

Adolescents, Overkill, Stains, Mad Society, the Detonators, Shattered Faith, Eddie and the Subtitles, Nervous Gender, Detox, China White, Black Flag, Circle One, the Offenders, and many more.[1] Yet, in terms of race relations between Anglo and Hispanic punks, ambiguity and ambivalence saturate the scene. For instance, in the fanzine *Outcry*, published in 1980, Greg Ginn describes Black Flag's early singer Ron Reyes (aka Chavo Pederast) as half Mexican, half black, while in the documentary *The Decline of Western Civilization* Reyes tells the camera that he is from Puerto Rico, yet no one mentions that drummer Robo (Robert Valverde) is from Cali, Colombia. Reyes "immediately says, 'But I want to live in America,'" recalls Martin Sorrenguy, the singer of Midwest Hispanic punk band Los Crudos and queer edge band Limp Wrist. He adds, "What kind of message does that send? It makes me fucking cringe . . . What many people don't realize is that punk has been portrayed as a white thing" (qtd. in Palafox 2000).

In 1984, the Olympic Auditorium in Los Angeles, which hosted massive hardcore shows, arranged an international punk show coinciding with the Olympic Games, featuring the Dead Kennedys, BGK (Belgium), Raw Power (Italy), but also the much overlooked Mexican hardcore band Solucion Mortal. Unity and multiculturalism seemed to be the powerful parallel theme coexisting in the commercialized Olympic discourse and the still-underground hardcore punk ethos, though the punk films of the era, like *Suburbia* (1984) and *The Decline of Western Civilization* (1980), do not include diverse voices at length. Although Alice Bag is featured in the documentary *The Decline of Western Civilization*, the iconic film does not capture the burgeoning East Los Angeles punk scene of the time. Such absences, plus Reyes's own ambivalence toward his place of origin, and his treatment by fellow band members remind us to heed Sorrenguy's input, for they might "say so much about the racism in society and . . . liberal

notions of a 'color blind punk underground' where race/racism does not exist" (qtd in Palafox).

Around the same time period, a supposed mariachi band, opening for the post-punk band Public Image Limited (featuring the former singer of the Sex Pistols, John Lydon) at the Olympic Auditorium in Los Angeles, endured the crowd spitting and throwing trash on stage. Looking back, one might consider what group presented a more punk rock performance, given the context in which rule breaking is supposed to be a priority. The folk band was Los Lobos, who had been pressed into opening the show by the other local band on the bill, the Plugz, led by Tito Larriva, a highly regarded early L.A. punk whose band released the first self-produced, self-released DIY full-length album (*Electrify Me*) from the 1977 punk cadre. Louis/Louie Perez, guitarist, drummer, and singer for Los Lobos, illustrated his impressions of the gig in his essay "Weird Hair Pendejolandia," featured in the book *Make the Music Go Bang*:

> I guess [Tito] convinced somebody that a bunch of unsuspecting Mexican folkies might be a laugh playing to a hall full of purple mohawks. We survived about ten minutes through a tidal wave of spit and 8,500 middle fingers before taking a break for it when the serious projectiles started to fly . . . once our hearts stopped pounding and the adrenaline subsided, we knew we were on to something. (qtd. in Snowden 1997: 112)

What the band drew from the ruckus was much more than a heightened, anxious, physical reaction to the loathing and spiteful energy in the room. It was transformational, a rite of passage that marked them as new participants in an edgy era that seemed to bridge two worlds, even as each side exhibited ethnocentric tendencies.

Perez continues:

> . . . to some Chicanos we were doing it all wrong, we as Mexican-Americans had our own rebellion,

our own concerns about equality and racial attitudes, but as musicians we had discovered a way to bring down walls and erase those imaginary boundaries that divide. . . . there was a camaraderie and sharing of experience that I have yet to feel again. . . . for a brief period of time, we stood shoulder to shoulder forming a bridge between East and West [Los Angeles]. (qtd. in Snowden 1997: 113)

This newly imagined L.A., centered in the core idealism of punk, was also described to me in 2002 by El Vez (Robert Lopez), formerly of the Zeros and Catholic Discipline:

That was the nice thing about being in that period, because it didn't break down into girl bands, guy bands, and Chicano bands. We felt a part of the music scene, punk rock in whatever forms it was . . . rather than saying we're Chicanos and we feel this way, or those are girls, and they feel this way. You felt . . . this is all music that we like, this is all music that is different than what we hear on the radio or see on TV. . . . being Chicano wasn't even a focal point or focus of the band. It was like, we're another band. I think people maybe pointed at the fact that we were younger than anyone else. It was a kind of nice thing because it didn't matter that we were Latinos. . . . It gave us a whole part of the scene, rather than us having to feel we're "this."

Alice Bag reinforced these impressions in a personal blog entry, stating that the first wave of California punk in the late 1970s was "a somewhat unique time in that race and gender roles were pretty much discarded. . . . no one had time to label us or put us in boxes. There was no one to say, 'You can't do this or that because you're a) a woman b) a Chicana'" (2005). In a folkloric sense, these quick, culture-rippling moments represent a time when old binary boundaries and roles—Hispanic and Anglo, female and male—blurred and almost dissolved as social rules, conventions, and mores were temporarily suspended. New

possibilities emerged in this punk rock era, however briefly.

Such border crossing, though, was never easy or free from repercussions. When I pressed Victor Gastelum—flyer artist (Adolescents, Agent Orange, and many others) whose finely crafted gig flyers helped sell out shows at Fenders Ballroom and other venues during the mid- to late 1980s—about race issues in punk, he answered rather straightforwardly that being punk rock meant carving a separate identity within Hispanic culture, too. Thus, bonds between marginalized punks were trans-racial:

I got into punk because it was inclusive, for better or for worse: it's where I belonged. . . . I don't think race was any more or less an issue in the punk scene than in the rest of society. . . . we were all young and maybe more open-minded to getting along. Back then it was a minority of people that decided to get into this thing, so if you saw somebody in the street or school that was a punker you kind of sympathized with them. Deciding to get into this music at that time could mean losing friends, getting threatened, being harassed. . . . you were already an outsider among "your people," so you knew that didn't have anything to do with getting along or having things in common. (2008)

These youth routinely suffered at the hands of police, who often identified them as unlawful, even placed them under surveillance and assaulted them; parents, who deemed them antisocial or reckless misfits; and teachers, who believed their rebellion was unwarranted, antipatriotic, and nihilistic. Whether Anglo or Hispanic, female or male, these youth found themselves bound together in loose tribes, like "united outcasts," according to female photographer Deborah Schow, that lived " . . . in our own cocoons at times, and it was a shock sometimes when going into the daylight after literally living at night with our own kind of economy" (2010).

Ratty Apartments as Punk Interzone: The Canterbury

Craig Lee, guitarist for the Bags, described the Canterbury Apartments in Hollywood as full of black pimps and drugs, overcrowded East Asian immigrants and dealers, and Chicano families (Traber 2000). This "Chelsea Hotel of the West," managed by a Rastafarian minister, or in some accounts a self-invented Islamic sect known as animalism, was home to punk luminaries such as Geza X, Don Bolles, Black Randy, and members of the Germs, Weirdos, Extremes, the Deadbeats, Zolar X, Go-Go's, and the Plungers. Lee's description is markedly different from impressions provided by punk scenester Connie Clarksville, who moved into the hotel in 1972. She told Alice Bag that it "was full of drag queens and pimps and gays" (2008). Additionally, Margot Olaverra, bass player of the Go-Go's, pictured it as "a haven for underclass marginals," while other visitors and residents recall white punk rocker subproletariats, Vietnamese refugees, Okies, Hell's Angels, and homeless people (Mullen and Spitz 2001: 167–69).

Lee played in the Bags with Alice Bag and guitarist Pat Bag (Patricia Rainone/Morrison, later of Gun Club, Sisters of Mercy, and the Damned), who lived at the Canterbury too. Using the rundown locale as a kind of lyrical staging ground—a way to demarcate native space against the burgeoning lore of foreign British punk—the band wrote "We Don't Need the English," which rails against "boring songs of anarchy" and the British code of dress, and even figuratively bans the British from the Canterbury.[2] However, when discussing the strident song—rife with protest and blatant localism—Alice Bag provided cultural, historical, and even psychogeographical context to the website *Agony Shorthand:*

> When I saw the Weirdos for the first time, that was what did it for me. They were instantly the greatest band in the world and no one could convince me otherwise. So yes, I felt that Los Angeles had the greatest band in the world, so that naturally meant we were the best. That's where "We Don't Need The English" on the *Yes L.A.* comp came from, the confidence that we were not a pale imitation of some other, better scene somewhere else, but that we had our own distinct sound and style which was the equal of any other punk scene. You have to understand that what people think of as the early L.A. scene literally consisted of no more than 50–100 misfits who all congregated within a one-mile radius of the Masque and Canterbury Apartments. . . . We all knew each other. We did pretty much nothing aside from party, work on our bands, art, writing, fashion. (2005)

As Traber also posits in his essay "White Minority," the Canterbury revealed disquieting fault lines that existed between ethnic residents, often imagined as lawbreakers, and the seekers of transgression through practice—whites (though some Hispanic punks too)—who could never really relinquish their relationship to real power and privilege, except through bursts of violence, which some punk residents endured. The punks might have reinforced many assumptions about marginalized people of color too. The "toughness" of punks hidden away in the Canterbury might indicate their acceptance and reinforcement of long-held Anglo assumptions about lower-class, African American, and Hispanic "virility" (2001: 28, 43). Though this may be true, I imagine the Canterbury as both a fulcrum and liminal space for the punks—a place where hegemonic rules for punks (race segregation, suppression, etc.) became temporarily suspended and a sense of insistent transgression highlighted and shaped. The Canterbury might be understood as a between and betwixt site, a "time out of time" era, and a negotiated, temporary, unbound punk space that might resemble Hakim Bey's notion of TAZ—the Temporary Autonomous Zones:

. . . its greatest strength lies in its invisibility. . . . As soon as the TAZ is named (represented, mediated), it must vanish, it *will* vanish, leaving behind it an empty husk, only to spring up again somewhere else, once again invisible. . . . The TAZ is thus a perfect tactic for an era in which the State is omnipresent and all-powerful and yet simultaneously riddled with cracks and vacancies. . . . the TAZ is a microcosm of that "anarchist dream" of a free culture. (1985, 1991)

The Canterbury was short-lived as a TAZ, but a thousand similar zones, documented in books such as *Punk House: Interiors in Anarchy*, prove that such spaces replicate and resurge.

Punks often left home due to violence, molestation, and other abuse. Some fled and sought places that many would consider distressing— "no man's land" and marginal, run-down, risky neighborhoods that became refuges. Some exhibited nuanced tendencies of people smoldering with pain and self-hate, often pathologized by outsiders, like psychologists. In an article titled "Violence Girl" by Alice Bag on her web site, she candidly explores how these multiple forces collided in her, instigating a kind of personal punk metamorphosis:

All the violence that I'd stuffed down inside of me for years came screaming out . . . all the anger I felt towards people who had treated me like an idiot as a young girl because I was the daughter of Mexican parents and spoke broken English, all the times I'd been picked on by peers because I was overweight and wore glasses, all the impotent rage that I had towards my father beating my mother just exploded. (date unknown)

The multiplying, disheartening otherness—the sense of gender exclusion and disparity; the sense of domestic violence and family breakdown; the anguish of an imperfect body in a country manifesting plastic perfection; and the immigrant dream meeting prejudice head-on—became distilled into the punk body, a site of negation.

The world Alice Bag encountered was the one still associated with characters inhabiting songs like "Los Angeles" (1981) by the punk band X, in which the main character flees the urban milieu. As Alice Bag recalls in her blog: "Another infamous racist was Farrah Faucet Minor, the subject of X's 'Los Angeles,' who 'had to leave' because she 'had started to hate every nigger and jew, every Mexican who gave her lotta shit.'" . . . My guess is that she had always hated us and I'd like to think that maybe I was the Mexican who gave her a lot of shit" (April 2005).[3]

White families built suburbs as a bulwark against this inner-city Los Angeles, abandoning it a decade earlier for miles of freeways and malls. Yet, by 1978 it was being recolonized (in quasi-"reverse white flight") by Anglo and Chicano punks. Those unwilling to occupy such fringes of society were targeted by bands like the Avengers, who sung "White Nigger," about moribund "sheep" working routine jobs who no longer rebel because they try to fulfill a vacuous and whitewashed American dream. The disconnect with this so-called empty, unsatisfying, and suburbanized ethos was central to Alice Bag as well, who has labeled her performances "chaotic, aggressive and therapeutic" (2007). In the psychogeography of the Canterbury and vicinity (the infamous club known as the Masque was one block away), Bag's Chicana-cum-punk identity and intense personal history fluidly blended into a twin engine of desire and resistance. As a result, her atavistic performances soon became a visible template of the style and mode of future hardcore punk. Some argue that Alice Bag paved the path that Anglo males later dominated, even hijacked.

The burgeoning hardcore genre occurred during an era when some punks, such as Randy Turner of the Big Boys, were warned not to venture beyond the parking lot of the Vex, a punk club situated in the "barrio." Though often associated

with the band Los Illegals, who released the bilingual single "El Lay," East L.A. beer distributor Joe Suquette started the Vex with permission from Sister Karen, a nun who ran the arts center—Self Help Graphics—on the premises (Mullen and Spitz 2001: 246). Punk clubs were often restricted to such marginal locales, but the local punk genre was also "ghettoized" in that the only West Coast punk bands signed to a major label were the Dickies and, briefly, Los Illegals. In addition, the ideas communicated by the bands and their fans were equally ghettoized, since they, at least on the surface, revered resistance and a sense of belonging "outside of society," as Patti Smith once sang (1978). Yet, as Ruben Guevara explained in 1980, "Most of the kids playing locally aren't punks. That's a joke. If you want to talk about punks, you've got to talk about East LA, because the real, true punks . . . the real outcasts, the people with something to bitch about aren't middle class white kids" (qtd. in Lipsitz 1994: 84). "Slumming" Anglo punks are not considered true rebels with a cause or "outside of society" at all. As Traber suggests, they were simply mimicking and perhaps mocking marginalized locals, which some critics have characterized as a "refusal of normative whiteness" and "fabricated minoritization." Though other Hispanic clubs like Azteca also featured punk concerts, The Vex is a case well worth examining.

"The Vex, a new club in East L.A., opened and fast became, along with the Starwood, the cat's meow in punkarama," Craig Lee writes in the cornerstone punk history book *Hardcore California*. "At the club, a strange and untimely Chicano punk scene formed, combining hardcore beachpunk (Undertakers, Stains) and plop pop (Los Illegals, the Brat)" (Balsito and Davis 1992: 56). A history of the club was published in *Los Angeles Magazine* in March 2003, by Josh Kun, repositioning the club as instrumental in the biography of West Coast punk, filling a gap created by earlier, almost entirely Anglo accounts:

From March to November 1980, the Vex was an oasis for Eastside punk bands who were tired of hustling for gigs on the Westside. The punk scene was no different than L.A. itself. The L.A. River was a line. Cross it, and the rules changed. On the Eastside, the Chicanos were their own mayors. But travel over the 6th Street Bridge to the Westside, and you were always reminded just whose city this really was. (2003)

These dividers, which Perez alluded to as well, unmask the racial tension that pervaded Los Angeles even as crosscultural punk music was surging across disparate neighborhoods. Yet Hispanic punks had to forge a third way—not strictly punk, not Hispanic garage rock even, but a new musical hybrid. Willie Herron III from Los Illegals attests: "I always felt that our scene was invisible and unrecognized. . . . We had to remain in the shadows. We couldn't be ourselves and represent the East L.A. we knew. We couldn't be white punkers, and we didn't want to be white punkers. We were trying to come up with our sound" (Kun 2003). Herron also decries the fact that, two decades after the L.A. punk explosion, West Side punks like Brendan Mullen still do not seem to understand the worldview of East Side punks: "They weren't flying the Chicano flag, and we were . . . [The Westside punks] hated us because we were throwing it in their . . . faces. . . . Our punkers were into the street. They were cholos with all the angst and the anger that was in our community. That was our punk music" (qtd. in Gurza 2008).

The Vex regularly welcomed the Brat, the Plugz, and countless Anglo and multiethnic punk bands, establishing an East L.A. scene that Kun argues was "West Coast punk's first multicultural utopia" (2003). Even more importantly, the music provided a soundtrack to a frenetic and empowering sense of community-building that reverberated well beyond the PA system's outer limits: "the city left its borders at the door. If you showed up, you weren't just pledging allegiance to a new

vision of punk, you were pledging allegiance to a new vision of L.A." (Kun 2003).

Yet, such fecund scenes and spaces are difficult to maintain.[4] Despite punk and hardcore promises to be an interrogation of former social ills and ideologies; to form an oppositional culture that destabilized systematic suppression of otherness and marginality; and to collapse and blur the distinctions between race, genres, and gender that had been handed down by the parent, teacher, and media-fueled narratives of U.S. culture, punk and hardcore often got mired in these same narratives. Many participants were unable to free themselves of the prejudice that had originally spurred punk rockers to pick up ramshackle guitars. An ongoing iconic Hispanic venue is La Casa De La Raza, located in Santa Barbara, California. Featuring a blend of social and cultural services since 1971, including hosting punk and hardcore acts like GBH, Kraut, DOA, Black Flag (who played a benefit show for their clinic), Social Distortion, Ramones, Hüsker Dü, and the Replacements during the 1980s, the beloved venue has been noted for its "cutting edge" environment.

Even if punk did partially fulfill these ideals by setting up temporary free zones like clubs that were "off the radar," then it is still a box within a wider world where conventions hold sway, as demonstrated by my exchange with singer-songwriters Richard Buckner and Alejandro Escovedo, who played in the Zeros and the Nuns, originally printed in *Thirsty Ear* magazine:

Escovedo: People are always amazed that there is this rock cross cultural thing that happens, but in places like California, or even Austin, Chicanos play with white guys who play with Asian guys. It seems pretty natural to me.

TE: But because there is still so much hostility between races, rock 'n' roll seems a special place where people come together and get along.

Escovedo: But it's always been like that: look at the whole roots of rock and blues. I really don't get any of that shit from anybody inside music, but I do from people outside of it. I mean we go through shit when we tour, like down in the South.

Richard Buckner: Like last night in Hattiesburg, Mississippi.

Escovedo: Yeah, it was like a police state there. Personally I do have a sense of fear, and I don't feel comfortable. (February/March 2000)

This feeling of anxiety lives on even as rock 'n' roll, and punk by extension, carves out a "different," inclusive, subcultural type of community. Again, to reinforce the earlier lyric by the band Really Red, America still teaches the fear, even when places like the Vex and Canterbury thrive.

In the Heart of Old Mexico: Deep South Punk in Texas

In Texas, the intersections between Hispanic and punk cultures were made manifest in multiple ways. Really Red actively outlined the mistreatment and suffering of Hispanics at the hands of notoriously brutal police in songs like "Teaching You the Fear": "One Chicano, with his hands cuffed behind his back / Beat him bout the head, let him know where he's at (he's in Texas!) . . . / Toss him in the bayou, watch him sink like a rat." Texas, in fact, produced a near-perfect trio of Hispanic-operated punk clubs: Raul's in Austin, Tacoland in San Antonio, and the Island in Houston, followed later by the Axiom, one of Houston's premier alternative rock venues, started by J. R. Delgado. "When I started going to the Island, Houston was going through some heavy racial tension between Hispanics and authorities, like the Moody Park riots, the result of Joe Torres being found in the bayou

with handcuffs, which Really Red wrote the song 'Teaching You The Fear' about," he reminds me. "I found out the owners were Hispanic, but again, that didn't come to mind—the Hispanic, non-Hispanic thing. The Island just didn't feel that way. It was a melting pot . . . with blacks, Hispanics, gays, glitter rock, avant-garde, and artist types. It was an avenue, a venue, for freedom of expression . . . angstful expression, which I've felt most of my life."

Impressed by local stalwarts Legionnaire's Disease, Delgado cofounded the Derailers, who played with pummeling Los Angeles punk pioneers Black Flag, whose singer at the time—Dez Cadena—is another noted Hispanic. Yet, as Delgado frames it, that "wasn't some sort of issue of consciousness." When Delgado joined with GE (Dennis) Mendez, from the band Killerwatz, in the Discharge-inspired hardcore outfit Doomsday Massacre, being Hispanic was a non-issue too. He later joined Party Owls and Sugar Shack, but the Axiom was the Mecca of his making. "What was great about the Axiom, which I felt I carried from the Island, was that inclusiveness," Delgado fondly admits. "Everyone was welcome. It was a family feel. People used to tell me that."

Juan Embil, a Cuban from Deer Park, Texas, might have loved Bad Religion's *Suffer* album in the mid-1990s, but a punk rock T-shirt did not buy him a pass into the city's exclusive, nearly-all white punk culture; on the other hand, the Mexican high school kids and certain family members berated him daily as well, telling him to stop being a "coconut" and be proud of *La Raza*. They considered his punk rock mode of dress to be a sign of closet homosexuality (a serious allegation in the Hispanic culture), and on a few occasions, they threatened to "beat the white" out of him. Kids like Embil often navigate between communities, form micro-communities with others, like black punks, who fit no cookie-cutter identity, or become islands unto themselves.

Instead of opposing Anglo culture, Trish Herrera's (singer and guitarist in the Mydolls) family aimed at acculturation. "They made me white, shop in a mall and speak English. I was brown, full of shame and drowned it with alcohol, then shopped at thrift stores and ripped up my clothes and safety pinned it back together. Did the brown shame whip my ass? Yes, it did," she confesses. "But I arose free from the addictions and tried to learn Spanish. Now I speak broken Spanish. It's hard when you live in Texas and ignorant white people say, 'I've got me a Mexz-can girl to clean my house or I've got me a Mexz-can to do my yard.' I learned to speak up and defend my Latina family." When pressed to comment about punk's multiculturalism, she responds, "Punk was the inclusive family. Not like hippies, all love and peace and drugs, but fucking angry as Hell, sick of it. And I fit right in and still do. The only difference is without drugs and alcohol I have the clarity to really say it loud now, louder than ever, yet quietly sneak over the fence and take over as well."

"Punk has always been inclusive. I mean if it's about railing against oppression, who better to speak out than those who experience oppression from generation to generation," argues George Reyes, drummer for the Mydolls. He tells me that the voices of each Latin music generation, from Sam the Sham's "Wooly Bully" to Carlos Santana's *Abraxas*, search for an "identity amongst the dominant culture."

"Punk is no different. My experience has drawn on native roots and culture to blend the expression." In fact, he notes, "When we were composing 'As Strange as Mine,' I definitely was thinking of Trish's dad and the Latin music that he and others made famous in the fifties and sixties. The use of timbales and Roto Toms are just a few of the Latin influences that make the song rock." Reyes's input suggests that punk music is an amalgam, a piecing together of various influences, drawn from each player's background, not a template blindly borrowed from the Clash and cohorts.

Rosa Guerrero, a writer, DJ, record label owner, and scene mentor, acknowledges that

rank-and-file fans of grindcore and metal might be heavily Hispanic too, but she's not certain that anything beyond language is the common thread. She suggests that disparate Latin identities (first generation/second generation, Mexico/Cuban, etc.) often become submerged into a punk melting pot. Just like members of Agnostic Front, the Adolescents, and Black Flag might not be seen as Hispanic, the same may be true for local bands like the Fatal Flying Guilloteens, the Kimonos, and Something Fierce. Yet, just by putting the pieces of the Hispanic-people-in-punk puzzle together while namedropping the Caprolites and the Takes, feelings of pride surface. When it comes to movers and shakers, she attests, Hispanics are at the forefront of the punk scene, though they might be victims of prejudice and fear that white bands could avoid. For instance, broken bottles in an alley become a convenient excuse for a bar owner to exclude future shows with a darker shade of punk.

Though brown, tattooed, angry, and accented are not exactly accepted in a poster child for Texas punk, Hispanics have been crosshatched into its fabric, from the Sex Pistols show in San Antonio in 1978, a year zero of sorts, to myriad local old school early 1980s punk, Mexi-punk, garage rock, rockabilly, cantina/ska, hardcore, and post-hardcore bands: Recipients, Vatos Locos, Magnetic 4, Flaming Hellcats, Los Skarneles, Will to Live, and Riverfenix/Fenix TX.

Hispanic Fingerprints on Punk Flyers

Hispanic artists have also served as indelible contributors to the style and overall history of punk gig flyers and posters, including the work of Mike Trujillo in Colorado; J. R. Delgado, Ric Cruz, Dana Somoza, Michael Martinez, and Charlie Esparza in Texas; Tim Gonzalaz and Jaime Hernandez in California, the latter of whom later penned the celebrated comic *Love and Rockets*; Rolo Castillo, who worked in the TAZ poster collective alongside former surf artist Jim Evans; Victor Gastelum, who drew many flyers for Sluglord productions and later worked for Greg Ginn (Black Flag) at SST Records and designed album art for rootsy Americana bands such as Calexico; and finally the irreverent Frank Kozik, whose mother is Spanish. When asked about his art by *Austin Chronicle* in 1997, Kozik revealed the intense dichotomy that viewers experience: "Some people think it's the greatest fucking pop art deconstructionist cultural trip in the world," says Kozik frankly—Frank is always frank. "Other people say it's pure fucking bullshit" (qtd. in Hernandez). Kozik began working for Club Foot in the mid-1980s, producing flyers for the likes of the Butthole Surfers and Scratch Acid, which included lead singer and poster artist David Yow, later of Jesus Lizard.

Such artists adeptly mixed graphic arts traditions with fluency and fecundity, not just for the sake of producing well-crafted art or exhibiting technical prowess but also, at one time, for the sheer utility of getting people to shows. As Sluglord producer David Swinson told me in Spring 2008, Gastelum's "flyer art was responsible for drawing large audiences. In fact, other promoters tried to do the same thing. His work was so special that people would save the flyers for years. I was in Baltimore recently, visiting a record store and found copies of his old fliers on the wall of the bookstore."

When I approached Bob Medina, a Denver-based Hispanic fanzine editor and show promoter very active in the 1980s and early 1990s, about his impression of race relations, identity- seeking, and tensions in punk and hardcore, he readily offered this insight:

> Punk to me was an identity and I would venture to say it was its own culture; it superseded established cultures and race. In a way, I see it as a truer version of the "melting pot." Basically, you stopped

being white, Mexican, black, or whatever and just became a punk. At first, it appeared that there was no hierarchy. In a way, we were all fucked up outsiders who didn't fit into any other place, so essentially we carved out our own space. This was my view from the time I got into it in 1982. I would say I pretty much kept that melting pot view.

I never considered myself a "chicano punk" or saw my involvement in the scene representing a minority segment of society. I saw punks only as punks and never distinguished them as "black" or "brown" or "white" or even "gay." That mindset of sub-categorizing is essentially a form of self-dividing and intentional segregation. The problem I have is when there are scenes within a scene. That could just be a human condition, people want to be a part of a group even if it something like "Gay-Filipino-west side-punx." Maybe this mentality makes more sense these days now that we have more choices and there are groups that cater to personal needs. I don't like it. Punk shouldn't be so complicated.

On the other hand, in high school I had been reminded by the skins and older punks (Anglos) that I was culturally a minority. I did get some shit when I first got involved, but it never amounted to anything significant and didn't deter me from being apart of the scene. Many of my friends in HS were pretty much the beginning of the Denver Skins, who some members eventually joined the Klan (one becoming a Grand Dragon). Even when they became part of that organization, we didn't stop being friends or I should say they didn't treat me any differently. I suppose by being color blind, I was able to connect with all aspects of the splintering punk groups. (2008)

If not for these Hispanic artists, editors, fans, crucial venues, and bands, punk history (and lore) would be diminished. These artists destabilize the various and rampant one-dimensional, crude, fixed, racist stereotypes of Hispanics as low-wage, low-tech workers/grunts and shiftless, barrio-dwelling "invisible minorities," stereotypes not limited to mainstream discourse but found in the punk community as well, as demonstrated by the lyric "I'm a Chollo" by the "comic" punk band the Dickies, who were signed to A&M at the time it was released (1980). "Bought me an Impala and I sold my van / Got a pair of khakis and a penectan / Now I'm a full-fledged Mexican."

Hence, the work of Hispanic bands, artists, and producers such as Chaz Ramirez, who played with Eddie and the Subtitles and produced the Leaving Trains, D.I., Adolescents, and Social Distortion, offset and even neutralize these belittling punk lyrics and worldviews. The input of Ramirez, as Mike Ness of Social Distortion reveals, helped them "shape ourselves, helping us achieve our sound, achieve our character" (qtd. in Boehm 1992). The Orange County punk sound was indelibly stamped and imprinted by the style and influence of Hispanic elders.

Going Suicidal!: Gangs, Lore, and Prejudice in Punk

Suicidal Tendencies, one of the first hardcore bands to be aired on MTV, were a prominent presence on the soundtrack of the movie *Repo Man* (1984), alongside the Plugz and Circle Jerks. They also played Alaska and were featured on an episode of *Miami Vice*. One of the issues confronting Suicidal included whether or not the band fostered a gang or ganglike following. However, band-as-gang analogies are deeply imbedded in punk. Jack Grisham from TSOL, when describing his earlier band Vicious Circle, casually noted, "Vicious Circle was more like a gang than a band, a brotherhood that just looked out for each other . . . we buzzed on constant ultra-violence in the pit . . . It was basically Clockwork fuckin' Orange County" (qtd. in Mullen and Spitz 2001: 226–27). Mired in elements of race, power, and turf (Grisham recalls "constant stabbings and beatings and people cruising" by his house at night)

the issue often symbolizes both subcultural and mainstream unease with the emergence of marginal and outsider groups within punk rock itself, especially as punk rock shifted from Hollywood's small, insular scene into the wider suburbs, where the growing youth movements could not escape or neutralize their own contradictory response to "rising above." When examining the Black Flag lyric "Rise Above," one might question whether white youth, seeking transgression through commodity culture, believed the lines "We're born with a chance . . . I am gonna have my chance . . . we are tired of your abuse, try and stop us, it's no use" (1981) applied to young Hispanic punks from East L.A. or beyond.

In far-flung Alaska, F. Harlan declared in the fanzine *Warning* that, "Rumors claim that Suicidal Tendencies are a gang, which is far from the truth. Suicidal Tendencies is a band! And just like any other band they have fans, which just like any other fans will show their support by dressing and displaying your name very proudly and in the neighborhood these guys come from to have something to believe in makes a lot of things more positive" (1983). The look signifying "vato"—bandanas across foreheads, caps with visors bent up (typically worn in skate scenes, too), homemade skull T-shirts, definable "Suicidal" scripts on stickers and flyers, fuzzy upper lips, flannel jackets buttoned on the top only, white shirts tucked into ironed Dickies pants or Ben Davis jeans, and Vans skate shoes or Zig Zag shoes—was captured by photographer Glen Friedman, who also produced their first record. Don Snowden has even suggested that the signifying style of hardcore punk in general, as represented by "the odyssey of bandanas from hardcore beach punk boots" were "adopted as a totem of outsider affiliation with Latinos and black street gangs" (1997: 9). Hence, the demarcation of Suicidal gear as representing gang culture, while "white" style simply reflects fan culture, becomes suspect and unstable.

Some of the art that emblazoned the T-shirts on the first Suicidal Tendencies album cover, shot by Freidman, were designs by the skater Jay Adams and Ric Clayton. In *Flipside* #40, singer Mike Muir notes the participatory nature of their fan base: "most of the individuals did their own [shirts]. There's some that aren't really good and spelled wrong . . . but we did that [showed them] because you don't have to be an artist to do it . . . anybody can do it" (Suicidal Tendencies 1983). Hence, part of the band's initial magnetism was due to this ethos, especially in neighborhoods that were predominately working class. Again, Muir testifies to this issue: "I think it's more accessible as far as punk rock [than] going out and buying a leather jacket that costs 200 bucks, boots and chains. . . . It's not a pose for us. That's the way I have dressed ever since I was a little kid" (1983). The cultural currency of the look rings with authenticity and suggests that such a DIY style actually undercuts the tendency of punk fashion to become just another commodity-based subculture. Instead, punk empowered fans to be creators and disseminators, not mere consumers.

As if highlighting the hardcore punk scene's ambivalence toward Hispanic participation, Suicidal Tendencies won both Best and Worst band polls in the annual *Flipside* awards, exemplifying the polarizing attitudes of the community. One irate, anonymous reader notes that gang affiliation does not have to be literal, but may be merely implied or signified, to have negative consequences in the very real power struggles within a neighborhood or scene:

On Rodney on the KROQ, Mike Muir states that he's not in a gang and that the reason he dresses like a fucking cholo is because he's dressed that way since he was a kid. . . . But that's not the important part. He proceeded to encourage kids to go to their gigs in Izod shirts! Mr. Muir don't you ever stop and look at your crowd? I suggest that you do sometime and see what your wonderful great

"following," the "Suicidal Boys," do to the kids that go and see you (especially little kids and girls). Look at how they beat the shit out of them because they are not Suicidal Boys or don't dress suicidal They trash halls, crash gates, destroy other people's cars, spray paint "Suicidal Boys" all over walls, and do other various "creative" things. Do you CONDONE this crap? If not, why don't you speak out against it?" (Anonymous 1984)

Explaining that his own brother is in a gang, he is offended because Suicidal Tendencies align themselves with a culture of violence—a very visible, physically coercive, and oppressive gang mentality. As a few *Penthouse* writers explored, this "ganglike" fan atmosphere prevailed amid neighborhoods that surrounded clubs like the Fleetwood in the early 1980s, turning them into supposed "war zones" (Palmer 1981 and Keating 1982).

Suicidal was banned from L.A. for a period of time due to their following; members had tattoos and were sentenced to jail time for crimes, violence did wreck shows, and original drummer Amery Smith was recognized as a member of the A13 gang. In *Maximumrocknroll*, another letter to the editor decries such gangs:

> They all suck. . . . Anyone who needs to have a gang behind them is a real loser. All the LA gangs, such as L.A.D.S., F.F.F., The Crew, and The League, suck the biggest of them all. You are the sons of the "Quincy" punks. None of you are punks. You are all Nazis that think you're bitchin' if you glue on Mohawks, wear dad's old army boots, and go to the shopping mall to start fights with any punk [who's] not in your gang. (Jim 1984)

Editor Tim Yohannen's perspective on gangs was unequivocal: punk's values "originated in mocking the violence in society, not imitating it. . . . When [people] act in gangs, their behavior is fascistic" (#21, 1985). For years, gangs were debated in the discourse of fanzines as fans tried to understand street-level intimidation and fear-mongering, the family-like dynamism of gang relationships, and the need for people to seek out alliances in a punk community that was supposedly pro-individualism.

The lyrics from Suicidal Tendencies' song "Join the Army," from the album of the same name, note the potential violence but also stress the trans-racial, cross-genre (a reference to hair length likely alludes to heavy metal fans), and border-jumping (calling on London, England) potential of a rock 'n' roll crew as a gang alternative: "Dressed down, homeboyz, minority—join the army / It's the size of your heart, not the length of your hair / Don't make no difference to me, the color that you be" (1987).

The music represents untrammeled hope and eagerness to unify across race lines. Black punker D. J. Story seems to support this argument when she writes "Punk rock saved my life," then tells readers of *Maximumrocknroll* that she once felt alone, cut off from the stifling, elitist cliques of punk, thus formed her own "littlest punk clique of all: lone-Black-who-grew-up-in-a-black-beighborhood-as-an-outcast-who-discovered-punk." Punk alleviated her chronic dissatisfaction and depression. The style she chose—a mailman's cap with upturned bill, handscrawled with the word "Suicidal," would "make Mike Muir proud" (#152, 1996). A photo taken from a mid-1980s Black Flag tour stop in Houston by Hispanic photographer Ben DeSoto also reveals another black DJ—Rad Rich—with similar gear, standing next to singer Henry Rollins with another black youth. Such instances suggest that such black youth felt part of the loose, informal, but still meaningful and welcoming cultural "army" that Muir describes in his song.

White youth sometimes did feel like outsiders when seeing Suicidal Tendencies in neighborhoods that were decidedly Hispanic, Scott Mitchell suggests. As a punk fan and avid journal writer who has posted historic reflections from

the hardcore era on his web site *Weirdtronix: Relics from 70s/80s So. Cal Punk*, he wrote this entry after seeing the band in Southeastern L.A: "The audience that night was packed with S.T.'s gang-like followers, since Pico Rivera was pretty much home turf to the whole Suicidal crew. Between the involvement of the PUNX people, the Pico Rivera locale, and the presence of Suicidal Tendencies and their fans, the evening definitely had a kind of punk/gang type feeling" (2003).

This was not the only band that attracted gang and gang-like fan bases, for they followed Anglo bands as well. Aggression, a skate-punk band, told *Flipside*, "It's time for the skinheads to mellow out, get out of the gang shit. Everyone has to do their own shit and whoever wants to come see us is welcome" (qtd. in Krk 1991). Lingering skinhead issues followed 7 Seconds as well, partly due to their early image and the content of singles like "Skins, Brains, and Guts." Steve Youth, bass player, argued as early as 1984 that "the skinheads we know were all pulling for unity and brotherhood . . . It wasn't a gang, it wasn't a club, it was just a lot of us friends—the crew or whatever you want to call it" (qtd. in Quint 1984). Yet, as their homemade tour video/diary shows, a few years later they were defending themselves in front of CBGB to a skinhead who claimed they had "sold out." Such notions of skinheads, gangs, and crews became enmeshed as one in the minds of many.

By 1985, two years before the *Join the Army* album arrived, the college-educated Mike Muir (Cyko Miko) framed the race and gang issue in *Task* magazine as Anglo anxiety stemming from minority cultures participating in what has been routinely miscategorized and racialized as a mostly white, middle-class rebellion. He suggests jealousy, racism, and fear of low-income participants were likely at the heart of the debate. He also infers that Suicidal Tendencies was one of the bands able to interrogate and question the hierarchal social order that was prevalent even within resistance punk of the time:

The simple answer is, you see five people and they have got mohawks and leather jackets, they're individuals. You see five people with Pendletons (flannel shirts), khakis and bandanas and they're gang members, you know? . . . where we came from it's a minority, lower-income place so you got the people with the hand-drawn shirts like on the album cover and stuff and mostly minorities and stuff . . . we went from opening up to headlining . . . there's these bands that've been bands for four years and they're going, ". . . Suicidal Tendencies . . . Fuckin' wetbacks!" . . . In L.A. you do a show and you've got 16–18 year old white kids from the Valley, upper-middle class, and you go to our shows and then you see black people. You don't see no black people at regular shows, you don't see no Mexicans at regular shows, you don't see any minorities and stuff. You go to our shows and it's mostly minorities. (qtd. in Greg C)

When he was still known as Mike Suicide, Muir was featured in a 1982 *Penthouse* article as a key informant about the emerging "self-destructive" and sociopathic hardcore scene. The writer depicts him as a man trying to form "both a band and a street gang" called the Mercenaries, replete with a phone list contact sheet so he can protect himself from Huntington Beach opponents. He had been a skinhead barely a year at this point; was built like a high school football player; wore a paperclip in his ear; regularly slamdanced himself into a bloodthirsty frenzy at the Starwood (clearing the floor); and is quoted by the writer—who dubs him a surf punk, a skinhead, a creep, and survivor—as calling himself a "Fascist." His band Suicidal Tendencies soon wrote the song "Fascist Pig": "I want to be a fascist pig / love to fight / what a thrill" (1983). Muir's Hispanic ethnicity is never mentioned in the article. Any mention of race is conspicuously absent in the overall narrative (Keating 1982: 77, 156).

One also needs to place the discourse about punk gangs into a wider framework in which a

constellation of such gangs existed. The album *Youth Report*, a punk compilation LP from the early 1980s, announces in the liner notes that, "Half of TSOL compromised one of the gnarliest skinhead gangs ever and somehow managed to rise above the violence."[5] The composition and definition of such gangs is quite debatable, as in the lore of the skate punk band Aggression, who preferred to label their music as "speed rock." In a 1985 interview, singer Mark Hickey acknowledged that prior to the band's ascent they were a de facto "gang":"It was before the band started, there were about 6 or 7 of us, and this one little rookie guy had a fucking power trip and he considered himself the 'head' of what we were, we were called the NASH. Stood for Northern Area Skinheads. And he started talking a bunch of shit and everything, and we didn't want to be involved in that" (Longabaugh). In this case, the gang was to some degree supplanted by the band, which likely offered an identity and path much more in tune with the members' attitudes and sense of youth culture.

Still, concerns about the notion and presence of gangs was powerful enough that letters addressing the issue disseminated in zines from Alaska (noted earlier) to Hawaii, where a California zine report by Ga-Ga the Boy attests that "Punks here like to slam and fight. Most are so damn stupid, it's pathetic. There are still gangs (punk ones, I mean). . . . Just stay clear of the skins, suicidals, and family, not to mention the drunks" (1985). I mention these historical side notes to offset the essentialist notion that gangs were primarily Hispanic in origin, which makes them scapegoats of a prejudiced, one-sided discourse. Even Lux Interior, singer of the Cramps, remarked to journalists that he was a member of an early-1960s gang called the Aristocrats who damaged phone booths and stole cars while listening to early garage punk music like the Trashmen. Known as "Angel," likely symbolized by a halo emblazoned on the back of his jacket, Interior and the gang emulated the novel *Clockwork Orange* by wearing bowler hats and white gloves and brandishing canes in sinister outings (Johnston 1990: 14).

Arthur "Killer" Kane, bass player for the ribald rockers and punk elders the New York Dolls, told *Uncut* magazine that they were basically "like a teenage gang" (Goddard 2004: 78). In turn, Glen Matlock, bassist for Sex Pistols, once explained that the, "Ramones handed down . . . the importance of a united front. They did that whole gang thing very well" (Clerk 2001: 8). Stiv Bators informed *Damage* fanzine that his band, the Dead Boys, "couldn't play in Cleveland at all . . . 'cause they thought we were a biker gang, 'cause we wore leather jackets" (qtd. in Hamsher 1980: 12). Kosmo Vinyl, the occasional press manager and associate of the Clash, recently described the band in similar terms as well, admitting, "It was meant to be a team thing, a gang, a band, not four disparate individuals" (Snow 2008: 82). Not all punks agree. Mark David, the drummer (at the time) of Long Beach, California–based hardcore band Final Conflict, argued to *Engine* zine that gangs are "about as far away as you can get from being an individual. . . . Punk rock is about being an individual" (qtd. in Avrg and Max 1996).

The notion of punk bands signifying and working like extended family units, or gangs, was powerful and attractive. Hugo Burnham, drummer for Gang of Four, once cynically noted that the Clash's gang-like mentality was a bit deplorable: "The Clash [became] the boys in the band . . . regurgitating the old myths of rock 'n' roll, with a strong gang image" (qtd. in Young 1981: 32). Yet, as Clash fan Mardi candidly tells it:

> as a teenage boy their tough-guy, outlaw image was
> something to aspire to. The Clash, far more than
> the Sex Pistols or the Damned, were a gang. And,
> more to the point, they made us - their hormonally
> challenged disciples - feel like we were also part of
> the same gang. They were, they argued, the same
> as us and everything about them portrayed an us-
> against-them attitude. It comes as no surprise to

hear, more than 25 years later, Simonon still talking about his "network of friends." (2004)

Such networks of fan-cum-friends quickly became a kind of normal form in punk lore, a trope that might have been also become literal, fully realized, explored, and tested by bands like Suicidal Tendencies.

Paul Simonon, now a well-regarded painter, sang the dub-esque Clash song "Guns of Brixton," which appeared not long after two articles were published about the Brixton neighborhood—"Police and Thieves on the Streets of Brixton" by David Dodd and "Brixton and Crime" by Melanie Philips, in the latter of which she notes the neighborhood "males . . . engage in 'character contests' to acquire a reputation and secure an identity" (1976). In "Popular Music of the Clash," Douglas Emery argues that Brixton itself was a psychogeographical wellspring: "From the streets of Brixton, the Clash acquired a series of powerfully felt experiences that bestow upon its music a sense of authenticity, and since white youth began to suffer the same marginal status (25% unemployment in the late 1970s), the Clash felt they should provide an energy to them just as reggae had communicated to black youth" (1986: 149). In such cases, the bands are a conduit for fan energy, propelling fans toward empowerment and pride. Thus, Suicidal Tendencies appear to embody and carry forth these traits, not originate them.

Mike Davis, a cultural historian whose outlook is shaped by urban sociology, Marxism, and labor history, links the pivotal point of gangs in Los Angeles in the early 1980s to broader issues endemic to a "supernova city": the struggles of the powerful, less powerful, and powerless, all tied to concerns over land development and use, including low-income neighborhoods being adapted by, or resisting forces of, the spatial economy, whose players included international financiers, city hall, homeowner-based slow-growth movements, and gangs. As the old Eastside rust belt–type manufacturing centers dried up, including companies that once offered salaried jobs in the steel, rubber, auto, and electrical sectors, young blacks and Chicanos' upward mobility was nearly shuttered at the same time their parents found it difficult to find work, too (1989).

As Davis observes, South Central Los Angeles suffered 45 percent unemployment, and five thousand Hispanic and black youth tried to apply to the longshoremen's union. The gang topography of the city was quickly parceled and radically redrawn by micro gangs, including desperate Cambodians and 18th Street homeboys. Thus, under the din of skyscrapers being built and the shadows of neon-lined minimalls, such "gangs," perhaps even the Suicidals, represent "a logic of social formation in a post-liberal context where gangs of all kinds, from the Reagan administration on down, set the tone" (1989). Gangs were an American response to tumultuous times, as they always had been. In Colorado, the editor of *Silent* zine lamented that, "Gangs are counterproductive" and "commit genocide, keeping minorities down. This is what the government wants because the government officials are rich and usually white" (Preston B.). Such punk discourse underscores the need for gangs to change strategy—fight power at the highest levels, not each other.

By the 1980s, the halcyon days of early punk rock vanished. Gig violence led groups like the Crowd to stop actively playing shows, though they did not necessarily see the events mired in race tensions. As guitarist Jim Kaa revealed to me, "The scene in L.A. always had a strong Latin/Mexican/Asian presence, though H.B. (Huntington Beach) was very white. It was never any problem in the early days, 1978–1980 and while the 1980s brought a great deal of violence to the scene, it did not seem gang- or ethnic-based, more punks versus hippies/authority thing. It seemed the 1990s spawned the serious skinhead/gang/race violence" (2008). This account suggests that race was not a primary cause of strife in the early-

1980s hardcore scene; instead, racial acrimony was a byproduct of the late-1980s era, in which skinheads became much more prevalent, exacerbating racial tension and conflict in what initially had been a multicultural punk movement.

In a 1988 *Maximumrocknroll* interview, Frank Agnew of the Adolescents, another band that withdrew from live shows around 1982 and 1983, was also disturbed by the violent aspect of the punk scene: "It started become more of a gang-oriented thing than being related to music." At the time of the interview, however, things began to reverse. As he outlines it, the "horrible" and "destructive" gangs that took away the identities of kids finally "began to separate themselves from the music." Looking back, he grapples with the history of violence that gripped Los Angeles youth: "there was an article in the *L.A. Weekly* on 'Violence and Punk.' And all of a sudden guys that were like football players shaved their heads and went to shows to beat up people. . . . The same thing with the kids who see the whole thing with gangs and colors in the papers and they want to be in a gang" (Thomaso 1988). In fact, many hardcore scenes throughout the United States had gang-like crews, local diehard fans that formed para-familial bonds. As Dave Dictor of the band MDC reminisced to me:

> I felt like, a lot of the punk rock and hardcore things were . . . I don't want to say gangs, but they were crews. The straight-edge crew out of Boston, the straight-edge crew out of D.C., were these crews of people. They were young guys just trying to—well, gangs are like families. People looking for people to look out for each other. At its best, you know. At its worst, it can be this mean-spirited, us versus them, beat anyone up you want to for power and kicks. . . . It was somewhat gang-oriented, but then in L.A. it was such a monster. (2008)

One might contextualize the Los Angeles punk/gang issue according to scale: if the gangs seemed

monstrous, that might simply reflect the sheer size of the overall scene. For instance, one Black Flag gig at the Santa Monica Civic Auditorium in early summer 1981 attracted over 3,500 attendees, whereas a typical hardcore punk show in Detroit might have only attracted a few hundred punks.

Critics often point to "reckless" punk lyrics and criticize allusions to lines like "getting heads kicked in" or "wrecking crews." Violent images likely stir violence in impressionable young listeners already prone to heated emotions, they insist. Tony Agnew, singer for the Adolescents, a teenager himself when the band launched their influential first album, takes aim at such misreadings:

> "Wrecking Crew" . . . is about tearing down the existing social order of 1979/1980. Nothing more or less. Teen angst, high school style. We were very much against punk on punk violence. . . . The song is more an anthem to survival (suicide is no way out, running away from home doesn't solve the problem) and joining a more tribal and basic primal pattern (join our primitive way of fun). [The lyric] "The violence never ends" simply refers to the mindless smashing of things, not of hurting people. To get an accurate idea of what we meant, think more along the lines of *Peter Pan*, not along the lines of the *Lord of the Flies.* Keep in mind that we were all a pretty wimpy bunch of guys, and the original lineup of the band in 1979–1980 still went to church on Sunday mornings (John, in fact, went to parochial school). Frank had a five-inch tail of hair that he bobby-pinned under a baseball cap so his dad wouldn't know he was slightly off center. (2004)

While the West Coast was subsumed by the threat of "Suicidals," the East Coast dealt with the volatile vector of Washington, D.C., supposedly a land of brash, ill-tempered, cutthroat hardcore punks that might illustrate the symbolic difference between the quick—the "harDCore" (D.C.-based hardcore punk) clique—and the moribund:

New York and older D.C. drug-punk culture. For Ian MacKaye of Minor Threat, gang allure likely related to a sense of unity, camaraderie, and self-protection for a mostly underage (under twenty-one years old) scene. In a sense, it provided gig-goers protection and the ability to hold a line against the forces of authority or physical intimidation. As he told the *Washington Post*: "I am fascinated by gangs. . . . I don't like going out and beating people's asses but I like the idea that if I have trouble, I have a lot of friends that are going to help me out. . . . To me, it was a great thing to see all these people get out there and be able to put back the bouncers, put back whoever was hurting somebody else" (qtd. in Anderson and Jenkins 2001: 82). Unfortunately, when these same kids made their way to New York, their "gang ethos" stirred antipathy and resulted in them being pegged as thuggish—cropped-hair bullies—by the likes of Jack Rabid, editor for the long-lasting zine *Big Takeover*; infamous rock 'n' roll writer Lester Bangs; and *Village Voice* critic Robert Christgau. When Washington, D.C.–based band SOA, led by ornery Henry Garfield (later Henry Rollins), played their last show with Black Flag in Philadelphia, the gig turned into a rout as D.C. gig-goers and local Kensington gang members clambered in a melee outside the club as police did nothing. Soon thereafter, Garfield joined Black Flag, whom he characterized as a "big gang" as well.

Blaming the media for violence in the punk scene has a long legacy, dating back to the earliest days of coverage. When a slightly wary *Rolling Stone* writer ventured to a Sex Pistols gig in 1977, an irate English pogoer admonished him: "The scene has been going on long enough to attract the idiots who believe the papers. . . . They're just trying to live up to their image. Regular violence is a lie" (qtd. in Young 1977: 68). Magazines such as *Rolling Stone* and *Penthouse*, whose article "End of the World?" portrayed L.A. hardcore as "anarchic, sociopathic rock 'n' roll noise for an anarchic, sociopathic subculture" (Palmer 1981: 48),

together with primetime shows like *Quincy* and *21 Jump Street*, normalized such discourse within the media and commercial television by "criminalizing" punk characters. Moreover, such discourse acted as a recruiting tool, enticing more aggressive, unstable, or marginalized viewers to live out their fantasies by joining the punk scene. Many times, punks admonished the press for misunderstanding the often ritual and choreographed nature of punk "violence"—slam dancing, especially—and blamed the media for opening punk's closed community to outsiders who were attracted to punk's teeth-bared "hateful" stance and physical vehemence, not to its artistic leanings. In short, the media created the dilemma, bolstered by a desire to profit from, and likely discredit, a youth culture it deemed problematic and anti-authoritative.

Everything That Rises Must Converge?

In places like Los Angeles and Houston, wide-ranging Hispanic punk movements still blossom, which often make intense impressions on outsiders, like British visitors. "I always thought Hispanics were like the working class punks in America. Their anger was real. It was what the white suburban bands were writing about while munching on their Twinkies. Whenever I was at gigs in Southern California, the Latino kids were the craziest dancers and the most dedicated followers of the bands it seemed," observed Welly, editor for long-running *Artcore* fanzine, singer for Four Letter Word, and one-time roadie for Chaos UK (2010). "[Hispanic punks] are the true definition of punk rock—outsider music for outsider communities," John Robb, pop culture historian and lead singer of the bands Membranes and Gold Blade, informed me during a 2006 interview. "Our [Anglo] outsiderness seems like a luxury compared to people pushed to the fringes of society. On the other hand, maybe they just

liked the music and happened to be Mexican/gay/black etc. Modern punk is really a feat, seeing the way that it has reached all corners of the globe . . . from China to Malaysian skinheads! I'm not sure if it's that unnoticed. Punk is one place where these issues are debated endlessly. Few other pop cultures even raise the debate."

In this sense, punk rock is not a bastion of unadulterated Anglo anguish and discourse, but a convergence space, a diverse hub and meeting ground, dedicated to probing questions regarding identity, status, agency, and autonomy in multi-ethnic communities. "In the 7th grade, I was re-introduced to punk rock music. I met this girl named Chelsi, and we befriended each other. She introduced me to the Dead Kennedys, the Casualties, and the Dead Milkmen. The song that was the story of our lives was 'Institutionalized' by Suicidal Tendencies," Hispanic teenager Maraya Medina from California disclosed to me. "That song spoke to us: we felt like outcasts, the black sheep of our family. We were all we had. Punk rock music was fast, loud, and rebellious. And at that time, that's how I felt. I wanted to be different than everybody in the town" (2010). Gina Miller (Rodriguez), singer and marketing director for SugarHill Recording Studios in Houston, sketched out a similar experience to me:

> Music has been in my life since I can remember. My mom was a mariachi singer in the 1970s and sang up until the time of her death. It is rumored that when my parents met in Mexico, it was because they heard each other singing back in forth and fell in love with each other's voices (our respective families lived next door to one another). As a child, I grew up around my mom singing the oldies and grew to love the R&B ladies (Tina, Shirelles, Diana Ross, etc). Our family would get together, and all my uncles and mom would play guitar and sing the old Mexican ballads almost every weekend. When I was about 15, I started hanging out with the girls who wore black nail

polish and listened to new wave—we were listening to The Cure, Morrissey, Joy Division and the like. Admittedly, my introduction into punk was pretty evolutionary. I moved back to Houston about 16, a shy girl in a huge metropolis. Music was my excuse to connect with the skater boys and the cool punk girls. Around high school, I learned a hard lesson in peer cruelty and discarded the trusting naïve girl for the more hard-edged punk rock persona. From pop-punk to rockabilly and ska and the 1950s girl bands' influences, I landed somewhere in the middle as the 'last resort' singer for my surf/garage rock band, The Magnetic IV. Back in the earliest days of practice, I would keep my back to the rest of the band. I was scared to death to sing in front of anyone. Later I joined The Kimonos, where most of the focus is off of me and onto the mania of my frontman/guitarist. I've grown as an artist. The biggest compliment I've received was at a show: I was about six months pregnant and ditched my high heels onstage—a friend said he'd never seen the gospel rocked barefoot and pregnant. Music is in my lifeblood. (2010)

Despite the age gap, regional differences, professional gains, marriage, and motherhood, Miller still feels equally compelled by punk's urgency and "edge," DIY aims, and legacy as any teenager being introduced to similar soundtracks.

Punk and hardcore provided a space for bands like the Plugz, the Bags, and others to reassert the flux and freedom of Hispanic identities in American music and culture. Imbued with infectious punk rock poetics and self-defined, sometimes elusive politics, these bands heeded no borders and bonded with disaffected listeners both inside and outside their own communities. Hollywood may be reified as ground zero for a defining portion of American punk, but neighborhoods stretching from the West Coast to Texas, underscored by a fadeproof Hispanic point of view, continue unabated,[6] to shape the future of punk rock in the lands of sun, anger, and La Raza.

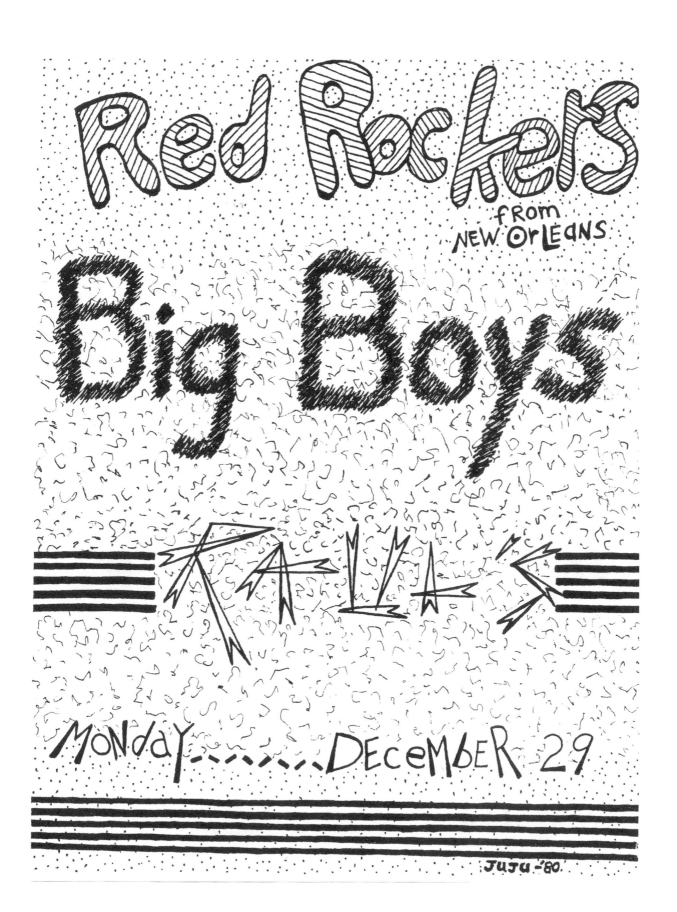

Big Boys and Red Rockers at Raul's, Austin, Texas, 1980, by Randy "Biscuit" Turner.

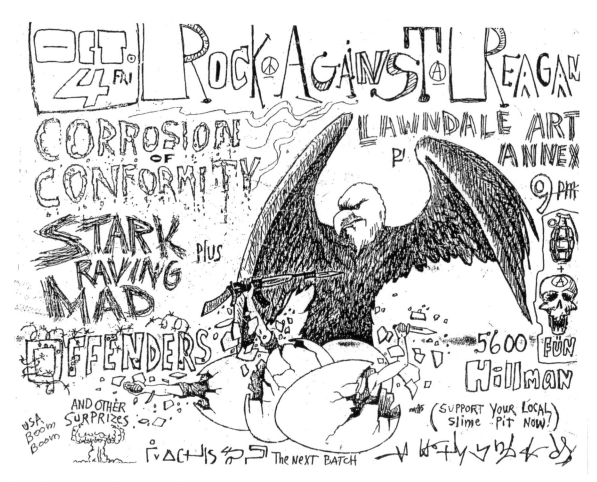

Rock Against Reagan at Lawndale Art Annex, Houston, 1985.

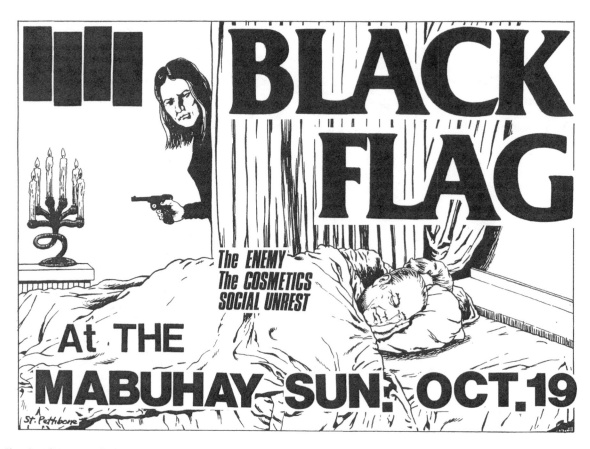

Black Flag, Social Unrest, and others at the Mabuhay, San Francisco, California,
by Raymond Pettibon, 1980.

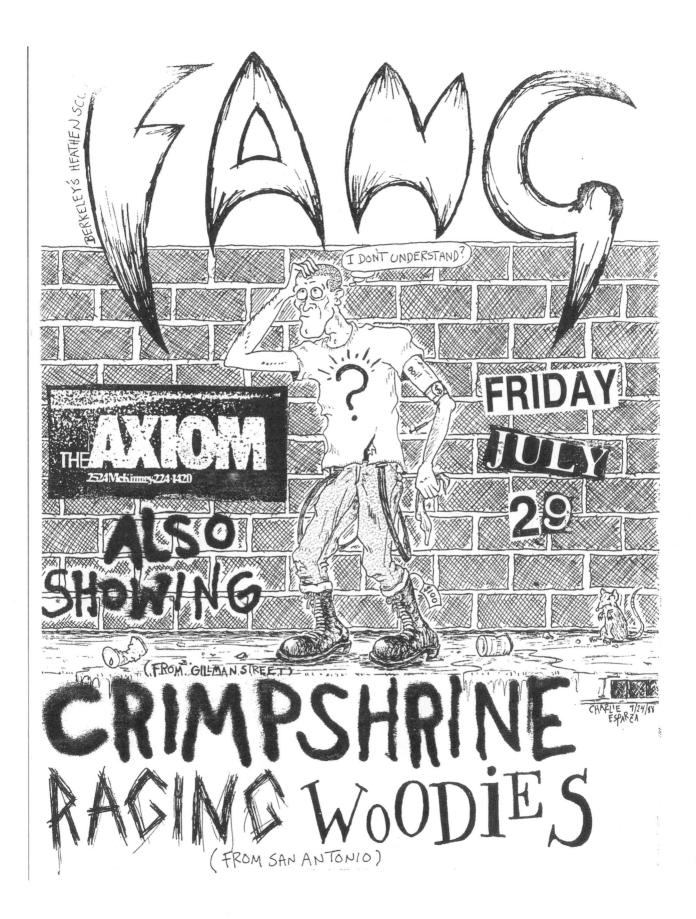

Fang, Crimpshrine, and others at the Axiom, Houston, 1988, by Charlie Esparza.

MINOR THREAT

D.C. HARDCORE

die kreuzen

MOO!

SUCK

MECHT MENSCH

CLICHÉ

SPECIAL 6:00 SHOW

$3.00

SUNDAY APRIL 17

WIL·MAR

953

...ught to you by Bone Air boys ® ®©® Bus

Minor Threat, Die Kreuzen, and others at Wil-Mar Center, Madison, Wisconsin, 1980s, by Bone Air Boys.

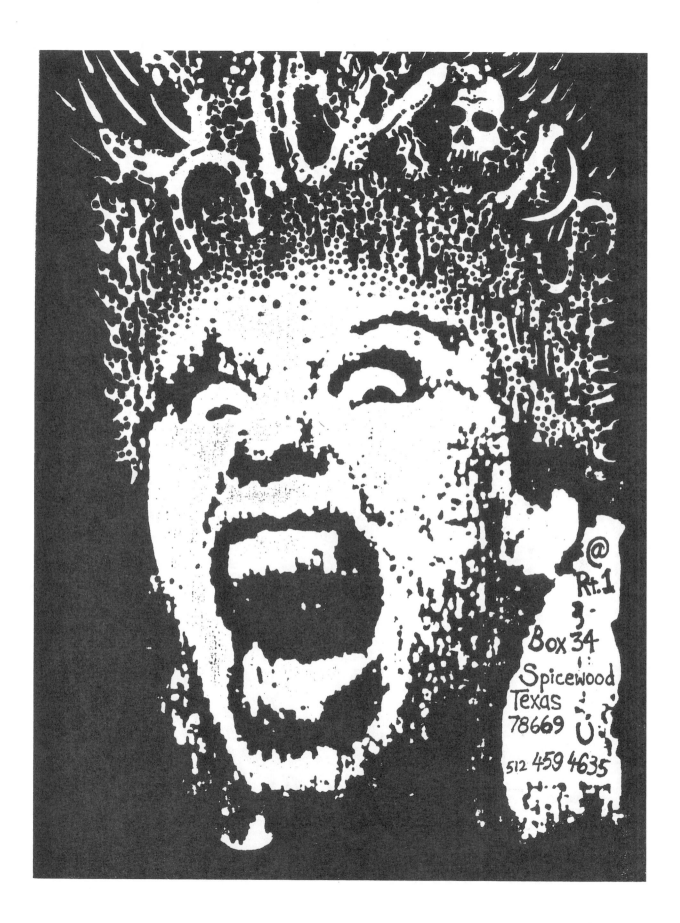

Hickoids at Rt. 1, Spicewood, Texas.

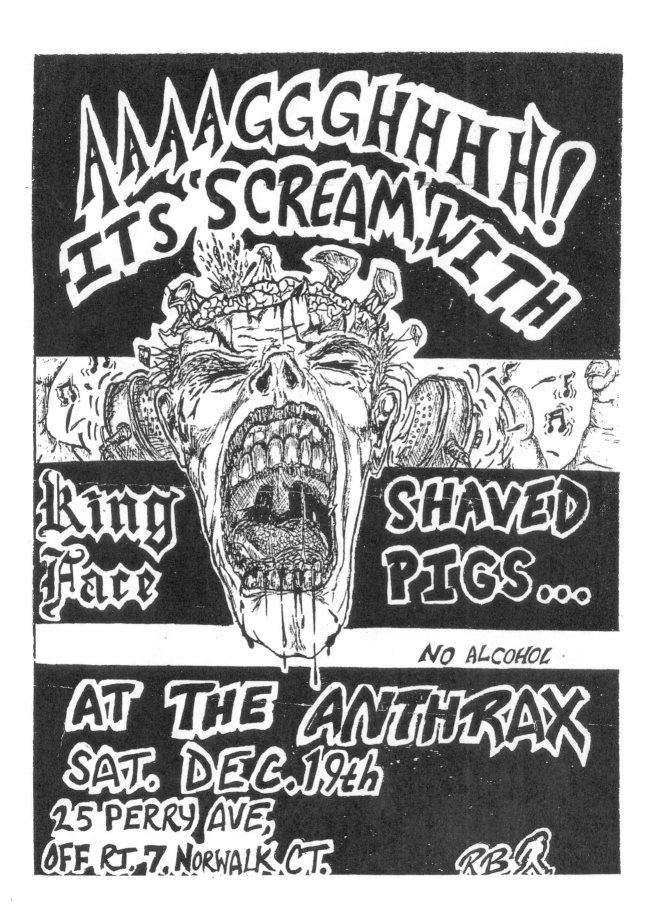

Scream, Kingface, and others at the Anthrax, Norwalk, Connecticut, 1980s, by R.B.

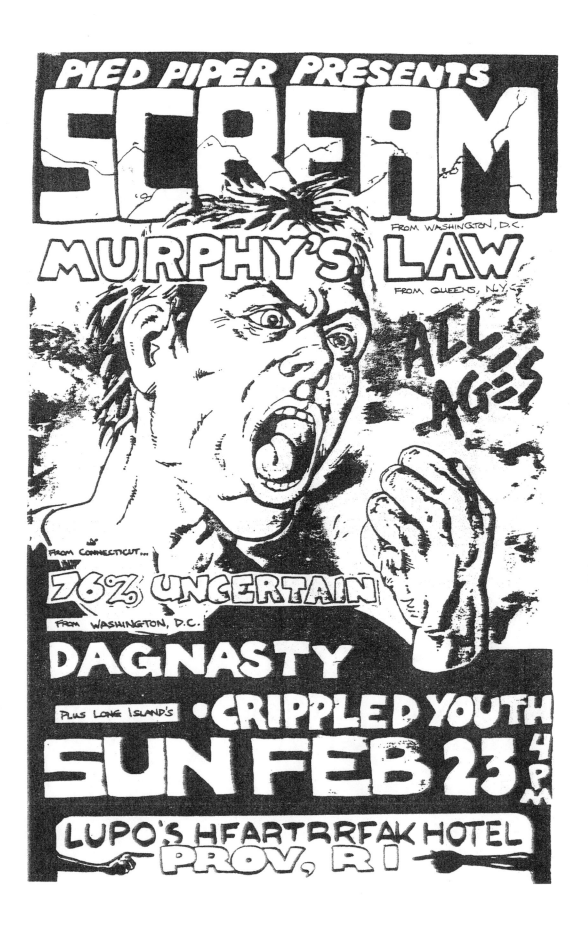

Scream, Murphy's Law, and others at Lupo's, Providence, Rhode Island, 1980s.

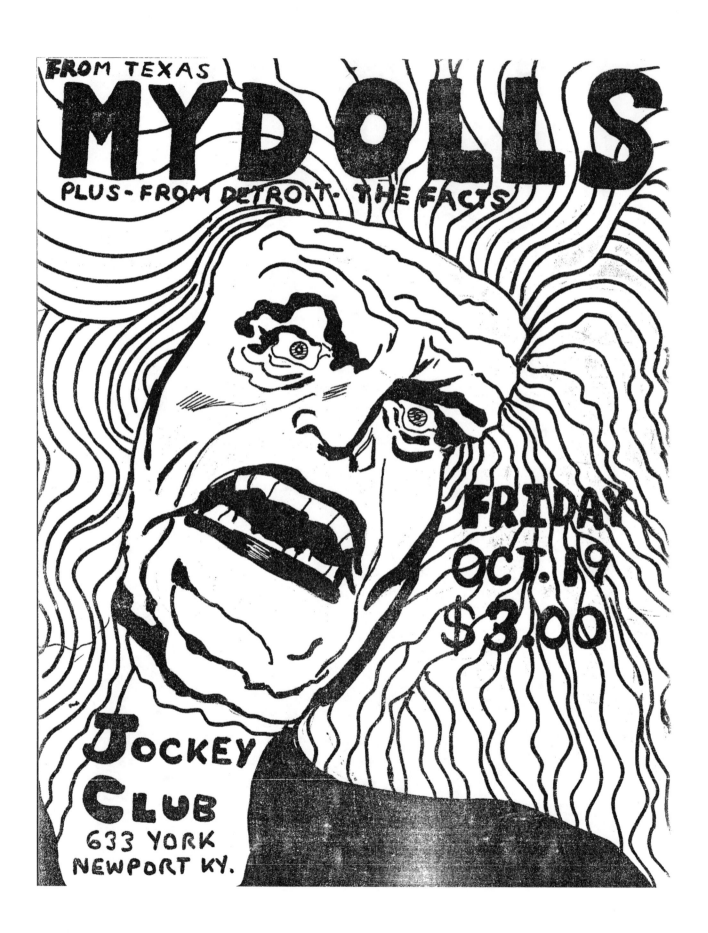

Mydolls at the Jockey Club, Newport, Kentucky, 1980s.

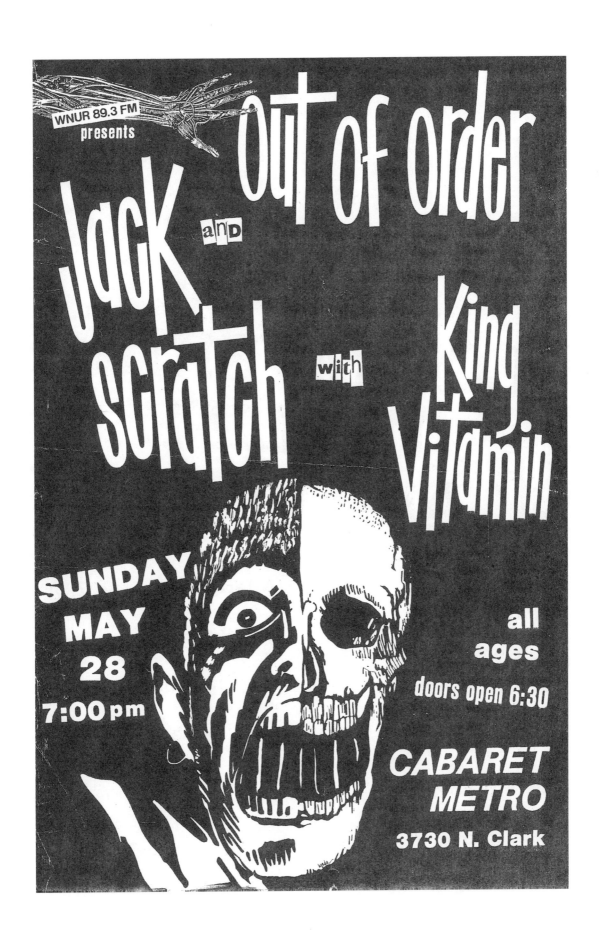

Out of Order, Jack Scratch, and others at Cabaret Metro, Chicago, 1980s.

CHAPTER NINE

COLORING BETWEEN THE LINES OF PUNK AND HARDCORE

There aren't any blacks.

—WOODY HOCHSWENDER,
"Slam Dancing: Checking in With L.A. Punk"
(*Rolling Stone*, 1981)

. . . there is no hint of any

derivation from Black music.

—GREG SHAW, "England's Screaming:
The Music" (*Bomp*, November 1977)

A large number of hardcore

people in New York are

Hispanic, black, oriental,

and Jewish . . .

—the editorial staff of *Guillotine* #8, 1984

For three decades, African Americans have been almost exclusively depicted in mainstream and even independent media as embodying the hip hop nation, signified by such media as an urban, often misogynist and materialistic, "street level" musical genre and lifestyle. Through absent or scant coverage, such representation effectively diminishes or even negates the contemporary influence of blacks on rock 'n' roll and punk. In doing so, the media perpetuates the notion of a homogeneous African American community that is easily containable and conventional. I seek to interrogate the common misconception that punk, essentially a multicultural participatory subculture, is a white (or Anglo) phenomenon alone.

What would the Jam, the Ruts, the Clash, Stiff Little Fingers, the Members, even the Undertones (who covered the Isley Brothers) and many other punk bands be without black music as their foundation or influences? As Joe Strummer from the Clash argued in *Record Mirror*, "We started playing reggae when everyone was saying white men can't play reggae, just like they used to say white men can't play the blues" (1978). One cannot fathom the Jam without "sweet soul music"—their covers of Arthur Conley, Curtis Mayfield, Otis Redding (reportedly Paul Weller's favorite singer, according to a 1977 *New Musical Express* feature on the band), James Brown, and War. Paolo Hewitt stresses such undercurrents in the liner notes to The Jam *Extras* CD booklet: "Black music had also played its role. As a young suedehead he [Paul Weller] had visited local joints such as the Atlanta, Woking Football Club and Knaphill Disco, where the sweet sound of ska and soul worked its way into his musical blood. . . . Indeed, the Jam's repertoire, for much of their early years, owed as much to Motown and Stax songbooks as any other music" (1992). The Ruts underscored punk reggae cultural hybrids both in song titles ("Babylon Is Burning") and stylistic flourishes ("Jah War"), while even the

forcible Oi band the Angelic Upstarts put out a reggae-tinted record (1983's *Reason Why?*).

Additionally, football terrace rockers the Cockney Rejects panned, or perhaps made ironic homage, to reggae in "Where the Hell is Babylon," which asks if "such a place exist[s]" and if the singer can get there on his bike. Meanwhile, the Two Tone

Punk is white and suburban.

—MYKEL BOARD (Maximumrocknroll, 1986)

Several blacks, also drably dressed and with rainbow stripes dyed into their short Afros, speckle the audience.

—CHARLES M. YOUNG, "A Report on the Sex Pistols" (Rolling Stone, October 1977)

ska movement—most prominently epitomized by the Specials, the Selecter, the Beat, and Bad Manners—was the convergence of two decades worth of youth-centered musical movements in British culture, perhaps even the moment when the "frozen dialectic" between black and white youth, described by Dick Hebdige at length in *Subculture: The Meaning of Style*, began to melt.

For American antecedents, what would the MC5 be without Sun Ra, Chuck Berry, and soul music? What would the Stooges be without the blues? Iggy Pop has lectured about their brand of

rock 'n' roll as African beats meeting the machine-age music of grease and oil Detroit. In fact, Iggy, whose real name was James Osterberg, journeyed to Chicago as a young man to learn blues drumming from James Cotton's percussionist, Sam Lay. The lyric "I Wanna Be Your Dog," which Pop transmogrified into a fuzz-laden teenage garage punk calling card in 1969, is evident in Big Joe Williams's 1947 song "Baby Please Don't Go."

Symbolically speaking, Iggy's whole stage persona personifies the snake from Eden. He anthropomorphizes it, becoming the undulating, slinky snake—the voodoo rocker child—surrounded by raw rock 'n' roll born from thick, tumultuous power chords that are bastardized blues supposedly stripped of culture references and history, forming a not-so-clean slate of white anguish. To some, this is the template of punk rock, a tireless model in waiting. W. Sheehan Thomas argues that Pop mixes this "white primitivism and so-called black primitivism" into a technical blueprint "without being able to master the form" (2007): thus, Pop evolves into a continued state of self-affirmation and self-destruction as he seeks the community and bonding that blues offers to black Americans (which Pop saw firsthand in urbanized Chicago and Detroit), but he can only deal with the absence of real community. Pop seeks musical distortion and dissonance, forever a witness to that which he cannot obtain.

Wayne Kramer, guitarist for the seminal proto-punk Detroit band MC5, who was also deeply influenced by black music, affirmed to me:

> Music itself is a tool. Language is a tool. It's all trying to carry a message, something about wherever I am at the moment. If I can be honest about that, then chances are someone else is at that moment. And if I do it right, and send a message to that message that you know, you are not alone, you're not the only one that feels that way. That's what great art has always done for me. That's what great literature does for me, that's what great painting does for me, that's what great music has done for me. When I hear James Brown or John Coltrane, I don't feel so alone. (2001)

Other punk pioneers, especially avant-gardists seeking expanded musical forms and thresholds, believed that some heralded black artists failed to push *enough* musical boundaries—truly to transcend—even when they had the talent and intellect to do so. David Thomas from Pere Ubu posits:

> I don't want to end up criticizing people like Nina Simone or Billie Holiday, but I don't particularly care for their singing. They are great singers, but they are not taking the voice . . . somehow they are not using the words and the voice in something new, and they are very limited in what they can do, and it's very linear I think. That has to do with a derivation within the blues, I suppose, but blues can be extremely abstract, whereas I'm sure that I have never seen that particularly in jazz singing. And even if I would grant you Billie Holiday and Nina Simone, you really can only name less than a handful of great singers in jazz, and they tend to be great not because of vision. (2004)

Within the discourse of punk, black music is something debated and explored on many different nuanced levels, not simply imagined as a homogeneous form to be appropriated and colonized.

The sense of common black/punk otherness was partially explained by Thomas in a *Rolling Stone* interview. Responding to a question about his music roots, and the sudden "explosion" of attention given to fellow Ohio bands like Devo, Thomas surmised: "It's typical of what happens in the Midwest that everybody gets ignored. . . . It's like being a black or a woman—you have to do your best, 'cause they don't care" (qtd. in Carson 1979: 23). All three—blacks, women, and punks—work under the radar. In far cruder terms, Johnny

Lydon suggested to *Rolling* Stone as well that punks and blacks occupy a similar status: "Punks and niggers are almost the same thing. . . . When I come to America, I'm going straight to the ghetto. And if I get bullshit from the blacks in New York, I'll just be surprised at how dumb they are. . . . I'm not asking the blacks to like us. That's irrelevant. It's just that we're doing something they'd want to do if they had their chance" (qtd. in Young 1977: 74). Many music critics argue that gangster rap, from the Geto Boys to NWA (Niggers With Attitude), and the political hip hop agitation of Public Enemy and Boogie Down Productions, later became that chance.

The New York Dolls embody another kind of confluence and hybridity, one that openly nurtures the black history and music present within the punk/glam/rock 'n' roll template. Their records feature tunes by Bo Diddley ("Pills"), Sonny Boy Williamson ("Don't Start Me Talking"), the Cadets ("Stranded in the Jungle"), the Coasters ("Bad Detective"), and Archie Bell and the Drells ("Showdown"). Their spring 2009 tour set list was completely immersed in the traditions of black music as well, including: soul ("We do Philly soul, Texas style!" they said), blues (singer David Johansen offered, "One of the first records I ever bought was Lightnin' Hopkins from Houston!"), reggae tinges (a surprisingly slow and nimble version of "Trash"), and R&B (the band smoothly transitioned from "Jet Boy" right into a reimagined "Hey Bo Diddley"). If both the Stooges and the Dolls represent proto-punk antecedents, then black music is, in essence, a fluid backbone of the punk style.

As Daniel Traber has noted, the very nature of punk within the commodity market echoes black culture, for (punk) established a permanent alternative to the corporate apparatus of the mainstream music industry by returning to a system of independent labels that resembled the distribution of post–World War II "race music" that influenced the white rockers of the 1950s (2001:32).

In addition, punk writer Chris Salewicz posited, "more important is the way punk still is presented, which is through the rootsiest musical business set-up that exists outside of reggae" (1982). Members of the Bellrays—guitarist Tony Fate and singer Lisa Kekaula—have even suggested that punk's roots go as far back as 1918 and include Louis Armstrong and Duke Ellington (Shame 2002), while Mike Watt, former bass player for the Minutemen, suggests his own tour circuit and DIY ethos link back to vaudeville and burlesque (Testa 2002). Writer Bruce Davis attested that the Ramones were "like the jazz musicians of the '50s and the blues players of the '60s who would play in clubs to a relatively small devoted following, and then go to Europe where they'd be greeted as heroes" (1990: 10).

Lastly, Vic Bondi, singer for Articles of Faith (a 1980s Chicago band inspired by the Bad Brains that manifested a taste for reggae, funk, and three-guitar hardcore punk agility), suggests that punk gave people a voice to counter and denounce oppression, which links back to jazz, prison work chants, slave hollers, and the spirit and blues found in Sly Stone's voice (2002/2010). An awareness of such historic threads places punk as a transhistorical, cross-cultural, synergistic negotiation between African American and white music cultures.[1]

In *Ink Disease*, a fanzine from the early 1980s, Franz Stahl from the mixed-race D.C. band Scream argues, "There are certainly more Blacks in punk than there are in rock 'n' roll." His bandmate (and brother) Peter, the singer, responds, "Blacks aren't exposed to it. The only exposure they get is from the media. It's all twisted and distorted. . . . I think it's just a prime example of this whole country, it's basically just as racist as when the *Emancipation Proclamation* was first signed" (#4). This racism might manifest itself as a sometime invisible barrier, noted by bass player Skeeter. When asked by Donny the Punk, a *Flipside* reporter, about how being black affects his relationship to the hardcore punk scene,

Skeeter responds: "It's different. You notice it every time you walk into a town. There's always some sort of hesitation. I feel a certain pressure, there's a block there, a wall" (1985). Perhaps the reclamation of punk history can become a way to unmask, destabilize, and defeat this ambivalence and racism.

Even within bands, such matters were actively discussed. When *Flipside* interviewed Swiz, featuring black hardcore singer Shawn Brown (formerly of Dag Nasty), the band openly debated racism in punk among each other. Whereas Shawn admitted that "No one has ever come up to me and said anything to my face," he also revealed that white so-called punk allies might befriend him while also demeaning Asians. This contradiction is not lost on the band. Drummer Alex notes that people might wear "Fuck Racism" T-shirts as an open demonstration of solidarity, yet turn around and use terms like "spic." Guitarist Jason also suggests that such T-shirts are not provocative within the relatively safe space of punk gigs, whereas if such shirts were worn in the Deep South one might have to "defend yourself." Bass player Nathan comments that, again, racism usually surfaces in more subtle forms, such as people saying comments off to the side of mixed-race bands but never confronting them directly (qtd. in Krk 1989). This is just one illustration of how bands grappled with the nuanced issues of racism in punk, in which the discourse of T-shirts, psychogeography of gig spaces, and private attitudes had to be routinely negotiated.

On the East Coast during the late 1980s, Norm Arenas, who later founded the zine *Antimatter*, played in seminal hardcore bands, including "Krishna-core" genre leader 108 and popular Texas is the Reason. The latter group bridged alternative rock with punk in the 1990s. At CBGB and other clubs he witnessed racial tension in the country's biggest city, where diversity and fusion was supposed to be an everyday reality. He describes the irony at length:

In NYC . . . mid to late 1980s, everybody and their brother had an anti-racist song, everybody was talking about unity, SHARP was on TV, you know, blasting the skinheads on *Geraldo* . . . A lot of people had questionable politics when it came to race. For example, it was acceptable for skinheads at the time, and pretty much everybody in NY was a skinhead at one point, in the 1980s . . . to say that they were "white pride" not "white power" and not quite understand or maybe understand too well what they were saying. Because I did realize that a lot of people I knew in the 1980s who said they were white pride and not white power did actually shift into white power. Even the people who were vehemently anti-racist didn't really go out of their way to meet many nonwhite people and there was a little bit of a fallacy in the whole thing that was not lost on me. When I went to shows and looked around me and you know, sang along to every youth crew song about racism, it did not fall on deaf ears that I was the only nonwhite kid in the house. (Laughs) Eventually, there were other people who I would see that I was really looking up to. When I first saw Absolution, when Chaka and Freddy Alva put out the *New Breed* compilation in the late 1980s—a compilation with all the new hardcore bands in New York at the time—I remember thinking how cool it was that a black kid and a Hispanic kid came and put out this tape. Those things actually did affect me. (2007)

I contend that punk music, often racialized and derided as white rebel music without much cause, has been far more multicultural than the genres of power pop, heavy metal, or most indie rock. This, in turn, interrogates David James's notion that L.A. hardcore was a "white musical production that was both popular and avant-garde . . . a completely recalcitrant stance against the bland conformity of mass society and the naturalization of consumption within it" (167). Instead, hardcore and punk provide a space for the likes of black lesbian female skater and drummer Mad Dog from

the Controllers—a way to reassert the flux and freedom of the black identity in American music and culture. The presence of Black punks is neither homogenized nor fixed. In fact, Mad Dog, who joined the Controllers even after Lorna from the Germs claimed they were racists (partly because bassist bass player DOA Dan painted a swastika on his chest), once told *Maximumrocknroll* that she is a "white man trapped in a black woman's body. You have to print that and if people don't get it, well then, fuck them" (Grant 1994). Fan and photographer Gaby Berlin recalls her presence: "The first time I met her she had set her drums up in the parking lot of that record store across from the Whiskey and was just drumming away. I actually thought she was a boy and I had a huge crush on her. I always thought she was the epitome of punk" (2005). Mad Dog was not a lone margin walker, and she reflects what Traber asserts to be a type of transgression—challenging the social order's core stable narrative—perhaps even accidentally, by revealing that each and every identity is a performance, replete with a costume (2007: 181). Thus, Mad Dog offers a critique of prescribed cultural restraints.

African Americans have been an essential force shaping rock music since they carved a classic form from a combination of sped-up blues, boogie-woogie big band piano, and rollicking rhythm and blues. Chuck Berry, Big Mama Thornton ("Hound Dog"), and Little Richard ("Tutti Frutti," later reworked as "Tofutti" by the hardcore band MDC) were powerful musical engines that energized the form with gusto, panache, and deep inspiration. Singer-songwriter Mathew Ryan framed the influence of such musicians on bands like the Clash, suggesting to *Uncut*: "I think the Clash realized, 'Wow, Chuck Berry was good, Motown was good.' So they went from anti-establishment to classicist on some level. ['Should I Stay or Should I Go?'] . . . This one's as good a rock song as 'Lucille'" (1993: 50). Malcolm McLaren acknowledged that "I never really believed that

anybody was gonna write anything better than 'Johnny B. Goode.' . . . [The Sex Pistols] was still in the very basic, raw, old-fashioned format, verse-chorus, middle eight, blah blah blah, R&B, Chuck Berry chords" (*Ben Is Dead* 1996). This appears to reinforce the insight of one rock 'n' roll social historian who recognized a "repetitive blues-based guitar solo" on "God Save the Queen," which is nonetheless "harmonically more complex than most blues," while also noting that the Clash dabbled in "Berry-style classic rock" on "Brand New Cadillac" and a Bo Diddley beat on "Hateful" (Friedlander 1996: 254, 257). In such context, American and even punk's British "ground zero" bands (1976) were still deeply indebted to black music.[2]

Countercultural icon and music critic Lester Bangs, once yelled at by NYC city punks for playing Otis Redding at a loft party in the 1970s, adored the Clash. In the 1979 essay "White Noise Supremacists," he admitted attempting Lenny Bruce–style method of "defusing epithets" by reclaiming them in the pages of *Creem* magazine:

> Now, as we all know, white hippies and beatniks before them would never have existed had there not been a whole generational subculture with a gnawing yearning to be nothing less than the downest baddest niggers. . . . Everybody has been walking around for the last year or so acting like faggots ruled the world, when in actuality it's the niggers who control and direct everything just as it always has been and properly should be.

Yet, by the time he authored "White . . .", he regretted these turns of phrase and his impromptu late-night party sessions when he would belt out mock-blues like: "Sho' wish ah wuz a nigger / Then mah dick'd be bigger." The article candidly unveils Bangs's self-realization that he blundered; he further suggests that racism is like a virus, infecting invisibly, which can cloud the brain and push poor judgment to the surface during moments of

distress or clumsiness: "You don't have to try at all to be a racist. It's a little coiled clot of venom lurking there in all of us, white and black, goy and Jew, ready to strike out when we feel embattled, belittled, brutalized. Which is why it has to be monitored, made taboo and restrained, by society and the individual."

This forthright cautionary tale might have been the result, as the essay alludes to, of Bangs hearing Andy Shernoff of the punk band Dictators calling Camp Runamuck the place "where Puerto Ricans are kept until they learn to be human" (likely not less ambiguous than Adam Ant's controversial song "Puerto Rican," with its "greasy haired dagos"). The essay also may be a response to the "cartoony" band Shrapnel, fingered as "proto-fascist" by music critic Robert Christgau, and featured Legs McNeil of *PUNK* fanzine, who spouted songs like "Hey Little Gook" from stage while years later telling writer Jon Savage that the original group of New York punks "were going: 'Fuck the Blues: fuck the black experience'" (qtd in Savage 1991: 138).

Such antipathy was not the sole provenance of New York City. In England, the band the Models produced a hand-drawn flyer for a Roxy gig in 1977 that promised "No reviving of Old R + B" and a "Nazi party." Their singer has since argued: "We weren't Nazis nor did we have any political views at all. We had no problem with Jews, Pakistanis, gays or any one else—we just hated everyone who lived in the straight world" (qtd. in Marko 2007: 119). None of these early questionable actions— usually considered shock tactics—overshadow the fact that black, white, and Hispanic musicians were converging in punk.

Note this following exchange between myself and Peter Case, whose band the Nerves was the first independent punk band to tour America (in 1977):

Ensminger: In 1977, Greg Shaw wrote that black music had no connections to punk rock, while Jon

Savage, in his book *England's Dreaming*, wrote "much of the music bled out any black influence," which strikes me as weird, because obviously the Clash, Jam, and Chelsea were highly influenced by black music.

Case: The Talking Heads were, who weren't really punk rock. But like Iggy and the Stooges, man, that's the connection that came up through the Ramones. Like Iggy is all about fucking black music. The Stooges were. They're about the blues, man. Like Iggy ran away and went to Chicago and got into music from watching blues guys in blues clubs. That's where Iggy is coming from, from a really soulful place. Same with the MC5. Those were his heroes. The MC5, those guys were totally into black music. I mean they were like into James Brown and Sun Ra. Stuff like that. So that's the influence on the Ramones, for one. On the other hand, the other influence on the Ramones is New York girl groups,[3] and the start of that whole thing was black, too. So the whole idea that there is no connection between punk rock and black music is a joke. There is no great music in the United States that doesn't have a connection to black music, including country. So, is that a slightly racist statement, I'm not sure. I think it is. It's at least deluded. Why they were so intent on there being no connection to black music, I can't get, but I dug disco. And nobody dug disco back then, but I thought disco was fuckin' rockin'.

Ensminger: And you used to play reggae songs on the streets in the early 1970s as well, right?

Case: I wanted to be a reggae singer. I was nuts over reggae. I was at the very first Bob Marley gig in North America, which was at the Matrix Ballroom in San Francisco. Me and my other guy from my street band ran in the side door. It was one of the best gigs I have ever seen in my life. Loud, fucking rockin'. Peter Tosh and Bob Marley, just a great gig. So, I was super into that. The other Nerves

weren't really into it. Jack wasn't really into soul music, but Paul was. Paul was into black music. I mean Jack appreciated it but only through a filter of . . . he liked songwriting. He liked certain things about it, but Paul and me were really into it. I was always really into it. (2008)

Case's account questions, even severs, the dominant discourse, present and promulgated both in mainstream press and the independent press, such as *Bomp*, that punk rock was a white genre somehow isolated from America's larger musical heritage, which was profoundly shaped by African Americans.

Patti Smith admitted to *Blast* magazine that when she was young she hated the Beatles and the Beach Boys: "I thought all that stuff was jive. . . . I liked James Brown and Marvin Gaye" (qtd. in Gross 1976: 53). Frankie Fix of Crime, a key San Francisco punk band from mid-1970s, admits that he and fellow member Johnny "hung out in the ghettos" before playing in the band because they "were very intrigued by . . . soul music, black culture" (LaVella 1989). He stresses, "that's where all good music comes from" and links that same tendency—whites taking cues from blacks—to bands like the Rolling Stones. Jeffrey Lee Pierce of the Gun Club not only loved Bob Marley but became turned onto "weird" swamp and blues 78s, jazz from Ornette Coleman, and zydeco that he heard when cohort Phast Phreddie would DJ at house parties (Mullen and Spitz 2001: 251).

Even the early 1980s Orange County pop punk style, epitomized by bands like the Adolescents and Social Distortion, has direct links to black music, as evidenced by the memories of Social Distortion singer Mike Ness: "We were listening to a lot of Generation X and Buzzcocks. Those guys grew up with Chuck Berry and the Stones and the Beatles—that's why the first wave of punk, whether it's Johnny Thunders or the Ramones, the very blues-based rock and roll with pop melodies but done punk style, is what I listen to" (Mullen

and Spitz 2001: 257). Additionally, Mike Watt, San Pedro bass player for the Minutemen whose first punk show as a gig goer was the Talking Heads at the Whiskey in 1977, told me: "To me, rock 'n' roll is some dishwasher from Mississippi who wants to put on a dress and yell 'Tutti Frutti.' It's not about being popular, or making someone big and they get whatever they want" (2002).

Tony Kinman, from late-1970s West Coast politically minded punk pioneers the Dils, who played a Free Elmer "Geronimo" Pratt (Black Panther member and godfather to 2pac/Tupac Shakur) benefit with the Avengers and African roots musicians Ibex, offered me a similar view:

To me, Little Richard is, if you are going to say, or talk to an alien, and he says, what is this rock music you are talking about, and you had Little Richard (imagine a *Twilight Zone*) and he's in a plastic booth playing "Lucille." Then in another Plexiglas booth you have Rick Wakeman doing "The Six Wives of Henry VIII." Which one are you going to point to and say, that's rock music? You are going to point to Little Richard. [The Damned] and the Ramones at the time were the most exciting shows I had ever seen in my life far as sheer over-the-top, primal Little Richard style energy.

I would not compare the Ramones' album to what I consider the single greatest recorded moment of rock music history. Do you want me to tell you what it is? It's in the Little Richard recording of "Lucille." You can still hear it on oldies stations. Little Richard is screaming so loud that he overdrives his mic. On the hit version, there's actually distortion recorded on that. That is one thing that no engineer these days would let anyone get away with, I don't care if you are ever recording for a shitty indie punk rock label. Punk rockers would not let that happen, nowadays. (2002)

Although punk writers such as Legs McNeil (*Please Kill Me: The Uncensored Oral History of Punk*) have used the Ramones as a cultural

marker to describe how punk severed itself from the black cultural roots of rock 'n' roll traditionalism, Kinman draws a line between the performative elements—the sheer electrifying atavism that serves as a significant bridge between the so-called dialectical genres, erasing or at least questioning their status as opposites. Kinman blurs the lines between eras and styles. Randy "Biscuit" Turner evokes a similar perspective in his lyrics for the Big Boys (who played clubs alongside Kinman's band Rank and File) song "History," revealing: "Punk rock's not so far removed / From Little Richard or the early Stones / Just look around and see how much / And just how little we have grown."

Turner, who was known to perform in femme guises and drag, including "whacky" make-up, wedding dresses, and pink tutus, not unlike Divine from John Waters's films, was likely drawn not just to the primitive musical formula of Little Richard but his ability to present alternative masculinities or queered rock 'n' roll personas. As the book *Cult Rock Posters* acknowledges: "the very appearance of Little Richard, a black man camping it up in make-up and pompadour hairdo, had proclaimed that he wanted to overturn social norms" (Crimlis and Turner 2006: 52). This was not felt by male viewers alone. Patti Smith also found herself drawn to him early on, telling *Rolling Stone*; "when I was a little girl—I heard Little Richard when I was about seven years old. And I said, yeah . . . it was like, I was part of a truly new generation, where everything had to be *redefined*: God, sex, everything" (Young 1978: 54). In many ways, punks followed the template of Richard, becoming living, physical metaphors for alterity, even the carnivalesque—uncontrollable bodies in an era of social malaise. James Stevenson, guitarist for punk stalwarts Chelsea and post-punk gender benders Gene Loves Jezebel, reinforced this to me: "I think androgyny has always been a crucial part of rock and roll. That kicking against the grain. You could take it back to Little Richard" (2006).

Psychobilly, mixed-gender, garage punk band the Cramps covered "Fever" by Little Willie John, an artist who predated soul music, which might reflect androgynous singer Lux Interior's early fascination with rhyming radio DJ Mad Daddy (Pete Myers), who spun doses of doo-wop, B-movie soundtracks (like *The Blob*), and raucous R&B when he was not showcasing rock 'n' roll novelty songs or attempting stunts like skydiving into a polluted lake in winter from 2,000 feet, immortalized in the Cramps song "Mad Daddy." According to Count Reeshard: "The Mad Daddy Show was awash in continuous sound effects, maniacal laughter, tons of runaway repeat-echo, all to the accompaniment of many, many greasy rock 'n' roll and rhythm 'n' blues 45s. Myers didn't work with prescribed playlists, nor was he encumbered by some draconian station format. The high energy music of his day, made by Blacks, Whites and Hispanics, the stuff universally reviled by older folks, was manna for Mad Daddy" (2007). During an interview with Reeshard, Lux Interior excitedly produced a photo from his archive that he obtained as a child—a promotional photo of Mad Daddy signed to him—"Eric."

The Cramps were influenced not only by "white," aberrant, Southern, hiccup-y rockabilly but also black and Hispanic music (such as their garage rock fave "Jump Jive and Harmonize," an East L.A. slab of teenage cool by Thee Midnighters oozing low-rider authenticity onto the airwaves) filtered through radio programs—the aural terrain of Lux's childhood. Even the stripped down minimalism of the Cramps has roots in black music, including the bluesy lyrical refrain of songs like "Wig Hat," which lifts blues lyrics; their covers of the Negro plantation song "Shortnin' Bread" and "punk bluesman" Andre Williams's "Bacon Fat"; and the early approach of the band, including its initial logic of leaving out a bass player. As Ivy and Lux told *Spin*:

Ivy: . . . the kind of music we play is so rhythmic, we couldn't see why a bass was so essential.

Lux: Like John Lee Hooker—he's got a lot of records that don't have bass. (qtd. in Gordon 1990: 92)

Similar memories of African American music are recalled by others. David "Tufty" Clough from Toxic Reasons and the Zero Boys played in mixed-race bands, including styles like jazz and funk-meets-black folk, prior to punk participation. Shawn Stern, singer for Youth Brigade, informed me: "I was listening to the radio when I was a little kid in the 1960s. AM radio was full of Motown, Jackson 5, and stuff like that. So yeah, all that's an influence on me, sure, definitely" (2004). Though Stern's band Youth Brigade did not share the style of the Cramps, they both fit under a very loose umbrella of a punk genre that is an outgrowth of American music, with all of its motley genes and hybrid power intact. Radio was a key to the roots of their raising.

The Talking Heads, a Rhode Island art band that migrated to New York's burgeoning underground mid-1970s punk scene, successfully reached a popular audience by merging punk musical craft with soul music in their cover of Al Green's "Take Me to the River," which was released as a single in 1978. During this same period, Pure Hell, a rock 'n' roll leaning first-generation all-black punk band from Philadelphia, emerged, playing with the U.K. Subs in England, even briefly backing Sid Vicious (Sex Pistols) at New York City gigs before releasing one rare, now coveted single, "No Rules"/"These Boots Are Made for Walking."[4]

The singer of the UK Subs, Charlie Harper, reminded me that the Sex Pistols covered Chuck Berry (as did Charlie in the pre-punk version of the Subs);[5] meanwhile, the lingering traces of such traditional rock 'n' roll did not go unnoticed by the Subs' guitarist:

Nicky came along, he said, "You've got to drop all this rock 'n' roll shit." But that's part of me, you know what I mean? I can't burn out of it. I tell you how it comes out, because Nicky will come up with a hell of a lot music for a song, then I'll say look, this bit's neat, you don't want to just pass it, this bit could be the verse, or between the chorus, it needs to be played eight times over. That's my kind of blues, R&B upbringing. (2004)

For German punk researcher Franziska Pietschmann (Franny Frantic), the UK Subs' first LP *Another Kind of Blues* (1979) is rife with black musical undercurrents, for it exhibits "basic blues chord progressions on songs like 'CID,' a harmonica on 'I Couldn't Be You" as well as sporadic bars with boogie-woogie-derived rolling bass lines on songs like "I Live in a Car,' 'Tomorrow Girls,' and 'Stranglehold'" (2009). The album does not sever itself from supposedly outdated, "ethnic" genre forms—the umbilical chord of black music—but openly embraces these styles.

In L.A. in 1979 alone, at least eleven punk shows featuring the Mau-Maus, Descendents, Urinals, Black Flag, Fear, and the Weirdos took place at King's Palace (later known as Raji's), a black bar, and at least two of the shows were reviewed in *Flipside* fanzine. Photographs from the book *Hardcore California* reveal the later presence of black punkers at clubs like the Starwood, Polish Hall, and Hong Kong Cafe. Black correspondent Tequila Mockingbird was a leading writer for *Flipside* who spent time with Keith Levene of Public Image Limited, among many others. Levene, who also played in an early Clash lineup, stressed to her that "how could somebody [referring to scenester Janet Cunningham] say that there was no black people involved in the punk movement when it was like the emergence of Dreads and Punks? . . . any conflicts were Black and White versus the Police, if anything" (1990).

Even in the hardcore punk era, references to black cultural influences abound in fanzines

like *Suburban Voice*, edited by Al Squint. Barry Hennsler, singer of the Necros and Big Chief, states that the reason he left the Necros was because he wanted to make black-influenced music a la Funkadelic, which was realized in Big Chief, a band shaped by soulful jazz, hip hop, and groove riffs. He hopes that the 1990s' hardcore kids will open their minds and discover John Coltrane (Quint 1993). The Big Boys, Texas punk funk hybrid band, discuss covering "Hollywood Swinging" by Kool and the Gang.[6] Kevin Seconds, singer of 7 Seconds, mentions his enjoyment of gospel music, while bass player Steve Youth says the band's musical tastes include Grandmaster Flash and suggests the band contemplated putting a funk song, like a novelty song (akin to their cover of "99 Red Balloons" by German pop star Nena), on their last record because "all of us like funk music" (Quint 1985).

This is not to suggest that the hardcore generation, as a whole, openly embraced, or reflected, black American culture, as Dave Dictor reminded me:

I think especially in the San Francisco scene, especially in certain scenes, people were open. People liked the idea that Darren Peligro [Dead Kennedys] was black and liked Orlando [Special Forces], who was black. There were people who definitely didn't want it to be a lilywhite musical revolution; they wanted people of all kinds of different backgrounds and colors and ethnicities, or whatever the right word is. The majority really wanted that. There really was only a small minority that just didn't want them. In fact, some of the first skinhead gangs in San Francisco had black guys in them. And then they kind of went white Aryan resistance, then they got into trouble with those guys, and they all hung out with each other. . . . In many scenes, there was a conscious effort to overcome racism, but since it was a post–rock 'n' roll phenomenon, and it kind of came out of the suburbs, it did have a 97 percent white start. To this day, bands in the Profane

Existence world, who are very politically conscious, like Aus Rotten and Witch Hunt, those kinds of bands, the scene is 97.8 percent white. It's just the way it works out. As far as the culture, that's who likes this music. (2008)

In Britain, female punk pioneer Poly Styrene from X Ray Spex, who was raised by mixed Somali-English parents, became a pivotal figure. According to Public Image bass player Jah Wobble, during the early punk era she was considered a strange girl who spoke openly about hallucinating and freaked out Johnny Rotten (qtd. in Raha 1999: 88). The critic Greil Marcus problematically described her voice as being able to disinfect a toilet. In turn, Karina Eileraas argues that girl bands often use the ugly voice as a tool for "cathartic expression, a means to articulate the 'self' while acknowledging that it is a site of friction, contest, incoherence, social inscription, and performativity. Girl bands use their voice as weapons. . . . But the ugly voice also constitutes a form of revolt against the grammar and syntax of phallogeocentrism . . . to remind us that language [like punk itself] is always pregnant with impurity" (1997: 125–26). If her voice was a toilet, impure, then that was her weapon of choice against the plastic world of pop music. She was un-pretty and unbound.

Judith Halberstam has referenced Styrene's lyric "I am a reject and I don't care" to illustrate punk's "stylized and ritualized language of the rejected" (2003: 153). Meanwhile, Styrene's other evocation to "Oh Bondage Up Yours," perhaps the band's most notorious single, still reverberates throughout pop culture, as argued by Steve Rubio:

The cultural force of "Oh Bondage!" in 1977 was empowering: the stagnation of the mid-70s, economic, artistic, psychic and social, was confronted with a NO so emphatic it became an affirmation, an insistence that things did not have to remain as they were . . . We love Rhino Records [reissue of

the song], because we get one last chance to stare down bondage, but as long as we are dealing with remembered bondage, we are powerless. Only by using Poly Styrene's cry as a weapon against our current, ongoing, bondage, can we be true to the spirit of 1977. (1993)

Rubio goes on to reinforce the concepts of Dick Hebdige, who notes that such an outcry as "Oh Bondage Up Yours"—the signifying sound of punk—becomes "codified, made comprehensible" through commodification (1979: 96). As a result, such protests and exhortations are rendered innocuous, made safe by becoming a product such as a T-shirt slogan or 45 rpm record. Yet, to remain committed to the ideal of the song— distressing "normalcy," reversing the gendered roles of power—the fight against bondage must continue. This powerful signal to revolt emanates not from the voice of a white middle-class teenager but from the voice of an ethnically mixed woman navigating a confluence of identities and cultures.

No single concise or cohesive history of black music's impact on punk rock currently exists, partly due, as I described earlier, to perspectives normalized within commercial and academic discourse. Such overviews typically stress the "whiteness" of the genre, partly epitomized by slanted views offered by the likes of Jim Curtis, who posited: "punk renounced black music—it was the whitest music ever. This was the principle reason you couldn't dance to it" (Rowe 1995: 56).

Such declarations are problematic for several reasons. First, people frequently did dance to punk music, whether they engaged in fervid pogoing or slamdancing as hardcore became the more aggressive 1980s punk musical mode. Second, Don Waller has noted in the book *Make the Music Go Bang* that indirect links between white and black culture within the musical heritage of punk are obvious: "First Generation [punk] is just a two car garage of white suburban horndogs falling off

their fruit boots trying to sound like the Stones trying to sound like the voice of authentic African experience" (qtd. in Snowden 1997: 22) This offhandedly suggests punk music bears the mark of the black man's burden and blues: to teach white youth resistance through musical tropes. Authors like Zanes have even suggested that punk shares core aesthetic approaches similar to black artists like Prince, in that he "shares with punk a deliberate play and challenge of the romantic constructions of authenticity" (1999: 45).

Punk was both deliberate play and an attack on notions of authenticity: sterile, overly trained musicians were not authentic, but raw power in the hands of amateurs was.

The Clash and the Convergence That Shook the Hybrid World

To further fissure the notion of punk rock as solely white music, one can see punk affirmed as hybrid, cross-cultural, or convergence culture in a testament from Mick Jones of the Clash, one of the first-generation bands: "Any gig we do is Rock Against Racism because we play black music; we're as interested in making sure that the black culture survives as much as that the white culture does. We play their music and hope they'll play ours. We have a common bond with these people" (qtd. in Orman 1984: 171). Jones seems to hope that punk was a stimulus and force of preservation, drawing people together to realize the power and excitement inherent in their related cultural traditions.

However, Stewart Home has illustrated in hindsight the not-so-latent racism in early punk, pointing out that the Clash sing about "Greek kabobs" on the first record (1995, 1997). Strummer would wear a "Chuck Berry is Dead" (as if negating his earlier pub rock, R&B-based band the 101ers) T-shirt; yet later, the Clash covered Toots and the Maytals and invited Bo Diddley,

Screamin' Jay Hawkins, Grandmaster Flash, Lee Perry, Treacherous Three, and the Bad Brains on stage to open for them, though not without controversy. New York concertgoers heckled and threw trash at Grandmaster Flash, but the other opening band on one Bond's night, Miller Miller Miller and Sloane, white high school youth— friends of the future novelist Jonathan Lethem who were discovered at CBGB while playing Aretha Franklin covers and disco-funk—did not get pelted and booed. *NY Rocker* did describe the same Clash fans as equally merciless to the opening white electro punk duo Suicide, "whose treatment was awful," leaving the band "dripping in blood and spit" (Trakin 1980: 31). British audiences were known to throw bottles at reggae artist Mikey Dread when he once opened for the Clash as well. In Vancouver in 1979, agitated crowds catcalled opener Bo Diddley. But even the Clash themselves did not escape the ruckus:

> The punks paid tribute to their heroes by slamming into each other, jumping onstage, throwing drinks and beer bottles at the band, and spitting at them. The Clash withstood the controlled riot for four songs, ducking and dodging the fusillade, then Strummer interrupted the music to mock them: "If anybody had any balls they'd be throwing wine bottles!" (Wallenchinsky et al. 1995)

Later, Joe Strummer pulled Bo Diddley back on stage to end their set with the Sonny Curtis and the Crickets/Bobby Fuller Four classic, "I Fought the Law."

Tony Kinman provided me a different assessment of the Clash's choices for opening acts:

> There's a long, historical tradition now for British bands to come over here and hire black opening acts. The Who had Toots and the Maytals open up for them and stuff like that. And I love Bo Diddley. To me, Bo Diddley is one of the gods. He is one of the untouchable icons of rock music. I didn't

expect the Clash to have ten punk rock bands open up for them, but when they had Bo Diddley open up for them, that was a failure of the imagination. It's just like U2 having B.B. King open for them at Dodger Stadium. Now, I know U2 might be thinking, we want to introduce this great classic legend to our young stupid audience, there's 70,000 of them out there. This gives B.B. a chance to stretch his legs, but when Bono came onstage to introduce B.B. King to his audience as somebody that we (U2) just recently discovered . . . Now, I know he didn't mean, we discovered this man, what he meant to say is that B.B. was a man U2 just recently got into. But you know they way it just sounded, right? I can imagine that B.B. was thinking, you know, "I remember when Eric Clapton or Jeff Beck gave me the exact same intro at the Fillmore in 1968. You know what, get me back to Vegas." To me, it was a similar thing to the Clash having Bo Diddley open up for them. I can dig it if Joe and Mick and the dudes just dug Bo, he happened to be their favorite performer, and they were just thrilled to have him play with them. (2004)

Some might insist that Strummer's earlier slight stab at neo-racism was just a guise to be "shocking" and "legit." His relationship to world music traditions—given full breadth on albums like *Sandinista!* and *Combat Rock* (which was recorded at Jimi Hendrix's Electric Ladyland Studio, the former site of a Charlie Parker club)—was fecund and long lasting. He was even a respected BBC world music DJ before his death. Yet some traces of prejudice might still remain on the song "Rock the Casbah," depending on how one interprets the song's vision of the Middle East, or the pantomime style of the video, which features a dancing Arab (played by their manager Bernie Rhodes) and a Jew, and a mishmash linguistic melting pot of Hindi, Arabic, Hebrew, and North African phrases uttered by Strummer. The potential problems of the song do not necessarily relate to the Arab and Jew skanking together in the streets and

hotel pool of Austin but rather to the fact that the Arab is holding a beer bottle, which is forbidden under Islamic law.

Mick Jones's own mixed tapes from the fertile time period of the early 1980s include music by Vanity 6, Dr. Jeckyll and Mr. Hyde, Peech Boys, Indeep, Marvin Gaye, and Diana Ross. Looking back, he has described that formative era's hip hop as symbolizing "community, the Zulu Nation, like an extension of reggae, and not boasting or gangsta" (Snow 2008: 88). Other band members even created the alias Wack Attack for him, since Jones was thrilled by the rap phenomenon. Don Letts, friend, video maker, and close ally of the band, even suggests:

> These guys were at the peak of their game, man. . . . I mean, they basically ran New York for the few weeks they were playing there. There was this amazing cultural exchange going on. I can't tell you what a buzz it was. WBLS, a totally black station, started playing "The Magnificent Seven" on heavy rotation, and they did a remix of it, where they had samples of Clint Eastwood and Bugs Bunny, and that was the soundtrack of the city for the whole period that the Clash were there, and beyond. (qtd. in Orshoski 2008)

A version of the track from 1980, titled "Dirty Harry," has surfaced on Clash bootlegs like *Golden Bullets*.

The triple LP *Sandinista!* features a wide range of genre-defying songs that blur borders. For instance, Allan Moore, in his book *Rock: The Primary Text*, outlines several instances in which the Clash eschew simple punk three-chord referents, using Jamaican Mikey Dread behind the mixing board to develop textures throughout (like extensive multi-tracking and use of echo), including using a 1930s period chord sequence and jazzy horns on "Jimmy Jazz," incorporating James Brown–esque horn parts on "Ivan Meets G.I. Joe," placing gospel voices on "Corner Soul," dolloping

"Washington Bullets" with Caribbean-style xylophone and pedal-steel guitar, honing in on funk bass lines for "Magnificent Seven," and adopting wooden reggae bass beats, known as "riddim," and reggae-infused tomtom drums on "One More Time" and "Guns of Brixton," which, lyrically speaking, is psycho-geographically located in the heart of multicultural, working-class England (1993: 117). In an overview of the Clash in *Uncut* magazine, Brett Sparks of the Handsome Family reminds us that the bass line of "The Magnificent Seven" is actually culled and adapted from "London Calling," while Norman Cook explains that the instrumental version of the song, known as "Mustapha Dance," vividly foreshadowed house music and is still routinely spun by club DJs today ("Clash City" 2003). Their 1979 track "Armagideon Time," the B-side to the single "London Calling," was written by dancehall progenitors Clement Dodd and Willie Williams.

While the Clash were finding new audiences and dissolving the musical and geographic borders of punk, even reinventing the notion of punk itself, their old fans became more and more alienated. Their peak on the U.S. charts came in 1982 with *Combat Rock*; backlash was inevitable, for this was the exact moment hardcore burgeoned. Dave Scott, drummer from Adrenalin OD, states:

> after *Sandinista* came out, many of the fans of the early Clash felt let down. Myself and a bunch of my friends from the early New Jersey hardcore band No Democracy decided to go to Rockefeller Center where they shoot *Saturday Night Live*. We were bored and always up for fun and decided we would heckle the celebrities as they came out into the lobby after the show. Ron Howard was the host, and the musical guest was the Clash. First out was Anson Williams, who played Potsie. We kept calling him Nazi. Then came the Van Patten kid from the *Karate Kid* movie. We were busting his balls so bad that he wanted to fight us, and then pissed him off further by making the Karate Kid stance on one

leg as security cooled him down and threw us out. This was perfect timing because out of the door minutes later came the Clash. They were really acting like rock stars then. They had the posse and the beatbox and the girls, especially Mick. My friends then followed them down the streets of New York City singing the Kraut song "Sell Out" as loud as possible. I felt bad 'cause they were such a great band. I'm sure they started off different. (2010)

While some hardcore bands like the Fartz did appear as opening bands during this time period, others shunned the more "corporate style" Clash, like Really Red in Texas, who were replaced as opening band by the Red Rockers, who ventured in from New Orleans. As John Paul, the bass player, points out:

> We did stand up for our ideals. However, it would have been awesome playing Hoffheinz Pavilion in Houston with the Clash. We were given a great opportunity for exposure and, in hindsight, I should've argued that we should play the gig for our own benefit and screw the Clash's ego. We were also offered a pittance to play, but y'know, it would've been historic now that people are still asking about Really Red and what we did. Was it our own egos that got in the way? Maybe we should have kicked some ass just for the fun of it and taken names later. (Williams 2010)

Singer U-Ron also ended up with mixed feelings about the affair.

> We were for it except we had some reservations about playing those types of huge venues. Then Butler showed me the contract rider from the Clash. They were demanding all this rock star crap for back stage. It was amazing and very disappointing to see. They were demanding china plates, silverware, tablecloths, cognac, and massive amounts of special catered food and drink and who knows what. I thought, what a bunch of petty bourgeois

crap! What a load of rock star posers! These aren't punks anymore, sez I. So we told Butler to tell the mighty Clash to piss off. . . . There was a line of people getting Joe Strummer's autograph and so I walked up to him like the drunken jackass that I was and said to him, as he was signing an Ellen Foley album that he and Mick had produced, "What's it all about Joe? Autographs?" He told me that, if he didn't do it then people would get pissed off. I said, "We don't want to be in a punk band and piss anyone off now, do we?" I was a bit of a jerk to old Joe, I suppose. I really liked him. May he rest in peace. So, no one saw Really Red opening for the Clash and we proved what? I don't know. Anonymity? (2005)

By the mid-1980s, singer and guitarists Jones and Strummer split company, forming two different Clash bands. When pressed to explain the situation, Strummer replied that Jones was no longer making "our music. He was playing with beat boxes and synthesizers. I was thinking 'It's time for us to stop ripping off the black people so much that they don't get on the radio anymore.' I didn't want to play South Bronx music, you know" (Goldberg 1984: 41, 47). Strummer suggests the Clash had been sidetracked into believing they were revered musicians and artists, which is self-indulgent and fatal, especially when considering black blues pioneer Robert Johnson "never thought he was an artist." So, even though Strummer rejected his former lineup's exploitation of black music, he still used a black legend to prove the "new, authentic" Clash's antecedents in black music history. Ironically, it was this version of the Clash that released *Cut the Crap*, replete with a fusion/hybrid urban sound (synthesizers and drum programming) in 1985.

Many consider this record a low point in the band's career, a misadventure because they used an ill-fitting approach markedly different from their first punk/reggae fusion ventures, like the recording session for "Police and Thieves" that

debuted on their first, self-titled album from 1977. Strummer vividly recalled that moment: "We were jumping up and down. We knew we had brought something to the party. It wasn't like a slavish white man's Xerox of some riff. It was like: 'Give us your riff and we'll drive it around London.' . . . Scratch Perry liked it. Him and Junior wrote it" (Egan 2003: 57). *Cut the Crap* seemed to lack such riffs, energy, and convergence. To many it was limp and lackluster, a truly white version of beatbox America with fuzzy punk shading overlaid with poetic conceits.

Clash manager Bernie Rhodes has taken credit for Jones's evolving taste toward such a musical sensibility, highlighting his own role in these terms: "I hipped Malcolm [Sex Pistols manager], Mick Jones . . . to the importance of Hip Hop, Burundi, graffiti, and new sampling technology during the Bonds' residency" (Snow 2008: 84). He also takes credit for tracking down Grandmaster Flash, remixing the Clash's "Magnificent Seven," and forging "Magnificent Dance." Meanwhile, Jones visited radio stations WBLS, Kiss-FM, and WKTU, eager to hear DJ Red Alert.

Rhodes's counterpart, Malcolm McLaren, manager of the Sex Pistols, became equally infatuated with the youthful, syncretic, Do-It-Yourself mix and mash style of black hip hop music culture fermenting in New York's boroughs. "The Sex Pistols *had* been heard of. But the interest in punk in Harlem was being generated out of DJ scratching," he informed *Interview* magazine. "I somehow found my way to a party that they were holding, completely black, where they were playing records like James Brown, the Monkees, the old Supremes, Diana Ross, and some punk records" (qtd. in Becker 1986: 262). Almost akin to white punks, the kids were "fierce, volatile . . . jumping up, gesturing and screaming"; as such, it felt "magical" to McLaren, unlocking a sense of possibility, especially since the kids "could regurgitate something that was packaged and make it sound magical again" (qtd. in Becker 1986: 262). Like

punks, the kids felt authentic, and they created and maintained a powerful and direct relationship to an audience while keeping their approach down-to-earth, spontaneous, and unlimited. More so, their impromptu style was not hindered by inherited musical chops or expensive equipment.

McLaren later would hit his stride as a record maker himself with the single "Buffalo Gals," an example of a fertile period in which he mixed songs and traditions from "Zululand and the mountains of Lima and the Dominican Republic and Cuban priests and Appalachian hillbillies all together under one roof" (qtd. in Isler 1983: 22). Like a punk folklorist and bricolage-based mixmaster, McLaren understood that both impressive dance potential and pagan power might be tapped and culled from such "primitive" convergence.

Black to the Future: The Politics and Dynamism of Black Punks

Don Letts is one of the most notable figures in all of punk rock. As a West Indian DJ and filmmaker who spun highly influential reggae records at the Roxy, London's premier punk club, he also directed two pivotal documentaries on punk, *The Punk Rock Movie* and *Punk: Attitude*, managed the mostly all-girl punk-reggae band the Slits, and authored *Culture Clash: Dread Meets Punk Rockers*. In addition, he took part in the pivotal Brixton riots. A photograph that captures the tension of the day—a "dread" making his way toward a police line in Notting Hill, which graced the front cover of *Black Market Clash*—is Letts himself (who appears on the back cover as well). In 1980 Joe Strummer told *Creem* he rented a spare room from Letts for a time. While Letts was immersed in new "roots rock reggae," he passed along a Trojan Records album full of bluebeat songs to Strummer, who quickly became totally smitten by the "cream of all the . . . stuff," thus likely shaping

the future aesthetic of tracks that became part of the Clash's repertoire (Whitall 1980: 60).

Dennis Morris, another first-wave black participant, had an indelible and profound impact on punk rock's visual history. As a savvy teenage photographer, he documented the meteoric rise of both Bob Marley and the Sex Pistols. His intimate portraits of reggae's much-lauded worldwide icon and punk's namesake raconteurs are evidence of rare trust and ease. In the case of the Pistols, he gained "unrestricted access to their strange and chaotic existence" for a year, which involved snapping hundreds of photographs. Later, due to his camaraderie with John Lydon, Morris traveled to Jamaica with Lydon and Virgin Records mogul Richard Branson, scouting reggae artists for Island Records. Lydon later bemoaned the fact that the label didn't sign acts that he enjoyed ("It's the only kind of music I really do like. . . . It's brilliant and I love it"), including Black Uhuru, the Congos, and Dennis Brown (Darling 1984: 28). Not only did Morris later work for the label as art director, he signed the Slits and forged the aesthetics of Lydon's venture Public Image Limited, including their record sleeves, corporate style logo, and their notorious conceptual *Metal Box* casing, which housed their second LP ("Dennis Morris").

Reggae music made a tremendous impact on early punk, helping to shape the music of the Members, Gang of Four, Stiff Little Fingers, Leyton Buzzards, the Police, Newtown Neurotics, and Public Image Limited, while even Canada's more hardcore band D.O.A., whose lead singer Joey Shit was a fan of Bob Marley, made forays into reggae by the early 1980s. Blondie covered the soft reggae tune "The Tide Is High" by John Holt of the Paragons. Found on the album *Autoamerican*, the song was part of the band's intention to create music forms, like the early hip hop/rap-based "Rapture," that converged genres and cultures. Guitarist Chris Stein admits: "We wanted to make music that would cross over. I

would like to see the record resolve racial tensions by bringing different audiences together. When the new wave kids and the rapper kids get together, that'll be something. Eventually, they'll all meet in the middle, where you'll have a strong race of young people that won't be divided by stupid racial issues" (Trakin 1981: 6). In Stein's view, vanguard music could, and perhaps should, create a deracialized youth movement. Letts, writing for the *Guardian* online, described the punks' taste for or kinship with reggae in these terms:

Reggae was a subculture that spoke in a currency with which the punks could identify. It was the soundbite-type lyrics, the anti-fashion fashion, the rebel stance and, importantly, the fact that reggae was a kind of musical reportage, talking about things that mattered. Songs like "Money in My Pocket," "I Need a Roof," and "Chant Down Babylon" struck an obvious chord with "the youth." The third-world DIY approach to creating the reggae sound was something else that the punks could relate to, as most of them had no formal music training. (2001)

In a history of the Roxy, Letts further points out that reggae and punk were black and white modes of addressing the same thing: the need for change. Whereas reggae used the trope of Babylon, punk used the trope of Establishment. Yet, the Slits' "punky reggae" hybrid surprised him due to the genres being "diametrically opposed . . . like chalk and cheese" (qtd. in Marko 2007: 126, 128).

Many punk acts joined the efforts of Rock Against Racism (RAR) gigs. The reggae band Steel Pulse penned the song "Rock Against Racism." Shows in 1978 ranged from the Clash playing to 85,000 people at Victoria Park along with X-Ray Spex, Tom Robinson, and Steel Pulse (filmed as part of the *Rude Boy* film) to gigs including bands like Joy Division (at the Factory in Manchester, in October), Adam and the Ants (Ealing College and Southbank Polytechnic), and Siouxsie and the

Banshees. Some of these bands played alongside reggae bands like Aswad and Steel Pulse. In later tours, the Clash shows also featured opening reggae acts Mikey Dread and Prince Hammer. Old school reggae stalwarts Toots and the Maytals, whose song "Pressure Drop" was avidly covered by the Clash, were invited to tour once but could not afford the Clash's 1980 six-week 16 Tons tour financing.

Still, critics leveled charges about punk songs that denigrated Puerto Ricans ("Puerto Rican" by Adam and the Ants), the use of swastikas and anti-Semitic lyrics ("Love in a Void" by Siouxsie and the Banshees), and Nazi prison camp references, including band names, album art, and lyrical lines taken from memoirs (Joy Division and the Skids). In 2001 Paul Hambleton argued on *Punk77.net* that Siouxsie was using a crude metaphor equating Jews with bankers (the same might be argued about writer Ezra Pound's poetic analogies of "usury"), and reminded readers that Siouxsie later dedicated the song "Metal Postcard" to avant-garde Jewish photomontage artist John Heartfield/ Helmut Herzfeld, while another song, "Israel," evokes the dreams of a liberated country singing "Happy Noel." In addition, Hambleton notes that Adam Ant's father was part of a British tank crew that liberated Belsen, and Joy Division's "Nazi" figure pictured on the "Ideal for Living" EP is actually stripped of its Nazi signifier, thus matching the look of a Komsomul (Soviet youth organization) member too. Hence, the "rehabilitation" of these bands was actually unnecessary, they infer, if a more nuanced media analysis was applied.

Furthermore, Adam and the Ants did play Rock Against Racism gigs, and when pressed to explain their fetish for Nazism in 1978 by the RAR periodical *Temporary Hoarding #6*, black drummer Dave Barbarrosa, who had been harassed by the National Front, remonstrated:

It's in my interest, isn't it! I'm a darkie! How can they call us a Nazi band when we've got a coloured drummer! I've got a Jewish mother and the other side of my family is black. I mean surely I must be the most anti-Nazi and anti-racist bloke! If the National Front ever get in power I'll be kicked out of the country right away. I wouldn't go around supporting people who wrote songs in favour of Nazism. I've got a kid and wife you know. I've got a lot to worry about if they get in. That's why doing these gigs are good for the band because it's important to do this just to clear the air. (qtd. in Homes)

Adam himself has explained the Puerto Rican song at length. While navigating his own notion of providing a voice to the oppressed in the interview, he outlines a sense of context and impetus. The misunderstood lyrics of the tune, he seems to infer, actually explore an underclass sense of self-defeatism, a condition that might be akin to William Blake's sense of "mind-forged manacles" or Bob Marley's notion of "mental slavery":

The Puerto Ricans in New York are on the bottom, on the floor, and lowest. You've only got to see *West Side Story* to know that number. If you get robbed by a Puerto Rican he nicks all your shoes and everything, they're really desperate people cos they're treated like fucking shit by the whites. . . . my song . . . is about a white woman who has actually got a pet Puerto Rican. I saw *Roots*, and what shocked me in that wasn't the slavery, wasn't the conditions, it was when that guy went into the black slave community, and they said to him, "Look, we're animals"—they'd accepted being fucking animals. The old black guys were going "Don't do nothing don't react" because it had been drummed into them. And that really made me sick, that really got to me. The fact that a human being can accept that he's garbage! So my song is about a white woman who has reduced a human being to dog status—because I thought that was a damn sight more powerful in a lyric than saying look at those poor Puerto Ricans. I've sung that song to Puerto Ricans from New York, and they loved it

man. Because it was singing about Puerto Ricans, and they just don't get sung about. (qtd. in Homes)

The Rock Against Racism gigs partially served as a front for the Trotskyite-led Socialist Workers Party campaign against insurgent right-wing National Front activities and countrywide racial tension, including controversial statements by David Bowie suggesting that England was ready for a fascist leader and Eric Clapton declaring that immigrants were overrunning the country. Thus, the RAR gigs utilized "cultural forms of the Black Diaspora such as reggae and carnival and juxtapos[ed] them with the renegade punk subculture. . . . RAR sought to catalyze anti-racist cultural and political solidarity among black, Asian, and white youths. RAR offered a particularly powerful example of what Vijay Prashad calls polyculturalism, a term which challenges hegemonic multiculturalism, with its model of neatly bounded, discrete cultures" (Dawson 2005: xi). Instead of subcultures being fragmented, isolated, and subjugated, RAR activities allowed for some kind of common front, an uneasy alliance at times, that confronted not only white and African cultural issues but Asian as well, though many historians fail to notice that aspect.

In defense of such multicultural punk history, Ian Goodyear reminds readers on the web page *Punk77.net*:

Although Asian music was not a feature of RAR gigs, solidarity with Asians under racial attack was very much a part of the organisation's remit. To cite a single instance, RAR was part of the coalition that built the 1979 Southall demo against the NF, at which Blair Peach was murdered. This was a mass mobilisation in an area with a large Asian community. (2001)

The mid-1980s also witnessed race solidarity in street activism and revolt, as Bo reported for *Maximumrocknroll* that "it is a well-known fact that skins and black youth fought side by side against filth/cops in the . . . Tottenham Riots," a melee in North London instigated by the death of a black mother whose home was raided by police after the arrest of her son (#34 March 1986). Thus, by no means were RAR gigs, or other riots, simply multicultural spectacles; instead, they included real witnessing, confrontation, and even extreme danger.

The Clash's close affinity with black culture has previously been noted in this book. One can also discover such links in Bob Marley's song "Punky Reggae Party," which name-drops Dr. Feelgood, the Damned, and the Clash. Marley demonstrates their similar conditions: "rejected by society, treated with impunity, protected by their dignity" (1977). Fan reaction to the Clash's combinatory agitprop and social-realist songs of the period has been largely unaddressed. In order to position the band in a greater context, and to see if their symbolic interrogation of whiteness in fact was modeled on black resistance, one can look at the discourse of fans.

For instance, the song "White Riot" recounts the Notting Hill race riot, a 1976 melee in which police arrested a pickpocket, instigating black youths to come to his defense. A picture of the tumult is pictured on the back of the band's self-titled debut album (1977). Clash biographer Marcus Gray characterizes the song as "envious" not "racist," meaning the song was not intended to stir up white anger toward blacks but to implore white youth to stop doing "what they're told to" and stop "taking orders," perhaps even pick up a brick like black youth (1995: 228). Another explanation is: "Exhilarated by what seemed to them a spontaneous example of revolt against oppressive forces—the black community had often complained of police harassment and discrimination—they wondered why they could not have a riot of their own—that is, a 'white riot'" (Egan 2003: 47). This did not sit well with drummer Terry Chimes and original guitarist Keith

Levene. On one hand, Levene refused to sing it, while Chimes, who believed in the power and fury of the song, felt the song was nonetheless naive (Egan 2003: 47).

One central inquiry is to ascertain whether songs like this led listeners to examine their own sense of status, power, and privilege. A blog entry by Mardi, who met with members of the band twenty-five years later, is able (albeit through reflection) to situate the lyrics within his own life at the time:

> Did I not understand that "White Riot" was all about his respect for black people and their stand against oppression? Had I not listened to the lyrics, in which he sang that he wished white people would take the same positive position? . . . despite going to gigs in the multi-racial town High Wycombe, I had never previously been forced to face up to my own inherent racism. It was an attitude that had been born from the simple fact that there were no black people in Marlow. I was ten when I met my first black kid. Some nice white middle-class family had adopted him. I can still remember being told in the playground that if the black kid touched me his colour would rub off on me. Even as a 14-year-old, race riots—or indeed the very concept of "racism"—meant little to me. So, Strummer forced my eyes open. (2004)

In 1976, during the peak of the Clash's early power and resistance in the U.K. rock press, the *New Music Express* interviewed them. Strummer, an avid fan of bluesmen Clarence "Gatemouth" Brown and Blind Willie McTell (whose songs he busked in the London subway, earning the name "Strummer" in his pre-Clash era), whose earlier band the 101ers covered R&B and the likes of Chuck Berry, and Mick Jones, who was a fan of Mott the Hoople, ska, and bluebeat before seeing the Sex Pistols, explained their lyrics. Exasperated by the press' inability to grasp the meaning of the song "London's Burning," they retort:

Strummer: The only thing we're saying about the Blacks is that they've got their problems and they're prepared to deal with them. But white men, they just ain't prepared to deal with them—everything's too cozy. They've got stereos, drugs, hi-fis, cars . . .

Mick: We're completely antiracist, We want to bridge the gap. They used to blame everything on the Jews, now they're saying it about the Blacks and the Asians . . . every body's a scapegoat, right?

Joe: The poor blacks and the poor whites are in the same boat. . . . They don't want us in their culture, but we just happen to dig Tapper Zukie and Big Youth, Dillinger and Aswad and Delroy Washington. We dig them and we ain't scared of going into heavy black record shops and getting their gear. We even go to heavy black gigs where we're the only white people there. (Miles 1976)

Hence, not only do the Clash find affinity with black music (Peter Silverton from *Trouser Press* reported in 1978 that the band had almost chosen the name Weak Heart Drops, a Big Youth song), sense of community, and streetwise agency, they recognize that they are margin walkers, borrowing from but not part of black culture. They were not mere exploiters either, but might be considered translators negotiating their whiteness through black cultural signifiers as a means of othering and authenticating themselves in the punk milieu— against a backdrop of garage punk bands simply churning out bellicose versions of yesterday's rehashed rock 'n' roll. His intentions will likely never be quite understood, but the result—an awakening or reevaluation of person, place, and power in an "everyday" budding fan like Mardi— is a legacy that Strummer would likely have found comforting. In fact, Strummer and Jones wanted white youth teeming with bigotry, and subsequent Paki-bashing tendencies, to wake up, even while Clash manager Bernie Rhodes appears to

approve of race-bashing in some instances, as a *Record Mirror* interview illuminates:

RM: What's your reaction to kids doing that?

Joe: What, bashing Pakis? I f—— tell 'em to lay off.

Mick: I tell 'em to lay off. I said to them, you're just doing it for the papers.

Joe: They should go down the House of Commons and bash up the people in there.

Bernie: Or Radio One . . .

RM: But you've still got kids beating up Pakistanis . . .

Bernie: There's a lot of Pakis who deserve it.

Mick: I don't think anybody deserves that.
(Clash 1978)

The signal seems clear, however: the powers that be, from Parliament to the Radio One officers, all those who shape national policy and marginalize youth, should be the target of white frustration, not immigrants and people of color.

Bassist Paul Simonon himself had longstanding, deep affections for reggae and black music in general, as his homemade tapes made for the trek across the United States for the Clash's 1979 Pearl Harbor Tour attest. Among his collection included four volumes of "Dread Control," Big Youth, The Temptations, "Natty," three volumes of "Dreadnought," Bo Diddley, "Blues," and "Motown." Such assortment, featured on the same tour when Bo Diddley joined the British punk legends as opening act, might surprise punk purists who imagine punk rock as a white genre ensconced in a cocoon, but comes to no surprise to those who understand punk as a fluid, syncretic genre.

Such musical fusion, interpenetration, and cohabitation between punk and reggae, Anglo and West Indian, and black and white cultures did not come without some confusion. As Strummer once walked back through the time when the Clash released "Bankrobber," a reggae-infused tune produced by Mikey Dread that reached #12 on the British charts, he remembered:

One day I went up to Ladbroke Grove to get a newspaper and a bunch of black school girls got off the bus, and one of them went, "There's that guy who did 'Bankrobber'" and they surrounded me and stood staring, 'cos they couldn't believe that some weird-looking white dude had made this record. I'll never forget it, they stood there staring at me, and didn't say anything. They couldn't compute it. (Clash 2008: 256)

They were not the only black girls seemingly infatuated with the Clash's music. A *Creem* writer reporting on a Clash gig in Detroit commented: "Hippies like the Clash. So do black people—I watched two black girls dancing, to see whether they favored the reggae-flavored numbers or not. They didn't. They're American girls, after all" (Whitall 1980: 43). In the U.K., the Clash's reggae-tinged numbers appeared to win them a black audience, but in the United States songs like "Train in Vain," with its R&B underbelly, held the attention of people like Bootsy Collins. The admired black funk bass player, who briefly played in James Brown's band and had a long stint in the band Parliament, supposedly listened to the song every day when he bought a copy in 1980 (Whitall 1980: 41).

Strummer's admiration for reggae star Jimmy Cliff is well-noted too, but it was not the Clash but the other old guard punk band Chelsea who covered Cliff's powerful "Many Rivers to Cross" on their self-titled debut LP in 1979. When asked why this song resonated with the band, guitarist James Stevenson told me:

It was Gene's idea—and I think the angst he gets across in the delivery of the vocal is really special. At the end of the day, the song is about pain and the difficulty we all face in moving forward through life. I think that's a subject we all have in common, and it rears its head in every form of music. There was a big riot at the Notting Hill carnival in 1981. I remember being there with Mick Jones. It was a very mixed race battle against the authorities, and I remember saying to Mick—"See, this is our battle too!" (2007).

This articulates the fact that white punks felt that convergence was desirable, and quite possible, between black and white youth culture, even within a society that had forcefully segregated and balkanized the two communities for decades.

When Chelsea singer Gene October was interviewed for the web site punkoiuk.co.uk, he testified: "Without reggae, without Bernie Steal, and Portobello Road, without all that black inspiration and reggae I don't think we would be around today. Those guys welcomed us. They did not mind the way we looked. They did not look down on us. They were downtrodden, we were downtrodden. We were in the struggle of life together" (2004). When I asked Stevenson to respond to that impression, he offered this insight:

Punk and reggae, as Gene says, shared a feeling of being repressed, downtrodden, the underdog. But it was also coincidence. Portobello Road and Notting Hill Gate was the spiritual home of punk in London, and there was a big black population there, including lots of reggae bands, so there was kind of a cross fertilization. Black music will probably always influence white musicians because those guys are so fucking good at making it. (2007)

In this light, October's feelings may be described as more spiritual, while Stevenson was looking back rather matter-of-factly in terms relating to the psychology of city space and musical craft. When mixed-race bands such as Two Tone icons the Specials set up gigs, white racists soon followed, trying to disrupt and cause a melee. Yet, one can imagine a different outcome while viewing the cover of Sham 69's "Hersham Boys" single: the cover depicts working class white and black youth gathered in front of a brick building for the camera, partners for the moment.

Looking back at the RAR gigs, some punk icons actually suggest that RAR actually divided communities, creating unneeded tension, backlash, and separatism in the scene. Such critics include the Stranglers, who were once decried as fascists. Hugh Cornwall, in an interview on *Punk77.net*, still insists that RAR aims, such as unity and tolerance, could have been reached in other ways:

We weren't going to jump on any political bandwagon. Dave, Hugh and Jet thought it was really stupid. The world isn't like that it's more subtle. We refused to do RAR. We went on tour with the reggae band Steel Pulse who played with a strong political message. When they played the midlands . . . they were getting bottles thrown at them and all types of abuse from the white Stranglers audience—our audience and they didn't know what to do. We were so embarrassed that we walked on stage and apologized. Jet made a speech. These are our friends and if you don't have the intelligence to respect their 45 minute set then you have no respect for us. If you have a problem we will be waiting by the side for you. Silence. And everybody listened to the set. The band who weren't sure about white people got to know us as friends. That said more about RAR bullshit. I think RAR created more division than not. (2005)

What Cornwall neglects to mention is that the Stranglers had originally asked both pop-punk reggae band the Police and reggae band Matumbi to join them on tour, and Matumbi passed them

on to Steel Pulse, who had also played gigs with the early punk band Generation X. Thus, RAR gigs were not the only events in which white punks and Caribbean or black youth converged.

In the United States the desire to foster such cultural convergence was not enough to overshadow the politics of the RAR organization, which was criticized stateside by groups like Nausea, who branded the group "leftie-commie crap" even though they still played the benefits (Non Grata 1990). Members of the mixed-race hardcore band Scream also denounced as corrupt the RAR organization, which was associated with Yippies, in *Ink Disease* #4. Singer Peter even suggests that the organization was involved with drug trafficking and organized crime, and the band felt "ripped off and manipulated" after playing a marijuana benefit masquerading as a Rock Against Racism show. The Bad Brains, an all-black Washington, D.C., hardcore band, felt somewhat differently, as Ian MacKaye of Minor Threat noted to me during an interview when I asked him about cross-cultural appeal at early D.C. punk shows at places like Madams Organ:

> We're taking about an extreme splinter audience. There was a lot of weird people, not necessarily a white audience, but people who were primarily white. This was a time when we were doing a lot of Rock Against Racism shows and H.R. [Bad Brains] was adamant about it. He had a really strong feeling about it. He felt that it was cool that they were doing things in England, but they should be playing in front of non-white people. . . . The Untouchables played one. We literally set up in a courtyard of the Valley Green projects and just played a concert for the kids. That was entirely a black audience, but H.R. was always pushing things like that. (2001)

Fugazi, for whom MacKaye sang and played guitar during the 1980s–2000s, also pushed audience and gig boundaries as well. For instance, on Christmas Day 1990, the band played the Lorton Correctional Facility in rural Virginia, where a few dozen black men seemed bemused by the four white post-punks entertaining them (Kim 1991: 83). One should also note that Minor Threat played shows with Trouble Funk, the popular and genre-defining go-go music pioneers who embodied a fervent and fecund dance music hybrid culled from funk, hip-hop, and R&B. Scream played in front of a majority black audience in the mid-1980s, sharing the stage with the likes of Chuck Brown and the Soul Searchers, Rare Essence, and Experience Unlimited at the D.C. Armory. By the late 1980s, other mixed-race D.C. hardcore bands followed similar paths, like Swiz opening a show for hip-hop legends Public Enemy.

In 1985, members of Washington-based Beefeater explained the breadth of their musical influences to *Maximumrocknroll*, listing the likes of the Isley Brothers, John Coltrane, and John Lee Hooker, to which interviewer Ian MacKaye of Minor Threat responded, "There's nothing like the authentic blues; that's where my heart lies too" (1985). Tomas, singer for the funk punkers Beefeater (and later Fidelity Jones), told *Ink* zine that he was a fan of Sweet Honey and the Rock (as was Joe Lally of Fugazi), which he declared, "a local feminist, blacklist, gospel group . . . they are the heaviest group in town . . . When they sing, everybody in the house listens, everybody . . . That's what I am hoping for [post-Beefeater], some sort of important music" (1986). That same year, Bo, writing a letter to *Maximumrocknroll* describing the state of punk race relations in England, attested: "There is genuine solidarity here. Not uncommon at all to see white and black hardcore youth as friends, best of it in fact, trust each other" (March 1986). The convergence of black and white youth happened in the crucible of music, sometimes in subtle, even unconscious shadings, and on the street, with the music as the soundtrack, forged in the mechanisms of community self-reliance and bonding.

Yet, even in places like Washington, D.C., cultural segmentation seemed to be a fact of life. "Punks are completely depriving themselves of 85% of the city's talent," bemoaned Tomas during a Fidelity Jones tour stop in California. Whites and blacks are "completely isolated from one another," he admitted, stressing that both were wasting away. Though he states that hip hop in the nation's capital lacked "a lot of message and direction in terms of integrity" and labels local genre go-go as "stupid music about dancing and being cool," he equally stresses that white punk music was more or less made for "skate kids in big tennis shoes" and doing "loud rock music about cigarettes" (Yohannen 1989). The format he increasingly turned to was percussive world beat that incorporated Caribbean rhythms and African elements.

Washington may represent a special case within American music history, for the town is a government hub within an African American–majority city, where two unequal communities live side by side. Therefore, many people involved in the city's punk and hardcore communities were not Middle America youth with a taste for derision and upsetting the status quo of endless ranch home–filled neighborhoods where weary dads came home from factories. These were often the children of the powers that be mingling with vivacious black inner-city cohorts. Fred Smith (now known as Freak), the fine-fingered guitarist of Beefeater, explains the set of circumstances shaping his story:

> In very early 1983, I had just quit my government job at the Dept of H.U.D. My dad was one of the first black U.S. deputy Marshals. My dad was a doo-wop singer in the 1950s with Marvin Gaye and Van McCoy. The band was called the Starlighters and had a hit song called "The Birdland." After they fizzled out, my dad got into law enforcement— the second generation of the Smith clan to do so. My mom was overseas working for the State Department (a gig she earned struggling in the ranks for at least 15 or so years) while working for a 1960s program called "Voice Of America." They divorced in 1971. As my dad kept stressing me to go into law enforcement as a lifelong career, the music side of me was tearing me apart. So, I finally decided for the latter. (2009)

This was an intriguing decision, for although punks often projected themselves as the epitome of a freedom-loving, anti-racist, participatory culture, the rank and file were often very white, even in D.C.

> All this punk rock shit was happening in D.C. as well as New York, Massachusetts, Michigan, Ohio, and L.A. I was so intrigued. It was kind of like the Hippie movement of the early 1960s but more radical and more in your face—"We are sick of this shit world, and we are now here to fucking change it whether you fucking like it or not" attitude. In this circle of mostly pale, tattered clothing, safety-pinned boys, aside from the few black fans in the audience, THERE WAS US!!!!!! Gary Miller, aka Dr. Know of the Bad Brains, John Bubba Dupree from Void [who also designed the cover for the Void side of their split EP with Faith], Stuart Casson of Red C and The Meatmen, and the late great David Byers of the Psychotics, Chucky Sluggo, HR (Bad Brains), and myself . Now I am just noting the guitar players, but would never, ever, exclude or forget Shawn Brown from Dag Nasty, their first original singer, and the late Nikki Young of Red C.

As Freak discovered punk rock, he found himself making connections with a vibrant subset of punks that were making punk rock a point of convergence, where gigs found blacks and whites making music together. This was not unlike after-hours mixed blues and jazz band jams late at night in formerly segregated cities throughout the Jim Crow era. Black punks, the inheritors of music-as-token-of-liberty, found themselves on stage,

ready to deal with possibilities and pain. Freak was about to become one of them.

> Thru friends & some various acquaintances, more notably a guy named Ray Tony aka "Toast" and Eric Laqdemayo, aka Eric L from Red C, I heard about Madams Organ and the Atlantis Club. Soon I was auditioning at old Dischord house for a band that, from the start, proclaimed, "We are not here to make any money, are you in?" My brother Big Myke said, "Fuck this" and split. I hung around. Beefeater had an amazing, but at any given time, a very tumultuous run, with two vegan militant vegetarians and throughout the 2½ years of our existence, three meat eating, substance abusing alcohol driven drummers, and myself! Let us all keep in mind that D.C. is what, 80% black and this punk rock scene was fueled by angst-ridden white kids, a lot of whom I found out had fucking trust funds waiting for them when they became of legal adult age. Shit, I didn't even know what a fucking trust fund was back then. It was very strange to be these "token" negros, playing in front of predominantly all white audiences, but we did it. As Shawn Brown and myself will attest, there were fucking issues man. A lot of fucking issues that we had to address when we did shows. When I first heard someone refer to me as the "negro Lemmy," I was floored. I immediately lowered my mic stand down from the height that I set it. When I heard Shawn Brown being referred to as "the negro version of Ian MacKaye," I was floored again. When I told him, he was taken aback but still plugged on. In retrospect, even in this new scene, I was always wondering, would racism ever end?!

Smith's family not only had roots in both popular music and D.C. officialdom, but like many African Americans who moved to large cities during the middle of the 20th century, also experienced deep psychological wounds as the result of racial hostility, geographical dislocation, and vexing family issues yet unresolved.

Earlier I described punk names as a form of performance—a guise that allows a sense of sovereignty to each "new" person. Each performer becomes a blank slate, ready to write a punk future. Yet, for African Americans, the issue of naming and renaming oneself has a dynamic that may be unique to their place and struggle within American culture.

> Like many blacks back then, through the 1930s until the early 1960s, a lot of fucking name changing went about due to many horrible scenarios always occurring in the segregated United States of America. I legally changed my name to "FREAK "some odd years ago. My birth name, Frederick E. Smith Jr., is not my real name. My real last name is "ELLIS." When I found this out in 1980, I was horrified, shocked, saddened, and felt raped by both the world itself for letting me be born as a lie and my parents, whom knew this shit but never told me until I was an adult. So not cool, man. There was some incident with one of my family members in the 1930s in another state, possibly a homicide. I really don't know. If this was the case at the time, I am very sure it was probably in self-defense against not getting lynched. My family keeps it very cryptic, but the truth was, this individual had to get out of town, disappear, and begin a new life. So, in doing so, the name was changed to "SMITH." I have never tried to find our true lineage and probably never will. That would be too much of a strain for me right now and would probably just make me very, very fucking angry to find out all the lives I could've known all these years but didn't because of this incident. And a lot of other blacks will tell you I am not alone with this issue. So, changing my name finally gave me peace that I had been seeking for a very long time. (2009)

Mark Philips was a black punk from D.C. who joined SUPA, a version of Positive Force aimed at teenagers that included:

a collection of ragtag non-conformist, bright as hell (for the most part) kids that were into punk rock and political activism. That's where I first met Dave Grohl. We both liked Mission of Burma AND Metallica—pretty diverse in those days. SUPA was a cool club for a smart black kid into punk rock. My SUPA buddies and I would go to shows all the time at 9:30, DC Space, Hung Jury, and other venues. We would often see Black Market Baby, Government Issue, Beefeater, Iron Cross, Scream, and tons of others. At shows, I never ever felt anything but 100% accepted by punks in the scene. (2009)

Like many others, though, Philips, who would later work with longtime scene pioneers Dave Smalley and Mark Stern among others, is still bothered by classic D.C. hardcore songs such as Minor Threat's "Guilty of Being White":

I'm sure as an eighteen-year-old guy in a punk band, Ian was just writing from the heart, but my feeling about "Guilty of Being White" was that it felt a little shallow given how complex the subject of race is. Ian is a hero of mine, but that song threw me. I felt it completely glossed over the complex nuances of race relations and took an attitude of moral equivalency. Slavery wasn't THAT long ago, there are still people alive today who were directly affected by it, such as my uncle Sherman Jones whose father (not grandfather) was a slave. He was just here in my living room three weeks ago. He is forever unable to trace his lineage back another generation, which is a luxury that most whites take for granted. I think the consequence of a song like "Guilty of Being White" is that idiots hear it and don't know their history, have no empathy or understanding and they use it as a justification for their own racist views, which, of course, was not at all the intention of the song to begin with. The fact that Slayer covered the song validates my point here because that is a band (that I love) which is known to have overt racists in its fan-base who no doubt contort its

meaning to conform to their twisted phony populist white victim viewpoint. (2009)

When pressed to offer more input on the racial dynamic in D.C., usually considered one of the most integrated punk cultures in the nation, Philips's assessment is clear and concise:

The metaphorical contrast I would make to describe DC's racial dynamic (at least at that time) would be that it was a mosaic as opposed to melting pot. DC was 85% black when I left. The rest of the country was 12% black. Let's say for argument sake that the DC Punk scene was 20% black, on a purely statistical basis, I would say that blacks were actually underrepresented if anything . . . Though on a statistical basis, only a few blacks were directly involved with or affected by punk rock, over time those indirect participants—blacks that were there to see a gogo band, residents of the projects etc.—experienced an indirect benefit. That indirect benefit makes Ian's efforts quite noble from a zoomed out perspective. . . . I doubt any of those people are walking around today singing "Betray," but maybe when they look back on that moment in their lives combined (hopefully) with several others like it, it impacts their social empathy and overall tolerance, which is more important than a song or a haircut.

In such a daily reality, being a black punk demanded patience, sacrifice, resolve, and intense self-scrutiny. Mark Anthony echoes in a letter to the editor of *Maximumrocknroll* in 1985, outlining his own margin walking:

I'm in a unique situation in that I feel the racial tensions from both sides of the color line. Most of the black people around here don't like me because I don't dress right. I usually wear jeans and a T-shirt. I don't listen to black music, and most of my friends are white. The whites that don't like me do so because they think I am trying to act white

by listening to "white" music. Talk about narrow minds! (1985)

The black and white subculture of punk was a kind of mental minefield, full of promises and pitfalls. One disgruntled black former punk participant, whose original involvement began after watching the film *Sid and Nancy* and listening to the Sex Pistols, which eventually led him to MDC's music and then to the local hardcore scene, went as far as declaring, "There should be no black kids in the hardcore/punk scene or any white dominated area of life." This segregationist view seems to stem from his view that, in the end, "integrationist blacks cannot break the group mentality and American programming white kids have," despite such kids listening to anti-racist Youth of Today songs (Just Another Nigger 1990). This fan turned to rap, and signed off on hardcore punk, which by 1990 had been infiltrated by deep and pervasive racist trends in certain pockets of the country.

Racial tension existed for an even earlier generation of punk pioneers in the late 1970s, including Snuky Tate, who played with members of the Mutants and Controllers. Despite punk's supposed "alternative" orientation, bias still held sway in this microcosm:

> I got out here [Los Angeles] and tried to get into a band but it wouldn't happen. Bands would advertise in the paper and I'd call them and say I want to be in their band and I'm black and they go "Uh, aa, uh" or they say something weirder. So I decided to buy myself an amp and do it my fuckin' self. . . . I've been punk since I was 5 years old . . . when I got locked up with a friend of mine I was 16 years old, me and a friend of mine who was white and they called me a punk and him a delinquent. (qtd. in Flipside and X-8 1979)

Like many black punks, Tate seems to assert that his black identity marked him as an outsider and a punk well before he learned guitar chords. White society, whether the police force or the punk community, maintained a color barrier difficult to tear down.

Philips alludes to other cultural and historical complexities as well that underscore the life of a black punk:

> Our parents' and grandparents' life experience was informed so greatly by slavery, the civil rights movement, and race issues, that being part of something that was anti-authoritarian, and founded for the most part by bored white kids was definitely a head spinner at that time. . . . Most of my punk friends growing up (and now) like London May (Samhain), Dave Grohl, Steve Hansgen (Minor Threat) were raised with the assumption of racial equality so it just was something that they didn't think about, and racism was the exclusive province of sub-literate inbreds. Then some guys, like Pete and Franz Stahl, and Henry Rollins have this quality where I feel like their connection to the black experience and understanding of it is in some ways deeper than mine. On the other hand, I have witnessed racist behavior from guys who play in well-known politically correct straight-edge bands. . . . Then there are the guys I know who play in bands that have crazy racist followers and friends, but they themselves would fight to the death for a black guy if he was one of their bros. (2009)

Punk music sometimes displayed an ambivalent attitude toward race, such as the song "Shadow Man" by the Dickies, which contains the lyrics, "[black man's] in the alley, he's big an' tall . . . hominy grits and watermelon / black eyed peas and armageddon" (1979). The song's lack of subtlety and loaded imagery does not undermine or interrogate racialized anxieties and fantasies but instead serves to reinforce, even concretize these stereotypes. Performed at least once live with black female backup singers, it is unsettling, even when singer Leonard told *Flipside* fanzine that the song was a "humorous sort of song in

a racist [way], but a good racist way. They [the back-up singers] . . . thought it was demeaning, but they were making a buck" during practice at a rehearsal studio. In Leonard's point of view, profit steers and overshadows conscience. Once the song was performed live, it made "sense to the women," he attests (Flipside and Stegall 1989). Unfortunately, the song also seems to capture a tone and attitude more akin to Tin Pan Alley and demeaning blackface parody than to countercultural punk. (Note: the first punk performer that Mad Dog from the Controllers met in L.A. in the late 1970s was the drummer of the Dickies.)

In addition, such punk "parody" of black culture also has origins in the work of Black Randy and his Elite Metro Squad, consisting of members from the Dils and Randoms, which issued the single "Idi Amin"/"Say it Loud (I'm Black and Proud)" on Dangerhouse in 1978. The band covered the song "Shaft" from the 1970s blaxsploitation film. Fellow punk singer Hal Negro has equated Black Randy's (whose alter ego was Mexican Randy) band to "tight rhythm and blues punk rock" with "sick-out raps" who offered tunes like "I Tell Lies Everyday," which were set "to some Sly Stone rip-off" (qtd. in Mullen and Spitz 2001: 104). The online music magazine *Perfect Sound Forever* summarized Randy's approach as taking

aim at the songs, exaggerating the swaggering manhood of one and the simple minded racial pride of the other to grotesque proportions. Another song has a man discussing his love for the syphilitic African dictator Idi Amin ("Idi-idi-idi Amin / I'm your fan! / Idi-idi-idi Amin / I'm your man!"). . . . He didn't try to make a virtue out of weakness like punk rock traditionally did—he wasn't the voice of the oppressed or an agent of the oppressor, but rather a howling, bitter laugh. He was a nihilistic satire of our collective vanity and ambition, and showed how the human desire for power is consuming and essentially always the same, whether it's in the form of a bloated celebrity, hipster,

African dictator, cultural icon or religious worshiper relying on God to provide. (Sunshine 2002)

Years later, Kidd Spike, who led the bands the Gears and Skull Control (featuring former members of the Skulls and Controllers) told *Maximumrocknroll*, "How could you sing 'Do the Uganda' and not have tongue in cheek. . . . people were asking me if I was offended. I told them it was a joke, because Idi Amin was a fucking bastard" (Grant 1994).

Set in this framework, when the lyrics reveal sentiments like "I Wanna get VD / Be real mean / I wanna be black and look like Idi Amin," the discourse is likely meant to be disruptive, raw, leveling, and ironic, not simply reflect a white punk reveling in racist stereotypes that bolster prejudice and misrepresentation. John Doe, bass player of X and friend to Randy, argues that he "was a precursor to punk rap. He was all about an ironic take on Iceberg Slim, Donald Giones, Dolemite . . . blaxploitation movies, black pulp literature, and the whole pimp culture underworld. . . . He loved the sheer preposterousness of someone eating part of their enemy to make a point" (qtd. in Mullen and Spitz 2001: 105). Still, one might wonder who the enemy really was—perhaps the bourgeoisie as well as the bloated, the self-comforting liberals and politically righteous punks. Presently, set at a critical distance and divorced from the Hollywood punk circle, the lyrics and "spoofs" may feel like part of a larger web of racist-tinged ambivalence, epitomized by the notion that such performances represent a white "translation" of black subcultural style.

Other seemingly racist issues stem from the front cover cartoon on the Black Randy 45 "Trouble at the Cup," which depicts a young white man putting shoe polish on his face so he could go incognito as a black man out west where he has sex with a man in San Francisco, a pig in Los Angeles, and finally gets fellated by a white woman as he smokes a cigarette and wears a T-shirt with the word, "Black" inscribed. The cell that finishes the

narrative announces with crude "blackspeak" vernacular alliteration, likely framing or recounting the white woman's perspective: "Can't Stump a Rump Pump. Big Bucko Sucker. For a Nickel More You Could have Been Green. They Say the Boulevard is No Place to Be." Although writers like Kristine McKenna have characterized him as a lampooning, "raunchy comedian in the tradition of Redd Foxx" exhibiting "staggering cruel" humor, his work is nonetheless vexing (Mullen et. al 2002: 263).

Sunshine's approach suggests that Randy's aims were purposeful and inventive, not just the random result, as piano player David Brown seemingly admits in a mini-history of Dangerhouse Records found on breakmyface.com: "a tragic mixture of genius and self-abuse, writing lyrics in PCP/alcohol/diabetic stupors which mirrored the despair of the human condition in a way that deserved immortality . . . [reveling] in grotesque parody mixed with sophisticated musical texture." Black Randy might have reflected an attempt to critique culture in a transgressive, carnivalesque, aggressively tongue-in-cheek, satirical format, but actually may have revealed deeper psychological fault lines—a subtext bathed in anxiety about race relations in America—that resonates even within the punk rock Lenny Bruce gestures. As Andrew Blake argues, "the place of . . . punk in loosening the formal structures of belief in Western cultures away from deferrent social values and towards individual hedonism is undoubted. However, many young white men rejected the loss of power implicit within this loosening" (1999: 5).

The music of Black Randy and the Dickies may exemplify the complex attitudes, including ambivalence about roles and power sharing, toward black culture in a time when blacks were not only forging an intensely dynamic hip-hop culture but also competing for jobs and shaping the music and ethos of punk in the post–Black Arts Movement era.

Tesco Vee of the Meatmen seemed to embody these same tendencies in the 1980s, for the same

rancorous man who told *Maximumrocknroll* and *Puddle Diver* fanzine that he was into N.W.A, described as a "nigger motherfucker" band (Sarah and Bob 1999) and "black innercity big beat" music, also sang vexing parodies such as "Camel Jockies Suck," "Crapper's Delight: Extended Beatbox Go Go Dance mix" (an evisceration of the Sugarhill Gang and black go-o music from D.C.) and "Come on Over to Mah Crib" (1987). Over the years, Vee has been imagined as an anti–politically correct provocateur and a fierce free speech advocate, explaining in the same issue of *Maximumrocknroll* that "I'm like the barometer of someone's boiling point. . . . I've been called everything through the punk circles. It's not all true. . . . People might say racist, sexist, homophobic. . . . Best description I ever heard was this guy Craig Tajis . . . [who] said the Meatmen were 'scatologically sophomoric with underlying savagery.' . . . It's always been tongue-in-cheek" (1999). Still, to some readers and listeners that irony and scatology may seem more like barbed barbarism and a "coon show" transformed into hip hop mockery. Others differ, like Steve Miller, singer of the Fix:

I laughed then, I laugh now. It was really funny. Tesco was/is a punk rock [Don] Rickles, undaunted by the uptight minders of the "culture." Wasn't this all about pissing off convention and those who had to mince words and worry about what everyone thought? So, then I laugh more at those who are made so uncomfortable by his utterances. Again, wasn't that part of the purpose? If one harbors some sort of condescending attitude toward other races—"those poor people, they need our benevolence and help, cuz after all, we're just fine and they can't help themselves"—I think that then gives way to some faux-outrage. (2010)

In contrast to these parodies and friction, one might look to the early 1980s benefit for the Coalition Against Police Brutality, which writer Gary

Indiana depicts in *Flipside* #38 as a "mainly black oriented [community] group" that began in the mid-1970s. While the Dickies song seems vexing and problematic, this gig at the Cathay club to raise funds for the coalition featured a wide array of punk bands, such as the Alley Cats, Minutemen, and Saccharine Trust, among others, which suggests a loose political and social alliance between races, not ambivalence and intolerance. The same might be said for the early-1980s hardcore song "United Races" by Cause for Alarm, with lyrics such as "one united free land / united races / struggling to live / united races" (1983). Hence, though some punk lyrics project racial ambivalence and stereotypes, others attempt to undermine racism and reveal a yearning for progressive social and cultural possibilities. Other songs, such as "Racism Sucks," "Anti Klan," and "Colour Blind" by 7 Seconds, "Race Riot" ("don't try it") by DOA, and "Born to Die" ("No war, no KKK, no fascist USA") by MDC reveal a counter-text to racial hostility and division, as does the track "New Aryans" by the New York outfit Reagan Youth, led by Dave Rubinstein, whose parents were Holocaust survivors. Also, a mid-1980s video captures the Newtown Neurotics (at the time their name was shortened to the Neurotics) playing a pithy, punchy version of "Living with Unemployment" (riffage nicked from the Members' "Solitary Confinement"), in which they deconstruct the racism inherent in the frictions of a capitalistic system, offering lines such as: I ain't got a job, and there's no work in the city/They, they always try to blame it on the blacks/But it's really those in power that stab you in the back (1986). Leader Drewett later formed the Indestructible Beat, which fused African and reggae styles with punk sensibilities.

One can also point to other anecdotal moments in which black culture and old school punk have converged briefly, such as Chuck Berry jumping on stage at the club Mississippi Nights in St. Louis to play a rousing rendition of "Roll Over Beethoven" with the Circle Jerks, or members of the Cleveland punk band the Pagans coming across Chuck Berry at the Hospitality Inn on Route 99. As recounted in singer Mike Hudson's biography, Berry was with his daughter at the time, sitting at the counter. When approached, Berry shook Hudson's hand: "I noticed his [hand] was about as big as center fielder's mit, wrapping completely around mine, which explained a thing or two about his style of playing. In the film *Hail! Hail! Rock 'n' Roll*, Keith Richards says meeting Chuck Berry was one of the biggest thrills of his life, and it was no different for us" (2008: 16). Even though punk might have been declared year zero, the beginning of a new, blistering zeitgeist, it was still very much rooted in the traditions of rock 'n' roll, and thus indebted to black culture icons.

One can also look at close, rewarding relationships between hip hop and punk culture beyond the biography of the Clash, such as the Radio, a weekly club situated near MacArthur Park in Los Angeles that was devoted to emerging hip hop in 1983. Brendan Mullen reminds readers that the club was "run by old Hollywood punk scenesters K.K. and Trudy" (qtd. in Snowden 1996: 85). Mullen's memory paints it as a vibrant mixed-race club, with an energy similar to the original L.A. punk venue the Masque, which he operated. Meanwhile, he also deejayed at Club Lingerie, which featured salsa, funk, hip-hop, and artists as diverse as the Cramps and Etta James, though he does acknowledge that such commingling was not free of the "n-word freely uttered by retarded bigots" (85). The Lingerie withstood such narrow-minded fans, serving as a model for future clubs who relied on such diversity to fill their venues on a weekly basis.

By the late 1980s and early 1990s, as political correctness seemed to shape punk culture, and identity politics became more pronounced, including the rise of the homocore/queercore gay punk movement, bands like NOFX explored sardonic ways to interrogate and defang both racism and righteousness, such as naming one of their

albums, *White Trash, Two Heebs, and a Bean* (an Anglo, two Jewish guys, and a Hispanic?), which pushed the limits of taste during a time of increasing self-consciousness in punk. Their single "Don't Call Me Whitey," featuring a white poodle on the cover, parodies the funky 1969 Sly and the Family Stone single "Don't Call Me Nigger, Whitey." Both records, in hindsight, seem to interrogate race and identity in punk culture while also foreshadowing the world of comedian Carlos Mencia and a new post-racial era less about the blurring of race, gender, and species but instead offering a critique of people hypersensitive to race, gender, and disability issues. To some degree, NOFX may imagine these self-policing tendencies in punk as being overly, and needlessly, puritanical— perhaps linking them to an earlier era of Black Randy and Tesco Vee.

Emergent Black Identities in 1980s Hardcore

Punk and hardcore bands with black members[7] signify a musical matrix in which African American and Anglo sensibilities converged, despite first-generation punks Elvis Costello (who described James Brown as a "jive ass nigger" and Ray Charles as a "blind, ignorant nigger") and James Chance (who dismissed the aura, or magic, of black music as "just a bunch of nigger bullshit") belittling black music and musicians. Perhaps these comments, as Richard Hell noted to Lester Bangs, are to be expected since, "All musicians are such scum anyway that it couldn't possibly make any difference because you expect 'em to say the worst shit in the world" (1979). Noting Costello's proclivity for black music, Lloyd Bradley attests in his book *Bass Culture* that the first check Costello ever signed with his new punk name (not his christened Declan McManus) was for "forty quid's worth of reggae tunes, one of which was 'Uptown Top Ranking'" (2000). Costello later

went on to record a song by Smokey Robinson, a testament to his own taste for soul music as well.

The documentary *Afropunk* traces the seminal, long-lasting importance of black contributions to the punk phenomenon, establishing the fact that blacks have been intrinsic and vital to the history of punk rock while exploring the otherness of blacks within punk communities. However, all of these noteworthy collaborations and convergences do not signal that punk was a space in·which power was fluid and equitable. The notion outlined in "Eating the Other: Desire and Resistance," by bell hooks, remains to be discussed:

> Subject to subject contact between white and black which signals the absence of domination, of an oppressor/oppressed relationship, must emerge through mutual choice and negotiation. That simply by expressing their desire for "intimate contact" with black people white people do not eradicate the politics of racial domination as they are made manifest in personal interaction. Mutual recognition of racism, its impact both on those who are dominated and those who dominate, is the only standpoint that makes possible an encounter between races that is not based on denial and fantasy. (1998: 371)

This also seems to be reinforced by black writer, punk, and activist Tasha Shermer, who writes:

> JUST BECAUSE YOU THINK RACISM IS WRONG DOES NOT MEAN YOU ARE NOT A RACIST. Whites will always have that underlying residual racism, and that applies as much to the punk rocker as it does to the redneck. People will always have the need to feel superior, and for whites one area that they have been made to feel is superior about them for so many years is the color of their skin. This does not change when you start to like punk rock. Yes, you can recognize that white superiority is false. Yes, you can work to change it, and yes, you have all made such wonderful

progress. But shreds of memories of being number one, even if it wasn't in your lifetime, will always haunt you. This is what causes my invisibility in your punk rock world. (2004)

One can argue that, until black punk musicians write their own histories, the dynamics and conditions within punk bands, and the community itself, will remain conjecture—partial, inadequate, and almost entirely manifested in white male gaze, memory, and biography.

Even second-generation U.K. punk bands like Anti Pasti have voiced concern that people overlook their connections to black culture, as evidenced by bassist Will Hoon's assertion: "We used to hang out in black clubs listening to dub reggae and Derby was/is an ethnically diverse city, so we were angry that difference and division were being exploited and problematised. We saw the problem as not being about race, but about 'haves' and 'have-nots,' regardless of race" (qtd. in Glasper 2005). GBH, one of the hardcore pioneers of British punk, released the track "Skanga (Herby Weed)" which alludes to marijuana, and perhaps Rasta culture, ensconced in the musical trope of a jungle boogie blues and "scat lyrics," which might be considered a form of minstrelsy. Within Oi, which has been historicized as a white, working-class youth hooligan culture, many West Indian fans existed, including former club bouncer and West Ham's Inter City Firm street fighting "general" Cass Pennant, who was known to save people from the wrath of skinhead gangs at places such as Stratfort Station.

All this was happening within the context of race baiting in the U.K. press, outlined by Dick Hebdige in his book *Hiding in the Light*: "In 1981, a new collective subject was proposed—the mass 'mugger'—the unruly, resentful and delinquent black mob," likely the institutionalized response to race riots that took place during the same period (1988: 19). Hence, punk may be understood as interrogating and responding to these fractious times, while in subsequent American hardcore, one can easily discover black craft—neo–hip hop—foundations in songs like "Men in Blue" by Youth Brigade, 7 Seconds' "Colour Blind Jam," the first verses of "Life Sweet Life" by Youth Gone Mad, and "Banana Split Republic" by False Prophets. What usually goes unnoticed is that the Youth Brigade rap was performed by their black roadie Marlon, who is only credited for providing "soul." Similarly, HR of the Bad Brains was not credited for singing on a Ramones song featured on the album *Halfway to Sanity*. MDC slowed down enough to perform a rigorous version of Jimi Hendrix's "Spanish Castle Magic" just as the equally political Dicks covered "Purple Haze" on the Rock Against Reagan tour. The D.C. post-hardcore band Soulside stripped down and reinterpreted "War," originally a consciousness-raising race speech to the United Nations by Haile Selassie, ruler of Ethiopia who is considered an avatar in Rastafarianism, which had been retrofitted to reggae music and transformed into a passionate, elegant song by Bob Marley on the album *Rastaman Vibration* in 1976.

In Texas, the punk music of the Dicks was especially tied to black music. Singer Gary Floyd grew up in rural East Texas, has demonstrated a lifelong love of Muddy Waters, and included an African American drummer in his first band. This does not mean that the blues elements were a conscious fusion of two cultures: instead, the hybrid style might signify an unconscious bolting together of latent influences from years of Floyd absorbing country and blues influences. As he expressed to me:

I always like blues. It's always been one of my favorite kinds of music. With the Gary Floyd Band, I actually did hard blues albums, and with the early Dicks my voice just seemed to project that, especially on songs like "Shit on Me," and "Shithole" had a little bit of a bluesy feel. When people expressed that after the fact, I was shocked. My parents are

music fans to the point that they listen to a lot of music. On Saturday evenings, there would be this long horror story for me of different country people like Porter Wagner, Buck Owens, and others. So, it was something I was listening to. Also the Grand Ole Opry and Panther Hall, which had Willie Nelson. It was my young hippie days, and I hated it. But you know what? It was there, and I was listening to it. And my mother used to listen to some bluesy things too. Then as music started progressing, there were people like Canned Heat doing the blues, then they did an album with John Lee Hooker, which opened a lot of people up to what John Lee Hooker was doing. (2002)

A similar exchange with John Brannon, singer for the hardcore punk band Negative Approach and post-hardcore band Laughing Hyenas based in Detroit in the 1980s, reveals links between himself and blues music:

Ensminger: People describe your voice as resembling delta blues singers . . .

Bannon: I used to listen to a lot of that, but not so much anymore. I could always play John Lee Hooker, or Howlin' Wolf and all that shit. When the Hyenas started out, I was really fed up with punk rock, and I really started to go out and buy blues records and digging all that shit, but I got so many different kinds of stuff that I listen to. (2004)

The tendency to branch out musically in the post-hardcore era also shaped the steadily increasing make-up of Henry Rollins' music library. The singer of Black Flag told *No Rockets* zine that "I listen to all kinds of stuff, classical, avant garde, jazz, John Lee Hooker. The Hook gets me going, and Lightnin' and Robert Johnson" (Cronin 1987). Similarly, Michael Azzerad's seminal book on American indie rock and hardcore, *Our Band Could Be Your Life*, reveals that Greg Ginn, guitarist for Black Flag, idolized blues guitarist B.B. King.

"I wasn't into popular music growing up," Ginn reveals in a Jay Babcock overview of the band for *Mojo* magazine. "I considered it something insubstantial, an insult to listen to. At UCLA, I'd go to the library and listen to Gil Scott-Heron, country, blues, classical and jazz, people doing stuff that you don't feel insulted listening to. I also saw a lot of good touring jazz and blues groups. I was never the 'rock 'n' roll kid'" (2001). Even as late as 2009, Kevin Williams from the *Chicago Tribune* hailed Ginn's "gutbucket blues tone" as a defining quality of the "instantly familiar" artist.

For years, singer Henry Rollins lived on a ten-dollar-a-day tour per diem crisscrossing the country with Black Flag, and when back in Los Angeles, he lived in a cinderblock shed with no plumbing in the backyard of Ginn's family. Still, he refused to equate these privations with the legacy of black rock 'n' rollers before him, telling a *Los Angeles Times* writer that, "We don't have it hard. . . . We're still alive. What about those blues singers? What about Hendrix, doing the chitlin' circuit with Little Richard, not getting paid, starving. That's hard" (Cromelin 1984). The article makes this clear: while Rollins might have sought potent inspiration, joy, and comfort from black blues music, he did not seek to "romanticize" his own condition, nor did he attempt to make a tenuous link between the suffering of blacks in the barely post–Jim Crow era and white punks who simply show up to see gigs, then go away, without having to endure the deep, entrenched stigmas and disparities that shape living in the United States as a minority (which is not to suggest that punks were not outcasts or mistreated by police, parents, and school systems).

In addition to blues, jazz has made a long and indelible impact (on Ginn as well), shaping the punk sound, most notably in the work of No Wavers like DNA and James White and the Contortions. Even Suicide was likened to both an "electronic blues band" singing "urban laments" and an "improvising jazz band" (Trakin 1980: 31). Jazz is equally

prevalent in the work of Mike Watt, bass player for the Minutemen and fIREHOSE. In addition to a long solo career over the last two decades, he has also served a stint with the reformed Detroit proto-punks the Stooges. Before one of his mid-2000s shows, he provided input:

> Coltrane said, I am trying to uplift people. . . . I listen to a lot of John Gilmore [Sun Ra's tenor saxophonist]. He says, I think music is a big reservoir [that we all dip out of]. So he's probably the biggest inspiration in my life right now. You know, I didn't grow up with jazz, didn't know anything about it. When I first heard it, it was groups like Albert Ayler, John Coltrane, and it sounded like punk to me, just from a different time. It was insane. And I couldn't systematize it like all the other music I heard into verse chorus, verse chorus. It sounded free, and reached me in different ways than other music. I was ecstatic. Kind of like the state I like to get in when I play, because you're so scared I try to whip myself into a kind of frenzy, a Dervish kind of thing in a way. I don't let the fear win on me or make me insecure or not let me engage. That's why I think songs are a dialogue, a conversation between instruments. It's not just everybody, like the piano, playing their little part. It's actually them engaging each other in conversation. That's a lot of my style, lexicon, or whatever, on my bass is, humility. (2002)

Hence, the conversation taking place between genres, the language of music, and cultures is much more nuanced and complicated than simply borrowing, appropriation, or mimicking, as has been cast by critics of the work of no-wave pioneer James White. Instead, Watt represents another kind of interaction, partially intellectual and intuitive, humble and earnest, that opens up spaces between cultures and signifies possible transcendence.

Despite punk rock being an avenue for race or cross-cultural symbiosis, the outside world, with its master narrative of segregation, suppression, and race anxiety, always reminded punks of their marginal status by exploiting the issue. The tumult and legacy of complicated race relations in the U.K., including massive riots and small gig upheavals, are far too numerous and complicated to explore here, but the U.S. scene does offer some revealing moments too. For instance, Dave Dictor testified: "Cops have been known to take punks to black housing areas just because they know the punks will get the shit beat out of them."

Australia also has a history of racially tinged violence experienced both directly and indirectly by both American and British punks. In the case of the Clash tour in 1982, bassist Paul Simonon recently recounted meeting local aborigines who wanted to speak at a Clash gig to "talk about their situation" in front of their audience, only to have one member's wife beaten at home by the police as they spoke. This soured the Australian leg of the tour for Simonon (Clash 2008: 335). Police also arrested Dead Kennedys black drummer D. H. Peligro while on tour. Sources disagree about the charge, though Jello Biafra told *Maximumrocknroll* that he was arrested on the street for unlawful assembly. When band mate East Bay Ray tried to intervene, he was removed in a separate police car.

In addition, police roughed up D. H. after a show in Wilmington, California. During roughly the same time period, Reggie Rector, guitarist for the mixed race punk band Secret Hate, was killed in downtown Long Beach. In *Flipside* #38, he was asked by Al Flipside, "Why don't you think more blacks are into punk?" He answered, "They're more into Michael Jackson," while his bandmate Kevin noted: "There's pressure not to be, if you hang out with a bunch of Crypt Town guys, they don't want you getting a Mohawk, or wearing a kilt" (1983).

However, HR from Bad Brains locates this pressure from another source—white culture—which he equates with Babylon. In *Flipside* #31, when

asked, "Why don't you think there are more black people into hardcore?" he responds: "Because of exposure . . . Babylon . . . black people ain't gonna find out about it until white people find out about it," to which his bandmate Gary responds, "Because of the Babylon system" (1982). Whereas Secret Hate equated the lack of involvement due to pressure from within the black community, the Bad Brains suggests that a supremacist system prevents black communities from exposure to hardcore; hence, as Stuart Hall suggests, media representations likely fix meaning, limit new potentials, and normalize identities.

Bad Brains were the band that challenged assumptions about punk musicianship, shook up and transformed black identities in punk rock history, and frequently, as in the case of the Clash and the Damned, used opening slots in punk gigs to interrogate the status quo of the genre in which they excelled. Bad Brains distressed and frayed such norms. Howard Wuelfing recalls:

My first contact with the Bad Brains was through Kim Kane of the Slickee Boys who submitted a review of a house party they played at, that ran in my *DesCenes* fanzine. He was utterly in awe of them. As I recall everyone in town was floored by the Bad Brains and singing their praises as well they should have as they were an incredible band, especially live. I remember them totally blowing The Damned off the stage at the Bayou one night. HR was like a black Iggy Pop and the rest of the band was impossibly tight and fast and the songs notably intricate and challenging. (2008)

Revisiting some theory of Hebdige, postcolonial theorist Paul Gilroy asserts: "Punk provided the circuitry which enabled . . . connections" between "black and white styles" while fostering punks to produce their own "critical and satirical commentary on the meaning and significance of white ethnicity" (1991: 122–23). Granted, he has little regard for Bad Brains, whom he tags in *The*

Black Atlantic as advancing "the white noise of Washington, D.C.'s Rasta thrash punk," which effectively divorces the band from its black musical antecedents (100). If we adopt Gilroy's view wholesale, Bad Brains were simply skilled nomadic musicians poaching white musical forms rather than reclaiming the music of their birthright, from John Coltrane to Chuck Berry. For instance, the tropes of "suffering" they employ in lyrics might be linked back to the Sorrow Songs discussed by W. E. B. Du Bois in *The Souls of Black Folk* (1903). I contend that Bad Brains update such American music, indebted to the spirit, story, and sweat of African Americans, though it is mediated and propelled by the "terrible" explosiveness of punk.

Originally a progressive jazz unit known as Mind Power, Bad Brains were influenced by mixed-race jazz fusion icons Spyro Gyra, reggae pioneer Bob Marley, and Stevie Wonder's spiritualism. When integrated into punk idioms, such musical tastes and abilities were well-regarded by peers during their heyday. "I thought the band was ferociously good," singer U-Ron Bondage of Really Red informed me, describing their 1982 gig together in Houston. "Technically amazing too. It was obvious to me that they could have been playing other types of more complicated music prior to being Bad Brains" (2005). This reinforces Wuelfing's impressions. On the liner notes to their *Greatest Riffs* CD (2003), the band thanks Miles Davis, Ohio Players, and Earth, Wind and Fire alongside punk stalwarts the Dead Boys, Cro-mags, and Eater: their musical influences ranged wide and did not merely reflect a crucible of "white noise."

Gilroy (like many academics) somehow imagines them as an overly simplified amalgam of white speed, urban angst, and "thrash" fury. He borrows Leroi Jones's (Gilroy chooses to use this instead of his later adapted name Amiri Baraka) assertion that black music in the Diaspora is essentially always in a state of flux and change, a cultural transmission full of disruption and breaks, and an

unfixed musical landscape. Yet, Bad Brains do not merit a position within this culturescape. Russell Potter draws even weaker conclusions, categorizing the band as "metalesque 'ska'" (much more aptly describing the music of Fishbone). Supporters who envision them as examples of cultural hybridity, he intones, are on the side of "recuperation" and "fuzzy plurality" (145). Neither writer fully grasps the band's historical significance— their rather rare genre-defining style. Neither is willing to concede that Bad Brains' translation of punk style— itself a translation (or appropriation) of subversive rock 'n' roll—is an unstable convergence that may reveal shared, integrated, or multicultural milieus.

Bad Brains mark the zero hour of hardcore music—the moment when the sounds of "white noise" became jet-fueled. As HR describes it to the fanzine *Ripper*: "When I first heard their [the Dickies] music I said, Gee it's so fast, this is really bad"—a vernacular form of verbal approval for the band's catchy, humming, and terse pop-punk (Tanooka 1982). The Bad Brains did not just translate the Dickies' format: they were generative. Before them, no single band played such a nimble, fertile, crossover speed jazz style. Whereas the Police also derived from jazz-fusion origins, they chose pop-reggae templates. Furthermore, Jello Biafra of the Dead Kennedys credits the British band Discharge as the first hardcore punk band, though the *Black Dot* sessions by Bad Brains, which were not released to the public for twenty years, reveal a uniquely hardcore format already existing in robust form by 1979 that outpaces early Discharge.

As soon as their first full-length cassette-only release appeared on Roir Records (1982), followed by the Ric Ocasek (of the Cars)–produced *Rock For Light* (1983), "white noise" writers, including Gary Bushel (a British proponent of street punk, including the emerging Oi sound) waxed enthusiastically about them, evoking mouthfuls of metaphors that posited Bad Brains as the avant-garde:

"They make Motorhead sound like they are standing still. They make Discharge sound like gentle balladeers. . . . Imagine the musical equivalent of a 90 second London-Brighton train film run on fast forward" (qtd. in Gimarc 581). Hence, historic credit for stimulating the hardcore genre might shift to Bad Brains even as music historians acknowledge that tracks by the Damned ("Love Song"), 999 ("No Pity"), Wire ("Mr. Suit"), the Ruts ("Criminal Mind"), UK Subs ("Telephone Number" and "You Give Me Disease"), the Germs, and singles by Middle Class and the Bags did provide intermittent, frenetic-paced examples of proto-hardcore. Bad Brains, banned and nearly broken, quickly symbolized the blazing potentials of the new genre.

One vexing issue still relating to Bad Brains is their embrace, and projection, of Rastafarian culture, which they simplify as "taking up the Nazarite vow" in the same *Ripper* interview (1982). They also suggested to *Suburban Voice* fanzine that Rasta culture is not bound to the black Diaspora: "Rasta is not no black nothing. Rasta is a function of the heart, it's the first law. Now, we have the first nation, which is Africa and we give credit to the dynasty of the Solomon lineage so this is the only reigning diplomatic credited Christian Orthodox function today but we do not function for blackness. I and I live for humanity. A man can be any color and be a Rasta" (1987). Their desire to evoke a transcultural frame for Rastafarianism, or their translation of Rasta tenets, may sour some Rasta supporters, while their religious orthodoxy troubled punks.

Dave Dictor from MDC, who underwent some tense moments while playing on the same stages with Bad Brains on a tumultuous 1982 Rock Against Reagan tour, penned lyrics like "We don't need your Jah's fascist doctrine" in the song "Pay to Cum Along" (1983). Though many punks might have imagined Rasta beliefs as exotic or just plain "weird" (as U-Ron Bondage described it to me), bands like MDC attacked them with the

same fiery aplomb they denounced institutional Christianity, especially after singer HR openly denounced the homosexual lifestyle of Randy "Biscuit" Turner, the singer of the Big Boys, a friend of MDC. Connections between Rasta and punk in general do not necessarily naturally resonate in terms of shared community mores. Al Long, onetime singer from the band Nausea, a fiercely political band from New York City circa 1990, admitted that, "The rastas I work with have little in common with me" (Non Grata 1990).

Questions imbedded in the work of Canadian cultural critic Richard Fung, as discussed by Coco Fusco in *The English Is Broken Here*, can be used to examine the sensitive postcolonial issues at stake. Fung maps out strategies to deal with cultural productions that converge with, or are the result of, cultural appropriation. Using his framework, I ask: Does Bad Brains' punk status place them within a subaltern group of the African Diaspora? Does the band misrepresent Rasta culture? To what degree does the band, or later offshoots such as HR and Zion Train, commercialize Rasta culture? Is black punk rock a distinct mode of cultural production, defined by agency and volition—self-control and self-representation? Is black punk a convenient tag or genre created by hegemonic forces, or does it counter racist forces, revise our notions of history, and treat white and black historical actors with equity and fairness? Lastly, did Bad Brains offer alternative visions of male masculinity or reify old sexist, homophobic modes of power? Those remain to be explored in future texts.

Truth and Consequences: Hardcore's Promises and Pitfalls

In *Black Culture, White Youth: The Reggae Tradition from JA to UK*, Simon Jones examines race relations and youth culture in Birmingham, England.

He rightly points out that some of the Clash's most compelling diatribes, like "White Riot," were easily co-opted and manipulated by people espousing fascist doctrine. Likewise, songs by the hardcore generation, like "Guilty of Being White" by Minor Threat, which features the highly personal, and some may argue overly immature and simplistic, insight of singer Ian MacKaye (an early admirer and cohort of Bad Brains who attended an urban Washington school district), was often "hijacked" by racist groups who rerouted the meaning. For such groups, the latter song was a tough examination of white working-class agitprop in the age of post-1970s black self-determination. As so-called victims of reverse discrimination, they denounced having guilt "for something I didn't do . . . a hundred years before my time" (1988).

Jones recognizes the "powerless, desire to shock, and sense of anger at official smugness expressed by punk's more working-class constituency," which were also the same traits and feelings often documented in fascist youth groups (100). He suggests that many contingent factors mediate the interplay and interaction between white and black youth. The notion of punk bands and scenes evoking or embodying multicultural "hybridity" becomes very complex. White youth's attraction to (along with the desire to appropriate) black cultural forms should be understood within a context of actual race relations. At a very minimum, these interactions become mediated by youth groups vying for territory, constructing identities in the age of black self-determination and punk culture shock, and competing for employment during times of national financial fissures, none of which can be understood by an analysis of style or musical content alone. As some critics posit, what journalists and musicians say can be very different from what they do.

In terms of establishing merging of horizons between black and white resistance cultures, contemporary hardcore punk singer Thomas Barnett

from Strike Anywhere provides a larger matrix to ponder. I quote him at length, since what he revealed to me in a 2005 interview is both detailed and nuanced:

> I think about this often, and have had an ongoing conversation on this subject with many older punks, hardcore kids, conscious rastas in Richmond and D.C., and other members of the African Diaspora, about the roots of punk and the parallels and differences between hardcore/punk and revolutionary black music in the Western world. . . . There isn't a punk rocker alive now who couldn't find an eerie affinity between the shrill anti-authoritarian rhyming rage in their favorite punk song and the frustrated, simmering patience of countless reggae numbers. It's just there.
>
> Some people have sworn by the "East London" theory . . . [in which] early British punk rock bands—and their embryonic, furiously self-reinventing tribes of friends and followers (back then even more fractured, heterogeneous, and, for that matter, androgynous, certainly hungrier and homeless— orphaned from rock 'n' roll already) are looking for pubs to play in, and the only sympathetic ears who'll take them in are the West Indian owned reggae clubs in the East End. Perhaps, if this is accurate to some degree, this is where the cross-pollination of ideas, and in a smaller way, sounds, first went down.
>
> You could look at it as a window getting opened for the disaffected, self-destructing white punks and artists, and the elements of post colonial black politics, human rights issues, and the awareness of a binary world system came crashing down through the music into their minds. The often paradoxical and personal politics of punk can be traced back to this artistic intersection, but perhaps this was just one highly public space in history where this same collision of white restlessness and countercultural reaction opened up to the waiting truths, methods, and life affirming ideas of revolutionary black culture."

The September 1983 issue of *Maximumrocknroll* features a long discussion between Ian MacKaye from Minor Threat and Dave and Vic Bondi of Articles of Faith, in which racism becomes a prevalent, and heated issue, as does Sab Grey's (Iron Cross) interview in *Guillotine* #8 from 1984, which covers the use of the triggering term *nigger* and racial violence in desperate neighborhoods (Wendy, Golf, and Annette). Similarly, an interview in *Touch and Go* (#16) reveals Grey's early sentiments regarding the reverse racism of blacks ("blacks are the biggest racists") and the notion that "everyone is" a Nazi. Later, when speaking with D.C. punk community chronicler Mark Anderson, he exhibited remorse for such comments and sentiments, but such discourse does signify D.C. as a site of sometimes very tense raw race relations. Moreover, one should note that Iron Cross's first bass player was black, and Grey's perspective is shaped by family heritage: his mother survived the London blitz and his father was "a German refugee from the Nazis." Hence, the only actual fascist element might have been their name.

Punk rock did not necessarily make convergence easy, or provide equal treatment to all participants, but it did make convergence possible and fruitful, despite contradiction and ambivalence within the community.

Bodies of Confidence, Desire, and Frenzy: Hip Hop Suaveness and Hardcore Havoc

I will use Bad Brains, and the seminal hip hop outfit Run-DMC, as samples to examine how black music culture unfolded in different forms during the early 1980s. As mentioned earlier, Bad Brains hailed from the Maryland/ D.C. area and were attracted to the raw power of punk after hearing the Sex Pistols. Even their name reflects their

fondness for contemporary punk of the time, since "Bad Brain" is the name of a Ramones song from 1978. At the time, D.C. had a small wellspring of punk and new wave bands, ranging from the college-crowd Urban Verbs to the garagey pop punk Slickee Boys and a small number of emerging teenage "hardcore" punk bands, like the Teen Idles. However, Bad Brains were able to harness their skill sets associated with jazz—nimble and adept musicianship, usually not considered an essential part of, perhaps even considered antithetical to punk performance—and added volatile, fierce speed and energy that pushed new boundaries.

In Queens, Run-DMC began a different approach to rap, utilizing the pared-down method of "two turntables and a microphone" that democratized music in urban areas by replacing live band members (and expensive instruments) with 12" record tracks that could be "mixed" live to create a backdrop to raps. This emergent style likely has antecedents with West African griots and Caribbean "toasting." In the new form, certain funk beats would be isolated and/or produced by drum machines, and the rappers would be free to "emcee" on top of this. What I am interested in examining is the visual representation of these forms in video form, including "Sucker MCs" by Run-DMC and "Banned in D.C." by Bad Brains at the infamous New York City club CBGB.

In a band photo on Wikipedia, Run-DMC's trademark gear includes very clean and neat Adidas, tight leather pants or jeans, uniform black fedora hats, and large gold chains. Their posture is rather uninviting: Jam Master Jay and DMC cross their arms, lean back or to the side somewhat stiffly, and stare at the camera directly. DJ Run appears more relaxed: with hands sunk a bit into both pockets, his body is slightly tilted, and he stares less "hard." Live in 1983 on an unattributed program available on *YouTube*, they outfit themselves in leather jackets, keep the fedoras, and sing on a stage for an urban dance show with

graffiti backdrops. In the song "Sucker MCs," they mention certain status symbols, including St. John's University, drinking champagne, Cadillacs, and credit cards.

In the Bad Brains video on *YouTube* shot at CBGB in 1982, one year before the Run-DMC clip, the band plays "Banned in DC," one of their hallmark songs that explains, in part, why they were banned from Washington D.C. clubs for being too uncontrollable. In the video, three of the members wear clothes that symbolize colors associated with Rastafarian style (green, yellow, red) and two of the members wear woven caps in the Rasta tradition. At this time, Bad Brains clearly identified with Rastafarians and integrated reggae into their live sets, thus in some ways they reflect Hebdige's hypothesis about the frozen dialect between white and black culture within the framework of a single hardcore punk band. Singer HR has dreadlocks, and his button-up shirt seems to contrast the T-shirts worn by the rest of the band and the gig's mostly white attendees. His manner might appear bombastic to some viewers, a dance of full-bore, feral, and molten fury. The crowd acts in kind, forming at times a dizzying free-for-all and abandon that contrast with Run-DMC's audience, who dance adroitly, smoothly, and fluidly, or gaze and cheer at the performers on stage. In the CBGB video, HR and the crowd meld at points. HR bends down and intensely interacts with the first row, dances on stage, and takes up a gyrating position in front of the amplifier as the guitar player wields a solo.

If one were to read this depiction taken from bell hooks—

> When young black men acquire a powerful public voice and presence via cultural production, as has happened with the explosion of rap music, it does not mean that they have (a vehicle) that will enable them to articulate that pain. . . . True it was conditions of suffering and survival, of poverty, deprivation, and lack that characterized the marginal

locations (. . .) It is the young black male body that is seen as epitomizing this promise of wildness, of unlimited physical prowess. . . . It was this black body that was most "desired" for its labor in slavery, and it is this body that is most represented in contemporary culture as the body to be watched, imitated, desired, possessed. (435)

—one might mistakenly believe that she is referring to the Bad Brains video, with its viable sense of explosion, public voice (even howl), wildness, unlimited physicality and musical prowess, and its intensely imitated form demonstrated by the white audience, as if HR is using the stage to act with and against the audience to interrogate all the pain and deprivation ("banned") associated with exile (with its Old Testament connotations that appeal to Rastas). I suggest that he is interacting with them in mock violence that actually becomes a kind of dance and choreographed ritual—a path toward catharsis, perhaps.

bell hooks, however, is describing rap music. I agree that that many rap bodies are desired by audiences, but I am also concerned that their bodies are envisioned as easily re-enslaved, commodified through dress that is corporate, rather than nationalistic or African inspired (Bad Brains's taste for Rasta dress). Next, their emphasis on wealth (college careers, caddies, and Champagne), the trappings of a bourgeois life, contrasts with Bad Brains' emphasis on survival and reclamation ("you can't hurt me . . . we got ourselves, going to sing it, gonna love it, gonna work it out at any length"). Lastly, the trope of suffering endures within Bad Brains (note their song "House of Suffering" on *I Against I*) song library, whereas Run-DMC later turned to clean rap and Christian lifestyles.

In the texts of bell hooks, Paul Gilroy, and other theorists, black punk rock cultural productions tend to be undervalued, absent, or deleted. Black resistance to hegemony reverberates in varied and vibrant musical forms: black punks were and still are at the forefront. While punk and hardcore may indeed be a genre and community ripe with convergence, and arguably, some contentious forms of hybridity, academics still lack the history, insight, and willingness to engage not only the discourse of independent and mainstream media and culture but their own academic leanings as well. As Thomas Barnett from Strike Anywhere stressed to me, there is a "closeness and affinity between black and white revolutionary arts," but the goal is to "make these connections clearer and nourishing again" so that punk rock does not simply become "another obedient, palatable form" (2005).

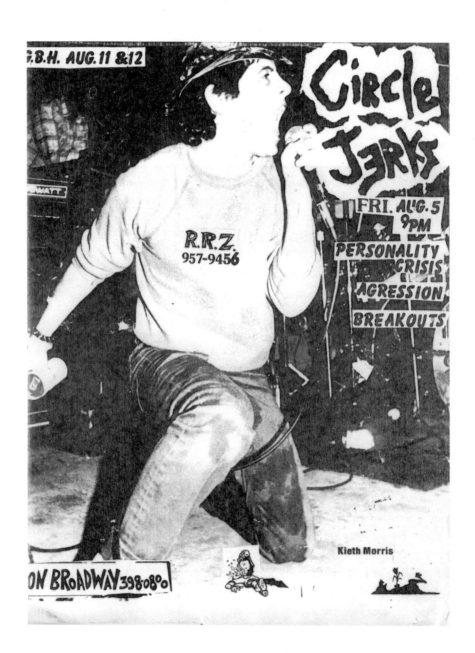

G.B.H. AUG. 11 &12

Circle Jerks

FRI. AUG. 5
9PM

PERSONALITY
CRISIS

AGRESSION

BREAKOUTS

R.R.Z.
957-9456

Kieth Morris

ON BROADWAY 398-0800

Circle Jerks, Aggression, and others at On Broadway, San Francisco, 1980s.

MDC

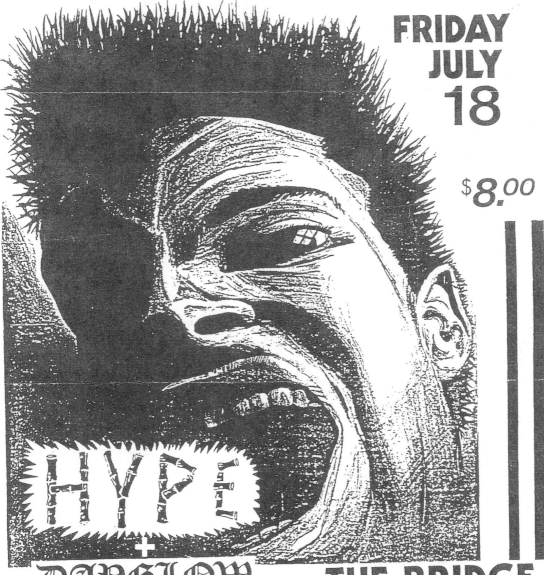

**FRIDAY
JULY
18**

$8.00

HYPE
+
**DAYGLOW
ABORTIONS**

**THE BRIDGE
507 bloor st w
toronto**

MDC, Dayglo Abortions, and Hype at the Bridge, Toronto, Canada, 1980s.

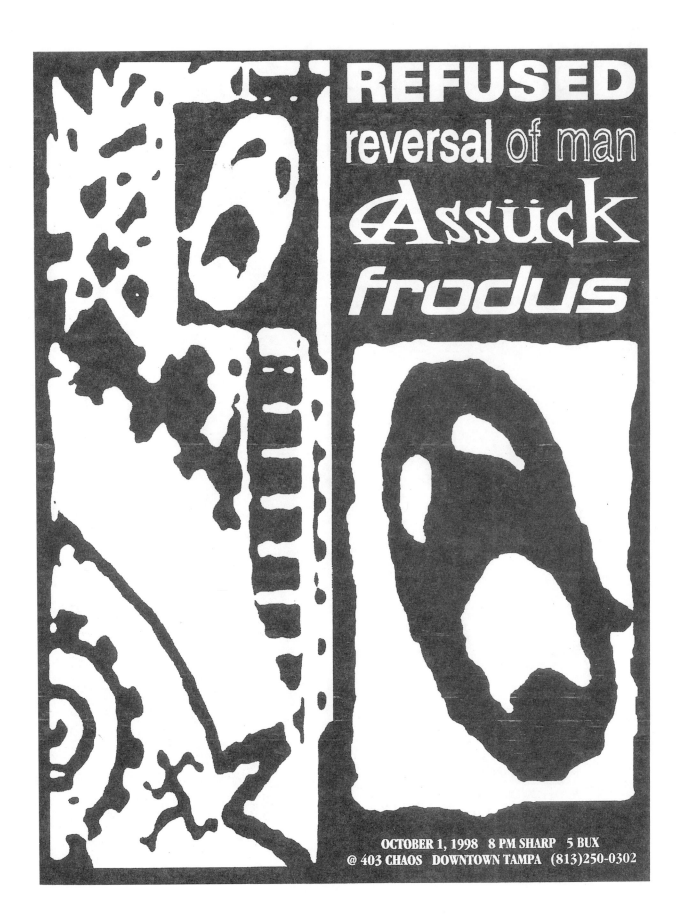

REFUSED
reversal of man
Assück
frodus

OCTOBER 1, 1998 8 PM SHARP 5 BUX
@ 403 CHAOS DOWNTOWN TAMPA (813)250-0302

Refused, Assuck, and others at 403 Chaos, Tampa, Florida, 1998.

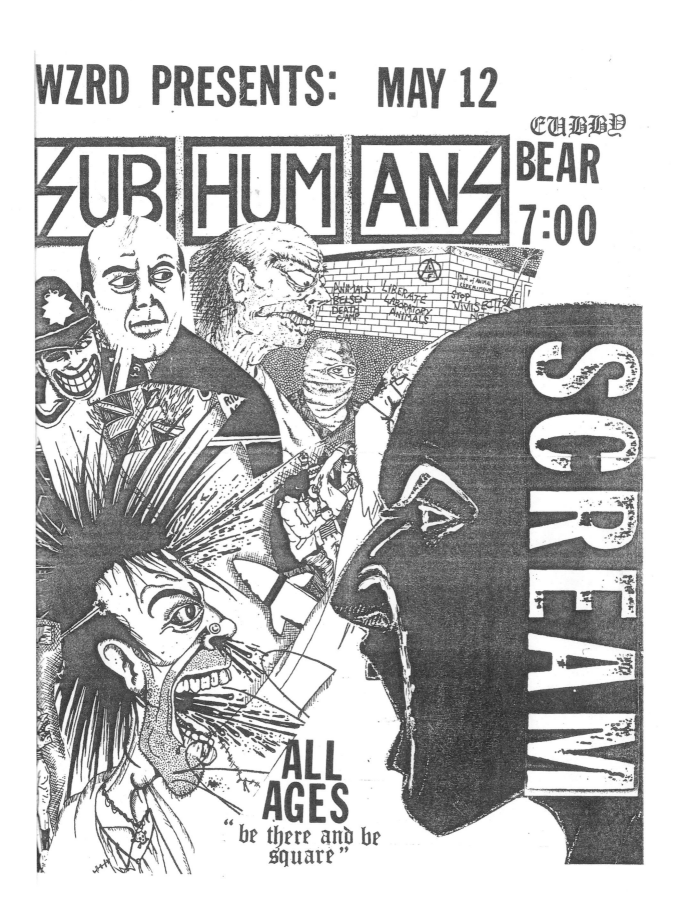

Scream and Subhumans at Cubby Bear, Chicago, 1980s. Appropriated record sleeve art.

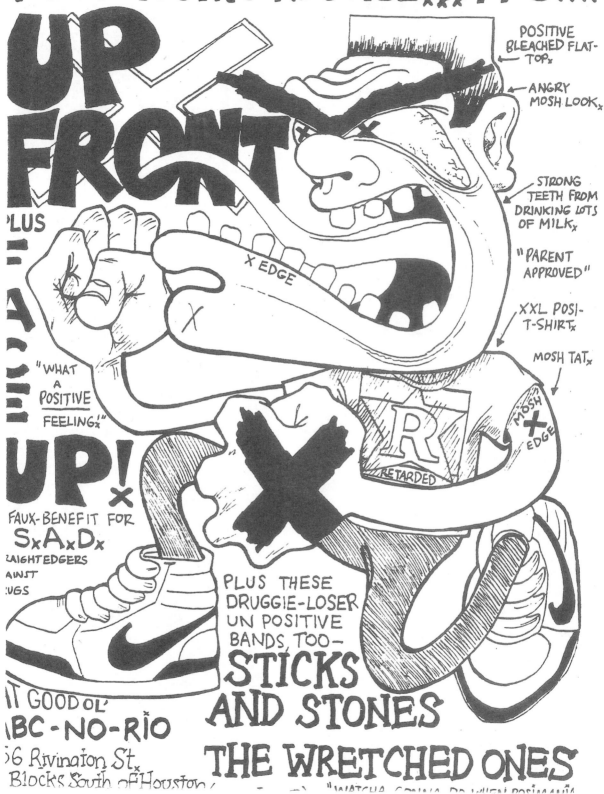

Up Front and others at ABC-No-Rio, New York City.

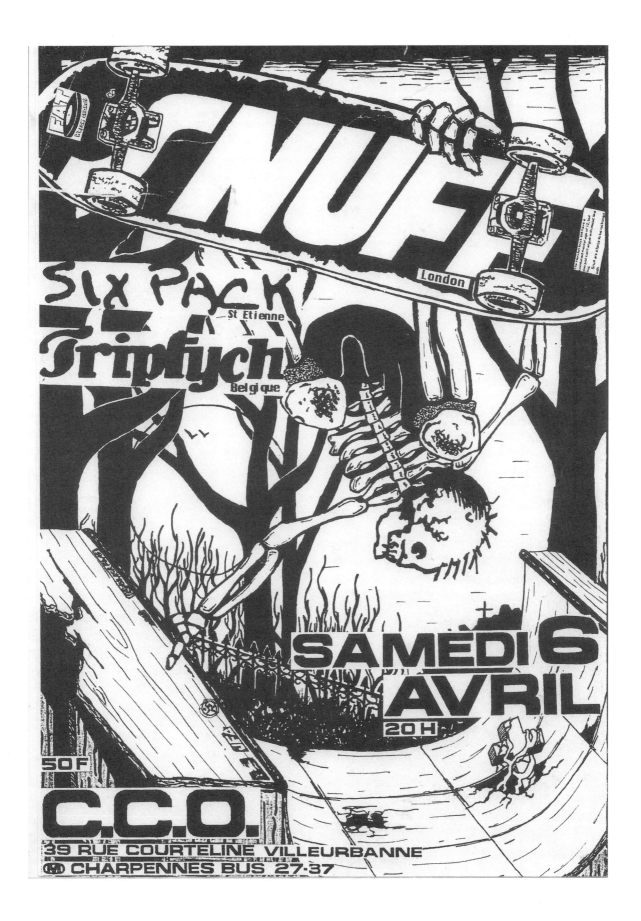

Snuff, Six Pack, and Triptych at C.C.O. in Villeurbanne, France, provided by Rémi Chaumat.

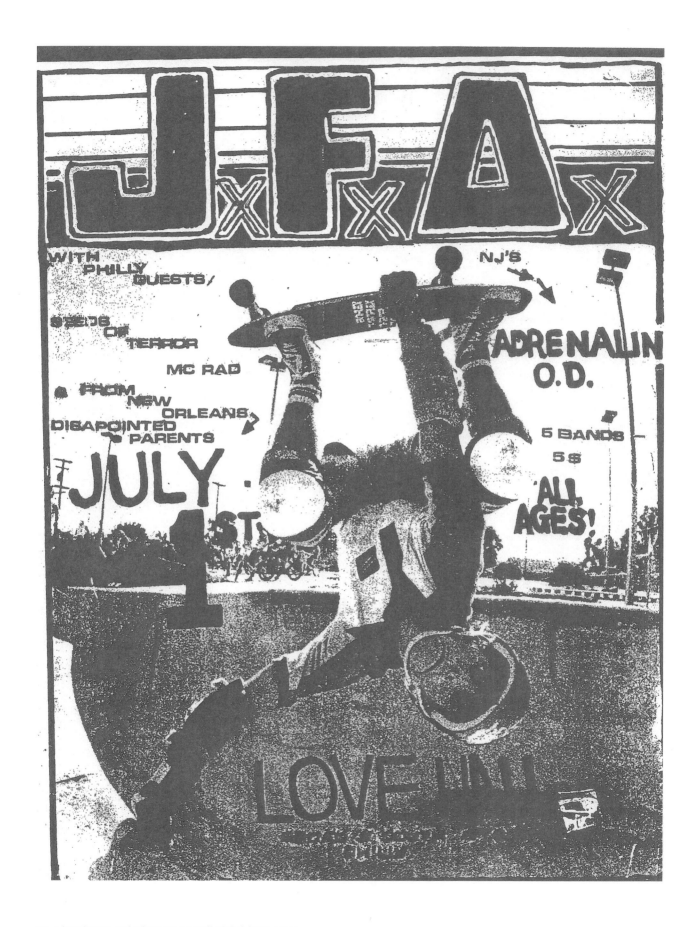

JFA, Adrenalin OD, and others at Love Hall, Philadelphia, 1980s.

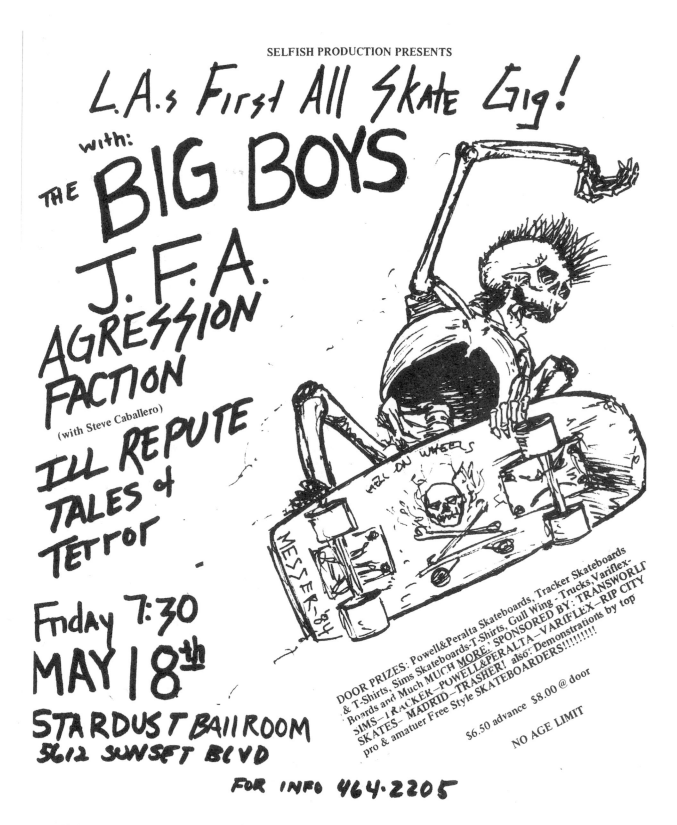

SELFISH PRODUCTION PRESENTS

L.A.s First All Skate Gig!

with:
THE BIG BOYS
J.F.A.
AGRESSION
FACTION
(with Steve Caballero)
ILL REPUTE
TALES of
Terror

Friday 7:30
MAY 18th
STARDUST BALLROOM
5612 SUNSET BLVD

FOR INFO 464·2205

DOOR PRIZES: Powell&Peralta Skateboards, Tracker Skateboards & T-Shirts, Sims Skateboards-T-Shirts, Gull Wing - Trucks, Variflex- Boards and Much MUCH MORE. SPONSORED BY: TRANSWORLD SIMS—TRACKER—POWELL&PERALTA—VARIFLEX—RIP CITY SKATES— MADRID—TRASHER! also: Demonstrations by top pro & amatuer Free Style SKATEBOARDERS!!!!!!!!!!

$6.50 advance $8.00 @ door

NO AGE LIMIT

TICKETS AVAILABE at TICKET MASTER, MUSIC PLUS, MAY Co, ALL SPORT MART STORES, VAL SURF-N. HOLLYWOOD-NORTHRIDGE WOODLAND HILLS, ZED-LONG BEACH, TOXIC SHOCK-POMONA, RECORD SHED-LAGUNA, VINYL FETISH-HOLLYWOOD, DISCOUNT- COASTA MESA, CAMEL-HUNINGTON BEACH, PEER-ANAHEIM, NEWPORT, SANTA MONICA, WHITE SLUG-SEAL BEACH

L.A.'s First Skate Gig with Big Boys, JFA, and others at the Stardust Ballroom, Los Angeles, 1984, by Messer.

Conclusion

Though posters advertising Creedence Clearwater Revival and Jimi Hendrix were made in the era of Vietnam napalm episodes, the War on Poverty, and burning American cities, they resemble European painters like Toulouse Lautrec and Alphonse Mucha, whose designs set in motion everything from lamp posts to book covers in the late 1800s. One never saw the brutality of the era in most psychedelic posters' heavily stylized thick lines, flat areas of color, and fancy type. Punk flyer graphics were a leap forward from flower power to artful aggression, like a first grasp of the "future now"—the fall of Saigon, mass murder in Cambodia, horrendous strife in Africa, revolution and hostage taking in Iran, and the Soviet invasion of Afghanistan. Punk chose not to escape, fold inward, or ignore these events. When something sinister was in the radar, like death squads and vivisection, punk graphics were often the bullhorn.

One difference now is that kids do not need to enter their own town, get deep in the streets, seize space, create DIY media on the skin of the city, and actually rub elbows with people. Mike Magrann, singer/guitarist for Channel 3, explained this "that was then/this is now" conundrum to me:

> It's hard to explain the whole ritualistic process that used to go into show promotion—especially in these MySpace cut and copy days! Since there was no mass media just waiting to devour any new information ya fed it, we really had to go out and target that audience, usually in the flesh. . . . The use of exacto knives, rubber cement, the trip to Kinko's—all a lost art I'm afraid! And then there was the distribution of the flyers, hitting the local record stores and hangouts, shuffling up the stacks of flyers by the door to make sure yours ended up on top! Of course, when you came back by the

store a day later your flyers were now on the bottom of the stack, or worse, in the trash already! When it came to actual street action, the staple gun was the weapon of choice. To this day, if you look closely at any telephone pole lining Hollywood Blvd they resemble some mutant strain of cacti, sprouting rust colored needles up to the reach of an eighteen-year-old bassist! My least favorite method of distribution was manning the gauntlet outside someone else's gig. Oh, the humiliation of having some fifteen-year-old punkette take one of the offered flyers, take one look at it, inform you that your band still sucks, and then dropping it to the ground as if it were a diseased pigeon. It's no wonder bands today (us included) make digital flyers, post them online, and with a click of the mouse send out to 5,000 spam folders. But then, what are these things? Virtual works of art, a mixture of ones and zeroes? They don't really exist, do they? I'd challenge any young band to click print, and then go and hand the flyer to the next kid coming out for a smoke! (2007)

Jan Roehik, a *Trust* fanzine writer and gig promoter, reminded me that the new generation takes a hybrid approach:

> I still rely on the good old-fashioned flyers and posters I make myself and send to 15 people around Frankfurt so that they hang the flyers in local bars and clubs. Maybe that's not useful at all, but it gives me as the "promoter" of the gig a good feeling that I gave my best in advertising the show. Plus the usual Internet message boards, newsletters. You can't say Print is Dead, or only Online Lives. The "thirty and over" people see that there is less print promotion, therefore think all is online, but that's not true. I say, "The younger the concert promoter, the more the concert promotion goes online." And

even that is not true. Everyone (if 15 or 45 years old) likes to take a print poster or flyer back home as a nice memory! Nobody will print out web-listings of gigs and hang them on their wall. (2008)

Digital flyer art may seem risk-free and defanged to a degree. Meanwhile, the living, not-so-secret punk flyer legacy not only maps out the metaphorical terrain of skate punk culture but also documents the participation of gay and lesbian, African American, female, and Hispanic punks. In doing so, this book hopefully proves that the tenacity of DIY punk street artists, the vivid flyers endlessly copied, and the multicultural gamut of punk will not easily disappear nor should they be restricted to the dustbins of history. To attend a noisy punk show and make a black-and-white copy machine flyer with nothing but tape, glue, and a pair of scissors may be a Dada-meets-punk cliché, but I would rather look back in defiance at the not-so-secret history of our still unfolding punk legacy, surrounded by the very real people who made it all happen, than depend on the whims of armchair philosophers—so-called wise academics—to tell me what happened, who was there, and why it happened. Instead, examine the flyers, listen to the witnesses, read the fanzines, and feel the flux and fury of the electric folklore, all over again.

Afterword

Beat Heart Beat: A Look at the Art of Randy "Biscuit" Turner

Bona fide maverick Randy "Biscuit" Turner was a gay Texas singer, self-taught artist, actor, and prop decorator whose life even inspired Mayor Will Wynne of Austin to declare October 8, 2006, in honor of the man that writer Jeff Derringer has dubbed "the original poster child for the slogan 'Keep Austin Weird.'" Turner's career, often overlooked outside the Lone Star state, spanned the era of cosmic cowboy mid-1970s Austin, which he loathed, favoring hard psych rock and funk, and the burgeoning new music scene of the late 1970s to the 2000s, when the new music scene splintered into factions ranging from cowpunk and hardcore to suave indie rock and rootsy traditionalism. Along the way, he took cues from former volatile art punks like Exene Cervenka from Los Angeles, various avant-garde art movements that dared to violate conventions and norms, and the keen mishmash style of local poster makers. In doing so, he forged a genuine, homegrown East Texas surrealism that spoke volumes about being a true outsider. As maker of so-called marginal art, he never fit the frustrating clichés that tend to brand homosexuality, punk rock, and the Lone Star state.

Biscuit churned out hundreds of fliers for his bands—including the Big Boys, Cargo Cult,

No one knows where you come from or knows your name, so you decide to step into the limelight and shine like a berserk disco ball. Suddenly, like Benjamin Franklin's press on fire, the world becomes inundated with your blitzkrieg media rampage of flyers and poster art. I do these missives to make your beanie propeller spin in no wind, laugh energy being used like a solar panel to power the absurd! I wish to see your eyes twirl like kaleidoscopic pinwheels like those wagon wheels on TV that spin backwards.

—RANDY "BISCUIT" TURNER

Swine King, and the Texas Biscuit Bombs—like he was throwing candy-coated 8.5" x 11" dreams in the wind, ready-made to get caught on flypaper the color of rainbow Lifesavers. His work ethic was obsessive-compulsive. On any given night, he could be found straddling humming Xerox machines down the street from his humble home, or working on collages in his spotless kitchen counter with oddball bits of toys, sparkle, glue, and scissors until dusk would blink over the blue bottle tree in his side yard and the Vespa leaning lazily out back. His works on paper, which reflect a strong portion of his collection, melded raw, cartoonish, childlike naiveté with an acute eye for 1970s Parliament/Funkadelic records (bold splashes of color, organic wavy lines, loose hand-written script), edge culture–infused skate art trends (turning rebel sports into rebel aesthetics), "found art" dioramas not unlike Mexican folk art, and slash-and-burn punk rock bravado that turned disposable everyday visuals—magazine layouts, postcards, and travel images—into bursting bricolage that freeze-framed pop culture, infusing it at times with a kind of brightness that mirrored the fuzzy glow of highlighter pens.

Until the moment he died in 2005, he was introducing his newfangled "Battleship Texas" skateboard to *Thrasher* (the Big Boys were the first punk band to have an official skateboard created for them, by local Dallas maker Zorlac) and yearning to be featured in *Juxtapoz*. He free-lanced for free as well. Being a Luddite of sorts, he continued to cut and paste posters by hand for bands he never even met, sending them works by regular mail. Unlike the morbid decay and apocalypse of illustrators like Pushead, the dark humor and nihilism of Raymond Pettibon, or the iconic leather-and-chain skull figures of Shawn Kerri, Turner's fliers evoke bombastic, feverish, squirmy, and irreverent Do-It-Yourself qualities, even if scrambled or imperfect. That was his vision of punk, for he did not revel in the stereotyped gory underbelly or compressed narratives of alienation.

Biscuit's fliers can be like an event unfolding in front of a viewer's eyes. They nurse a kinetic spirit, as if they are a referendum on having fun. Like traditional handmade "instant art," they mimic the notion of being spontaneous, urgent, and primitive, yet are zealously detailed and controlled, and exhibit a kind of *horror vacui*. As in many flyers no space seems untouched. Biscuit reminded *Artcore* fanzine: "Flyer art and posters are now a big musical business. I enjoy seeing wonderful offset press production runs, but I think I enjoy homemade, Do-It-Yourself at a copy center better. So much of the new posters all look the same to me. Boring. I'm not saying mine's any better, I just wish I saw more of what I enjoy!" (qtd. in Welly 2004).

So-called crudeness is ideal, for it represents the human touch that evokes a subconscious nod to art history (from Dada to puncturing Pop to supermarket comics of all stripes), the lurid underground flavor and ethos of R. Crumb, Rat Fink, and others, and the cheap and accessible copy-machine wit and rebellion of off-the-cuff punk xerography. All these elements retain potency in an era when flier art has become increasingly mechanized, watered-down, homogenized, neutered, and diluted. The Internet social sites teeming with small Adobe Illustrator manufactured virtual flyers cannot compete with markers and pens any more than they can with brushstrokes and torn and melded paper collages.

In his last interview, Biscuit described his early childhood experience with art to the *Austin Chronicle*: "I remember my third-grade art teacher looked me right in the eye and told me I had promise as an artist. I guess even at that time I saw things a little different than everyone else. Then in sixth grade I had a wonderful art teacher who took me under her wing and encouraged the heck out of me. So, believe it or not, while growing up in a little, 4,000-person town I had some

incredible encouragement by artistic adults who were trapped in that ugly little nightmare of a school system, but were very, very good at what they did" (qtd. in Savlov 2005).

Exene Cervenka, singer of the Los Angeles band X, was a longtime friend who often stopped by his house on tour and would join him in scavenger hunts at the disheveled, humidity-caked, last-call Goodwill thrift store near Austin's airport, where Biscuit would toss piles of dirty, banged-up dolls and Gatorade colored muumuus into his plastic cart. She referred to Biscuit's house as the best gallery in Austin. Yet, due to plain, old-fashioned modesty, Biscuit always made sure that people understood that he did not make art in a cultural vacuum, for he revered local poster artists like Guy Juke, Kerry Awn, Steve Marsh, and Gilbert Shelton.

Biscuit lived in a house literally stuffed with assemblage pieces: eye-gobbling, wonky-colored, silly, chaotic, and poetic plastic-tassel art that really defines his kinesthetic genius: until his last pain-wracked days, he was a computer-shunning, mostly self-taught "whacky" art rambler who believed in the poetry of human goofiness, or the surprise intelligence buried in the mess heap of pop detritus. Like an outsider artist edging toward a market, his last show was supposed to be in the side room of a video rental shop. With an ironic jab, he always joked about the art education of one of the other Big Boys. At the time I met him he had sold only a handful of pieces, and if I remember correctly, he ended up getting most of those pieces back. The week of his death, he was featured on the front cover of the *Austin Chronicle*. In fact, the issue was left on his front walk, just yards from his body, which lay indoors for four days. The reporter, who had worked on the article for weeks, finally discovered an open door and alerted authorities. After his death, a gallery auction of Biscuit's work, including many that once decorated the walls of his house, netted over $10,000 (the seminal Texas indie film director Richard Linklater supposedly purchased ten), which went to his mother, who he deeply loved without question. He also had a bountiful collection of black panther TV lights, Japanese toy robots, miniature metal airplanes, boxes of posters ranging from the 1970s concert hall Armadillo World Headquarters to Emo's, and other intense pop culture ephemera (including, surprisingly, an original Big Boys reel-to-reel studio master) that he hoarded from flea markets and discount stores over the years. It was a kitsch version of heaven, and he was the master of ceremonies, the curator of curiosity.

Notes

Chapter One

1. In folklore this tendency is dubbed *polygenesis*, in which multiple geographical and cultural areas give rise to the same related phenomena.

2. Punk flyer antecedents may also include the illicit production and iconography of woodcut printed cards from four hundred years ago; the anti-Nazi "modernist" woodcuts of Gerd Arntz; the work of Frans Masereel, beloved "wordless novelist" and Flemish painter; the expressionistic woodcut maker Albert Hahn; the Edgar Allen Poe book illustrations by Arthur Rackham; and finally the art of Washington state native and communist Richard Correll, whose woodcuts graced the weekly *Voice of Action*.

3. Jon Savage argues:

Punk announced itself as a portent with its polysemy of elements drawn from the history of youth culture, sexual fetish wear, urban decay, and extremist politics. Taken together, these elements had no conscious meaning but they spoke of many new things: urban primitivism; the breakdown of confidence in a common language; the availability of cheap, second-hand clothes; the fractured nature of perception in an accelerating, media-saturated society; the wish to offer up the body as a jumble of meanings. (1991: 230)

4. In a February 1997 interview in *Punk Planet*, he acknowledges aiming to create a "dialectic of punk." Using another emic/insider perspective, most evidenced by a picture on the front cover of the book featuring a live photo of Slaughter and the Dogs (whose song became the basis of his book title), with Homes's face circled in order to highlight his close-to-the-ground personal history, he borrows an overall template from a book on genre theory in film, parodies "jive" journalism of his time, including "groovy Neil Marcus," and surveys his favorite records and bands, all while mounting interesting propositions.

5. Later in Homes's book, he opines that there are no such things as punk bands, just punk records, which are indeed just novelties, even trivial: "Punk itself is best understood as a dialectical interplay between the notions of novelty and genre" (1997). However, he does note that Johnny Rotten's voice is too "expressive" for mere novelty.

He opposes the work of culture elites like Savage, which he wants to "overthrow," especially when they "shore up their theory by appropriating punk rock" (1997). Likewise, in 2003, Captain Sensible of the Damned informed me:

I identified with the working class side of it, being of that persuasion myself. There is a debate going on between the two sides of the historic aspect of punk, whether it was like the bands themselves that invented this phenomena, or whether it was Malcolm, Jamie Reid, and Bernie Rhodes, the kind of university types who were pulling the strings, which is led by Jon Savage's *England's Dreaming*, which is a ripe load of shit if you ask me. I much prefer Johnny Rotten's *No Irish, No Blacks, No Dogs*.

In that text, Johnny Rotten openly admits: "We didn't sit around and wax Situationist philosophy. Never . . . They were too structured for my liking, word games and no work. Plus they were French, so fuck them. Mind games for the muddled classes" (Lydon and Zimmerman 1994: 202).

Stewart also insists that the concepts of punk genres vary and change over time. Lastly, in the same chapter he explores the dialectical interplay between notions of the authentic and counterfeit, suggesting that Greil Marcus exposes his own "class prejudice and petit-bourgeois values" when promoting or supporting university bands like Gang of Four and Au Pairs (1997). The whole style and methodology is rendered with wry intelligence, especially when he later argues that punk was simply "sound and fury, signifying nothing . . . just a lot of confusion and chaos with various individuals working at cross-purposes" (1997).

6. Jon Savage takes a fairly typical line: early punk wasn't proletarian; it was an art movement, like an English version of (Andy Warhol's) Factory. In fact, comparisons were made between punk activities and the European avant-garde of the 1920s. Andrew Czezowski saw his innovative club the Roxy (which launched Wire, the Vibrators, and Slaughter and the Dogs) as a contemporary Cabaret Voltaire—the centre of Dadaist events around 1917 (Marcus 1989: 197).

7. Bodies, clothing, and makeup become modes of interrogation, a resolute reimagining of signifiers. Van M.

Cagle reminds readers in his book *Reconstructing Pop/ Subculture*:

> Traditional objects such as safety pins (innocence) and garbage bags (dirt) were worn in a contemptible manner. Likewise, makeup was worn to be seen, not applied to fabricate a natural look. Clothes lifted from pornography, like bondage gear, were worn openly, an act that publicly announced the most "depraved" of private desires; Even more dangerously, punk "signs" could be imprinted onto the flesh, as when Sid Vicious and Iggy Pop cut themselves with bottles on stage, hence creating a tantalizing byproduct, a punk rock art strategy that was increasingly masochistic, anarchic, and erotic. (1995)

In many ways, these punk forerunners triggered Bakhtin's idea of the carnivalesque, which emphasizes bodily excess and grotesque pleasures (comic debasements that both mock and subvert), and the use of profanity, vulgarity, and degradation to overturn social hierarchies. Still, clothing and scars alone did not make one a punk. "The English made [punk] into a sort of carnival, counterfeit type of thing," Joey Ramone once told *Flipside*, suggesting that such tendencies were not aligned with punk's original values (qtd. in Matsumoto 1988).

8. Writers have protested the use of such terms as "carnivalesque" and tried to debunk the concept, in articles such as John Goshert's "'Punk' after the Pistols: American Music, Economics, and Politics in the 1980s and 1990s," which posits: "the use of carnivalesque symptoms, for instance, in contemporary commercialized and sanitized punk images of the Sex Pistols and other 'alternative' groups, either to confirm or deny punk's political potential, is already a misplaced focus. Those images can only be used, whether as subversive or reactionary, as recuperative of a commercial system that punk would disrupt at its very foundations" (2001). One could argue that punk did recuperate part of the music industry, but it also spawned an alternative economy of underground labels, zines, and businesses and a long-lasting trading network (such as flyers and "bootleg" cassette tapes, especially of rarities and live show recordings) as well, not to mention a surrogate postal service used by touring bands and fans who hand-delivered items to separate scenes.

9. Songs like "Have Fun" by Gang Green and "Don't Forget the Fun" by German hardcore punks the Spermbirds come to mind as well. Such humor was even essential to the Pistols, who announced: "We're not stars.

That's ridiculous. . . . We're in this for total fun. It'll be a good thing if we destroy all the hype and bullshit that rules this fucking music business. . . . We're the nicest bunch of guys you'd ever want to meet" (qtd. in Goldstein 1978: 148). Years later, this same sentiment was reiterated by Paul Westerberg, singer of the Replacements, who insisted to a *Creem* writer that "punk was amateurism, for yourself, for fun" (Holdship 2007: 235). Joey Shithead from DOA echoed such sensibilities in the documentary *Punk's Not Dead*, telling the camera, "we did it for fun." Joey Ramone reminded *Flipside*: "We're a fun band. But life isn't just all fun" (Dynner 2006, qtd. in Matsumoto 1988). Robert Newman, in an overview of Seattle gig posters, suggests that a duality between fun and rebellion was vital to the underground music scene (Chantry 1985: 5). Billy Childish has suggested that humor-drenched Dada may have foreshadowed the approach of punk too: "Kurt Schwitters said, The artist creates, the critic bleats. He always had a great sense of humor, which he brought to his art, and he never took himself seriously—that's punk rock" (qtd. in Vale 2001). Yet, as Ian MacKaye stressed to me, perhaps the punk rock ethos is concerned not with fun but happiness:

> There was a point when I felt that punk rock was all these people yelling about making life better, and part of what I thought making life better was about was being happy. I thought if you really wanted to reach that, then you should not just fight to be happy, but actually start allowing yourself to be happy. This is not a trivial thing. I'm not talking about having fun. Fuck fun. I'm not interested in fun. I'm talking about when people are fighting for happiness, or fighting to be free. (2000)

Chapter Two

1. In addition, Elizabeth Grosz writes that the corpse represents "the very border between life and death, it shifts this limit into the heart of life itself," representing a final form of expulsion from the social body (1989: 75).

2 including the GoToHells, Hell's Engine, Hellfire Trigger, Hellbender, Hell City Kings, Hellshock, Fearless Iranians From Hell, the Hellriders, the Earth Hell Band, Hello Hell, Nocturnal Hell, Hellstomper, Miguel Hell and the Bombshells, Women from Hell, Pioneers of Hell, Living Hell (production company), Hellnation (band and zine), *Hellbound* (zine), Hellbound Hayride, Hellations, Hell No, *Hellbent*

(zine), *Hell's Torture* (zine), Crusty Hells, Hellhouse, Hellburger, Hell in a Handbasket, Helldriver, This is Hell, Hellcats, Hellwitch, Hell Hue, Hell Krusher, Hell Upside Down, Hellbillys, Hellbilly Hellcats, Hellfire, Helltunes (label), the Alcoholic Helltones, Hellride, Death Hell Battle Tank, Hellcats from Outer Space, Hellchild, Straight to Hell, the Exhumed from Hell, Cocktail Waitresses from Hell, Squirrels From Hell, Elves from Hell, Hell in a Handbasket, Hellhinkel, Hellmen, Mean Guys From Hell, Hyper as Hell, Hellocaust, Hellshock, Hellcows, Hellbastard, Hellbender, Hell's Kitchen, Traipse to Hell, Hell Bastard, Hell Moppers, Hell Yeah, Hell Yeah Bowlers, Hell on Earth, *Raising Hell* (zine), See You in Hell, Rancid Hell Spawn, Badasses from Hell, Heavy Hell, Hell in Hell, Cows from Hell, Flowering Ralph and the Badasses from Hell, and Hell-Bastard.

3. As in these names, such as the Devils, Red Devils, Devil Dogs, Evil Devil, Dare Dare Devil, Go-Devils, 27 Devils Joking, Folk Devils, She-Devils, Silver Tongued Devil, Devil's Elbow, Lexington Devils, Bwana Devils, Devil Doll, *Devil in the Dishes* (zine), Devil in Miss Jones, Murder City Devils, The Chintz Devils, Ikadevil, The Krontjog Devils, Dust Devils, Devil's Inn, *Toilet Devil* (zine), Lexicon Devil, The Tazmanian Devils, *Demon* (zine), Checkered Demon, Satan's Penis, Sinister Sisters of Satan, Satanburger, Satan Panonski, Agents of Satan, Big Satan Inc., Boxcar Satan, Satanic Malfunctions, Satan's Monastery, Satan's Pimp (label), Satanic Surfers, Satan's Old Lady, Satanic Republicans, Satan's Cheerleaders, Satan's Bake Sale, Satan's Antiseptic Tricycles, and Satan Viking Hyenas from Hadeas. Plus, Lucifer Wong.

4. Human Sewage, Fecal Corpse, Corpse Fucks Corpse, Tattooed Corpse, *Corpse Ripper* (zine), Our Corpse Destroyed, The Corpse, Skate Korpse, Maggot, Rancid, Rancid Vat, Rancid Remains, Peace Corpse, Floating Corpse, Charred Remains, Cradle of Filth, Sound of Corpses Rotting, Sticky Filth, Filth, Bloodied Bacteria, *Bacteria of Decay* (zine), Bacteria Flyers (flyer service), Stench of Corpse, Peace Corpse, Corpus Vile, Rotting Corpses, Maggot Fodder, Tumor Circus, Maggot Sandwich, the Maggots, Maggot, Abnormal Growth, Rotting Dead, Angel Rot, Crotch Rot, Body Rot, Rotten Fux, Rot in Hell, Rotten to the Core, the Rotters, Rotten Boils, Rotten Piece, Order of Decay, I Am Bacteria . . . I Am Filth, Savor of Filth, Crimson Corpse (a label), Rot, Mind Rot, Exhumed, Gang Green, Utter Stench, Excrement of War, Noxious, Rigor Mortis, Peace Corpse, Ripping Corpse, Aus Rotten, Rothead, Rot Shit, Septic

Death, Septic Tumor, Filth, UK Decay, *Urban Decay* (zine), State of Decay, Chronic Decay, Social Decay, Mental Decay, and Suburban Decay.

5. 100 Demons, 45 Grave, Gravediggers, Unholy Grave, Flaming Demonics, the Demonics, Demon System 13, Gargoyles, Coffin Break, American Werewolves, Black Vampire, Vampire Lezbos, Wolfman and the Nards, Skulldiggers, The Skulls, The Grim, The Evil, Evil Conduct, Evil Substitute, Evil Mothers, Frontier of Evil, Something Evil, Evil Bird (Records), Evil Army, Evil Sister, Sheer Terror, Daily Terror, Cry of Terror, Vermin Poets, Vermin from Venus, Terror Cake, Mortal Terror, Sick Terror, Stress of Terror, Civil Terror, Waking Terror, Balance of Terror, *Terror Pop* (zine), *Terror Skate* (zine), Excruciating Terror, Epileptic Terror Attack, Tommy and the Terrors, Konsum Terror, Extreme Noise Terror, the Holy Terror, Reign of Terror, Cold Blood Terror, Terrorgruppe, Nine Shocks Terror, Guillotine Terror, Appalachian Terror Unit, Pitch Black, Prime Evil, Chaotic Evil, the Ghouls, Ghoul, the Ghoulies, Ghoul Squad, Grave Robbers, Groovie Ghoulies, Blood Moon Howlers, Doom, *Doomsday* (zine), Legion of Doom, Thulsa Doom, Voice of Doom, Tigers of Doom, Prophecy of Doom, *Scrolls of Doom* (zine). Plus, one should not miss variations of the Horror, Horror (distributor), Horror Planet, Horror Vacui, Horror Plant, and the Horrorpops.

6. Necromancy, Necrotomy, Nekromantix, Necracedia, Necrophilism (also the songs "Necrology" by the Flower Leopards, "Necrophilia" by GBH, the ad for "a necrobestial nightmare" by the band Barnyard Ballers, or the album *Necrophiliac Hits* by Ingron Hutlos). In addition, a list could include Corpse Molestation, Millions of Dead Girls (not a MDC lineup), Bhopal Stiffs, Lucky Stiffs, Rabid Fetus, Exhumed, Scattered Bodies, Dead but Unburied, Rise from the Dead, The Undead, Dead Elvis, Dead Boys (and their former name Frankenstein), Dead Cobains, Dead Kennedys, Dead Bodies Everywhere, Tattooed Corpse, Fecal Corpse, Circle of Dead Children, and 149 Dead Marines.

7. Dead and Gone, Dead Zone, Dead Man's Shadow, Deathside, Already Dead, Dead by Dawn, Over My Dead Body, Saturday is Dead, Death Piggy, Born/Dead, Death Head (Productions), Black Death, Death Trap, Dead to Fall, Death to Tyrants, Deadscene, Dead City Rebels, Dead C, Dead Squash, Dead City Psychos, Death Toll, World Burns to Death, Bury Your Dead, Death is Your Language, Brain Dead, Dead After School, Crib Death, Death From Above 1979, Deadlock, Corporate Death, Bang You're Dead, Dead Season, Deadbodieseverywhere, Deathcharge, Dead Fink, Death's Head Quartet, Nuclear

Death Terror, Deathcheck, Deathcore, Death in the Family, Dead Squad, Ninja Death Squad, *Ben is Dead* (zine), Dead Drunk, Play Dead, Appalachian Death Ride, Death Ride 69, Hands of Death, Deads Eds, Asbestos Death, Deaf not Dead, Circus of Death, Dead Herring, Dead Aim, Blue Screen of Death, Deadverse, Dead Pawns, Melodic Death, Young Death, Dead Airbourne Goats, Dead Unknown, *They Won't Stay Dead* (zine), Thrash Til Death, Dead Kids Records, All Bets on Death, Dead Martyr Society, Dead Hand, Messiah Death, Dead Lazio's Place, Dead Swans, Dead and Bloated, Black Angel's Death Song, Dead Inside, Death Culture, Recipients of Death, Death Breath (label), Corporate Death Burger, Dead Lazlo's Place, Dead Flowers, Death Patrol, One Death Two, *Score of Dead Youth* (Fanzine), Dead Horse, Deadcats, Dead Nude, Deadbeats, Deadzibel, Dead Man's Choir, the Dead Youth, Dead Alive (label), Some Kind of Weird Dead Thing, Death of Marat, the Naked and the Dead, Death Valley (label), the Death of Her Money, the Five Deadly Venoms, 666 Dead, Deadseraphim, Dead Boys Can't Fly, Liquid Death (label), *Deathly Impalement* (zine), Kiss Me Deadly, Dead Uncles, the Star Death, Dead Surf Kiss, *Dead at Birth* (zine), Dead Allison, Bored to Death, Deadweight, Deathcore, Bass Drum of Death, Taiwan Deth, Death Penalty, Mass Death, Death Warmed Over, Better Dead than Red, Deadwind, Dead Jacksons, Death by Crimpers, Dead Sam Club, Dead Men's Theory, Deadly Weapons, I'd Rather be Dead, Death Planet Commandos, Label Me Dead, Dead Sheriff, *Dead Ones Review* (zine), the Horrible Death Sensations, Dead Seasons, Deathsquad, Deadskins, Face Death, Suburban Death Machine, Electric Deads, Dead Tank Records (label), Dead Section, Deathless, Dead Wrong, Deadly Right, Dead Zone (zine), *Dead Clown* (zine), Florida = Death, Dead Pledge, Dead Planet, Dead Moon, Born Dead Icons, Death X Death, *Death to the World* (zine), Dead Letter Auction, Dead Pedestrians, Dead Soil, Dear Diary I Seem To Be Dead, Death Comet Crew, Dead Kaspar Hausers, Blue Eyed Boy Minister Death, Dead Milkmen, Another Dead Juliet, Death Row, Nuns on Death Row, Dead Beats, Death Wish Kids, Death Folk, Death by Milkfloat, Fuck Me Dead, Dead Heroes, Glorious Death, Death Shall Rise, the Working Dead, the Bobby Death Band, *Easy Death* (zine), Almighty Lumberjacks of Death, Conquest for Death, Death Mickies, Left for Dead, Process is Dead, *Death Imagery* (zine), Dead Farmers, Dead End (both band and zine), Dead End Guys, Dead End Dragstrip, Dead End Boys, Dead End Famous, A Death Between Seasons, Book of Dead Names, Deathtopia,

Superman is Dead, Deadly Ground, Dead Pits, Dead Set, Dead Nittels, Dead Cats, Dead Beat (record label), Dead Beat (band), Dead to Fall, Choke their Rivers with Our Dead, Dead Ends, Death After Death, Over My Dead Body, The Dead River, The Dead Ones, Dead After School, Deathcamp, Dead Stop, Nuclear Death, Societic Death Slaughter, Instant Death, Death Warned Over, Dead Memento, Dead Joe, Dead Man Walking, Dead Stoolpigeon, the Deadites, Happy Death, Killed by Death (record label), Deadfall, Death Trip, Death Watch, Deathcage, Deathskulls, Dead Friends, Dead to Me, Dead Eddie and the Commonwealth, Steel Tigers of Death, George Is Dead, Dead Poetic, Deathtoll, Aerobic Death, Found Dead Hanging, Dead Inside, Dead Betties, You're Dead, Blessed are the Dead, Death Skulls, Day of the Dead, Dead Cop (zine), Dead Celebrities, the Boy You Hit is Dead, Dead Roses, Dead Steelmill, Dead or Alive (production company), Death Side, Death of Anna Karina, Dead Red Sea, Dead Fish, *Smell of Dead Fish* (zine), Dead Serious, Union of the Dead, Three Days Dead (label), Dead Pig (label), *Dead in the Dirt* (zine), Dead in the Water, *Deadjournal* (zine), Death Side, Death Midget, Kiss of Death (label), A Death for Every Sin, Near Death Experience, Death Squad, Dead Nation, Wanted Dead, All the Dead Pilots, Dead Empty, Death Puppies, DeadWishKids, Deathrest, Radio Dead Ones, *Barbie's Dead* (zine), *Reagan Death* (zine), *Sparked in the Dead Eye* (zine), *Brain Death* (zine), Death Sentence, Dead Silence, Little Deaths, Crimson Death, Deathbag, Scholastic Deth, Near Death, Death Before Dishonor, Christian Death, Death of Glory, 1Death2, Death of Gods, Death Before Disco, Dead End Cruisers, Drop Dead, *We Have the Deathray!* (zine), Dead Tech 3, the Dead Space, Dead Relatives, Deathspeak, Dead America, Deathreat, Death Toll, *Deadfuck Commando* (zine), Slow Death, My Dad is Dead, Dead Heir, Deadzibel!, Dead Vaynes, Certain Death, Cleveland Bound Death Sentence, Deathro Skull, Suburban Death Machine, Death Warrant, Death Midgets, Death Records (record label), Civil Death, Gastuck Systematic Death, Quick and the Dead, Death and the Compass, Death By Stereo, Deathrats, and Death First.

8. Flesheaters, Venom P Stinger, Venom Godflesh, Mutants, Sex Mutants, Beach Mutants, Los Mutantes, the Fiends, More Fiends, the Monsters, Hollywood Monsters, Monster X, Man Made Monsters, Monster Squad, Mad Monster Party, Die Monster Die!, Monster Truck Driver, Monster Zero, I Monster, Pussy Monsters, *Here Be Monsters* (zine), *Closet Monster* (zine), 3-D Monster/s, Scary Monsters, the Monster That Terrorized

the World!, Yard Monster, Munster (record label), More Fiends, Fiendz, the 4 Fiends, Septic Sawblades, Bloodsucking Creeps, Flesh Eating Creeps, Bloodsucking Freaks, Toxic Waste, Toxic Reasons, Toxic Avengers, Psycho, Cosmic Psychos, American Psycho Band, *Total Gore* (fanzine), Temperamental Psychotics, Bloodsuckers from Outer Space.

9. Mummies, Zombie Squad, Concombre Zombie, Zombie Terrorist, Acid Zombies, Toxic Zombies, White Zombie, Zombie Toolshed, Zombi, Zombie Clergy, Zombie Dogs, Sabertooth Zombies, Bop Zombies, Zombie Zoo (club), Sewer Zombies, Ewok Zombies, Acid Zombies, Redneck Zombies, Zombilly, Zombie Mosh (Productions), *I Was a Teenage Zombie* (zine), and Astro Zombie.

10. Lethal Virus, Alien Virus, Intestinal Disease, *Psychedelic Disease* (zine), Legionaire's Disease, the Germs, Germbox, Germ Attack, Girl Germs, United Mutation, Cancer (zine and band), the Virus, Infect, Infest, the Parasites, Legion of Parasites, Global Parasite, Pestilence, Social Parasites, Virus Insurrection, Virus X, the Plague, Marching Plague, Violent Plague, Those Who Survived the Plague, Ebola, Cancerous Growth, Abcess, Malignance, Malignant Growth, and Malignant Tumor.

11. In this next phrase culled from Golub, I will substitute the phrase *punk flyers* for the word *Guernica*, referring to the intensely well-regarded Picasso painting of a bombed city during the Spanish War, not to equate the suffering of the population during the time of war to that of punks, but to examine the sense of aesthetics flyers represent as they address horror:

> Rhetorically, punk art might be viewed as vehicles for disseminating "news," as the visual metaphor of a newspaper, a super-photograph or comic strip. It is "read" urgently, and the viewer is assaulted by the tumult and violence—the crowded, sensual, discordant and primitive ordering of ideas. Thus (like instances of the impact of exceptional news) a "punk flyer" or a "punk cover" is stridently eloquent, tensely insistent on the reality of the events portrayed, utilizing the "news" to gain immediacy to re-enact the totality of the event as news. (Gumpert and Rifkin 1984: 29)

When interviewed by *Maximumrocknroll* in 1983 and asked about his "gory" or "horrific" graphics, flyer artist and illustrator Pushead proposed that, "if you want someone to remember something, let them remember in horror. The #1 thing to control people in the world is 'Fear,' and no one has conquered that" (#8).

Chapter Five

1. In the aftermath of prepackaged corporate punk, the style of "queer edge," referring to straight-edge hardcore punk made by gay men, and "queercore," a similar strain of hardcore by gay men who do not identify with the straight-edge lifestyle, have seemingly reclaimed the hardcore punk genre. Traditional hardcore punk sometimes reveals a masculine and homophobic narrative that seems to contrast the lore of punk being a music produced by and for marginalized outsiders and rebels. Early 1980s bands like the Meatmen and Angry Samoans might represent these tendencies in hardcore punk. In contrast, straight-edge bands like Youth of Today offered so-called positive portrayals of hyper-masculinity in songs like "Youth Crew" and "Standing Hard" that seem implicitly queer-oriented to some observers. Lately, hardcore punk gays and allies have contested homophobia by poaching the style and content of the genre, even the gig spaces. They sometimes reveal the latent homosocial/homosexual orientation of hardcore rituals, texts, and fan participation as well, which links current bands like Black Fag, Limp Wrist, and Knifed to punk and hardcore's first wave of "out" gays from the 1970s and 1980s, including the Dicks, Big Boys, and Wayne County.

The roots of the term *punk* have often been delineated as a term for a prostitute and later as prison slang to denote a man (sometimes referred to as black) being on the receiving end of a sex act. To place the term more directly in relation to punk, one can look to author Brendan Mullen, who, when asked if Jim Morrison of the Doors was a punk, told *3 A.M.* web zine:

> I'm sure Morrison was the kind of guy who would have insisted a punk was somebody who got butt-fucked in jail—a person coerced into receptive sodomy for protection of life and limb. . . . What's your archetype? Casting a punk as a sniveling Sid-style brat with a loutish attitude? A wormish petty criminal straight out of *Dirty Harry*? Or, according to Webster's, someone regarded as "inexperienced or insignificant"? Is a punk also a bit of an anarcho-intellectual leftist type with an unresolved Oedipal Complex, or is it someone who gets forearm-fucked in jail? (qtd. in Ruland 2002)

Punk has a similar long history with queer culture, attests Matt Wobensmith, founder of *Outpunk* zine, since "gay music and punk have been synonymous since the 1970s"

(qtd. in Schalit 2001: 320). In turn, writer Caroline Croon even suggests that punk was the first culture in which trans-sexuality was a "nearly realized fact of life" (qtd. in Robinson 1978: 8-H). To evaluate punk, in part, is to evaluate the queering of the genre, something entirely missing from a cultural studies analysis provided by the likes of Dick Hebdige, who focused on the signifying style of punk and the frozen cultural dialectic between white and black youth.

Chapter Six

1. During the heyday of the late 1970s and early 1980s, women rippled throughout punk music underground, including no less than [with much help from Jenny Woolworth's archive]: the Motels, Pearl Harbor and the Explosions, Grrls, the Dogs, the Babylons, Radios, Dickbrains, Absentees, Enemy, Bohemia, Accident, Bush Tetras, the Contractions, 30 Second Flash, Accident, UXA, the Reactors, Theoretical Girls, the Erasers, the Static, Ut, Mars, Venus and the Razor Blades, the Sillies, Venus and the Flytraps, The Punts, Voodoo Shoes, the Rentz, Castration Squad, the Visitors, Meyce, Fur Bible, Boneheads, Interpol, the Black Dolls, Debbies, Inflatable Boy, the Clams, the Debs, the Thrills, Cherry Vanilla, the Varve, Snatch, the Fuckettes, Beast, the Silencers, Shreader, VS, Lubricants, Ella and the Blacks, Modern Physics, the Thrills, Nervus Rex, X (Australia), the Shirts, Backstage Pass, Pink Section, Hostages, the Bloods, Bohemia, Bound and Gagged, Anonymous, Ama Dots, Beakers, Death Patrol, Beelzebub Youth, VKTMS, the Derailers (Houston), Legionnaire's Disease, Cliché, Mary Monday, the Lepers, Whoom Elements, Absentees, Stickmen with Rayguns, the Monsters, Waxx, the Visitors, Sexsick, AK-47, Rough Cut, God on Drugs, Toxic Shock, Eight-Eyed Spy, Beirut Stomp, Repellents, Heathens, Eyes, Pylon, the Foams, Fried Abortions, Morbid Opera, Cubes, Joy Ryder and Avis Davis, Chinas Comidas, Cardboards, Hans Brinker and the Dykes, Dress Up Like Natives, Ama-Dots, Kaos, Textones, Chickadiesels, Cancer Girls, Mad Society, Maggots, Klitz, Modernettes, Mary Monday and the Bitches, Burn Center, Unit 3, the Urge, Stickmen, Static, Destroy All Monsters, Red Cross, Nasty Facts, the Maps, Catholic Discipline, Cheap Perfume, Mood of Defiance, Standing Waves, Conflict (Arizona), the Wrecks, Even Worse, the Cubes, Raid, the Rats, Los Microwaves, Chi Pig, F Systems, and the Urge.

Canada's the Curse, the Demics, Restless Virgins, B Girls, Pantychrist, Tyranna, and Last Prayer.

France's the Lous, the Stinky Toys, Mathematiques Modernes, Anouschka Et Les Prives, the Questions, Ici Paris.

Japan's Friction, Sheena and the Rokkets.

Australia's Suicide Squad, X, Animals and Men, and the Systematics.

Switzerland's Liliput, Glueams, and Aboriginal Voices.

Germany's Aetztussis, Carambolage, Clinch, Hans-A-Plast, the Ace Cats, Nina Hagen, Malaria, NEU!, and the Stripes.

British envoys: the Partisans, Gynecologists, Fourth Reiche, Dolly Mixture, Gay Animals, Drug Addix, Derelicts, Head Cheese, Half Japanese, Big in Japan, Toxicomane, Aquila, Outsize Oddments, Performing Ferrets, Blitzkrieg Bop, Au Pairs, Ludus, Mekons, Sick Things, the Doll, the Fall, Rezillos/Revillos, Delta 5, Action Pact, Skeletal Family, Gymslips, Youth in Asia, Vital Disorders, Lost Patrol, Fatal Microbes, Altered Images, Celia and the Mutations, Cast Iron Fairies, Petticoats, Killjoys, Potential Threat, Crass, Chefs, A Certain Ratio, and Vice Squad.

For more, see www.jennywoolworth.ch/archive/archive_af.html.

By the mid- to late 1980s, 1990s, and 2000s, women continued to be core conceptual creators, helping to shape:

new wave, alt rock, roots pop, goth pop, glam rock, grunge, and post-punk: Cherry Bombz, Toto Coelo, Legal Weapon, Blood on the Saddle, Bananarama, L7, Gits, Lovedolls, Tex and the Horseheads, Super Heroines, 7 Year Bitch, Janitor Joe, Smut, Bulimia Banquet, Fondled, Superchunk, Hole, the Muffs, Buried in 69, The Bell Jar, Nymphs, Motel Shootout, Love Dolls, Screamin' Sirens, Silverfish, Delilah Jacks, Calamity Jane, Sircle of Soul, Bean, Papa Wheelie, Pandoras, Action Now, Amy Lamotta, the Direct Hits, the Didjits (L.A.), the Rage, Estrojet, Mad Monster Party;

political agitprop: A.P.P.L.E., Treason, Nausea, Anti-Schism, Jesus Chrust, Civilized Society, Insurgence, Godless, Spitboy, Instant Girl, Karma Sutra, Antisect, the Joyce McKinney Experience;

Riot grrrl and queercore agents: Bikini Kill (who inspired the cover band Pussywhipped), Sleater-Kinney, Tribe 8, Lucy Stoners, Womyn of Destruction, Third Sex, Team Dresch, the Frumpies, Mecca Normal, Slant 6, Sta-Prest, Sue P. Fox, Jenny Toomey, Autoclave, Jack Off Jill, Raooul, Nomy Lamm, Excuse 17, Oiler, Canopy, Third Sex, Cheesecake, CWA (Cunts with Attitude), Tattle Tale, Growing Up Skipper, the Need, Team Dresch, Fifth Column, Bangs, Free Kitten, the Quails, the PeeChees, and Bratmobile, among others already mentioned.

Europeans:

Yugoslavia: Tozibabe;

Poland: Post Regiment;

Hungary: Aurora Clakaco, Riziko Fucktor;

Finland: Terapia, Thee Ultra Bimboos, Irstas;

Denmark: Gorilla Angreb;

Switzerland: Chin Chin;

Sweden: Doughnuts, the Upskirts, International Noise Conspiracy, Vicious Irene, and recently Masshysteri and Mary's Kids;

Netherlands: Bambix, Indirekt, Sexy Dex, the Ex, Nog Wott;

Austria: No Oppression;

Mexico: Melodic Death, XYX;

Turkey: Spinners;

Spain: Pleasure Fuckers, Solex, Electric Garden, Killer Barbies, Los Democratas, Pretty Luck Fuck, Gargamboig;

Great Britain: Smart Pills, Pussycat Trash, Thee Headcoattees, X-Men, the Earls of Suave, Slingbacks, Potential Threat, Rubella Ballet, Diaboliks, Spectreman, Empress of Fur, Del Monas, Go-Kart 800s, North 7 Superslot, One by One, Sacrilege, Pink Kross, Prolapse, Fuzzbox, Huggy Bear, Kenickie, Shop Assistants, Mambo Taxi, Holly Skinned Teen, Holly Golightly, Helen Love, Pussycat Trash, the Phantom Pregnancies, Linus, Shelley's Children, Budget Girls, Sister George, Voodoo Queens, Boyracer, Bugeyed, Health Hazard, Pussycat Thrash/Red Monkey, the Fight, Dan, plus younger bands such as Suicide Milkshake, Chaps, Pens, Trash Kit, Sceptres;

Ireland: Pink Turds in Space, Paranoid Visions;

Czech Republic: Cul De Sac;

Italy: Piolines, Not Moving, Brazen, Klase Kriminale, Gas;

Germany: Hans-A-Plast, Malaria, Träsh Torten Combo, Gee Strings, Stattmatratzen, Heimatglück, B-Bang Cider, Troublekid, Petticoat Government, Barefootgirls, Beware of the Cat, Razorquills, Sugar Crash, Tittenbonus, Kamikaze Queens, Seduce, Feast of Friends, Stage Bottles (early lineup), Hawi Madels, Jingo De Lunch, the Vageenas, Mars Moles, the Venusshells, Shityri;

Sweden: Free Love Society, Scarlet Drop, International Noise Conspiracy, Doughnuts, and younger bands such as Masshysteri;

Belgium: Sin Alley, Rothead, Reiziger;

France: Pin Prick, Heyoka, and newer bands like La Fraction, Attentat Sonore;

AND

Australia: Lawnsmell, Screamfeeder, Magic Dirt, Cherry Black, the Heroines, Circle Pit, Elijah;

New Zealand: Jonestown Olympics;

Asia: Hang on the Box, Nonstop Body, Red Bacteria Vacuum, Lolita No. 18;

Argentina: Sentimento Incontrolable, Cadaveres, Penadas Por La Ley, Pasto A Las Fieras, Las Hijas Del Misterio, Comando Suicida;

Brazil: No Rest.

Japan: Shonen Knife, Last Bomb, Melt Banana, Pappys, 5.6.7.8.'s, Union, Detroit, Gomess, Cigaretteman, Kyah, Tonight, Beardsley, Bleach, Comes, Freaks, Sekiri, Romantic Gorilla, Titan Go King's, Lolita No. 18, Routettes, G-Zet;

USA:

The New York City and state school: Honeymoon Killers, Live Skull, No Thanks, Nilla, Ultra 5, Snuka, Scum Goddess, Swamp Goblins, The Meneaters, Trick Babys, Times Square, Killer Kowalskis, the 99s, The Devotchkas, New York Loose, Boss Hog, the Goons, Freaks, Fuzztones, Youth Gone Mad (formerly of L.A.), the Wives, Da Willys, Band of Susans, Scab, Sorry, Ugh, Stallions, White Man's Grave, Stisism, the Service, Raunchettes, Hissyfits, White Zombie, Fur, Bad Popes, Voluptuous Horror of Karen Black, Gossamer, Screaming Females, A Day for Honey, Kicking Giant, Lunachicks, Sister's Grim, Shrieking Violets, and younger bands such as Zombie Dogs and I Object!;

New Jersey: Stormshadow, Dahlia Seed, Sand in the Face, the Skabs, Children in Adult Jails, Gut Bank, Sexpod, Killer Instinct, S. Process;

Midwest: Bhang Revival, Babes in Toyland, HSR, the Blue Up!, L-Seven, the Hellcats, Budget Girls, Pet UFO, Wise Decision, the Letterbombs, Algebra Suicide, Dissent, Musical Suicide, Barbie Army, Headnoise, Smears, Scrawl, the Beautys, Despondent Youth, Heike's Baby, Tyrades, Plague, Tem Eyos Ki, RVA 6-01, Repellents, Teen Idols, the Cynics, IMIJ, Wanda Chrome and the Leather Pharoahs, the Strike, Inept, Naked Aggression, Brainiac, Selby Tigers, Ereshkigal, 8 Bark, the Chicken Hawks, the Scissor Girls, Lazy, Bang Bang!, the Soviettes, Mouse Rocket, Manhandlers, Facefuck, Miss May '66, O-Matic, Nashville Pussy, Vivians, The Heathers, Busy Signals, Deer Attack, These Magnificent Tapeworms, Von Bondies, Paybacks, Gore Gore Girls, Demolition Doll Rods, Kitten Forever, Lost Sounds, Daylight Robbery, Condenada;

Florida: Mutley Chix, Target Practice, Squat, Wanksister, NDolphin, Ovarydose, Crustaceans, I

Love a Parade, Reina Aveja, Baskervilles, Backwash, Gunk, Discount, Condenada, Dollyrots, This is My Fist, Brethren;

Colorado: Anti-Scrunti Faction, the Hectics;

Connecticut: Kitty Badass, Mankind?, Bedroom Rehab Corporation;

Nevada: Sentiment, Loadstar;

Oklahoma: Woodpussy;

Oregon: Rancid Vat, Alcoholics Unanimous, Scapegoat, the Tribe, the Lookers, Cadallaca, Heartless Martin, Dead Moon, Adickdid, Gift, Comrade Bane, Destroy All Blondes, Godless, the Epoxies, Defect Defect, New York Rifles, Gift, All Girl Summer Fun Band, Happy Bastards, CeBe Barns Band, Lebenden Toten, the Obliterated, Bog People, Funhouse Strippers, Magic Johnson, Berserk;

California: Impending Doom, Leaving Trains (early lineup), Twisted Roots, Swa, Flesheaters, Peace Corpse, Raszebra, Red Aunts, Creamers, Texas Terri, Paper Tulips, Forbidden Beat, Rizzo, Scabs, Bitzy Bop, Girl Jesus, Snap-Her, F. Defective, Super Pussy, Daisy Chainsaw, Tyranny of Structure, Outside Inside, Riot Act, Supercharger, Paxston Quiggly, Women from Hell, Spent Idols, Toilets, Ramonas/Sheenas, Rainbows End, Arlan's Army, the Caltransvestites, Lutefisk, Best Revenge, Super Heroines, Geko, Rejected Motherfuckers, White Trash Debutantes, the Dread, Foxations, Tongue, Cockfight, Third Grade Teacher, I Monster, (Impatient) Youth, Peer Pressure, the Penny Dreadfuls, Sluts for Hire, Ms. 45, Tilt, Retching Red, Applicators, Distillers, the Web, Crotchet, the Shitbirds, Suckdolls, Bobsled, Black Fork, the Skirts, Generator, Holy Water, Groovie Ghoulies, Bimbo Toolshed, Butt Trumpet, Skunk Drunk, Betty Blowtorch, Mini-Skirt Mob, Sister Goddamn, Sugarfreaks, Borax, X-It, the Count Backwards, Henry's Dress, Pink Fuzz, Red 5, Sick F*cks, Zero Hour, Blister, Methadone Cocktail, Dos, Skull Control, Cockfight, Blue Bonnets, Frosted, Divisia, Butt Trumpet, 4 Gazm, Gargoyles, Smut Peddlers, Trillion Stars, the Chubbies , Patsy, Half Empty, Jack Acid, the Darlings, Longstocking, Ballgagger, Mack, Clouds, Snack Cake, the Bleach Hags, Ida, Belrays, Screaming Bloody Marys, Media Children, the Tantrums, Red #9, Dick Circus, Cameltoe, Snort, Guillotine, the Dread, All or Nothing, Rebels and Infidels, Sister Double Happiness, Bad Posture, Tanks, Kamala and the Karnivores, Sta-prest, Ragady Anne, Vicious Ginks, Bitch Fight, SF Flowers, Hammerlock, Bourbon Deluxe, Stepford Five, Squint, Weenie Roast, Honeymooners, Jack Killed Jill, Wrecks, the Lies, the Angoras, Gargoyles, Halo Friendlies, Lisa and Her Slaves, Loudmouths, Clown Alley, Burning Witches,

Gruk, Bruise Violet, Fabulous Disaster, the Clarke Nova, the Pomeranians, Short Dogs Grow, and younger bands like Rocket, the Checkers, Go Betty Go, Sputterdoll, Brilliant Colors, Black Fork, Surrender, Street Eaters, Abrupt, Oilers, MDC (1992–93 line-up);

Boston area: White Women, Dangerous Birds, Uzi, Feminine Protection, Victory at Sea, Last Stand, Astroslut, Disarray;

Pennsylvania: Suburban Wives Club, Pink Daffodils, Last Cry, Wormhole, Thorazine, 2.5 Children, Combat Crisis;

Virginia: Unseen Force, Four Walls Falling;

South Carolina: Negative Reaction, Deboning Method;

North Carolina: Inept, Blue Green Gods, Superchunk, Milemarker;

Philadelphia: Delta 72, Dr. Bob's Nightmare;

Washington, D.C.: Slant 6, Broken Siren, Fire Party, Motor Morons, Holy Rollers, the Make-Up, Chalk Circle, Urban Verbs, Slickee Boys, Red C, Dove, Madhouse, Nuclear Crayons, the Deceats, Hate from Ignorance, the Nurses, Tru Fax, Insaniacs, Jawbox, Cupid Car Club, Skull Control, Tiny Desk Unit, the Warmers, Mourning Glories, Cold Cold Hearts, D. Ceats, the Shirkers, the Points, Deathrats;

New Mexico: the Drags, Liar, Psychodrama, Rondelles, Eyeliners, Elephant;

Arizona: the Peeps, Hell on Wheels, Burning Bush;

Washington: Dickless, Excuse 17, Melvins, Teen Angels, 66 Saints, Not My Son, Black Its, Buttersprites, Gloryholes, Belle Jar, the Statics, Boycott, Rotten Apples, the Need, the Fakes, the Pet Stains, Unwound, Kill Sybil, RVIVR;

Detroit: the Paybacks, Brood, Demolition Doll Rods, Laughing Hyenas, Dark Carnival, Gore Gore Girls, the Fondas, Detroit Cobras, the Bobbyteens;

Colorado: Nine Twenty Nine;

Maryland: Girl Bites Girl, Moss Icon;

Arkansas: the Gossip

Louisiana: Necro Hippies, Deny It, Crackbox, New Bloods, Firebrand;

Texas: Swine King, New Girl Art Trend Band, Limacon, Helldorado, Inhalants, Hormones, Pain Teens, Faceless Werewolves, Tokyo Nites, Dirty Sweets, 1,4,5's, the Applicators, Inhalants, Sincola, Kiss Offs, Sparkle Motion, Teen Titans, Pork, The Hates (one line-up) Poopiehead, Finally Punk, Girl in a Coma, London Girl, Gun Crazy, Magnetic Four, Sugar Shack, Lucky Motors, Zipperneck, Manhole, Japanic, Junior Varsity, Kimonos, the Gigis, the Alcoholic Helltones;

Georgia: B-52s, Skull, Doll Squad, Snatch, Yum Yum Tree, Catfight;

Canada: Unwarranted Trust, Industrial Waste Band, Boom Shanka, P.O.S., Third Sex, Chicken Milk, Obnoxious Race, Cub, the Chitz, MAOW, Insult to Injury, Pussy Monsters, Glory Stompers, the Systematics, General Fools, 30 Second Motion Picture, the Monarchs, Submission Hold, Nu Sensae, Sweet Nothings, and Smear.

2. Including Roberta Bayley (Elvis Costello, the Clash, Richard Hell, and the Ramones, including their debut LP), C.A. Vaneria (*The Boston Years: The Music Scene in Photographs, 1979–1986*), Naomi Petersen (Scream, SST Records), Erica Echenberg (*Sniffin' Glue* and *Punk Lives*), Carol Segal (*Punk Lives*), Christine Boarts (*Slug and Lettuce*), Ann Summa (*The Beautiful and the Damned*, Laurie Holland (DOA/*Royal Police*), Kate Simon (the Clash, Patti Smith), Pennie Smith (Clash, Elvis Costello), Bev Davies (*Subhumans*/Incorrect Thoughts; DOA), Ruby Ray (*Search and Destroy, RE/Search*), Anette Weatherman (The Roxy), Leslie Wimmer (Double O), Annette Green (Wire), Elisa Graff (Bad Brains), Stacy Weiss (Carsickness), Laura Levine, Lisa Haun (the Clash at Bonds), Yuka Fujii (UK Subs/*Tomorrow's Girls*), Debbie Schow, Kerry Colonna, Alice Wheeler (Gas Huffer), Mimi Baumann (Scream), Clarinda Wong (Flyboys), Sarah Hill (Samiam/*I Am*), Jenny Lens, Holly (Exploited/*Army Life*), Mim Michelove (Gang Green, Mighty Mighty Bosstones), Lori Shepler (Circle Jerks/ *Gig*), Alison Braun (Aggression/*Don't Be . . .* , *Channel 3*), Marla Rose (*Channel 3*), Ilisa Katz (Dag Nasty/*Can I Say*), Marcia Resnick (Bad Brains), Melanie Nissen (The Weirdos), Lynn Goldsmith (Patti Smith), Katie Babbin (Naked Raygun/*Home*), Wendi Lombardi, Greta Moon (Mudhoney/*You're Gone*), Catherine Ceresole, Carole Carstensen (The Dicks/*These People*), Dorothy Low (Bad Brains/*Quickness*), Liz Brinson (Onespot Fringehead/ *Farewell*), Monica Gesue (Slant 6/*What Kind . . .*), Diane Bergamasco (Mission of Burma),Wild Sandy (The Cramps), Sarah Woodell (Bad Brains), Leslie Clague (Bad Brains), Lisa Sherman (Bad Brains), Sybil (Party Owls/ *Why Drag it Out?*), Tiffany Pruit (Faith/*Subject to Change* and split LP with Void), Kim Gregg (Faith/*Subject to Change*), Sandy Tennyson (Final Conflict/*Ashes to Ashes*), Susan Dynner, Rebekah Youngman (Vertebrats), Elena Gialamas (The Cynics/*Blue Train Station*), Julie Entropy, Jennifer (Minutemen/*Tour Spiel*), Amy Pickering, Lorraine Jones (Toy Dolls/*10 Years . . .*), Cynthia Connely (*Banned in DC*), Liz Goodman, Susie J. Horgan (*Punk Love*), Anne Ulrich (*Trust*), Heather Mull (Anti-Flag/*A New . . .*), Kristine Nyborg (Nerve Agents), Jennifer Cobb (Jawbreaker), Jessica Humphrey (Nerve Agents), Monica Sigona (Nerve Agents), Anne Brown (Nerve Agents), Patricia Anderson (Hot Water Music/ *Finding . . .*), Alyssa Tanchajja, among many others.

3. The infamous Los Angeles clubs the Roxy and Whiskey were, according to Kereakes, 100 percent run by women (Bag 2005). The Underground in Morgantown, West Virginia, home of the Th' Inbred, was owned and operated by Marsha Baber, a fellow traveler of Abbie Hoffman; a woman booked punk shows at Jagged Sky in San Antonio during the early 1980s; Siouxsie C co-booked shows at Portland Underground; and Dody DiSanto cofounded the 9:30 Club in Washington D.C. In Oklahoma, Michelle Martin booked punk shows at the Jailhouse in Norman, while older scenester Ms. Queenie Taylor ran the Old Waldorf in San Francisco. Michelle Myers, whose career stretched back to the 1960s, booked bands at the clubs Music Machine, the Whisky a Go Go, and Madame Wong's in Los Angeles.

Genya Ravan produced the Dead Boys' *Young, Loud and Snotty*; Nicole Panter managed the Germs and helped release the Avenger's EP "The American in Me"; Suzy Shaw still runs the *Bomp* zine archives and record label, while the label Frontier was started by *Bomp* employee and contributor Lisa Fancher, who released albums by the Adolescents, TSOL, and Suicidal Tendencies. In addition, much of Frontier's early artwork (Adolescents, Circle Jerks) was conceived by Diane Zincavage, who also created record sleeves for Channel 3, China White, and Flyboys as well. Other flyer/poster artists and album illustrators include Betsy Van B (Fidelity Jones), Gee Vaucher (Crass, Tackhead), Rachel Sengers (Marginal Man/*Double Image*), Kandy Stern (Youth Brigade/*Sound and Fury* first pressing), Rose Harrison (Siouxsie/ *Kaleidoscope*), Dana F. Smith (*PEACE* compilation), Kathy Whitney (Subhumans/*Pissed Off . . .*), Conny Jude (The Jam/*This is the Modern World*), along with art designers Linder Sterling (Buzzcocks/*Orgasm Addict* magazine/ *Real Life*), Jane Higgins (Mudhoney/ *You're Gone*), Cynthia Connolly (Dischord), Laura Costas (*Government Issue*), Joyce Woods (DOA/ *Bloodied . . .*), Olga Gerrard (*Rat Music for Rat People*), Tina Simmons (GBH/*City Baby . . .*), Helena Rogers (posters for the Rats), Lisa Anne D. (posters for Swa), Rene Flores (the Generators/ *Excess . . .*), Lisa Sutton (Wipers/*Best of . . .*) Ellie Hughes (Naked Raygun/*Understand?*, Bad Brains/ *Quickness*), Myrna Harvey (SNFU/*If You Swear . . .*), and Sue Dubois (*New Wave* compilation on Vertigo).

Andi Ostrowe and was the road manager for Patti Smith, Karen Bemis managed Naked Raygun, while

Debbie Gordon managed the Dicks. Gabriella Lopez produced Painted Willie, Michelle Garvik produced DOA's *The Dawning . . .* compilation, while Laura Croteau and Stacey Cloud were executive producers for Rapid Cat records, including the Offenders' seminal Texas hardcore album *Endless Struggle* (1985). Such female participation reached far beyond the American scene as well. Antonio Cecchi, guitarist for Cheetah Chrome Motherfuckers, stressed *to Maximumrocknroll* that women in the 1980s Italian scene didn't necessarily play in bands but were active in all other areas, especially the squat movement (Lester 1986).

The origins of Frontier, as Lisa Fancher tells it:

Besides working in a shitty suburban record store called Licorice Pizza, I spent post-high school life working at Bomp Records (all props go to Greg and Suzy Shaw, who were my saviors). Working for an indie label meant I knew all the various steps to putting out records, and even distribution, it didn't occur to me to do it myself initially because Greg was so on top of the local scene as evidenced by the Weirdos, Zeros, and Devo. I got paid very sporadically because *they* got paid very sporadically so sometimes I would get a paycheck for $1500! Of course that might have been for two and a half months, don't be too impressed! Besides my crummy fanzine, *Biff!Bang!Pow!* I also wrote for the *LA Herald Examiner* and made a few bucks reviewing cool touring/local bands or picking on clay pigeons like Styx and Pat Benatar (My boss was Ken Tucker, who's now the "TV guy" at *Entertainment Weekly*).

In short, I was floating around with no particular aim or purpose in life other than buying records and going to shows. When I interviewed the Flyboys for the *Herald Examiner*, they said they had no label so I thought—what the heck, I could do that. Of course, I ran it by Greg to make sure I had his blessing. He wasn't that fired up about the punk scene by '79 so I decided to take the band in the studio. We recorded in the middle of the night at Leon Russell's Shelter studio in the San Fernando Valley. The engineer was Jim Mankey (Sparks, Concrete Blonde) and the producer was Scott Goddard, who had a couple songwriting credits on Dickies' earliest songs. (Johnette Napolitano answered the phone at Shelter!) Since I was paying those Jim and Scott under the table, the rate was fine and it was a seven song EP. When it was mixed, it didn't sound so great, but that wasn't the point—I was Cecilia B. DeMille! The Flyboys record

was started in mid-'79 and I finally released it in March of 1980. Naturally, the band broke up before it came out . . . If I had a lick of sense, I would have just chalked it up to experience and moved on. Since I had zero chance of being accepted into college and subsequently getting a "real" job, I just decided to stick with it. So . . . I didn't borrow money from anyone. I used my various paychecks if and when they came in! (2005)

4. This was offset by the tune "Big Women" by Anti Scrunti Faction, featuring punk women in the Rockies who sang "big women we got flabby thighs/ we're ugly in your eyes/no make up for disguise/we won't live your lies." This seemingly attacks not only the sexism of GBH but forcefully attacks the *whole notion* of the femme body of plastic perfection—the demure, inviolable, manicured, underweight, heavily maintained body.

Chapter Seven

1. Including at least: Cherry Vanilla, Verbal Abuse, the Eyes, the Odd Squad, the Next, Party Owls, the Rents, Catholic Discipline, the Faction, No Mercy, Beowulf, MDC, Naked Raygun, Final Conflict, the Vandals, Stalag 13, Narthex Structure, Mad Parade, Heart Attack, Agnostic Front, Cause for Alarm, Urgent Fury, Justice League, Thorn, Nausea, Chicano-Christ, Insted, Inside Out, Backlash, Struggle, the Warmers, and Shelter.

2. The Sex Pistols, who penned "Anarchy in the UK," did not play Los Angeles, but they did play San Francisco in 1978, and guitarist Steve Cook helped engineer some songs by the Avengers.

3. The song was also immortalized in a Los Angeles mural by Peter Quezada who incorporated the line, "She had to leave Los Angeles . . . ", yet he chose the figure of female singer Annabella Lwin, the singer of Britain's Bow Wow Wow, to typify the punk look of the era.

4. As Brian Qualls from the African American punk band the Warriors describes the vibe in the Kun article, there was a "Vex spirit," which Kun translates in the larger sense of, "punk was another word for unity." This mattered in a scene that soon splintered and stratified itself, but it also fills in where Craig Lee missed an opportunity to explore the other shades of punk, or provides some cultural space that filmmaker. The club, which Penelope Spheeris completely overlooks in *Decline of Western Civilization*, moved a few more times, reopening under new owners and operators after a mayhem-filled,

disastrous Black Flag gig at the original location, and its demise later on was seemingly sealed by rumors suggesting that a punk was shot in the head by a Chicano on the premise. Not long after, the club found itself short of money and soon closed its door after a "legendary" hardcore punk performance featuring the Circle Jerks and Adolescents playing a benefit for *Flipside* magazine.

5. An overview of that era and personalities has been published online at http://greaserama.com by one of the participants, Shaggy AKA PunkRod Todd, who described the gangs as Cliques with Names, since the gangs often evolved and revolved around bands. Here is a partial overview that he outlines, which paints a richer, and darker, picture of the scene that is often found in so-called punk histories:

> . . . T/C- THE CONNECTED . . . were a very diverse group . . . very into dressing "non-trendy" and took a lot of cholo style mixed with the punk—most of them were also skaters . . . their main bands I remember were the OZIEHAIRS, and a little later—Twisted Roots. These kids were always everywhere and were always getting their pictures taken (this was a big thing- to see yourself in a 'zine, paper, the news, or a "fer use" . . .)

> H.B.'s, which simply meant Huntington Beach. These guys followed TSOL and were usually middle class to rich beach kids who had a real pack mentality, prone to chicken shit style "jumps," and generally regarded by the older and Hollywood/LA folks as tourist assholes fucking things up for everyone.

> Mike Muir had THE MERCENARIES . . . It was decided STB and a few other cliques would unite under the mercenary banner to take care of the HB problem. After this loose "mercenary confederation" was formed it just wasn't the same for the beach punks up in Hollywood. At its peak there were a SHITLOAD of mercenaries. Mercenaries were identified by a pachuco cross drawn on the upper cheek with a sharpie or eye liner.

> Mercenary bands were: CIRCLE ONE, SUICIDAL TENDENCIES, CRANKSHAFT, etc. A sizeable chunk of mercenaries morphed into the massive SUICIDAL BOYS / V13 cliques.

> Another noticeable and notable punker gang at this time . . . was L.A.D.S. This stood for Los Angeles

> Death Squad. I can remember seeing "punk death squad" painted in the alleys in the neighborhood between the Starwood and Okidog . . . These initial LADS were stylish and charismatic dudes who were always out and got their pictures taken a lot. I remember seeing Alex and Louie, decked out at Okidogs, in matching LA Death Squad jackets (Eisenhower type jackets as cholos would wear, with iron-on "olde english" style lettering), black Dickies, creepers and/or winos.

> Death Squad also had arm bands with the skull and crossbones. Many also wore punk staples—leather jacket and engineer's boots with LOTS of chains, spurs, bandanas, and the all-important leather key ring thing. Death Squad were, I must grudgingly admit, the SNAPPIEST DRESSERS of the bunch. A few STB/MCP's became LADS.

> MCP (Mid-City Punx) were my clique—consisting of kids from Highland Park, Downtown, Echo Park, Atwater, Glendale, Hollywood, East LA and Monterey Park/ Montebello. We were close with Circle One people, Mike and Jim Muir, THE CHIEFS and lots of other Hollywood people, lots of East LA folks- like the STAINS. (2006)

6. In more recent years, Hispanics have been on the forefront of punk, including hardcore punk bands Los Crudos/Limp Wrist, Mundo Muerto, Union 13, Youth Against, Bread & Circuits, Struggle, Life's Halt, Manumission, Synod, Dogma Mundista, Subsistencia, and Huasipungo, the post-punk mutations of At the Drive-In/Mars Volta, the pop punk of Scared of Chaka, the fiercely political Anti-Product, Spokane's infamous garage roar gone glam the Makers, jokester super-band Manic Hispanic featuring an amalgam of punk personalities like Steve Soto (Adolescents) and Gabby (Cadillac Tramps). Also, Chicago produced Arma Contra Arma, MK Ultra, Sin Orden, Condenada, Tras De Nada, and Youth Against while longtime punker Derrick "Rick" Ponce's bands included Disrobe, Mob Action, and Rat Bastards; El Paso produced Wednesday and At the Drive-In; LA produced Kontra Attaque; while San Antonio has recently birthed polka-core (punk/polka hybrid) players Pinata Protest; and Portland produced Magic Johnson, a two-piece featuring Latin art kids from L.A. When a large city in Texas, like Houston, is dissected, one can see the continuous legacy of Hispanics in punk, including the Magnetic Four, Black Leather

Jesus, the Kimonos, Fenix TX, Flaming Hellcats, Vatos Locos, Will to Live, and many more, while national bands have thrived, like Ruido, Mas Ke Ruido, Bruise Violet, No Church on Sunday, Golpe De Estado, FISHHEAD, Thee Looters, No Mind Asylum, Peace Pill, Dehumanized, Butt Acne, Plain Agony, Eske, Ultratumbados, Peligro Social, Bloodcum, Peace Pill, and The Tumors.

Newer bands working with LA Raw Ponx thrive as well, including Rayos X, Kruel, Poliskitzo, and Tuberculosis.

Meanwhile, Mexican punk and hardcore bands from the last thirty years include no less than Sendero, Amichi Della Terra, Atoxxxico, Descontrol, Disolucion Social, Herejia, Histeria, Masacre 68, M.E.L.I., KKcore, Adictos Al Ruido, Libertad Para Todos, Cacofonia, Rebel D'Punk, Yaps, Rombecabezas, Energia/Defectuosos DF, Sindrome Del Punk, Sedicion, SS-20, Tortura Auditiva, Anarchus, Decadencia, Resistencia Entre El Poder, Anarchus, Hog, Asfixia, Anti-Gobierno, Heregia, Collectivo Kaotico, Ciudad Humeante, Especimen, Parche de Ira, Xenofobia, Putas Mierdas, Ratas Del Vaticano, and XYX.

Chapter Eight

1. In a more positive light, the notion of squat sites as places of contestation is outlined by the online magazine *Do or Die* in the article "Desire Is Speaking," in which the writer, describing squat life, once a staple of punk communities in the Netherlands from 1978–1984, reminds readers:

> . . . at the moment, when "neo-liberalism" is the only ideology and the market economy has colonized everything—even our genes—these practices show us possibilities for other ways of living, other economies, or even the end of the economy. There is an ongoing discussion about the necessity of creating an alternative economy that is less dependent on the mainstream market and the state. The Dutch VAK-group, for example—a federation of houses, studios, workplaces, companies, a farm and financial institutions—strives towards an alternative infrastructure based on anarchist ideas, such as local democracy and federation. By supplying financial means, skills, experiences and other services, new projects can be supported and existing projects can network. Another example of an alternative economic system is the flourishing LET- schemes, local exchange systems without money, based on trading skills. (Rhizomes: date unknown)

My own experience traveling through Europe on a punk poster tour in 2004 with the band Retisonic revealed a nuanced network of squats of varied political persuasions that featured bars, art galleries, band performance halls, bookstores, eateries, and childcare facilities, all operating on the margins of official business.

2. Another history of stencils is outlined by art critic Peter Walsh, who opines: "Street stencils . . . have a deep relationship to the systems of hobo symbols that operated during the nineteenth and early twentieth centuries . . . indicating information like 'be prepared to defend yourself,' 'you may sleep in a hayloft' or 'must work to eat' enabled the vagabonds hopping trains to communicate with each other without letting the police and other authorities in on the message" (1996). In the case of Crass, the stencils spoke not just to a secret society of punks avoiding the police, but they also spoke in raw and confrontational ways to police and parents as well. The politics of use—the control of a piece of environment—is not the sole conflict here. Language is as well. Again, Walsh typifies this larger core issue—the control of information:

> This controlling of information through the coding is played out daily in society at large. Scientist, doctors, and art critic . . . protect their turf by inventing jargon. Banks, governments, organized criminals, and military organizations protect their power bases by encrypting their secrets. Abstract artists protect their rarefied domain by imbedding esoteric historical information in their gestural languages. By replicated these power structures on a small scale . . . stencillers . . . like the hobos, highlight the presence of social class systems and point to the existence of information have and have-nots . . . We are left with the image of stencil practitioners, free to roam the city at will, but in actual practice held separately in ideological jail cells, tapping their secret messages back and forth. (1996)

3. In 2008, AK Press published a new book on Crass, *The Hippies Now Wear Black*, while the methods and purpose of Crass remain potent. For instance, on the popular web site Flickr, in which people can upload their own photos and join groups, the antiwar stencil group has no less than nine hundred members, featuring a

variety of images and text, including the logo of *Star Wars* poached and remade as "Stop Wars." Other stencils offer recycled hippie phrases such as Make Love Not War and common Gulf War I and II protest slogans such as "No More Oil for War." One particularly powerful image includes Uncle Sam from the WWI-era "I Want You for the U.S. Army" campaign art by James Flagg, with four million originally printed earlier last century, reimagined as "I Want You in Afghanistan." The once lionized iconic image is severely parodied, featuring a Pinocchio-sized nose and clown face. Even today, Crass' concept of the readymade stencil as graffiti alternative still empowers the latest era of war protestors. This is highlighted in part by a new generation of punk street taggers, such as the self-identifying "punk graffiti artist" Revolting Mass, who does both freehand and stenciling, from defacing beach signs to adding deep blue skulls with Mohawks on squat walls, while his posters pitch slogans like "9-11," "Babylon's Burning," "Fascists Racists and Haters of Refugees Follow Your Leader [blow your head off like Hitler]," and "Fuck the System Liberate Yourself" (http://www.ablazegraphics.co.uk: 2001). Hence, punk and graffiti have come full circle from the insurrectory acts of Crass to third-generation punk graffiti applied to London's skin by a generation hounded by the Anti-Social Behavioral Order, part of the 1998 Crime and Disorder Act codified into law, to tackle "anti-social behavior." Such punk "actions" can still be considered as a subculture's resistance to the state's willingness to legislate and curtail behavior that it deems provocative, alarming, and distressing.

4. Including, at the very least, the Black Flag graffiti logo and black bars on a white sheet backdrop on the videos for "Depression" and "Police Story," featuring Dez Cadena on vocals, from Target videos; the liner note photo of TSOL from *Dance With Me*; the back photo of Joan Jett's *Bad Reputation* album; the photo of Black Flag shot by Laura Levine for *Penthouse* article by Robert Palmer (featuring other bands' names like "Bad Brains" and "Stimulators"); the Don Rickles prime time sitcom *CPO Sharkley* from March 1978 features the Dickies playing in a room wounded with dizzying graffiti; shots of a young man spraying graffiti begin the video for Gun Club's 1983 performance of "The Lie" on Dutch TV; a *Flipside* #31 graphic for (Impatient) Youth features Strap on Dick Chris and friend slumped next to a door and wall, and Social Distortion playing live in front of their spray-painted name; myriad Ed Colver photographs (45 Grave in which the band name "Dead Kennedys" is

evident in a heap of graffiti; a 1979 shot of Stiv Bators, inundated by latrinalia; a shot of the Mau Maus found in *Hardcore California*, whose writer Craig Lee can be found in an opening photo behind a barred window, surrounded by graffiti; and three photos featured on the insert for the album *Youth Report*, a punk compilation, including shots of Shattered Faith, Channel 3, and Bad Religion); the logo for the film *Punk Rock Movie* by Don Letts; promo photo for the Dishrags circa 1980; a 1983 Spin blurb on MDC, featuring a shot of the band alongside their graffiti "No War No KKK No Fascist USA"; a Bob Gruen shot of Blondie featured in *Bomp*; famous photographs of the Dead Kennedys by f-stop Fitzgerald feature the band in hand-sprayed T-shirts emblazoned with shirts marked by the letter S, which is divided down the middle by each member's tie, thus forming symbols ($) for money; photographs of Barbara Kitson of the Thrills, later featured on the Bacchus Archive release "NAFLTC"; photographs by Ruby Ray featuring Sid Vicious in San Francisco, Sally Ray of the Mutants, and rockabilly Ray Campi, among others; a Ann Suma photograph of Middle Class, featuring the scrawled words "Slush," "Flopside" (or perhaps *Flipside*), and "Everybody Loves Somebody Be A . . ."; a photograph of Pleasant Gehman at Zero Zero in 1981 with the phrases "Visit Ohio," "Get Plasmatized," and "Happy Birthday Veronika"; Murray Bowles photographs of Really Red, Hüsker Dü, and Los Olvidados; a press photo of the Pagans from Cleveland, Ohio, featuring the band seated in front of a wall littered with rock 'n' roll posters and the huge scrawl "Pagan Mania!"; a *Flipside* issue #40 layout of an interview with the band Ribzy features a stark black and white reproduction of the band hanging on to a wall with band graffiti such as the Fuck-ups and Discharge; the Pariah album *Youths of Age* has the album title emblazoned in graffiti-style, located at the end of a line of punks and skins waiting alongside a brick wall; both Youth Brigade's versions of the *Sound and Fury* LP portray police intervening and harassing a punk spray-painting the band's logo on city walls; a savvy photo of Paul Westerberg in 1983 with the graffiti "Replacements suk" behind him; the Canadian band D.O.A. photographed in front of the heavily graffiti-scrawled Berlin Wall while on tour in 1984; Flipper's "Gone Fishin'" LP's inside label photograph of graffiti on the backside of a truck ("San Fran," "The Slug," "NYC"); mid-1980s photos from a cemetery in Ventura, California, showing band names such DOA, GBH, and WASP; the Washington D.C. punk band Scream photographed by

Tomas (Beefeater) in a graffiti-lined room for the *Bang on the Drum* album and "Walking by Myself" 7" single sleeve (1986); in *Punk Lives* #1 reporter Nevill Wiggins reveals, "During the winter of 1980, someone took a can of spray-paint to the wall of Hatton Cross tube station and daubed this dramatic legend: 'Theatre of Hate live on in your dreams and will kill you'"; the vinyl LP label for the Government Issue album *You*, featuring a photo of the band in front of the heavily tagged Berlin Wall, including the line "The Wall Will Fall"; lastly, a graffiti-tagged, upturned living room is featured in Suicidal Tendencies' "Possessed to Skate" video (1986). Images of tagging continue to thrive in punk art, as evidenced by the front cover for the 2004 release *Cruisin for a Bruisin* by the garage punk band The Bobbyteens, which features a band member spraying the band's logo on a red wall with white aerosol script, and more recent releases like a self-titled EP by Midlife Crisis, with their logo painted on a wall, and the *T4 Project*, which features an illustration of a punk tagging a wall.

5. In the zine, Zark attests, "The chances of our striking down the city posting law as unconstitutional in the state court are very good. If that happens, we will put the poster police and their money making scam out of business." Later, he describes this as "sweet revenge." In an attempt to help fund his efforts, punk bands like APPLE, the Radicts, the Dream Smashes, the Lie Detectors, and Masters of the Obvious held a benefit gig. In 1989, Zark reported to Charles Bernstein that he underwent three trials, and the city sought $22,000 in damages.

In contrast, over a period of two years, the city only fined the Roxy $200.00, though the club routinely plastered the city with posters. Zark was also supported by the rock 'n' roll critic Dave Marsh, who some say penned and popularized the term "punk." Soon, having quickly disseminated to bordering localities, the tactics were not confined to New York City. Zark recounts: "We've learned that in New Haven, Connecticut, and Kingston, New York, there are poster police modeled after the New York City poster police and they do nothing but the same thing. They run around and look for posters and then take the names off the posters and chase people down, use undercover tactics, threats, and intimidation to issue massive fines. This is complete cultural repression (qtd in Bernstein 1989).

Appeals for justice even came forth from Central Europe, highlighting the tension between individual expression, freedom of press, and state suppression: "At the time there was a strike going on in the shipyards of Poland and a petition was circulated and about 400 people signed it in Poland voicing their disapproval in the anti-postering law of New York City" (qtd. in Bernstein 1989).

Chapter Nine

1. Such interrogation of stereotypes leads to what Stuart Hall has described as "making stereotypes uninhabitable" in his lecture "Representation and Media" (1997). The discussion and assertion of a rich, complex, and nuanced black presence in punk rock "frays" both the assumptions about punk rock being centered in a fixed, natural, and normalized white presence, cemented through popular discourse, which in effect undervalues or negates all other cultures present in punk. My emphasis on reclaiming the roles of people of color in punk hopefully undermines fixed, normalized assumptions, rendering them unstable and arbitrary. This creates new potentials for meaning and modes of empowerment for a generation previously unaware of punk's diversity, which is revealed in my exchange with Cheetah Chrome from the Dead Boys:

Ensminger: As black music became grounded in hip hop, do punk bands keep the other legacy of black music—Chuck Berry and Little Richard—alive and well?

Cheetah Chrome: All of that "boring old fart" crap got taken too seriously, and bands got scared to play songs from the '50s unless they were by Eddie Cochran for some reason. Kids today don't have the reverence for artists like Berry and Little Richard—or Motown for that matter—that my generation did, and it's their loss. In the '60s, you'd hear Marvin Gaye and the Supremes in between the Beatles and Stones, black and white music on the same stations. After punk and rap, that don't happen anymore, and it should." (2010)

2. The Midwest garage punk band the Replacements covered "Maybelline" in 1981, while guitarist Billy Zoom "neatly wrenched" guitar lines from "Brown-Eyed Handsome Man" for the X tune "Year 1," according to writer Debra Rae Cohen. John Leland describes their overall music on the first album *Los Angeles* as a knotty, awkward, "Chunk Berried punk barrage" in a 1984 issue of *Trouser Press*; Johnny Thunder's band Gang War covered "Around and Around"; and even street punkers

Sham 69 began as a r&b cover band covering the likes of "Roll Over Beethoven"). In turn, the Ramones' mid-1990s documentary "We're Outta Here" features Richard Hell, former singer for mixed race band the Voidoids, exclaiming, "I think of them as kind of being the secret real Chuck Berry of the 1970s and 1980s. They made smash hit after smash hit, it's just that nobody bought them" (1997). In fact, when reviewing the Ramone's album *Subterranean Jungle*, one writer maintains that Johnny "proves he's as good a Chuck Berry disciple as the best of them" (Isler 1983: 37). Perhaps in homage, Chuck Berry's song "School Days" appears on the soundtrack to the Ramones-centered film *Rock 'n' Roll High School*. And when *Creem* magazine covered the Sex Pistols gig in Tulsa, Oklahoma, the writer enthused that singer Johnny Rotten "slithered behind his mike stand, stalking about in a hunch-backed Chuck Berry duck walk" (Goldskin 1978). Mikey Plague, front person for longtime NYC band Stisism, insisted to *Maximumrocknroll* that, "The true roots of Punk trace back to the 50s Jerry Lee Lewis, Chuck Berry" (qtd. in Wilkins 1996). When describing the overall music style of the Cramps, British writer Ian Johnston testified they were "always . . . more Chuck Berry than Alice Cooper" (1990: 82). In the early 1980s, *Penthouse* writer Robert Palmer argued Billy Zoom's (the guitarist from X) "ideas come from such rock fountainheads as Chuck Berry" (48), while recently in *Spray Paint the Walls* Tom Troccoli, Black Flag roadie and singer himself, claims the Sex Pistols reminded him of "Chuck Berry with Gary Glitter drums" (Chick 124). These plentiful testimonies indicate that black music seemingly shaped the roots of New York punk rock as well, or at least analogies to black music became part of the conscious language of writers attempting to describe the stripped down, back-to-basics style. Whether the discourse was accurate remains to be explored.

3. The Ramones covered the Ronettes' "Baby, I Love You" on *End of the Century*. Veronica Bennett/Ronnie Spector, in turn, covered their songs "Bye Bye Baby" and "She Talks to Rainbows" while also appearing on the Misfits' record *Project 1950*. She has also collaborated with Patti Smith and the Raveonettes recently.

4. The UK Subs are also likely the only band on either side of the Atlantic that shared bills with both Pure Hell and the Bad Brains, two pioneering all-black punk bands.

5. As Harper recalls: "Well, before the UK Subs I was in a band called the Subs a year before the UK Subs in 1976, and we were still playing a lot of Chuck Berry songs. The Sex Pistols even played Chuck Berry songs. We were by the bar and people were leaving the pub afterwards and they'd be singing "Stranglehold," and I turned to my mate and said, 'They're singing "Stranglehold," not "Johnny be Good" or "Roll Over Beethoven." They're singing our song.' I still remember (laughs) the chill running down my back thinking, they're singing our songs not these great standards. I thought, we're in with the chumps there. That's the way to go."

6. The Big Boys also covered "The Twist" by Chubby Checker. Because of the Big Boys cover, punk columnist Felix Havoc once wrote in *Maximumrocknroll* that Kool and the Gang "have had more interaction with true hardcore" than any newer school of post-hardcore bands like Braid, the Get Up Kids, and Promise Ring (#185: 1998).

7. Including Death, the Cheifs, the Idols/London Cowboys, Germs, Richard Hell and the Voidoids, the Crowd (black drummer Barry Cuda, first line-up), Snuky Tate (backed by the Mutants), Dead Kennedys, Demob (United Kingdom), UK Decay (United Kingdom), S.C.U.M. (Canada), the Shades, Plasmatics, Basement Five, Bad Brains, Controllers, Whipping Boy, Y-DI, JFA, Sharon Tate's Baby (Chicago), Secret Hate, WHY, Los Olvidados, Special Forces, Urban Waste, Dag Nasty, the Warriors, Burn Center, Scream, Enzymes, Void, Dove, McRad, Mutley Chix, Red C, Psychotics, Snot, the Pagans (Austin), Mad Society, Sadistic Exploits, the Kravens, Homo Picnic, the Fix, Vale of Tears, Eye for an Eye, Fire Party, Psychotics, Meatmen, Beefeater, Madhouse, Swiz, Dove, Kingface, Neon Christ, The Stupids (United Kingdom), Men with No I.Q.'s, Hot Spit Dancers, Stillborn Christians, Lost Cause, Zero-Defex, Underdog, Earth Army, Tread, Street Vengeance, Oxbow, Necromatx, Sweetbelly Freakdown, Trenchmouth, Down by Law, That's It, Tribe 8, Cheater, Tuff Nutz, Chloe, Burn/Orange 9MM, IMIJ, Gories, Oxblood, the Templars, and later bands like Yaphet Kotto, Franklin, Darlington, Zen Guerrilla, Kill Sadie, Christiansen, Thorazine, Blacktop, Safehouse, Canderia, New Bloods, Pretty Girls Make Graves, Deny It, This Month in Black History, the Jewws, and versions of Fear, Hickoids, Blast, Suicidal Tendencies, and Joykiller.

Works Cited

A.C. "Zany Guys/Harvet/Dicks at C.V.II." *United Underground*, July 1985.

Agent Orange. "Interview with Agent Orange." *Band Age* #2 (1987).

Agnew, Tony. Excerpt from "From Frontier to Eternity: A Talk with Frontier Records' Lisa Fancher." By David Ensminger. *Left of the Dial* #8 (2004).

Alba, Steve. "Where Do I Start?" n.d. http://www.salbaland.com/powerflex.html.

Alexander. "Interview with Jack Grisham." *Loud Fast Rules*, 2006.

Alloway, Lawrence. *Lichtenstein*. New York: Abbeville, 1983.

Anderson, Aaron. "Positively 4th St.: Raunch Records." *Slug Magazine*, February 2006. Accessed 30 December 2007. http://www.slugmag.com/article.php?id=484&PHPSESSID=06b85c00c08eb6d37\3e3e69e75c26352.

Anderson, Mark, and Mark Jenkins. *Dance of Days: Two Decades of Punk in the Nation's Capital*. New York: Soft Skull Press, 2001.

Angel, Jen. Column. *Maximumrocknroll* #172, September 1997.

Angel, Johnny. "Slam Dance Down Memory Lane." *Raygun*, October 1993.

Anonymous. Letter to the Editor. *Flipside* #41 (1984).

Anthony, Mark. "Letter to the Editor." *Maximumrocknroll* #25, May–June 1985.

Applebome, Peter. "Unlikeliest Punk Heroes." *Texas Monthly*, November 1982, 139.

Arnold, Gina. *Kiss This: Punk in the Present Tense*. New York: St. Martin's Griffin, 1997.

Aronson, Marc. *Art Attack: A Short Cultural History of the Avant-Garde*. New York: Clarion Books, 1998.

Art: 21. Interviews with Raymond Pettibon, 2001–2007. Accessed 20 May 2010. http//www.pbs.org.

Austin, Joe. *Generations of Youth: Youth Cultures and History in Twentieth-Century America*. New York: New York University Press, 1998.

Avrg and Max. "Interview with Final Conflict." *Engine*, 1996.

Azerrad, Michael. *Our Band Could Be Your Life: Scenes from the American Underground, 1981–1991*. New York: Back Bay Books, 2002.

B., Preston. Editorial. *Silent* zine. nd.

B., Val. "Chicago Scene Report." *Maximumrocknroll* #29, October 1985.

Babcock, Jay. "Their War: or, Black Flag, 1977–1981. Or, Black Flag: The First Five Years. Or, The Making of Hardcore: the Problem Child of Punk." *Mojo*, December 2001. http://www.jaybabcock.com/blackflag.html.

———. "A Twelve-Step Program in Self-Reliance. How L.A.'s Hardcore Pioneers Made It Through the Early Years." *L.A. Weekly*, June 22–28, 2001. Accessed 8 April 2008. http://www.breakmyface.com/bands/blackflag1.html.

Bad Brains. "Interview with Bad Brains." *Flipside* #31 (1982).

———. "Interview with Bad Brains." *Forced Exposure* #2 (1982).

———. "Interview with Bad Brains." *Suburban Voice* #21 (1987).

Bag, Alice. "Diary of a Bad Housewife." 2007. Accessed 4 April 2008. http://alicebag.blogspot.com/2007/02/interview-questions-and-faqs.html.

———. "Interview with Connie Clarkson." *Alicebag.com*. January 2008. Accessed 2 November 2008. http://www.alicebag.com/connieclarksvilleinterview.html

———. "Racism in the Early Punk Scene." 17 April 2005. Accessed 23 October 2008. http://alicebag.blogspot.com/2005/04/racism-in-early-punk-scene.html.

Bag, Kevin. "A Big Gulp of a Talk with Byron (editor of *Forced Exposure*)." *Damp* #1 (1987).

Bag, Pat. "Interview with Theresa Kereakes." *Women in L.A. Punk*. April 2005. http://www.alicebag.com/theresakereakesinterview.html.

Baird, Joulee. Letter. *Maximumrocknroll* #35, April 1986.

Balsito, Peter, and Bob Davis, eds. *Hardcore California*. San Francisco: Last Gasp, 1983.

Bangs, Lester. "If Oi Were a Carpenter." *Bad Taste: A Lester Bangs Reader*. Ed. John Morthland. New York: Anchor Books, 2003.

———. "Jello Biafra Is No Cretin." *Bad Taste: A Lester Bangs Reader*. Ed. John Morthland. New York: Anchor Books, 2003.

———. "The White Noise Supremacists." *The Village Voice*. 1979. Accessed 3 January 2008. http://72.14.253.104/search?q=cache:ZcaRlDqHW3sJ:www.mariabuszek.com/kcai/PoMoSeminar/Readings/BangsWhite.

pdf+james+chance+just+a+bunch+of+nigger+bullshit&hl=en&ct=clnk&cd=2&gl=us&client=firefox-a.

Bansky. *Wall and Piece*. London: Century/Random House, 2006.

Bartlett, Gracie. "Girls Do Not Need To Be in Bands to Validate Their Voice in the Punk Scene." *Heart Attack* #22, May 1999.

Baulch, "Creating a Scene: Balinese Punk's Beginnings." *International Journal of Cultural Studies*. 2002. Accessed 29 Dec. 2007. http://est.sagepub.com/cgi/content/abstract/9/2/223

Beal, Becky. "Disqualifying the Official: An Exploration of Social Resistance Through the Subculture of Skateboarding." *Contemporary Issues in Sociology of Sport. Revised Edition*. Eds. Andrew Yiannikis and Merrill J. Melnick. Champaign, IL: Human Kinetics, 2001.

Beatty, Marie. *Gang of Souls*. DVD. Music Video Distributors. 2008.

Becker, Robert. "Malcolm McLaren." *Interview*, April 1986.

Beefeater. "Interview" *Ink*, 1986.

Beefeater. "Interview." *Pit* #1 (Fall 1986).

Berlin, Gabby. Interview. "Women in L.A. Punk." *www.alicebag.com* October 2005.

Bernstein, Charles. "An Interview with Rob Zark." The Botox Franknstein Archival Interview Series #7. Conducted December 1989. Posted 17 June 2005. Accessed 16 May 2008. http://themishegasmaster.blogspot.com/2005_06_01_archive.html.

Bey, Hakim. *T.A.Z.: The Temporary Autonomous Zone, Ontological Anarchy, Poetic Terrorism*. Brooklyn: Autonomedia, 1985, 1991.

Beynon, Bryony. Column. *Maximumrocknroll* #323, April 2010.

BGK. "Interview with BGK." *Constructive Rebellion* #2.
———. "Interview with BGK." *Maximumrocknroll* #43, December 1986.

Bibs. Letter to the Editor. *Maximumrocknroll* #57, January 1988.

Blake, Andrew, ed. "What's the Story?" *Living through Pop*. New York: Routledge, 1999.

Blecher, Jörg. "Dead Kennedys, Cynicism, and Discursive Space." 2001. Accessed 15 November 2007. http://www.glocalweb.de/joerg/html/uni/deadke/literatur.htm.

Blush, Steve. *American Hardcore*. Los Angeles: Feral House, 2001.

Bo. Letter to the editor. *Maximumrocknroll* #34, March 1986.

Board, Mykel. "Obituary for Tim Yohannan of Maximumrocknroll." *Maximumrocknroll* #179, April 1998.

Boehm, Mike. "Going Out of His Way to Help Young Punks." *Los Angeles Times*, 10 December 1992. Accessed on web, 20 May 2010.
———. "Kids of the Black Hole." *Los Angeles Times*, 23 July 1989.
———. "Yawn Farewell for Punk Room." *Los Angeles Times*, 5 August 1998.

Bondi, Vic. Liner Notes. *Articles of Faith. Complete Vol. 1. 1981–1983*. Alternative Tentacles Records, 2002.

Bondi, Vic, Ian MacKaye, and Dave Dictor. "Rap Session." *Maximumrocknroll* #8, September 1983.

Borden, Iain. *Skateboarding, Space and the City*. Oxford: Berg, 2001.

Bou, Louis. *Street Art: The Spray Files*. New York: Collins Design, 2005.

Bradley, Lloyd. *Bass Culture: When Reggae Was King*. London: Penguin, 2000.

Brauer, David E. *Pop Art: U.S./U.K. Connections, 1956–1966*. Houston: Menil Collection, 2001.

Brennan, Carol. "Cramps—The Biography." 2008. Accessed 1 May 2008. http://www.musicianguide.com/biographies/1608001577/Cramps-The.html

Brett, Philip. "Queering Pitch." *Reading Rock and Roll: Authenticity, Appropriation, and Aesthetics*. Ed. Kevin Dettmar and William Richey. New York: Columbia, 1999.

Bromberg, Craig. *The Wicked Ways of Malcolm McClaren*. New York: Perennial Library, 1989.

Bronski, Michael. *Culture Clash: The Making of Gay Sensibility*. Boston: South End Press, 1984.

Brown, Bill. "An Introduction to the Situationist International." *Maximumrocknroll* #19, November 1984.

Brown, David. "The Story of Dangerhouse Records." Accessed 12 December 2008. http://www.breakmyface.com/bands/dangerhouse1.html.

Buchloh, Benjamin. "Raymond Pettibon: Return to Disorder and Disfiguration." *Raymond Pettibon: A Reader*. Philadelphia: Philadelphia Museum of Art, 1998.

Buckland, Fiona. *Impossible Dance: Club Culture and Queer World-making*. Middleton: Wesleyan University Press, 2002.

Buhrmester, Jason. "Agnostic Front's *Victim in Pain* at 25." *Village Voice*, 1 December 2990. http://www.villagevoice.com/2009-12-01/music/agnostic-front-s-victim-in-pain-at-25/.

Burchill, Julie, and Tony Parsons. *The Boy Looked at Johnny*. Boston: Faber and Faber, 1978.

C., Greg. "Interview with Suicidal Tendencies." *Task* #2, 27 April 1985. Accessed 3 January 2008. http://homepages.nyu.edu/~cch223/usa/info/suicidal_Taskinter.html

Cabanne, Pierre. *Dialogues with Marcel Duchamp*. Cambridge: Da Capo Press, 1987.

Cagle, Van M. *Reconstructing Pop/Subculture: Art, Rock, and Andy Warhol*. Thousand Oaks, CA: Sage, 1995.

Canzonieri, Sal. *Electric Frankenstein!* Dark Horse Comics, 2004.

Carson, Tom. "Pere Ubu: Life on the Fringe." *Rolling Stone*, 12 July 1979.

Chalfant, Henry, and James Prigoff. *Spraycan Art*. London: Thames and Hudson, 1987.

Chang, Jeff, and DJ Kool Herc. *Can't Stop Won't Stop: A History of the Hip-Hop Generation*. New York: Macmillan, 2005.

Chantry, Art. *Instant Litter: Concert Posters from Seattle Punk Culture*. New York: Abrams, 1985.

Cheplowitz, Mel. "Flyer Art." *Maximumrocknroll* #35, April 1986.

Chick. "Interview with Winston Smith." *Big Bang Fanzine* #1 (1996).

Chick, Stevie. *Spray Paint the Walls*. Omnibus Press, 2009.

Choi, Esther. "Red Monkey." *Heart Attack* #22, May 1999.

Ciaffardini, David. "Rockin' Roll Model: An Interview with Ian MacKaye of Fugazi." *Sound Choice* #15 (Summer 1990).

Ciminelli, David, and Ken Knox. *Homocore: The Loud and Raucous Rise of Queer Rock*. Los Angeles: Alyson Books, 2005.

Clash, The. *The Clash*. New York City: Grand Central Publishing, 2008.

Clash, The. "Interview with the Clash." *Record Mirror*, June 1978.

"Clash City Rockers." *Uncut*, December 2003.

Clerk, Carol. "Joey Ramone. 1951–2001." *Uncut*, May 2001.

Colegrave, Stephen, and Chris Sullivan. *PUNK: A Definitive Record of a Revolution*. Cambridge: Thunder's Mouth Press/Da Capo, 2001.

Coon, Caroline. "The Clash: Down and Out and Proud." *Melody Maker*, 13 November 1976.

Cooper, Dennis. "Between the Lines: An Interview with Raymond Pettibon." *L.A. Weekly*, May 2001.

Cornwall, Hugh. "Interview with Hugh Cornwall." *Punk77.co.uk*. 2005. Accessed 13 February 2008. http://www.punk77.co.uk/groups/stranglersjjburnelino53.htm.

Cotter, Holland. "Miro, Serial Murderer of Artistic Conventions." *New York Times*, 31 October 2008.

———. "The Poetry of Scissors and Glue." *New York Times*, 14 September 2008.

Crane, Diane. *The Transformation of the Avant-Garde: The New York Art World*. Chicago: University of Chicago Press, 1989.

Crass " . . . In Which Crass Voluntarily Blow Their Own." 1986. http://www.southern.com/southern/label/CRC/.

Crawford, Carrie. Column. *Heart Attack* #22, May 1999.

Creed, Barbara. "Lesbian Bodies: Tribades, Tomboys and Tarts." *Sexy Bodies: The Strange Carnalities of Feminism*. Ed. Elizabeth Grosz and Elspeth Probyn. New York: Routledge, 1995.

Crimlis, Roger, and Alwyn W. Turner. *Cult Rock Posters*. London: Aurum Press, 2006.

Crimpshrine. "Interview with Crimpshrine." *Maximumrocknroll* #63, August 1988.

Cromelin, Richard. "The Flag Is Up for Henry Rollins." *Los Angeles Times*. 1984.

Cronin, Tim. "Henry Rollins and the Economy of Expression." *No Rockets*, July 1987.

D'Ambrosia, Antonino. *Let Fury Have the Hour: The Politics of Joe Strummer*. New York: Nation Books, 2004.

"Dangerhouse: A History." 19 April 2007. http://www.breakmyface.com/bands/dangerhouse1.html.

Danser, Simon. "Beyond Anti-Capitalism." *Foamy Custard*, 2003. Accessed 28 January 2008. http://www.indigogroup.co.uk/foamycustard/fc011.htm.

Darling, Cary. "Tired of the Clash, Tired of Punk, and Tired of You! Johnny Rotten." *BAM*, 10 August 1984.

Davis, Bruce. "Joey on the Ramones." *The Bob*, Winter 1990.

Davis, Eric. "Hare Krishna Hardcore." *Spin*, Summer 2005. Reprinted on www.techgnosis.com.

Davis, Mike. "Homeowners and Homeboys: Urban Restructuring in LA." *Enclitic* 11.3 (1989).

Davis, Thomas. "A Moment in Time with an Art Legend." 6 March 2004. http://www.expressobeans.com/wiki/index.php/Frank_Kozik_Interview.

Dawson, Ashley. "Do Doc Martens Have a Special Smell?" *Reading Rock 'n' Roll: Authenticity, Appropriation, and Aesthetics*. Ed. Kevin Dettmar and William Richey. New York: Columbia, University Press, 1999.

———. "'Love Music, Hate Racism': The Cultural Politics of the Rock Against Racism Campaigns, 1976–1981." *Postmodern Culture*, September 2005. Accessed 25 December 2007. http://muse.jhu.edu/journals/pmc/v016/16.1dawson.html.

DeMello, Margaret. *Bodies of Inscription: A Cultural History of the Modern Tattoo Industry*. Durham: Duke University Press, 2000.

"Dennis Morris." Accessed 15 March 2010. http://www.dennismorris.com/intro2.html.

DiPuccio, Pat. "I Had a Mohawk in Third Grade." *Fizz #7* (1996).

Doe, John. Interview. *No Depression*, July/August 2000.

Dogtown and Z-Boys (film). Directed by Stacy Peralta; written by Stacy Peralta and Craig Stecyk. Agi Orzi Productions, 2001.

Donny the Punk. "Interview with Scream." *Flipside #48* (1986).

Downey, Ryan. "Interview with Duncan Barlow." *We Owe You Nothing, Punk Planet: The Collected Interviews*. Ed. Dave Sinker. New York: Akashic Books, 2001.

Drate, Spencer. *Swag: Rock Posters of the '90s*. New York: Abrams, 2003.

Drayton, Tony. Interview with Electric Chairs. *Ripped and Torn #6* (1977).

Drunk, Ted. "Interview with the Lunachicks." *Flipside #121* (1999).

Dunn, Kevin. "Never Mind the Bollocks: The Punk Rock Politics of Global Communication." *Review of International Studies* 34 (2008).

Dynner, Susan. *Punk's Not Dead*. Aberration Films, 2007.

"Ed Meese and the Question of Pornography." *Maximumrocknroll #67*, December 1988.

Edge, Ben. "Interview with Lifetime." *Big Wheel*, March 2006.

Egan, Sean. "London's Burning." *Uncut*, 2 February 2003.

Eileraas, Karina. "Witches Bitches and Fluids: Girl Bands Performing Ugliness as Resistance." *The Drama Review* 41.3 (Autumn 1997).

Emery, Douglas. "Popular Music of the Clash: A Radical Challenge to Authority." *Political Anthropology* Vol. 5. Ed. Myron Aronoff. London: Transaction Publishers, 1986.

English, Marc. "When the Going Gets Punk the Punk Turn Pro: A Brief Dissertation on Punk Rock Album Design." *Commodity #3*, January/April 1995.

Ensminger, David. "Texas Punk Music Is Gay." *Houston Press*, 8 April 2009.

Ensminger, David, and Welly. "The Art of Jeff Nelson." *Artcore #25* (2008).

Epstein, Daniel. "Interview with the Cramps." *SuicideGirls.com*. 25 July 2003. Accessed 22 February 2007. http://suicidegirls.com/interviews/The+Cramps/.

Ernesto. "Hello Sailor! A Punkshow, Masculinity Made Flesh." *RE/fuse #3* (2005).

Esquibel, Zecca. "Interview." *Punk 77*. 2006. Accessed 15 March 2010. http://www.punk77.co.uk/groups/Zecca_Esquibel_interview_2006.htm.

Evac, Sam, Tim Boiling Point, and Jon Inward Moniter. "And the Time Is Now: An Interview with Go!" *Maximumrocknroll #87*, August 1990.

Farber, Jim. "The Mudd Club: Disco for Punks." *Rolling Stone*, July 1979.

———. "The Ramones: Too Punk to Pop." *Hard Rock Video #7* (1986).

Fastbacks. "Interview with the Fastbacks." *Ruckus #2* (1993).

Fauquet, Gigi. Letter to the Editor. *Maximumrocknroll #47*, April 1987.

Fauteux, Jacqueline. Letter to the Editor. *Flipside #63* (1989).

Fear. "Interview with Fear." *Rebel Sound #7* (1993).

Fleming, Robin. "Interview with the Distillers. *Juice Magazine.com*. Accessed 3 January 2008. http://www.juicemagazine.com/distillers.html.

Flipside, Al. "Interview with Black Flag." *Flipside #22* (1980).

———. "Interview with D.I." *Flipside #47* (1985).

———. "Interview with the Dicks." *Flipside #32* (1982).

———. "Interview with Sado-nation." *Flipside #40* (1983).

———. "Interview with Secret Hate." *Flipside #38* (1983).

Flipside, Al, and Hud. "Big Boys Interview." *Flipside #32* (1981).

Flipside, Al, and Paul Hessing. "An Interview with Blackbird." *Flipside #57* (1988).

Flipside, Al, and Tim Stegall. "Interview with the Dickies." *Flipside #60* (1989).

Flipside, Al, and X-8. "Interview with Snuky Tate." *Flipside #13* (1979).

Freccero, Carla. "Unruly Bodies: Challenges to the Regime of Body Backlash: Two Live Crew and Madonna." *Visual Anthropology Review* 9.1 (Spring 1993).

Freeze, The. *Token Bones*. Liner Notes. Dr. Strange Records, 1997.

Friedlander, Paul, and Peter Miller. *Rock 'n' Roll: A Social History*. Boulder: Westview, 2006.

Fusco, Coco. *English Is Broken Here: Notes on Cultural Fusion in the Americas*. New York: The New Press, 1995.

"Future of Punk, The." *Daily Impulse*, 1 June–31 July 1987.

Ga-Ga the Boy. "California Scene Report." *AOK* 1.3 (1985).

Gablik, Suzi. *Has Modernism Failed?* Thames and Hudson, 1984.

Gaitz, Ronnie. "Houston Scene Report." *Maximumrocknroll #40*, September 1986.

George, Nelson. *Hip Hop America*. New York: Viking, 1998.

Gibson, Jim. *Electric Frankenstein!* Dark Horse Comics, 2004.

Gilbert, Pat. *Passion Is the Fashion: The Real Story of the Clash*. Cambridge: Da Capo, 2005.

Gilmore, Mikal. *Nightbeat: A Shadow History of Rock and Roll*. New York: Doubleday, 1998.

Gilroy, Paul. *"There Ain't No Black in the Union Jack": The Cultural Politics of Race and Nation*. Chicago: University of Chicago Press, 1991.

Gimarc, George. *Punk Diary: The Ultimate Trainspotter's Guide to Underground Rock, 1970–1982*. Milwaukee: Hal Leonard Corporation, 2005.

Glasper, Ian. Liner Notes. *Anti-Pasti—The Last Call*. Captain Oi, 2005.

Goddard, Simon. "New York Dolls." *Uncut*, June 2004.

Goldberg, Michael. "A Fired-up Joe Strummer Brings His New Clash to America." *Rolling Stone*, March 1984.

Goldskin, Patrick. "Sex Pistols in the Promised Land." *Creem*, April 1978.

Goldstein, Patrick. "Interview with the Sex Pistols." *CREEM: America's Only Rock 'N' Roll Magazine*. New York: Harper and Collins, 2007.

Goldthorpe, Jeff. "Interview with Maximumrocknroll." *Radical America*, November/December 1984.

Goodyear, Ian. Posting. www.punk77.co.uk. 2001. Accessed 20 February 2008. http://www.punk77.co.uk/groups/RogerSabinreplies.htm.

Gordon, Robert. "Cramps." *Spin*, August 1990.

Goshert, John. "'Punk' after the Pistols: Alternative Music, Economics and Politics in the 1980s and 1990s." *Popular Music and Society* 24.1 (2001): 87–109.

Grad, David. "Interview with Gregg Ginn." *We Owe You Nothing, Punk Planet: The Collected Interviews*. Ed. Dave Sinker. New York: Akashic Books, 2001.

Grant, Paul. "An Interview with Skull Control." *Maximumrocknroll* #138, November 1994.

Gray, Marcus. *Last Gang in Town: The Story and Myth of the Clash*. New York: Henry Holt and Company, 1995.

——. "A Review of Babylon's Burning: From Punk to Grunge." *Trakmarx*, July 2007. Accessed 4 November 2009. http://www.trakmarx.com/2007_03/05-mg.html.

Greenwald, Gary. *The Punk Called Rock*. Pamphlet. Publisher information unavailable.

Gross, Michael. "Patti Smith: Misplaced Joan of Arc in a Bicentennial Blitz." *Blast*, August 1976.

Grossberg, Lawrence. *Dancing in Spite of Myself*. Durham: Duke University Press: 1997.

Grosz, Elizabeth. "Julia Kristeva: Abjection, Motherhood, and Love." In *Sexual Subversions: Three French Feminists*. Sydney: Allen and Unwin, 1989.

——. "Language and the Limits of the Body: Kristeva and Abjection." *Future Fall* (1987).

Grushkin, Paul. *The Posters and Art of Frank Kozik*. San Francisco: Last Gasp, 1997.

Gumpert, Lynn, and Ned Rifkin. *Golub*. New York: New Museum of Contemporary Art, 1984.

Gumption, Sheri. Column. *Maximumrocknroll* #185, October 1998.

Gurza, Agustin. "LA Punk History Is a Serious Subject." *Los Angeles Times*, 24 May 2008. Accessed 13 August 2008. http://articles.latimes.com/2008/may/24/entertainment/et-culture24.

Habell-Pallan, Michelle. "'Soy Punkera, Y Que?' Sexuality, Translocality, and Punk in Los Angeles and Beyond." *Loca-Motion: The Travels of Latina and Chicana Popular Culture*. New York: New York University Press, 2005.

Haenfler, Ross. *Straight-edge: Clean Living Youth, Hardcore Punk, and Social Change*. New Brunswick, NJ: Rutgers University Press, 2007.

Hager, Steven. *Art after Midnight*. New York: St. Martin's Press, 1986.

Hahn, Lance. "Save Your Local Graffiti Writers." *AOK* 1.3 (1985).

Halas, Gabriela. Letter to the Editor. *Heart Attack* #35, August 2002.

Halberstam, Judith. "What's That Smell?: Queer Temporalities and Subcultural Lives." *S&F Online*. 2.1 (Summer 2003). Accessed 22 February 2008. http://www.guardian.co.uk/Archive/Article/0,4273,4283671,00.html.

Hall, Stuart. Lecture. 1997. http://www.mediaed.org/assets/products/409/transcript_409.pdf

Hambleton, Paul. Posting. *www.punk77.co.uk*, 17 July 2001. Accessed 20 February 2008. http://www.punk77.co.uk/groups/RogerSabinreplies.htm.

Hammond, Linda Dawn. "Photos: Pyramid Club, Michael Rroman, NYC 1984." Rebel Rebelle—Punks and Provocateurs Photo Exhibit. 2005. http://rebelrebelle.blogspot.com/2005/03/photos-pyramid-club-michael-roman-nyc.html.

Hamsher, Jane. "Stiv Bators and the Dead Boys." *Damage*, July 1980.

Hannon, Ed. "An Interview with Mero from Knifed Part II!" *Left of the Dial*. 5 March 2008. http://www.leftofthedialmag.com/?p=425#more-425.

Hanrahan, Noelle. "Underground Women." *Puncture* #19 (1990).

Hargraves, Hunter. "Doing the Queer Time Warp." *San Francisco Bay Guardian*, 20 June 2007. Accessed 26

December 2007. http://sfbayguardian.com/entry.php?page=3&entry_id=3887&catid=107&volume_id=254&issue_id=314&volume_num=41&issue_num=50.

Harlan, F. "Henry Rollins." *Warning* #8 (January/February 1983).

———. "Suicidal Tendencies." *Warning* #8 (January/February 1983).

Havoc, Felix. Column. *Heart Attack* #18, Summer 1998.

———. Column. *Maximumrocknroll* #185, October 1998.

Hawk, Tony, with Sean Mortimer. *Hawk: Occupation: Skateboarder.* New York: ReganBooks, 2001.

Hebdige, Dick. *Hiding in the Light.* New York: Routledge, 1988.

———. *Subculture: The Meaning of Style.* New York: Routledge, 1979.

Heimann, Jim. "Rethinking Illustration." *Single Image,* Spring 2000.

Henning, Michelle. "Don't Touch Me (I'm Electric): On Gender and Sensation in Modernity." *Women's Bodies: Discipline and Transgression.* Eds. Jane Arthurs and Jean Grimshaw. New York: Continuum International Publishing Group, 1998.

Henry, Tricia. *Break All the Rules! Punk Rock and the Making of a Style.* Ann Arbor: UMI, 1989.

Hensley, Chad. "A Look Beneath the Foundations: An Interview with Fugazi." *Fizz* #7 (1996).

Hernandez, Raoul. "I'm Sorry, Yogi!" *Austin Chronicle,* 15 September 1997. http://weeklywire.com/ww/09-15-97/austin_music_feature2.html.

———. "Once a Dick, Always a Dick." *Austin Chronicle,* 15 May 2000. http://www.austinchronicle.com/gyrobase/Issue/story?oid=oid:77163.

Hewitt Paolo. Liner notes. *Extras,* The Jam, 1992.

Heylin, Clinton. *Babylon's Burning: From Punk to Grunge.* New York: Viking, 2007.

Hickey, Mark. "Interview with Aggression." *Flipside* #40 (1983).

Hilladdin. "The Cramps and the Crowd at the Whiskey." *Final Solution,* December 1979.

Hochswender, Woody. "Slam Dancing: Checking in with L.A. Punk." *Rolling Stone,* 14 May 1981.

Hodkinson, Paul. *Goth: Identity, Style, and Subculture.* Oxford: Berg, 2002.

Hogan, Richard. "Looking Flash Means Hard Work for the Clash." *Creem,* 31 May 1981.

Holdship, Bill. "Interview with the Replacements." *CREEM: America's Only Rock 'N' Roll Magazine.* New York: Harper and Collins, 2007.

———. "They Want to Spoil the Party So They'll Stay: The Clash." *Creem,* October 1984.

Hollis, Richard. *Graphic Design: A Concise History.* New York: Thames and Hudson, 1994.

Holstrom, John. "Interview with John Holstrom." *Kicking and Screaming* #12, September/October 2005.

Home, Stewart. *Cranked Up and Really High.* 1997. Accessed 2 June 2008. http://www.stewarthomesociety.org/cranked/content.htm.

———. "Interview with Stewart Home." By Andy. *Fear and Loathing,* July 1994.

———. "We Mean It Man: Punk Rock and Anto-racism, or, Death in June Not Mysterious." *Datacide,* 2000. Accessed 15 March 2010. http://www.stewarthomesociety.org/dij.htm.

hooks, bell. "Eating the Other." *Feminist Approaches to Theory and Methodology: An Interdisciplinary Reader.* Eds. Sharlene Hesse-Biber, et al. New York, Oxford University Press, 1998.

Hooten, Josh. "Interview with Winston Smith." *We Owe You Nothing, Punk Planet: The Collected Interviews.* Ed. Dave Sinker. New York: Akashic Books, 2001.

Horn, Mike. "Interview with Crime." *Punk* #11 (1977).

Hoskyns, Bob. *Waiting for the Sun: Strange Days, Weird Sounds, and the Sound of Los Angeles.* New York: St. Martins Griffin. 1999.

Hsu, Bill. "SPEW. The First Queer Punk Fanzine Convention. May 25 1991. Randolph Street Gallery, Chicago." *Postmodern Culture* 2.1 (1991). http://muse.jhu.edu/journals/postmodern_culture/v002/2.1r_hsu.html.

Hubbard, Chris. "Interview with Bum Kon." *Maximumrocknroll* #305, October 2008.

Hudson, Mike. *Diary of a Punk.* Niagra Falls, NY: Tuscarora Books, 2008.

Hughes, Mel. "Commitment XXX Records." *Direct Hit,* N.A.

Hunter, Kev. "Epileptics: A History." Accessed 6 October 2008. http://www.punk77.co.uk/groups/epileptics.htm.

Hurchalla, George. *Going Underground: American Punk 1979–1992.* Stuart, FL: Zuo Press, 2005.

Indiana, Gary. "The Next Riot You Attend, Be More Than a Witness . . . A Report on What to Do That May Help You." *Flipside* #38 (1983).

Iron Cross. "Interview with Iron Cross." *Touch and Go* #16 (1982).

Isler, Scott. "Malcolm McLaren: From the Eye of the Storm." *Trouser Press* #85, May 1983.

———. "The Original Is Still the Greatest." *Trouser Press* #86, June 1983.

Jake. "U.K. Scene Report." *Maximumrocknroll* #37, June 1986.

James, Blaze, Kimberly Kuban, and Mark Compe. "Interview with Tender Fury." *Pussyfoot* #3.

James, David E. "Poetry/Punk/Productions: Some Recent Writing in LA." *Postmodernism and Its Discontents.* Ed. Ann Kaplan. New York: Verso, 1988.

Jenkins, Henry. "Converge? I Diverge." *Technology Review,* 1 June 2001. Accessed 28 January 2008. http://www.technologyreview.com/Biztech/12434/.

———. "Taking Media in Our Own Hands." *Technology Review,* 9 November 2004. Accessed 28 January 2008. http://www.technologyreview.com/Biotech/13905/.

———. *Textual Poachers: Television Fans and Participatory Culture.* New York: Routledge, Chapman, and Hall, 1992.

Jenkins, Henry, and David Thorburn, eds. *Democracy and New Media.* Cambridge: MIT Press, 2003.

Jenkins, Sacha. "Graffiti: Graphic Scenes, Spray Fiends, and Millionaires." *The Vibe History of Hip Hop.* Ed. Alan Light. New York: Three Rivers Press, 1999.

Jim. Letter to the Editor. *Maximumrocknroll* #19, November 1984.

Johnston, Ian. *The Wild World of the Cramps.* New York: Omnibus, 1990.

Jones, Heather. "An Interview with Frank Kozik." *Sin* 2.12 (December 1993).

Jones, Michael. "Why Make Folk Art?" *Journal Of Western Folklore,* October 1995. Accessed November 2007. http://www.jstor.org/view/0043373x/ap050185/05a00030/0.

Jones, Peter. "Anarchy in the U.K.: '70s British Punk as Bakhtinian Carnival." *Studies in Popular Culture* 24.3 (2002).

Jones, Simon. *Black Culture, White Youth: The Reggae Tradition from JA to UK.* London: Macmillan, 1988.

Joy. "Interview with Operation Ivy." *Flipside* #57 (1988).

Julien, Isaac, and Colin MacCabe. *Diary of a Young Soul Rebel.* London: British Film Institute, 1991.

Just Another Nigger. Letter to the Editor. *Maximumrocknroll* #87, August 1990.

Kaufman, Ronen. *New Brunswick, New Jersey, Goodbye: Bands, Dirty Basements, and Search for Self.* Hopeless Records: 2007.

Keates, Jonathan. Introduction. *Roman Nights and Other Stories,* by Pier Paolo Pasolini. Trans. John Shepley. London: Quartet Books, 1994.

Keating, Robert. "Slamdancing in a Fast City." *Penthouse,* February 1982.

Keithley, Joe. *I, Shithead: A Life in Punk.* Vancouver: Arsenal Pulp Press, 2004.

Kelly, Matt. "Interview with Gary Floyd." *Cool Beans* #5 (1995).

Kennedy, Kathleen. "Results of a Misspent Youth: Joan Jett's Performance of Female Masculinity." *Women's History Review* 11.1 (2002).

Kim, Taehee. "Major Threat: Fugazi Flips Off the Mainstream." *Option* #41, November/December 1991.

Koht, Peter. "Obscene but Not Heard." *Metroactive,* 16–23 November 2005. Accessed 20 May 2008. http://www.metroactive.com/metro-santa-cruz/11.16.05/suicide-girls-0546.html.

Kristal, Gabriel. Column. *Heart Attack* #25, February 2000.

Kristeva, Julia. "Approaching Abjection." *Oxford Literary Review* 5 (1982).

Krk. "Interview with Aggression." *Flipside* #71 (1991).

———. "Interview with Swiz." *Flipside* #62 (1989).

Kruger, Barbara. "Remote Control: Barbara Kruger on Television." *Artforum,* April 1989.

Kthejoker. "Don't Blow Bubbles." *Everything2.com,* 4 March 2004. Accessed 12 January 2008. http://everything2.com/index.pl?node_id=1523682.

———. Posting on Bad Brains. *Everything2.com.* Accessed 3 January 2008. http://everything2.com/index.pl?node_id=1523682.

Kulick, Don. *Travesti: Sex, Gender, and Culture among Brazilian Transgendered Prostitutes.* Chicago: University of Chicago Press, 1998.

Kun, Josh. "Vex Populi: At an Unprepossessing Eastside Punk Rock Landmark, Utopia Was in the Air. Until the Day it Wasn't." *Los Angeles Magazine,* March 2003. http://www.elaguide.org/Peoples/joshkun.htm.

Lahickey, Beth. *All Ages: Reflections on Straight Edge.* Revelation, 1998.

Laing, Dave. "Interpreting Punk Rock." *Marxism Today,* April 1978.

LaVella, Mike. "Interview with Crime." *Maximumrocknroll* #73, June 1989.

LeBlanc, Lauraine. *Pretty in Punk: Girls' Gender Resistance in a Boys' Subculture.* New Brunswick, NJ: Rutgers University Press, 1999.

Leeway. "Interview with Leeway." *Constructive Rebellion* #2.

Leland, John. *Why Kerouac Matters.* New York City: Viking, 2007.

Leslie, Esther, and Ben Watson. "The Punk Paper: A Dialogue." http://www.militantesthetix.co.uk/punk/Punkcomb.html.

Lester, Ken. "Interview with Cheetah Chrome Motherfuckers." *Maximumrocknroll* #39, August 1986.

Lethem, Jonathan. "The Clash." The Ego Is Always in the Glove Compartment. Blog. Originally published in the *New York Observer*, 2000. Accessed 6 December 2008. http://www.jonathanlethem.com/the%20clash.html.

Letts, Don. "Dem Crazy Baldheads Are My Mates." *Guardian Unlimited*, 24 October 2001. Accessed 22 February 2008. http://www.guardian.co.uk/Archive/Article/0,4273,4283671,00.html.

———. *Punk: Attitude*. Capital Entertainment, 2005.

———. "Voices from Rock Against Racism." *Socialist Worker Online*, 14 July 2007. Accessed 5 December 2009.

Lewis. Wyndam. "Inferior Religions." 1917.

"Life Through Lime Colored Glasses." Editorial. *AOK* 1.3 (1985).

Lipsitz, George. *Dangerous Crossroads: Popular Music, Postmodernism, and the Poetics of Place*. New York: Verso, 1994.

Livermore, Lawrence. Letter from the Editor. *Maximumrocknroll #94*, March 1991.

———. "Tourists Saved from Skateboard Menace." *Lookout*, August 1986.

Longabaugh, Matt. "Interview with Aggression." *Common Level #3*, September/October 1985.

Lovece, Frank. "Wendy O. Williams." *Genesis*, December 1986.

Lydon, John, with Keith and Kent Zimmerman. *Rotten: No Irish, No Dogs, No Blacks*. New York: Picador, 1994.

Lyons, Jessica. "Collectors Still Flock to Classic Vintage Posters . . . " *Art Business News*, April 2001.

M., Jim. Letter to the Mydolls. 30 June 1981.

MacKaye, Ian. "Interview with Beefeater." *Maximumrocknroll #25*, May/June 1985.

MacPhee, Josh. *Stencil Pirates*. New York: Soft Skull Press, 2004.

Manzoor, Sarfraz. "The Year Rock Found the Power to Unite." *Guardian*, 20 April 2008. Accessed 6 December 2009. Guardian.co.uk.

Marcus, Greil. *Lipstick Traces: A Secret History of the Twentieth Century*. Cambridge: Harvard University Press, 1989.

———. "MTV DOA RIP." *Artforum*, January 1987.

Mardi. "The Clash: A Teenage Love Story." Posted online, 28 September 2004. http://alterdudes.blogspot.com/2004/09/clash-teenage-love-story.html.

Marko, Paul. *The Roxy London Wc2: A Punk History*. Britain: Punk 77 Books, 2007.

Marshall, Bertie. *Berlin Bromley*. London: SAF Publishing, Limited. 2006.

Matheu, Robert. "Wendy and the Plasmatics: 1984 Will Be a Little Early." *Creem*, September 1981.

Matsumoto, Jon. "Interview with Joey Ramone." *Flipside #57* (1988).

Maw. "Interview with Vaginal Creme Davis." *Flipside #70* (1991).

McClard, Kent. Editorial. *Give Me Back*, Summer 2007.

McClelland, Susan. "Straight-edge Kids." *Maclean's*. 17 May 1999. Accessed 14 May 2008. http://www.thecanadianencyclopedia.com/index.cfm?PgNm=TCE&Params=M1ARTM0011956.

McCloud, Scott. *Understanding Comics: The Invisible Art*. New York: Harper, 1994.

McDermott, Catherine. *Street Style: British Design in the 1980s*. New York: Rizzoli International Publications, 1987.

McDonnell, Evelyn. "Girls and Guitars." *Out*, April 2000.

McEvilley, Thomas. "Royal Slumming: Jean-Michel Basquiat Here Below." *Artforum*, November 1992.

McGonigal, Mike. "Pettibon with Strings." *Chemical Imbalance* 2.3 (1991).

McIntosh, Barbara. "Punks, Wavers, and Poseurs." *The Houston Post* 5 October 1980.

McKenna, Kristen. "Remembrance of Things Past." *Forming: The Early Days of Punk*. Santa Monica, CA: Smart Art Press. 1999.

McLaren, Malcolm. "Interview with Malcolm McLaren." *Ben Is Dead #27* (1996).

———. Introduction. *The Album Cover Art of Punk*, by Burkhardt Seiler. Berkeley, CA: Gingko Press, 1998.

McLinden, Aimless. "More Cheap Gimmicks: The Gospel According to the Cramps." *Damage*, July 1980.

McNeil, Legs, and Gillian McCain. *Please Kill Me: An Uncensored Oral History of Punk*. Updated. New York: Grove Press, 2006.

Meadows, Kriscinda. Abstract for "Zombie Culture: The Audience and the Undead." 2006. Inter-Disciplinary.net. http://www.inter-disciplinary.net/at-the-interface/evil/monsters-and-the-monstrous/project-archives/4th/session-2-unearthing-the-undead/.

Meggs, Philip B. *A History of Graphic Design* (3rd edition). Hoboken, NJ: John Wiley & Sons, 1998.

Mie-gang, Thomas. "My Messiah Will Rise . . . To Kill Again." *Raymond Pettibon*. Verlag Fur Moderne Kunst Nurnberg, 2007.

Mike, Bullshit. Column. *Maximumrocknroll #98*, July 1991.

Miles, Barry. "The Clash: Eighteen Flight Rock . . . " *New Music Express*, 11 December 1976.

Mitchell, Scott. *Weirdtronix, Relics from 70s/80s So. Cal Punk.* 2003. Accessed 18 February 2008. http://www .members.tripod.com/weirdotronix/index.htm.

Mockingbird, Tequila. "Interview with Keith Levine." *Flipside* #64 (1990).

Moore, Allan F. *Rock: The Primary Text.* Buckingham and Philadelphia: Open University Press, 1993.

Moore, Ryan. "Postmodernism and Punk Subcultures: Cultures of Authenticity and Deconstruction." *Communication Review* 7 (2004).

Moore, Thurston. *Mix Tape: The Art of Cassette Culture.* New York, Universe, 2004.

Moore, Thurston, and Abby Banks. *Punk House: Interiors in Anarchy.* New York: Abrams, 2007.

Morf, Devon. "Interview with Dennis Jaggard of Scared Straight." *Maximumrocknroll* #82, March 1990.

Moser, Margaret. "Holiday in San Antonio: The Night the Sex Pistols Went Off at Randy's Rodeo." *Austin Chronicle* 10 January 2003.

Mullen, Brendan, Don Bolles, and Adam Parfrey. *Lexicon Devil: The Fast Times and Short Life of Darby Crash and the Germs.* Los Angeles: Feral House, 2002.

Mullen, Brendan, and Mark Spitz. *We Got the Neutron Bomb.* New York: Random House, 2001.

Mydolls. Letter to the *Free Beer Press.* 1983.

Napier-Bell, Simon. *Black Vinyl White Powder.* London: Ebury Press, 2001.

Newlin, James. "'Gimme Gimme This, Gimme Gimme That': Confused Sexualities and Genres in Cooper and Mayerson's Horror Hospital Unplugged." *ImageTexT: Interdisciplinary Comics Studies* 4.3 (2009). Accessed 18 March 2010. http://www.english.ufl.edu/imagetext/ archives/v4_3/newlin/.

Nobakht, David. *Suicide: No Compromise.* New York: SAY Publishing, 2005.

Non Grata, Alicia. "Interview with Nausea." *Maximumrocknroll* #82, March 1990.

Noriega, Chon. Introduction. *Just Another Poster? Chicano Graphic Arts in California.* Santa Barbara: University of California Press: 2001.

Nylons, Judy. "In with the In Crowd: The View from Under the Floorboards." *Johnny Lydon: Stories of Johnny: A Compendium of Thoughts on the Icon of an Era.* Ed. Rob Johnstone. London: Chrome Dreams, 2006.

Nyong'o, Tavia. "Do You Want Queer Theory (or Do You Want the Truth)? Intersections of Punk and Queer in the 1970s." *Radical History*, Winter 2008.

O'Brien, Lucy. "The Woman Punk Made Me." *Punk Rock, So What?* Ed. Roger Sabin. London: Routledge, 1999.

October, Gene. Interview. 2004. punkoiuk.co.uk.

O'Hara, Craig. *The Philosophy of Punk: More than Noise.* Updated. San Francisco: AK Press, 1999.

Oi Polloi. "When Two Men Kiss." *Pigs for Slaughter: 20 Years of Anarcho-Punk Chaos.* Step 1 Records, 2006.

Orman, John. *The Politics of Rock Music.* Chicago: Nelson-Hall, 1984.

Orshoski, Wes. "DVD Looks Back at the Clash's 'Revolution.'" *Billboard.com.* 25 April 2008. Accessed 6 December 2008. http://www.bill board.com/bbcom/news/article_display .jsp?vnu_content_id=1003794881&inp=true.

Owen, David. "Making Copies." *Smithsonian*, August 2004.

P., Jeff. Review of Anthrax club. *Maximumrocknroll* #19, November 1984.

Palafox, Jose. "Interview with Martin S. from Los Crudos. Part II." *Maximumrocknroll* #203, April 2000.

Palmer, Robert. "End of the World?" *Penthouse*, July 1981.

Parker, James. *Turned On: A Biography of Henry Rollins.* London: Phoenix House, 1998.

Penalty, Jeff. "Raymond Pettibon." *Swindle*, 20 May 2010.

Perez, Louis. "Weird Hair Pendejolandia." *Make the Music Go Bang: The Early L.A. Punk Scene.* Ed. Don Snowden. New York: St. Martin's Griffin, 1997.

Philips, Melanie. "Brixton and Crime." *New Society*, July 1976.

Phillips, Susan A. *Wallbangin': Graffiti and Gangs in L.A.* Chicago: University of Chicago Press, 1999.

Pietschmann, Franziska. "A Blacker and Browner Shade of Pale: Reconstructing Punk Rock History." Technische Universität Dresden. 2010.

Pitkin, Hanna Fenichel. *The Attack of the Blob: Hannah Arendt's Concept of the Social.* Chicago: University of Chicago Press, 1998.

Pitre, Sean. "Cultural Studies and Hebdieg's Subculture of Style." 7 December 2003. Accessed 15 November 2007. http://www.tagg.org/students/Montreal/Tendances/ PitreHebdige.html.

Plymouth (England) City Council. Business Improvement District Baseline Agreements. "Graffiti and Flyposting." 2007. Accessed 30 January 2008. http://www.plym outh.gov.uk/bidgraffitiflyposting.

Polifka, Herbert. "New Revelations about the Activities and Destruction of the GDR Section of the Communist Party of Germany/Marxist-Leninist (KPD/ML)." *Roter Morgen*, 24 December 1997. Accessed 3 October 2008. http://www.revolutionarydemocracy.org/rdv5n1/ gdrkpd.htm.

Potter, Russell A. *Spectacular Vernaculars: Hip-Hop and the Politics of Postmodernism.* Albany: SUNY Press, 1995.

Powers, Ann. "Dream Weaver: A Teen Fantasy Chronicle in Six Tracks." *The Village Voice Rock & Roll Quarterly* 5.2 (Fall 1992).

Pushead. "Interview with Pushead." *Heart Attack* #35, August 2002.

———. "Interview with Pushead." *Maximumrocknroll* #8, September 1983.

Quint, Al. "Interview with the Big Boys." *Suburban Voice* #7 (1983).

———. "Interview with Gary Floyd." *Suburban Voice* #41 (1998).

———. "Interview with Good Clean Fun." *Suburban Voice* #44 (2000).

———. "Interview with Martin Sorrendeguy." *Suburban Voice* #46 (2003).

———. "Interview with 7 Seconds." *Suburban Voice* #13 (1984).

———. "Interview with Springa of SSD." *Suburban Voice* #33–#34 (1993).

———. "Random Thoughts." *Suburban Voice* #33–#34 (1993).

Rabid, Jack. "Profile of Hüsker Dü." *Interview.* April 1986.

Raha, Maria. *Cinderella's Big Score: Women of the Punk and Indie Underground.* Berkeley, CA: Seal Press, 2004.

Reeshard, Count. "Pete 'Mad Daddy' Myers, The Final WHK Broadcast." *No Condition Is Permanent.* 24 October 2004. Accessed 22 February 2008. http://permanentcondition.blogspot.com/2007/10/pete-mad-daddy-myers-final-whk_9762.html.

Rettman, Tony. "Jimmy Gestapo Talks A7." *Double Cross: Dedicated to Hardcore* 18 December 2008. http://doublecrosswebzine.blogspot.com/2008/12/jimmy-gestapo-talks-a7.html.

Review page. *Flipside* #31 (1982).

Reynolds, Simon. *Rip It Up and Start Again.* New York: Penguin, 2006.

Rhizomes, Utopian. "Desire Is Speaking." *Do or Die* #8 (1999). http://www.ecoaction.org/dod/no8/desire.html.

Rhodes, Carl, and Robert Westwood. "Authenticity, Resistance, and Punk Rock." *Critical Representations of Work and Organization in Popular Culture.* New York: Routledge, 2008.

Robb, John. *Punk Rock: An Oral History.* London: Ebury, 2007.

Robinson, Richard. "Success Seen in Commercial Field for Punk." *San Antonio Express,* 23 January 1978.

Rollins, Henry. "Interview." 2007. *Queerpunks.com.*

Rosenburg, Jessica. "Riot Grrrl: Revolutions from Within." *Signs: A Journal of Women in Culture and Society* 23.3 (Spring 1998).

Rowe, David. *Popular Cultures: Rock Music, Sport, and the Politics of Pleasure.* London: SAGE Publishing, 1995.

Roxy London WC2, The. Harvest Records, 1977.

Rubino, Diana. "Interview with Trish Herrera and Linda Bond of the Mydolls." Newspaper Clipping. http://mydolls1978.wordpress.com/2009/02/13/mydolls-press-material-no-40/rubinointerviewcopy/.

Rubio, Steve. "Oh Bondage Up Yours." *Bad Subjects* #6, May 1993. http://bad.eserver.org/issues/1993/06/rubio.html.

Ruland, Jim. "California Screaming—An Interview with Brendan Mullen." *3 A.M.,* 2002. Accessed 3 October 2008. http://www.3ammagazine.com/litarchives/2002_jul/interview_brendan_mullen.html.

Rumsey, Spencer, and Jeff Gottesfeld. "The Young and the Hairless." *East Village Eye,* August 1984.

Ryan, Matthew. Interview. *Uncut* (1993).

S., Steve. Posted on Black Flag site. October 1998. http://www.ipass.net/jthrush/flag1998.htm

Sales, Nancy Jo. "The Golden Suicides." *Vanity Fair,* 12 December 2007. Accessed 27 December 2007. www.vanityfair.com.

Salewicz, Chris. Liner notes. *Burning Ambition.* Cherry Red, 1982.

Salyers, Christopher. *CBGB's: Decades of Graffiti.* New York: Mark Batty Publisher, 2006.

Sante, Luc. "Public Image Ltd." *The Show I'll Never Forget.* Ed. Sean Manning. Cambridge: De Capo, 2007.

Sarah and Bob (of Kreylon's Underground). "An Interview with Tesco Vee's Hate Police." *Maximumrocknroll* #99, August 1999.

Savage, Jon. *England's Dreaming: Anarchy, Sex Pistols, Punk Rock, and Beyond.* London: Faber and Faber, 1991.

———. "Punk London." *Evening Standard,* 1991.

Savlov, Marc. "Making Biscuit: Punk Icon Randy "Biscuit" Turner Serves Art 24/7." *Austin Chronicle,* 19 August 2005. Accessed 13 May 2009. http://www.austinchronicle.com/gyrobase/Issue/story?oid=oid%3A285396.

Schalit, Joe. "Interview with Matt Wobensmith." *We Owe You Nothing, Punk Planet: The Collected Interviews.* Ed. Dave Sinker. New York: Akashic Books, 2001.

Schjeldahl, Peter. *Let's See: Writings on Art from the New Yorker.* New York: Thames and Hudson, 2008.

Schor, Mira. "Girls Will Be Girls." *Artforum,* September 1990.

Scream. "Interview." *Ink Disease* #4 (1983).

———. "Interview." *Touch and Go* #21 (1982).

Sculatti, Gene. "Ramones Review." *Creem*, August 1976.

Sender, Rikki. Letter to the editor. *Maximumrocknroll* #34, March 1986.

7 Seconds. "Walk Together, Rock Together." *Walk Together, Rock Together*. BYO Records, 1985.

Shame, Dan. "Loud and Clear: The Sermon of the Bellrays." *Maximumrocknroll* #227, April 2002.

Shank, Barry. *Dissonant Identities: The Rock 'n' Roll Scene in Austin*. Middletown: Wesleyan University Press, 1994.

Sheehan. "Talkin Shop with Art Chantry." Conducted 31 May 1998. http://www.rotodesign.com/art/art.html.

Shermer, Tasha. "Black Invisibility and Racism in Punk Rock." *HipMama*, 18 May 2004. Accessed 23 October 2008. http://www.hipmama.com/node/1979.

Shewchuk, Greg. "Skateboarding as Mind-Body Practice." *Arthur*, May 2008.

Shields, Rob. "Boundary-Thinking in Theories of the Present: The Virtuality of Reflexive Modernization." *European Journal of Social Theory*, 2006. Accessed 28 December 2007. http://est.sagepub.com/cgi/content/abstract/9/2/223.

Shithead, Joey. *I Shithead: A Life in Punk*. Vancouver: Arsenal Pulp Press: 2004.

Silverton, Peter. "Greatness from Garageland." *Trouser Press* #26, February 1978.

———. "Paris Hippodrome—Marxist Festival." *Sounds*, 17 June 1978.

Simpson, Mark. *Men Performing Masculinity*. New York: Routledge, 1994.

Sinker, Dave. "Not Just Boys' Fun Anymore: The Growing Girls Revolution in Skateboarding." *Punk Planet* #25, May/June 1998.

———. *We Owe You Nothing, Punk Planet: The Collected Interviews*. New York: Akashic Books, 2001.

Smith, Patti. "Review of Dylan's *Planet Waves*." *Creem*, April 1974.

———. *Introduction to North East Punk Flyers, the 80's*. Boston: F.N.S. Publishing, 1993.

Snow, Matt. "Death or Glory." *Mojo*, November 2008.

Snowden, Don. *Make the Music Go Bang: The Early L.A. Punk Scene*. New York: St. Martin's Griffin, 1997.

Sommer, Tim. "Siouxsie/Banshees." *Trouser Press* #59, February 1981.

Spears, Jacon. "Graffiti, Punk Rock Posters Featured in Warhol Exhibit." *The Pitt News*, 22 Aug. 2006. http://media.www.pittnews.com/media/storage/paper879/news/2006/08/22/AE/Graffiti.Punk.Rock.Posters.Featured.In.Warhol.Exhibit-2221899.shtml.

Spencer, Amy. *DIY: The Rise of Lo-Fi Culture*. London: Marion Boyars Publishers, 2005.

Spitz, Ellen Handler. *Image and Insight: Essays in Psychoanalysis of the Arts*. New York: Columbia University Press, 1993.

Sprouse, Martin. "An Interview with *World War II Illustrated*." *Maximumrocknroll* #94, March 1991.

Stabb, John. Liner Notes. *Government Issue. A HarD.C.ore Day's Night*. Dr. Strange Records, 2008.

Stark, James. *Punk '77*. San Francisco: RE/Search Publications, 2006.

Steele-Perkins, Christopher, and Richard Smith. *The Teds*. London: Travelling Light/Exit, 1979.

Stegall, Tim, and Al Flipside. "Complete Dickies." *Flipside* #60 (1989).

Stein, Arlene. *Shameless: Sexual Dissidence in American Culture*. New York: New York University Press, 2006.

Stevens, Andrew. "Turning Rebellion into Money: An Interview with Andy Czezowski and Susan Carrington." *3 A.M. magazine*, 2003. Accessed 4 November 2009. http://www.3ammagazine.com/music archives/2003/jan/interview_andy_czezowski.html.

Stewart, Neil. "Sound and Vision: Hardcore Is Alive and Well in Montreal." *Bandersnatch*, October 15, year unknown.

Story, D.J. "Last Will." Column in *Maximumrocknroll* #152, January 1996.

Suicidal Tendencies. Interview. *Flipside* #40 (1983).

Sukenick, Ronald. *Down and In: Life in the Underground*. Sag Harbor, NY: Beech Tree Books, 1987.

Sunshine, Aaron. "Black Randy." *Perfect Sound Forever*, May 2002. Accessed 19 April 2008. http://www.furious.com/Perfect/blackrandy.html.

Sylvain, Sylvain. "An Interview with Sylvain Sylvain of the New York Dolls." *Brooklyn Vegan*, 18 August 2006. Accessed 4 April 2010. http://www.brooklynvegan.com/archives/2006/09/an_interview_wi_11.html.

Szemere, Anna. *Up from the Underground: The Culture of Rock Music in Post Socialist Hungary*. University Park: Penn State University Press, 2001.

Tanooka, Tim. "Bad Brains." *Ripper* #7 (1982).

Testa, Jim. "Mike Watt: Tugboat or Minuteman? Contemplating the Hereafter." *Jersey Beat* #72, Fall/Winter 2002.

Thomas, W. Sheehan. "Iggy's Blues." *Journal of Popular Music Studies* 19.2 (2007).

Thomaso. "Interview with the Adolescents." *Maximumrocknroll* #67, December 1988.

Thompson, Robert Farris. "Requiem for the Degas of the B-Boys." *Artforum*, May 1990.

Todd, Shaggy AKA PunkRod. 2006. http://greaserama.com.

Traber, Daniel. "L.A.'s 'White Minority.' Punk and the Contradictions of Self-Marginalization." *Cultural Critique.* 48.1 (2001).

——. *Whiteness, Otherness, and the Individualism Paradox from Huck to Punk.* New York: Palgrave/Macmillan, 2007.

Trakin, Roy. "Blondie: If Music Be the Flood of Love Play On." *Hit Parader*, June 1981.

——. "Suicide Commits Itself." *New York Rocker*, May 1980.

True, Everret. *Hey Ho Let's Go: The Story of the Ramones.* London: Omnibus Press, 2002.

"T-Snakes, Mydolls, No Go Go's." *Free Beer Press.* Date unknown.

Turcotte, Bryan Ray, and Christopher Miller. *Fucked Up and Photocopied: Instant Art of the Punk Rock Movement.* Updated. Berkeley, CA: Gingko Press, 2001.

Turner, Grady. "Raymond Pettibon." *Bomb* magazine, Fall 1999.

Turner, Randy "Biscuit." Editorial. In *My Rules*, by Glen E. Friedman. Burning Flags Press, 1982.

——. "Punk Hoedown from the Sticks to the Streets." *Left of the Dial* #7 (2004).

Vale, V. "An Interview with Billy Childish." *Real Conversations No. 1.* San Francisco: RE/Search Publications, 2001.

——. "An Interview with Henry Rollins." *Real Conversations No. 1.* San Francisco: RE/Search Publications, 2001.

Vale, V., and James Stark. *Punk '77.* 3rd Edition, San Francisco: RE/Search, 2006.

Vallen, Mark. "Punk Flyers from 1977 Los Angeles." *Art for a Change.* Accessed 2007. http://www.art-for-a-change.com/Punk/pflyers.htm.

Vassel, Nicola. "Rapping With." *Jean Michel Basquiat: 1981, the Studio of the Street.* Ed. Diego Cortez, et al. Milan: Charta, 2007.

Vee, Tesco. "Interview with Tesco Vee." *Puddle Diver*, 1987.

Verdi, V. Letter to the Editor. *Maximumrocknroll* #32, January 1986.

Vig. "Behind the Scenes: Ottawa Offers." *Maximumrocknroll* #28, September 1985.

Walker, John A. "Overview of Situationalism." *Cross-Overs: Art into Pop/Pop into Art.* London: Metheun, 1987.

Wallechinsky, David, Amy Wallace, Ira Bassen, and Jane Farrow. *The Book of Lists: The Original Compendium of Curious Information.* Canada: Knopf, 2005.

Waller, Don. "In Search of the Elephant's Belle." *Make the Music Go Bang.* Ed. Don Snowden. New York: St. Martin's, 1997.

Walsh, Peter. "Mapping Social and Cultural Space: The Ramifications of the Street Stencil." Essay published to coincide with *On the Street—Off the Street* exhibition at Maryland Art Place. 1996. Accessed 28 December 2007. www.stencilpirates.org.

Walter. "Interview with Larissa from Laughing Hyenas." *Maximumrocknroll* #94, March 1991.

Warr, Tracey. *Panic Attack: Art in The Punk Years.* Ed. Ariella Yedgar and Mark Sladen. London: Merrell, 2007.

Weasel, Ben. Column. *Maximumrocknroll* #98, July 1991.

Weisbard, Eric. "Punk's Twenty-Fifth Anniversary." *Spin*, May 2001.

Weiss, Eric. "The Bad Brains." *Rumpshaker* #5 (2000).

Weissman, Benjamin. "Review of Pettibon's show at the Richard Bennet Gallery." *Artforum*, May 1990.

Weller, Paul. Interview. *Uncut* (1993).

Welly. "The Art of Shawn Kerri." *Artcore* #18 (2002/2003).

——. "Interview with the Biscuit Bombs." *Artcore* #21 (2004).

Wendy and Golf. "An Interview with Agnostic Front." *Guillotine* #8 (1984).

Wendy, Golf, and Annette. "An Interview with Iron Cross." *Guillotine* #8 (1984).

Whitall, Susan. "The Clash Clamp Down on Detroit Or: Give 'Em Enough Wisniowka." *Creem*, June 1980.

Wiggins, Nevill. "Theatre of Hate." *Punk Lives* #1 (1982).

Wilkins, Scott. "Interview with Stisism." *Maximumrocknroll* #154, March 1996.

Williams, Kevin. "The Many Sides of Guitar Monster Greg Ginn Will Be on Display." *Chicago Tribune*, 27 March 2009. Accessed on Web 8 March 2010.

Willis, Susan. "Hardcore, Subculture American Style." *Critical Inquiry*, Winter 2003.

Wing, Chris. *Big Book of Austin Punk-Era Posters and Images.* Self-published, 2003.

Wojcik, Daniel. *Punk and Neo-Tribal Body Art.* Jackson: University Press of Mississippi, 1995.

Wood, Robert. *Straightedge Youth: Contradictions and Complexities of a Subculture.* Syracuse, NY: Syracuse University Press, 2006.

Worth, Liz. "On a Mission . . . Bad Brains Stops and Starts." *www.exclaim.ca*, July 2007. Accessed 3 January

2008. http://www.exclaim.ca/articles/multiarticlesub.a spx?csid1=112&csid2=9&fid1=26374.

Yohannen, Tim. Column. *Maximumrocknroll* #21, January 1985.

———. "Dead Kennedys . . . Call it a Day—Jello Talks of the Past, Present, and Future." *Maximumrocknroll* #44, January 1986.

———. "Interview with False Prophets." *Maximumrocknroll* #46, March 1987.

———. Interview with Tomas. *Maximumrocknroll*, 1989.

Young, Charles M. "Rock Is Sick and Living in London: A Report on The Sex Pistols." *Rolling Stone*, 20 October 1977.

———. "Visions of Patti." *Rolling Stone*, 27 July 1978.

Young, Jon. "Outside the Bands Don't Toe the Line." *Trouser Press* #59, February 1981.

Youth Report. Bomp Records. 1982.

Zamyatin, Yevgeny. "We." *Russian Literature of the 1920s: An Anthology*. Ed. Carl A. Proffer. New York: Ardis, 1987.

Zanes, R. J. Warren. "Too Much Mead?" *Reading Rock 'n' Roll: Authenticity, Appropriation, and Aesthetics*. Ed. Kevin Dettmar and William Richey. New York: Columbia, University Press, 1999.

Zeff, Sharisse. "Talking Heads' Music for the Global Village." *Upbeat*, January 1981.

Interviews and Personal Correspondence with the Author

Arenas, Norm. Interview. 15 January 2007.

Barber, Tony. Phone interview. September 2008.

Barnett, Thomas. "History Is the Uneven Deeds of Humanity: Left of the Dial Consults Thomas Barnett of Strike Anywhere." *Left of the Dial* #8 (2005).

Bondage, Michelle. Email interview. 14 May 2008.

Bondage, Mish. Email interview. Spring 2008.

Buckner, Richard, and Alejandro Escovedo. Interview. *Thirsty Ear*, February/March 2000.

Buzzcocks. "An Interview with the Buzzcocks." *Left of the Dial* #5 (2004).

Case, Peter. Interview. 2008.

Chrome, Cheetah. Interview. April 2010.

Circle Jerks. "Circle Jerks: Live Long in the Day of the Jackal." *Left of the Dial* #2 (2002).

Cooper, Paul. Email. January 2008.

Delgado, J. R. Interview. 15 February 2009.

Dictor, Dave. Interview. September 2008.

Doll Rod, Margaret. "Punk Rock Folklore: The Words of Women." 2008. http://visualvitriol.wordpress.com/punk-rock-folklore-the-words-of-women/.

Easy Action. "Talkin Trash with John and Ron from Easy Action." *Left of the Dial* #2 (Winter 2002).

El Vez. Interview. 2002.

Embil, Juan. Interview. 18 February 2009.

England, Sabina. Interview. September 2010.

Fancher, Lisa. "From Frontier to Eternity: A Talk with Frontier Records' Lisa Fancher." *Left of the Dial* #8 (2005).

Floyd, Gary. "Interview with Gary Floyd of the Dicks." *Left of the Dial* #1 (2001).

Gastelum, Victor. "Inked and Amped Up Between the Lines. An Interview with Victor Gastelum." *Left of the Dial*, February 2008. http://www.leftofthedialmag.com/index.php?s=gastelum.

Greta from Bang Bang. "Punk Rock Folklore: The Words of Women." 2008. http://visualvitriol.wordpress.com/punk-rock-folklore-the-words-of-women/.

Guerrero, Rosa. Interview. February 2009.

Hannah, Chris. Interview. *Left of the Dial*, 2004.

Harper, Charlie. Interview. 2004.

Herrera, Trish. Interview. 20 February 2009.

Jarboe. "The End Is Just Another Way to Say Begin Again: What We Talk About When We Talk to Jarboe." *Left of the Dial* #7 (2004).

Jones, Christopher. Email interview. 24 April 2008.

Kaa, James. Interview. 2008.

Kinman, Tony. "Interview with Tony Kinman of the Dils." *Left of the Dial* #3 (2002).

Kramer, Wayne. Interview. 2001.

Larsen, Al. Interview. June 2010.

Liberace of Black Flag. Email interview. 11 February 2008.

MacKaye, Ian. "Interview with Ian MacKaye." *Left of the Dial* #1 (2001).

Magrann, Michael. "Don't Turn the Channel: An Interview with Michael Magrann of Channel 3." *Left of the Dial* #3 (2003).

Medina, Bob. Email. November 2008.

Medina, Maraya. Interview. October 2010.

Miller, Gina. Interview. August 2010.

Miller, Steve. Email interview. 21 May 2010.

Palm, Mike. Interview. June 2010.

Philips, Mark. Email interview. August 2009.

Ray, Dianna. Interview. 15 February 2009.

Reyes, George. Interview. February 2009.

Reynolds, Simon. Interview. 2006.

Robb, John. "An Interview with John Robb of Goldblade and the Membranes." *Left of the Dial*. 2 April 2007. http://www.leftofthedialmag.com/index.php?s=john+robb.

Roehik, Jan. Interview. 2008.

Roessler, Kira. "Uno: The Often Invisible Life of Kira Roessler of Black Flag and Dos." *Left of the Dial*, 30 August 2006. http://www.leftofthedialmag.com/?p=94.

Rollins, Henry. "Interview." 2007. Queerpunks.com.

Schow, Deborah. Interview. 2010.

Scott, Dave. Email interview. Spring 2010.

Sensible, Captain. Interview. 2003.

Smith, Freak. Interview. 2009.

Smith, Jeff. Interview. 2006.

Soto, Steve. "An Archive Interview with Steve Soto of the Adolescents and Manic Hispanic." *Left of the Dial*. 16 August 2006. http://www.leftofthedialmag.com/index.php?s=Steve+Soto.

Stern, Shawn. "Punk Blood Brothers: A Look Back with Youth Brigade/BYO Co-founder Shawn Sterns. Part II." *Left of the Dial* #8 (2005).

Stevenson, Bill. "Man Versus Machine: An (Un)Simple Story. An Interview with Bill Stevenson." *Left of the Dial* #5 (2003).

Stevenson, James. "Interview with James Stevenson." *Left of the Dial*, 17 April 2007. http://www.leftofthedialmag.com/index.php?s=james+stevenson.

T., Dina. Email interview. 16 January 2008.

Thomas, David. Interview. 10 October 2004.

Togay, Ben. "Got the Queer Edge: An Interview with Youth of Togay." Interview with Ben Togay. 13 April 2008. http://www.leftofthedialmag.com/index.php?s=youth+of+togay.

———. Email interview. 2 October 2008.

TSOL. "Interview with TSOL." *Left of the Dial* #1 (2001).

U-Ron. "One Eye on U-Ron from Really Red." *Left of the Dial* #8 (2004/2005).

Watt, Mike. "Punk Rock Could Be Your Life: An Interview with Mike Watt." *Left of the Dial* #3 (2002).

Welly. Interview. 2010.

Weulfing, Howard. Email interview. 20 August 2008.

Williams, John Paul. "It's Not Just Entertainment: The Legacy of Really Red. An Interview with John Paul Williams." *Maximumrocknroll* #323, April 2010.

Index